More praise for *Compassion Fatigue*

"This is a very important book. Criticism of the American press — broadcast and print — for its foreign coverage is hardly new, but Professor Moeller does a masterful job of exposing the causes and the results of this failure. Her work should open the public's eyes, and, indeed, those of the press itself, to the danger to our democracy if remedy is not forthcoming."

— Walter Cronkite

"*Compassion Fatigue* demystifies the editorial formulas which lead to homogenized, Americanized and unconscionably thin international news coverage. In this important work, Susan Moeller holds American news moguls, editors, jouranalists and their audiences accountable for failing to overcome public apathy and to assume the unprofitable responsibility to accurately report and measure the human significance of epidemic, assassination, massacre and famine."

— Scott Armstrong, former *Washington Post* reporter, founder of the National Security Archive and co-author of *The Brethren*

COMPASSION FATIGUE

WITHDRAWN

**HOW THE MEDIA SELL
DISEASE, FAMINE, WAR AND DEATH**

SUSAN D. MOELLER

Routledge
New York and London

Published in 1999 by
Routledge
29 West 35th Street
New York, NY 10001

Published in Great Britain by
Routledge
11 New Fetter Lane
London EC4P 4EE

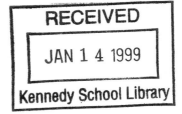

10 9 8 7 6 5 4 3 2 1

Library of Congress Cataloging-in-Publication Data

Moeller, Susan D.
 Compassion fatigue : how the media sell disease, famine, war, and
death / Susan D. Moeller.
 p. cm.
 Includes index.
 ISBN 0-415-92097-3 (hardbound : alk. paper)
 1. Disasters—Press coverage—United States. 2. War—Press
coverage—United States. 3. Television broadcasting of news—United
States. 4. Sensationalism in journalism—United States. I. Title.
PN4888.D57M64 1998
070.4'4936334—dc21
 98-14075
 CIP

To
Walden Jeffrey Davis
and
Sethly Martin Davis

who made my writing on this subject
so much more than an intellectual exercise.

With all my love.

CONTENTS

FIVE

INTRODUCTION:
RIDING WITH THE
FOUR HORSEMEN

The leaders of the new world disorder are the Four Horsemen of the Apocalypse: famine, war, death and pestilence.

—John Omicinski,
"'Superpower' Disappearing from Lexicon,"
Gannett News Service, July 30, 1994

While we debate how to improve our health care system, build the information superhighway and protect the spotted owl, the Four Horsemen of the Apocalypse—War, Disease, Famine and Death—gallop . . . leaving behind scenes of unspeakable horror which occasionally burst onto our TV screens or momentarily claim our attention.

—J. R. Bullington,
"No Easy Solutions to End Suffering,"
The Virginian-Pilot, September 4, 1994

"The Four Horsemen are up and away, with the press corps stumbling along behind," charged activist Germaine Greer, after a series of debacles in 1994, ranging from ethnic slaughter in Rwanda and Bosnia, famine in the Horn of Africa and an outbreak of flesh-eating bacteria in Britain. "At breakfast and at dinner, we can sharpen our own appetites with a plentiful dose of the pornography of war, genocide, destitution and disease."[1]

Sometimes, like in 1994, it seems as if all that the media cover are those regions of the world trampled by the Four Horsemen of the Apocalypse. At times it seems as if the media careen from one trauma to another, in a breathless tour of poverty, disease and death. The troubles blur. Crises become one crisis.

Why do the media cover the world in the way they do? We stagger to follow their lead. Is our balance off? Or is theirs?

If the operating principle of the news business is to educate the public, why do we, the public, collapse into a compassion fatigue stupor? Are we too dull to keep up with the lessons? Or are the lessons themselves dulling our interest?

Compassion fatigue is the unacknowledged cause of much of the failure of international reporting today. It is at the base of many of the complaints about the public's short attention span, the media's peripatetic journalism, the public's boredom with international news, the media's preoccupation with crisis coverage.

What does compassion fatigue do? It acts as a prior restraint on the media. Editors and producers don't assign stories and correspondents don't cover events that they believe will not appeal to their readers and viewers.

Compassion fatigue abets Americans' self-interest. If conventional wisdom says that Americans are only interested in their own backyard, the media will prioritize stories where American political, cultural or commercial connections are evident.

Compassion fatigue reinforces simplistic, formulaic coverage. If images of starving babies worked in the past to capture attention for a complex crisis of war, refugees and famine, then starving babies will headline the next difficult crisis.

Compassion fatigue ratchets up the criteria for stories that get coverage. To forestall the I've-seen-it-before syndrome, journalists reject events that aren't more dramatic or more lethal than their predecessors. Or, through a choice of language and images, the newest event is represented as being more extreme or deadly or risky than a similar past situation.

Compassion fatigue tempts journalists to find ever more sensational tidbits in stories to retain the attention of their audience.

Compassion fatigue encourages the media to move on to other stories once the range of possibilities of coverage have been exhausted so that boredom doesn't set in. Events have a certain amount of time in the limelight, then, even if the situation has not been resolved, the media marches on. Further news is pre-empted. No new news is bad news.

Compassion fatigue is not an unavoidable consequence of covering the news. It is, however, an unavoidable consequence of the way the news is now covered. The chapters that follow identify the ruts into which the media have fallen in their coverage of international crises. Through these studies, the media's repetitive chronologies, sensationalized language and imagery and Americanized metaphors and references are compared and exposed. Through these studies the inevitability of compassion fatigue is made apparent.

. . .

Sixty years ago, in the fall of 1938, Britain's Prime Minister Neville Chamberlain traveled to Munich and together with the leaders of France and Italy signed a pact of appeasement with German Führer Adolf Hitler. Chamberlain returned to England and announced "peace with honour" and "peace for our time." The dozens of photographers covering the Munich Conference and Chamberlain's return captured pictures of the prime minister, the quintessential Englishman, standing thin and tall, smiling slightly, with a furled umbrella on his arm. The world recalled those images when less than six months later Hitler's forces swallowed Czechoslovakia, and less than a year later when the German army marched into Poland and began World War II.

To this day heads of state do not carry furled umbrellas.

For years I thought I was the only one who remembered the world around me through images. Ask me about the piano lessons of my childhood and I am more likely to recall the crocus-strewn lawn outside the studio where I took my lessons than any piece of music that I so painfully memorized. Ask me about the years I spent swimming competitively and I am more likely to remember the elderly man stricken with polio who watched my team practice than the hours of repetitive laps that I swam.

As I remember the events of my life, so too do I remember the history of the larger world. I remember the unusual and the extraordinary, not the quotidian and familiar. "Important" global events, with negligible exceptions, have taken place outside my ability to witness them. So I have experienced those happenings in the same fashion as most people—I read about them in the paper or I watched them take place on television. Like most Americans my age and older I can tell you where I was when John F. Kennedy was shot, and I clearly remember sitting in front of the television that weekend for the funeral. Certain scenes fascinated me: I engraved in my mind the images of the boots placed backward in the horse's stirrups, the black veil which hid but didn't hide the grieving Jackie Kennedy's expression, the solemnity of the two children as they watched their father's cortege. Years later, when I studied the assassination, I was shocked to realize that Caroline Kennedy was my age—I had so successfully frozen my image of her at age 6 at her father's funeral.

It was only after college, while working as a graphic designer and then later as a photographer, that I began to realize I was not the only one who organized the world according to images. I began to appreciate the power of images and the near-absolute power of the right image. But it wasn't until I returned to graduate school and then began to teach in universities that I began to systematically investigate the media's ability, and even authority, to categorize the world by images.

Now I frequently travel around the country, giving lectures about how the American news media cover world affairs. In the course of my talks I refer to several of the major incidents, disasters and wars of the last 30 years. And I have found that whether I am speaking in San Diego or in Boston my audience has a common recollection of these events — a recollection consisting not of personal, firsthand memories but of memories strained from the media's coverage.

In some respects my audiences have a homogeneous method of gathering the news: People from California and Massachusetts alike tune in to the network news, read the national newsweeklies and receive wire service accounts in their daily papers. That homogeneity helps to account for the similarity of images people recall of international affairs. To a great extent the audiences I have talked to hold the same images of major world events. They might interpret those images differently from one another, but to a surprising degree the original images are identical — they are the dramatic ones, the ones depicting violence, the ones prompting emotion. Through a mental inventory of these images it becomes evident that the public doesn't remember and the media rarely fix on the everyday affairs of other countries. Their meat and potatoes are the moments of crisis: the fear of Ebola, the pathos of Ethiopia, the shock of Rabin's assassination, the horror of death camps again in Europe. Such images have become international news. Such images are what we, the American people, know of the rest of the world.

Is crisis coverage really "image"-driven? What is the meaning and importance of our categorization of crises by images — by narrative images, photographic images, video images? Why, despite the haunting nature of many of these images, do we seem to care less and less about the world around us?

I wrote this book to answer these questions.

This work analyzes four sets of case studies, organized around the crises represented by the Four Horsemen of the Apocalypse — pestilence, famine, death/assassination and war/genocide. These "Four Horsemen" chapters are the investigative backbone of this work. I spent a long, careful and even painful time selecting which crises should be included.

First, I tried to analyze recent case studies. Most are drawn from the 1990s — although some crises do date back into the 1980s. But further than that I did not go. Since 1980, changes in computer and satellite technologies, mergers and acquisitions among the media and the creation of institutions such as CNN and *USA Today* have made it difficult, if not impossible, to extrapolate meaningful comparisons and conclusions across a longer period of time.

Second, I tried to choose those case studies that would illuminate certain key

questions about the media's coverage of different regions of the world. Do the media cover crises in Europe in the same way as crises in Asia or Africa, for instance? I tried to select parallel troubles within the time frame I had set myself, in order to better gauge the validity of my theories. I was curious to determine, for example, whether all famines which take place in the developing world receive the same kind of attention. I was also interested to discover whether the assassination of Israel's head of state, for instance, received the same amount and style of coverage as the assassination of the head of state of Egypt — or of India and Pakistan for that matter. (My selection of parallel events, however, has led to one glaring omission among my list of case studies. I look at no crisis that occurred in the Western Hemisphere. And while I believe my conclusions hold across time and space, other scholars might well want to test my arguments by analyzing the media's coverage of crises in the Americas.)

In all cases I was especially motivated to investigate exactly how the media covered these particular events. Typically we, as media consumers, are so fixated on what the media are telling us that we don't stop to inquire how and why they are saying what they say and showing what they show. The method and manner of the media's coverage are effectively invisible. The meaning of the media's coverage of crises is rarely examined, but its import is incalculable — hence the imperativeness of studying and scrutinizing it.

At times in this work, I refer to the media as if they were a single entity. Of course, they are not. In my research for this book I have focused primarily on the U.S.-based media (a distinction that is increasingly hard to make, as news-sharing agreements, cooperatives and mergers make such definitions less meaningful). I have looked at CNN and the three major television networks: ABC, CBS and NBC; the three major newsweeklies: *Time, Newsweek* and *U.S. News & World Report*; the wire services: Associated Press and United Press International and, to a lesser extent, Reuters; and most of those major newspapers which support substantial foreign bureaus: *The Boston Globe, The New York Times, The Wall Street Journal, The Washington Post, USA Today, The Miami Herald,* the *Chicago Tribune* and the *Los Angeles Times.* At times there is a uniformity of coverage among the television networks, the magazines and the newspapers. On other occasions the demands of the different kinds of media, as well as the different news managements, mandate extremely different coverage — in both style and content. How different that coverage is, is a major question addressed in the following chapters.

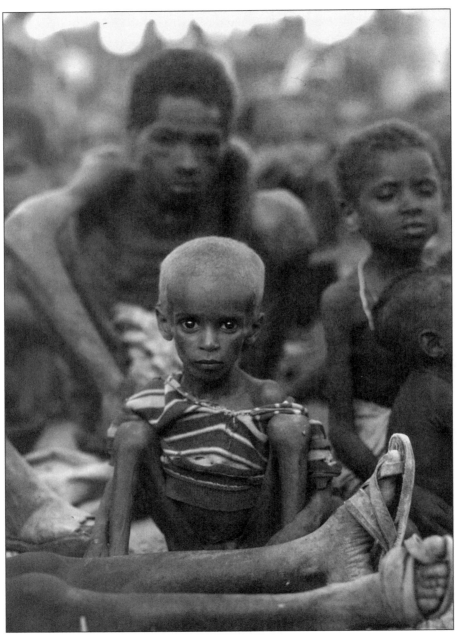

"The Road to Hell," *Newsweek*, 21 September 1992
"Moral imperatives may soon take precedence: Starving orphan in the village of Wajid."

CHAPTER ONE

COMPASSION FATIGUE

1991 was a bad year. Disasters occurred all over the globe: Earthquakes in Soviet Georgia, Iran and Costa Rica killed hundreds and left tens of thousands homeless; a cholera epidemic in Peru killed more than a thousand and infected another 145,000; a cyclone in Bangladesh killed 138,000 and destroyed a million and a half homes; war in Iraq turned two million Kurds into refugees from Saddam Hussein and killed tens of thousands as they fled over the mountains; and famine and civil war in Africa killed hundreds of thousands and left 27 million at risk.

By early May, spokespeople for international organizations and the relief agencies had run out of hyperboles. "We have had an unprecedented spate of disasters," said Philip Johnston, president of CARE. "We're dealing with 15 of them at the moment." "The needs are overwhelming," said Al Panico, director of international relief for the American Red Cross. James Grant, executive director of UNICEF, said, "These are really the most severe set of problems one can remember coming at one time since the end of World War II." And Richard Walden, president of Operation USA, called the flare-up of global crises "biblical in proportion."[1]

The international organizations and the relief agencies were forced to practice institutional triage. The Red Cross workers who had experience with earthquakes were tied up aiding Kurdish refugees. Crates of medical supplies, especially intravenous solutions, had been shipped to fight the cholera in Peru, and so were unavailable to send to the cyclone victims in Bangladesh. Blankets and weatherproofing materials needed in Bangladesh had already gone to help the Kurds fleeing Iraq. And food, flashlights, water-purification tablets and water-storage containers were scattered too thinly between famine-stricken regions in Africa and earthquake zones in Central America, the Middle East and Central Asia. Tom Drahman, CARE's manager for Asia, said, "People that have been doing this for a long time are hard-pressed to recall a time in history

where things have been so dramatic. It seems there is a disaster, not only of the week, but of the day. It has to stretch (our) finite resources."[2]

Like emergency-room triage, triage of emergencies does not necessarily mean that the sickest case gets the first and most help. Sometimes the sickest case is the most hopeless case, and receives little more than a Band-Aid of care—just enough so the hemorrhaging is not embarrassing. In the spring of 1991, the short-term calamities eclipsed the longer-term and ultimately more deadly disasters of famine and war. Americans viewed the damages caused by the cyclone and earthquakes as one-shot problems with specific solutions. And they felt guilty about the Kurdish refugee situation, remorseful that the United States hadn't come to the aid of the rebellion. As a *New York Times* editorial put it: "The plight of the Kurds has priority, since their exodus directly resulted from an American-led war against Iraq."[3] So the refugees and the cyclone and earthquake victims received an outpouring of attention and support. But the starving in Africa, in numbers far greater than the victims of the earthquakes, cyclone, cholera and Persian Gulf War combined, received relatively little political or media attention until late in the summer of the following year.

With not "enough money, manpower or sympathy to go around," wrote *Newsweek*, fears for the displaced Kurds and concern for the fate of Bangladesh "submerged an even deeper dilemma: the plight of sub–Saharan Africa . . . in what Save the Children, a relief agency, calls, 'the worst famine in Africa in living memory.'" "People worldwide must have the feeling of 'African famine again?'" said Dr. Tatsuo Hayashi of the Japan International Volunteer Center. "Donors are tired of repetitious events, and Sudan and Ethiopia are repetitious," said a CARE official in Nairobi. "Every time there's a famine in Africa . . . you can always count on somebody asking, 'Hey didn't they just do that last year?'"[4]

1991 was different than the halcyon years of the mid-1980s when African famine relief was in vogue. In the eighties, Americans were able to focus on one international catastrophe. A BBC videotape of skeletal Ethiopian children dying as the camera rolled aired on NBC in late October 1984 and galvanized public sympathy. The entertainment industry came onboard en masse with the global hookup of the Band Aid and Live Aid concerts. And the song "We Are the World," recorded in 1985 by stars such as Michael Jackson, Harry Belafonte, Stevie Wonder and Bruce Springsteen, made famine relief the year's cause célèbre.

Six years later, news of African famine evoked a "been there, done that" attitude. "For the most part," said *Newsweek* in May 1991, the famine in Africa "has not captured the attention of the world press. Journalists already visited this tragedy, during the sub-Saharan famine from 1984 to 1985 that took more than a million lives. Rock stars threw benefit concerts to help raise almost $300 million

in relief aid. That the problem has returned full force might seem a slap in the face of philanthropy."[5]

"Traditional donors, battered by so many appeals, are weary of pouring money into crises that never seem to go away," said reporter Elaine Sciolino in *The New York Times* that same month. "The result," she added, "is a discouragingly contagious compassion fatigue."[6]

It all started with an advertising campaign. We have all been cued by that famous series of ads by Save the Children. You can help this child or you can turn the page. The first time a reader sees the advertisement he is arrested by guilt. He may come close to actually sending money to the organization. The second time the reader sees the ad he may linger over the photograph, read the short paragraphs of copy and only then turn the page. The third time the reader sees the ad he typically turns the page without hesitation. The fourth time the reader sees the ad he may pause again over the photo and text, not to wallow in guilt, but to acknowledge with cynicism how the advertisement is crafted to manipulate readers like him — even if it is in a "good" cause. As the *Chicago Tribune*'s 1998 series investigating four international charities bluntly stated, "Child sponsorship is one of the most powerful and seductive philanthropic devices ever conceived."[7]

Most media consumers eventually get to the point where they turn the page. Because most of us do pass the advertisement by, its curse is on our heads. "Either you help or you turn away," stated one ad. "Whether she lives or dies, depends on what you do next." Turning away kills *this* child. We are responsible. "Because without your help, death will be this child's only relief."[8] In turning away we become culpable.

But we can't respond to every appeal. And so we've come to believe that we don't care. If we turn the page originally because we don't want to respond to what is in actuality a fund-raising appeal, although in the guise of a direct humanitarian plea, it becomes routine to thumb past the pages of news images showing wide-eyed children in distress.

We've got compassion fatigue, we say, as if we have involuntarily contracted some kind of disease that we're stuck with no matter what we might do.

But it's not just the tactics of the advocacy industry which are at fault in our succumbing to this affliction. After all, how often do we see one of their ads, anyway? . . . unless it's Christmastime and we're opening all our unsolicited mail.

It's the media that are at fault. How they typically cover crises helps us to feel overstimulated and bored all at once. Conventional wisdom says Americans have a short attention span. A parent would not accept that pronouncement on

a child; she would step in to try to teach patience and the rewards of stick-to-itiveness. But the media are not parents. In this case they are more like the neighborhood kid who is the bad influence on the block. Is your attention span short? Well then, let the media give you even more staccato bursts of news, hyped and wired to feed your addiction. It is not that there's not good, comprehensive, responsible reporting out there. There is. "Sometimes," said the late Jim Yuenger, former foreign editor with the *Chicago Tribune,* "you put the news in and people just aren't going to read it and you have to say the hell with it."[9] But that type of coverage is expensive as well as space- and time-consuming. It rarely shows enough bang for the buck. So only a few elite media outlets emphasize such coverage, and even they frequently lapse into quick once-over reporting. "We give you the world," yes, but in 15-second news briefs.

The print and broadcast media are part of the entertainment industry—an industry that knows how to capture and hold the attention of its audience. "The more bizarre the story," admitted UPI foreign editor Bob Martin, "the more it's going to get played."[10] With but a few exceptions, the media pay their way through selling advertising, not selling the news. So the operating principle behind much of the news business is to appeal to an audience—especially a large audience—with attractive demographics for advertisers. Those relatively few news outlets that consider international news to be of even remote interest to their target audiences try to make the world accessible. The point in covering international affairs is to make the world fascinating—or at least acceptably convenient: "News you can use." "When we do the readership surveys, foreign news always scores high," said Robert Kaiser, former managing editor of *The Washington Post.* "People say they're interested and appreciate it, and I know they're lying but I don't mind. It's fine. But I think it's an opportunity for people to claim to be somewhat better citizens than they are."[11]

But in reality, they're bored. When problems in the news can't be easily or quickly solved—famine in Somalia, war in Bosnia, mass murder of the Kurds—attention wanders off to the next news fashion. "What's hardest," said Yuenger, "is to sustain interest in a story like Bosnia, which a lot of people just don't want to hear about." The media are alert to the first signs in their audience of the compassion fatigue "signal," that sign that the short attention span of the public is up. "If we've just been in Africa for three months," said CBS News foreign editor Allen Alter, "and somebody says, 'You think that's bad? You should see what's down in Niger,' well, it's going to be hard for me to go back. Everybody's Africa'd out for the moment." As Milan Kundera wrote in *The Book of Laughter and Forgetting,* "The bloody massacre in Bangladesh quickly covered over the memory of the Russian invasion of Czechoslovakia, the assassination of Allende drowned

out the groans of Bangladesh, the war in the Sinai Desert made people forget Allende, the Cambodian massacre made people forget Sinai and so on and so forth, until ultimately everyone lets everything be forgotten."[12]

The causes of compassion fatigue are multiple. Sometimes there are just too many catastrophes happening at once. "I think it was the editor Harold Evans," said Bill Small, former president of NBC News and UPI, "who noted that a single copy of the [London] *Sunday Times* covers more happenings than an Englishman just a few hundred years ago could be expected to be exposed to in his entire lifetime."[13] In 1991, for instance, it was hard not to be overwhelmed by the plethora of disasters.

So compassion fatigue may simply work to pre-empt attention of "competing" events. Americans seem to have an appetite for only one crisis at a time. The phenomenon is so well-known that even political cartoonists make jokes about it, such as the frame drawn by Jeff Danziger of a newsroom with one old hack saying to someone on the phone: "Tajikistan? Sorry, we've already got an ethnic war story," and another old warhorse saying on another phone: "Sudan? Sorry we've already got a famine story."[14]

Even during "slower" disaster seasons, there is always a long laundry list of countries and peoples in upheaval. Many and perhaps most of the problems are not of the quick-fix variety—the send-in-the-blankets-and-vaccination-supplies-and-all-will-be-well emergencies. Most global problems are entrenched and long-lasting, rarely yielding to easy solutions available to individuals or even NGO and governmental authorities. "The same theme just dulls the psyche. For the reader, for the reporter writing it, for the editor reading it," said Bernard Gwertzman, former foreign editor at *The New York Times*.[15]

Tom Kent, international editor at the Associated Press, noted the same problem in covering ongoing crises. "Basically, in our coverage we cover things until there's not much new to say. And then we back off daily coverage and come back a week or a month later, but not day-to-day." He could tell, he said, when the sameness of the situation was drugging an audience into somnolence.

> We can certainly get a sense for the degree that people care about a story in the public. For example, when Bosnia started, people were calling up all the time for addresses of relief organizations and how we can help and all that. We did lists, and then requests dropped off. And in the first part of the Somalia story we heard "How can we help?" "How can we get money to these people?" We sent out the lists, then those calls dropped off. Either the people who wanted to contribute had all the information they needed, or there just wasn't

anybody else who was interested. In Rwanda, we got practically no inquiries about how to help, although our stories certainly suggested there's as much misery in Rwanda as anywhere else.[16]

Sometimes to Americans, international problems just seem too permanent to yield to resolution. Sometimes even when problems flare out into crisis—by which point it is too late for the patch-'em-up response—the public is justified in believing that outside intervention will do little good . . . so what's the use in caring?

It's difficult for the media and their audience to sustain concern about individual crises over a period of months and maybe even years. Other more decisive—and short-term—events intervene, usurping attention, and meanwhile, little seems to change in the original scenario. There is a reciprocal circularity in the treatment of low-intensity crises: the droning "same-as-it-ever-was" coverage in the media causes the public to lose interest, and the media's perception that their audience has lost interest causes them to downscale their coverage, which causes the public to believe that the crisis is either over or is a lesser emergency and so on and so on.

Another, especially pernicious form of compassion fatigue can set in when a crisis seems too remote, not sufficiently connected to Americans' lives. Unless Americans are involved, unless a crisis comes close to home—either literally or figuratively—unless compelling images are available, preferably on TV, crises don't get attention, either from the media or their audience. Some of the public may turn the television off when they see sad reports from around the world, but unless the news is covered by the media, no one has an opportunity to decide whether to watch or not. "Thanks to the news media," noted *Newsweek*, "the face of grieving Kurdish refugees replaced the beaming smiles of victorious GIs." Publicity, *Newsweek* argued, "galvanized the public and forced the president's hand." In just two weeks, the Bush administration sent $188 million in relief to the Kurds.[17] It's a bit like that tree falling in the middle of the forest. If it falls and no one hears, it's like it never happened. The tree may lie on the forest floor for years, finally to rot away, without anyone ever realizing it once stood tall.

If the public doesn't know, or knowing can't relate in some explicit way to an event or issue, then it's off the radar. And that is the most devastating effect of compassion fatigue: no attention, no interest, no story. The lack of coverage of starvation in Africa in the spring of 1991, for instance—even though the famine was potentially more severe than the one in the mid-1980s—meant that there was no understanding of the crisis, no surge in donations and no public pressure on governments or international organizations to do something. Africa was not a

"headline event." Public response, humanitarian agencies believe, is in direct correlation to the publicity an event receives; the donor community depends on the media to spotlight the world's disasters. But the problem with famines, for example, is that they just aren't considered newsworthy until the dying begins. Before the massive die-off, relief agencies searched, said Joel Charney from Oxfam America in early May 1991, "to find a way to dramatize the situation in the Horn of Africa to the point where the media will begin to pay attention."[18]

Some crises are reflexively covered in the media. The media, print and broadcast alike, enthusiastically report on natural disasters, for example. These once-a-year or even once-in-a-lifetime events are in the "Wow! What a story!" category. When NBC anchor Tom Brokaw learned that one of the Yellowstone forest fires was near to an NBC correspondent who was about to do a live report near Old Faithful geyser, he exclaimed off-camera to the correspondent, "Holy shit!" The blood-pumping, adrenaline-high excitement is the reason many journalists are in the profession.[19] Crises are the stuff of myth and movies; they send a journalist's heart racing—and they also send everyone to the TV or newspaper to find out what is happening.

But much of journalism is repetitious—or at least seems that way. Turn on the news and you see crime stories, scandals, budget reports and even full-blown crises that all sound alike. Ironically, even though the uncertain outcome of a catastrophe is what makes it so compelling—both to report on and to consume as news—once the parameters of a news story have been established, the coverage lapses into formula. Mythic elements—the fearless doctor, the unwitting victim—will be emphasized, but they will fall into a pattern. Myths, after all, are stories. Some are heroic, some are tragic, most are predictable.

Formulaic coverage of similar types of crises make us feel that we really *have* seen this story before. We've seen the same pictures, heard about the same victims, heroes and villains, read the same morality play. Even the chronology of events is repeated: A potential crisis is on the horizon, the crisis erupts, the good guys rush in to save the victims but the villains remain to threaten the denouement. Only the unresolved ending makes the crisis narrative different from a Disney script where the protagonists live happily ever after. The dashing French doctors and American Marines rescued the starving brown child-victims in Somalia, for example, but the evil warlords stole away the chance for peace and prosperity. "Especially in America, we like to think of things in terms of good guys and bad guys," said Malcolm Browne, former foreign correspondent for AP, ABC and *The New York Times*. "If one of the partners in a conflict is one that most people can identify with as a good guy, then you've got a situation in which it's possi-

ble to root for the home team. That's what a lot of news is about. We love to see everything in terms of black and white, right and wrong, truths versus lies."[20]

By power of suggestion, the media so fix a conception in our minds that we cannot imagine the one thing without the other. "We do mislead," said Browne. "We have to use symbolism. Symbolism is a useful psychological tool, but it can be terribly misused. It can be misleading. It can lead to great cruelty and injustice, but all of those things are components of entertainment."[21] Once a story commands the attention of the media—or once the media deems a story worthy of attention—reporting styles, use of sources, choice of language and metaphor, selection of images and even the chronology of coverage all follow a similar agenda.

Other distortions occur. Sensationalized treatment of crises makes us feel that only the most extreme situations merit attention (although the media still self-censors the worst of the stories and images from crises—such as the most graphic pictures of those Kurds killed by Iraqi chemical weapons in Halabja or the photos of trophy bits of flesh and body parts flaunted by Somalis allied with Mohammed Farah Aidid). Dire portraits are painted through relentless images and emotional language. A crisis is represented as posing a grave risk, not only to humanity at large, but to Americans specifically. Unless a disease appears to be out of a Stephen King horror movie—unless it devours your body like the flesh-eating strep bacteria, consumes your brain like mad cow disease, or turns your insides to bloody slush like Ebola—it's hardly worth mentioning in print or on air.

It takes more and more dramatic coverage to elicit the same level of sympathy as the last catastrophe. "Can shocking pictures of suffering, which elicited so much charity in 1984, save those at risk in Africa and the Subcontinent this time?" asked *Newsweek* about the famine in 1991. "Images are stopgap measures, at best; and their repetition breeds indifference."[22] What is strong today may be weak tomorrow. Journalists want their coverage of crises to be a "page-turner," but frequently the public's response is to just "turn the page." Voilà. Compassion fatigue.

The Americanization of crises also plays into this proclivity. Americans are terribly preoccupied with themselves. The Americanization of events makes the public feel that the world subscribes, and must subscribe, to American cultural icons—and if it doesn't or can't it is not worth the bother, because clearly the natives are unworthy or the issue or event is. Media consumers are tied to a tether of cultural images. This is a fact well-known yet rarely acknowledged. Peoples in other countries know that when they use Western icons to help define their struggles the West pays greater attention. So the student democracy movement in Tiananmen Square made sure to carry their Statue of Liberty in front of the cameras and protesters outside an Indonesian courtroom sang the

civil rights anthem "We Shall Overcome" while facing the microphones. Would our interest in those events have been as great without those signifiers? We draw historical parallels and make cultural connections between our world and that of the "other." The lone man defying the Chinese authorities by standing in front of the line of tanks was for us another Patrick Henry shouting, "Give me liberty or give me death." We take for granted the placards quoting Thomas Jefferson and Martin Luther King, Jr., which are written in English—but are carried by citizens of China or Croatia or Chechnya.

And when the natives of other countries haven't drawn our parallels for us, the American media suggests similarities. "I'm big on comparisons," said Karen Elliot House, president of Dow Jones International, the parent company of *The Wall Street Journal*. "I think most people want to know are we better or worse than Poland and why." The American filter, the notion of relevance to the United States, is very important. Since our knowledge about the lands outside our borders is minimal, even the abbreviated version of events which makes it into the news has to be translated for us. "Remember all these countries in Eastern Europe have been lost to American consciousness for 50 years," said *Wall Street Journal* former foreign correspondent Walter Mossberg. "In order to get people to understand why they should care about this, you do have to resort to historical analogies."[23]

Political scientists Richard Neustadt and Ernest May noted, in their book *Thinking in Time: The Uses of History for Decision Makers*, that in "serious" situations decision makers refer to past events "in the form of analogy with someone speaking of the current situation as like some other." "The success of the Bush policy in equating Bosnia, in the public's mind, with Vietnam," commented Johanna Neuman, former foreign editor for *USA Today*, led to Clinton's "ambivalence" about involvement. "In the face of this political judgment not to intervene," Neuman said, "television pictures tugged at the public's heartstrings, but only briefly after each episode of violence. There was a half-life to public reaction, as talk about the marketplace massacre was soon replaced in television studios by analysis of the Nancy Kerrigan–Tonya Harding skating scandal."[24] The Kundera theorem of only one crisis at a time held, speeded by the use of historical precedent prompting Americans to an immediate political position— in this case a disinclination to get involved—and a disinclination to learn more.

Journalists, like the rest of us, see the world through the lens of their own culture. They, like we, can't much help it—but they could try harder to explain the world in its own terms. "Why do we have to constantly describe things in terms of American television shows?" criticized the late Karsten Prager, former managing editor of *Time International*. "Who gives a damn about the reference to Barney?"

Former *U.S. News* foreign editor John Walcott also admitted being wary of analogies, although using them himself on occasion. "I wrote one into a story a couple of weeks ago," he said in mid-1994, "where I was saying that Nelson Mandela was being called upon to be both George Washington and Abraham Lincoln to his own country. But that was merely a sort of tool for bringing home to Americans the enormity of his task and also something of his personality—because he has elements of both—to make you more familiar."[25] In this light, the assassinated Israeli Prime Minister Yitzhak Rabin becomes the martyred Lincoln, the ill-fated Gandhi family becomes the ill-fated Kennedy clan and the debacle in Bosnia becomes either a quagmire like Vietnam—as President Bush suggested—a test of appeasement like Munich or a holocaust like the Nazis' Final Solution.

Of course, there is a peril for those journalists who use analogies to spark readers' and viewers' understanding of an event within the space of a sentence or two—beyond the danger of grossly oversimplifying the event. The journalists have to be fairly confident that their audience is familiar with the analogy—which is why, typically, only the most common references are used. As AP's Tom Kent put it, "I'm surprised that many readers know what Munich is. Somebody asked me the other day if we should write a story comparing the siege of Gorazde to Dien Bien Phu. Well, by the time you get through how they're not the same, you've already lost 1200 words." Historical analogies, said Kent, "are dangerous. I would much rather coach someone to say 'Bosnia is Munich' than to say it ourselves."[26]

The premium on news gathering is to select such details from an event as can give a reader a sense of identity with the topic. "Don't drive the reader away with great long gobs of dutiful background," said Yuenger. "Slip it into a story in a way that's natural and doesn't make the reader's head hurt." "Done right," Bill Small added, "it can be a tool to set the stage for important opinion-making. In television, without the space [that newspapers have], it is the only way to provide background." It is easier, faster and more provocative to weave those details together toward an end of creating arresting, if familiar images than of creating a complex and esoteric account. It is easier, faster and more provocative to say that Rabin is a martyr like Abraham Lincoln than to explain the intricacies of Rabin's history and the relationship of his government to Israeli society and the Palestinian peace process. "By reducing news to images in that way," said former foreign correspondent Malcolm Browne, "most of its important content and practically all of its thought is eliminated. And so news is no longer a tool for viewers and readers to reach important opinions about, it's a manipulative kind of operation."[27]

So, of course, we fall victim to compassion fatigue.

Crisis coverage is déjà vu all over again.

THE PRACTICE OF JOURNALISM
AND COMPASSION FATIGUE

In mid-January 1991, during the first night of Operation Desert Storm against Iraq, millions tuned in to CNN as its reporters gave live accounts of the bombing of Baghdad. Said writer Peter Coffee, "The truth behind such catch phrases as 'small world' and 'global village' has rarely been as clearly shown."

But in the early morning hours that Thursday, one reporter's comments revealed how even cutting-edge satellite technology is limited by the human element. "I wish I could tell you what was happening in the other directions," the reporter said, as he described for the CNN audience the scene outside his window. "I wish we could find an extension cord for this phone."[28]

The audience listened to the technological miracle of live reporting from a hostile combat zone, but could only hear what the reporter said while tied to his tether of a phone cord. High technology has made the world smaller, but it has not made journalists omniscient.

We, the consumers of the American media, are also tied to the end of a too-short cord. Our cord is the media itself. What we know about the world is circumscribed by what the media are able to tell us—and choose to tell us—about the world. And their omissions, wrote *New York Times* columnist Max Frankel, have broad ramifications. "A shallow understanding of the world will damage the nation's sense of itself, its commerce and its standard of living and may blind it to even greater threats."[29]

Compassion fatigue ensures such a shallow understanding.

"Reporters love the word 'crisis,'" said Bernard Gwertzman, now editor of *The Times* on the web. But what makes a crisis? "I don't have a definition," Gwertzman said, "some things feel like a crisis and others don't."[30]

Stories traditionally are published or fronted or aired depending on the answers to a range of questions. *Timeliness*: Did the event just happen? *Proximity*: How close is the event, physically and psychologically? *Prominence*: How many people have some knowledge or interest in the subject? *Significance*: How many people will (potentially) be affected by the event? *Controversy*: Is there conflict or drama? *Novelty*: Is the event unusual? *Currency*: Is the event part of an ongoing issue? If not, should people know? *Emotional appeal*: Is there humor, sadness or a thrill? And when the medium is television, a final question looms: How good are the pictures?

How are those questions applied to international events? News values are not universal; they are culturally, politically and ideologically determined. According

to a 1996 survey by the Pew Research Center for the People and the Press, Americans pay close attention only to those news stories of "natural or man-made disasters and stories about wars and terrorism involving the United States or its citizens." The media, said one veteran foreign correspondent, is only interested in "earthquakes and revolution."[31]

A 1995 Pew study outlined the media's coverage of international affairs as the following:

1. 40 percent of international news stories have conflict or its "conditions" as "the direct driving event."
2. "Foreign events and disasters usually must be more dramatic and violent to compete successfully against national news."
3. One-third of all international stories are "essentially about the United States in the world, rather than about the world."
4. Certain regions and topics are under-reported: Africa and South Asia, Australia and the Pacific Islands, and agriculture, demographics and education.[32]

Many studies have also noted that events occurring in the United States' neighbors are also underreported. "It was Scotty Reston who once wrote," recalled Bill Small, "that Americans will do anything for Latin America except read about it." "The United States," said Gwertzman, "is traditionally isolationist, more than most countries. It doesn't take much to persuade our people that foreign affairs is a very secondary kind of story. Americans say 'Who cares?' It's a kind of know-nothingism, but it can be pretty powerful." Attempts to broaden the news menu—even slightly—have not met with success. For its 75th anniversary issue, *Time* magazine compiled a list of its ten worst-selling covers since 1980. They included: "Anguish Over Bosnia" (May 17, 1993), "Benjamin Netanyahu" (June 10, 1996), "Boris Yeltsin" (March 29, 1993) and "Somalia: Restoring Hope" (December 21, 1992). Only two foreign stories made the covers of *Time*'s best sellers of all time—the death of Princess Diana and the start of the Persian Gulf War. What foreign news sells, these statistics suggest, is dramatic moments, not thoughtful analysis. "For example," said the *Miami Herald*'s director of international operations, Mark Seibel, "the quintessential foreign *Miami Herald* story was the bombing of the Jewish center in Buenos Aires. Now, that plays to all our audiences. You've got a terrorist attack, the Jewish center, involving Latin America. You can't ask for a better story."[33]

Disasters, together with U.S. war and terrorism stories, are Americans' favorite news items.[34] "Armageddon is intrinsically entertaining," observed former foreign correspondent Malcolm Browne. "The book of Revelation is one of the

most popular biblical ones." Violence—a "big bang"—trumps almost all other kinds of news. A CBS producer who covered the war in Lebanon in the early 1980s observed, "You've got a TV audience that's used to war movies. Real explosions have to look almost as good. There's almost a boredom factor." If the news isn't up to Hollywood caliber, indifference can steal in. Without snazzy production values, a war sparks no interest.[35]

It's not that the media—even editors and producers—typically lack imagination or initiative. But they do have a finite amount of money to spend on covering the news. For example, the three leading video news agencies (APTV, part of the Associated Press, Worldwide Television News, and the video division of Reuters) bitterly contest their market share, as the news organizations that use them are economizing by cutting back on the services they use. To boost their dominance, each of the agencies strives for the most dramatic pictures, with the result, said Mathias Eick, an African correspondent for Worldwide Television News, that "It is left to the people on the ground to decide what is worth the risk and what is not. I leave it to your imagination what happens if you say to your boss that an assignment's too risky, and your competitor gets the picture."[36] Of 23 Associated Press journalists killed on the job since 1876, six have died in the last five years—four of them photographers. The recent trends of crisis coverage and cost consciousness have meant that journalists—who are increasingly free-lancers, with little institutional support—are having to put themselves in increasingly risky situations to get the images of violence that are compelling enough to shoulder the stories onto air or into print.

Not every story seemingly worthy of coverage will make the media's news budgets. For TV, it costs about two or three thousand dollars for a ten-minute satellite feed—double that if a network is sending pictures for both the morning and evening news. "Budgets make a difference," said ABC's Ted Koppel. "It would be nice to pretend that news organizations cover all major crises wherever they happen, whenever they happen, but we don't. We have only so many reporters, producers, camerapeople, only so much money to spend. Every new disaster that strikes is covered, not just on the basis of the story's importance but also on the basis of allocating resources."[37] "We do nothing that costs less than $10,000 when we move somewhere," said CBS's Allen Alter. "You just see the dollars flying out the window, and then when you need to go to a place like Iraq or Sarajevo, they say, 'Time's up, no more money.' So what do you do? It's a lot of prioritizing by me and other managers about is it worth it."

"The costs are very much a factor in the economy of the '90s, much more so than they were in the early '80s," continued Alter. "I think people in the news business, in the networks, in newspapers everywhere, . . . ten or so years ago—

before money- and belt-tightening and us and the other networks being taken over by real businessmen—used to say, 'Go do it, I don't care what it costs as long as it looks good.' And now it's: 'What does it cost? And I'll tell you if it's worthwhile, see how much I want to spend on that.'"[38]

In the spring of 1991, for example, news organizations were suffering from having spent so much money on covering the war in the Gulf. A conflict in which Americans are engaged absorbs all the dollars, time and space allotted for international affairs. "If there was a civil war in Chad and 50,000 troops got in there tomorrow," said Alter, "you can bet that tomorrow Chad would be on the front page and everybody would know a lot about Chad. And in Somalia, a country that had no running water and no electricity, we built the equivalent of three television stations there in a few days and everybody was transmitting live pictures from Mogadishu."[39] It's not the major stories that suffer in coverage, it's the midlevel crises that receive less attention because of all the money flowing to the one top item. As a result, the American public gets a less well-rounded portrait of international affairs.

Money is essential. Without the financial resources, there's no story. "We're very, very conscientious about how much stories cost," said ABC foreign editor (and former comptroller) Chuck Lustig. "We get daily rundowns about how much we spent today and how much we will spend tomorrow. We're very insistent on people, when doing story proposals, doing budgets. And the other thing is when we go places and do stories, we try to do more than one story while we're there—costbreaks." Still, many argue that the built-in waste and excesses at the networks rival that of the U.S. government. "Hell," said former CBS vice president Peter Herford, "they even exceed it."[40]

When deciding where or whether to go cover a story, location is another factor. How do the media choose which crises to cover? Crises are covered for political, strategic, commercial and historical considerations. But even when foreign editors think that there is news that needs to be covered, where it comes from makes a difference. "Somehow in the competitive marketplace for space within the paper," said Simon Li, foreign editor of the *Los Angeles Times*, "somebody sets the bar pretty high for stories from South America. Now maybe if we had a more brilliant reporter there, more stories would get in. But pragmatically, there doesn't seem to be that craving for stories from there. Try that in Israel—there'd be no question."[41] Yet newspapers do a better job than television at representing global diversity. Brookings Institution public policy expert Stephen Hess conducted a study of the media between 1989 and 1991 and discovered that newspapers reported from 144 countries (out of a possible 191 countries), and television reported from 79. Television's relentless focus on the Middle East

(5 percent of the world's population, 3 percent of its GDP, but 35 percent of the foreign dateline stories) helped skew the coverage away from other regions. Hess found that when he assessed the media's coverage in terms of population, it "grossly underrepresents Asia . . . and somewhat underrepresents Africa." Coverage of the Americas, he found, was relatively proportional and the Middle East and Europe were overrepresented. When he analyzed the coverage against the wealth of nations, "western Europe and Asia are underrepresented, eastern Europe and the Americas are in balance and Africa and the Middle East are overrepresented."[42]

Adding CNN to the picture changes it somewhat. Hess discovered in his study of television news in the last six months of 1992 that "CNN reported from almost twice as many countries (forty-one, as opposed to twenty-six on ABC, CBS, and NBC combined)." But he noted that "they covered the same subjects in about the same way."[43]

There are several tongue-in-cheek equations floating around that purport to formalize the business of deciding what crisis to cover. At the *Boston Globe*, "it was a figure of about 2.43 and divide the number of bodies from the miles to the Boston Common. I can't remember if it was the numerator or the denominator, but if it was over 2.43 it was a page-one story," joked former foreign correspondent Tom Palmer. You also had to put the GNP of the country into that formula. "For instance, if it's Japan, that cuts the mileage in half."[44] More simply, said Ted Koppel, "The closer to home that a crisis strikes, the more likely it is to get attention."

Location. Location. Location. "It's not so much the event as where it's happening," said the *Journal*'s diplomatic correspondent Robert Greenberger.[45] "I swear to you," said his colleague, Walt Mossberg, "this applies to all the newspapers, some more, some less. Is it a place Americans know about? Travel to? Have relatives in? Have business in? Is the military going there? You're not going to get on page one with something about Bangladesh nearly as much as you do with something about some country where your readers have some kind of connection."[46]

In the crisis-prone year of 1991, with little left in the till and with the cutting of television news division budgets, Koppel said, the networks, especially, couldn't afford to cover all the disasters that occurred far from home. So they chose chauvinistically. The media don't necessarily cover crises "on the basis of how many people are involved," said Koppel. The allocation of resources is decided on grounds other than the sheer number of those at risk. "It becomes a question of American involvement," said Koppel. "I would argue the reason we're focusing on [the Kurds] is that there are still a lot of Americans involved over there." National security interests and the direct involvement of Americans trump the numbers. "That's not only a political or economic reality, it's a human

one. We tend to care most about those closest to us, most like us. We care about those with whom we identify.

"One little girl trapped at the bottom of a Texas well had the entire nation holding its breath," he said at the start of a *Nightline* program. "The plight of Kurdish refugees in Iraq has at least engaged our interest. But millions starving in Africa, as many as 25 thousand drowned in Bangladesh, over 1,000 killed by cholera in Peru barely get our attention. Why?"[47]

Columnist Barbara Ehrenreich, of *Time* magazine, answered Koppel bluntly on the same show with a new factor. Race matters. "If there were a couple of million blond, blue-eyed people facing starvation somewhere, I think the media coverage would be so intense we'd know their names by this time. We'd see them as individuals." The *Chicago Tribune* led a 1990 article about Americans' lack of interest in foreign coverage with this anecdote: "At a gathering of Third World visitors here [in Washington, D.C.] recently, an African stood to ask a question of columnist James J. Kilpatrick. 'Why is it that American journalists don't care about my country?' the African asked. 'What country do you come from, sir?' Kilpatrick responded. 'Uganda,' the man answered. 'Why the hell should I care about Uganda?' said Kilpatrick, as diplomats around the room wheezed and struggled to catch their breaths."

"Unless Americans are involved in the story," the article continued, "the level of interest among many readers and most editors ranges from pale to pallid." But, the article concluded, "Their interest perks up a bit if there are pictures of some major calamity, bloody pictures. . . . Any foreign story without blood or Americans or both has a tough time."[48]

It is difficult to find news in the media about sub–Saharan Africa, for example, unless the United States is involved or something horrific has happened. It isn't called the "Dark Continent" for nothing. The newsroom truism goes: "One dead fireman in Brooklyn is worth five English bobbies, who are worth 50 Arabs, who are worth 500 Africans." "There is a certain arbitrary number game we play," admitted Gwertzman from *The New York Times*. "How many have to get killed before it's news?"[49]

Much of the developing world used to have a better time of it, during the Cold War, when it could be viewed as part of the Communist–Free World chessboard. The Cold War turned even obscure international news into events in the national interest. Journalists covered the proxy wars that raged, ignited in part by the inherent instability of newly postcolonialist nations and fueled and sustained by the geopolitical objectives of the Americans and the Soviets. But now, in the absence of the communist bogeyman, how does the media relate national interest to events in remote locations? "Frequently," said Michael Getler, former

deputy managing editor at *The Post,* " that's done through the human factor."[51] Tom Kent from AP told of his experience with two similar Africa stories:

> We made a real commitment to the story of a huge ethnic killing in Burundi, but, due to distances, we could not get the kind of color in the writing and graphics that we got out of Rwanda. Tens of thousands of people were killed in Burundi, as they were in Rwanda. But in Rwanda we were able to get people to the scene and write it really well, and we got tons of play. In Burundi we got very little play. So the question is: Do Americans care about Africans getting killed? And the answer is: Depends on how you write it. . . . Have you ever picked up the *New Yorker*—an old *New Yorker*—and found a page and a half about how ball bearings are made, which you'd never read, but it's so well done that you're reading it? That's what we have to do with foreign news.[51]

In an absolute sense, coverage of the world has suffered since the fall of the Soviet Union. Arms control stories, for example, don't have the resonance they did during the Cold War and neither do stories about conflicts in the former "proxy" states of the United States and the U.S.S.R. Except for the "reflexive" kind of stories, the no-brainers that scream to be covered, the developing world is now largely ignored. "One of the things that I regret is that there are vast regions of the earth that we don't cover better," said Yuenger in 1994. "I should have devoted more time and energy to Third World thematic stories, and I'm trying to, I just haven't done that very well."[52]

In the post–Cold War era, journalists are now covering the news from an American perspective—not a U.S. versus Soviet perspective, although that perspective is more a function of what the home office is looking for than what the people in the field are finding. "That's part of the tension between the foreign correspondents and the editors and Washington staffs back here," said *The Wall Street Journal's* Walt Mossberg, "because the foreign correspondents obviously tend to see more of the perspective of the country they're in and less of a narrow American perspective." Carroll Bogert, foreign correspondent (and former acting–foreign editor) at *Newsweek,* agreed that what was covered "has to do with the predilections of the editors in New York." How the decisions are made about what to cover is "a fairly flukey thing, I think," she said. "There was one editor who just for a long time had a thing about Yugoslavia. You know, it's a lot of messy ethnic things, and the editor felt Americans didn't know or care about Bosnia. And some editors find China tedious. Other times I think it's just quirks

of fate. Media watchers and others often see conspiracy, but it's not something that's deliciously complex. We just want to get the story out. There's a lot that's just accidental blundering and happenstance."[53]

Henry Grunwald, the former editor-in-chief of *Time* magazine and a former U.S. ambassador to Austria, wrote in the prestigious journal *Foreign Affairs* that in the aftermath of the Cold War's certainties, the media is "searching for a different organizing principle—North-South tensions, religion versus secularism, nationalism versus internationalism." "To the extent that it can be done at all," he said, "it will take all the skills of reporting, writing and reasoning, plus a few tricks of the trade usually described under the heading of 'human interest.' That often means an appeal to terror and pity, the stuff of tragedy (and sensationalism)." Or what Yuenger called a "rich, red raw meat" kind of writing.[54]

"I think the entire profession is leaning toward the bring-it-down-to-the-man-in-the-street level, to the human level," said Juan Tamayo, former foreign editor at *The Miami Herald*. "We're heading into a period in which foreign reporting, which used to inform and educate, is now being asked to entertain," he continued. "How can we change our product to attract or keep our readers? And the answer is, give them entertaining stuff. Let's not bog them down with all this heavy crap, let's entertain them. We're not giving our readers news anymore. We're not giving them something to chew on. It's light. It's fluffy. It's crap."[55]

To fend off readers' compassion fatigue, sensationalism, formulaic coverage and references to American cultural icons often predominate over thoughtful, less reflexive reporting. As journalist Christopher Hitchens wrote in *Vanity Fair*, nearly all reporting on Africa is a pastiche of Evelyn Waugh's *Scoop* and Joseph Conrad's *Heart of Darkness*. "Until recently," observed African historian Roland Oliver, "there were at least the Cold War and the struggle against apartheid to provide some ongoing themes of continent-wide dimensions. Now, it seems that . . . we are presented only with civil war, famine and AIDS, with the same or similar pictures used over and over again. It is not that the scenes depicted are untrue. It is that they represent such a small part of the truth."[56]

Multiple academic studies have borne out this statement, observing that coverage of the South, especially the developing world, is even more likely to be sensational in nature than coverage of Northern and Western events. The image of Africa as "primitive" and "tribal," for example, persists in words and images—we can't seem to shake the mythic Africa, made famous by Stanley and Livingstone, Teddy Roosevelt and Edgar Rice Burroughs. Coverage of Africa still runs heavily to such topics as travel safaris and animals—*National Geographic*–style—or war, epidemics and famine.[57] Stories either emphasize the exotic or the crises. To check this, think of Rwanda. Recall how many stories

appeared on Rwanda before the recent genocide that didn't mention Dian Fossey's gorillas.

Too much harping on the same set of images, too much strident coverage with insufficient background and context, exhaust the public. "With Bosnia, I think," said Karen Elliot House of *The Wall Street Journal*, "I find *The Post* and *The Times* coverage extremely difficult to read. All of them to me are like reading chapter one over and over, or they're like opening a book in chapter 13. You don't know what came before and you don't know what comes next, you just know that it's like a movie stuck, or a record stuck. It just doesn't advance."[58]

And stories on television are worse—typically episodic and dramatic, giving the "who-what-where-when," but not the "how" or "why" of a foreign story. This is not only bad journalism, it's bad entertainment. As Franklin Roosevelt, the master player of the American psyche, observed, "Individual psychology cannot, because of human weakness, be attuned for long periods of time to a constant repetition of the highest note in the scale."[59] Undifferentiated mayhem leads to emotional overload.

But in fairness, this style of coverage is not always an active choice—it can be the result of the logistics of covering global news. Many problems of coverage stem from faults inherent in the news-gathering process. For example, lack of language training makes journalists dependent on translators and other intermediaries. As a rule, American correspondents do not speak the local languages of Africa and Asia—and even of much of Europe. And in some regions, their primary sources for leads—the local media—are often either unreliable or nonexistent. As a result, the correspondents become overly dependent both on government or other official sources for information, learning only the one side—the official spin—and on the pictures of the news events, which often depict seemingly self-explanatory violence.

Lack of a sufficient number of correspondents to adequately cover a region also hampers coverage. "TV has a smaller newsgathering staff overseas than the wire services (though both tend to rely heavily on stringers and news exchanges with foreign news organizations)," noted Bill Small. Partly, added former TV and wire service reporter Malcolm Browne, that is because the function of the television networks "is not so much to gather the news as to package it. The big TV news money goes for production, satellite communications, anchor salaries, transportation and hotel costs for the supporting crews and much more. . . . The TV correspondents themselves sometimes feel lost in the crowd."[60]

As news budgets tighten and bureaus abroad are shut down—especially in network television—foreign correspondents are forced to cover more and more

territory.[61] The "news net," the pattern of locations where full-time foreign correspondents are posted, often precludes—or at least makes difficult—the gathering of stories from regions and countries outside that net. "Today," wrote columnist Max Frankel, in late 1994, "each network pretends to 'cover' the world with seven or eight full-time correspondents; none of them breathe the air of South America and few ever tour Asia or Africa. For filler, they buy footage from foreign networks and part-timers. To be sure, when American troops are sent abroad and when the President sojourns at a colorful (or comfortable) foreign summit, the great anchors—Jennings, Rather and Brokaw—can be found reading the nightly news from a distant beach or rooftop. But their customarily swift return pronounces even those foreign stories instantly dead."[62]

"Are newspapers any better?" Frankel asked.

"Not many," he answered. "USA Today, which proclaims itself a model for the future, normally devotes more space to the United States weather map than to all foreign news." In 1994, The New York Times had around three dozen full-time correspondents abroad, the Los Angeles Times had almost that many, The Washington Post fielded two dozen as did The Wall Street Journal (not counting 60 or so on the staff of its European and Asian editions). The Christian Science Monitor and the Chicago Tribune each kept about a dozen reporters overseas. But add all these numbers together, noted Frankel, and the result is that "America's picture of the planet is painted by a total of only 400 American correspondents, including those from news magazines and wire services, plus a few hundred foreign nationals assisting them."[63]

As a result, no longer residents of all the countries they cover, journalists become parachutists jetting madly to regional crises, jumping into situations cold. This manner of covering the world is nothing new, it's just becoming more common in more places. Transportation and communication technology have made parachute journalism feasible now for television as well as print reporters— as long as a journalist is able to put in 18-hour days, reporting in one time zone while feeding stories to New York on another. "Technology has ruined the life of the foreign correspondent," bemoaned NBC reporter Richard Valeriani. Journalists can now spend more time getting to and from stories than actually backgrounding and covering them. The classic tale is told by Ken Auletta in his book about the three major networks: "Bill Stout of CBS was in Saigon and was urgently dispatched to Sydney, Australia, where the executive producer in New York wanted him immediately. 'Jesus, you know how far Sydney is from Saigon?' said Stout. 'It's an inch and a half on my map,' shouted back the producer."[64]

Parachutists are generalists, "trained in crisis, not countries," said former foreign editor Johanna Neuman, who should know. "They live for the anecdote

that captures a sense of place." "Nobody hits the ground running like television reporters," said Steven Hess. "These people are brilliant for 72 hours. But tune in a week later and you realize how thin their understanding of the story is." This "fireman's" ability to fast-focus on an erupting crisis has abetted journalists' tendencies to lapse into formula, sensationalism and Americanized coverage. As foreign correspondents are chosen less for being regional experts than for being good writers and a quick study, the images they bring back—especially for television—are increasingly generic.[65]

The "generic" effect is accelerated when parachute TV journalism degenerates further into "voice-over" journalism. Cutbacks in the networks' budgets means that reporters are increasingly turning into packagers, narrating from New York or London over someone else's videotape. And when the tape comes, not from a foreign correspondent with the network but from a video wire service, former NBC executive Tom Wolzien said, "Nobody has the foggiest idea who made it or whether the pictures were staged." The correspondent doing the voice-over often has little background on the story and little personal knowledge of the situation. CBS correspondent Martha Teichner described her distress about doing voice-overs: "I was asked to do Somalia for the weekend news and I've never been to Somalia and I'm thinking, Oh my god, what am I gonna do? I get every bit of research I can find, but even if I'm correct and accurate, I'm superficial. And I don't want to be superficial."[66]

Photographer Susan Meiselas noted the same tendency in print journalism. Newspapers and magazines, she said, "would just as soon use a stock picture as send someone out to do any real reporting."[67] As a result, the marriage between a reporter's piece and the accompanying still images can be strained at best.

A third limitation to adequate reporting stems from a lack of access to an area—through government prohibitions or failures in transportation. The media are often handicapped by official restrictions on movement and coverage. "We can't get into Saudi Arabia on any active basis," said CBS's Allen Alter. "We try all the time, when there's any kind of military crisis in the Gulf, and the Saudis say ask the Pentagon, and the Pentagon says you have to ask the Saudis, and we never get anywhere, and soon the event is over. We can't get into Syria, except for Damascus, and they control it. You can't get into Iraq, except when they want to let you in."[68]

In Cambodia under Pol Pot, in Afghanistan after the Soviet invasion, in South Africa during apartheid, in Israeli-occupied Gaza during the Intifada, in Sudan, in Tibet, in southeastern Turkey, visas into a country or access to a specific region are often denied to journalists. A study by media analyst William Adams, for example, found that "during the height of the worst massacre in

modern times, the networks' evening news coverage of Cambodia averaged only ten minutes a year. The carnage was virtually ignored until it was far too late to arouse world attention."[69] The Pol Pot regime refused to allow Western journalists to enter the country. The story could still have been reported from the outside using the testimony of those who had escaped the killing fields, but journalists were skeptical of the extraordinary reports from those few refugees who had fled across the border to Thailand. Journalists wanted either to see the conditions with their own eyes or to source the story with a "dispassionate" Western observer—such as a worker with a humanitarian agency. Barring those two possibilities, the story didn't get told.

The hostility of governments or rebel groups as well as problems of transportation and communication can make remote reporting a necessity. The genocidal fighting in Rwanda, for example, was more often covered from the more convenient refugee camps in friendly territories than from the war-torn country itself. But even when there's little danger, airline schedules and routings in certain parts of the world, such as Africa, are so minimal that it is often faster to travel from one neighboring capital city to another by way of Paris or London or Frankfurt. And once a journalist is ensconced in a country, it can often take days or weeks to travel around getting the story, occasionally out of touch with the home office during that time. Because news gathering for each story can take so long, other stories are consequently missed. Media critics Sanford Ungar and David Gergen told of the instance when a *Washington Post* reporter missed covering two attempted coups in African countries as a result of two weeks of incommunicado traveling with the Ethiopian rebel forces in Tigre.[70] As a result of such incidents, editors and producers are reluctant to agree to the time commitment necessary to cover events on the ground in remote locations. The consequence is that even major stories are covered at a distance, such as the reporting on famines and disasters in Africa from the European offices of aid or U.N. organizations.

The tyranny of numbers or money or geography or access may keep certain disasters effectively invisible. Relatively few people at risk of dying or dying in out-of-the-way locations where Americans have little or no security or business interests, or dying where journalists can't get visas or have to put their lives at risk may doom a disaster to obscurity. "If the story is a famine in the Sudan," said the late Lee Lescaze, former foreign editor at *The Wall Street Journal* and *The Post*, "I make the same callous decision that other people do, that who cares about the Sudan? It's not high on anyone's priority and it's an incredibly nasty place. You probably don't rush there. If it's that dangerous, it's not worth it. On the other hand, going to Sarajevo, that's worth it. You can get wounded or killed in Sarajevo, but at least it's a 'who's trying to kill you?' not some drunken guy floundering down the street."[71]

. . .

The most insidious of the reasons for minimalist reporting is the constant restriction of time and space. The world cannot really be covered in the 21 or 22 minutes of news broadcast in the networks' evening programs or in the hundred-odd pages of the newsweeklies or even in the thick wad of newsprint of the Sunday *New York Times*. Given newshole constraints, the stories most likely to disappear from news programs and newspapers are continuing international stories. "Ultimately, we're in the business of triage," admitted John Walcott when he was at *U.S. News*. "That's what I do, is triage, and so do my counterparts everywhere else."[72]

The finiteness of time and space in all three mediums—television, newspapers and newsmagazines—is exacerbated by the media's proclivity to feature domestic news, especially of an "entertaining" nature. The trend is especially prominent at the networks' flagship programs: ABC *World News Tonight*, CBS *Evening News* and NBC *Nightly News*, witness the fact that all three have had features with such names as "American Agenda," "Eye on America" and "The American Dream." According to *The Tyndall Report* which monitors the networks' news programming, in 1989, ABC, CBS and NBC collectively devoted 4,032 minutes to stories from correspondents posted at foreign bureaus. By 1995, that figure had declined to 1,991. ABC went from 1,397 to 784, CBS from 1,454 to 740 and NBC had the largest percentage drop, from 1,181 to 467. The *Report's* content analysis of the three programs showed where the lost minutes were going. In 1995, for example, the Big Three spent 1,592 minutes on the O.J. Simpson murder trial, 418 minutes on the Oklahoma City bombing and 318 minutes on the war in Bosnia.[73]

By its nature, television is an instrument of simplicity. In a typical length story of a minute 20 seconds, a correspondent has at most 150 words to speak, or about a third to a half of a typewritten page. Even a story at double that length cannot provide much context or background. Television is essentially a headline service. The late Dick Salant, president of CBS News, measured Walter Cronkite's copy and discovered it added up to two columns of *The New York Times*. "Even my most cleverly written monologues never told more than half the story," admitted Malcolm Browne about his reporting for ABC from Vietnam. "And despite their factual accuracy, they didn't convey the sense and feel of reality; at root, they always smelled of greasepaint."[74]

It's not only that broadcast news stories are of necessity short, it's that news— especially international news—is often simplified by television's packaging of it. For example, there are "tell" stories, described by Allen Alter as "when the anchor tells it without pictures—when he's just doing ten seconds without pictures. 'In

Britain today they voted on blah blah blah.'" And there are "newsreel" stories, described by Alter as "voice-overs back-to-back, about four or five items. We used to do them as individual voice-overs, but now they're kind of bunched together and we run them one after the other. Cairo, Baghdad and Baton Rouge—fifteen seconds each, and flood update."[75]

But television does have compensation in its pictures. "We're very conscious here, in all of what we're doing, that we must exploit the tools available to us to the maximum possible extent to preserve our position up against the guys who make beautiful color moving pictures," said Robert Kaiser, former managing editor of *The Washington Post*. "Words are challenged, and if we don't have the best possible words we can get and the most vivid writing we can get, then we're failing."[76]

The pressure is on at newspapers, too, for shorter stories, because space is shrinking and because the big complaint they hear from readers is "I don't have time." Average-length stories have dropped from a high of 1,000–1,200 words to 700–900 words, although many foreign editors argue that the news shrinkage has caused "an improvement" in coverage. Stories are "tighter, more to the point," "more thoughtful, more comprehensive, better written" and "better at telling readers about the significance of the news." The increasing difficulty of getting stories in has caused editors, such as Simon Li to make "smarter selections about what stories to run." And the late Jim Yuenger noted that the foreign stories "really are better written—if they weren't, I wouldn't be able to get as many of them into the paper as I do."[77]

Long stories are agreed to less automatically. At *The New York Times*, for example, a reporter can't write a story that exceeds two columns—about 1,800 words—without getting masthead approval for it. In cases where approval is given, the story is called a "Special Report." Art is required and the copy has to be divided up into packages, each with its own subhead.

(Ironically the one paper, *USA Today*, charged with initiating the slippery slope of shorter articles and more pictures has been, Peter Herford said, "the only paper I know which increased its story length over the past 15 years." And Bill Small suggested that *USA Today* has in fact "changed most of America's major newspapers mostly for the better—in graphics, sports detail, weather, financial reporting and feature writing. And today's version has far more content, including foreign news, than its critics think. It is not America's best read paper for nothing; in most markets [and in some ways, in all markets], it provides much that the local newspaper does not."[78])

The wire services, too, (or the "news agencies" as they prefer to be called now that the technology has changed) have felt the pressure to conform to the

graphic and visually laden television and *USA Today*–type journalism. At AP, said editor Tom Kent, "we have been forced to think more like a newspaper than we ever did before." Fifteen or 20 years ago, when teletype machines oozed out 50 words a minute, a 500-word story on the wires was a very long story. Then high-speed transmission came along, and an average story became 800 to 1,000 words. But increasingly stories are sent out keyed to the layout demands of the member papers. Instead of sending out stand-alone text, a package will be created of story and a sidebar and pull-out quotes. "The AP and UPI," said Small, "are often as guilty as their clients in providing the factors [that] lead to compassion fatigue. They, too, emphasize coverage of what their clients want and they too are criticized in many underdeveloped countries (and even in many fully developed ones) for the 'Americanization' of their coverage."[79]

Rarely first off the mark in international affairs, the newsmagazines are especially dependent on peripheral images and graphics for their appeal to consumers. As Walt Mossberg, at the photographless *Wall Street Journal*, said: "I think some of the most powerful news stills are in the newsweeklies. Somalia was a good example of that."[80] John Walcott told of the extraordinary hoops which *U.S. News* would go through to put graphics into a story. A cover article that ran in February 1994 on military foreign policy, for example, featured a detailed illustration of life aboard an aircraft carrier. "It literally had a two-page gatefold graphic that took you a half an hour to get through," he said.

> The ultimate size of it was driven very largely by the fact that no one had ever done a cutaway graphic of an aircraft carrier. I was astounded to find this out. Well, it turned out that the raw material was all classified. So we had to go through this big song and dance to get the drawing from the shipbuilder, which we finally did. Then we actually sent the graphic artist out on the carrier. He went out for three days and walked all over the carrier with his Polaroid camera and his sketchbook to peruse the thing. That resulted in that cover package amounting to three to four pages.[81]

But despite such outstanding efforts, in many ways, the newsmagazines are losing their relevance. "*Newsweek* is something of a lemming," said its former acting–foreign editor Carroll Bogert. "The newsmagazines are a particular breed of animal which watch what the other media do in order to do stories that reflect the public interest—even more, I think, than other media that tend to follow the general public mood. That's the whole point of reading *Newsweek*. You open it up to find the things that were defined by other media to be current. So if

other news media—the networks, *The Times, The Wall Street Journal*—if they're covering a story to death, than we can't not cover it to death.

"I think the growth of TV news—not specifically CNN, but also the networks' expanded news coverage—has changed the whole configuration," she continued. "CNN meant that *The New York Times* could not just give you the facts, because that's what CNN did. If you look at *The New York Times*, they do now what we used to do. They have a running story and they have a sidebar. If *The Times* is doing that, then we can't do it and we, in turn, have to turn in another direction. And the question is, what do we do? And I think the answer, at *Newsweek*, is more voice. You're not just getting the facts, you're getting someone's view of the facts."[82]

Many critics have charged that the media has been policy-driven, that the great international story in past years was the Cold War contest—to the exclusion of all else. "Now," as *The Post*'s Robert Kaiser has said, "just as diplomacy is completely discombobulated, so is journalism." Now the North Star of coverage is often the competition—from both the high and low ends of the spectrum. "One of the great dangers in journalism—and we all succumb to it from time to time—is writing for each other," said Walcott. "We're sitting around writing stories saying, 'Wait till they read this at *The New York Times!*' We're insecure about how we're getting along, because it takes a certain amount of courage to go off on your own." And Jim Yuenger at the *Chicago Tribune* admitted, "There's no avoiding the fact that we have gone to color and graphics more, partly as a result of *USA Today*. I don't have a problem with what we've done, but how much of this stuff are we going to do? Where are we going to stop so that we don't look like a cereal box?"[83]

As always, newspapers, newsmagazines and television don't want to get beat by the competition—either in the stories they cover or in the packaging they come in. As a result, much of the media looks alike. The same news, the same pictures. What's the inevitable result much of the time?

Compassion fatigue.

Compassion fatigue is not the inevitable consequence of similar events or lingering events. It is a consequence of rote journalism and looking-over-your-shoulder reporting. It is a consequence of sensationalism, formulaic coverage and perfunctory reference to American cultural icons. So the challenge is for each member of the media in each of the three genres to cover untold stories and to cover the obligatory stories in a distinctive manner. "You must say about Bosnia or Somalia or Chechnya, 'There's all this human tragedy going on, and it should be reported, and this is why,'" said former *L.A. Times* foreign editor and former *New York Times* foreign correspondent Alvin Shuster. "You just have to come at it in a different way. I've always felt that you have to tell people things they *should* read,

even if they don't seem to be all that interested in it. You can't just take a poll every day and say, 'What do you want to read today?' If they're tired of Chechnya, that doesn't mean we can't go on with Chechnya. We have to, but we have to do it in some way that's going to attract the reader."[84]

IMAGES AND COMPASSION FATIGUE

"For just an hour or so," wrote novelist Martin Amis after hearing CNN's breaking story of the death of Princess Diana, "it felt like November 1963." He said he turned to his two sons and told them, "You will always remember where you were and who you were with when you heard this news." Although for Amis "a sense of proportion" soon returned—the "true comparison" being, "of course," "not with Kennedy but with Kennedy's wife"—for others the comparison lingered. The shock of Diana's death was likened everywhere to the Kennedy assassination. Hyperbole was rampant. *New Yorker* writer Kurt Andersen repeated one editor's comment to him that "This is the most important event since John F. Kennedy was assassinated."[85]

It wasn't, of course. Indeed, there was very little that was apt about the analogy . . . with one key exception. Both John Kennedy and Diana Spencer had during their lives become world-renowned cultural icons. And their metaphoric stature became even more clear upon their deaths. If President Kennedy became, in hindsight, King Arthur who had reigned for one glorious moment in Camelot, Princess Diana became Helen of Troy whose beauty launched a thousand ships. For all her worthy causes—AIDS, hospices, land mines—Diana was most famous for her face. "What made millions love her, what made her unforgettable," wrote *Life* magazine in its Collector's Edition, "was not her words, nor really any specific achievement. It was her visual eloquence—her style, her empathic gestures, the drama that played out on her beautiful face." Her face launched a thousand magazine covers—43 of them in *People* magazine alone. "In the 16 years since her marriage," wrote *Newsweek* columnist Jonathan Alter, "she became not only the most famous woman in the world, but the only personality who consistently sold big in the global marketplace."[86]

The media clearly understood her ability to boost sales and ratings—and gauged their coverage of her death and funeral accordingly. "We pretended," wrote *New York Times* columnist Max Frankel, "that a sad accident was a universal catastrophe, that the deportment of Britain's monarchy bears on the fate of humanity and that civilization's great challenge now is to rewrite the laws of privacy, to make the world safe for celebrity."[87] *USA Today's* total circulation for the week after Diana's death was several hundred thousand above normal. *The Washington Post*

sold more than 20,000 additional copies of its Sunday editions the day Diana died and the day after her funeral. *Time* magazine sold 850,000 copies on the newsstands of its first issue about Diana's death and 1.2 million newsstand copies of its commemorative issue. To put that in perspective, a respectable newsstand sale of an average issue is 180,000. Those two issues were the largest sellers in the history of *Time* magazine—a history that dates back to 1923. And television seemed to report on nothing else. According to *The Tyndall Weekly*, which tracks the three networks' stories, the Monday night after her death the networks devoted 95 percent of their broadcasts to the story. By the week's end, her death had received more nightly coverage than any event since the 1991 coup against Gorbachev.

Diana's success at selling papers and magazines and boosting ratings was just one more goad to the industry to celebrity-ize the news. And the fact that her death received more network news coverage in a week than the landing of U.S. troops in Somalia—or even the O.J. Simpson trial, the Mississippi River floods or Hurricane Andrew—was a clear sign that the trend was continuing. At her death, Diana most clearly represented the late-20th-century phenomenon of the melding of news and entertainment, the vanishing boundaries between newsworthy events and celebrity spectacle. "Only the most determined literalist," wrote Alter, "could fail to see a connection between her death and her epoch, a time—our time—when celebrity obsession seems as out of control as a hurtling Mercedes on a late summer night in Paris." Corporate pressures, the bottom-line imperatives of the mega-media conglomerates have pressured their news components to produce entertainment-oriented reports. But this, acknowleged former *U.S. News & World Report* editor James Fallows, is a "Faustian bargain. . . . In the short run it raises your audience," he said, but "in the long run it threatens to destroy your business, because if the only way you make journalism interesting is by making it entertainment, in the long run people will just go to entertainment, pure and simple, and skip the journalistic overlay."[88]

Media moguls have long known that suffering, rather than good news, sells. "People being killed is definitely a good, objective criteria for whether a story is important," said former *Boston Globe* foreign correspondent Tom Palmer. "And innocent people being killed is better." The selective coverage of foreign events is coverage of the deaths of the famous, of famines and plagues and genocide. Watching and reading about suffering, especially suffering that exists somewhere else, somewhere interestingly exotic or perhaps deliciously close, has become a form of entertainment. Images of trauma have become intrinsic to the marketing of the media. Papers are laid out, newsmagazine covers are chosen, television news is packaged to make the most of emotional images of crisis. "The

kinds of dramatic pictures of starving kids," said CBS News foreign editor Allen Alter, "which started on the BBC and kind of filtered over to the States, the Rumanian orphans and things like that, those are the kinds of images where people [in the media] say, 'Oh, my God,' and use them over and over."[89]

As various academic studies have observed, photographs which accompany stories on international affairs—especially from Africa, Asia and the Middle East—commonly feature mayhem and pathos.[90] "As for international news," said Malcolm Browne, the journalist who took the iconic Vietnam War image of the burning monk, "I think we do care more now about the really poignant image from wherever it happens to be. As a page-one leader, not necessarily attached to the story, but with a reefer saying, 'Here's your BB [Bloated Belly—shorthand for "starving child"]. Details within.'" Americans expect the worst, and the photographs in the media—whether ad campaigns or humanitarian appeals—reinforce their audience's predispositions.[91]

The media rarely act on the basis of the "pleasure principle;" they are more likely to run striking but essentially negative news images than feel-good pictures. Yet various studies conducted on direct-mail fund raising in the donor community have suggested that most people have a distinct preference for positive photographs. Identical appeals were married to either upbeat (clean child smiling) or depressing (dirty child sad) images. The direct mail with the positive photographs garnered slightly more donations and greater sums of money per household than those with the negative images.[92] Threatening and painful images cause people to turn away, and since the media prioritize bad-news images, this tendency may partially account for Americans' compassion fatigue.

What does it mean when we become blasé about the pictures we see? Images of suffering and disaster—from pictures of the grieving Princes William and Harry to photos of the flattened Mercedes in the Paris tunnel—are appropriated to appeal emotionally to readers and viewers. As *The New York Times* columnist Max Frankel says, "Conflict is our favorite kind of news."[93] Crises are turned into a social experience that we can grasp; pain is commercialized, wedged between the advertisements for hemorrhoid remedies and headache medicines. In that cultural context, suffering becomes infotainment—just another commodity, another moment of pain to get its minute or column in the news. Our experience and our understanding of a crisis is weakened, diluted and distorted. If the news shows prompt us to equate chronic famine with chronic fatigue syndrome we are somewhat relieved. It helps absolve us of responsibility for what we see and can do little about. So with relief, we forget and go on with our everyday lives—until some other crisis image seizes our attention for a second.

Simple pictures, emotional pictures, pictures that can be distilled into a plain and unmistakable message can drill into the minds and hearts of their audiences. John Fox, an Eastern European specialist at the State Department, told of the photographs that came out of Bosnia after a busload of refugee children was shelled. "The images just kept mounting," he said. "The images came, they never stopped, and that's what got to people . . . you had to steel yourself just to get through the day."[94]

The public screams, "Stop those images!"—meaning: "Do something!" but also, sometimes, meaning: "I don't want to know any more." Didactic images can overload the senses. A single child at risk commands our attention and prompts our action. But one child, and then another, and another, and another and on and on and on is too much. A crowd of people in danger is faceless. Numbers alone can numb. All those starving brown babies over the years blur together. "Maybe we've seen too many anguished faces in too many faraway places pleading for help through our television set," wrote *St. Petersburg Times* columnist Jack Payton in response to the deluge of crises in the spring of 1991. "Maybe the Kurds, the Bangladeshis, the Ethiopians and the Mozambicans have finally pushed us into the MEGO, or My Eyes Glaze Over, syndrome. Maybe Joseph Stalin was right after all when he said, 'One death is a tragedy, 1 million deaths is a statistic.'"[95]

The New York Times tested that principle in one of its stories that same spring, interviewing 50 Americans across the nation. Many said they were "moved by the suffering, but overloaded, confused, even numbed by so much sorrow from so many places at once. . . . Kay Hamner, an Atlanta executive, and Roux Harding, a Seattle window cleaner, find the images on the evening news strangely unaffecting. 'You can see real true-to-life pictures, but your mind reacts to it almost as if it's just a movie,' Ms. Hamner said. Mr. Harding remarked, 'It's too surreal when you're watching television.'"[96]

New York University communication scholar Neil Postman was not surprised by the comments of those interviewed in *The Times*. "The sheer abundance of images of suffering will tend to make people turn away. People respond when a little girl falls down a well. But if 70,000 people in Bangladesh are killed, of course people will say, 'Isn't that terrible' but I think the capacity for feeling is if not deadened, at least drugged." "People seem to be paralyzed or just giving up," observed Tom Getman, director of government relations for the Christian relief organization World Vision, in 1991. "They seem to be saying to themselves, 'With so much going on, there's little one person can do.'"[97] The public can imagine the rescue effort needed to rescue one trapped little girl, one starving child threatened by a vulture, but the mind boggles at the logistics necessary to save millions.

Some people don't want to be reminded of their helplessness. "I get upset watching the babies dying," said Caroline Trinidad, a housewife and mother of four interviewed in *The Times* article. "Who the hell wants to see that? I switch the channel." Others feel drained by all the tragedy and by the seemingly repetitive crises. "Americans just get tired of seeing starving people on television," said Al Panico of the Red Cross. "They end up just turning the television off."[98]

Sometimes the fatigue is due to simple overexposure. The same thing that happens to movie stars and rock stars can happen to crises. They can get overexposed. (Oddly, Princess Diana seemed to be the one exception to that rule.) And when they are overexposed, they quickly become yesterday's news. Ignored and forgotten. Fashion moves on. The Bosnians, the Kurds, the Ethiopians, the Sudanese, the Somalis just disappear from view. Although it is demonstrable that many global events have a grave political, social or even ethical significance for the United States, it is conventional wisdom that Americans know little and care less about international affairs. Photographer Luc Delahaye took a memorable picture of an infant rescued from the Tuzla fighting in Bosnia, its face covered with blood. The photograph made the cover of *Newsweek* . . . and it was one of *Newsweek*'s poorest-selling issues of all time. As Smith Hempstone, the former U.S. ambassador to Kenya, put it: "I think that we may have reached the son of 'horror fatigue' situation in which, when you've seen one starving baby, you've seen them all."[99]

Crisis coverage demands pictures. Arresting images may not prevent compassion fatigue—they may in fact promote it by causing viewers to turn away from the trauma—but no pictures for a crisis is even worse. If a story doesn't have a visual hook, an audience will often ignore it. Better to have their interest for a time, than not to have their interest at all. "If a reporter has a special story," said the *Tribune*'s Jim Yuenger, "he or she is urged to take photos—although there's no requirements that they do that—but to take photos, or hire a photographer to take them, so that we can take that special story that we pay all this money to maintain them overseas for, and make it as attractive to the newspaper as we possibly can."[100]

Especially when covering international affairs, journalists must excite the imagination of their readers. "A story is more likely to get on the front page if it's a feature that has a good picture," said Bernard Gwertzman, former foreign editor at *The New York Times*. "And we won't run a series without a lot of pictures. We have to have them. That's the trend all newspapers are moving to. . . . The way it works here is we just do our stories and hope we have decent pictures to go with them. And often if we get good stories and no pictures, we hold up the story until we get some pictures." The Associated Press, which is the main source of

international news for most of the nation's print and much of the broadcast media, will also hold stories, for a cycle or a day or longer until pictures are available. "If it's urgent, of course, we can't do that, but otherwise we'll hold it as long as it takes," said Tom Kent, the international editor. "I've been at papers at decision time and I've seen AP stories get thrown in the wastebasket because there was no picture or graphic to go with them."[101]

For the newsmagazines the pressure is even greater to include photographs and graphics. At a time when television, 24-hour radio and niche magazines are all bombarding the public with easily digestible news, the general newsweeklies have all decided that to attract and hold readers' interest, they need to regularly redesign their layouts, use graphics and run compelling pictures. "There are a lot of news stories that do not lend themselves to good pictures," noted *Newsweek*'s Carroll Bogert. "Like the Japan story, there you have Asian guys in suits. Couldn't be more boring. Sometimes there's a story you have to cover but there's no good visual. A lack of good pictures can kill it."[102]

With a distant event there is a need to make an audience "feel" the situation. Northern whites had long acknowledged the legal apartheid of the American South, but they didn't "feel" its effects until photography and television in the late 1950s and 1960s brought the emotional blow of racism to the front pages and airwaves. Images help to legitimate the use of the word "crisis" for an event. A "crisis" occurs when the abstractions of injustice or racism or prejudice or pain, violence or destruction become concrete on a scale large enough to attract attention. It is the role of imagery to make the incorporeal, corporeal. That is how images tap so easily into our emotions, which respond more readily to flesh-and-blood people than to ephemeral concepts, however transcendent. News needs to be related to an individual's experience in order for that individual to take it in. Images effect that more easily, partly because common ground can more readily be discovered in a photograph than in paragraphs of text: That is a picture of a child; I, too, have a child.

Yet there is an instinctive distrust of allowing emotions to influence and govern our reactions. We may say pejoratively of someone that "his heart rules his head." On one side of the balance we place the intellect, facts, truth, analytical reasoning and scientific investigation. On the other side we place the emotions, pain, pleasure, gut reactions and "women's" intuition. This division blinds us from seeing that an emotional response to imagery is also an intellectual one.

Confronted with two images of a mother breastfeeding a child—one the image of the tired and dusty Migrant Mother nursing her infant during the Great Depression; the other of a Somali infant, flies glued to the child's eyelids, trying to nurse from the mother's shriveled breast—we react with greater emotion to the

photograph of the African child. Both photographs are aesthetically compelling. But even though we may have more in common with the American mother and child, we know with a fair degree of certainty that the American infant will survive with a measure of health even if it has limited prospects. The African infant, it seems, cannot possibly survive; and even if it does survive, the ravages of famine will have seriously compromised not just the health but the developing brain of the child. The fictions of imagination are overwhelmed by the tangibleness of the picture. What reverberates in our memory is our empathetic response to the visual stimulus. We apply our intellect and reason to the evidence we see—and then we respond, emotionally, to what critical theorist Walter Benjamin called the "aura": an image's elusive, charismatic and sometimes haunting presence. Photographs move us from the particular to the general, and from the general to the particular. "Just what kind of person are you?" asks an ad for Save the Children. "What kind of person can ignore the heartbreak in a child's face? How can anyone with a heart for children . . . for life . . . for decency . . . not reach out to help ease the pain of children so young, so defenseless, so needy?"[103]

A photograph provokes a tension in us—not only about the precise moment that the image depicts, but also about all the moments that led up to that instant and about all the moments that will follow. We see a news image of a starving child and a hovering vulture. Well we, too, have a child, and it is horrible to contemplate our child dying and becoming carrion for a vulture. Where are that child's parents? Siblings? Was the little girl left by her mother to die? Or did the mother die, and now the child is left alone? Did the child manage to crawl to help? Why didn't anyone see the child and help her? Did the child survive? The photograph stimulates a controlled emotive response—*emotive* because it acts on us sub rosa, under the level of our conscience intellectualizing; *controlled* because we retain the power of turning the page.[104]

Our commonalty with the image, the fact that we can understand in part how terrible it is to have a child in distress, is tempered by the fact that we who only look at the image are not literally there. We—and our children—are exempt. And we are blameless for not taking action, for not helping that starving child. We didn't know, we weren't there. But—and this is the key hitch—now that we know the horror, we will share in the guilt if we just turn the page. We will become complicit. Our responsibility becomes not only that child—whose story is a foregone conclusion—but other children threatened. If we turn the page—according to the logic of the advertising campaign—we become part of the problem. Photographer Kevin Carter, who took the 1993 photo of the Sudanese toddler threatened by the vulture, did not help that particular child, but his image, which was seen all over the world, became part of the global

humanitarian effort to prevent apathy. A little over a year later Carter won a Pulitzer Prize for his effort. Two months after he accepted the award in New York he committed suicide. He had earlier told a friend "I'm really, really sorry I didn't pick the child up."[105] Being close enough to photograph the starving child meant being close enough to help. The responsibility to bear witness does not automatically outweigh the responsibility to be involved.

The moral dilemma, as typically construed, opposes direct aid to one victim against the more remote, yet wider effect of a published photograph. Jim Dwyer, Pulitzer Prize–winning columnist for the late *New York Newsday*, says the only ethical justification for a reporter's intrusion into a victim's life is that he will help.[106]

But what is our justification for looking? And what is our justification for turning away?

In more ways than the metaphorical, compassion fatigue has become an insidious plague in society. Just as the overuse of antibiotics has made people immune to their benefits, the constant bombardment of disasters, with all their attendant formulaic, sensationalist, Americanized coverage, has made the public deaf to the importuning of news stories and relief agencies. We turn the page, as the Save the Children advertisement cautions us against, and leave the troubles of others behind.

If all the media treated international crises as priority news items, there would be no benefit in "switching the channel." The story would be everywhere. But such unanimity rarely occurs. Despite the undoubted significance of "hard" news—whether about international events, domestic politics, business and economics or the environment—the media pander to the public's interest in gossip and celebrity stories. And marketplace concerns effectively mandate that there will be no lasting redefinition of news—omitting the fluff and emphasizing those events and circumstances that have an important effect on the lives of Americans.

Compassion fatigue is easier to catch and harder to overcome if there is something flashy that clamors for our attention. Odd juxtapositions of other stories, or even ads and commercials, usurp some of the power of news imagery. One's mind can linger gratefully on frothy stories of celebrities or glitzy car and beer ads—in effect, pushing away pictures of suffering. True, advertisements in print periodicals and commercials on television pay the way for reporters, correspondents, photographers and camera operators to cover the news. But the ads and commercials also create a context for the news that makes it easier for an audience to remain unaffected by a story's words and images. (This is a concept

that is understood by the media—witness the lack of ads during the network première of Steven Spielberg's *Schindler's List*.)

The ad in the December 6, 1992 *New York Times Magazine* for an extraordinarily expensive Steuben crystal vase observed, "Sometimes the strangest juxtapositions just happen." A few spreads later an advertisement for Hellmann's Real Mayonnaise admonished its readers to "Bring Out Your Holiday Best." On the following page, the cover story began. A two-page, black-bordered black-and-white photograph by James Nachtwey pictured a starving Somali woman being brought to a feeding center in a wheelbarrow. Bring out your holiday best, indeed.[107]

A few months earlier, *Time* magazine, in its September 21, 1992, issue, ran a story entitled "A Day in the Death of Somalia." Several pages into the story a large color image by Christopher Morris dominated the right-hand page. A dead child was being washed for burial. The child's ribs looked like a chicken carcass after all the meat has been plucked off the bones, and the skin covering the child's stomach bore no resemblance at all to skin or a stomach—it had the appearance of a collapsed puddle of milk skin from a cup of cocoa.

On the opposite page, Lucy—of *Charlie Brown* fame—screamed from the black hole of an open mouth. But she wasn't screaming in pain over the death in extremity of the child whom she faced. She was screaming, so the balloon caption said, "Now hear this! MetLife has Mutual Funds."

On the following two-page spread, the article ended with two photographs on the left-hand page: one of eight bodies wrapped in rags lying before several open graves and the other of the head of a dead young man being held by other hands, prior to his being shrouded for burial. The features of the young man are sunken, his neck sticklike. How could he have lasted as long as he did?

On the facing right-hand page was an advertisement for Habitrol's nicotine patch. A color photo in tones similar to those of the images from Somalia—terracottas and teal green—pictured an attractive black woman baring her arm to show her skin patch. The headline stated "Portrait of a Quitter" and read, in some fashion, as a commentary on the dead of the previous page.[108]

A reader wrote in to *Time* to comment on the Somalia story and its surrounding advertisements. "I wonder at the process by which these pictures came to be juxtaposed," said Paul J. Bauermeister, of St. Clair, Missouri. "The effect is jarring, and it is one of the most telling judgments I have seen on the ease with which the self-absorbed First World is able to ignore the suffering in the Third World. This lesson in compassion makes me tremble."[109]

Form can matter as much—or more than—function. Layouts, adjacent stories, lead-in pieces make a difference to how we understand the news. It is disturbing

to realize, for example, that our sympathetic capacity to suffer emotionally and intellectually is partly regulated by the talents of the photographer and the aesthetic merit of an individual image. An arresting image transfigures its subject, so that we find the representation of starvation visually stunning, so that we look upon the African child and find its pain and desperation literally unforgettable. Images, wrote novelist E. L. Doctorow in *The Book of Daniel*, "are essentially instruments of torture exploding through the individual's calloused capacity to feel powerful undifferentiated emotions full of longing and dissatisfaction and monumentality."[110] Yet a badly focused and poorly cropped image of a child in identical circumstances will make little or no impression.[111] It is not the subject alone that makes the statement, it is the subject married to a technically proficient, stylishly appropriate packaging that reverberates in our memories.

A simple redactiveness in the images of a crisis can be the most powerful way of calling attention to an issue. The best pictures, said the great 19th-century British historian Thomas Macaulay, "exhibit such parts of the truth as most nearly produce the effect of the whole." But the selection of those parts is a task rife with problems. Commonly, crisis images do not describe epiphanies, but formula. Crisis images feed into formula coverage. Dave Marash, a correspondent for ABC News *Nightline*, has noted how much television relies on "familiar pictures and familiar texts." He observed, for instance, the TV code for "hurricane": "Palm trees bending to the gale, surf splashing over the humbled shore, missing roofs, homeless people showing up in local gyms. You see it once or twice most years."[112] (On occasion not only is the same code used by various media, but the exact same images are repeated—a consequence of the fact that most of the media subscribes to or has access to the same photo agencies, wire services and/or satellite news services.)

Especially when a crisis is a "foreign" event, there is a tendency to fall back on hackneyed images, often revealing more about what the crisis is thought to be than what the crisis actually is. Formulaic images "label" a crisis so that it is identifiable. "Wars," said photojournalist Eugene Richards, "have to look the same way from picture to picture. . . ." And "when they do," noted Susan Meiselas, "it can be hard to tell them apart—especially when the people and places look the same, too, as in the conflicts in Nicaragua and El Salvador or Rwanda and Burundi."[113] "War" is signaled by photographs of men with guns, not, for example, by images of a barren landscape—even if that landscape is seeded with mines, and is, in effect, as much a war zone as that street filled with guerrilla fighters.

Other varieties of crises have their own "look," too. For instance, photography can give a disease the imprimatur of an epidemic by cueing an audience to formulaic elements, say, doctors in "space suits," signaling that the disease is

highly contagious or, say, the microscopic appearance of a virus, signaling that the disease is aberrant. Images, by design, cannot help but simplify the world. What matters is the quality of their simplicity.

Images of crisis and their accompanying metaphors rely on a repertoire of stereotypes: the heroic doctor, the brutal tyrant, the sympathetic aid worker, the barbaric mercenaries, the innocent orphans, the conniving politicians, and so on. The images induce the public to fit these models into the current crisis. Each stereotype employed implies or presupposes a story line which in turn implies or presupposes an appropriate political response. If the images that document a crisis are of starving orphans, the remedy is humanitarian assistance. If the images are of the brutal tyrant, the remedy is military force.

There is a built-in inertia that perpetuates familiar images. Without them "reality" becomes more complex, less immediately understandable, more "real"—and perhaps more interesting. But because, other than choosing to watch or not to watch or to read or not to read, the media's audience has little direct control over the news they receive, the audience can't easily vote for a more individual style of coverage. The public's most direct response to coverage that it doesn't like is to lapse into ennui. In an oft-cited passage in Jonathan Kozol's book on poverty in urban America, *Amazing Grace*, a mother with AIDS is told about compassion fatigue among the well-to-do. She says to Kozol, "I don't understand what they have done to get so tired."[114] They haven't *done* anything. But as they sit passively in front of their TV sets, they've been barraged with redundant images.

Since we are not typically conscious that news images are being repeated, they have an insidious and usually imperceptible effect.[115] Yet this compassion fatigue is a problematic response to read. It may be perfectly evident that readers are not interested in a news event—for example, they may not buy the magazine with Bosnia on the cover—but it is less clear whether the low sales of that issue are due to the public's lack of interest in Bosnia or just to the style of coverage. So the media's reaction is often both to pull Bosnia from the cover of all future issues and to change their news style to include more "reader-friendly," human-interest content.

In theory, photographs can have a beneficial influence on the public's interest in international affairs; positive, upbeat photographs can encourage readers and viewers to read and watch the news. The public is more likely to tune in or read on if a story is more than gray copy or talking heads. And the public is more likely to have a higher recall of facts and themes when there is visual accompaniment to a news item.[116] But unfortunately, this accompaniment is not always objectively

functional. "Sometimes," said *L.A. Times* director of photography Larry Arm-strong, photographs are "used more as ornamentation. Sometimes they're used more in terms of 'We've got to fill our hole, break up some space.'" Photographs do not always illuminate the key facets of a story, nor do they always speak perti-nently about them. "Rightly or wrongly," said Mark Seibel, former assistant man-aging editor at the *Miami Herald*, "I think the photo's an afterthought."[117]

Television, especially, cultivates a kind of negligence about imagery. Images on the news are too often driven not by what needs to be or should be told, but by whatever images are available on the station's "B" roll. Yet 1960s media guru Marshall McLuhan popularized the notion that it does not matter what the tele-vision reporters say because the pictures in the background tell their own story.

Images on a screen are easily subsumed into the flow of time, bypassing the mind. Watching TV, one's eyes become a passive instrument; rarely does one have to make any active, visual judgments or effort. Still images, by contrast, are still. One can look and look and look. The electronic images on television blur and melt away, while the still photograph stubbornly resists dissipation. Con-fronted by a photograph, one searches the image. A photograph is the sum of moments that have come before. The recognition that the image is a record of what has happened up to that instant, inspires questions about what might come to pass. Photographs freeze time, then dole it out infinitely, as long as one chooses to look and wonder. They are the "residue" of continuous experience.

Photography, more than the movies or television, as Roland Barthes has said, is the collective memory of the world.[118] Photographs make an indelible impres-sion; we remember events by reference to the pictures of them. To list just a few iconic images from the last decade: the lone protester standing in front of the tank in Tiananmen Square; the black vulture looming over the Sudanese child collapsed on the way to a feeding station; the dead American serviceman being dragged through the streets of Mogadishu; the bloodied toddler in the Okla-homan firefighter's arms. The Roman statesman Marcus Tullius Cicero wrote that "The most complete pictures are formed in our minds of the things that have been conveyed to them and imprinted on them by the senses, but that the keenest of all our senses is the sense of sight, and that consequently perceptions received by the ears or by reflection can be most easily retained if they are also conveyed to our minds by the mediation of the eyes."[119]

Film and video take their viewers inexorably along a foregone path, while memory and photography are individually haphazard. The flashes of time can be shuffled how one will. Memory, like an anthology of still photographs, con-sists of slices of discontinuous time. Both the remembered and the photograph exist as a moment in time and as a moment out of time. Both champion the

individual standpoint over the collective position. Film and videotape are relatively careless mediums—not in their construction, but in their audiences' responses. "That's one of the effects of TV," said Jim Yuenger, "that it's shortened the national attention span."[120] Confronted by a film narrative you sit waiting for what is going to happen. When it all ends you realize that your anticipation overwhelmed your delectation of the passing moments.

Perhaps still images in newspapers and magazines function better to fix events in the memory than videotaped images on television—although they may not inspire immediate action as readily. The stage management of the Persian Gulf War, which resulted in live press conferences, sanitized video shots of "surgical" air strikes and in few photographers and cameramen gaining access to the ground fighting, demonstrated that Americans could fight a war and a short time later remember only the chalk talks by the generals.[121] "My son, who's 27, was telling me that the Persian Gulf War didn't happen," said Yuenger in 1994. "I said, 'What?' He said, 'There wasn't any Persian Gulf War. Consider it from the point of view of someone my age. We don't know anyone who went, no Americans got killed, we didn't see any Iraqis get killed. It's just CNN footage of these bombs and then there's victory parades and Bush and Stormin' Norman standing tall.' It's not a part of the history of our time for a whole generation of people."[122]

The emotional pull of still photography remains peculiarly strong when we reflect on the current state of technology, when we can sit in our living rooms and watch a war raging live on the other side of the globe. Most of the visual spectacle of televised war is scarcely more memorable than a game in a video arcade; the still image leaves a deep footprint in our imagination. Perhaps it's easier to contract compassion fatigue when the pictures are on TV than when the images are in print, because one has a personal, intimate relationship with printed still photos. One has to touch the page to turn the page.

Videotape—and still photography—have other limitations as well. Trends and economic and political causes or repercussions, for example, are hard to film. As CBS anchor Dan Rather puts it, "You can't take a picture of an idea." Typically what photographs and videotape can do and do do is quite literally put a "face" on the text. When a television correspondent speaks, for example, about a Center for Disease Control doctor "dressing like an astronaut: all seams sealed, two pairs of gloves, and a personal respirator," images show the *2001* look. When a magazine article talks about Ebola as a "thread-like filovirus," pictures give an electron microscopic perspective on the long and looping appearance of the virus.[123]

But while a photograph may offer evidence that a man is dying, it does not tell of the significance of his illness.[124] Images rarely inform; more typically, they

inspire. Most images are little more than illustrations. Much of the way we "read" images is directed by the appended headlines, captions or stories. In general, published photographs have some text appended to them; images used for the purpose of telling the news are dominated by language. A photograph is strong evidence that something existed like what is in the picture — but what that "something" means is less clear. Mark Twain told of looking at a famous painting:

> A good legible label is usually worth, for information, a ton of signif-
> icant attitude and expression in a historical picture. In Rome, peo-
> ple with fine sympathetic natures stand up and weep in front of the
> celebrated "Beatrice Cenci the Day Before Her Execution." It
> shows what a label can do. If they did not know the picture, they
> would inspect it unmoved, and say, "Young Girl with Hay Fever;
> Young Girl with Her Head in a Bag."[125]

As the spin doctors know, how we see a picture depends on its tag. In 1992, for example, the media's choice of images from Bosnia fed into the metaphorical debate as to whether the situation was more like the Holocaust or more like Vietnam. When we were shown photographs of the "death camps" we were implicitly being asked whether we were going to stand back and watch these new "Jews" die. When we were shown pictures of the fighting we were implicitly being asked whether we were willing to become embroiled in another quagmire. The images and metaphors concealed grave truths, but not solely about the crisis they claimed to represent. Often crisis images are about more fundamental matters: primal fears and human psychology, American history and the dominant belief system of American society. The media's selection of photographs from Bosnia revealed more about the United States than about the war being fought in the former Yugoslavia.

Because images cannot explain themselves, as writer Susan Sontag has noted, they are "inexhaustible invitations to deduction, speculation, and fantasy."[126] But there remains an expectation of meaning. To decode that meaning from an image, viewers must know what they are looking at, whether it is authentic, when and for what purpose it was made and what were the circumstances, conventions and constraints on its creation.[127] Images are bewitching sirens, luring us with promises of knowledge, but leaving us with little more than the memory of a compelling face. The images are not meaningless; in many ways, they do warn us of the rocks below, but they also tempt us to ignore those rocks in favor of their mesmerizing song. Americans were so captivated by the compelling images of the starving in Somalia, for example, the dangerous shoals

of warring tribal factions were disregarded. Words may give meaning, but in our visual era, images are essential to effective communication—especially in the telling of the news. Images have authority over the imagination.

When a crisis occurs in a place about which Americans know little, images are often married to known metaphors—images are published emphasizing a certain one-note theme. Many of the images and metaphors that have become clustered around present-day crises have been associated in one form or another with similar crises for generations. Associations already in the collective imagination creep into the perceptions of new events. The assassination of a foreign head of state is referred back to America's fallen hero, JFK; the state-sponsored decimation of entire populations is cloaked by the mantle of "Holocaust"; the ravages of mysterious diseases are heralded with the cry of "plague."

The interaction between the fundamental constants and the dynamic events suggests the appropriate specific images and metaphors. For instance, war prompts thoughts about courage and promises and loyalty to allies. It is not happenstance that it was the image of General MacArthur striding back through the Philippine waves—not one of him fleeing the islands—that became an icon of World War II. And it is not happenstance that it was the image of the helicopter evacuating Americans from the Saigon rooftops—not one of Marines landing at Da Nang—that became an icon of the Vietnam War. Imagery can embrace opposites.

The appeal of both images and metaphors is that they convey a wealth of information in a relatively small package. It is frequently the case that visual images or metaphorical expressions can more succinctly describe a face or a place or a moment in time than can paragraphs of narrative. Narrative is time- and space-consuming. And when space in print and time on air are expensive and in finite quantities, the reporting on any crisis, no matter how compelling or immediate, has to be constricted to fit the medium. That condensing is often achieved through the selective use of formulaic images and sensationalized or Americanized metaphors.

The problem is, however, that the selected bit of information found in any image or metaphor cannot possibly accurately represent the situation that it purports to depict. Images and metaphors may provoke an emotional response from an audience, and in that respect may focus the attention of the public on an event that otherwise might have been neglected, but that event is almost certainly more complicated. The impact of the Depression was felt by groups other than that of the Migrant Mother, the war in the Pacific was both less and more than the glory of the Flag Raising on Iwo Jima, the end to Camelot did not come with John-John's salute to his father's caisson.

When images and metaphors are used in conjunction, they have the potential to synergistically obfuscate rather than illuminate the known situation. If all that a reader knows of the dismemberment of Yugoslavia is the metaphor of "Holocaust" prompted by the photograph of the emaciated faces of the Bosnian Muslim prisoners peering through the barbed wire of the Bosnian Serb POW camp, then a disservice has been done to the complexity of the Balkan conflict. The existence of the Serbian camps is incontestably important and newsworthy, but the de facto parallels of Serbs to Nazis raised by the use of the metaphor of "Holocaust" are neither especially accurate nor useful. The Bosnian negotiations had "a kind of resonance to the Munich conference," said Gwertzman from the *Times*, "but there's really no Nazi force out there, you can't really compare the Serbs to the Nazis, it's not fair. But people do it, and we take note of it, and I think what you're implying is true."[128]

There is another problem stemming from the labeling of crises by images and metaphors. Once an audience is familiar with a label, it becomes easy to dismiss the event itself by rejecting the label. And that rejection can become a form of compassion fatigue. Since few people have (or take) the opportunity to learn about the news in detail, a label may be one of the most specific things a person knows about an event. Since labels, to be effective, must be part of a culture's common language, a person will have a history of responses to that label. A person will often dismiss a politician for being "liberal," for example, if that person associates "tax and spend" behavior with liberalism. Similarly, an event labeled "famine," for instance, may call up associations of starving children and selfless aid workers. If an audience is not interested in, or is bored by, that scenario, the famine will be ignored—a casualty of compassion fatigue, caused by a reflexive and limiting use of labels. With labeling comes the ability to categorize, to say, "Oh, this is a famine," like Biafra or Ethiopia. But with categorizing comes the tendency to dismiss, to say, "I know about this. I've seen this before." As the coverage of a famine continues, so too does the vulnerability of that crisis to compassion fatigue.

Most news generates images that remain anchored in a specific time and place. Even dramatic events typically give rise to images that only linger in the public's memory for the duration of that crisis. But on occasion an epiphany occurs in an ongoing news story, a decisive moment is identified, and the essence of that story is crystallized into a compelling news icon. Many times that icon is a visual, photographic one, for example: the training of fire hoses on civil rights demonstrators in Birmingham; the keening of a bystander over the body of a student shot at Kent State; the exploding of the space shuttle *Challenger*. Other times

memorable images are evoked through narrative word-pictures, such as Winston Churchill's "Iron Curtain," John F. Kennedy's "Camelot," George Bush's "Read My Lips." But whether or not the news icon is created through a photographic or a verbal image, it is sustained by the meanings that journalists, sources and the public project onto it.[129]

The repeated use of an iconic image comes to dominate the originating event; the entire story, crisis or conflict is distilled into that one or a very few other signifying images. The force of an icon comes from its documentary authenticity, from the acuteness of its aesthetic or verbal vision, from the perception of the importance of the original event, from the ubiquity of its reference and from the sense of shared experience it engenders. Form and content are intrinsic to a photographic image. "A photograph becomes more illustrative when it is content-driven," observed Susan Meiselas, "and more aestheticizing when form is paramount. What makes an iconic moment is when these two come together with precision."[130] A brief look or phrase can recall such an icon to the mind's eye, and once embedded in memory it has the power to shift the framing of other news stories. Its use prompts both an intellectual and an emotional response to the initial crisis. But it also evokes—and at times even provokes—larger social, cultural and/or political themes. Its application in other settings may forge linkages between otherwise dissimilar events. It may add a historical marker or context to a narrative that would otherwise have none. It may also add a note of drama or comedy to an otherwise bland recital of facts or analysis.

The prevalence of news icons suggests that journalists desire to emphasize those moments that have metaphorical potential. In a world of quick sound bites and scant column inches, evocative shorthand is imperative. Icons are a form of stereotype, a less transparent means of categorizing a particular event than the more traditional conventions. Used indiscriminately, dumped gratuitously for the sake of novelty into all kinds of news stories, icons can quickly lose their effectiveness and initiate compassion fatigue. But used more sparingly, incorporated into stories not as a tic but as an insight, they can illuminate unrecognized public policy issues or tensions. They can act as "focusing events," serving to push certain problems into the news and onto the public agenda. They can be both indicators of the existence of tensions or fears and as catalysts for responses to those concerns.[131]

Images have always played a role in the defining of a crisis, but in the coverage of international affairs they are often the chief manner by which Americans "see" and "remember" a crisis. Given the importance of images in contemporary politics and in historical memory it is critical to discover what ideas are

represented by those images. What is the resonance of a certain image for those who see it? A public image may range from a simple stereotype to a complex mental picture. It may incorporate visceral emotions, inarticulate feelings, unconsidered beliefs, as well as carefully thought-out ideas. Images of the gassing of the Kurds in 1988, for example, will take their meaning for each person from his or her beliefs about and prior knowledge of such topics as chemical warfare, historical military actions against civilians, foreign tyrants and the Middle East.[132] "Experiments show that we must have a rough idea of what to look for," wrote historian Spencer Weart in his study of the images of nuclear power, "some previously learned mental picture, or we even have trouble recognizing an object in a drawing. In short, as a result of experience every simple image, from direct perception to elaborate mental representation, becomes connected with various other things in a web of associations."[133]

Imagery is the common denominator of a culture, a means of communicating the dominant culture's values and set of ideas, rich in symbols and mythology. To be effective, imagery must draw upon a "language" of recurrent themes and values widely shared and easily understood by its audience.[134] Context matters. The photograph of the lone Chinese who stopped a column of tanks in Tiananmen Square became a symbol of freedom and individual rights to Americans. In China, that same image was used to demonstrate that the troops had exercised humanitarian restraint in not mowing the man down. For both countries, the imagery supplied, in a fragmented form, much of what their ideologies did: It supplied "a world image convincing enough to support the collective and individual sense of identity."[135] Imagery reflects its culture's ideology, its self-image and its relationship to the world.

The issue is, as *Time* magazine put it, "Who controls the culture?" "The Third Reich," *Time* said, "proved beyond all reasonable doubt what the constant pumping of hate-filled images and inflammatory statements can do to a culture."[136] To control the culture, one must control the pictures. Even images taken to serve merely as historical documents can change their meaning depending on the context in which they are seen. The cumulative effect of the identity photos taken of those who were tortured and killed by the Khymer Rouge during the era of the Killing Fields was little more than that of a telephone book for Pol Pot's regime. Today, those images form a testimony to genocide, just as do the recital of tattoo numbers or the mound of eyeglasses from Auschwitz.

The right image can condemn a murderer or elect a president. After the military triumph of Desert Storm in 1991, President Bush became politically mired in the debacle of the abandoned Kurdish refugees. A Doonesbury cartoon identified the administration's problem: "So what happened?" asks Bush. "What

happened to my perfect little victory?" "We lost control of the pictures, sir," his aides reply. "During the war, we killed 100,000 Iraqis, but we controlled the media, so no one saw the bodies. With the Kurds, it's a different situation. Every baby burial makes the evening news. . . . I'm afraid we are just going to have to tough it out. At least until we can get the pictures back on our side."[137]

Few of us are visually literate. We are familiar with the notion that words are malleable; we know about the manipulative powers of rhetoric. But few of us are as aware of the potential that images offer for manipulation. And rarely are the machinations exposed—whether they are as blatant as government photo-ops, as sneaky as editorial slights-of-hand or as instinctive as journalistic biases.

Convention has it that photography is that lantern of Diogenes, sending rays out into the world's dark corners. Conventional wisdom is wrong. Photography can illuminate the shadows, but it can also cast its own. Images can lie outright: They can be published with misleading captions, they can be morphed on computers. But they can also be more subtly influenced. The censoring of images— or the denial of access to image making, as occurred during the Persian Gulf War, can skew the public's perception of an event. "What you see in the media are the pictures that didn't get away," observed longtime photographer Carl Mydans. "And there's no way of knowing how many important, how many wonderful images there are that we saw, that we wept for, but that we didn't make. Just think how much more there is to history, how much more experience there is that photojournalists didn't quite get."[138]

Once the pictures are "in the can," the editing of images to emphasize one aspect of a situation can equally skew perception. The taking and the publishing of images is inherently undemocratic. Even if one discounts the limitations of technology and access, there is still an astonishing range of images from which the single one is selected. We, the audience, are seduced into believing in the freedom of the press, because rarely, at least in the United States, is the viewing of certain images prohibited. But the viewing is just the last act in the series of image production and dissemination. There is an ideological construct (or constructs) behind every image. There are moral, cultural, social and political assumptions in the taking and the publishing and the viewing of images.

Images serve a myriad of functions within a culture: They can be taken to offer aesthetic repose, to fulfill a breaking-news function, to keep an historical event in memory, to confront authorities with evidence, to serve as mute testimony. Like contemporary affairs, the historical past can be co-opted by seductive imagery (as Oliver Stone's *JFK* film demonstrated). Images taken or appropriated to represent the past determine how we view history. They are not passive illustrations; they are ideological constructions designed to justify national

ideals resonant today. The endless arguments about what should be included in school textbooks reminds us that history is shaped by the selective presentation of images, people and events.

Who we believe we are and how we perceive the world to be have a powerful effect on world events. Photographs cannot initiate a moral or political stance, but they can reinforce one. In Bosnia, said Johanna Neuman, "the pictures may have moved the leadership to threaten or cajole or implement sanctions or even, finally, to strike from the air. The pictures produced a policy of humanitarian assistance. . . . But never did the pictures prompt the West to enter the war on the ground. . . . The bottom line never changed."[139] Neither the taking nor the viewing of images impels great action. An understanding of imagery and metaphors—and the initiating ideology—provides no constant guide to the behavior of a culture. It does, however, help to delineate the structure within which policymakers deal with specific issues and within which the attentive public understands and responds to those issues.[140]

Despite the fact that CNN, the three television networks and some of the world's best photojournalists—James Nachtwey, David and Peter Turnley, Luc Delahaye, Jon Jones, Christopher Morris, Anthony Suau, Gilles Peress, Corinne Dufka, Tom Stoddart, Roger Hutchings and even portraitist Annie Liebovitz—have all camped out in Bosnia, despite the fact that there were more photographers and cameramen killed there in three years of fighting than in ten years of war in Vietnam, there was little political will to intervene. Would more images of the caliber of the raped Moslem women or the emaciated POWs staring bleakly out from behind Serb barbed wire have made a difference in the U.S. commitment there? Or would more iconic photos just have left us with more guilt? As the American response to Bosnia proved, images' power to provoke action has not only dimmed, but it never operated at all unless the appropriate response was immediately apparent and relatively simple. It makes sense that when the public—via the American government—is effectively prohibited from action—if a crisis is too complex or entrenched for amelioration—compassion fatigue results.

Compassion fatigue is a result of inaction and itself causes inaction. "Our experience is that over the last couple of years our appeals for Bosnia have seen declining returns," said John McGrath of Oxfam in 1995. "I think people feel it's a situation with no end. They feel that if the politicians can't sort it out or don't have the will to sort it out then what can the public do?"[141]

If the news-reading and news-watching public does linger over images of suffering, if the imagery is arresting enough, and if the crisis hits us at Christmastime when our sympathies are most awakened, maybe we'll send a few dollars to

some aid agency. But we can't stop everything to care about a child thousands of miles away, even if he is dying. Compassion fatigue leads to a take-it-or-leave-it attitude: "Hey, if I miss the news about Bosnia today, I'll catch it tomorrow." So much for the suffering in the Balkans and the fate of millions who live only two hours away from our last holiday at EuroDisney.

Our moral fatigue and exhausted empathy is, in some degree, a survival mechanism. "When we see fairly horrendous pictures that upset us emotionally," noted psychology expert Dr. Geoff Scobie, "we have some sort of mechanism which prevents us getting quite so emotionally upset the next time we see something." There is always an audience for images of quality, but there is a fatigue for continual—even live, on-air—suffering. "The ability to stun an audience by delivering real-time pictures of events as they happen is ebbing," said Johanna Neuman. "Call it compassion fatigue or media over-saturation, but television pictures of a starving child or a mass exodus of refugees no longer tug as strongly."[142]

Compassion fatigue's passivity—the "fatigue" part—is not neutral. Save the Children ads promise that if we respond, if we throw off our compassion fatigue, action will result, a child will be saved and we will become caring human beings. If we respond to that Save the Children ad, we check off a box that reads "Yes, I'm the kind of person who cares."[143] Compassion fatigue militates both against caring (as Save the Children crassly plays on) and against action.

It even militates against memory. Milan Kundera wrote, "The struggle of man against power is the struggle of memory against forgetting."[144] If we don't care, if we take no action, we will forget—if indeed we ever knew—what caused a particular crisis. Images are our most efficient—although certainly not infallible—mnemonic device; images call up events and eras and feelings in the blink of an eye. But if we tune out those images, we forget. It's true, it's sad that the media's coverage of crises is so formulaic, that iconic moments become symbols, then stereotyped references that become at best a rote memory. But better a stereotyped memory than no memory. Better to recall Somalia in terms of starving babies, than not to remember the country at all.

But perhaps if the coverage of crises was not so formulaic or sensationalized or Americanized we wouldn't lapse so readily into a compassion fatigue stupor. The tension among what "is," what we are "shown," what "action" we take and what we ultimately "remember" is at the heart of our understanding of global events.

"An Outbreak in Africa Spreads Global Fear," *Newsweek*, 22 May 1995
"Centers for Disease Control and Prevention researchers with viral samples."

CHAPTER TWO

COVERING PESTILENCE:
SENSATIONALIZING
EPIDEMIC DISEASE

We had no such thing as printed newspapers in those days to spread rumours
and reports of things, and to improve them by the invention of men, as I have
lived to see practiced since.
— Daniel Defoe, *A Journal of the Plague Year*, 1721

"**N**ot since the Black Death has such mysterious evil visited England," noted
Newsweek, only half-jokingly, about the announcement in late May 1994
that 11 people in Britain had died from a virulent strain of group A strepto-
coccus.[1]

"Just about everyone was suddenly talking about the killer bug that destroys
human flesh, and some wondered whether the world was facing a new scourge
even more horrifying than AIDS," *Time* magazine chimed in.[2]

The American media's coverage of the "deadly flesh-eating bacteria" story
bore all the stylistic hallmarks of their reporting on an outbreak of a deadly dis-
ease. Coverage of the "toxic strep" scare—the stories' format, language, meta-
phors and images—resonated with American cultural history, folktales and
myths. Fearsome similes were employed as a measuring stick against which
to gauge the new threat. Hoary medical icons, such as the Black Death, and
fashionable ones, such as AIDS, brought to mind visions of an easily contagious
fatal or disfiguring disease felling millions. Strep A was not just a bacteria, but,
more melodramatically, a "mysterious evil," a "killer bug," a "horrifying new
scourge."

The coverage fit into the pre-existing formula, emphasizing the sensational,
the macabre and the personal. The fact that most experts agreed that there "is no
'killer bug' sweeping the country," saying that the number of cases was "still low
and still falls within expected ranges" seemed to deter few media sources from
gleefully reporting on the purported outbreak. As *Time* wrote, the story was "too

deliciously terrifying to resist."[3] The American media covered the cluster of cases in Gloucester in western England and elsewhere in Britain, often by beginning with graphic accounts of the victims' suffering, as did this piece by *Newsweek*:

> After contracting the infection, claimed a nurse, her abdomen turned transparent as a fishbowl, while the tissue underneath went black. A vicar described how the disease forced surgeons to amputate all his fingers and both legs. One woman caught the bug and died after a Caesarean operation. Another was left horribly disfigured.

The articles then turned to vivid comments by the victims' doctors or by experts in the field:

> "The whole of the muscles down one side of her back were virtually digested," her doctor told the Associated Press. "If we had not got rid of them she would have been dead within 24 hours."

Then the articles concluded, dutifully, with statements downplaying the potential threat to people in Britain and in the United States:

> "There is nothing out of the ordinary at all in what's happened," says Aberdeen University professor Thomas Pennington, an expert in streptococcal infections. "The risk is about the same as being struck by lightening."[4]

Sensationalism, formulaic coverage, reference to metaphors familiar to an American audience. These are the hallmarks of the media's coverage of outbreaks of disease. Usually the outbreaks don't last long enough for Americans to lapse into compassion fatigue. A couple of weeks of terrifying coverage and the media is on to the next crisis. But the method of coverage sets the bar higher for the next incident, the method trains Americans to want ever more sensational details, the method prompts the media to consider covering only the most threatening, most aberrant, most contagious epidemics. A new outbreak of disease will have to meet the flesh-eating standard or the "Ebola Standard." Those illnesses which merely kill in some pedestrian fashion—like diarrhea or measles—will garner no attention at all, and become, ultimately, the casualties of compassion fatigue syndrome.

. . .

Disease, especially epidemic disease, is not only a biological phenomenon but a social, cultural and political one.[5] How societies respond to catastrophic outbreaks of disease is measured by their level of emotion and fear, their trust in science and medicine, their experience of pain and illness and their reaction to disability and death.[6]

The public which generally lacks knowledge about international affairs is at an even greater disadvantage when trying to follow the story of an outbreak of disease abroad, because it often lacks basic knowledge about the functioning of science and medicine as well. Therefore, in these instances, media audiences are especially dependent on the media as information sources and for guidelines about how to feel and how to react.

Somewhat surprisingly, despite the potential sensationalist appeal of stories about a disease run amuck abroad, not many of these events make the evening news and the front pages of the newspapers. In 1992–93, for example, an extremely lethal epidemic of Kala-Azar (visceral leishmaniasis) broke out in southern Sudan afflicting tens of thousands of people. Because the region was held by the rebel forces in a country wracked by civil war, little information was available and few outsiders could get in to confirm the little that had leaked out. The logistics of news gathering, but also the chilling effect of compassion fatigue when considering whether to budget news from a country such as the Sudan, kept the epidemic all but invisible to the world.[7] As William Ahearn, a vice president and executive editor at Associated Press, observed: "I haven't been at too many newspapers where I've heard people in charge ask, 'Well, what did we leave out today?'"[8]

The "epidemics" that have received attention have not always posed the most obvious medical danger, either to the region in which the outbreak has occurred or to the global environment. Why is there little or no coverage of the World Health Organization estimates that 3.2 million children die every year of diarrheal diseases before reaching their fifth birthday? Or of the approximately 2 million people who die every year of tuberculosis? Or of the more than 27,000 American children, half of them under 4 years old, who contracted measles during 1990? One hundred died. Or of the thousands of Americans who die every year of influenza? The answer is compassion fatigue.

Body counts alone, even from the United States, do not make the news nor determine the extent of coverage. So whose lives count? How do the media select which epidemics to cover? Preventable tragedies, illnesses which have cures or vaccines, and cause their harm less because of their innate virulence

than because of want of money or public will, rarely make splashy headlines. The best predictor of coverage is an indication that some horrible disease is spreading and posing a global—or at least widespread—risk to people of the same demographic profile as the media's audience (white, middle-class Americans).[9] Joseph McCormick, chief of the Special Pathogens Branch of the Centers for Disease Control (CDC), noted: "Again and again, the viruses that emerge from the remote parts of the earth and assail the indigenous population only gain attention when they move out of a small area to affect larger numbers—or when they kill off wealthy people or foreigners, especially Americans. Diseased white Westerners are always a sure bet when it comes to attracting attention. If the right people aren't infected or dying, outbreaks that occur all the time . . . go unnoticed."[10]

It was only after the media discovered American cases of strep A, for example, that that story received any real attention and moved out of the flesh-eating "joke" category and into the serious-threat category. One indication of the shift is that from the release of news about the British "outbreak" until the news broke about American cases there were only 16 stories total in the surveyed "elite" media outlets (according to a Nexis search[11]), a period of 11 days. Then, during the next three weeks, the group A strep story made the news more than 90 times. *The New York Times* even gave it an editorial. Yes, the disease was rare, but as the editors said, "Suddenly we all feel vulnerable." They warned: "If, after suffering a wound or deep bruise, you experience an infection that grows rapidly worse . . . don't just shrug it off and assume all will be better tomorrow. The time you waste could cost your limb—or your life." As *Time* magazine had it: "Streptomania Hits Home."[12] The number of stories in the media ballooned—and might have been even greater if the incidence of the American cases hadn't coincided with the murder of Nicole Brown Simpson and subsequent media frenzy over O.J. Simpson. ABC's magazine show *20/20* even scheduled a story on invasive strep A for June 17, and went on the air that night announcing the upcoming segment—then pre-empted the entire show with live coverage of the O.J. Simpson–White Bronco chase. The *20/20* segment on strep A aired the following Friday.

The closer to home the epidemic, the more likely the coverage. An outbreak of strep A in India, say, would probably not have made the American media's news budget. Americans assume that ghastly, deforming diseases, like leprosy, for example, are endemic there. But an outbreak in England was another matter. In sum, those diseases which make it onto the front pages and into the 6 o'clock news are those that surmount the compassion fatigue hurdle. They are

the rare and physically or psychologically close ones, like strep A's flesh-eating bacteria or the dementia of Creutzfeldt-Jakob Disease (CJD), or those that send a shiver up the spine no matter where the breakout, like the Ebola virus.

These diseases make the list because their existence contradicts a broadly held American belief in the power of medicine. Americans believe that a cure for all ills is not only probable, but certain—given enough political clout and scientific research and development money. After all, smallpox has been eradicated from the world and polio from the Western Hemisphere. But true tales of grisly diseases put the lie to this belief—and in so doing stave off compassion fatigue. Dr. Michael Wilkes, professor of medicine at UCLA, noted at the time of the flesh-eating bacteria outbreak: "For decades, and maybe even half a century, the American medical machine has tried, to a great extent, to put a myth over the public that everything is within our ability to control, that we have medicine and we have technology and we have surgery to deal with the common ills of humans. It's these sorts of episodes that pop their heads up on a regular basis, that remind the public how terribly vulnerable we all are, and how medicine is really very much an art, not a science."[13] The horror of certain diseases—Ebola or CJD, for instance—is all the greater for the lack of any remedy in sight. For Ebola, for CJD, there is no cure, there is no vaccine, there is ultimately no effective treatment.

The media not only gave these diseases coverage, but turned the disease outbreaks into iconic news images. The outbreaks became more than medical emergencies, they became symbols of larger forces and greater problems. Their images and terminologies were applied to other incidents outside the initiating disease episode; by the end of the media's coverage of such outbreaks as strep A or CJD, the diseases themselves had become cultural metaphors. An Ebola Standard had been created.

The media cover epidemic disease in the same way as they cover other varieties of crisis, by turning to formulaic coverage, sensationalized language and Americanized references. It is no accident that similarities pervade most of the news stories on an epidemic. The baseline of the formulaic coverage is Americans' anxiety about their lack of control over what they believe should be controllable. Disease and death should be manageable, government and science institutions should be able to protect the public's health. So during an epidemic, when a breakdown in control mechanisms are apparent, the stories the media tell are those that play on the fears of the public.

Pervasive in all the stories is the noting of panic and horror in response to the outbreak. In its coverage of invasive strep A, for example, *Newsweek* noted that

"It is important to remember that the United States is *not* experiencing anything like an epidemic. Still," the article continued, "no one disputes that strep A can be very serious. The disease is communicable, spreads through the body with astonishing speed and can cause either necrosis or TSS [toxic shock syndrome] or both. It maims and it kills." As CNN put it: "The result is an epidemic, not of the bacterium, but of the fear of it." And depending on the epidemic, certain competing approaches to the story are played out in the articles or on television. As Mary Tillotson said about strep A on the talk show *CNN & Company*: "The doctors say, 'Don't worry,' but the pictures say, 'Oh, yes, you should.'"[14] Stories may focus on the uncontrolled spread of an epidemic disease and the political and scientific attempts to control it, on the fatalism of the victims and the freneticism of the professional experts, on the dirt and primitiveness of the indigenous environment and the space-age hygiene of the Western medical efforts, on the bureaucratic or institutional culpability in the current disaster and on the bureaucratic or institutional responsibility to avert a further catastrophe.

Even a cursory perusal of stories in the media about epidemic diseases will show that despite very different biological and geographical contexts the stories share similar characteristics. During the initial few days of coverage, the stories, whether they appear in newspapers, magazines or on television, tend to follow the inverted-pyramid, information tradition, emphasizing the facts and documenting the event, but usually giving little more than "who," "where" and "when." Generally these "incident" reports say that some authority, medical or political, has announced an outbreak of a certain disease, but that confirmation of the specifics will be forthcoming. One day or several days later the "what," the "why" and the "how" are established. Official sources are employed to convey authority and to "objectively" identify what is important, why it is important and how long it will be important.[15] The responses of government or medical authorities dominate these few days. During the first day or two of coverage of the September 1994 outbreak of plague in India, for example, anchor Bernard Shaw of CNN interviewed a spokesman from the World Health Organization (WHO) for the evening news, while other CNN news programs talked with other doctors and with experts from the CDC.

After those first few days the stories are typically more narrative, a style favoring the creation of protagonists, victims and antagonists, suspense and conflict. (One reason why, for example, epidemic stories in the three newsmagazines— *Time*, *Newsweek* and *U.S. News*—which are on weekly not daily deadlines—are more likely to have a fictionalized tone, spirited language and sensationalistic metaphors.) The raw journalism of the earlier stories gives way to stories richer

in symbolism and rhetoric. Said the *Chicago Tribune* several days into the plague story:

> Their faces wrapped in cloth to keep out the germs, hordes of pan-
> icked Indians are mobbing bus and train stations in this western city
> to escape a plague. "There is panic in Surat," senior district official
> V. H. Thakkar said in an interview. About 200,000 residents have
> fled Surat since the first plague death on Tuesday. The disease, the
> pneumonic plague, is a more deadly strain of the bubonic plague,
> or "Black Death," that ravaged 14th Century Europe.[16]

Dramatic and tragic elements are emphasized by a focus on individuals and a more vivid use of language and metaphors. *The Washington Post* ended one of its plague articles with the story of a mother at the hospital bedside of her 2-year-old son. "If he lives," she said, "I'll go and offer prayers to the gods and donate the weight of the child in sugar to be distributed to the poor." And even those occasional background pieces that appear to stress unemotional explanation and education about how the disease functions and how the medical and political response teams are working, are often answering implicit or explicit community-based fears that the epidemic will become a threat to the United States. "The plague is easily treated if it's discovered in time," noted CNN, two weeks into the plague outbreak, "but if not, it is often fatal. International flights to and from India are being checked and sprayed, and even India's famous Mother Teresa was stopped for plague checks in Rome, where her Air India flight had landed after a flight from Bombay and Delhi."[17]

Typically, few stories early on in the coverage of an epidemic will give more than a passing mention of the social, cultural or political causes of the epidemic—few say little more than "plague is caused by rats" or "Ebola is spread through the reuse of syringes." (An exception to this rule was the coverage of Creutzfeldt-Jakob Disease in England in 1996. The coverage of this outbreak overwhelmingly addressed the initiating "mad cow" disease and rarely even mentioned CJD or specifics about the "human" mad cow disease. Reasons for that may be that although millions of people were at risk for the disease only 11 fatalities had actually been documented, that the impact of the epidemic of mad cow disease on the British beef industry was so devastating, and, more frivolously, that the term "mad cow disease" was much more arresting than "Creutzfeldt-Jakob Disease.")

. . .

Although the outline of the media's response to epidemic diseases remains remarkably constant among outbreaks, the tone of the coverage can vary. Perhaps the most significant variable is the novelty, or, alternatively, the familiarity of the disease.[18] The 1995 Ebola outbreak in Zaire, for example, hit the news the very same week that a made-for-TV medical thriller about a devastating virus sweeping the United States aired and shortly after a Hollywood blockbuster on the same subject came to theaters across the country. Several books on Ebola or Ebola-like epidemics were also coincidentally on the best-seller list. Popular culture had the country primed for panic. Ebola had become a symbol of imminent doom; from the paperbacks and the movies Americans had become familiar with this most exotic and novel of viruses. So, when the disease actually emerged, the media seized on the story as a legitimate sensationalistic news item. "Ebola" had become a word like "plague," a word freighted with associations: Not only a real disease but used metaphorically, in other contexts, it evoked apocalyptic terror.

A second variable affecting the tone of coverage is the violence of the epidemic, measured by the severity or gruesomeness of its symptoms, the total number of the stricken and the percentage of fatalities. Is there any cure? Does it eat your face, turn your organs to mush or make you crazy? The revulsion reserved for certain physical horrors—facial or genital disfigurement, uncontrollable bleeding from bodily orifices, dementia—accounts in large part for the attention given to certain diseases. Even articles which carefully include the dispassionate testimony of medical experts typically discuss the effects of the disease with lurid, and often stereotyped language.

A third variable is the geographical and social incidence of the epidemic. Is the epidemic in a remote African village or is it in urbane London, where so many Americans travel for business and vacation? What is its incubation rate—days or months or years? Can someone who is infected but not symptomatic get on a plane and bring the disease unknowingly to the United States? Is the disease endemic only among the poor or specific minority risk populations or does it threaten much larger constituencies—such as all those who have consumed British beef or beef by-products? Is it effectively random? In other words, how much do Americans have to fear?

The media's greatest level of attention is reserved for epidemics that are novel, violent and intense and pose at least a perceived danger of breaking out of their bounds to threaten the United States. It's at those moments that pack journalism kicks in. "Newspapers," said *The Lancet* during the strep A scare, "have specialist medical and science correspondents to help them filter out signals from mere noise, but there are times when specialists can do nothing except

hunt with the pack. 'I felt a bit like Peter O'Toole playing Lawrence of Arabia,' one of them told me, 'in that scene when the Bedouin suddenly charge off and massacre the retreating Turks, shouting no, and oh god, and don't, and then thinking, what the hell and getting out the sword and digging in the spurs.'"[19] Such herdlike reporting helps to legitimate and reinforce fears of the vulnerability of middle Americans to disease and concerns about public health attempts to protect the public. On these occasions, the news media do journalistically what Hollywood accomplishes in such films as *Outbreak*: draw people into their stories by playing on their worst nightmares. And while nightmares may not be the best basis for dispassionate reporting, they do at least keep compassion fatigue at bay.

Those international events that make it into the news are likely to be both deviant events and events that hold some significance for the United States. Epidemics, especially epidemics of rare or horrific diseases, certainly fit into the "deviant" category, and they become significant if they pose a threat to Americans or the United States. It is common, therefore, to see these characteristics reinforced within the articles on the epidemics. Selection of sources, quotations, events and even narrative language typically contribute to creating a sensationalist portrait of the disease and to fostering a belief in the plausibility of the spread of the outbreak. When images are included in a story, they, too, tend to reinforce both the aberrance and the potential threat of a spread of the disease.

Headlines, subheads and leads often set the tone of coverage for audiences. "'Galloping Gangrene' Reportedly Kills 5," was the graphic headline for one *Los Angeles Times* article on the 1994 strep A scare. The lead elaborated: "A bacterium that eats human flesh in a form of 'galloping gangrene' has reportedly killed at least five people, causing near-panic in an area of western England." "The Plague of Panic," was the head for one *Newsweek* article on the 1994 pneumonic plague epidemic in India. The subhead explained: "India: The disease is deadly—and terrifyingly contagious. Outbreaks of pneumonic plague across the country raised fears around the globe." "'Mad-Cow' Scare Threatens Britain's Beef Industry; Revelation of Human Risk Triggers Panic," wrote the *Chicago Tribune* in 1996 about the purported linkage of CJD with mad cow disease (bovine spongiform encephalopathy). And *Newsweek* titled its 1995 article on Ebola, "Outbreak of Fear." Its table of contents teaser began "An Outbreak in Africa Spreads Global Fear."[20]

Once the bottom-line agenda has been set—that a particular disease is horrifyingly fatal and contagious—the articles move on to Americanize the disease and its outbreak by referring to familiar metaphors. In the coverage of the strep

A, CJD, plague and Ebola epidemics, certain metaphors were repeatedly used: science-fiction metaphors, animal metaphors, crime, detective or mystery metaphors, apocalyptic metaphors and military metaphors.

"It sounds like a science-fiction horror," began a *New York Times* editorial on strep A. "We are accosted by invaders from an unseen world," wrote *Time* magazine. And *U.S. News* gave a sci-fi slant to a title and lead on Ebola: "Horror in the Hot Zone," it reported. "The usually bustling, noisy hospital in the town of Kikwit, Zaire, was eerily quiet last week."[21]

Sometimes the stories took a less otherworldly bent, referring to the medical experts as if they were lion tamers in the circus, speaking of "taming" the "malevolent little beasts."[22] Or as best-selling author Robert Preston wrote about Ebola: "The more one contemplates the hot viruses, the less they look like parasites and the more they begin to look like predators. It is a characteristic of a predator to become invisible to its prey during the quiet and sometimes lengthy stalk that precedes an explosive attack."[23]

Other stories spoke about "disease detectives" who were tracking down a "culprit," a "crafty virus," a "murderous virus" or a "hardened killer" that "eluded detection."[24]

Journalists often used doomsday metaphors and nuclear holocaust references to speak about the epidemics. The locus of the outbreaks was called "Ground Zero" or the "epicenter." And other, more specific doomsday scenarios were mentioned. In its article on Ebola, *Discovery* magazine questioned, "Were we now facing a real-world Andromeda Strain?"[25]

The military and war metaphors were perhaps the most common: Viruses were referred to as "epidemiological bombs" or "explosions," doctors and medical teams were called "commandos" and "shock troops" and hospital wards were called "war rooms." At least two major newspapers used the headline "India Battles Plague" during the first few days of the pneumonic plague outbreak.[26]

Metaphors even play a role after the coverage of an epidemic has faded—but then the new metaphors are of the disease itself. In the months following the outbreak of invasive strep A in Britain in May 1994, for example, reporting on the disease subsided, but mention of the phrase "flesh-eating" did not. "Flesh-eating" entered the lexicon as a news icon: Windows 95 is a "flesh-eating" bacteria infesting computers around the world; car leases gobble up profits faster than a "flesh-eating" virus; sports fans' outrage over the absence of instant replays has spread like a "flesh-eating" virus; the newspaper industry is infected with some creeping "flesh-eating" virus that is causing downsizing and closures. Author Arthur Kroker published a book using the phrase "flesh-eating" as a defining

term for the era: *Hacking the Future: Stories for the Flesh-Eating '90s*. And "flesh-eating" even became applied to the next scary disease, Ebola, which became known as another "flesh-eating" virus.

But sometimes the most compelling metaphors in the media's coverage of disease outbreaks are analogies to other diseases.[27] When a medical story breaks out of the back pages of the professional journals and goes on the wires there is a need to develop the scientific context. By reference to more familiar elements of medical experience, expectations are created. Analogous illnesses offer cues as to how a new threat should be viewed; the media suggest how one disease is like and unlike others. Is this new disease invasive like cancer or insidious like AIDS? Is it like the Black Death?

There is power in naming—the reason why many doctors don't tell their patients they've contracted AIDS or cancer. As one French physician explained, "When you tell them they have the [AIDS] virus, you kill them."[28] Analogy and metaphor turn into analogue. A disease is not only *like* the plague, it *shares* all the characteristics of the plague. A disease is not only *like* the Black Death, it *is* the Black Death. Few epidemic diseases are spread by casual contact; Ebola, CJD, yellow fever and cholera, for example, are transmitted by bodily fluids or an exchange of tissue, not by shaking hands. But Americans, who don't know much about science and medicine,[29] imagine that all epidemics are like the mythic epidemic—highly infectious and usually fatal. That description describes the collective memory of the plague.

Historically, of all diseases, the plague, which felled millions and repeatedly changed the course of history, reverberates most dolefully: the plagues of the Old Testament, the plague of Thucydides, the plagues of medieval Europe. Today, even though plague outbreaks in lesser-developed nations, such as the one in India in 1994, can be controlled with antibiotics—even the airborne pneumonic plague is not invariably fatal—the historic meaning survives. The plague continues to be mentioned in the same breath as AIDS and the trendy "emerging viruses" of Ebola, dengue and Lassa fevers. As Robert Preston, the best-selling author of *The Hot Zone* wrote in an op-ed in *The New York Times* during the Indian plague crisis, "Even with all of the advances of the last 100 years in medical technology, the world may be closer to the Middle Ages than policy makers realize."[30] "Plague" as a late-20th-century disease is upon examination no more threatening than many others and much less threatening than some. Thus the reality of the disease is less scary than the history of it; the Black Death is a more terrifying image than the modern-day plague. "Plague" has come to have a generic meaning, according to *The American Heritage Dictionary*: "a pestilence,

affliction, or calamity, originally one of divine retribution." All feared diseases have come to be plagues—and once labeled as such they assume the features of *the* plague. Calling a new disease a "plague" adds context to a media story on its outbreak and signals to readers and viewers the gravity of the situation. But it also infuses the new disease with overtones of godforsaken inevitability.

Susan Sontag noted in her work *Illness as Metaphor and AIDS and its Metaphors* that "disease occurs in the *Iliad* and the *Odyssey* as supernatural punishment, as demonic possession, and as the result of natural causes." Most of us, at the end of the 20th century, think that those first two characterizations are quaint ways of looking at illness. But if at some level we didn't believe in part in those causalities, there would be no stigma attached to certain diseases. Media stories on epidemics would not satisfactorily report that certain victims are promiscuous or touchingly linger on pathetic images of victims who are children or nuns. Our instinctive response to such reports is that promiscuity reaps what it sows but that the felling of the young or the clergy is not fair. But, of course, in a world completely dominated by the viral or bacteriological origin of disease, fairness does not enter into the picture. Even diseases on an epidemic scale are natural phenomena, not events "with a moral meaning," as Harvard historian of science Steven Jay Gould has said. There is—or at least there should be—"no message" in their spread.[31]

In telling the story of a disease, photographic images provide journalists with opportunities to hype. Including photographs in a story boosts the perceived visibility of that story and provides an external coherence for the text. For example, a disease outbreak doesn't become an "epidemic" in the eyes of the media and the public until it has been identified as aberrant and highly contagious, and photographs can be the best signals of those two qualifiers. Photographs can suggest the outlines of an epidemic and they can also suggest ramifications of an epidemic where few exist, such as the susceptibility of children or the vulnerability of Americans to the disease.

Different media during an epidemic will run pictures on the same several topics, and those same topics are likely to repeat again during the next epidemic. Most published or aired images (including graphics, photographs and videotape) fall into six defining categories:

First, in order to establish their objectivity, their seriousness and the thoroughness of their research, the media include hard-science images in their stories: an electron micrograph of the causal virus or bacteria (usually color-enhanced in neon scarlet, chartreuse and cobalt tones) or a medical diagram of how these agents reproduce in the body.

Second, to illustrate the source of the epidemic (if known), pictures are published or aired of the insects—such as fleas—or animals—such as rats or cows—that harbor the disease.

Third, to establish the contagiousness of the disease, photographs are shown of space-suited doctors or technicians and of masked civilians. Often when the outbreak has occurred in a Third-World environment, photographs of seam-sealed doctors are juxtaposed with bandanna-ed civilians as a way of demonstrating the inadequacy of indigenous efforts to combat the epidemic.

Fourth, to establish the deviant nature of the disease, explicit, if not revolting images are shown of the victims and/or their injuries.[32]

Fifth, to establish the deadliness of the epidemic, the media show photographs of the dead or of burials and funerals.

Sixth, to suggest that the epidemic is under control and to bring closure to the coverage, the media publish or air pictures of cleanup efforts. Sometimes images of antiseptic, sterile laboratory scenes depicting Western efforts to halt the spread of the epidemic are contrasted with images of messy, local mop-up efforts by impressed sanitation workers.

These six categories can themselves be roughly sorted into two types: descriptive and confrontational pictures. In a "descriptive" photograph an individual (or individuals) is engaged in an activity and the purpose of the media's use of the image is to visually explain the "what" or "how" of the action. (Almost all photographs of crowds fall into this category.) A "confrontational" photograph depicts a person or persons making eye contact with the camera and, by extension, with the media audience. These aggressive images are often run large or centrally in print publications; they are a way of engaging readers or viewers, of making them witnesses and participants, vicariously at risk, vicariously guilty.

Other generalizations prevail. Images which include only one or at most three people are overselected, except when "crowding" is part of the subtext of the story, i.e., the crowded conditions of the slums of Surat, India, helped foster the plague. One of the reasons for the use of photographs with very few people is simply practical: It is easier for an audience to see the action or the emotion in the image, even if it is a small one. And all things being equal, even run large, a simple picture of a lone individual is more visually arresting than one jammed with people. But often it is the subject of a photograph which prompts how many people should be included. Photographs of space-suited doctors almost always depict just one person to better communicate the impression that it is a war of man against microbe. Photographs of graphic injury, such as the wounds from flesh-eating bacteria, usually show just one victim—while those diseases which are fearsome, less because they disfigure a person and more because their

contagiousness can level a community, are depicted with photographs of many victims. And images charged with affirming the doctor's role as healer invariably include at least one doctor and one patient in the frame.

Euro-Americans are also more likely to be photographed as individuals, while nonwhite peoples are more likely to be photographed in large groups. Partly this is a result of the profile of the diseases: For example, the outbreaks in Britain of strep A and CJD typically struck just one person at a time, while Ebola and the plague which occurred in Zaire and India leveled dozens. But even when it would make no difference how many people were pictured according to the intent of the picture, people of color are less likely to be pictured alone or in small, intimate groups.

The chief exception to that rule of thumb is when the photograph is of a child. All children, no matter their race, are typically photographed alone or with only one other person—usually the mother. In pictures of mother and child, the mother is usually "backgrounded"—she is literally in the background of the image and the focus of the reader is drawn to the child first. Often the reason for her inclusion is to more poignantly show the affliction of the child by having the mother's face express her fear and distress at her child's condition.[33] Children are very credible "message sources"; photographs of children—and by extension mothers and children—offer believable documentary evidence.[34] Even though it can be presumed that the photographer is an adult, the fact that a prepubescent child is taken to be incapable of calculated dissimulation, means that an image of a child is convincing evidence of the existence and the scope of an epidemic. As a result, photographs of children (especially infants and preschool-age children) are common images in the coverage of an epidemic (and in the coverage of all crises)—even when the epidemic doesn't pose a more significant danger to children than adults.[35]

The American public's expectation of what an epidemic "is" is reinforced as much by the imagery as the text of stories on the outbreak. The de facto restriction of imagery during an epidemic to the several categories and types listed above means that media coverage of an epidemic rarely surprises—an intuitively arresting thought when it is remembered that epidemics, by their nature, are almost always unexpected and unpredictable. This lack of surprise, the sameness of the imagery—and, by extension, the purported sameness of the diseases—could lead to compassion fatigue if enough outbreaks made the news. Perhaps that's one more explanation for why relatively few do make the headlines. There's no dearth of newsworthy illnesses out there. But if the media covered too many epidemics, that old blasé feeling would creep in. Since the news media are part of the entertainment media, they are primed to tell the most

compelling stories they can. If they don't, they lose their audience to other, more arresting sources or more simply to apathy and compassion fatigue. As former CBS producer Peter Herford wryly observed, "'Compelling' is the word that drives TV news and magazine shows. 'Compelling' is the first three rules of television—like 'location' in real estate."[36]

Epidemics are typically short-term crises. It may actually take weeks or even months for a disease to run its course, but there is a climatic period in the crisis when it seems as if all literal hell were breaking loose. The media feature those moments.

As events rapidly unfold in a worsening disease disaster, an American audience has little time for boredom. The crisis is represented as a real-life Hollywood blockbuster. With breathless anticipation, the media's audience hangs on each new bulletin. The threat, the risk, capture Americans' attention. And when the threat and risk are lessened, the story is dropped. Because there is rarely any immediate geopolitical or commercial significance to disease outbreaks for Americans (mad cow disease was an exception) the media feel free to end their coverage of an epidemic when they want. So there is little occasion for Americans to say "Enough, already," for them to subside into a compassion fatigue stupor. Formulaic, sensationalized and Americanized coverage of short-term crises does damage to Americans' notion of illness. By selecting extreme diseases and by focusing on the most exaggerated incidents in an outbreak, Americans' threshold of concern about medical threats is set artificially high.

Most often compassion fatigue is invoked to explain the circumstance of the public losing interest in a crisis that has stabilized without resolution—the public's standing aside while children continue to starve or while a minority group continues to be decimated. But compassion fatigue can help explain the failure of the media to cover small disasters, minor crises, lesser problems. In the strep A story, said The Lancet, the media acted like Scheherazade, "forced night after night to spin tales that leave the listener wanting more, because when she ceases to do so she will die. This is a romantic image, but not a false one. When readers stop reading newspapers—and they do when they don't want to hear the stories they are being told—then newspapers die. There is a corollary: when newspapers discern somehow there is a particular story that is going down well they all start telling it. They could choose not to, but they don't."[37]

If people are trained by the media's reporting to care only about major catastrophes, they are not likely to concern themselves with the small blips in the world. If the threshold is set to the Ebola Standard, it is a near certainty that coverage of a measles outbreak or a diarrhea epidemic will provoke little more than

a "ho-hum." So there is minimal incentive for the media to cover stories when the journalists are assured beforehand that their audience will "turn the page." And the journalists' culpability in setting that Ebola Standard in the first place does not change the decision process at the media's institutions.

MAD COWS AND ENGLISHMEN: CREUTZFELDT-JAKOB DISEASE, BRITAIN, MARCH 1996

The disease, it is said, is a one in a million. That is it affects about one person in a million, worldwide, on average, every year. In 1978, it attacked the Russian-born choreographer George Balanchine. Balanchine, the co-founder and artistic director of the New York City Ballet, the century's greatest choreographer, who is mentioned in the art world in the same breath as Pablo Picasso and Igor Stravinsky, first noticed that something was wrong when he couldn't pirouette as he had been used to. He was slightly unsteady. A neurologist detected nothing abnormal.

Then, after coronary bypass surgery in the spring of 1980, his equilibrium got worse. His stumbles left red smears on the hallway to his doctor's office from the red elbow patches on his jacket. Clearly something was wrong with his cerebellum, the portion of the brain that controls balance. The doctors hypothesized that it might be arteriosclerosis and they gave him aspirin to reduce his chances of a stroke.

Then his eyesight and hearing began to fail—especially distressing because he needed to hear the music and design the lighting for his productions. He had two eye operations.

His condition worsened. Doctors in New York and Washington, D.C., subjected him to every esoteric test they could think of—except for a brain biopsy. Balanchine rejected that course of action.

He became increasingly confused and fell often. After breaking two ribs, despite the attentions of companions around the clock, he entered Roosevelt Hospital in November 1982. Rudolf Nureyev knelt in tears beside his hospital bed. Mikhail Baryshnikov brought him spicy Georgian food in hopes of re-animating him. But Balanchine couldn't remember conversations that had occurred a few minutes before. He couldn't walk. He couldn't use his hands. He died on April 30, 1983, from pneumonia, a complication from the fact that he couldn't swallow.

At last a brain biopsy could be done. After his death, his brain was sliced into layers, stained and examined under a microscope. The layers of tissue looked like sliced Swiss cheese. Finally it was known. He had died of the fatal and

incurable malady, Creutzfeldt-Jakob disease (CJD), one of a small group of obscure diseases called spongiform encephalopathies.

So far four spongy encephalopathies have been found in humans: CJD; kuru, a disease discovered in the 1960s in the Fore tribe of Papua New Guinea, transmitted by the custom of handling and eating the human brains of tribe members before burial; and Gerstmann-Sträussler syndrome (GSS) and fatal familial insomnia (FFI), both inherited, the latter discovered only in 1992. As far as is known, none of the diseases can be spread by contagion, nor through the blood or sexual contact. But they can be spread by eating or touching infected nerve cells—as in kuru—or through injections and transplants of tissue, such as corneas and the dura that covers the human brain. More than 60 children have died of CJD, traced to their treatment with pituitary growth hormone, extracted from the pituitary glands obtained from thousands of human cadavers. And Balanchine's physician at Roosevelt Hospital, Robert Wickham, hypothesized that Balanchine contracted the disease from the animal "glands" in the rejuvenation injections he received at a Swiss clinic.

Usually Creutzfeldt-Jakob disease strikes people in their 50s, 60s and 70s, after taking years or even decades to become symptomatic. Molecular biologists are beginning to understand that it results from the alteration of a protein that occurs naturally in the brain. In some people a genetic mutation makes the protein defective, in most people another agent achieves the same result. In both situations the altered protein accumulates in fibrous plaques, causing the degeneration of several types of brain cells. Once the disease emerges, its course is relentless. Destruction of brain cells impairs an individual's ability to see, hear, speak and move. Muscles spasm, affecting balance. Dementia ensues, mimicking Alzheimer's disease, a related disorder that is not classified as a spongiform disease.

Although Creutzfeldt-Jakob disease was only recognized 75 years ago when two German doctors, Hans G. Creutzfeldt and Alfons Jakob, independently reported the first cases, spongiform diseases go back for centuries. The first record of these diseases was not in humans but in sheep. In the 18th century, shepherds in Iceland noticed that a bizarre illness was killing their flocks. First the animals staggered, then they trembled, became irritable and itched so badly that they left hunks of wool on rocks and trees. Incidence of the disease was noted in northern Europe and Scotland. In England, the sheep's relentless scratching gave the disease the name *scrapie*.

Two centuries later, beginning in 1986, cows in Britain began dying of bovine spongiform encephalopathy (BSE), better known as "mad cow disease." BSE resembled scrapie and kuru. As one Wiltshire farmer described the

progress of the disease: The cow "begins losing weight, walks unsteady and sometimes a bit sideways. It stares; it begins shaking, lowing. It's nervous, upset. It can go berserk. It may charge." The disease became endemic. As the business editor of *The Economist* wrote, "The countryside began filling up with deranged cows." The disease was traced to protein supplements fed to cows which contained remains from sheep infected with scrapie — a practice known to its detractors as "industrial cannibalism," a phrase that conjured up shades of kuru.[38]

For decades it had been common practice in Britain as well as Western Europe and the United States for ground-up bits of animals — including bits of sheep brains and spinal cords — to be fed to cattle to make them grow faster. British farmers used a higher proportion of animal parts than other countries and processed their sheep carcasses at lower temperatures, and as a consequence, some believe, they saw far more cases than anywhere else.[39]

The British government insisted from the beginning of the BSE epidemic that there was no link between mad cow disease and Creutzfeldt-Jakob disease in humans. The tabloids charged a government cover-up, pointing out that it had long been known that diseases could jump species, witness smallpox from cattle, measles from dogs and influenza from pigs. Mad cow disease became an on-again, off-again staple in the news.

In July 1988, the government banned animal feed containing meat and bonemeal. But because, like scrapie, BSE can pass from pregnant females to their fetuses, more than 10,000 cows born after the ban contracted the disease. Then in 1989, still insisting that there was no connection between the two diseases, the British government passed a law requiring slaughterhouses to dispose of bovine offal — brains, spines and related parts. In other words, they took measures to keep the part of cattle carcasses likely to cause infection out of the human food chain. Unlike conventional infectious agents, spongiform diseases are resistant to heat, ultraviolet light, radiation and many chemical disinfectants. As a result, if a spongiform agent in nerve cells passed into foodstuffs, there is no guarantee that technologies such as cooking, pasteurization, sterilization, freezing, drying or pickling would destroy it.

Agriculture minister John Gummer went on television in 1990 and fed a hamburger to his 4-year-old daughter, Cordelia, to back up his contention that British beef was perfectly safe. Still a trickle of stories persisted. As *The New York Times* noted, "people know that laws are one thing and obeying them another."[40] And the public had reason to fear. Surprise random inspections showed that half of the slaughterhouses were in violation of the regulations. And because until 1990 farmers only received 50 percent compensation for a cow afflicted with BSE, they often tried to keep the disease hidden.

BSE persisted. In 1992–93, the rate of mad cow disease reached a peak of 900 to 1,000 cases a week. By January 1996, the rate had fallen to around 300 a week. But the incidence of Creutzfeldt-Jakob disease increased, nearly doubling between 1990 and 1994, reaching 55 cases that year, 13 more than the previous year. Finally, more than a decade after the first incidence of BSE, on March 20, 1996, the British Government admitted that "there may be a link between what is known as mad-cow disease, a deadly neurological affliction of cattle . . . and a similar fatal brain disease in humans." Health Secretary Stephen Dorrell said there was "no scientific proof" that the disease could be transmitted from cows to humans, but he told a stunned House of Commons that "a committee of scientists set up to advise the government on the issue had linked an unusual outbreak of the human disorder, Creutzfeldt-Jakob Disease, to exposure to the cattle disease."[41]

The special government surveillance unit established in Edinburgh had "identified a previously unrecognized and consistent disease pattern" of CJD that suggested a new variant. Ten new cases of CJD had been investigated. The committee saw as significant that some of the victims were in their teens and that four others were dairy farmers whose herds had been infected with BSE.[42] Robert Lacey, professor of microbiology at Leeds University, one of the first to raise the alarm years before, now said, "There are signs we are seeing the beginning of a human epidemic." He told the media that a half million people could develop the disease in a worst-case scenario, although others dismissed his estimate as gross hyperbole. But since the incubation period of the disease—like with other slow viruses—is at least a year and perhaps decades long, hundreds, thousands, even millions of people might have been infected but not yet begun to show symptoms. And with no test for the disease until symptoms emerge the public could not be assured of continued health. It didn't help public confidence when a reporter showed up at former agriculture minister John Gummer's house during the first week of the crisis with a hamburger in hand . . . and Gummer turned it down.

The day the government conceded a possible link, a headline in the *Daily Mirror* screamed, "Mad Cow Can Kill You." The paper quoted experts who believed that more than one million infected animals had already been consumed. The day after the announcement, France, Germany, Belgium, Sweden, Portugal and the Netherlands suspended the importation of British beef and cattle. One-third of British schools said they were taking beef off their menus. And Health Secretary Dorrell admitted on the BBC that one of the options being considered to restore faith in the British beef industry was the destruction of Britain's entire cattle population of 11 million animals, devastating the half of

all British farmers who earn some of their income from cattle and the 350,000 people who are employed in the industry.

On Saturday March 23, 1996, three days into the crisis, fast-food giant McDonald's suspended the sale of British beef products in all its 660 restaurants in Britain. Until it could switch over to European beef, McDonald's sold no hamburgers in its restaurants. Burger King and the British chain Wimpy's followed suit. But beef remained on the menu at Buckingham Palace, at 10 Downing Street and at the Tower of London.

On March 29, Britain banned the sale of all meat from cattle over 30 months, about 4.5 million head. On April 1, at an emergency meeting of the European Union (EU), Britain offered to slaughter the 4.5 million older cattle, those that might have eaten the contaminated feed mixture before it was outlawed. The slaughter would have hit the dairy industry hardest, since milk cows live longer than cattle raised for beef and show a higher incidence of BSE. As CNN noted, 4.5 million cows to kill would mean "the destruction of one cow every 40 seconds" for six years.[43]

By the summer, the number of cattle the British offered to slaughter had again dropped, to 147,000 head, but the government agreed to the destruction only if the EU would lift the ban on British beef exports. Then on September 19, the British government halted the agreed-upon slaughter. Speaking in the House of Commons, Agriculture Minister Douglas Hogg now called for the slaughter of only 22,000 head, those deemed at greatest risk of contracting the disease.

Meanwhile a trickle of new CJD cases emerged, and experts were quoted as saying that if a massive epidemic was going to occur, it would start happening soon. "The only way to know for sure is to wait, " said Paul Brown, the medical director of the laboratory of central nervous system studies at the National Institute of Neurological Disorders and Stroke (NINDS), a division of the National Institute of Health (NIH).[44]

From the moment the CJD–BSE story broke in late March 1996, the American media's coverage (and to a great degree the international media's, as well) vacillated between the two main stories: the "economic catastrophe of unprecedented dimensions" and what "might be the biggest public health calamity this century."[45] Although very early on there was an intense scrutiny and description of Creutzfeldt-Jakob disease, for the most part the "epidemic" of CJD was in the hypothetical future. The immediate story was the known quantity of the ravaged cattle industry. So despite the admitted devastation of CJD, the disease ended up taking second place in the news to the economic demise of British beef.

Thursday, March 21, 1996, the first day of the story, as the *British Medical Journal* reported, was "human victims day, with the blurred family snaps of those who had succumbed to CJD staring out from the front pages." In print and on television, family members spoke about those who had died. CNN correspondent Bob Reynolds, in the first-day coverage, interviewed the mother of Peter Hall, who had died of CJD in February 1996 at age 20. Hall's mother described her son's condition: "He couldn't feed himself. He couldn't toilet himself. He couldn't dress himself. It's awful. He wasn't speaking much. He wasn't speaking at all by then."[46]

But by the next day, Friday the 22nd, "British beef producers," as the *British Medical Journal* observed, "had replaced consumers as victims, as the world removed British beef from the menu. . . . Newspaper photographs of downcast farmers at Banbury cattle auction replaced those of doomed teenagers." Even stories that included mention of the disease's effects, led with news about the beef industry. Stories in *The New York Times*, *The Post* and the *L.A. Times* didn't get around to discussing the victims of Creutzfeldt-Jakob disease until their fifth to seventh paragraphs.[47]

For the next several weeks, if there were any victims in evidence to be pitied, they were the farmers—although the media typically made clear that the reason for the devastated beef industry was the purported connection between CJD and BSE. "If bombs were falling on Hatherleigh [a village in the West Country of England], the shock of the mad-cow disease scare gripping Britain could hardly be greater. All 1,000 of the village's residents owe their existence in one way or another, to cattle," said the *Chicago Tribune*. "The greatest worry now is suicide among farmers," the *Tribune* continued.[48]

With the exception of a few background pieces on the pathology of the disease a week or so into the crisis, the print media emphasized the dimensions of the "cow" story, not the "disease" story. Some representative headlines were: "Beef Loses Its Savor in Britain," "Some British Beefeaters Are Not Anymore," "No Big Macs for Britain," "Beef Crisis Butchers British Economy," "How Now Mad Cow?" "The Making of a Major Political Disaster," "For the Tories, A Prime Disaster," "British Beef Crisis: A Menu for Despair," "The Beef that Built an Empire," and "A Scare Story of Mad Cows and Englishmen."[49] On television, however, a medium which relies on visuals and that consequently has had a hard time covering economics or making it sexy, correspondents and talk-show hosts lingered longer on the more photogenic—and more scary disease story. *ABC World News Sunday* interviewed doomsayer Lacey. "We're actually going through one of the biggest biological experiments of mankind," said Lacey, "where the whole of a nation has been challenged with an infectious agent."

CNN London correspondent Rob Reynolds sounded the same note: "A lot of people here are very, very concerned about the beef that they may have eaten over the past 10 years, whether or not that will eventually come back to haunt them; and the really sinister part . . . is that the disease takes 10 years, or even longer, to show up its first symptoms."[50]

Yet ten or so deaths hardly make a tremendous epidemic. Even 55 cases a year, if their incidence is sporadic rather than clustered, are not much reason for general alarm. So it was hard even for television to sustain an emergency status for the disease and its victims, no matter how "gruesome" the symptoms. What the media did do, however, is give most of their space and time on the disease to those spokespeople crying "Watch out" rather than those who were saying "Don't worry." Everybody quoted John Pattison, the microbiologist who headed the British government's commission, as saying that he could not deny the possibility that Britain might face an AIDS-like epidemic.[51] And everyone explored the American ramifications of the crisis.

Were Americans at risk at home or abroad? On March 21, 1996, day one of coverage, ABC anchor Peter Jennings asked medical editor Tim Johnson, "Any reason for Americans to worry in any way?" Johnson replied that "there has been no evidence of mad cow disease [here in the United States] and no evidence of the human disease that is of such concern in England. So while Americans may want to cut back on their beef consumption for other reasons, fear of mad cow disease should not be one of those reasons." The same night, CNN anchor Natalie Allen asked the medical editor of *Condé Nast Traveler* magazine, Richard Dawood, "What are the implications for people traveling to Britain? Should they be alarmed about this?" "I don't think there's anybody who can really put their hand on their hearts and say that British beef is safe," responded Dawood. "I think that there are so many other things to eat when you are coming to the U.K., it shouldn't deter people from coming. There are many other things to eat."[52]

As the crisis continued the media continued to raise the issue of whether Americans should fear a domestic outbreak. CNN interviewed the wife and daughter of a 44-year-old Florida man, Angel Balcarcel, who died two days before, on March 27, of Creutzfeldt-Jakob disease. "Just before Christmas," his wife, Connie, said, "he started acting differently. . . . He was real tired. He was having a little of a problem walking. He speech was just a little slurred every once in a while." Then he began jerking uncontrollably and falling down. Three months later he died. "Balcarcel," noted the CNN correspondent darkly, "had never been overseas."[53]

Closer than that the American media couldn't go—but they could make other explicit connections between the British crisis and the United States. McDonald's and Burger King made for front-page headlines and top-of-the-news stories when they dropped beef from their menus. Photographs and video-tape showed McDonald's restaurants with signs promoting a vegetarian burger or, after they had switched to Dutch beef, signs declaring that "non-British beef" was used in their hamburgers.[54]

Once the fears of immediate contagion had been investigated and considered to be slim, the media turned to treating the disease in a somewhat jocular man-ner. The mad cow story bred innumerable lame jokes and bad puns, but the whole affair suffered from lack of graphic interest and ultimately lack of general interest. Concern could not be sustained for long without more cause—more ill-ness or more deaths. Compassion fatigue threatened. Many articles in print ran with no photographs or merely postage-stamp size ones. Indeed, the best pictures to come out of the weeks of coverage were not photographs, but cartoons and illustrations of berserk bovines and an equally mad John Major.[55] The disease was just not photogenic. Television was forced to run and rerun tape of what seemed to be the only bovine on record stricken and shaking with BSE—poor "Daisy" the cow. But print outlets had even fewer visuals available. Deranged cows don't look much different than normal ones in still photographs—and neither do addled humans. There were too few victims of Creutzfeldt-Jakob disease for their survivors to be a news staple, and since there was little ongoing laboratory work, the traditional pictures of medical technicians hunched over their microscopes were essentially absent.

As a result, the photographic depiction of the mad cow crisis divided up into four rather ordinary categories: pictures of riddled brain tissue or graphics detail-ing how the brain is attacked; pictures of cows grazing, being milked or in slaughterhouses; pictures of McDonald's or other restaurants that traditionally serve British beef; and pictures of British politicians, often Prime Minister Major, Health Secretary Dorrell, Agriculture Minister Hogg or former Agricul-ture Minister Gummer.

None of the images were of the arresting, take-a-second-look, award-winning variety.[56] Only the photographs of the politicians were especially animated or at all confrontational, and those were the images that illustrated the notion of a *dis-ease* epidemic least well. Without any catchy graphics it is easy to see how the print media, in particular, put up little protest to covering the story as the days and weeks passed more as an economic event than as an epidemic. There just were not the visual aids to support multiple stories on the horrifying nature of the two-twinned bovine and human diseases.

(International trade stories—which is what the CJD/BSE news became— have a different standard for coverage. Since they are written more for a business than a general audience, compassion fatigue is less of an issue. Although there's nothing more sleep-inducing—and less visual—than watching Ph.D. econo- mists spar over their spreadsheets, where money is in question, interest will always reside. So it made sense that the short-term disease crisis became a long- lasting, if not front-page economic story.)

Although it was never really clear whether the Creutzfeldt-Jakob disease "out- break" was really an outbreak after all, at least early on the media did cover the story rather consistently with their coverage of other epidemics. The media referred often to public fear and panic, calling the epidemic "scary" and "petri- fying." The *Los Angeles Times* noted that "consumer fear and anger" have caused millions to abandon beef, "historically as much a part of the British psyche as rain." And although there wasn't much opportunity for the media to linger over the pathetic details of the disease because there were so few documented victims, they still mentioned specifics about those few victims who were accessi- ble. *People* magazine ran a three-page story—complete with a bedside photo- graph—about 18-year-old Vicky Rimmer who contracted CJD in 1993, and still lay in a coma, no longer able to "move, swallow or see." The L.A. *Times* quoted Vicki's grandmother: "Vicki has a healthy heart and a good pair of lungs. There's nothing wrong with her except her brain, which is like a sponge."[57]

And the media's stories often played out competing perspectives on the so- called "epidemic," reporting on the frantic attempts of the political and scientific communities to check the two diseases. Stories blamed the government for the catastrophe to the beef industry and featured the government's efforts to avert the wholesale collapse of the market. Stories lauded the medical and science commu- nities for their recent discoveries of how the casual agents operate, yet excoriated them for playing God by trying to engineer a better cow. "The mad cow crisis is not like Noah's flood or the Black Plague," said commentator Richard Blystone on CNN. "With great sophistication we now create our own calamities. . . ." "In other words," wrote John Darnton, the London correspondent for *The New York Times*, "runaway science itself was on trial. It was undoubtedly a coincidence in timing, but only two weeks before the scare over mad cow disease, which is thought to have originated in the centuries-old disease in sheep called scrapie, the front pages of newspapers carried photographs of two identical sheep. They were clones pro- duced from a laboratory-grown cell, and occasioned a certain amount of clucking about the abominations that man is perpetrating upon nature."[58]

But most tellingly, the stories followed the pattern of previous epidemics in their extravagant use of metaphors, comparing CJD to AIDS and Ebola and calling it a "plague," a "time bomb" and "a horror agent right out of science fiction."[59] (Richard Rhodes in his 1997 medical detective book *Deadly Feasts* even called it Britain's "new Black Death"—an echo of the analogies made during the flesh-eating bacteria scare.) Military metaphors were common; the *L.A. Times* called the whole disaster "a typical British 'cock-up'—the last in a long line stretching back from Lloyds of London through the battle of the Somme to the Charge of the Light Brigade."[60] Others compared the BSE–CJD connection to an iceberg where "British scientists are detecting only 10% of the cases," to a "genie . . . out of the bottle" and to "Russian roulette."[61]

And many in the media commented on the importance of beef to the British, mentioning that the French nicknamed the nation *Les Rosbif*, and that the soldiers who guard the Tower of London are called "Beefeaters." "The Roast Beef of Old England is a fetish, a household god, which has suddenly been revealed as a Trojan horse for our destruction," said the British paper, *The Guardian*.[62]

While the potential for a pandemic—especially from a cause as ubiquitous and pedestrian as beef—made for an arresting tale and tempted hyperbole, the hypothetical nature of the threat to humans ultimately chilled the coverage. As was to be demonstrated by the media's reporting on famines, there's no great interest in what-could-be's. Interest doesn't really begin until the dying begins. Body counts alone may not dictate coverage, but without a high casualty figure a crisis won't remain in the news budget. Even a death toll in the hundreds or thousands is no guarantee that Americans won't sink into compassion fatigue, but a high toll helps to make the coverage of a crisis more imperative—even if the eventual outcome of the coverage ends with a slump into compassion fatigue.

It's probable that if CJD had been tied to the eating of Asian or African water buffaloes it would never have come to the public's attention at all. A possible threat to an Asian or African population is not seen to be as compelling a story to an American audience as the same threat to a British population. After all, the American media ignore with relative impunity Asian and African crises where actual deaths number in the hundreds and thousands. Why would they pay more attention to a *potential* disaster?

It all gets back to the media's perception of Americans' interest in and tolerance level for international news. The media perceives that compassion fatigue will surface if a story is about a region that Americans care little about or is about an issue that's not especially germane to U.S. interests. But as the flesh-eating

bacteria incident showed, Britain is a natural locus for American attention, even when a crisis there seems relatively frivolous or insufficiently established.

The mad cow disease episode demonstrated that even if a story originates in Britain—a nation of great historical, cultural and political concern to Americans—and revolves around the eating of beef—a staple in the American as well as the British diet—it will still move quickly off the front pages when the media runs out of sensational details to tell. A threat, a catchy-named disease and liberal use of bad puns will only take a story so far.

THE DOOMSDAY DISEASE: EBOLA, ZAIRE, MAY 1995

The funeral of Sister Dinarosa Belleri in Kikwit, Zaire, was marked by neither the gracious gestures nor the lengthy ceremony that had attended the death ten days earlier of Sister Floralba Rondi, a fellow member of the Little Sisters of the Poor order.

When Sister Floralba became ill three of her best friends, Sister Dinarosa, Sister Clarangela Ghilardi and Sister Danielangela Sorti, together with a Zairian nun, Eugenie Kabila, from the Sisters of St. Joseph order of Turin, tended to her at the same makeshift hospital where she had lived and worked for 43 of her 71 years. When her fever worsened the three Italian nursing nuns put Sister Floralba in the back of their four-wheel drive vehicle and drove her to a clinic 50 miles away. She was unconscious when they arrived, and they all took turns at her bedside, monitoring her intravenous drip and praying for her recovery. When she died on April 25, 1995, the three sisters brought her back to Kikwit to be buried.

The hospital in Kikwit is not much, but what little there is is due to the care and work of the nuns. The nuns nursed patients in the 350-bed ward, assisted at operations, scrounged medicines, begged basic supplies, managed the hospital's administration and even kept the generator going. "Anything that is working here," said Belgian doctor Barbara Kerstëins, "was run by the nuns."[63]

Of all the Italian nuns, Sister Floralba had lived the longest in Kikwit. Sister Clarangela, age 64, had come to Zaire 36 years before, Sister Dinarosa, age 58, had arrived almost 30 years previously, and Sister Danielangela, age 47, had arrived in 1978. As the oldest of the group, Sister Floralba was much loved and widely known. When she died of what was thought to be the endemic malarial fever, hundreds mourned her passing. Her body was carried in a procession all through the Kikwit hospital and then through the town to the cathedral, where she lay in an open coffin for two days. Her friends and those she had nursed over

the years came to pay their respects. They stood over her coffin, wept, held her hands and caressed her face. Many followed the funeral cortege out to the grave-yard as she was laid finally to rest.

By the day of the funeral the four sisters who had nursed Sister Floralba had all fallen ill. On May 6, Sister Clarangela died. On May 12, Sister Danielangela died. On May 13, Sister Eugenie died. And on Sunday, May 14, Sister Dina-rosa died. By then the whole world knew of the sisters' deaths. The five nuns had not died of malaria. They had died of Ebola.

The last respects paid to Sister Dinarosa befitted her status not as the hospital's chief administrative nurse, but as an Ebola victim. Only ten hours after her death, her body was unceremoniously splashed with bleach, shrouded in a plastic body bag, and laid in a wood coffin. The coffin was placed on a hospital gurney and wheeled out of the hospital, over the potholed main road to the cemetery. Her pallbearers wore full-length green surgical gowns, heavy plastic work goggles, surgical face masks, white hard hats, thick gloves and knee-high rubber boots. But the procession was led by Bishop Edouard Mununo in his regalia, and the coffin itself was papered in a springtime print of blue and pink flowers.

Almost 200 people had come to see her grave dug, but only a small group of Jesuit missionaries and foreigners gathered close as Bishop Mununo sprinkled holy water on her coffin. The local men, women and children had scattered back to a distance they believed was safe, and there they stood solemnly watch-ing, T-shirts, handkerchiefs or brightly colored wraps covering their noses and mouths.[64]

The name Ebola, said *Newsday*, "is synonymous with terror. . . ." The virus, said ABC News, "is frightening because it is so lethal and so unexplained." "Ebola inspires fear," said *USA Today*, "because it is mysterious and a horrible way to die."[65] The media spoke as one. You do not want to get Ebola.

Under an electron microscope, Ebola doesn't look like many other human or animal viruses. It is not small and rounded, but long and snakelike, one of the very few members of a new class of viruses known as "filoviridae" (from the Latin "filum" meaning thread). Ebola works by targeting part of the host body's immune system, circulating tissue macrophages, defensive cells which roam the body in search of invaders. Ebola enters the macrophages, reproduces, and hitches a ride as the cells travel from one organ to another. The virus then infects the endothelial tissues that enclose capillaries, blood vessels and critical organs such as the kidneys and the liver. As the viral colonies reproduce they

puncture microscopic holes through the tissue walls, allowing blood to leak out internally into interstitial spaces and externally through the ears, eyes, nose, mouth, genitals and even pinprick holes in the skin. Hemorrhaging is uncontrollable. Blood loses its ability to clot. As the endothelial tissues deteriorate, internal organs lose their cohesiveness and turn into puddles. The surface of the tongue goes soft and pulpy and is spat out or swallowed. The lining of the gut sloughs off and is defecated along with massive amounts of blood. The excruciating diarrhea causes irreversible dehydration. The underlayers of the skin die, making what's left tissue-paper thin, tearing at the slightest touch. Headaches turn to madness. As the brain becomes choked with dead blood cells, generalized grand mal seizures are triggered. Death often comes after one final seizure, during which virus-laden blood is spewed over anyone and everything nearby. One blood droplet harbors more than a hundred million virus particles.[66]

There is no vaccine or treatment for Ebola. Antibiotics accomplish nothing. Attempts at rehydration can cause drowning as intravenous fluids flow out of membranes made permeable. The incubation period is two to 21 days. After the first symptoms appear, death usually results within days. The only chance for survival is for the patient to stabilize long enough that the patient's own antibodies have time to react.

Ebola is considered a "Level 4" virus: a virus handled at the highest degree of laboratory containment by scientists taking extraordinary precautions and wearing the ultimate in space-suit-like protection. "Level 4" is the category reserved for viruses which are lethal to humans and do not respond to treatment.[67] Like AIDS, Ebola is spread through contact with infected bodily fluids. The chief means of transmission in its major outbreaks have been either surgery and routine lab work performed under conditions of primitive hygiene or close contact with desperately ill patients or the dead. The repeated use of disposable syringes, which by their nature cannot be resterilized (the plastic does not withstand boiling), has been the greatest culprit in the dissemination of the virus.

In many ways, however, Ebola is not like AIDS at all. AIDS is a slow virus; there is a long span of time, probably years, in which a symptomless individual can infect others. Ebola works quickly. By the time a person is contagious, he is typically very ill. Among humans, an epidemic of Ebola seems to last a finite, fairly short period of time. If a virus is too immediately deadly it has less of a chance to spread, so Ebola appears to compensate by reducing its virulence over a period of months. AIDS does not. Since the Antwerp Institute of Tropical Medicine identified the Ebola virus in 1976, fewer than 800 people have died. In that same span of time, according to the WHO, rabies, considered the most

deadly virus known, has claimed 627,000 lives. And AIDS has killed one and a quarter million people.

Still, when Ebola strikes, it is fearsome—and it will continue to be so until the elusive source of the virus has been discovered. Ebola's burnout during human epidemics implies that its natural host is not man. After the Kikwit outbreak, researchers looking for the original carrier collected 30,000 plant, insect and animal samples from the Fôret Pont Mwembe where Patient Zero contracted Ebola. But to date, there are no answers.

The Bicentennial year, 1976, was a bad one for diseases. In the middle of all the patriotic hoopla in the United States, American attention was riveted to two public health crises: the Swine Flu "epidemic" and Legionnaires' disease. There was little public interest leftover for an African outbreak of some unusual new hemorrhagic fever.

Almost simultaneously in the late summer of 1976 two independent epidemics had broken out 500 miles apart: the first, in July in N'zara, a town in southern Sudan; the second, in September in the Catholic mission village of Yambuku in north-central Zaire (now the Congo). As far as anyone knows these were the first appearances of what became known as the Ebola virus. In N'zara, 280 people contracted the disease, almost 150 died. By the time scientists were allowed into the area, the epidemic was all but over. But samples were collected and some were passed along to the CDC. Within three days, the Americans had a picture of the virus. They believed that although it appeared to be related to the Marburg virus, a mysterious virus that had erupted in Marburg, Germany, transmitted to lab workers from African green monkeys, this N'zara virus was something new.

Then came word of another epidemic, this one centered in the mission hospital of Yambuku. The hospital was the major hospital and dispensary for some 60,000 villagers living in the central Bumba Zone. It had a staff of 17 nursing sisters, most of whom had only taken a several-day-long training course. Every morning the clinic issued five syringes to its nurses. They were used again and again throughout the day. Most of the 300 to 600 patients seen daily received injections of some sort: antibiotics for infections, chloroquine for malaria, vitamin B_{12} for pregnancy.

The virus spread to more than 50 villages in the area, finally subsiding when most of the staff at the hospital died. By the end of the Yambuku epidemic about the same number of people had become infected as in N'zara, but in Yambuku 100 more had died than in the Sudan, including 13 of the 17 nuns. As was to be

the case 19 years later in Kikwit, many of the dead in Yambuku died as a result of poor medical practices at the mission hospital.

Lab work on the two epidemics demonstrated that although the two diseases are clinically the same, the Sudan strain and the Zaire strain have genetic and biologic differences. The evidence all seemed to point to the fact that lightning had struck twice. Then it largely disappeared. A few isolated Ebola cases re-occurred, striking a child in Tandala, Zaire, who died the next year. And a small outbreak infecting 34 people occurred in 1979, again in N'zara. But then complete quiet. Ten years passed and a world away, in late 1989, an epidemic erupted among a group of 100 Philippine monkeys quarantined in one large room in a facility in Reston, Virginia, a suburb of Washington, D.C. All 100 monkeys in the one room were euthanized. Then a second and a third room became infected. Then an animal technician fell sick with symptoms suggestive of Ebola. Although he later proved not to have the disease, his illness terrorized the authorities.

The Reston strain of Ebola turned out to be harmless to humans. But the presence of Ebola in the United States raised some frightening implications. What if the microbes had possessed the ability to infect humans? Individuals from the Philippine distributor to animal cargo handlers at Amsterdam and JFK airports to employees at research labs all over the United States were in the chain of possible infection. After Reston, far more stringent testing and quarantine guidelines were put in place—although to questionable effect as the Reston virus turned up again in monkeys from the same origin, once in Siena, Italy, in 1992 and twice more in the United States, both times in Alice, Texas, in 1990 and 1996.[68]

Finally, 15 years or so after the last human epidemic of Ebola, another major epidemic broke out. This time in Kikwit, Zaire. And this time, the United States was primed to give the outbreak attention. Richard Preston's book *The Hot Zone* on the Reston incident was still on *The New York Times* best-seller list after 30 weeks. Warner Bros. had a current blockbuster with their movie *Outbreak* about an apocalyptic Ebola-like virus that threatens the entire United States. And on Monday night, May 8, 1995, only two days before the Kikwit epidemic splashed across the news, NBC aired the made-for-TV thriller, *Robin Cook's Virus*, about an African virus that mysteriously stalks a series of American cities.

According to *Newsday* reporter Laurie Garrett, who won a 1996 Pulitzer Prize for her coverage of the 1995 epidemic, the index case, the first person to be infected, was a 35-year-old Kikwit farmer named Gaspard Menga. Around Christmas 1994, Menga lived for three weeks alone in the rain forest 18 miles

from his home to make charcoal to sell as fuel in town. In early January he staggered in pain out of the forest, already feverish, already suffering from unexplained bleeding. His family took him to Kikwit General Hospital where he lay for a week before he died on January 13.

Menga's wife, Bebe, and his uncle, Philemond Nseke, collected his body and prepared it for burial, a traditional task that involves washing the body. Then Bebe and Philemond fell ill. Relatives took care of them and buried them when their time came. And so it went. By March 9, of 23 members of the extended Menga-Nseke family, 14 had died of Ebola—four in Kikwit General Hospital. In each case the family was told that the killer was shigella, an extremely contagious infection that also causes bloody diarrhea and kills thousands of Africans every year.

At some point during the doomed hospital stays of four of the members of the family, Kimfumu, a 36-year-old laboratory technician, drew blood samples from all the suspected shigella cases. By the first week in April, he too had fallen ill, his belly distended. The doctors suspected a perforated intestine caused by typhus. On April 10, they operated. Finding no perforation, they removed his inflamed appendix. When his condition didn't improve, they opened him up again. This time the reason for his agony was clear. Huge pools of blood filled his chest and stomach cavity—every organ was hemorrhaging uncontrollably.

Kimfumu died. And then one by one so did the members of the two surgical teams who had worked on him: four anesthesiologists, four doctors, two Zairian nurses and two Italian nursing sisters. And then people who they had come in contact with fell ill and died, and so on and so forth.

On May 5, Dr. Tamfu Muyembe, a leading virologist at the University of Kinshasa, in Zaire, arrived to begin his investigation. He knew immediately that the outbreak was not shigella, since as a bacterial infection it should have been cleared up by the doses of antibiotics given to the patients. Muyembe recognized the symptoms as ones he had seen 19 years before when he had been a member of the medical team that had fought the first-ever Ebola outbreak. "I dare to say," he remembered a year later, "that anyone who has seen a case of Ebola will never, never forget it."[69] On May 7, Muyembe sent word to the World Health Organization that Ebola was back in Zaire. On May 9, the story hit the American media.

Three days after the call from Muyembe, a team of experts gathered in Kikwit, collected from the top institutions for public health in the world. Their mission—backed by the Kikwit Red Cross and other volunteers—was to stop the epidemic. Cleaning the Kikwit hospital alone was a monolithic task. When the international team walked into the wards on May 10, there was no running

water, only sporadic electricity, no bed linens, few mattresses and virtually no supplies—including no cleaning products. Many patients lay on the floor, surrounded by their families, their blood seeping into the concrete. David Heymann, an American epidemiologist trained by the CDC, described the scene: "There was blood everywhere. Blood on the mattresses, the floors, the walls. Vomit, diarrhea . . . wards were full of Ebola cases."[70] The staff, all civil servants, had not been paid for four years. All worked jobs on the side.

The delegation began paying the hospital staff. They rigged up a rainwater collection and filtration system to provide water. They established a *cordons sanitaire*—a thin plastic wall sealing off the Ebola victims from other patients. They dispensed gloves and masks. They trained medical students to work in surveillance teams combing the region looking for Ebola cases and in education teams teaching the local citizens how to protect themselves against infection.

By the end of June, the work was essentially all over. The hospital had been sanitized. And the virus had burned itself out, waning in both transmissibility and virulence. The virus was most ferocious early on in the epidemic; the highest rate of death was in January and February, the lowest rate in June. Three hundred and sixteen people had contracted the Ebola virus, 245 died, a total rate of 77 percent.[71]

Since Kikwit, Ebola has not gone off the media's radar. One reason is that since Ebola has come back, there have been other small African outbreaks. The second reason for Ebola's continued presence in the news is that it has entered the public's consciousness as "one of nature's most fearsome killers." Ebola, CNN reminded its audience, is "a mystery virus with a fearsome reputation as a doomsday disease. . . ."[72] All the media have done special stories or series on "emerging diseases," reminding readers and viewers of the epigraph for the movie *Outbreak*. At the beginning of the film, on a black screen, these words by Nobel laureate Joshua Lederberg come up: "The single biggest threat to man's continued dominance on the planet is the virus."

The Kikwit epidemic received epidemic coverage. The Ebola outbreak had everything: it was dramatic, it was dangerous, it had self-sacrificing nuns as "angels of mercy," it had the virus hunters as "disease cowboys."[73] It was gruesome, it was thrilling. Pop culture had made it incredibly current, but it was "real" news. It was a great story.

Even in the elite media, the Kikwit epidemic received more than twice the coverage that the plague or Creutzfeldt-Jakob disease had done in the same period of time. The stories themselves were longer, and there were more of

them. During the first days of the coverage of the epidemic, many daily newspapers didn't just run one story, they ran several. *USA Today*, for example, ran two stories Thursday, May 11, on "the spread of the deadly Ebola (Pronounced: EE-bola)." And *The New York Times* ran two articles on May 10, one long article with a chart and map on May 11, and three articles, including an editorial, on May 12. All three newsweeklies carried lengthy articles in their first issues after the outbreak and television, too, gave it extraordinary coverage. Bernard Shaw hosted an hour-long CNN prime-time special on May 14, entitled "Apocalypse Bug." ABC News had stories on the outbreak five days out of the first week of coverage. *Nightline* had not one, but two episodes on Ebola—one on the first full day of coverage, Wednesday, May 10, and the other two weeks later on Wednesday, May 24. And ABC's magazine show *Day One* was canceled while co-anchor Forrest Sawyer was in Zaire reporting on Ebola.

Although one or two news outlets, including the *Chicago Tribune*, released a news brief about the epidemic late on Tuesday, May 9, most of the media didn't cover the story until the next day. That "first" day, May 10, both television and the newspapers covered the outbreak "straight"—inverted-pyramid style. The main points of interest in this opening day were the nearly unanimous reference to the disease—not yet officially confirmed as Ebola— as the "mystery" or "mysterious" virus and the nearly unanimous inclusion of mention of the recent films and books on the same subject. *The New York Times* even made its "mention" an entire article, "'Emerging Viruses' in Films and Best Sellers," saying: "While doctors still debate whether the new agents are homegrown ones that have acquired a special virulence or exotic agents unleashed on the world as civilization invades their forest refuges, writers and film makers have rushed in to chronicle the horrors of mystery viruses."[74]

By day two, May 11, after a press conference given by the WHO and the CDC about preliminary laboratory findings, the mysterious Zairian virus was more authoritatively linked with Ebola. Medical correspondent Lawrence Altman of *The New York Times* weighed in with an article and chart on Ebola, the *Los Angeles Times* carried an infobox on Ebola to accompany its story, and *USA Today* went all out, identifying the virus as Ebola in its headlines and running a question-and-answer article on "what's known about the mysterious virus."[75]

Stories on day three, May 12, still for the most part led with the who-what-where-when news: the death of a third nun, the arrival of the international medical team in Kikwit and the Zairian government's measures to contain the epidemic. But some stories also began to raise the issue of a global spread. The *Chicago Tribune* had anticipated the topic with a story on May 11 entitled "U.S.

Ebola Outbreak Unlikely, Experts Say." Although the article, like the headline, emphasized the fact that "Ebola is relatively difficult to spread," it didn't completely discount the possibility of "some spread on a limited scale." As *The New York Times* May 12 editorial mentioned, "the fragility of our defenses in the age of jet travel" means that "now, with the cold war over . . . we may have less to fear from rogue nations than from rogue viruses."[76]

By the weekend, stories had turned from a factual accounting of victims' deaths to tales of the medical detectives' successes—both in the field in Kikwit and at home at the CDC. Chronologies of the virus' outbreak and its identification jostled with photogenic details of the "hygienic precautions" being taken, from gloves and masks to body bags and doctors' "space suits."

By Monday, May 15, five days into the coverage, feature-laden stories about the death of the sixth nun, about the poverty and government corruption in Zaire and about the whole host of newly discovered "emerging viruses," including AIDS, predominated and lasted out the week: "The frightened people of this central African city," wrote *USA Today* in a page-one story, "buried Sister Dinarosa Belleri Sunday, just hours after the Italian nun died of the mysterious Ebola virus that is terrorizing Zaire." Conditions in Kikwit "are very much like they are in most villages and towns in Zaire," said correspondent Gary Strieker on CNN, "they're very impoverished, they're not very sanitary." "Mankind's arrogance has been exploded by the emergence of new maladies, such as AIDS and Ebola," reported the *Chicago Tribune*, "both of which are hard to catch but are ruthless in exploiting their opportunities once they are loose in a human body."[77]

Ebola made for a picturesque story, in words and in images. Ebola, as Laurie Garrett in *Newsday* noted, quoting a WHO doctor, "'is the big one—this is what we're always thinking about when we talk about serious, dangerous disease threats.'" Even the gray newspapers, such as *The New York Times*, incorporated into their stories grisly, graphic details of the virus' effects, sprinkled their copy with evocative metaphors and analogies and ran arresting graphics and compelling photos. Headlines in the magazines and papers seduced readers with allusions to the film and novel blockbusters: "Outbreak: From Awful Rumor to Deadly Truth" or "Horror in the Hot Zone."[78]

Hollywood and the best sellers had primed the media for language that in any other situation would have been considered well over the top. "If the word [Ebola] doesn't make your hair stand on end, it should," said *Newsweek*. Ebola was depicted as a reptile, insect or some feral beast—a "serpent," a "wicked bug"—that needed to be "tracked to its secret lair." Less lyrically, others used phrases familiar to nuclear war scenarios or natural disasters, describing Kikwit as

"ground zero" or the "epicenter." But the most popular manner of referring to the virus was in Armageddon-like terms. *The Hot Zone's* Richard Preston and even Laurie Garrett in her tome *The Coming Plague* had raised the specter of Ebola as the Andromeda Strain. So it was but a short jump for the newsmagazines, newspapers and television to refer to it as "the ultimate horror," a "doomsday disease," the "apocalypse bug," a "plague," a "nightmare" and a "biological Satan." Even *Redbook* magazine warned its women readers in an article entitled "Deadly Viruses: Do You Know How to Protect Your Family?" that "'The Ebola virus doesn't mean the end of the world is coming, but it is a warning.'"[79]

After those characterizations, it was almost redundant for the media to speak about such epidemic disease standards as panic and fear. All the media mentioned the "panic [Ebola] can cause" and the "weeks . . . filled with fear." Ebola "triggers terror," said *USA Today*, "sending shock waves world wide." Even the most prestigious newspapers got graphic. "The Ebola virus," said the *Los Angeles Times* in one article "literally eats away at internal organs, causing a horrible death by massive bleeding out the eyes, ears and other openings." "The virus," said *The New York Times* in one piece, "makes the body's internal organs bleed and rot." "It turns internal organs to mush," said a *New York Times* editorial.[80]

But *Newsweek* and *Time*, the television specials and to some extent *USA Today* did dwell more on the sensational than the other media surveyed. Not only in their choices of metaphors, but in their verb and adjectival choices, the two pre-eminent newsmagazines hyped up the story. Their descriptions of the progression of the disease were the most graphic of the surveyed media. "When she got home," said *Time*, describing one victim's death, "her incision began to bleed. Then her organs began to melt. The red-black sludge wiggled out of her eyes, her nose, her mouth." "The victim's capillaries clog with dead blood cells, causing the skin to bruise, blister and eventually dissolve like wet paper," *Newsweek* explained. "By the sixth day, blood flows freely from the eyes, ears and nose, and the sufferer starts vomiting the black sludge of his disintegrating internal tissues." Or, to quote more randomly from just two pages of the same May 22 *Newsweek* story: the "gruesome mystery" virus "raged," "possibly" through "sprawling slums" and "squalor," government officials were "terrified," then the "virus jocks," "disease cowboys," or "commandos of viral combat" "divvy up the sleuth work" a "thickness of a glove away from certain disease and possible death."[81]

As sensationalized as *Time* and *Newsweek* were, it was CNN's special "The Apocalypse Bug" and ABC's *Nightline* which lost all restraint in handling the story. Consider this opening statement from the CNN special on May 14: "It is an ancient prophecy—the ruling powers of evil will be destroyed by god in one

chaotic cataclysm, an apocalypse. Have we reached that moment in the form of mysterious viruses? From HIV to Ebola, microscopic killers are on the loose, and we are increasingly powerless to stop them. Welcome to CNN Presents. I'm Bernard Shaw." But even that characterization of Ebola didn't flout as many journalistic standards as did *Nightline*'s show on May 10, the first day of ABC's coverage of the epidemic. As an article in *The Washington Post* criticized, "The national obsession with Ebola and the potential for similar diseases to appear has led to a sort of Cuisinart effect. Ideas and images from sensationalistic films such as the televised *Robin Cook's Virus* are blended with information from more authoritative works such as writer Laurie Garrett's *The Coming Plague*. ABC's *Nightline* and other news programs even used scenes from the fictional movie *Outbreak* to sharpen reports on the Zairian Ebola outbreak last week."[82]

Nightline opened its Wednesday, May 10 evening report with a clip from *Outbreak*: "There will be panic the likes of which we've never seen." Then said Ted Koppel in a voice-over, "In this country, it's still the stuff of fiction." After lead actor Dustin Hoffman intoned, "We can't stop it," Koppel's voice-over continued, "In Zaire today, it's only too real"—implying that the Zairian outbreak mirrored the movie's version. A moment later in his opening monologue, Koppel admitted to the use of the fictionalized scenario:

> Just to keep things in perspective, the Ebola virus, on which we're focusing our attention this evening, only exists in this country in our fevered imaginations. We have watched Dustin Hoffman pretend to deal with a pretend outbreak in a pretend movie, and that has made us more receptive than we might otherwise be to a genuine outbreak that is killing people, horribly and very quickly, in Zaire. It is an important story, and we're not above using a couple of movie clips to engage your interest in it, but what is most important, as John Donvan now reports, is to keep what's happening in perspective.

From that statement, it appeared as if Koppel "got" it, as if he understood that the movie was just a hook to lure in viewers to a substantive discussion of this new, "emerging virus."

But what happened next in the program demonstrated that despite its protestations, *Nightline* didn't keep "what's happening in perspective." John Donvan's report began, once again, with Hoffman's line: "We can't stop it." And Donvan continued to use clips from the movie throughout his piece (the first third of the program), to say that the public was in danger of conflating the fictional with the factual. Fine, but what was his contribution toward putting the virus in

perspective? He said that "half" of the "virus nightmare was coming true." He didn't say which half. Instead he said that "Ebola is, without question, a biological Satan, a serpent of a virus. . . ." He then showed the clip of actor Donald Sutherland's projection of the *Outbreak* virus destroying the United States within 48 hours. "In the Hollywood version," said Donvan, "what would happen next is inevitable." And although he showed two medical experts stating that "the virus is not very transmissible," he closed the issue by speaking to author Richard Preston who said that Ebola, like AIDS, is "attempting . . . to break into the human species and to spread widely."[83]

For many in the media, referring to AIDS was an easy means of characterizing Ebola. Media outlets piggybacked on the public's horror of AIDS, but often represented Ebola as the more fearsome of the two viruses. Ebola, said *U.S. News* is "a virus more terrifying than AIDS." "'If you stick a needle into yourself that has been in an AIDS patient's blood, there's a 1 in 2,000 chance you'll get infected,' the *L.A. Times* quoted an infectious-disease specialist as saying. "'If you do the same with Ebola, you've got a 90% chance of dying.'"[84]

AIDS was also a way of bringing the fear home. "Like AIDS," said the *Chicago Tribune*, "Ebola is thought to be an infection of monkeys that sometimes can cross species lines and infect humans." And Ebola, like AIDS, had come "out of Africa" to threaten the United States. An undercurrent in much of the coverage was that this outbreak could have only happened in Africa, that the outbreak was almost to be expected. "The Ebola virus could hardly have chosen a more vulnerable country to strike than Zaire," read the lead of an article in *USA Today*. "That a medical crisis of this kind would occur in Zaire is 'not surprising.'" "And now, from a remote Africa, more bad news," read the lead of an opinion piece in the *Los Angeles Times*. "Must we care about this one?" "We must," the article said. Why? Because "Zaire is a very big country, as far spread even as one-third of the United States. Another reason is that Zaire borders on other big countries. . . . There can be no way to isolate Zaire or its epidemics. Elsewhere, AIDS has already shown us this."[85] Why should we care? Why should we not "turn the page"? Not because we should care about people dying in Africa, but because we ourselves could get sick. We should care because of our own self-interest.

Certain of the images familiar from other epidemics resurfaced during the Ebola outbreak: electron micrographs of the neon-colored virus, photographs of family members at the bedside of dying victims and pictures of faces masked against infection.[86] Other images spoke more directly to the specifics of the Ebola epidemic, especially photographs of scientists in bubble suits and pictures of the dead

being buried in body bags or attended by pallbearers in almost combatlike protective gear. Used or viewed individually, most of the photographs spoke to the question of contagion; in different ways the different types of pictures communicated to their audiences that this is a disease to be feared. The electron micrograph blobs of virus were not just cold scientific evidence, they were framed in captions as "gruesome" killers that meant "trouble." The images of the dead and dying were not the cozy, if antiseptic images of hospital vigils familiar from the flesh-eating bacteria or mad cow disease epidemics. The photographs depicted the dying and the dead as solitary, "cursed" victims, left alone with the virus. While bedside pictures typically show family or physicians interacting with patients—even if the interaction is contrived—many of the images of Ebola victims showed them by themselves, or showed the family members looking plaintively into the camera rather than anxiously at the victim—the victim's fate, their look implied was a foregone conclusion. "You get it and you die," read one caption.

One genre of images, those of masked civilians, was reminiscent of those pictures common during the coverage of the plague in India. The Ebola images, like the plague photographs, were confrontational; many of those who had their faces covered stared directly into the camera—directly into the eyes of you, the reader. "What are you going to do?" their eyes—and the picture—questioned. Yet, there were some distinctions between the photographs of the two epidemics: Almost uniformly, the Ebola "masked" images were of children, and the photographs featured just one or sometimes two masked children—not a whole crowd. If there was one iconic photograph from the epidemic it was an image of this sort, a picture of two young boys, T-shirts pulled up over their noses and mouths, standing amidst shoulder-high grasses, staring not at the camera but at something off in the middle distance. The lush greenery hinted of a tropical locale, the impromptu masks implied some fear of infection, the concerned, fixed gazes suggested that something to worry about was out there, somewhere. The open, childish faces arrested viewers; they could not be complicitous with the diffusion of this plague—their role was as potential victims. These were children at risk. "These boys," said one caption, "waiting for the body of a relative to be taken out of a Kikwit hospital, don't understand how Ebola is transmitted."[87] These were the children the international medical team was trying to save.

At the other end of the emotional spectrum as the images of children were the photographs of the lab technicians dressed up like astronauts. These pictures screamed contagion—this virus is so deadly it can only be approached with the utmost caution and protection. The second *Nightline* on May 24, for example, aired footage of doctors "dressing like an astronaut: all seams sealed, two pairs of gloves, and a personal respirator."[88]

Photos of scientists at the CDC doing mysterious experiments with vials and vats all surrounded by a swirling fog were often aired following or laid out next to or after the images from Zaire: space-age technology and primitive hygiene. *Newsweek*, for example, began its May 22 eight-page spread with a heavy, black, three-word headline "Outbreak of Fear" next to a two-page photo of the two young masked boys. This first layout was followed on the next two pages by a "straight" photo, about half the size of the first image, of a CDC "disease cowboy" suited up, isolating viruses for analysis. Two pages later *Newsweek* ran a movie still of Dustin Hoffman in his protective helmet, in an unwittingly self-confessed attempt, as the caption recorded, to heighten "public tension about emerging viruses." *Newsweek* did not take a subtle approach at covering the epidemic. At every turn, it confronted readers with images and headlines geared toward stoking "laymen's fears that new, exotic microbes are getting the upper hand," as the blurb in the table of contents said. The large photograph in the table of contents showed two CDC researchers in full suits, handling viral samples, as the headline below them shouted "An Outbreak in Africa Spreads Global Fear." And the cover, by photographer Brian Wolff, was a close-up of a heavily gloved researcher's hands holding a vial of Ebola virus in a biosafety Level 4 lab at the U.S. Army Medical Research Institute of Infectious Diseases. The photograph was a simulation. The bold headline read: "Killer Virus. Beyond the Ebola Scare. What Else Is Out There?" Of the six photographs in the Ebola issue (not counting a half dozen electron micrographs of various viruses), four were of space-suited scientists, one was of the two masked children, and the sixth was of an American medical team rehearsing airlifting a victim in an isolation stretcher—in effect a stretcher in a bubble of plastic.

A final genre of images emerged during the second week of coverage, following the funeral of Sister Dinarosa. Photographs from her funeral displayed in single images the dichotomy achieved through the pairing of the Zairian civilian pictures with the high-tech researcher pictures. In the funeral shots the cheerfully papered, flimsy coffin tied shut by three white ribbons contrasted with the pallbearers outfitted in serious green drab, head-to-toe protective garb.[89]

By the year's end, images and details about the Ebola epidemic had come to be conflated with images and details from the pop cultural appearances of the virus. The Zairian epidemic had served to legitimate the terrifying premise of *Outbreak*. Which had made more of an impact on Americans? Well, as *U.S. News* reported in its special New Year's issue, "Cases of the Ebola hemorrhagic fever during this year's outbreak in Zaire: 315; number who had died as of June 1995: 244. . . . Amount the movie *Outbreak* reaped in box office receipts during

its opening weekend in the United States: $13.4 million."[90] Ebola's celebrity status was due less to Kikwit than to Warner Bros.

Certainly Ebola's entrance into metaphor superstardom had a lot to do with the pop status of the disease. By the summer of 1995, every trendy writer, from *The Nation* to *The Weekly Standard*, was tossing an Ebola simile into his article. Ebola had become a news icon: elected officials were fleeing the Democratic party as if it were a "nest of Ebola"; academics were taking joy in releasing the "Ebola virus of deconstruction" on the literature of the past; sex is like some "hot form of Ebola" spreading uncontrollably through every type of media; people talk about discounting in the cruise industry "as if it is the Ebola virus"; lawyers may be as popular as "houseguests with Ebola." Ebola became such a ubiquitous news icon that *Newsweek* ranked it in its column of "overexposed noisemakers," together with Martha Stewart, John F. Kennedy, Jr., Brady Bunch nostalgia and beach volleyball.[91]

A more serious cost of Ebola becoming a celebrity was the association yet again of Africa with "savage African diseases ready to break out anywhere at any moment," as Britain's *Sunday Telegraph* put it. Africa's heart-of-darkness stereotype grew even darker. Good news abounded in Africa, but it was Ebola that had captured the world's attention for weeks. More prosaic bad news abounded, too, like the news that 250 people had been stricken with polio not far from the region of Ebola outbreak, or that 30,000 people in Angola were infected with sleeping sickness, or that cholera was raging in Mali, or that thousands from across West Africa had died of meningitis. But all these diseases were treatable, known quantities, no longer considered—by the West, at least—to be "savage." These epidemics were not newsworthy epidemics to Americans. "Let's face it," said a U.N. official, "the world's threshold for suffering is just higher in Africa than it is for other places." As Howard French in *The New York Times* wrote: "death by the thousands in annual measles outbreaks or a toll of millions from malaria, are non-events for an outside world that has already moved on to associating Africa with endemic HIV infection and has found an even more spectacularly grim image of a diseased continent: Ebola."[92]

And so a new standard of disease crisis was created: the Ebola Standard, the standard against which all other epidemic diseases are now measured.

Compassion fatigue is a consequence of dwelling on such an extreme example. The most insidious compassion fatigue effect is not that people will follow a story and then drop it out of boredom or apathy or overload, but is that there will be no story to follow in the first place because the media didn't think the news

was arresting enough to tell. When the admittedly sensational Ebola is represented in such a sensationalized fashion by the media and by Hollywood, other diseases pale in comparison. So stories of more prosaic illnesses barely register; they're ignored, underreported. The gauge of news values shifts: The assessment of "proximity," "prominence" and "significance," as well, of course, of "controversy," "novelty" and "emotional appeal" are all affected by the Ebola Standard.

The Ebola Standard will no doubt survive, until some Andromeda Strain virus is found that is communicated not through an exchange of bodily fluids — a fairly rare and controllable occurrence — but by airborne droplets. Perhaps a virus, like the fictional "Ebola" in *Outbreak* that can be spread to an entire city by one sneeze in a crowded movie theater, will emerge. Surely that outbreak would circumvent compassion fatigue. And just as surely, it would recalibrate the measure of news values.

"Landscape of Death," *Time*, 14 December 1992
"Beyond Hope, Beyond Life: A child, its eyes covered with flies, tries to take milk from its mother's shriveled breast."

CHAPTER THREE

COVERING FAMINE:
THE FAMINE FORMULA

We knew the Somalia story had arrived when the networks rolled into Mogadishu. The Marines and other American forces were coming, 28,000 of them—nobody quite knew when—and television had to be there to record the American-doing-good-for-the-starving-Somalis Christmas images. . . . CBS was the first in, with a 707 bearing five tons of equipment, and an armada of light aircraft ferrying Dan Rather, and more than 40 reporters, producers and technicians. CNN, NBC and ABC were not far behind.

—Jane Perlez "Gunmen, $150 a Day,"
The New York Times Magazine,
January 24, 1993

Conventional wisdom has it, as Senator Paul Simon wrote in 1994, that "The media brought the disaster of Somalia into our living rooms. The American people and our government were moved to action." How did the media accomplish this? Through pictures. "It is unfortunate," said Senator Nancy Kassebaum, "it takes these pictures to really bring it home." "We collectively don't become aroused to really lend the vigor of focus to an issue," she said on another occasion, "until pictures are shown on television. And that's what heightens public awareness. That's what really drives an outcry."[1] Somalia appeared to be one of those rare occasions when the pictures (especially on television) really did overwhelm the syndrome of compassion fatigue.

The framing of the news and, eventually, the ubiquity of the coverage prompted Americans to care about those going hungry in Somalia—just as the television coverage of the famine in Ethiopia six years before had galvanized the American public. But the impact of the Somalia pictures was localized; it was not so strong that it spilled over regionally to make Americans care about the starving Sudanese, too. The images pushed Americans to care about helping the

Somalis; the pictures did not push them to call for an end to famine everywhere. The Sudanese were not on television. And so, out of sight, out of mind. No matter that the two countries were next-door neighbors.

Governments act when there is a sufficient public demand for action, so the argument goes. As one reader of *Time* wrote in response to photographs from Somalia: "These are our brothers and sisters in the flesh. Can anyone put pressure to bear on our government to help them?"[2] *Time's* cover story on the stands the week that the U.S. Marines landed in Mogadishu, in December 1992, included a four-page photo-essay entitled "Landscape of Death." It was prefaced by this short column of text:

> The harrowing faces of starvation, the inert shapes of death. These are the images that have finally brought the world to Somalia's rescue. Why did it take so long, when some reporters have been telling the story for months? Such is the power of pictures: people are starving and dying in Liberia, Sudan, southern Iraq, Burma, Peru, yet no massive aid is offered. Humanitarian concern has no logical stopping point, but the world's attention is hard to capture. It is easy to argue that policymakers should not wait for gruesome television footage before they respond. But if images like these are what it takes to bring mercy to even one people in peril, so be it.

The photograph that punctuated the end of that column, about 3½ inches square, was a close-up of an infant trying to nurse from a shriveled breast, while flies feasted on its shut eyes.[3]

Starving children are the famine icon. If the chief metaphors employed in the media's coverage of epidemic disease are the frightening ones of the Black Death and of AIDS, their coverage of the assassinations of foreign leaders is paralleled with the martyred deaths of Lincoln and Kennedy, Martin Luther King, Jr. and Mohandas Gandhi, and their coverage of genocide references the horrors of the Holocaust, the media's coverage of famine is distilled down into the simple iconic image of a starving infant. An emaciated child is not yet associated with the stereotypes attached to its color, its culture or its political environment. Skeletal children personify innocence abused. They bring moral clarity to the complex story of a famine. Their images cut through the social, economic and political context to create an imperative statement.

Typically that statement is first enunciated by the newspapers, then television and the newsmagazines follow. "Television . . . frequently takes its cue from what some of the larger newspapers decide is news," said Dan Rather. But if a

story is to "take traction . . . to have impact and particularly to have staying power," Rather said, "somebody in national television has to be willing to devote the resources and time to it." Once that commitment has been made, donations to relief agencies start rolling in and the government sits up and takes notice. The American Red Cross, for one, said its disaster contributions earmarked for Somalia rose in direct proportion to the amount of media coverage given the crisis. And virtually the first words spoken by President Bush when he addressed the country in November 1992 about his decision to send the troops were of the "shocking images" that had haunted Americans for weeks.[4]

But such "atrocity" pictures, as some called them, often appeared without a political context—which didn't seem to be a problem, until U.S. troops were already in Somalia, and the political context became a millstone around the neck of the U.S. commitment. "Atrocity imagery is among the most powerful political weapons of the 20th century; sentimentalizing it is a mistake," wrote Charles Paul Freund, somewhat presciently in early December 1992.[5]

"Pictures don't tell us the answers," said Richard Lacayo, in *Time* magazine. "They tell us why the questions are important."[6] Pictures from famines clearly demonstrate the power of images, but they also clearly demonstrate their limitations. Words have to accompany images. The right images can seize an audience's attention, but only words can teach an audience the meaning of those pictures. It's tempting for television, especially, to believe that capturing the public's attention for a subject is all that needs to be done. That in itself is not easy. But that is just the first and perhaps the easiest step to take. The harder job is to retain the public's interest long enough to educate. Repeating the iconic starving children images is a short-term strategy that, if continued, teaches little and ultimately contributes to an audience's decline into compassion fatigue.

Starving children unequivocally attract notice, but the repetition of their images suggests that all that is needed to resolve the crisis is food. Feed the children and the famine will be over. But a lack of food is rarely the originating cause of a famine—food may save lives, but it won't end the famine. As Americans found out in Somalia, there are more intractable problems in a famine—problems that need to be understood, certainly by the American government and military, but also by the American people. As the three-year-long debacle in Somalia argued, the media needed to have covered the story from its outset—before the crisis stage. They needed to have covered the story more thoroughly, more consistently, on television as well as in print. If the complexity of the Somalia situation had been better understood, perhaps the Americans would have proffered humanitarian relief earlier and more lives would have been saved from starvation and disease. And perhaps Americans would have been

more wary of the "nation-building" effort once the Marines had been committed and less surprised and less knee-jerk reactive when the effort went sour.

Americans routinely refer to famines as disasters. They have "a vision of famine as something simple, huge, and apocalyptic," in the words of Alexander de Waal, one of the influential writers on the subject.[7] Until recently, as a result of the 19th-century Malthusian debate, famines used to be seen as the natural consequence of drought and the resulting food shortage—they fell into the category of natural disasters, rather than the category of man-made disasters. Natural disasters were considered to be those clearly in the "Act of God" class: volcanic eruptions, hurricanes, earthquakes, floods and droughts. Man-made disasters were those in which humans were more evidently at fault: industrial accidents, civil wars, refugee migrations.

But recently that terminology has become passé. So the jargon has changed. Natural disasters have mutated into "simple emergencies" and man-made disasters are now "complex emergencies." Simple emergencies usually call for a straightforward humanitarian response—the providing of food, shelter and medical supplies. The stereotype of this kind of emergency is an unpredictable disaster, as in the case of an earthquake, but some of these sorts of disasters can be tracked in advance by a few days, as in the case of hurricanes and cyclones, or by a few weeks, as in the case of river floods.

By contrast, complex emergencies more clearly demand not only humanitarian relief, but also social, political and even military attention. They can be of several types. They can be foreseeable for weeks and maybe even months, such as most famines and epidemics, they can be deliberate, resulting from wars and civil strife, and they can be accidental, occurring as a result of some technological mishap. Complex emergencies lead to a breakdown of civil society, as demonstrated by the symptoms of a lack of food, frequently deteriorating into starvation; economic collapse, involving hyperinflation and massive unemployment; the failure of governmental authority, often triggering ethnic or religious violence and human rights abuses; and the movement of great numbers of people.

It is fair to say that those countries prone to famine have been prone to both drought and war. The effect of mere drought can be countered by the importation and distribution of food from outside an affected region as well as by those at risk dipping into reserves of stored food or selling some assets in order to purchase necessary foodstuffs. But war interferes with both local and external responses.[8] "Long-term amelioration" of famine, said *The New York Times* in 1991,

Today

"demands more than Live Aid concerts or airdrops. It requires ending wars, securing human rights, abating population growth and preparing in advance for predictable disasters."[9]

Most American casual observers of famine would argue that famine needs no intellectualized definition. The images of famine, they would say, speak for themselves. The bloated bellies, matchstick limbs, balding heads, wizened faces and fetal positions of the starving are not subtle signs to be easily overlooked. In fact, in his seminal work on the subject, Harvard political economist Amartya Sen said that one can very often diagnose a famine, "like flood or a fire—even without being armed with a precise definition."[10] Yet a definition is important because it provides the criterion on which food aid is released or withheld and on which the media decides newsworthiness.

Writers on the topic of famine have identified a hierarchy of human conditions triggered by a lack of food—hunger, undernourishment, malnutrition, starvation and famine. Many of us can distinguish between ordinary hunger, when meals are skipped, and undernourishment, when undereating becomes chronic. The distinctions among malnutrition, starvation and famine are for most Westerners less familiar, but can be given as the following: "Perhaps when a man keels over and collapses from lack of food, then that can be accepted as the dividing line between malnutrition and starvation. . . . Perhaps when whole families and communities keel over, then it can be called a famine." Malnutrition, then is a condition that may harm one's health, but not by itself unto death. Starvation, if it lasts, causes death. If many starve, during the same period, of the same causes, then that is a famine; widespread and catastrophic cases of starvation comprise a famine. But starvation, even widespread and catastrophic, is not irreversible. A famine can exist without massive dying, despite the stereotype promulgated by media images. "If a relief programme ever was completely effective," noted one famine theoretician, "nobody would actually die, but nor would most observers doubt that a famine had occurred."[11] Local and/or international intervention can arrest a presumptive fatal decline—and did so, for example, in southern Africa in 1992 and Ethiopia in 1994. But Americans heard little of those success stories. Instead of seeing images of thin survivors from Botswana or Zimbabwe in 1992, for example, they saw pictures of the dying and the dead in Somalia.

The successful arrest of a famine can have ironic implications. Without a high death toll, those who cried "famine" can be charged with "crying wolf." Only a few months before the peak of the 1984 famine in Ethiopia, a U.N. official charged the Ethiopian government with exaggeration: " 'You have been

telling the world of this problem in 1982 and 1983, but we've not seen the people dying like flies yet.'"[12] The "no corpses, no attention" rule may make sense for media news budgets based on body counts, but it's bad development policy.

The equation of famine with starvation unto death is a particularly Western definition.[13] Because Americans only witness famine through the intercession of the media, their view is that famine always kills. As British TV reporter Peter Gill wrote about the 1984 famine in Ethiopia, "the Western world—Governments, media, international aid organizations, and many private relief agencies—responded only when people were dying, not to the warning signals and not to the challenge of trying to avert famine."[14]

Indeed, the interest in getting "death" was so great after the massive commitment of American humanitarian and military aid to Somalia in the fall of 1992 that Scott Bob, the East Africa correspondent for Voice of America, noticed a camera crew at a feeding center pushing a microphone right next to the mouth of a child who had crawled off to die. "When one of the aid workers demanded to know what . . . they were doing," Bob recalled, "the sound man said 'my editor wants us to get the sounds of death.'"[15] The gruesome intrusion of that camera crew was justified in the editor's mind as necessary to break through the American audience's compassion fatigue for yet another depressing story. The extremity of the "sounds of death" was an obscenely misguided effort to signal to viewers that this story was out of the ordinary, that this story was, quite literally, about life and death.

Like other "complex" disasters, famines are usually easy to see coming. Famines that end up killing thousands or millions of people don't just happen overnight. But a story whose thrust is "Famine Likely" is not a front pager or a top-of-the-news item. Such a story is lucky if it makes it into a "World Briefs" section or into a "Global Wrap-up" package. In the spring of 1991, for example, famine conditions in the Horn of Africa—Sudan, Somalia and Ethiopia—were in place, but the deaths hadn't happened yet. "Relief professionals have been trying to get people interested in the crisis in Sudan—300,000 are going to die—but it's less dramatic. It doesn't happen all at once," said Lisa Mullins, program director for disaster response and resources at InterAction, a coalition of 132 relief agencies, including CARE and Oxfam America. But, noted Jon Hammock, from Oxfam, "the gruesome pictures will come to us very soon."[16] By the time the "gruesome pictures" finally made the covers of *Time* and *The New York Times Magazine* in the fall of 1992, hundreds of thousands of Sudanese and Somalis had died. Then the aid and public attention came pouring in. Too late for many.

Another misconception that Americans have about famine is that starvation alone causes the deaths. But it is not just the severely malnourished who die; according to nutritionists, "the vast majority of famine deaths occur among children who are not severely malnourished."[17] For many trapped in a famine's downward spiral, the greatest threat to life is not sheer starvation, but epidemic diseases opportunistically unleashed by famine. The starving are debilitated and unable to withstand the spread of infectious diseases, exacerbated by crowding, lack of shelter and clothing, minimal sanitation and inadequate and/or polluted water supplies. For both local and international relief organizations, the challenge of controlling famine mortality entails the providing of medical care as well as adequate food and water.

Most newspaper-reading and television-watching Americans are familiar with the physical signs of acute famine, having seen photographs and films of its victims. Some of the images are of people suffering from chronic protein deficiency, or kwashiorkor, a disease striking among black Africans, for it turns the hair red or even white and makes it straight and limp. Skin rashes are severe, ranging from scaly to ulcerated, and faces and bodies are bloated, swollen with fluid. Eye problems and heart failure are common. The body of a kwashiorkor sufferer does not retain heat well; many children die of hypothermia when moved away from the warmth of their mothers.

Even more common images during famine are of those affected by marasmus, the victims of rapid, extensive caloric deficiency—or, more simply, starvation. These are the walking skeletons, their limbs so attenuated that it appears impossible for them to bear the weight of their bodies. The child with marasmus has an old man's face on a tiny body. Heads of victims seem disproportionately large, and shoulders, elbows, knees and ankles are little more than bony knobs. Muscles are wasted away and the buttocks disappear. Skin is loose and wrinkled, often plagued by rashes. Diarrhea is the rule and parasitic infection is endemic. Malaria, measles and tuberculosis are common complicating burdens.[18]

The media stereotype of a famine is that only the very young and the very old die. Partly that impression is a result of the fact that Western reports of famine are often stories of famines in refugee camps, where the majority of the refugees are women and children—the men either having been killed or having remained in the countryside to fight in the war that precipitated the refugee crisis and famine. It is true that very young children and the elderly suffer the highest mortality rates during famine—but so do they during normal times. (The

Horn of Africa has an infant mortality rate, for example, higher than 120 deaths for every thousand live births. The U.S. infant mortality rate, by contrast, is about ten deaths for every thousand live births.) Researchers have shown that the highest proportional increase in deaths is among older children and adults, perhaps due to the fact that these groups do not benefit from the fortified supplementary foods given to younger children in relief camps and that these groups suffer a larger proportional increase in wasting than do younger children.[19]

Famines that kill make for good stories. Journalists can come away with compelling pictures and tales of drama and conflict, complete with heroes, villains and innocent victims. A "'good famine story,'" observed Alexander de Waal, somewhat caustically, "is that of a family who have [*sic*] been forced to abandon their home, have lived off nuts and berries, whose children are starving or already dead, and whose only hope lies in the charity of a (preferably foreign) aid programme. This is not to say that journalists deliberately exaggerate the scale of the suffering that is going on (though sometimes they do); merely that their professional priorities lead them to characterize a famine situation in a certain manner."[20]

When covering disasters there is a standard formula to follow. Stereotyped images, stock phrases and common abstractions reinforce an established way of interpreting the news. "Reporters can 'tell it like it is' within 60 seconds, rapidly sorting key events from surrounding trivia, by drawing on reservoirs of familiar stories to cue readers," observed one Harvard academic. Once established, it's hard for the stereotypes to disappear. Despite the Ethiopians' success at averting a famine in 1994, for example, they are still often represented as the helpless victims they had been in 1984. The stereotypes even persist in periodicals that make an effort to report on positive stories. In May 1994, for example, the British publication *The Economist* illustrated an article on the country's first-ever multiparty parliamentary elections with a photograph of a small malnourished child.[21]

Numerous observers have noted that there is a "template" for famine reporting. To fit the formula, first, people must be starving to death. Take the Somalia story. For months the media ignored the war in which hundreds of civilians were being injured and killed everyday by the "war lords" and local "thugs." "The Western media," said Edward Girardet, a documentary television journalist, "couldn't care less about Africans killing Africans. There were enough places in Africa with people killing each other. So what? Anything else new? What editors really wanted was a famine. A solid, Ethiopian-style hunger story." Only when

the media "finally had its famine story . . . was the situation considered news-worthy. . . ."[22]

Second, the causes of and solutions for the famine must be simplified. There is a tendency for the media to view a famine as if it was a natural disaster, beyond the control of people. That allows the media to avoid a serious assessment of the factors that created the famine. Instead the media typically distills a famine's multiple causes into single problems: for example, drought, as during the 1984–85 famine in Ethiopia, or general chaos, as during the 1991–92 famine in Somalia. Simplistic causes suggest and make plausible simplistic solutions—such as the giving of money—and tend to exaggerate the agency of Western aid and to minimize the involvement and efficacy of indigenous efforts. The stories rarely challenge the notion that Western money and technology are the key missing factors in the famine equation; instead they focus on the threats to the correct usage of the foreign aid.[23]

Third, the story of the famine must be told in the language of a morality play, with good and evil fighting for ascendancy, and characters fit into the parts of victim, rescuer and villain. Victims must be sympathetic—usually women and children—and credible for the American public—not aligned with known ter-rorist or "extremist" political groups. Intermediaries—such as humanitarian workers—who are perceived as being above partisan politics or self-interest must be available to "interpret" the ongoing scenario.

And four, there must be images—ideally available on a continuous basis. Any cutoff of pictures, whether caused by problems of access or censorship, shortfalls in the media's budget or glitches in the communication technology, risks sever-ing the entire story.

Generally this stereotyped reporting occurs once a famine has become a big story. But there are earlier stages in coverage. Famine stories commonly follow a four-step chronological pattern.[24]

1. The first time news of a famine appears is when the famine is "imminent." This "early predictor story," as Michael Maren, a journalist and former aid worker has identified, is typically a news brief, a very few column inches of story, buried deep in the elite print press under a catchall "World Wrap-Up" section. Usually a wire service story—often from the British service Reuters when the famine is African—the dateline is commonly Geneva, Rome, Paris or Brussels, sites of the headquarters of various U.N. agencies and relief organizations, the originating source or sources for the news of the famine. The thrust of these news briefs is that huge populations are at risk of starvation. But because that can be said of many peoples in many regions of Africa at any given time these

news briefs do not make much of a stir. The story remains an international organization story ("The World Food Program of the United Nations today announced that . . .") rather than an African story ("Hundreds of members of the Dinka tribe . . .").

2. If the "starvation" continues to progress, it is likely that some correspondent covering Africa for the elite press—occasionally a freelancer with impeccable credentials in the region—will, on a sweep through the territory, do a lengthy "trend" story featuring the famine. Coverage of the famine will be one part of a larger article on government corruption, civil war, international aid and/or ecological conditions in the affected region. The story will heavily cite official sources of information. During the next weeks or months, this initial trend story will inspire several more scattered features, all concluding that famine in Africa is periodically endemic, that there is too much to do, that little's changed. However, in order to justify the writing of the articles at this time, comparisons will be drawn between this new confluence of problems and recognized crises in the past—saying, for example, that Mogadishu, Somalia, is "Africa's Beirut"[25]—or between this new famine and catastrophic past famines, such as the Ethiopian famine of 1984–85. Numbers in the millions will be cited for people at risk of starvation and death. Photographs will often appear with the stories, but not all of them will be of the starving—some will be of soldiers or aid transports, and so forth. As a result the images will cause little more than a ripple of attention.

3. If the coverage is to continue and grow, it does so because of some precipitating event, usually involving Americans—for example, a tour of the area by a high-profile Congressional delegation or a moral call-to-action by some major international player or celebrity. Almost over night, the famine will become a front-page, top-of-the-news story. Print and television reporters, photographers and camerapeople flood the area. At this point, the story is grossly simplified: clear victims, villains and heroes are created; language such as "harrowing," "hellish," "unprecedented," "single worst crisis in the world," "famine of the century" is employed; huge numbers are tossed off frequently and casually, with few references to sources. As one disaster reporter noted, there is "a common peril in disaster reporting—exaggerating the immediate and long-term impact. We will *always* gravitate toward the largest kill count. . . . We will *always* speculate (and sometimes predict) the cosmic consequence."[26] And grim and graphic photographs, especially of dying children, become ubiquitous.

4. Partly through happenstance—the climaxing of step-three coverage at a time when there is no other major international event, no wars with Americans engaged, no dramatic terrorist action, no devastating natural disaster—the famine becomes an American crusade. The famine dominates the media's

coverage of international news, and for a while even domestic events. It becomes the focus of presidential and congressional debate and action. It becomes a cultural and moral bellwether for the nation. The blanket attention drives a massive outpouring of charitable donations; newspaper articles and television programs—even the elite ones—list the addresses and toll-free numbers of the involved humanitarian agencies. By this stage, the story has become a runaway engine. As Michael Maren argues, it is now "impervious to facts that do not fit the popular story line."[27]

The success of that morality play story line rests on the fact that it is easy to understand and appreciate. "The victim and his rescuer have become one of the totems of our age," wrote the former head of Médecins Sans Frontières, Rony Brauman.[28] The set piece is ideal material for television and superficial print coverage: The cause of the famine is simple, the solution is obvious, the victims are innocent, the rescuers are heroic—and those thwarting them are villainous.

In the world of the famine morality play, good and evil are clear cut. There is a requirement, Brauman states, "for purity of victim status." The status of victim is only granted "in cases of unjustified or innocent suffering. . . . He must be 100 percent victim, a non-participant."[29] Mothers and children make ideal victims, while men associated with violent political factions can starve by the thousands without creating a flutter of interest in their victim status. The men are culpable, it is assumed, in not only their own deaths, but in the deaths of the truly blameless. Only when victims have been identified as "bona fide" are they candidates for compassion. The media have few hesitations about using pictures of extremes to emphasize who's good and who's bad: juxtaposing a picture of a starving mother or child with an image of men brandishing automatic weapons, say.[30]

This simplification can occur because the stories are about the victims, not by them. The victims are seldom heard, though often photographed. Few note the incongruity of invading the starving's privacy, as if they were not human, for the ostensible purpose of advertising the need for humanitarian aid. "Haua Mohamed Mahamoud knows nothing of the western media's right to know," wrote Nick Charles, a reporter for *The Plain Dealer*. "All the 10-year-old knows is when cameras, microphones and foreigners with pen and paper appear in the casualty ward at Baidoa Hospital, she is stripped naked. Her only bit of protection and privacy, a shorn piece of sack cloth, is removed so that the world can see her sores, her wounds, her pain. Their eyes examine her thin chest, count her protruding ribs, invade her most private parts. Rightly hailed for its dogged pursuit of a story too long ignored by the world, the media at times seem insensitive to the threads of dignity that some Somalis cling to."[31]

Because of the language barrier between journalists and famine victims, the perceived lack of articulateness (for reasons of education or health) of the victims and/or the chosen angle of the coverage, only a handful of famine news stories use common people as sources. When their words appear at all (usually in features), the words are personal histories, not political, economic or social commentary. Usually the perspective of the famine victims is assumed—implicitly in the photographs ("I'm hungry.") or explicitly in the reporter's narrative ("The mother is tired."). With no voice of their own, they can be made to represent or reflect whatever sentiment is desired. When children in Britain were shown a photograph of a smiling African woman and her child, the majority of responses were that "if they look contented 'we must have helped them.'"[32]

The central heroes of this famine world are the Western aid workers. "The age of the 'French doctors,'" said Brauman, has come. "The humanitarian volunteer, a new, newsworthy figure, neither statesman nor guerrilla, but half-amateur and half-expert," is the famine's "front man," both actor and narrator. The relief workers are portrayed as ministering angels in their self-sacrificing efforts to assist the victims. As the former president and the policy director of Oxfam America have written, "By definition they are noble. There appears to be an unwritten rule in the media to go easy on the relief agencies. If mistakes are made, the relief agencies are less liable because their motives are pure." And, after all, in the typical famine scenario it is the relief agencies that have brought the crisis to the media's attention and made it possible for journalists to get entrée to the story. As a BBC correspondent covering the Somalia famine remarked, "Relief agencies depend upon us for pictures and we need them to tell us where the stories are. There's an unspoken understanding between us, a sort of code. We try not to ask the question too bluntly, 'Where will we find the most starving babies?' And they never answer explicitly. We get the pictures all the same."[33] The humanitarian workers' elevation to hero status is almost a quid pro quo.

Among the relief workers the doctors and the nurses receive the most attention. Theirs are the glory jobs, the saving of lives, one by one. Other aid workers—such as the office administrators or the sanitation engineers who provide clean water and dig latrines and perhaps save more lives than the doctors but do so less sensationally—are overlooked. As one commentator wrote, "I doubt if even the French version of 'sanitation engineers without borders' would have quite the dramatic ring of 'Médecins Sans Frontières.'"[34]

In contrast to the victims, the relief workers are extensively quoted. As the on-scene mediators in the famine world, their comments are used both as the "deus ex machina" of the stories and as providers of verbal "color." Their words give the political and social context and much of the anecdotal fillip.

Early on during the chronology of famine coverage, there are few villains. There is little need for them in stage one coverage, as the causes of the famine are usually represented as simple abstractions: drought, chaos, war. And in stage two coverage, the famine is typically reported on as only one manifestation of a whole host of regional issues. Only when the coverage makes it into stage three and four are villains discovered. As famine becomes the focus of stories, the context of it is foregone in lieu of more detail about the famine itself—the suffering of the victims, the tremendous efforts of the aid workers. But heroic sacrifice alone can only fuel so many stories. When coverage of a famine lasts longer than a few days, there has to be mention of problems and the villains who create them. When the famine is seen as intractable, when the efforts of the humanitarian agencies are seen to be inadequate to bring a rapid end to the famine, reasons for the failure have to be found. Ergo, villains: the local military authorities who harass the relief personnel—in Somalia, for example, the "warlord" Mohamed Farah Aidid and his "thugs"—and the false heroes, the "Lords of Poverty," as one critic has termed them, the United Nations bureaucracy which fails to respond in time or sufficiently or appropriately[35]—in Somalia, the office of Secretary-General Boutros Boutros-Ghali.

When covering famines, the media rarely prioritize the establishing of their objectivity—as they attempt to do when covering international diplomacy. The media take what they believe is an unassailable position: that it is bad to let people starve to death. Their coverage, their use of language, their choice of images all flow from that assertion. Most of the famine stories—even those that cover the "hard" news—have a strong emotional content related through the use of adjectives and adverbs, anecdotes and personal testimony and through the accompanying images. Once a famine hits stage three and certainly stage four, provoking an emotional response to the famine becomes the point of coverage; the manner of the telling of a famine story helps underscore the morality play perspective. A September 1992 *Newsweek* article, for example, ran three good-size photographs by Peter Turnley. The first, of a small skeletal child with whitened hair staring directly into the camera, repeated as its caption "**Moral imperatives may soon take precedence**: Starving orphan in the village of Wajid." And the article ended with this story: "[Teresa] Hinkle, the American nurse [for International Medical Corps, a U.S. relief agency], won't soon forget the day a Somali woman collapsed in the dirt outside the hospital in the Somali town of Baidoa. 'She was just this beautiful young girl who made it that far and died,' says Hinkle, on the verge of tears. A baby boy was in the dead girl's arms, still barely alive. 'She got the baby that far,' Hinkle recalls thinking, 'I couldn't

let her down.' But Somalia allows no room for sentimentalism. Hinkle's intervention was too late: the motherless child died of malnutrition and dehydration within hours."[36] If a reader turned the page after the close of this story and felt nothing, it wasn't for lack of trying on the part of *Newsweek*.

Henry Grunwald, the former editor-in-chief of *Time* magazine and a former U.S. ambassador to Austria, cites images as a key way for the media to "stir emotions." Images, he said, "now have even greater impact than they did during the Vietnam War. It is the heartrending television pictures of starvation . . . that helped persuade Americans to police the tribal wars and banditry in Somalia."[37] The media know that the ultimate heart-tugger is a story or photograph of a child in distress. When the victims are children, compassion fatigue is kept at bay longer than it might be if adults were the only casualties represented. Adults can be seen as complicit in their own demise; it's difficult to justify the death of a child. A recent study that investigated relief groups' use of photographs in their fund-raising efforts noted that children were the most credible "message sources," that close-ups generated reader interest and that a child staring straight into the camera increased the personal appeal for donations.

The study, published in the prestigious academic journal *Journalism Quarterly*, also confirmed previous studies that found that "the most influential campaigns are those reinforcing predispositions."[38]

Using this logic, the media in their coverage of each new famine just tweaks the famine image a little; the coverage is geared to remind the public of previous debacles. If the previous famine garnered attention, so the argument goes, mimicking its coverage will garner attention for the newest crisis.

But this conduct encourages compassion fatigue. The conflating of famine stories encourages audiences to believe that a new famine is but a continuation of the past one . . . only worse. The fundamental continuation of the famine saga tempts an audience into questioning whether caring is futile, whether—if the starving, like the poor, are always with us—it is not debilitating to little effect to care about those threatened. If the intent of the media's stories is action (as their lack of objectivity would argue), and past action seems incontestably to have accomplished little (otherwise, why would there be another famine?), an audience can't help but feel that any response on its part is meaningless. This is a recipe for compassion fatigue.

Walter Lippmann wrote, in 1922, that the press was "like the beam of a searchlight that moves restlessly about, bringing one episode and then another out of darkness into vision." From blackness into blinding glare. And then back into blackness. It's a problematic way of covering the world. But as distorting as the media's representation of famine might be, those disasters which manage to

cut through the compassion fatigue night to have their moment in the bright lights may be the fortunate ones. "Lucky are the people in Yugoslavia and Somalia, for the world is with them," wrote a missionary in a letter smuggled out of southern Sudan. "It may be a blessing to die or get killed in front of the camera because the world will know."[39]

THE ARCHETYPAL MEDIA FAMINE: ETHIOPIA, FALL AND WINTER 1984–1985

Wizened men trudge, leaning on sticks for support. A skeletal multitude sits in the sand. Burlap wrapped corpses lie in rows. A mother and the baby she bore two months ago are shrouded together. Another mother cradles her dead child; a second baby lies dying in her lap. A 3-year-old, last of a mother's children, dies.

Dies on camera.

The videotape put words to these images.

> Dawn, and as the sun breaks through the piercing chill of night on the plain outside Korem it lights up a biblical famine, now, in the 20th century. This place, say workers here, is the closest thing to hell on earth. Thousands of wasted people are coming here for help. Many find only death. They flood in every day from villages hundreds of miles away, dulled by hunger, driven beyond the point of desperation. . . . 15,000 children here now—suffering, confused, lost. . . . Death is all around. A child or an adult dies every 20 minutes. Korem, an insignificant town, has become a place of grief. . . .

An estimated 470 million people around the world ultimately witnessed the death of that 3-year-old.[40] The force of that child's passing, captured on videotape by cameraman Mohammed Amin and reporter Michael Buerk mobilized Americans as had no previous media or government report on the famine in Ethiopia. In one fell swoop, years of apathy about starving Africans were swept away.

There is a certain point in the process of starvation when intervention cannot reverse its effects. That is when the massive dying starts. And since the media typically only report on a famine after the dying begins, by the time the media have riled up their audience to do good, it is too late for many. By the time donor aid arrives in the camps for displaced people, usually after the several-month-long lag

time necessary to gather, ship and transport the bulk food assistance, the death rates have already begun to drop.

Media coverage, reliant upon visuals to tell a famine story, is not an effective crisis warning system. "In the case of the famine in Ethiopia," noted Andrew Natsios, the vice president of the development agency World Vision and a former AID official, by the time the media weighed in, "most of the people who were at risk of dying (by some estimates 1 million people) had already died."[41] By the October 1984 BBC and NBC broadcasts of the Amin/Buerk film 100 people were dying in Korem every day. And the Korem feeding center was only one of 240 across the country. "It was too late for many six months ago," said a British relief worker in November. "It is too late for others today and too late for many tomorrow."

The major media institutions were not panting to tell this story. Fears of compassion fatigue drained the media's interest in telling another famine story, another trouble-in-Africa story. Even the Amin/Buerk tape was rejected by NBC before it reversed its decision and aired the Korem piece on October 23, 1984. For at least two years Ethiopians had been at risk of starvation and few in the Western media had bothered to report on the pending crisis in any sustained fashion. In the United States, in the more than nine months before the October 1984 airing of the videotape, even print coverage was sporadic. *Newsweek* itself admitted that while its international edition had covered the famine story over the past years, the domestic edition covered it "only intermittently" until the NBC broadcast.[42] Only the major papers gave the story any real play prior to October. In the first nine months of 1984 *The New York Times* had published 12 articles, four on the front page and *The Washington Post* six, three of them on its front page.

The Amin/Buerk footage did not tell the world anything new, but the power of the videotape negated the compassion fatigue in the news audience. The tape made the famine a political priority. It prompted a public outcry, filled the coffers of the relief agencies and made a decisive response almost impossible for American politicians to avoid.

"The famine in Africa is not just a routine disaster. It is one of the central historical events of our time," said one development official. "It is probably the greatest calamity that has ever befallen humankind," said the director of the U.N.'s Office of Emergency Operations in Africa. And "no one," said the *Los Angeles Times*, "was resorting to hyperbole."[43]

For at least two years prior to the BBC and NBC broadcasts of Amin/Buerk's videotape, the famine in Ethiopia had been unfolding—and the country had been suffering through revolution and war for eight more. Save the Children

Fund had opened a feeding center in Korem as early as December 1982, and by early the next year 1,000 children were already on emergency feeding. By the end of 1983, 2,000 children at the Korem camp were being fed. By midsummer 1984 in the Korem center, Save the Children was feeding 8,000 children a day—and 100 people a week were dying.

By 1984, Ethiopia had suffered through several years of catastrophic droughts, which first struck the northern regions, including Eritrea, Tigre and Wollo—where Korem is located—and then engulfed the South. First regional productivity collapsed with a dramatic loss of cattle and a sharply reduced availability of seeds, and then came the nationwide disintegration. By 1984 the country was in the grips of a famine the likes of which it hadn't seen for a century. Early warning systems (EWS), including those of the international aid agencies and Ethiopia's own national EWS, had provided timely notice that relief was urgently needed (although there was confusion and dissension in the donor community over how much outside relief was necessary), but these warnings were not sufficient to overcome the reluctance of the United States and other Western powers to send massive assistance to an African government closely aligned to the Soviet Union.

Also giving the Western nations pause was the fact that in 1984, the year of the famine, the Ethiopian government, embroiled in a civil war with Northern separatists, spent 46 percent of its national budget on arms—neglecting as a consequence, agricultural and rural development aid.[44] As one observer later commented, "The one early warning system you need of famine is lists of which governments are spending disproportionate amounts of their GNP on military activities: look at Ethiopia, Sudan, Chad, Angola and Mozambique."[45] Potential donors charged that if the Ethiopian government would not commit a substantial amount of its own resources to the crisis, the international community would hardly feel obliged to help.

Domestic priorities of the Ethiopian Marxist government of Mengistu Haile Mariam dictated that news about the famine should not get out. 1984 was the tenth anniversary of the overthrow of Emperor Haile Selassie.[46] Mengistu directed his attention to that celebration and to the task of orchestrating "elections" for the newly formed, official Marxist-Leninist party. In his five-and-a-half-hour speech that culminated the four-day September anniversary, delivered to the assembled dignitaries, his countrymen, and some 200 reporters, he did not once speak about the famine.

So that the famine would not overshadow his political agenda, his administration denied visas to Western news organizations to visit the countryside. Starving migrants who had marched to Addis Ababa in search of food, were stopped

at roadblocks seven or eight miles north of the city. Foreign journalists in the country to cover the anniversary never got a chance to see the desperate, just a few miles away.

Even though Mengistu would not acknowledge the famine, his government's Relief and Rehabilitation Commission (RRC) had provided evidence of the drought and crop failures to the international community as far back as May 1981 when it had delivered a report to the United Nations Conference on Least Developed Countries. The RRC had also attempted to individually court Western interest by inviting foreign journalists to the region. These efforts did result in some coverage; for example, German filmmaker Hannelore Gadatsch made a documentary in May 1983 that prompted 14 million marks in donations. And *Washington Post* correspondent Jay Ross visited the troubled northern regions in June 1983 and wrote a five-part series that prompted a visit by a seven-member delegation from the House Foreign Relations subcommittee on Africa. But that same summer NBC's senior foreign correspondent John Cochran and his crew were denied entry visas to report on the famine. (Although he did file reports on the spreading devastation from Senegal and Kenya in September.) For reasons more for cost than access, ABC and CBS gathered material on the crisis from Europe.

The following year, in January, Republican Senator John Danforth visited the region and showed photographs from his trip to President Reagan. And in May 1984, 25 Western and African print journalists were given special visas to again travel in the northern highlands. A few stories were written. "We knew there was a crisis there, and we wanted to get in," said Warren Hoge, *The New York Times'* foreign editor, "but visas were hard to get and we had to report our stories from outside the camps." The news trickled out, but with few visual images it drew little public attention. "Before the story broke worldwide," said Larry Armstrong, director of photography at the *L.A. Times*, "I had tips from some friends that there were really horrible conditions there. We proposed it to the paper. They turned down the proposal." And no stories aired on television in part because Ethiopia would not grant visas for camera crews. Said Joseph Angotti, NBC's European news director, "It was kind of a low priority with us."[47]

Then in late May the Mengistu government cracked down and refused travel permits to foreigners: journalists, diplomats and representatives from relief organizations, alike. Still an occasional special piece emerged: In the beginning of July 1984, for example, *The MacNeil/Lehrer NewsHour* covered the "specter of drought, famine and mass starvation in Africa." And in England, as part of a general African Hunger Appeal, ITV aired on July 17 an hour-long documentary by

filmmaker Charles Stewart originally called "Seeds of Hope," but changed for obvious reasons to "Seeds of Despair." Six days before "Seeds of Despair" was broadcast, the BBC, which had been asked to screen its hunger appeal at the same time, realized that it would be beat in the famine competition if it didn't have a dramatic piece of its own. The "Beeb" called its Johannesburg correspondent Michael Buerk in a panic, hoping that he and cameraman Mohammed Amin could get into Ethiopia and then satellite a news package of "pictures of harrowing drought victims" to them in time to preempt the ITV documentary. In what Buerk described as "series of miracles," expedited by the British relief organization Oxfam, that is what happened. Fifteen minutes after their plane landed in Addis, the journalists were on their way to Wollayta, a feeding center a day's drive south of the city. They got their story in time to drive back to the capital, fly out, and satellite the report from Nairobi. The BBC aired the piece a few hours before ITV broadcast "Seeds of Despair." Together the two pieces prompted donations in England of £10 million.[48] But the flurry of interest in Britain did not generate a comparable interest in the United States; in the summer of 1984 Americans were riveted by the twin spectacles of the Olympics and the presidential conventions.

And then, back in England, just as the Disasters Emergency Committee wanted to close their hunger appeal in October, along came the second Amin/Buerk videotape and started the giving all over again. Mohammed Amin, who lived in Kenya, was the African bureau coordinator and cameraman for Visnews, an organization founded by Reuters, the BBC and Australian television and joined by NBC and other subscribers. In the fall of 1984, Amin and Buerk decided to return to Ethiopia to follow up on the July story. First denied a return visa, Amin made such a fuss that visas were given to him and Buerk. The two journalists were flown to Ethiopia by the relief agency World Vision on October 16. From Addis, they flew to Makalle, a feeding center in the north where Amin used a light half-inch video recorder to videotape a camp with "something like 80,000 people and virtually no food at all." "The people who were not being given the food," said Amin, "they were so quiet and patient. There was still a lot of pride in them. They were still hanging on to the kids they fully well knew were going to die. We filmed all this." They videotaped a feeding center for babies, then drove to Korem. "The subject was so horrifying and brutal," Amin said. "When we were editing back in Nairobi, it hit me very hard that it was more than another story."

Back in London on October 23, NBC's general manager Joseph Angotti turned down the BBC's invitation to view the ten-minute piece before it was first broadcast. But NBC producer Donna Mastrogelow Ryan took a cab over to the

BBC to see it. She was so struck by the footage that she convinced Angotti and Frieda Morris Williamson, the NBC bureau chief, to watch the 12:30 P.M. BBC news. "It just knocked us all right through the roof," Angotti said. He immediately called Cheryl Gould, NBC's foreign producer in New York. But NBC refused the story. "Their response was that they would consider it, possibly for the next day or day after," said Angotti. They were preoccupied with the election and "bored with the thought of another African story."

Angotti went home and watched the tape again when the BBC reran it on the 9 P.M. news. He was still stunned. Realizing that the time difference still allowed for getting it on the NBC *Nightly News* that evening, Angotti phoned the London bureau and instructed the night producer to feed the material to New York on the regular evening satellite at 10 P.M. Then Angotti called the *Nightly News*'s executive producer, Paul Greenberg, and told him that he was "feeding the BBC report whether he wanted it or not." All Greenberg had to do, Angotti told him, was watch it when it came in on the satellite.

Greenberg collected anchor Tom Brokaw and some others to view the videotape. "There are a few times," Greenberg later said, "that a newsroom can be brought to a complete silence, and this was one of those occasions. All the side talk and worried preparations for the evening broadcast, all the gossip and talk of political campaigns and concern for the night's stories just stopped. Tears came to your eyes, and you felt as if you'd just been hit in the stomach." With time running out before the broadcast, two of Greenberg's own correspondents' reports were dumped. Brokaw called the Ethiopian segment "The Faces of Death in Africa." Two and a half minutes of the tape ran that night and another two and a half minutes ran the next night.[49]

The phones at NBC, like the phones at the BBC in London, began ringing off the hook. Thousands wanted to know what they could do to help. The media ran lists of those relief agencies working in the region. Numerous articles and broadcast stories told of people being touched by the images of starvation. Before October 23, American donations to charities working in Africa had been growing, but slowly. The few long articles in the major newspapers, the mass mailings from the relief agencies and the appeals from churches had all helped raise funds. But all of a sudden the dribbling became a flood. In the 36 hours after the NBC broadcast more than 10,000 people called Save the Children. By November 2, Save the Children was receiving 2,000 pieces of mail a day. In one month, Save the Children received $1.4 million in donations and Catholic Relief Services received nearly $3 million. Other groups reported a similar surge.

Seemingly everyone was stirred. Corporations contributed. The U.S. State Department held a ceremony to honor the Lauhoff Grain Company of Danville, Illinois, for contributing the equivalent of one million meals—and for organizing ten other companies to handle the bagging, storing, loading and shipping of the food. Small businesses contributed. Florist Jim Rapoli raised $900 by selling roses outside supermarkets near his home in Plaistow, New Hampshire. When he first saw the NBC broadcast, he said, "I sat there and cried. But I realized my tears won't feed those kids. My roses might." And individuals contributed. Renee Cheng, a Harvard University senior, organized a campuswide fast and "hunger banquet" and sent about $3,000. Oxfam reported that "one woman on social security said she often has to eat pet food herself but wanted to send in $5." And a 4-year-old boy emptied his piggy bank, sending in $18.[50]

The magnitude of the suffering had helped create the impact, but it was the quality of the images that made the scenes so arresting. For Americans unused to British news styles, the slower pace of Amin's camerawork allowed its audience to form strong impressions. "It was as if each clip was an award-winning still photo," said William Lord, executive producer of ABC's *World News Tonight*. "The American style is more breathless, with quick cutting of pictures," noted Courtenay Tordoff, foreign news editor for the BBC. "We tend to let the pictures run longer, and we tend to use more sound without commentary."[51]

Within two weeks, NBC, CBS and ABC had all sent their own crews to the camps in Ethiopia. "As if to make amends"—*The Christian Science Monitor* wrote—"the Ethiopian ambassador in London personally stamps entry visas into the passports."[52] *60 Minutes* aired a story from Ethiopia on November 18. Within a month, each of the three networks had shown about a half dozen reports each on various aspects of the famine.

A setback in coverage then occurred on October 31 when Indian Prime Minister Indira Gandhi was assassinated. For a few days, the media focused almost exclusively on India, forcing Ethiopia off the news. If the pictures from Africa hadn't been so extraordinary, that would have been the end of it. But Ethiopia wasn't forgotten. With the simmering down of events in India and the presidential election over at the beginning of November, the famine story again dominated the news. "It is a good visual story because it is a part of the world almost nobody has knowledge of," said Lane Venardos, the executive producer of the *CBS Evening News with Dan Rather*. Coverage had been intense, he said, "because there is not a whole lot of other news in the world, and the pictures kept getting more and more compelling."[53]

In Washington, election-year squabbling over the question of whether aiding the starving in Ethiopia meant helping a communist country, ended. U.S. food aid to Ethiopia in the year before October 23 was about 115,000 tons valued at around $55 million. In the month following October 23, 142,000 tons was already sent on its way, with many times that amount committed and much more in the works. Prior to October 23, the Reagan administration decided that money for African food aid should be tied to military support to El Salvador and the contras in Nicaragua. Democratic House Speaker Tip O'Neill charged that "this administration has shown that it is ready to starve Africans so that it can kill Latin Americans." As a result of all the attention on Ethiopia (and much lobbying by relief groups), the emergency food aid became attached to a motherhood bill. The famine had turned into hot politics, and, said Lawrence Pezzullo, the director for Catholic Relief Services, "The media were just an incredible force in this."[54]

Even after the Amin/Buerk videotape aired, no one predicted that Ethiopia would become the next year's cause célèbre. One month after the NBC broadcast, CBS's Venardos predicted that the story would become a victim of compassion fatigue. "Television," he said, "has a low threshold of 'I've seen that before.' I don't think there are a lot of new stories." Even relief officials, such as Laura Kullenberg, the Oxfam project director for the Horn of Africa, believed that "the media's and the public's attention spans are very short." Only Michael Buerk, the narrator of the film, was prescient in suggesting that the television producers were underestimating the public's continuing interest. "People are dulled by the frequency with which they see certain things on television, like bomb blasts in London or Beirut," he said. "But if the suffering is beyond that level there is a tripwire and their emotions are engaged."[55]

By December, with Christmas coming, Ethiopia soon became the place to be. "Politicians, Actors Gather in Ethiopia: Drama of Famine Victims Draws Celebrities," read one *Washington Post* headline. American congressmen, church leaders, United Nations officials, and private philanthropists all came "to take part in what the Czech novelist Milan Kundera calls 'the Grand March of History' and to behold this latest spectacle of human misery on a grand and grotesque scale."[56] By the first week in December actors Charlton Heston and Cliff Robertson had come, made charity films and gone. British feminist Germaine Greer as well as Mother Teresa made visits. And Senator Edward Kennedy arrived for Christmas with his son Ted and daughter Kara. His children, especially, were shocked and dazed by what they saw. Said Kennedy's official Ethiopian escort, "There was just a clumsy feeling of helplessness and

grief."[57] In an article Kennedy wrote for *People* magazine, he asked, "Are we grandstanding by coming here?" And then he answered, "I don't think so." He quoted his son. "It's all so preventable, so senseless." A picture of Senator Kennedy with a starving child accompanied the article.

Bob Geldof, the Irish singer, was one celebrity who refused to be photographed holding starving babies. Geldof organized the British all-star assembly called Band Aid which released the fund-raising song "Do They Know It's Christmas" in November 1984. Geldof came to Ethiopia after the song's release, flying in on January 5, the Ethiopian Christmas Eve. As his plane landed in Addis Ababa, Mother Teresa was waiting to leave. The saintly Indian and the Irish rocker had a brief exchange of words. Geldof went on to help organize two other massive benefits: the group of 45 rock stars called USA (United Support of Artists) for Africa which recorded "We Are the World" in March; and the Live Aid concerts that linked the United States and England in 16 hours of music and which were seen in 108 countries in July 1985. The Live Aid Foundation, which administered Live Aid and Band Aid funds, raised $60 million. USA for Africa, raised $34 million in the United States and an estimated $15 million abroad.

For the media covering these events, the celebrity story practically eclipsed the cause. In covering Live Aid, for example, reporters became caught up in the thrill of watching Mick Jagger and Tina Turner cavort on stage. Many compared the concert to Woodstock and drew connections between the new pop altruism and 1960s anti-war activism. Once again, a foreign issue was distorted—in this instance by the media drawing comparisons between the cause of African famine and the cause of American 60s youth culture.

In 1984 the print media still relied on the who-what-where-when style of news. Newspapers were most likely to use the inverted-pyramid, just-the-facts style of reporting, newsmagazines less likely. But newspapers and newsmagazines alike believed that the "facts" were more important than narrative storytelling. In the month after the Amin/Buerk videotape aired, the print media focused on the international response of governments, institutions and individuals to the famine. It was as if the Amin/Buerk piece had said all that could be said about those who were starving, and all that was left was for the print media to write about who was helping and who should shoulder the blame for the disaster. During the first full week of November, for example, *The New York Times* ran two op-eds and one Week-in-Review article on the Ethiopian government's use of starvation as a weapon in the long-term civil war in the North (22 years long in Eritrea and nine years in Tigre).

Many other stories that first month discussed "numbers"—number of the victims, amount of donations, statistics of international relief—rather than gave "stories" of the hungry. The Amin/Buerk tape had pre-empted the drama, and all the print media did was put facts and figures behind the faces. Even in the multitude of articles that detailed the outpouring of public charity for Ethiopia the inclusion of "stories" was rare, and those stories that were included were often not stories of Ethiopians but of Americans who were touched by the hunger and need of the starving.

It wasn't until a month after the NBC broadcast—coincidentally Thanksgiving week—that the print media in general began to realize that the victims—and their stories—belonged at the center of the news. That week—and then again close to Christmas—stories in print began to prominently feature those who were hurting—although such stories rarely began an article. Print periodicals still tended to lead with the "news" and incorporate the human-interest elements several paragraphs down.

It was most typical for the newsmagazines to use vivid stories. *Newsweek's* cover story on the famine, Thanksgiving week, for example, told of a grim reenactment of "Passover." "Doctors were forced to perform a gruesome act of triage," *Newsweek* said, "selecting only the hardiest refugees to receive food and clothing. The physicians would work their way through the teeming crowds, using marking pencils to place crosses on the foreheads of those who stood the best chance of survival. Aid could not be wasted on the weak."[58]

Television, on the other hand, continued to emphasize the photogenic stories of the famine victims. Even the relatively measured reporting of *The Mac-Neil/Lehrer NewsHour* was not above using dramatic footage from the refugee camps to give color to its otherwise standard format of talking heads. CBC correspondent Brian Stewart, for example, reporting for *The NewsHour* from Ethiopia, used a story and footage of a dying child in his piece which aired on November 9.[59]

Eventually, on television and in the more feature-oriented articles in the press, powerful language came to supplement the powerful photographic images. Writers worked hard to find words to describe the human devastation. According to *Newsweek*, for instance, the Ethiopians were "haggard hordes," "dusty columns of lame, gaunt Africans," "hungry," "debilitated," "starving," "dying," "sufferers." *Time's* article that same week wrote of the "parched, scabrous earth" and the "sickly sweet smell of decay," the "emaciated people" "half crazy for food," and the "bodies of children wrapped in burlap parcels tied with string." And a front-page story in *The New York Times* that same week described "the scenes of horror: a mother who thrusts her baby at a visitor so that

he may better view the baby's loose flesh, covered with sores, and the infant's sunken, yellowed eyes. There are the old men, sitting on the ground, their faces vacant, looking as if they are waiting for the dust to claim them. There are the rows of wasted bodies covered with ragged shrouds and innumerable flies, the dawn harvest of another night of hunger in this northeast African nation."[60]

The powerful poetry of these "horror stories," the media said, described "the African nightmare." References to the "horror" and to the living "nightmare" of starvation were almost mandatory in the coverage. The media rarely used the kinds of clever metaphors or analogies that they did to speak about epidemic disease, for example. Those appeared too facile, too gimmicky for stories about dying children. The only metaphors used were those which have become so common that they are almost unidentifiable as such—like "nightmare" or *U.S. News & World Report*'s use of verbs: the camps "choked" with refugees or death "stalking" the weak.[61]

Most international observers believed at the time, and still today, that no credible mortality figures for the 1984 famine could be determined. The Mengistu regime had little interest in providing an accurate accounting, and since so much of the country is so inaccessible—the majority of the population lives a two-day walk from a road built for vehicles—there was no way for outside organizations to determine how many Ethiopians died of hunger or of hunger-related causes out of sight of the feeding camps. Still, experienced foreign relief officials have guessed that the number of deaths must have ranged from about 400,000 to one million.

For Americans, much of the force of the famine story came from the fact that from the moment that the Amin/Buerk videotape aired, it was clear that literally millions were at risk—and that hundreds of thousands had actually died. The pain of extreme hunger had to be multiplied by the hundreds, thousands and millions who were suffering. (In that respect the story differed from news stories about epidemic diseases, which rarely in recent decades—with the exception of AIDS and cholera—have ever killed more than a thousand or so in a single outbreak.) To communicate the numbers of those at risk and dead, many photographic images depicted crowds of the starving—on the road as refugees or in the camps waiting for relief food—or depicted the dead—often multiple corpses laid out in rows but occasionally individual bodies watched over by relatives. *Newsweek*, for example, ran a one-and-a-half page photograph in the opening spread of its November cover story "An African Nightmare," of a seemingly endless ocean of children, clothed in rags and sitting patiently waiting for food at the Korem relief camp. It neatly illustrated the subhead that read "Famine sweeps

the continent, killing hundreds of thousands of people and endangering millions more."[62]

Time magazine ran several pictures of the dead to accompany its Thanksgiving week article entitled "The Land of the Dead." The story, written by Pico Iyer, began with a description of a "zawya," or a "house of the dead." "Although it is not long after dawn," Iyer wrote, "26 bodies have already been wrapped in filthy burlap shrouds on the earthen floor. . . . Inside, in accordance with Muslim custom, Hussein Yussuf is tenderly washing the shriveled body of a three-year-old boy. 'This is the first water this child has had for a long, long time,' says the 60-year-old man." Two photographs of mothers grieving and survivors standing in dawn guard over the dead illustrated the piece. Two weeks earlier *Newsweek* used an image taken by Mohammed Amin, captioned "Body count," of a similar solemn line of men and women watching over two rows of bound and burlapped bodies.[63]

The media, which since Vietnam had shied away from grim or grisly images, had finally been persuaded that it was necessary to include the more horrific images in the coverage. The extraordinary quality of the October Amin/Buerk tape had convinced NBC that it was essential to air, but it took far longer for the print media to cover the story as explicitly. And, in many ways, they never did. While strong individual word-stories and photographs appeared in print, such as the *Newsweek* and *Time* stories mentioned above, they were not used in such quantities or in such a way as to have the impact or effect of the NBC broadcast.

The photographs from Ethiopia pictured iconic scenes familiar to famine watchers: the shipping and unloading of sacks of food aid; the movement of groups of refugees; crowds of the starving either waiting for handouts or having just received food; individual children being fed; doctors, nurses or aid workers tending to the sick and hungry; rows of shrouded corpses; men carrying the dead; and, especially, mothers cradling dying or dead children.

The presence or absence of food or medical assistance in images frequently signaled the tone of an article. Those stories that emphasized the value of the international relief effort showed images of children receiving food or of children eating or of doctors or nurses tending to children. For example, a photograph in *The Christian Science Monitor* illustrating an article about how the Western press prompted the sending of Western aid was captioned "Welcome food for 500 children in Korem, Ethiopia—one of six daily meals organized by Save the Children(UK)." The photograph accompanying a sidebar article in *Newsweek* that listed the addresses of the relief organizations, entitled "What You Can Do," pictured a small child drinking from a large white cup, the large eyes of the child gazing over the rim of the cup straight into the camera. And the

photograph that illustrated a *Time* article on the sending of relief depicted a Red Cross doctor caring for a starving child at a relief camp in Wollo province.[64]

Alternatively, articles that emphasized that Western attention was "Too Little—Too Late," as one headline reported, carried photographs of starving children in their mother's laps, heads turned, eyes closed, near death from lack of food. (Other images that addressed the same concern pictured the "logistical nightmare" of moving the vast ocean of food sacks languishing on the docks to the "starving population."[65]) And articles whose primary intent was to demonstrate the utter tragedy of the famine, the unfairness that it seemed to strike those who were the youngest and most innocent, ran photographs of children so frail and wasted it seemed impossible that they could still be living—but who were clinging tentatively to life through the intercession of a nasal feeding tube. The images juxtaposed the high-tech, clear plastic tubing with dirt floors and rag clothing and the black limbs of infants hardly larger in diameter than their pale nasal tubes. The point of these images was typically not the knee-jerk no-brainer that Western medicine could bring benefits to the starving, but the obscenity that there was a need for such a gross invasion of the helpless. In one photograph a mother is holding her child in her arms, feeding him through a syringe held to the feeding tube. The infant's eyes are closed, his mouth is open, one hand is thrown out, the other lays on his breast. White adhesive tape holds the nasal tube in place. "The face of Ethiopia," the caption read, "skeletal, ravaged, a social disaster of unspeakable proportions. . . ."[66]

Yet despite the strength of such individual photographs and verbal portraits, the October Amin/Buerk videotape—and the other television coverage that followed—had a greater power to rip through the grasp of compassion fatigue than any of the print coverage. As early as the summer of 1983, *Washington Post* correspondent Jay Ross had drawn an extraordinarily graphic word-portrait of distress. His front-page piece, which included three photographs, could hardly have been more prominently placed or written more emotionally. These were the opening words of the more than two-thousand-word article:

> By the time you read this article, Bezuayhe Tesema, a 2-year-old wisp of skin and bones, is certainly dead.
>
> When I saw her at the Zwi Hamusit "shelter" late last month, Bezuayhe weighed less than 9½ pounds and was only 24 inches long. The average healthy American baby usually reaches that weight a month or two after birth and would be three times her weight by age 2.

Suffering from pneumonia, often one of the harbingers of death in childhood malnutrition, Bezuayhe had lost more than 10 ounces since her last weighing two months before. Her tiny ribs protruded against her shriveled skin; her arms were like toothpicks. Flies covered her eyes and almost as much of Bezuayhe's body as her ragged clothes. They also crawled in the cup of milk she was too weak to drink, despite her mother's pleading efforts.[67]

The three photographs which accompanied the article were of Bezuayhe Tesema, of other malnourished children and of the Zwi Hamusit burial ground. The article—and the series of which it was a part—did prompt some congressional investigation, but made barely a ripple among the public.

It took television—and 16 more months of misery—for the story to catch on. David Anable, the international news editor of *The Christian Science Monitor* noted that the force of television was obvious even in just "a few minutes of live film from those camps." "It's very hard to do that in print," he said, "no matter how hard the copy, no matter how many photographs you publish." Jerry Lamprecht, general manager of foreign news at NBC agreed, "This is the kind of story where television shows what it can really do." The broadcast of the Amin/Buerk videotape was taken to be one of those unequivocal moments in television history when a TV story matters, when indifference disintegrates under the moral imperative of television pictures. "The famine has been going on for a long time and nobody cared," said Steve Friedman, the executive producer of *Today*. "Now it's on TV and everybody cares."[68]

Eight years later, in time for the coverage of the famine in Somalia, the print media had learned the lessons of television's coverage of Ethiopia. They learned that compassion fatigue about a subject such as African famine could be overcome by good writing, great pictures and concerted play on the news. "Imagine you are being asked to write a letter home every week to describe a different aspect of life in the area you are assigned," wrote *The New York Times* foreign editor Bernard Gwertzman in a general memo to the *Times* foreign staff. "We want to know what the aspirations of the people are, what kind of lives they lead. . . . Whom would *you* like to read about at length? Above all, we want to hear their voices in your stories."[69] Newspapers learned to personalize international crises. They learned to tell stories—in even the most news-driven articles. They learned to use pictures, lots of pictures—and not just once, but repeatedly. They learned to use photographs not just as illustrations for articles, but as ends in themselves, as photo-essays. They learned to take advantage of the fact that

the still image can still best capture a moment of epiphany. When covering disasters, they learned to let the public see the pain and hear the pain—and then see it and hear it again and again and again. What television had in immediacy, newspapers, and to some extent even magazines, could make up for in repetition. Archetypal stories and photographs that had been rarities in the coverage of the 1984 Ethiopian famine, for example, became typical in the coverage of the 1992 Somali famine.

The print media learned too that through adjustments to *how* they covered the news they could overcome prior-restraint compassion fatigue about one type of story, famine in Africa. But it occurred to very few members of the media that other, even more insidious varieties of compassion fatigue remained: compassion fatigue about stories that didn't have an American military or political angle, that didn't have an American or Western precipitating event. The disparities in coverage of the Sudan and the Somalia stories in 1991 and 1992 would emphasize that oversight.

JUST HOW MUCH OF A DISASTER DOES A DISASTER HAVE TO BE? SUDAN AND SOMALIA, 1991–1993

This is how Jack Kelley of *USA Today* began his September 9, 1992 article on Somalia:

> It was enough to bring tears to the eyes of even seasoned relief workers. A blind, fly-ridden, 3-year-old girl crouched beside her bone-thin mother. Both lay on the desert ground as the child tried desperately to feed the woman. The girl, name unknown, groped for her mother's mouth. The woman, estimated to be in her mid-20s, didn't move. "You can take my food," the girl said, combing her mother's hair with her hand. But it was too late. The mother was dead. And no one had the heart to tell the child.[70]

It took more than a year of famine for starving Somalis to overcome the compassion fatigue hurdle and make the front pages and the evening news programs in the United States. It took more than a year for the story to register on the media's radar. "You're always going to be blindsided by some stories," said John Walcott, former foreign editor of *U.S. News.* "Rwanda is the quintessential example, Somalia before it." The media may have been blindsided by the story,

but only because they had been keeping their eyes closed. The African story was just not identifiably big news until the massive dying began. "It takes the spectacle of open mass graves and children sobbing over their dead mothers to prick American interest in Africa," said *The New York Times*.[71]

But once the plight of the starving had been certified the American media came up to speed. "Not many people knew one sub-clan from the other in Somalia and we had to learn it fairly quickly, so we did," said Walcott. "And I think the reporting on Somalia that we and everyone else did, suggests that it's doable."[72] Once the news of the famine broke in the United States, the media told their stories of horror over and over again—on videotape, in pictures and in words. Correspondents vied to tell the most distressing—and the most moving. The pathos became the news peg upon which the stories were hung.

Of course, it was no coincidence that the exponential surge in coverage occurred when U.S. policy turned to Somalia and Americans began to airlift food to the troubled region. Compassion fatigue was routed by the sensationalism of the story and, more critically, the Americanizing of the crisis. "The American filter, the notion of relevance to the United States, is very important," said Robert Greenberger, correspondent for *The Wall Street Journal*. "It's very parochial. You can look at a place like Sudan, all the elements that are present in Somalia—famines, war, extremists—are over there, and the difference is that CNN hasn't covered the Sudan. There're no Americans there. It's not our problem." Without a connection there's no interest. With no interest, there's no coverage. "Sudan," said a *Boston Globe* correspondent, "is one of those sorts of faceless countries."[73]

Somalia became a point of interest when Americans became engaged there, but it too had been "a sort of drop-in place," in the word of *L.A. Times* former foreign editor Alvin Shuster. "These are the places you'll send a correspondent once in a while," he explained, "but you don't really cover intensely. When the story gets interesting—as in Ethiopia, the BBC film triggered interest—we're on top of it, we're there, we'll send people in. Once that film was seen, then everyone's interest was obviously peaked and we were all on top of it. We didn't necessarily discover it, but we were there. Same with Somalia."[74]

What distinguished Somalia from Sudan? The political alignment of the country and the logistics of coverage meant that American involvement was possible. And once Somalia made the news budget, (because, as Allen Alter, foreign editor of CBS News, said, "it's on the radar screen in Washington"), it was a foregone conclusion that Sudan wouldn't make the cut. "If I said to someone . . . 'Let's go to Sudan,' they would say, 'It's too close to Somalia. It's going to look and sound the same. It's not going to make much of an impression.' In a way,"

said Alter, "you want people to remember what you've done, and they're not going to remember that you've been there or that you've covered it when it's just another one of those stories about starving black people."

The timing of the Sudan story mitigated against its coverage. It never really had a break-out event and the long-running famine was overshadowed by the more accessible one next door. For CBS, for example, the request to go to the Sudan came when Dan Rather was in Tokyo for an economic summit. "Half the staff was on vacation and the other half was in Tokyo," remembered Alter. "And Tokyo was a big venture and quite expensive. The timing was just wrong. We spent a month and a half in Somalia and spent three and a half million dollars covering Somalia. Also, Sudan was just not quite on the front burner as an international issue in Washington. It's like, 'Sudan, who cares?' Well, there's a very good story there, and people will care if you show it to them. And I thought long and hard about it . . . but for me to send somebody to Sudan, it's about five people and five hundred pounds of overweight. We do nothing that costs less than ten thousand dollars when we move somewhere."[75]

So with the exception of a few moments of coverage, Sudan stayed off the front pages and evening news shows and Somalia—after an interminably long lead time—came to dominate them. The same set of factors that caused the Somalia story to triumph over compassion fatigue, caused the Sudan story to be buried. The Somalia story was relatively accessible, Americans were involved, and so it became the one-crisis-at-a-time to receive attention. It pre-empted all other Africa stories. It pre-empted all other famine stories. It pre-empted all of the other pathos stories in the world. It became the cause du jour. And then, after the Marines went in and the famine somewhat coincidentally ended, it, too, got pre-empted, by Bosnia and South Africa and Haiti and Rwanda and so on and so on and so forth.

Although Somalia and Sudan have never been in the first rank of American interests, they have not always been of negligible importance. Throughout the years of the Cold War, the strategic location of the two countries made them into a contested arena for the superpowers.

Sudan, Africa's largest country, has a population estimated at 25 million people, a quarter of whom live in the South. The Northern Arabs, who are Muslim and who control the Khartoum government, discriminate against the Southern Africans, who are either Christian or observe traditional religions. Although most of the country's resources lie in the South, the southern regions have virtually no infrastructure. In the colonial era the South had only a few doctors, a few hospitals and only a handful of government schools. Today, almost 40 years

later, the region still has no running water, no electricity, no telephones, no mail system, little money, virtually no schools or public buildings and only a few miles of paved roads—and not many dirt ones either.

The current fighting erupted in the early 1980s when the Southern Dinka chief John Garang formed the Sudanese People's Liberation Army (SPLA) backed by the Ethiopian dictator Mengistu Haile Mariam—and Mariam's backer, the Soviet Union. The Khartoum government, which had a Cold War alliance with the United States, received hundreds of millions of aid dollars in response and even more in military assistance. The money was enough to keep the military dictatorship afloat for a while, but not enough to end the conflict. In April 1985, five days after General Jaafar al-Nimeiri had visited President Reagan, the army high command deposed him. It called for democratic elections in 1986, which brought to power Saddiq el-Mahdi, whose party had won the most seats in parliament.

For a moment in 1989, after a horrendous famine caused by drought and conflict killed a quarter of a million people, it appeared that peace was possible. But General Omar Hasan al-Bashir, backed by Hassan al-Turabi's National Islamic front, seized the Khartoum government in a coup and reignited the war. The war has been fought unremittingly ever since, although complicated by a split in the rebel SPLA after the collapse of Mengistu's regime in Ethiopia in 1991. The new government in Ethiopia kicked the SPLA out, resulting in an internal SPLA power struggle between the two main Southern tribal groups, the Dinkas and the Nuers. The Nuer chief Reik Machar made a bid to seize control of the SPLA. It failed. Machar then led a breakaway faction to create the South Sudan Independence Movement. War broke out between the two tribal groups, exploited by the Khartoum government. Thousands died in the conflict, several hundred thousand more in the resulting famine.

In the spring of 1991, relief agencies were well aware of the indications of coming famine in Sudan, but Western donors were loathe to act: Sudan garnered little Western sympathy because its military government supported Iraq in the Gulf War crisis. Western donors also believed Sudan's repressive regime would appropriate any food aid for its army leaving little for the country's starving peasants. "Anyone who tells you that politics has nothing to do with humanitarian aid is way off the wall," said a senior Western relief official in Khartoum.[76] As the Sudan situation made clear, politics play a role in disaster triage.

Since then, the war within the South and between the North and the South has continued. Sudan has been at war for 30 of the last 40 years, 13 of the past 17 decades. The best guess is that since 1983 1.5 million Sudanese have died and 85 percent of Southerners have been displaced. It is a seemingly intractable

situation. Since the Western powers, including the United States, suspended their aid programs to Sudan in 1985, Sudan has received little more than emergency food assistance. It became an international pariah as a result of its support for Saddam Hussein during the Gulf War. Not only did it forfeit ties with the United States and Europe, but with Saudi Arabia and Kuwait as well. Egypt, Tunisia and even Libya have turned a cold shoulder to the country. One new patron has emerged, however: Iran. In recent years, Sudan has been accused of providing sanctuary for some of the world's most violent terrorist groups.[77]

Khartoum has kept its wars and its famines in the South under wraps. It bars foreign journalists and Western diplomats from traveling in the region. As a result not much news gets out. As Sudanese Catholic Bishop Paride Taban told Charlayne Hunter-Gault on *The MacNeil/Lehrer NewsHour* in the fall of 1992, "Because no journalists are allowed to travel to these areas, no fact finding . . . how many died, there is nobody to see this evidence. At least in Yugoslavia, in Somalia, you have got the media. You have got the television, but this is not allowed by the Sudan government. . . ."[78]

Somalia, created four years after Sudan from a marriage of former British and Italian colonies, began life in 1960 as a relative democracy. Nine years later Major General Mohammed Siad Barre seized power and made a concerted effort to erode Somalia's operating clan system in favor of "scientific socialism." Barre courted the Soviets. That relationship led to an enormous influx of advanced weaponry and military advisors—and concomitantly, to an undermining of the nation's stability.

Then in 1974, after Emperor Haile Selassie fell in neighboring Ethiopia, Ethiopia's long-standing alliance with the United States self-destructed when the new Marxist government of Mengistu Haile–Mariam took over. A superpower swap resulted. The Soviets rushed in to the vacuum, sending weaponry and advisors to Mengistu, and the Americans, in turn, began shipping defensive weapons to Siad Barre to check the Ethiopians. By the end of Siad Barre's regime a decade and a half later, U.S. military aid to Somalia totaled $200 million and its economic assistance exceeded a half a billion dollars.

During the next decade and a half, domestic discontent in Somalia led to a 1978 coup attempt and the formation in 1981 of the Somali National Movement (SNM) among the Northern Isaaq clan. From its base in Ethiopia, the SNM initially overwhelmed the government's forces. Siad Barre sought retribution. He razed the Isaaq's regional capital of Hargeisa, killing thousands of civilians and pushing hundreds of thousands of refugees into Ethiopia. But other clans, seeing his weakness, took up arms. The United Somali Congress (USC)

formed in the South in 1989. In a final desperate act, Siad Barre turned the army loose on the Hawiye clan sections of Mogadishu, destroying much of the city and provoking widespread rioting.

Shortly before Siad Barre finally fled Mogadishu, on January 3, 1991, U.S. Ambassador James Bishop sent an urgent cable to Washington warning that the lives of embassy personnel were threatened by armed looters surrounding the 40-acre compound. Washington hastily moved up the planned evacuation. After a 460-mile flight that twice required midair refueling, helicopters carrying Marines dispatched from Operation Desert Storm rescued the last ten U.S. diplomats in-country together with 250 foreigners from 30 different countries. According to the *Chicago Tribune* a year and a half later, the evacuation "was every bit as dramatic as the last rescue missions from the U.S. Embassy in Saigon, but Americans didn't hear much about the Mogadishu airlift at the time. The war against Iraq was about to begin and all eyes were on the Persian Gulf."[79]

The *Tribune* nicely summed up what happened next.

> The departure of the international diplomatic corps, forced out by Somalia's bloody civil war, marked with finality the point at which Somalia ceased to matter to the outside world. Over the next 18 months, the situation in Somalia grew increasingly desperate. But there were no diplomats to file reports back to their capitals on the growing food shortages, there were no politicians fretting about which side would prevail in the bloody civil war and there were no "national interests" being threatened by the chaos.[80]

Siad Barre's withdrawal at first split the USC forces in two. Men commanded by General Mohamed Farah Aidid gave chase to Siad Barre, while others, under the control of Ali Mahdi Mohamed, a wealthy businessman and hotel owner, remained in the capital and declared themselves the new government. In the North the Isaaq clans formed an independent Somaliland Republic, a state unrecognized outside the region. By late spring, all the various clan militias had turned on each other. By November 1991, the country was divided into 12 zones of control and the struggle between Aidid and Ali Mahdi had escalated to a full-scale civil war.

The only foreigners who had remained after the embassies' evacuations were a handful of people working for Western relief agencies. And although they repeatedly issued warnings of "an impending humanitarian crisis of unprecedented proportions," both the United Nations and the United States directed

their efforts toward negotiating security deals—to minimal effect. Finally, the International Committee of the Red Cross (ICRC) which had never left the country, finding no alternative, brought in massive amounts of relief themselves. By August 1992, almost one-third of the global budget for the Red Cross was being spent on Somalia. Almost all the food that reached the country arrived through their organization. But it didn't begin to be enough to meet the needs of the starving.

Throughout the disaster-filled spring of 1991 the countries of Somalia and Sudan had appeared sporadically in the news. Occasionally a reporter or commentator would pause in the middle of hand-wringing over the post–Gulf War debacle of the Kurds or the cyclone and earthquake-prompted troubles in Bangladesh and Costa Rica to note the famine conditions in the Horn of Africa.

Beginning in May, wire service briefs and short articles datelined Washington, New York or Geneva quoted officials from international assistance organizations warning, as did the lead of one story, that "almost 21 million people in Sudan, Somalia and Ethiopia—25 percent of those African nations' populations—face possible starvation this year. . . ."[81] These articles were classic "stage one" stories: news briefs that noted the "imminence" of a famine, alerted readers to huge populations at risk, were sourced by relief organizations—and had virtually no public impact.

As the famine "progressed" over the course of the next nine months, through January 1992, a smattering of "stage two" stories appeared in print and on television. These reasonably lengthy "trend" stories, such as CNN's weeklong series "Famine in Africa," featured famine in the Horn as a part of larger pieces on the business of international relief, the arms trade and the endemic civil wars, the region as a safe haven for terrorists and the causes of the general sub-Saharan famine. In hindsight, these stories could be grouped together to form a fairly nuanced portrait of the famine and its context, but at the time it seemed as if there was no sustained reporting on the burgeoning crisis. One measure of the extent of early coverage is that in all of 1991 *The New York Times* and *The Washington Post* published a total of 186 news items mentioning Somalia; in 1992 the total was 1,025, with the majority of those items appearing toward the end of that year. In 1991, the networks noted the famine in the Horn only haphazardly. Former CBS medical correspondent Dr. Bob Arnot had wanted to travel to the region, for example, but, as he said a year later, "it was too early and too dangerous."[82]

When the stories did appear, warnings of impending doom heightened the sense of crisis. Justification for a story's appearance dictated that no matter when the story appeared, catastrophe was only weeks away. Sam Donaldson, anchoring *PrimeTime Live* in May 1991, opened Diane Sawyer's segment with this

introduction: "Tonight, Diane Sawyer in Somalia, where the effects of civil war are destroying efforts to save millions of people who face starvation, where the next few weeks could mean the difference between life and a horrible death." Eight months later, in January 1992, Ted Koppel on *Nightline*, asked Andrew Timpson, the African program officer for Save the Children, U.K., this question: "How much time is there before the food situation becomes so grave in Somalia that we're likely to confront mass starvation?" And Timpson answered, "I think we're talking about two or three weeks before we see an awful tragedy."[83]

Typical of stage-two stories, those pieces that did appear often referenced a past crisis in order to gain credibility for the new, budding disaster. Mention was made of the Ethiopian famine of 1984–85, by concluding that this new crisis in the Horn was "possibly the worst since" then—or by saying, simply, "What, again?" And images of past famines were evoked. "The pictures are eerily familiar," observed the *Los Angeles Times*. "African children are starving, again." "Just about everybody remembers the first time we saw those children in Ethiopia in 1985, the ones with the haunted eyes," said Diane Sawyer on *PrimeTime Live*. "Well, today, at this moment, as many as five times that number stand in danger of famine, not just in Ethiopia but the Sudan and across to Somalia, all victims of drought and war." The media were not subtle about their use of pictures of the starved and the starving. The announcer on *PrimeTime Live* challenged the audience, á la Save the Children, to "Look into these eyes. This child is one of two million people who may die if help does not arrive soon in Somalia."[84]

The stage-two stories introduced other topics, characters and language that were to be reprised once the coverage kicked into stages three and four. Many of the stories introduced a theme that was going to resonate in the media's coverage of the next two years: the chaos and anarchy of Somali society. To this end, many of the pictures in these stage-two stories featured rebel fighters and armaments, what one *Los Angeles Times* photo caption called "the emblem of the Horn of Africa."[85]

Then, in January 1992, the Horn of Africa famine stories dribbled out. The few stories that did appear over the next several months focused either on the "alliance for terror" between Sudan and Iran or on the anarchy of Somalia: "Like the former Soviet Union and Yugoslavia, Somalia has effectively ceased to exist as a unitary state," said *U.S. News & World Report*. A major cause of the dearth of articles about the famine was that many in the media believed they had been deceived the previous year. As one article asked, "Why aren't there 32 million corpses littering the African bush?" "In my 1992 report," admitted one official with the United Nation's World Food Program, "I have to deal with the question of why don't we have all these dead bodies." The media charged the

international aid community with "crying wolf."[86] By the spring of 1992, best estimates were that the 1991 death tolls in even Sudan and Somalia (among the worst affected countries) had been in tens of thousands, rather than the millions. This discrepancy helped stifle new or continuing coverage. Rather than focus on the thousands who did die—and the countless others who were doubtless saved by the relief efforts, many felt they had been misled. As a consequence, the media looked with the greatest skepticism on the new estimates that far greater numbers would die in 1992.

But 1992 proved the truth of the crying-wolf fable, for the wolf did finally come. The wars and drought continued, and those who had indeed survived 1991 had done so by the slimmest of margins, partly on the relief, partly on stores of seed grains, partly on the collection of weeds and leaves, and partly on simple starvation. By the spring of 1992 there was no margin left.

In late April 1992, through May and June, it looked like there might be a break-out famine story—the kind of story that might cut though the compassion fatigue and be the precipitating event for stage-three, all-out coverage of famine in the Horn. The event was, as *Newsweek* termed it, the "Trek of the Orphans." It was irresistible. More than 10,000 boys, "some as young as three, none older than 17" had walked from the border of Ethiopia to the border of Kenya—to escape the fighting in Sudan.

Over the late spring and summer of 1992, all the major media outlets covered the boys' search for safety, which, as Jane Perlez in *The New York Times* wrote, was "a four-year, 1,000-mile odyssey of starvation and endurance across three countries." The story was not only a dramatic tale about the survival of thousands of children, with minimal assistance from adults and international relief agencies, but served as a dramatic preface to the famine and civil wars plaguing the region. Many articles used the boys' stories to discuss the regional drought and famine or to investigate the conflict between the Islamic fundamentalist government in Sudan's Northern capital of Khartoum and the rebel Sudan People's Liberation Army in the south. Perlez's front-page article in the *Times*, for example, used the story of the boys to discuss, first, the starvation "reminiscent of the worst cases of the Ethiopia famine nearly a decade ago" and, second, the "longstanding internal conflicts in Somalia, Ethiopia and the Sudan."[87] But, finally, without direct American involvement in the situation the lost boys could not sustain the media's interest and no other single riveting event occurred to carry on the coverage. The Sudan story sputtered out, not to reappear again in the press until a brief spurt of interest a year later, in the spring of 1993.

News of the entire Horn of Africa might have disappeared then too in favor of the more compelling international story of the discovery of "death camps" in Bosnia, if it hadn't been for a confluence of events in the summer of 1992. In June, Smith Hempstone, U.S. ambassador to Kenya, traveled to refugee camps along the Somali border with Kenya, and filed what subsequently came to be known as the "A Day in Hell" cable. Officials at the State Department, the National Security Council and ultimately President Bush read the powerfully written account of the conditions in the camps.

Then a month later, came the turning point in U.S. policy. Senator Nancy Kassebaum, the ranking Republican on the Senate Africa subcommittee, took a tour of the camps along the borders. She returned to testify before Congress and to speak to the media. Immediately, said former Secretary of State Lawrence Eagleburger, "Though there wasn't broad support for humanitarian efforts in Somalia, there was intense pressure from a few key members" of Congress— "particularly my good friend, Senator Nancy Kassebaum." Kassebaum announced on *The MacNeil/Lehrer NewsHour* that she felt "strongly" that the U.S. needed "to help the people of Somalia." That same week, U.N. Secretary-General Boutros Boutros-Ghali delivered a public rebuke of the Security Council for its inaction in Somalia. Boutros-Ghali charged that the Security Council was devoting too many resources to what he termed "the rich man's war" in the remnants of Yugoslavia (where more than 15,000 U.N. peacekeepers were deployed) and ignoring less visible conflicts in Africa, such as the war in Somalia.[88]

Americans—among others—reacted immediately to the implicit charges of racism and almost criminal compassion fatigue. As *New York Times* columnist Anna Quindlen noted:

> The new Secretary General of the United Nations, Boutros Boutros-Ghali, an Egyptian who is the first leader of the UN from the continent of Africa, has referred to the Bosnian conflict as the "rich man's war." He means it is a white man's war, a Eurowar, in its combatants, its victims and its international interest. That makes aid no less necessary. Just as the color of its children must make no difference in our help for Somalia. Surely our attention span can encompass two mortal crises at once. Surely our empathy can transcend race.[89]

Despite a statement from U.S. AID officials that the United States had supplied more than $63 million in relief aid to Somalia—more than it had sent to

all the republics of the former Yugoslavia—and, in addition, had funded airlifts of food to the starving Somalis, pressure grew for the United States and the United Nations to take more decisive action—and for the media, too, to turn its attention to Africa.[90] *USA Today* columnist Barbara Reynolds noted that the media had been taking their cues for coverage from the issues raised in the presidential conventions that summer. "In this race between two white politicians covered mostly by white, middle-class reporters," she wrote, "issues not centered on white suburban, middle-class values often don't fit. Thus, much of the media is not sending reporters to Somalia or making it the BIG STORY on the evening news. How many Somalis have you seen quoted in news stories, in contrast to Yugoslavians, whose suffering is made vivid in print and on TV?"

On August 14, the beleaguered President George Bush ordered an emergency U.S. military airlift of food to Somalia. And, after initially rejecting a U.N. Security Council plan to send a force of 500 armed U.N. troops back in July, President Bush also authorized a U.S. military airlift of the Pakistani guard force.

The first of the 500 armed U.N. "peacekeepers" arrived in Mogadishu on September 14. Three days after they arrived, U.S. AID official Andrew Natsios, the man chosen to coordinate the airlift operations, held a briefing for the press. He said, "I want to emphasize that the United States' position in all this is to stay out of the clan warfare. . . . We have no political interests, no economic interests, and no military interests in Somalia. Our only interest is a humanitarian one."[91]

The conjunction of all these events, beginning in late July, turned Somalia into a major story. Media interest grew exponentially. By Bush's announcement of the airlift in mid-August Somalia was a certified stage-three story. Statistics and huge numbers representing those at risk of starvation began flying fast and furiously. The dead bodies were piling up. Once again, by the time a starving population had caught the attention of the media, they were "dying like flies," in the words of Patrick Vial, the general coordinator for Médecins Sans Frontières in Mogadishu. Every media outlet included the grim numbers. *Nightline* noted that by the beginning of September more than 100,000 Somalis had died. *The Washington Post* quoted the estimate by U.S. AID that "as many as one in every four Somali children under the age of five has already perished." *The Los Angeles Times* ran an editorial commending the airlift entitled "Every Minute a Child Dies."[92]

Compassion fatigue had turned into anxiety. Natsios had held five news conferences on Somalia in the last year. The first three drew two reporters each, the last two drew 50. "I hate to say it, but I think the difference was the American

airlift." The media followed the flag; "the standard rule—the closer to home, the bigger the story—prevails," wrote *New York Times* TV critic Walter Goodman. "As if the people of Somalia did not know enough misfortune," Goodman continued, "they have had to compete for attention not only with Hurricane Andrew but also with a brutal war in Europe. Two dead children in Bosnia made a bigger story on one television evening than scores of thousands of dead and dying in the eastern Horn of Africa did for weeks; in Bosnia, a camera was on the scene." In Somalia, said Paula Zahn apologetically on *CBS This Morning*, "the cameras were late in arriving." I only hope, said CBS medical correspondent Dr. Bob Arnot after his live broadcasts from Somalia in mid-August, that they "aren't too late."[93]

Editorials and columns around the country called for a "long-term commitment to supply Somalia." Somalia, said a *Boston Globe* editorial, "deserves vigorous attention in the name of a common humanity." And most famously Anna Quindlen compared the prospect of U.S. involvement in Somalia to the recent Gulf War. "Just a year ago some of us, unpersuaded by the high moral principles involved in giving our all for cheap oil," she said, "were saying that America could no longer afford to police the world. With the President's Gulf War bluster about liberation, we lost sight of the best reason to involve ourselves in foreign affairs—because it is sometimes obviously the moral thing to do."[94] Suddenly Somalia had everything: starving babies, the imprimatur of the "worst" disaster of the moment and an American military presence—on a "moral" and humanitarian, not aggressive mission.

The evening of Friday, August 14, ABC News anchor Peter Jennings delivered the breaking news of the U.S. military airlift. At the end of the broadcast he announced the program's "Person of the Week"—which was not an individual, but an organization: the International Committee of the Red Cross. "There is no more chilling example of human suffering than in Somalia," said Jennings. "Seventy percent of the entire population is severely malnourished. As many as 5,000 people are dying every day as the result of famine." Somalia, so the segment said, is "a kind of pure hell" where "warlords and armed gangs are in charge over all." It is "a nation on the verge of national suicide." And the ICRC is there, said Jennings, "to ease the suffering." In one story, on the very night of the announcement of definitive American involvement, ABC swung into stage-three coverage, anticipating the worst-case scenario, predicting the cosmic consequences and labeling the victims, heroes and villains.[95]

The other two networks quickly joined the story. "We're going to cover it more now," said Steve Friedman, executive producer of NBC *Nightly News*. "People are now getting into Somalia with the relief agencies, so it isn't as dangerous to go

there." When it became clear that the famine was generating "more phone calls than in recent memory," the story graduated even to the morning "news" programs. CBS News correspondent Dr. Bob Arnot did the first live network reports from Somalia, which aired on *CBS This Morning* the week of August 24. "It's the only time I've ever cried on TV," he said, after seeing a boy who had been left for dead at a hospital. "You see death all around you. They have a body wagon that comes around that will take 100 to 200 bodies every morning. You go to the hospital and there are dead babies who've been left for them to take care of and it's simply too late."[96]

By mid-August all the kids were doing it. Television and the print media were on the spot sending wrenching stories back to the United States. Stories on and photographs of the famine's victims, heroes and villains became ubiquitous. The tales of woe—especially of child victims—led the coverage on air and in print. ABC's reporter Jim Laurie began a report from Somalia with this mother and child: "Norey Maden and her seven-year-old daughter, Noor, have walked four days in search of food. Offered a biscuit, Noor barely has the strength to chew. . . . It is always the very young who suffer most in famines like this." And the *Chicago Tribune* ran this AP piece about children and mothers: "Every day at dawn, the starving children, many weak with hacking coughs, line up and wait patiently to be fed. On this day, there would not be enough of the Red Cross–provided rice and beans to go around. . . . Only half the children had been fed. The unfed ones scrambled in the dust on hands and knees, wailing and fighting for single grains of rice. They shoved them in their mouths, getting mostly dirt. . . . Amid all the jostling, Ambia Mohamed Barken, 25, cradled a child under each arm. They were twins, born a day earlier."[97]

The victims garnered the most attention, but images and stories also focused on what a *Los Angeles Times* editorial called the "heroic and overburdened relief workers who have risked their lives for months." Photographs and videotape showed the doctors and nurses at work, and framed the pictures with captions and language that emphasized either the immense need for their efforts or the benevolence of their work. *Nightline* interviewed an American surgeon with a medical team in Baidoa. "We have no gowns, no drapes," said the doctor. "We do have gloves. We just simply put on a rubber apron, like going to the butcher shop, and do our thing." These are the people, said Ted Koppel, "Americans who, amid the death and despair, are struggling to do what the rest of the world hasn't been able to do thus far: make a difference."[98]

It was the Americans and the other foreign aid workers who were the "heroes"—not the Somali people who were struggling to survive. Story after story emphasized who was who. "They are heroes," said one commentator on CNN

News in early September. "ICRC, The Red Cross, The Children's Fund, Save the Children. Folks have been there making sacrificial donations of human flesh and blood."[99] In most of these stories there was no explicit acknowledgment that it was the Somalis who were making the greatest flesh-and-blood sacrifice.

Other stories used the relief workers as a way in to talk about the random violence, the "harsh primitive social Darwinism" in the country. Michael Hiltzik in the *L.A. Times* quoted one relief official as saying that Mogadishu was "the most dangerous port on Earth, and for my agency it's the most difficult place of the 40 or 50 in the world where we operate."[100] And Koppel introduced a September *Nightline* with these words: "Imagine a nation steeped in chaos, no government, no police, and civil war among clans and subclans almost too numerous to count. To this already frightening scenario, add millions of starving people, many of them armed with guns, and you have Somalia today."[101]

Those with the guns were the villains of the piece. "The thugs who hire themselves out as security guards ostensibly to help these [relief] workers instead often divert the food to their families or the warehouses of businessmen seeking to make a killing on the black market in neighboring Ethiopia and Kenya," said an *L.A. Times* editorial. And Andrew Natsios talked to Jim Lehrer about the "young gangs of thugs, young kids — they're teenagers." "They're high on a drug called khat [an herbal amphetamine]," he said, "which they all chew all afternoon. By the end of the afternoon, they all think they're Rambo. They have AK-47s around their necks and they run around shooting everybody."[102]

By mid-September the parameters of the Somalia story had solidified: starving mothers and children as victims, humanitarian assistants as heroes, and "thugs," "hooligans" and "Rambos" as villains.

Then the story ratcheted up. On September 15, one day after the arrival of the first U.N. armed troops, the Pentagon announced that a U.S. amphibious-ready group carrying about 2,400 Marines was heading for Somalia to support the U.N. airlift. That same week, the three newsweeklies on the stand all featured photo-heavy stories on the famine. From that mid-September Pentagon announcement until late November a steadily increasing number of stories followed the famine and the relief effort.[103] The general tone of the coverage changed little from the previous month and a half, but the stories, especially in the feature-friendly newsweeklies, tended to be longer, contained more graphic verbal and visual images and more consistently labeled the players with value-laden language.

In the midst of large, gripping photographs that readers called "indescribable," bringing "tears not only to my eyes but also to my heart," *Time* magazine

reporter Andrew Purvis told a series of heartrending stories: of a small girl whose steaming ration of gruel is knocked from her "wizened hands" scalding her, "but far worse" destroying "the day's only meal"; and of a 5-year-old boy who dies—after his parents and eight other brothers and sisters—watched over by his last sibling, an elder brother "who now rocks quietly weeping by his side." Or *USA Today* which began one article with this story: "Don't pick her up or bother feeding this one, a Somali refugee told me, she's too far gone. At her feet lay a bone-thin 10-year-old girl dying of starvation and disease. Maggots had already entered her left eye, and flies were feasting on an open wound." And ended the article with another story: "Like a 12-year-old boy whom relief workers called Ali. He wanted to bury his mother—his last remaining family member—but was too weak to do so and died of starvation on top of her. Their intertwined skeletons are still awaiting burial outside Baidoa."[104]

The victims were painted in extremes. Word-pictures described desperation: a dying child "snatched" to her mother's "bony chest," mothers "tearing" bowls of food from starving children to feed their own. And more often than before, the stories depicted the victims of the famine as bereft of family, alone in their struggle for survival. With the exception of photographs of children waiting in line for food or of bodies lined up to be buried, the images depicted solitary people—not necessarily by themselves, but through careful cropping, seen to be alone. As a result, the impression was created of a man-and-godforsaken people; as one letter writer to *Time* said, "To see photographs of African children emaciated and slowly dying of starvation makes one think that the Almighty has turned his back on them."[105]

As Americans learned more about the horrors in Somalia, the prominence of the aid workers—Western doctors, nurses and other volunteers—in the media's stories diminished. Although the few stories that did focus on their efforts portrayed them in as heroic terms as before, recognition of the degeneration of Somali society left less room for heroes and more room for villains, "the wackos with guns out there," as *The New York Times* put it, who are responsible "for Somalia's astounding levels of violence." "Somalia seems doomed," said *USA Today*, "misery is wed to mayhem." Who's to blame? The "bandits armed with weapons left over from Somalia's days as a Cold War pawn." Or the rival clansmen with loaded AK-47s or U.S.-made M-16s who "brag about how many women they've sexually assaulted in recent months in exchange for food."[106]

The media also discovered new bad guys: the U.N. bureaucracy where "posturing has sometimes replaced real work." Many in the media had complimented the work of the U.N. special representative to Somalia, Algerian diplomat Mohammed Sahnoun. According to *Newsweek*, "he got a feel for Somalia

by meeting with clan members and elders and by venturing into villages shunned by U.N. agencies. He targeted new areas in desperate need of assistance, won approval from local clan lords for 500 U.N. troops to protect Mogadishu's port and airport and held high-level meetings between the principal warring factions." But Sahnoun was also "appalled" by the United Nations' torpor, which he said "had cost lives." For his outspokenness he lost his posting—and the United Nations lost much of its credibility. Both *Newsweek* and *U.S. News*, for example, ran as subheads in their articles the phrase: "The United Nations' failure."[107]

The occasional story also noted the arrival and involvement of the famous. "The latest media celebrity to arrive," reported *The Washington Post*, "was former Australian Prime Minister Bob Hawke, in his new capacity as an occasional correspondent for Australian '60 Minutes.'" These "princes" and "princesses," like the Somali supermodel Iman and former movie star Audrey Hepburn rarely had much of substance to contribute—other than their own celebrity, of course.[108] Iman, "who is married to David Bowie," *Newsweek* said, narrated a BBC documentary on the crisis and "joined members of Congress in urging the United Nations to intervene more forcefully in the famine and civil war. . . ." Hepburn, CNN reported, who traveled to Somalia as the Goodwill Ambassador for the United Nations Children's Fund (UNICEF), came to London to tell the media that "much, much more" aid is needed.[109]

The media had made Somalia into a cover story, but it had not yet become an American crusade. It remained a stage-three—not stage-four—event. And according to some, even that amount of attention was on occasion too much. *Time*'s managing editor Henry Muller, the man responsible for deciding what made the cover of the magazine, was widely criticized for "failing to put Hurricane Andrew on its cover, featuring a piece on starvation in Somalia instead." The "blunder" helped to kick him upstairs to the No. 2 corporate post of editorial director. Muller, who had been at *Time* for 22 years, said he found the move "emotionally very difficult. It was certainly not my idea." Jim Gaines, the publisher and managing editor of *Life* and a former editor of *People*, moved into *Time*'s managing editorship. It would be "a terrible mistake," Gaines said, to assume he planned some sort of "*People*-ization" of *Time*.[110]

The public was concerned about the dead and dying, but not absorbed to the distraction of all else. One indication of Somalia's status was the fact that the public's pocketbook remained closed. InterAction, an umbrella group of international aid agencies, reported at the end of September that "money given for

relief in Somalia in the last six months amounts to only 3 percent of the $110 million raised for Ethiopia during the first six month of that crisis." "I'm becoming increasingly convinced that it's futile to try to recapture the mood of the country in October of 1984 when responding to the famine in Ethiopia became chic," said Joel Charney, the executive director of Oxfam America. Bosnia—and the demand at home in the wake of Hurricane Andrew—were siphoning off money and attention. "Our fundraising is up some, but not where we need it to be," said CARE spokesman John Mohrbacher, "We assume it's the psychological interference of all these other disasters."[111]

Then, the day before Thanksgiving, the Bush administration decided to send "at least 15,000 and perhaps as many as 30,000" American troops to Somalia as part of the U.N. forces there. The decision became public Thanksgiving day when President-elect Bill Clinton was notified and expressed his approval for the plan. Finally, with the massive commitment of American soldiers, the crusade began.

Money and attention began flowing. "Moved by images of suffering in Somalia and confident that donations can make a difference now that United States troops are in the country," said *The New York Times* a month later, "Americans are contributing generously to a blizzard of fund-raising appeals, relief officials say." Among those giving after the troops arrived was an economics professor at Columbia University who wrote a $10,000 check to CARE. "I don't spend all my salary and Somalia is the part of the world where people are in the worst conditions now," the professor said. "So that's why I did it."[112]

The announcement of the decision to send troops and then, in short order, the U.S. troops arrival in Mogadishu on December 8, turned Somalia from a big story into THE story.[113] The clearest signal of the media's certification of Somalia's transfiguration into a stage-four story was the "emplacement" of the "network news big guns." CBS's Dan Rather, NBC's Tom Brokaw and ABC's Ted Koppel (Peter Jennings chose to stay in New York) all traveled to Somalia, joined by a formidable lineup of producers and other correspondents, such as CBS's Bob Simon and CNN's Christiane Amanpour, who left Bosnia to cover the Somalia story. It was the first time the networks had sent so many star newscasters to a foreign country since January 1991 when all three network anchors covered the Persian Gulf War.

These high-profile anchors and reporters have become, said *New York Times* TV critic Walter Goodman, our "certifiers of disaster." "Without even meaning to," said *Rolling Stone*'s media critic and former TV news producer Jon Katz, "they give . . . an added element of drama, endorsement and heroism."[114] The

newscasters were garbed for theater. As Jonathan Yardley in *The Washington Post* noted:

> Brokaw appeared on NBC in a khaki shirt artfully opened nearly to the waist, revealing what gave every evidence of being a designer T-shirt; his hair was perhaps windblown, perhaps stylist-blown. Dan Rather too had opened his shirt—or maybe it was a jacket—in his case to reveal a blue polo shirt, which by late in the week had itself opened to reveal an admirable expanse of hirsute chest; this was entirely appropriate, for Rather chose the moment to describe for us what he chose to call, with characteristic felicity of phrase, his "descent into Hell." All of which made for an absolutely smashing show, which in the minds of those chiefly responsible for producing it was exactly the desired result.[115]

Arrival of the Marines in Mogadishu bumped evening news ratings to their highest level since the Persian Gulf conflict in February 1991. In the first week of coverage, ABC led with a rating of 12.2 and an audience share of 22, CBS was second at 10.9 and 19, and NBC drew 10 and 18. CNN, by contrast, did poorly. Two years previously, on the first night of the Gulf War, January 16, 1991, it had pulled in a rating of 19.1 and a share of 25. On the first night of the Somalia operation, CNN had a 3.2 rating and a share of 5—still, the Somali figures were 90 percent better than CNN's usual prime-time average. (A single national A.C. Nielsen network rating point in 1992 represented 931,000 households. One CNN cable point equaled 611,000 homes. A share is the percentage of sets tuned in.)

Already by the first week, network costs hovered at the $2 million mark—an amount that ensured that the intense coverage would continue, if only so that the networks could recoup their investment. The costs were so high because the networks had each brought in so many people and because they had to bring everything with them—starting with power generators and suitcase-size "fly-away" dish antennas for live feeds. "We are bringing a ton of equipment," said CNN vice president Eason Jordan. "You might as well be traveling to the moon." "We had to be our own supply sergeant," agreed NBC News foreign news director David Miller. And *Nightline* executive producer Tom Bettag said, "This is bring your own tent, bring your own water and bring your own Spam."[116]

Still the Persian Gulf War had taught the networks to husband their resources, to keep "protective money right up to the end of the year," as CBS

News president Eric Ober said. That tactic together with the fact that in a presidential election year news coverage had focused on the United States meant that the networks could afford the grand logistics of Operation Restore Hope. "The domestic political scene took so much air time that foreign stories seemed less important," said NBC's Miller. "I have people overseas whose energies were being deflated by the political stuff because they couldn't get on the air. They were looking for work; now they've got more work than they can handle."[117]

The media was in position for the landing of the American forces. As the lead in the page-one next-day story in *The Washington Post* read, "The Marine Corps has passed a new milestone in military history: the first amphibious landing televised live." The first pictures home, taken through the lens of an infrared camera, were broadcast by CNN about 12:40 A.M. Somali time, Wednesday, December 9 (4:40 P.M. December 8, Eastern time). *The New York Times* described the midnight arrival: "The troops landing in Somalia yesterday jumped from their rubber boats and headed into the dunes—and into the glare of television lights. More than 75 reporters and camera crews were waiting on the beach with microphones on and videotape rolling. [*The Post* claimed there were "roughly 300 reporters and camera operators."] The pictures they beamed to American viewers had the smoothly produced look of a made-for-television drama, with everything from distant shots of soldiers clambering ashore to close-ups of their camouflage uniforms as the troops made their way through the sand, and through the horde of journalists." Even Dan Rather admitted that it was "a sort of Hollywood-ish, almost cartoonish situation on the beach."[118]

But as he and most of the other journalists said in their own defense of the media circus: The press had been invited by the Pentagon, who had told them "exactly when and where the landing would take place and even offered advice on camera positions." "The brass," said *Newsweek* columnist Jon Alter, "wanted this mission of mercy well covered." "It's clear that since Vietnam," said media critic Jon Katz, the Pentagon has "learned the lesson of television—how to use television in a way that's helpful to them. The bottom line is, the heart of every 10-year-old in the country has to beat a little faster when they see the SEALs storming ashore."[119]

After the fact there was a great condemnation of the "farcical scene" at the landing, where the Navy SEALs were "outnumbered 10 to 1 by reporters," according to Peter Jennings on ABC. Pentagon officials publicly expressed anger at the extent of the media's intrusiveness, in particular the use of the television lights that they said could temporarily blind helicopter pilots and reconnaissance troops using night-vision goggles. In response, most journalists claimed that the "mondo beach party" was only "a small, unseemly blot" on their record, reminding their

audiences, as Jane Pauley did during a special edition of *Dateline NBC*, that it was media coverage of the famine that helped bring about the operation in the first place.[120]

"This is the media's season for Somalia," said commentator Howard Rosenberg, in the *L.A. Times*, two days after the Marines' landing. "Newscasts had been featuring them for months—living cadavers, hollow-eyed and expressionless while waiting to die. But more recently, television viewers have been seeing the new faces of Somalia. Dan Rather, Tom Brokaw and Ted Koppel."[121] With the arrival of the 28,000 American troops the images changed; famine victims became the backdrop for reporters' stand-ups and for the troops' heroism. As Yardley in the *Post* put it, "As for the honchos of the networks, Somalia provides a perfect opportunity to dress up in khaki and do live stand-up feeds as, in the background, African masses gaze at them in speechless awe."

The skeletal figures didn't disappear—yet. They just receded into the distance and became the context for the American troop commitment. The children of Somalia remained the victims, the Somali gunmen—who Tom Brokaw repeatedly called "yahoos"—remained the villains, and the new heroes were the U.S. troops "on a Christmastime mission" to do what lame-duck President Bush called "God's work."[122] The media featured stories of the "Mission of Mercy" or the "Taking on the Thugs," as the headlines of the cover stories in *Newsweek* and *Time* read that first week after the landing.

Mention of the "humanitarian" nature of the U.S. involvement was de rigueur. "The people of Somalia, especially the children of Somalia, need our help," said President Bush in his address to the country on December 4. "Only the United States has the global reach to place a large security force on the ground in such a distant place quickly and efficiently and, thus, save thousands of innocents from death." "Bush," said Charles Paul Freund in *The Washington Post*, "cast the United States as if it were the Red Cross with a Pentagon."[123]

There was, however, a certain awkwardness about the timing and placement of U.S. troops. Against the backdrop of American self-congratulation, Richard Dowden, a British correspondent and editor, asked a series of hard questions about the choices made by the Bush administration.

> Why was the decision taken to go in three months after the peak of the famine? August 1992 was the worst month for deaths but the decision to move was not taken till late November. Why did the troops land in Mogadishu at all? The famine was a local one, restricted to a particular agricultural area west of the capital around

the provincial towns of Badera and Baidoa. There was hunger in the capital but the International Committee of the Red Cross (ICRC) had it under control. The famine area could have been secured as a safety zone and supplied from Kenya. Why was it necessary to try and take over the whole country?[124]

Still, most of the media bought into—or inspired—the "moral imperative" of sending the troops. Yet even before the Marines arrived the focus of much of the coverage had become, in *Newsweek*'s words, "When will it be time to leave—and how hard will it be to get out?" "With the cold war over," *Newsweek* said in its cover story, "missions of mercy provide a worthwhile use for America's military muscle. But the rules for compassionate intervention have not been spelled out with enough clarity. . . . Should the world intervene only in nations like Somalia, where peacemaking is relatively easy? Or is there also a moral obligation to use force in horror-struck countries like Bosnia, where intervention would be bloodier and success far less certain?" "Why Somalia and not Bosnia?" asked columnist Charles Krauthammer. "One wit put it this way: We don't do mountains. The first principle of humanitarian intervention is: It must be doable." The media and the American public believed that Somalia (as opposed to Bosnia, for example) was doable. Not as doable as Bush, who wistfully suggested that the job might be done by January 20, the day his presidency ended. But doable nonetheless. Eighty-one percent of Americans surveyed in *New York Times*/CBS News Poll immediately after the landing believed that the "U.S. is doing the right thing in sending troops to Somalia" and 70 percent believed that "sending troops to Somalia is worth the possible loss of American lives, financial costs and other risks"—even though two-thirds of them expected that the U.S. troops would remain in Somalia for three months up to a year.[125]

The stage-four coverage of Somalia lasted for about a month. Although it verified, as *The Washington Post* headline had it, "The Apocalypse Now Is Famine," the heart of the coverage was not the Somali victims, but the American heroes. Even those people "who were politically opposed to military intervention in other countries could understand and approve sending troops to provide the basic sustenance of life," said *The Post*. "But many were torn by the possibility of danger, death and a prolonged stay for the troops."[126] And quickly that fear came to overwhelm the coverage of Somalia; stories and finally pictures of the starving gave way to images of the guns.

It wasn't only American self-interest that prompted the shift; by early in 1993 the famine was essentially over. Many of those saved owed their lives to the distribution of relief. But January also brought rains. The drought ended. And

Aidid, who had greeted the first Marines with handshakes and had attended two peace conferences arranged by the United States, decided to disrupt the mission. In June his forces killed 24 U.N. troops. And the Americans who had come to the country with "visions of charity," as *Time* magazine put it, turned their attention to capturing Aidid whom they credited with being the major obstacle to peace in the country.[127] In August 1993 all the feeding programs stopped. And the combat mission became seen as the new, integral component of America's humanitarian goals.

What started as a "noble, workable and just" cause, in the words of columnist Clarence Page, effectively ended that fall.[128] On September 25, 1993, a single shot by an Aidid militiaman brought down a U.S. helicopter. Eight days later, on October 3, two more helicopters were shot down and 18 Army Rangers were killed in a day-and-night-long assault on Aidid's military command. As Hector was dragged by Achilles around Troy, the near-naked corpse of an American was dragged through Mogadishu by Somali youths—and so too the Americans' image of invulnerability and "noblesse oblige." That jeering mob jump-started the public's anxiety—and brought the press coverage back in force.

The Somalis responsible for that act, said Republican Senator Phil Gramm in a widely quoted remark, "don't look hungry to the people of Texas," drawing no distinction between the gunmen and their millions of victims. Voicing the same sentiment, although with a different spin, President Bill Clinton said, "I'm just not going to have those kids killed for nothing"—and by "kids" he meant American soldiers, not Somali children. From October until the last U.S. troops went home six months later, the American media was reinvigorated. (The last U.N. troops went home in March 1995, abandoning Somalia to its chaos, "little different," said *New York Times* reporter Donatella Lorch, "from that of a few years ago."[129] In the parlance of international diplomacy, Somali today remains a "failed state.")

For Americans, "the catalysts of wrath," said *USA Today*, "are haunting images of death on TV broadcasts and front pages." According to a Gallup poll, Americans who saw the photos of the body of the dead U.S. soldier being dragged through the streets were more interested than those who did not in the immediate withdrawal of American troops and in the sending of more weapons (and, oddly enough, more troops) to the region. They also expressed less interest in using U.S. troops in future humanitarian efforts. As *USA Today* said in its accompanying article, "The compassion that resulted in wide support for the original mercy mission has evaporated." According to an ABC News poll, four out of five of those backing a U.S. withdrawal favored it even if that resulted in another famine.[130]

For the six months until the U.S. withdrawal, the chief story was the military "fiasco": "In a miserable tale of missed signals, a mission to feed the starving turned into an urban guerrilla war. . . ." The famine story had become the 1990s Vietnam story: "Mogadishu is still a long way from the Mekong Delta," wrote David Hackworth in *Newsweek* the week after the helicopter downings, "but let's not take even one more step in that direction."[131]

And so was born the "Somali doctrine," the inheritor to the "Vietnam syndrome" that argued that the United States should not get involved in faraway crises when its own security is not in danger.

The famine story was well and truly over—and effectively had been since the American troops had arrived to save the starving. In the year and four months of the American ground engagement in the country, there was only one brief moment when famine in Africa once more seized the top spot in the news. But it wasn't the famine in Somalia, it was the one in Sudan. And it grabbed the public's attention not because the public (or the media, either) were longing for a new famine story to replace the passé Somali one, but because of a single image so compelling that it won the Pulitzer Prize for feature photography that year. (The other photograph to win the Pulitzer that year was *Toronto Star* reporter Paul Watson's image of the body of the American soldier being dragged through the streets of Mogadishu.)

In March 1993, Kevin Carter, a member of "The Bang-Bang Club," one of a group of white South African photojournalists known for their images of apartheid and black factional violence, decided to go to Sudan to photograph the war there. Soon after his plane touched down in the village of Ayod, he began shooting photos of the famine victims. People were dying at the rate of 20 an hour. Seeking relief from the masses of people starving to death, he wandered into the open bush where he saw a small, emaciated girl collapsed from hunger en route to the feeding center. Carter first heard the girl making a soft, high-pitched whimpering and crouched to photograph her. Then a vulture landed a short distance away. Carter waited 20 minutes, careful not to disturb the bird, hoping it would spread its wings and make a better image. It did not, and after Carter snapped several photographs, he chased the bird away and watched as the little girl resumed her struggle. Afterward he said, he sat by a tree, talked to God, cried, and thought about his own daughter, Megan.

After another day in Sudan, Carter returned to Johannesburg. Coincidentally, *The New York Times*, which was looking for pictures of Sudan to run with a story by Donatella Lorch, bought one of his photographs of the little girl and ran it on Friday, March 26, 1993. As *Time* magazine wrote, "The picture immediately

became an icon of Africa's anguish." Newspapers around the world reproduced the image of the starving little girl and the patient black and hooded vulture. Hundreds of people wrote and called *The Times* asking what had happened to the child. In an editors' note four days after the photo first appeared, *The Times* said, "The photographer reports that she recovered enough to resume her trek after the vulture was chased away. It is not known whether she reached the center."[132] Carter was praised for capturing the horror of famine and criticized for his heartlessness in not aiding the child. Americans called him in the middle of the night asking why hadn't he rescued the girl. Carter found it difficult to explain that at the time she was just one of hundreds of starving children in Ayod.

The next April, the Pulitzer Prizes were announced. *The New York Times* flew Carter to New York to receive his award. Two months later, worn down by job and personal pressures, he committed suicide. He told a friend, "I'm really, really sorry I didn't pick the child up." His suicide note said: "I am haunted by the vivid memories of killings & corpses & anger & pain . . . of starving or wounded children, of trigger-happy madmen, often police, of killer executioners. . . ."[133]

The trauma inherent in famine stories—whether in Sudan or Somalia—lent itself well to graphic, sensational depiction, in both words and images. The scenes were so extraordinary that ordinary language and imagery couldn't do them justice. In Somalia, for example, the people themselves were identified by picturesque words that attempted to communicate the great gulf between people met in one's common experience and these characters, good and bad. Then, unlike the Ethiopian coverage six years previously, attempts were made to translate the essentially incomprehensible situation through metaphors familiar to Americans.

Most media referred to the extremity of the starving by using qualifying adjectives: The starving were "frail," "naked," "bony," "skeletal," "hungry," "desperate," "exhausted," "teary-eyed" and "on the verge of death"—and those were descriptions from only one article. By contrast, the villains and heroes were distinguished by creative choices of metaphorical nouns. The bad guys were "grasping warlords," "outlaws," "hooligans," "yahoos," "Rambos," "angry wasps" and "gun-toting" or "khat-chewing thugs." And the good guys—first the relief workers and then the American soldiers—were "selfless heroes," "a beacon of hope," "heroic volunteers doing what amounts to almost American Civil War–type surgery," "the humanitarian version of the French Foreign Legion,"

and, referring to the soldiers: the "U.S. Cavalry," the "favored big brother" and "more Jimmy Stewart than John Wayne."[134]

Even more creative and evocative was the choice of metaphors used to describe the context of the famine. Some journalists used images of gloom and doom. Somalia is "a human nightmare," "pure hell," "a Pandora's box" or "an unexploded health bomb close to detonation." Somali culture is "in the dark ages" or a type of "harsh, primitive social Darwinism." Somali violence is "a hurricane of interclan wars" or a "form of the 'Stockholm syndrome.'" But the most popular metaphors were those warning of biblical-caliber death and destruction: "Its troubles seem like Old Testament plagues, irresolvable and inevitable," "A famine of apocalyptic proportions is unfolding" or most frankly "Apocalypse has descended upon Somalia."[135]

The most catchy metaphorical references were to pop culture. The more erudite journalists recalled the novel *Scoop*, British author Evelyn Waugh's satire of English journalists chasing rumors of war in the fictional African country of Ishmaelia. But most reporters stuck to Hollywood and films for their comparisons: Tom Brokaw said the landing in Mogadishu resembled "a *Dr. Strangelove* movie" and Ted Koppel found it "Fellini-esque." Other journalists mentioned *Apocalypse Now* or *A Clockwork Orange*. And several compared Somalia to the "post-apocalyptic film *Mad Max*" and the Somali gunmen to its "road warriors."[136]

Many journalists used historical events freighted with meaning to describe the Somali situation. The reference that seemed most appropriate was to Ethiopia, but other stories compared Somalia's situation not to previous famines, but to previous debacles of one kind or another. Somalia was like World War II: "Somalis are in the midst of their own terrible holocaust." Somalia was like Cambodia: "We can't stand by and permit endless killing fields." Somalia was like Lebanon: "The vicious power struggle between rival clan warlords has turned Somalia's capital into Africa's Beirut." And most typically, Somalia could become Vietnam: "How do we distinguish a Vietnam-like quagmire?" Even the three presidential candidates in the first presidential debate each cautioned against the danger of repeating Vietnam: "We can't get involved in the quagmire, but we must do what we can," said then-candidate Bill Clinton.[137]

Occasionally the big guns of language were pulled out when commentators wanted to compel action. Shades of "Never Again" were mentioned. Ted Koppel on *Nightline* referred to the "human tragedy" in Somalia as "a crime against humanity," as a way of signaling to his guest, U.N. Secretary-General Boutros-Ghali, that taking military action had become "a moral imperative." But most

evocative was the use of the single word "genocide." Somalia "looks for all the world like genocide," wrote Jonathan Yardley in *The Post.* "At what point does a violation of humanitarian norms become so extraordinary as to justify, indeed morally compel, military intervention?" asked Charles Krauthammer. "At the point of genocide," he answered. "In Somalia . . . the issue is the physical destruction of entire populations. . . . Genocide may not be the intent of those stealing food from the mouths of starving millions. But it is the effect. One murder is a crime. A million murders is a crime against humanity."[138] The choice of language was a choice of perspective. Defining was not, is not, documentary, but propaganda.

As had been the case with the famine in Ethiopia in the mid-80s, most Americans saw the horror of the Somali famine on their television screens. Repeatedly, the anchors in their lead-ins to the news packages from Mogadishu warned their audiences of the disturbing nature of the footage. And as with the disclaimers before certain violent prime-time dramas, the warnings alerted viewers that something out of the commonplace was about to be shown. Watching videotape from Somalia became like rubbernecking on the highway, people slowed down to look when cautioned about the accident ahead.

Unlike the African famine less than a decade earlier, the media did not resist the disaster's potential for sensationalist coverage. Many of the iconic scenes, familiar from Ethiopia — of sacks of food aid, of crowds of the starving, of doctors tending the sick, of children being fed, of men carrying the dead, of mothers cradling their dying children — reappeared more graphically, more confrontationally. New categories, such as gun-toting teenagers, emerged as well, by definition framed in a confrontational manner.

The genres of images appeared both on television and in print. Indeed, sometimes they were the very same pictures. For example, David Friend, *Life's* director of photography, persuaded his editors in September to pre-empt the front section of the *Life's* November issue to run a handful of the most stunning pictures of famine-stricken Somalia taken by some of the best European, American, African and Asian photographers. He then suggested that the 50 or so images that didn't make it into the magazine be put on exhibit for the holidays. Through a connection with the nephew of Boutros Boutros-Ghali, who worked in the marketing division of Time-Warner, the exhibit went on display at the United Nations — and were up when the Security Council passed a resolution authorizing use of U.S. troops to intervene in Somalia.

After the U.N. exhibit, the networks picked up the images. Charles Kuralt's CBS show *Sunday Morning* featured the photographs and so did *NBC Nightly*

News. "The newsroom came to an absolute stop when we ran the photo essay," said Tom Brokaw. NBC included a UNICEF telephone number in its segment so viewers could pledge money. The piece ran for one minute 40 seconds and showed 19 of the exhibition's 54 color and black-and-white images. UNICEF didn't have enough operators to answer all the calls. More than $16,000 was raised in two hours, and 1,200 people called within 24 hours. "I think the still photo is unequaled in its impact, in revealing the essence of horror," said Friend.[139]

In comparison to the photographic coverage of the Ethiopian famine, in the Somalia coverage there were typically more close-ups, they were run larger, more were used and more controversial scenes were depicted. Once again, children were the signature of the famine. *U.S. News* ran a full-page photograph of a 3-year-old child being weighed in a sack, hung from a literal gallows; she had been measured in the balance of justice, the image implied, and the world found her wanting. Other news organizations also used children as an emblem of the suffering of Somalia. *Time* magazine's cover on the stands when the Marines landed, for example, was the close-up face of a young Somali child, pictured larger than life. The photograph, taken by Christopher Morris, showed the boy, bald, features sunken to a skeletal level, staring into a middle distance past the reader, behind the reader. This was not a child who could look ahead. And neither could the infant, futilely suckling from its mother's withered breast, on the first page of the cover photo-essay, whose eyes were glued shut by a half dozen flies feeding at each eyelid. And neither could the child in the same photo-essay, so featherlight as to disappear in the folds of its burial blanket carried by its young mother, "the Pieta of Baidoa," the caption read.[140]

The pictures from Somalia, like the language of the reporting, took a conscious perspective. Photographs of the shipping of the food aid, for example, were used not simply as illustrations of Western relief but as documents of the perfidy of the clan gunmen who were preventing the millions of feed sacks from getting to the needy. *U.S. News*, for example, ran a David Turnley photograph, taken with a wide-angle lens, two-thirds of a page deep and running across the gutter onto the facing page. The entire frame was filled with food sacks, and a few men toiled like ants, carrying the cumbersome sacks on their backs to somewhere unknown.[141]

Images of the gunmen pictured them "armed and dangerous," as one caption said, dressed in pseudo-military khaki, waving automatic weapons and brandishing fists, with mocking smirks and sneering eyes—or alternatively, with shadowed dark sunglasses on. These were visual translations of the words "thug" and "hooligan" that were employed so casually. (Conversely, images of the

American troops going into Operation Restore Hope showed them clear-eyed and square-jawed, competent and confident, waving the flag and brandishing "thumbs up.")[142]

Photographs of the starving waiting to be fed, could also carry an edge. Some images, as before, showed Red Cross workers ministering to the frailest children. But the images were not always feel-good ones, success stories of skeletal, but surviving refugees. In a land where the food often didn't make it to the suffering in time to help or where it was likely to give out before all were served, pictures depicted scenes where children waiting for their chance at the gruel had to be "beaten back with a stick" or where children and adults just couldn't make it at all. Such as a two-page, full-bleed photograph by Jean-Claude Coutausse twice run that size by *Time* magazine during the fall and winter of 1992, of a child, "too weakened by hunger to stand," held only from utter collapse by her mother's hands "whose arms are barely stronger." Or a two-page, full-bleed photograph by Betty Press in *Newsweek* which showed a woman draped in a feed sack with a pail for food beside her, "too weak to eat," lying on the dirt, "waiting for help—or death." She had made it to the relief station, only to lie, waiting to die in sight of the food.[143]

Even images of death had a punch greater than a simple accounting of the dead could deliver. Photographs showing the ritual washing of the dead before burial took on greater meaning when water was so precious that the cleansing of the body was the first bath the dead person had had for months. Pictures which showed the care with which the bodies were prepared for burial drew attention to the individuality of the dead. Briefly, the starved were not statistics. Many images also documented the collection of the dead. Bodies, which were traditionally wrapped in cloth and tied with string, lay in photographs like narrow bundles the dimension of skis or a skinny pool umbrella. Only the odd foot poking out here, or a rounded shape suggesting a head there, or a crook in the bundle reminiscent of a bent hip and knee offered any indication that the bundles had been formerly human. How could those weightless parcels ever have been alive?[144]

Again and again, officials and the media commented on the effect of the images—especially the television images. To hear the talk, it was William Randolph Hearst and the Spanish-American War all over again. The media furnished the pictures, and voilà, a war.[145] TV had become the new diplomat in foreign affairs, said former Assistant Secretary of Defense Richard Perle. "Embassies are behind the curve. While sitting in the bubble, in a secure room

in some embassy trying to figure out what to advise, the people in Washington may have made up their minds watching television." George Kennan, the brilliant former director of the State Department's Policy Planning Staff, believed that the haunting images of the starving had produced an emotional response in the American public which had then pressured the U.S. government into a hasty decision to intervene. In his *New York Times* op-ed piece (which coincidentally appeared on September 30, 1993, immediately before the October deaths of the American soldiers), he decried the lack of a traditional, deliberate decision-making process within the State Department.[146]

Even former Secretary of State Lawrence Eagleburger verified the power of the TV images. He told CNN:

> I will tell you quite frankly television had a great deal to do with President Bush's decision to go in in the first place, and, I will tell you equally frankly, I was one of those two or three that was strongly recommending he do it, and it was very much because of the television pictures of these starving kids, substantial pressures from the Congress that come from the same source, and my honest belief that we could do this, do something good at not too great a cost and, certainly, without any great danger of body bags coming home.[147]

Cutting-edge technology—satellites and cellular phones and "real-time coverage"—allowed the media to become players. (Sometimes the media quite literally became players. Dan Rather and his entourage were the first Americans to arrive in Kismayu, the port city in the South, and the starving residents cheered him, believing the Marines had arrived.) And the response of the government acted as an unofficial sanction of television's power. Secretary of Defense Dick Cheney watched the Marine's landing on TV and President Bush kept up with developments by watching the networks and CNN.[148]

Many considered television's power a positive trend. "Compliments, then to television's ability to bring into millions of homes horrors that policy makers might have preferred not to confront," said Walter Goodman. But the reliance on images, and particularly televised images, did raise problems. "There is a disquieting aspect to the notion of policy being driven by images on the tube. The television camera is as blunt as it is powerful; it is a prisoner of its own immediacy." Simplicity is not always a virtue. Images overwhelm analysis. Because of failures by both the government and the media to better inform the public about the American mission to Somalia and the indigenous troubles there, the photos

and videotapes helped define the story. And even more than print, television dis-tilled the situation into American soldiers rescuing the starving masses from the drug-crazed hooligans. "Words can't describe the children seen on the news-casts," wrote columnist Tom Dorsey. "Somalia is a complex story. . . . But the pictures of thousands of pathetic people are easy to understand." Good pictures make for a straightforward story. "It is the agony portrayed in a scene like that which has finally caused governments to act in Somalia," said Peter Jennings in a wrap-up of a piece about a remote feeding center.[149]

The "sentimental" pictures were partly responsible for getting the United States into Somalia. And many argued they were instrumental in getting it out, as well. *Newsday* correspondent Rita Ciolli wrote, "Emotional pictures, stirring the sentiment of the American public, have signaled both the entrance and exit of U.S. military forces in Somalia." The pictures of the dead and battered Amer-ican serviceman touched a very raw nerve, at a time when Capitol Hill had already grown sensitive to pressures for withdrawal. On October 7, 1993, Presi-dent Clinton addressed the nation: "This past weekend we all reacted with anger and horror as an armed Somali gang desecrated the bodies of our Ameri-can soldiers."[150]

But, of course, as ABC anchor Peter Jennings argued, "it is too simple a for-mula to say pictures in, pictures out."[151] In a keynote speech given at Columbia University in February 1994, CBS anchor Dan Rather, took on George Kennan and the others who criticized the television coverage of Somalia. "It takes more than pictures to move the American people," he said. "If, as our critics say so often, it was the pictures . . . that sent us to Somalia, I ask why those images did not send us sooner. . . . The pictures were around for a very long time. I ask why television pictures did not send American ground troops into Bosnia two or three years ago, or two or three weeks ago, or today?" The answer, Rather said, is that "the choices were up to the American people and the American leaders. Not American television. . . . Having U.S. forces out by January 19, 1993, as we had promised, was the right idea. The trouble, however, is that evidence indi-cates there was never any intention to do that. That was the trouble. But it is not trouble created by television."[152]

The media, or even TV, were not the problem in Somalia—or, at least, they weren't the entire problem. But the media could have, should have paid more notice, sooner, more thoroughly, more consistently to the crisis. The media should have, could have ignored the dictates of compassion fatigue. If the relief agencies could get into Somalia, stories could have gotten out. Less money could have been spent on the beach-party landing and more could have been spent developing and promoting the story in 1991 and the spring of 1992. Television

executives and print editors could have selected their budget of international news stories more on the basis of independent news judgment than official government policy. "If we are collectively at fault," said Peter Jennings, "it is because we haven't paid enough attention."[153] And if not enough attention was paid to Somalia, what can be said about Sudan? Except, "Here lies another victim of compassion fatigue."

"Farewell to a Peacemaker," *The Washington Post*, 7 November 1995
"President Clinton consoles Yitzak Rabin's widow, Leah. He eulogized (*sic*) Israeli prime minister as a martyr for peace and a victim of hate."

CHAPTER FOUR

COVERING DEATH:
THE AMERICANIZATION
OF ASSASSINATIONS

> The act of an Israeli's killing Rabin is comparable to an American's gunning down someone essential to the birth and development of the assassin's home nation, someone like a James Madison or Thomas Jefferson.
>
> — Brad Mislow, Decatur, Georgia,
> "Letters," *Time*, December 4, 1995

Thirty-five years after the assassination of John Fitzgerald Kennedy in Dallas on November 22, 1963, Americans show no signs of tiring of the subject. "In Death," said a *New York Times* headline to an article by Tom Wicker, "J.F.K. Continues to Loom Larger Than Life." From the guided tours of the motorcade route to the plethora of reappraisals each fall in the media on the anniversary of his death to the intense controversy that erupted with the release of Oliver Stone's movie *JFK* to the brouhaha over the auction of the estate of Jacqueline Kennedy Onassis, Americans find the mythology of President Kennedy irresistible.

According to Wicker, "Americans continue to hold the 35th president in improbably high regard—not just as a man of star quality, whose life was cut short in a moment whose origins are still debated, but as a national leader ranked in some polls with or above Abraham Lincoln and Franklin D. Roosevelt." Even though Kennedy was in something of a political slump at the time of his death, even though his "Thousand Days" in the presidency were marked by seemingly continual crises—the Bay of Pigs, Berlin, the Cuban Missile Crisis, the confrontations between blacks and whites in the American South, the beginnings of the war in Vietnam—even though his reputation has been tarnished since his death by allegations of sexual and political improprieties, the legend endures that if the fatal shots had not been fired, a new age would have

been ushered in. The disasters of the '60s and '70s could somehow have been avoided.

"The mythic manner of his death," wrote Wicker, is the reason for the continued mourning and the ingenuous faith that he would have changed the course of history for the better. "The hero cut down at the height of his glory," he said, "is a staple of legend-making. And when such a fate befalls a figure of youth and beauty, the legend becomes even more of a romantic drama. . . . In the soul-shaking years since his death, as between disillusionment and legend, Americans have chosen legend—as if to hold in memory their own sense of themselves and their country as they most wished them to be, as they used to believe they were."[1]

The manner and the meaning of Kennedy's death resonate beyond his personal standing in American culture. His assassination and all the varied ramifications of it have been appropriated by the media as a touchstone for other political murders. His assassination—like a very few others: Abraham Lincoln, Martin Luther King, Jr., Mohandas Gandhi—has become iconic; it has become a historical, Americanized reference employed by the media to make the news of a distant death of a foreign head of state more "comprehensible" and more engaging to an American audience.

The Kennedy saga (and that of the few other famous assassinated leaders) is integrated by the media into stories of international assassinations in the belief that the public's fascination with Kennedy's demise and his place in American culture will transfer to this new story. Understanding of the meaning of a new death is enhanced by references to JFK, and indifference to the country or weariness for another episode of violence is mitigated by borrowing the public's enchantment with the Kennedy legend. In other words, the media attempt to forestall compassion fatigue by paralleling a new death with the mythic death of President Kennedy.

The assassination of a leader of a country of concern to Americans—countries where Americans have substantial political, commercial or cultural interest—is an event of reflexive interest to the American media. Coverage of such an event falls into the "of course" category. "Of course, we'll cover it." The assassination of a major leader circumvents prior-restraint compassion fatigue. Assassination falls clearly into the category of crisis, and the media prioritize crises in their news budgets. Sudden death, sudden political and social dislocation are components for a good story. But how is that story to be covered? How extensively? For how long? In what depth? Using what resources?

If the Kennedy assassination is chosen as the Ur assassination story for Americans, those questions are resolved by reference to the coverage of Kennedy's death and subsequent funeral. Although the media may not at all times be cognizant of the correspondence between the coverage of the new murder and Kennedy's assassination, the form of those November days of mourning has so entered the culture that it is almost impossible to conceive of an alternative manner of covering an assassination.[2] "The speeding limousine, Lyndon B. Johnson's swearing-in, and the funeral procession were images of the assassination imbedded in the consciousness of Americans who lived through those long days," said Tom Wicker.[3]

As with other crises, therefore, coverage of assassinations relies on a formulaic chronology of events, a stereotyped and exaggerated use of language, metaphors and imagery and an obligatory application of American cultural icons. Phrases freighted with allusions to past assassinations and sensationalized, or even just emotional language, triumph over staid prose and suggest that this new crisis has a special and particular appeal. And parallels drawn to American mythological figures such as Kennedy and Lincoln distract an audience from thinking of the crisis as foreign. The JFK connection suggests that this new killing will have the same immense effect on the nation in which it occurred as Kennedy's assassination continues to have for the United States. American self-interest is engaged, and in the media, as in conversation, the mass of people have a longer attention span for topics related to themselves than for topics of remote concern. As with other crises, the coverage of assassinations is molded by the media's responsiveness to compassion fatigue syndrome. It's not the "news" itself that dictates the shape of coverage; past accounts of comparable events are a better predictor of the level and tenor of reporting.

Not all assassinations are of equal consequence for Americans. In the past decade or so, coverage of the assassination of the Israeli prime minister, for example, was more extensive than the assassination of the prime minister of Sweden, which was more extensive than the assassination of president of Sri Lanka.[4] Since the overarching interest of both the print and broadcast media is to attract and retain their audience, choices about whether to cover a crisis, how to cover it and when to move on to cover something else are prescribed by the supposed "entertainment" value of the crisis. Compassion fatigue establishes a hierarchy of events and issues that is reliably adhered to.

Like famines, most Americans would probably agree that they know an assassination when they see one. But in general conversation the term is imprecisely

defined. Assassination is more than murder. The concept of assassination encompasses three distinct elements: (1) the death of a political leader; (2) the political motive of the killer; and (3) the political and cultural interpretation of the assassination event.[5]

The assassin's motive is his message.[6] John Wilkes Booth was driven by his love of the Confederacy to kill President Abraham Lincoln. Sirhan Sirhan, the assassin of Robert Kennedy, wanted to deny the presidency to a pro-Israeli politician. Beant Singh and Satwant Singh assassinated Indian Prime Minister Indira Gandhi in revenge for the army's killing of hundreds at the Sikhs' holiest shrine, the Golden Temple in Amritsar. Yigal Amir killed Israeli Prime Minister Yitzhak Rabin in an attempt to stop Israel from turning over control of much of the West Bank to the Palestinians.[7] Assassination is a direct attack upon a government. It becomes a choice when an assassin determines that he cannot get satisfaction through the normal workings of the political process. It is immaterial whether or not he is rational or irrational.

The force of an assassin's message resides in the method and the success of his act. Assassination is a statement to society that even the mightiest can be held accountable. And the greater the security surrounding a national leader, the more daring the act, the more the power of the assassin's political perspective is pressed home to the audience. "The assassination of Anwar Sadat is a case in point," said H. H. A. Cooper in his classic work *On Assassination*. "Gunning down a head of state in the very presence of the nation's armed forces on parade says something that a less spectacular, if safer (from the assassin's perspective), killing would have failed to articulate."[8]

Through the media the deed of an assassin is enhanced. Televised images of the assassination itself, as in the case of Sadat's death, or, at least, photos of the wounded or dead victim and of national and international mourning, give the weapon that struck down the leader greater force than it had as a simple instrument of death. The media's act of showing and telling allows the assassin's act to resound more loudly throughout the country—and the world. "One well-aimed bullet reaches a huge target population," said Cooper. "It was the life of the person, John F. Kennedy, that was taken on the streets of Dallas on 22 November 1963. But the fact of one man's death pales into insignificance beside the meaning of his death for millions of Americans and others around the world. It was what Kennedy had come to symbolize—and would later symbolize—that was struck down that day."[9] Every death worthy of the name "assassination" erodes the political forum and the social fabric of a nation.

· · ·

The origin of the term "assassin" is Arabic, and has been traced to the "Assassins," an exiled group of the Ismaili sect in Islam which flourished in Persia for 200 years after the first millennium. Stories which appeared in the travel accounts of Marco Polo and others described the "Ashishin's" superlative talent in murdering their enemies: They carefully selected a target and precisely plotted his death. By the 12th century, tales of the Assassins had spread throughout Europe and found their way into poetry and myth. By the 14th century, the word "assassin" had lost its particular meaning; it was no longer tied to the Ismaili group, instead it had come to mean any murderer who kills a public figure by stealth for reasons of fanaticism or greed.

Political murders, of course, predated the Ismaili Assassins. And others, too, had justified murder with ideological and religious arguments. "But," according to historian Bernard Lewis, "they may well be the first terrorists. 'Brothers,' says an Ismaili poet, 'when the time of triumph comes, with good fortune from both worlds as our companion, then by one single warrior on foot a king may be stricken with terror, though he own more than a hundred thousand horsemen.'" Terror is one means by which a limited organization can seek large-scale objectives. "This was the method," said Lewis, that the Assassins may well have "invented."[10]

The equation of terrorism and assassination has survived to the present day, especially in the media. It's true, assassination, together with bombings and kidnappings have become part of the terrorist arsenal. But most assassinations of heads of state—those assassinations that receive the greatest media coverage—are "one-offs" where the intent is not to terrorize a political group, but to strike down a specific political figure. David Rapoport who wrote one of the most influential works on the subject contends that while "there is a close relationship between the assassin and the terrorist, there are profound differences between [them], differences which can be appreciated best by focusing on the meaning of their actions, rather than on the acts themselves. . . . Assassination is an incident, a passing deed, an event; terrorism is a process, a way of life, a dedication."[11]

The history of the Assassins is not chiefly at fault for the media's frequent conflation of terrorism with assassination. The media's news values are. As was evident in the media's coverage of epidemic disease, the media prioritize events that are lethal and that pose a risk to others—particularly to those "others" who are American or who are demographically similar to white, middle-class Americans. Events that can be categorized in this way are least likely to prompt compassion fatigue in the elite media's audience; sympathy for the dead and

self-interest for one's own continued health are palliatives against compassion fatigue. So when the media seek to label a crisis, they often choose that label which holds the greatest news value. "For the most part we do not first see, and then define," wrote Walter Lippman in *Public Opinion*, "we define first and then see."[12] "Terrorism" is a word that seizes the attention of an audience. Acts of terror are lethal and there is a presumption of future risk. Political assassinations, as narrowly defined, while lethal, do not typically pose a continued risk. Terrorism implies an ongoing threat to innocent people whose only fault lies in being in the wrong place at the wrong time. The terror of terrorism is in the randomness of its victims. Political assassination, on the other hand, targets just one person. The general public is at no great risk of bodily harm.

The public's interest in learning about an assassination is in direct proportion to the perceived importance of the target and, to a lesser extent, to the identity and motive of the killer. When curiosity about those subjects is sated, the assassination media "event" ends. If, however, a terrorist connection is made, the event has no identifiable end. The story can be followed into the indeterminate future. Noam Chomsky and Edward Herman argue that "Among the many symbols used to frighten and manipulate the populace of the democratic states, few have been more important than 'terror' and 'terrorism.'"[13]

As an observer might expect then, it is the norm for sudden deaths of heads of state to be labeled as terrorist acts—at least by a quoted news source, if not explicitly in the narrative of a reporter. And since it is the journalist's prerogative whom to interview and quote, it must be assumed that the use of quotations that link assassination with terrorism serves the media's agenda.[14]

In news stories, assassinations can be thrust into a prior pattern of terrorist activity, even if the previous terrorist incidents didn't include assassinations. The "suspicious" death of Pakistani President Mohammad Zia ul-Haq in a plane crash (together with the U.S. ambassador and numerous high-ranking Pakistani military officers) falls into this category. "There is speculation that Zia's death was an assassination," noted an article in *The Christian Science Monitor*. "If it were, it would follow a rise in terrorist incidents in Pakistan, most thought to have been carried out by the secret police of the Soviet-backed Afghan government."[15]

Assassinations can be represented as part of a global pattern of terrorism. The week of the assassination of Prime Minister Indira Gandhi of India, William Safire led his *New York Times* column with: "Margaret Thatcher escaped and Indira Gandhi was cut down; Ronald Reagan lived and Anwar Sadat died; the Pope survived and a pro-Solidarity Polish priest was secretly murdered. Every world leader is the target of some madman, or nationalist group, or religious fanatic, or other world leader willing to employ terrorists."[16]

And assassinations can be linked to terrorist cults or conspiracies to suggest a broader-based threat to the social order. The day after the assassination of Egyptian president Anwar Sadat, reporter Barbara Crossette in *The New York Times* wrote, "Reagan Administration officials said during the day that at least one of the six suspects in the assassination had links to an Islamic fundamentalist cult called Takfir Wahigra, which reportedly had been formed in the 1960s to advocate "sacred terror." And the weekend following the assassination of Israeli Prime Minister Yitzhak Rabin, Daniel Williams in *The Washington Post* led his story with: "Israeli police say they have discovered a weapons cache 'befitting a terror group' at the home of the professed killer of prime minister Yitzhak Rabin, while the country's top police official portrayed the assassination as the fruit of a conspiracy rather than the action of one man."[17]

Taught by the controversy surrounding the Kennedy assassination, Americans view skeptically all assassinations since then. Assassinations suggest conspiracies to Americans, even when they are represented simply as the act of a single assailant. "In the United States there seems to be a compulsive tendency to suspect conspiracy in the face of facts not easily explained," noted one scholar.[18] The mystery that swirls around even the most clear-cut assassinations allows the media considerable latitude in their framing of the event.

"We live in a world erected through the stories we tell," wrote media critic George Gerbner. "Violence and terror have a special role to play in this great storytelling process. They depict social forces in conflict. They dramatize threats to human integrity and the social order. They demonstrate power to lash out, provoke, intimidate, and control. They designate winners and losers in an inescapably political game."[19] Assassinations make good copy. The sudden death of a world leader is not only a political event that cries out for coverage, but it is an incident that can be framed by the media into a compact, compelling narrative of family and nation, hero and villain, grief and mystery, solidarity and strife.

The story the media tell of an assassination is not the only story that can be told. There is never just one interpretation of a crisis, never just one perspective to a story. As Lippman wrote in the 1920s, "Every newspaper when it reaches the reader is the result of a whole series of selections as to what items shall be printed, in what position they shall be printed, how much space each shall occupy, what emphasis each shall have. There are no objective standards here. There are conventions."[20] Following those conventions creates a journalistic authority, a narrative of events that presumes to be *the* narrative. Since the American audience for international news does not personally experience the

events that are covered, there is rarely any corrective for the media's version. And there is rarely even any cognizance that the media's rendition is itself "framed." Only if multiple similar events are compared is it made evident that conscious choices guided the media's coverage. Many news frames appear to be natural, unforced, perhaps even self-evident ways of reporting on a story. Yet comparison makes clear that the media's choices are "not inevitable or unproblematic," as media analyst Robert Entman has noted, "but rather are central to the way the news frame helps establish the literally 'common sense' (i.e. widespread) interpretation of events."[21]

The assassination convention is the Kennedy assassination. In covering those four days in November 1963, the journalists assigned to the story concentrated on the "immediate tasks to which they had been assigned. Their accounts," wrote historian Barbie Zelizer, "generally focused on five moments of coverage: Kennedy's shooting; the hospital; Johnson's swearing-in; the follow-up to Kennedy's shooting, including the murder of Lee Harvey Oswald; and Kennedy's funeral."[22]

Coverage of an assassination begins, as Tom Wicker said of the gunning down of President Kennedy, "when it [is] all over." Even when journalists are present at the actual assassination, the first breaking news is typically from the nervous vigil at the hospital. For example, CNN broke the story of Prime Minister Rabin's assassination with this live report.

> Hello, I'm Catherine Callaway in Atlanta and this just in to CNN. Shots have been fired at a pro-peace rally in Tel Aviv. We have learned that Israeli Prime Minister Yitzhak Rabin was attending the rally. Shots were fired at the rally. It is not being confirmed if he was injured in this incident. We do know that he is being treated or is in an emergency room. We do not know if he is being treated for any injuries or not. . . . We'll have more details as they become available.[23]

For the next while, rumors as to the condition of the fallen leader are passed on as news, and, in the intervals between hospital bulletins, the first tentative reconstructions of the assassination are presented to the media audience. Since the breaking news of the victim's condition is offered simultaneously with the available information on the attack, the first stage of coverage of the assassination "event" can be considered to include both the moment when the assassin strikes and the period until it is established that the head of state has died. This first stage typically lasts for the first "day" of coverage, but the precise duration

depends on when the attack happens, how long the leader survives and how long it takes before there is official confirmation of the death.

For example, after the shooting of Anwar Sadat on Tuesday, October 6, 1981, he was rushed to a military hospital, arriving there at 1:20 P.M. (7:20 A.M. in Washington, D.C.) in a coma, with no detectable heartbeat. An hour and 20 minutes later doctors pronounced him dead. President Ronald Reagan who was given news of the shooting at 7:25 A.M., still believed at 9 A.M. that Sadat was alive, even though he had just been declared dead—and had effectively been dead at least since his arrival at the hospital. It wasn't until after 11 A.M. that the White House received information that Sadat had indeed died. Through an "informal understanding" with Egypt, Vice President Hosni Mubarak was "permitted to make an announcement before the United States." Finally, seven hours after the attack, Mubarak confirmed Sadat's death. As a result of the delay, American television didn't declare Sadat "officially" dead until just before 2 P.M. Eastern time, although NBC, while waiting for definite news from the hospital, had already aired several times a "chilling audio tape of screams, shouts and shots" from the scene of the assassination at the military parade, accompanied by "still pictures of prostrate bodies that the newsmen could not identify for their viewers."[24]

Newspapers, handicapped by just one opportunity a day to tell the news, couldn't get news of the assassination into Tuesday's papers. By Wednesday, therefore, the American papers, even those on the West Coast, led their Wednesday papers not only with the recapitulation of the assassination attack and the declaration of Sadat's death, but also with the news of the succession of Mubarak as "the effective ruler of the country" and the probable meaning of his assumption of the presidency.[25] In covering breaking news events such as assassinations, the broadcast media is privileged. Broadcast always has a beat on print sources: Day one on television is perforce day two in the newspapers. Depending on what time of day (U.S. time) an assassination occurs, television can be as much as several news cycles ahead of the newspapers. By the end of the first day following an assassination (up until the newsmagazine programs and the late evening news), television can have already aired bulletins on the assassination itself, the confirmed death of the victim, and the changes in the chain of command. If the story unfolded early enough in the day, other companion pieces may be broadcast, including reaction stories: the response of world leaders to the assassination, especially American leaders (often the president and former presidents); policy stories: the presumptive effect of the assassination on geopolitical policy (focused on American security issues); and the upcoming-funeral stories: speculation about who will attend the funeral (will it be the president or vice president, for example). In all four deaths under study, television handled these

stories on the days they happened, leaving most newspapers to play catch-up the next day.

The second day after an assassination, or, more comprehensively, the second phase of reporting (often appearing on day three in the newspapers) the first-stage stories are followed up, but the dominant story becomes the assassin—who is he (or who are they), what was his motive, what threat remains and what is the response of authorities. For example, on Thursday, October 8, 1981, two days after Anwar Sadat's death, the lead headline in *The Washington Post* was "Extremists Blamed for Sadat Killing." On Thursday, November 1, 1984, the day after Indira Gandhi's assassination and the second day of newspaper coverage (she was killed shortly before 9:30 A.M. Wednesday—or 11 P.M. Tuesday on the East Coast, just in time for newspapers to remake their front pages and put the story in Wednesday's paper), *The New York Times* front-page headline read "Gandhi, Slain, Is Succeeded by Son; Killing Laid to 2 Sikh Bodyguards; Army Alerted to Bar Sect Violence." On Friday, August 19, 1988, two days after the unexplained plane crash that killed Mohammad Zia ul-Haq, the *Chicago Tribune*'s front-page headline was "Probers Look for Sabotage in Zia's death." (Zia died on Wednesday the 17th at 4:30 P.M. Pakistan time. The twenty-hour time difference between Pakistan and the U.S. West Coast just allowed the *L.A. Times* to break the news of the death in its Wednesday edition. The news missed the deadline for the East Coast papers.) And on Monday, November 6, 1995, two days after Yitzhak Rabin, was killed the *Tribune*'s lead headline announced "Assassin Intended to Murder Peres Too."

The third-stage of coverage of an assassination is typically the day of the funeral. As scholars of assassination have written: "Public participation in funerary observances takes a variety of forms, each of which indicates some facet of the emotions aroused by the death of the victim. Has the cause for which the victim stood also been lost with his death? Is his departure felt as a personal deprivation?"[26] In the media the funeral is framed by the words of the mourners. The family and the assembled dignitaries each have a voice in the stories, with the result that the coverage is both histrionic and somber. "Granddaughter's Intimate Words Move Audience to Tears," read the headline of one story covering Rabin's funeral in *USA Today*. "Though we no longer hear his booming voice, it is he who has brought us together again here in word and deed for peace," said President Clinton, as reported in *USA Today*'s "cover story" on the funeral.

Depending on the day of the week when the death occurred and the day of the week of the funeral, the stage-three coverage of the funeral can end the continuous reporting of the event. But if the cycle did not overlap with a weekend (for example, newspaper coverage of the funerals of Sadat, Gandhi and Zia all

fell on a Sunday), the Sunday following the assassination the papers in their week-in-review sections and the networks in their weekend magazine shows will run a news analysis or trend piece. So, for instance, on the Sunday after Rabin's funeral the *L.A. Times* collected three pieces in its Opinion section under the joint headline "Rabin's Legacy"—two of which were written by the former secretaries of state Henry Kissinger and James Baker—and *The Washington Post* ran a piece in its Outlook section titled "Going to the Extremists: After Rabin's Murder, It is Likud That Must Control the Crazies."

The close of the assassination cycle comes when the media reassert the supremacy of the established political and social order. Articles appear suggesting, as Elaine Sciolino did in *The New York Times* after Rabin's funeral, that "assassination for political ends works only seldom—and hardly ever in the way the assassin intended."[27] In other words, the reigning political system prevails. On that same Sunday, several papers ran similar trend stories that all made the same point—that viewed in the long-term, assassination is ineffective as a political weapon. In addition to *The New York Times*'s article "Assassins Usually Miss the Larger Target," *The Denver Post* ran a piece headlined "Assassinations Are Brutal But Futile" and *The Record* (NJ) headlined another story "Assassination Often Accomplishes Little."

Then, with those stories of closure, the coverage effectively ends. The assassination is off the front pages and off the newscasts . . . until related breaking events, such as the trial of the assassin or the general election of a successor, prompt a brief story. Even more clearly than with epidemic diseases, the media treat assassinations as short-term crises, rarely lasting (with continuous reporting) as long as a week. The political and/or social context that makes an assassination possible and the enduring impact of a head of state's death are rarely revisited once the immediate death-to-funeral cycle is past (except during the coverage of a new related event).[28]

The coverage arbitrarily works to tidy up a complex event into a neat package of death, mourning and funeral. An assassination "story" becomes like television's prime-time dramas where a murder is committed, investigated and resolved all within an hour-long show. On TV, such as on NBC's *Law & Order*, if loose ends aren't tied up by the end of the program the custom is that they are miraculously resolved in the interim between shows. In the world of international news, if the loose ends aren't tied up by the time the last story in the cycle is published or broadcast, the practice is that they are forgotten.

The media respond rhetorically to assassination crises by employing powerful labels—such as "martyr" and "peacemaker"—and sacred principles—such as

"sacrifice" and "tolerance" and "order"—on behalf of the victims and against the killers. The application of these labels and principles remains remarkably constant among assassinations, although the extent to which they are applied and the exact choice of labels and principles does depend on the particulars of each crisis.

The most significant variable in their application is the geopolitical status of the victim's country of origin and the personal status of the victim in the world arena—and, of course most especially, in the United States. Rabin and Sadat, equivalent world figures, inasmuch as they were the representatives of Israel and Egypt, countries of enormous political and economic significance to the United States, and inasmuch as they were the moderating influences in their own countries' political struggles, received surprisingly comparable coverage considering the greater investment of the United States in the security of Israel. *The Washington Post*, for example, eulogized Sadat with these words: "Anwar Sadat was, to put it simply, a great man, a historic figure. . . . Many people and nations benefited from Anwar Sadat's gifts." And it said this of Rabin: "Yitzhak Rabin, a brave and brilliant soldier and a diplomat of towering achievement, will be mourned around the world."[29]

By contrast, Indira Gandhi and Zia ul-Haq represented the two chief nations of South Asia, a region of importance, but not of as critical importance to the United States—either politically or culturally—as the Middle East. The engagement of India with the Soviets alienated Washington from Gandhi's government, and the relationship of the United States with Pakistan was purely a marriage of convenience entered into because of their mutual dislike for the Soviet presence in Afghanistan and India. And while India and Pakistan paralleled Egypt and Israel in that they had a history of war against each other, the hostility had not ceased, nor was either Gandhi or Zia considered a proponent of regional peace. Gandhi's greater stature on the world stage, a function of her family history, her prominence as a female head of state and her leadership of one of the world's most populous countries, led to both greater coverage and more positive coverage of her death than of Zia's. The mystery surrounding the plane crash of Zia and the lack of an identifiable assassin, joined together with Americans distaste for Zia who had taken power in a military coup and ruled Pakistan largely under martial law since then, and the generic American suspicion of Muslim countries (a characterization that fit Egypt as well), helped to minimize coverage of the suspicious circumstances of Zia's death.

A second key variable affecting the style and quantity of news of the assassinations is the timing of a crisis. At the time of the Sadat and Rabin assassinations there were no other major domestic or international events commanding

attention. The crisis in Egypt and Israel and the American and global responses took clear precedence in the budgeting of the news. The timing of the Gandhi and Zia assassinations was not so fortuitous. Gandhi was killed on Halloween 1984, less than one week before the American presidential election. Her funeral was on Saturday, three days before the election; the media were eager to turn their attention back to the more immediate domestic drama. And Zia's death also conflicted with the American political process; his plane went down on August 17, 1988, the same day that the Republican National Convention nominated George Bush as their nominee for president. The plane crash did not even make the lead story in *The New York Times* (although it did in *The Washington Post, USA Today,* and the *L.A. Times*), despite the fact that the U.S. ambassador to Pakistan, a U.S. brigadier general, and ten of Pakistan's senior army officers had all also perished in the explosion.

And a third variable influencing the tone of news coverage is the ability of the media to directly connect the events to the United States. An assassination is Americanized; American links to the foreign events are played up. The relationship of an assassinated head of state with the United States is closely examined; photographs of the leader at the White House are a common accompaniment to assassination stories, for example. The reaction of prominent Americans to the deaths and the travel of the presidents, former presidents or cabinet officials to the funerals receives conspicuous attention. And more dramatically, the media can suggest that the extremism and terrorism responsible for the killing pose a threat to the United States. In 1995, for example, *USA Today* ran a prominent article as part of their Rabin assassination coverage that was titled "Investigation of Jewish Extremism Reaches into USA."[30]

As others have observed, the media in their reporting on terrorism tend to be judgmental, inflammatory and sensationalistic.[31] Coverage of assassinations is similar. Why? One reason is that compassion fatigue is deemed less likely to occur when the language of the stories is partisan and emotional, when, in other words, an audience is trained to care about what happens. Defining one side as the good guys and the other as the bad guys prompts viewers and readers to become invested in the outcome of events. The growing trend in all media toward anecdotes and narratives and news analysis suggests that the media believe that neutrality or studied objectivity is of less interest to the public than storytelling and opinion writing. "Perhaps because so many of them were reared by television and think screenplay when writing, the current generation of reporters prefers to tease the reader with throat-clearing trivia," harumphed Max Frankel, irritated by the "annoying newspaper attention."[32]

Just as stories on terrorism are crafted to seize an audience's attention, so too are stories on assassinations. By repeating and reinforcing words and images, the news frames a certain construction of events and works to make others invisible. Through judgmental and sensationalist language a familiar moral structure is made memorable. In the Sadat and Rabin assassinations, the act of killing itself was characterized as "brutal," "ruthless" "terrorism," the victim was portrayed as a "courageous" "friend" and "martyr," and the assailant or assailants were depicted as "fanatics" or "zealots," part of the "lunatic fringe" who "murdered" in "cold fury." In sum, the whole event was a "ghastly" "tragedy." Words categorized the assassinations.[33] And so the audiences were directed to feel revulsion at the extreme violence of the act of assassination, to experience a sense of personal loss at the death of the leader and to apportion responsibility for the killing to a marginal, radical group. Assassination in this light was never tyrannicide, the justified killing of a despot. It was murder most foul.

As scholar Robert Entman has observed, "The essence of framing is sizing—magnifying or shrinking elements of the depicted reality to make them more or less salient."[34] Breaking-news stories as well as editorials and news analyses use language to craft a public image of the fallen leaders. The media consistently offer information in a way calculated to be supportive of the status quo and to marginalize the opposition and make it appear extremist. Even if "both" good and bad sides are represented, the "good" side will usurp the times and places of prominence. Which side is told first? Which headline is above the fold? There are repurcussions to *Time* magazine featuring an image of a proud and courageous Indira Gandhi on its cover, and burying its story on Hindu violence against the Sikhs in the back of the book.

While the ostensible point of much of the coverage of the assassination events is to deliver the facts as they happen, news stories called Rabin a "warrior for peace," for example, and Sadat a "symbol of peace," Gandhi "India's revered mother" and the former general Mohammad Zia ul-Haq "bold and courageous." The assassinated leaders' roles in life and their influence after death are carefully framed. The media note the victims' literal and figurative sacrifices for their countries and detail their physical suffering at their assailants' hands. The manner of their deaths becomes a defining feature of their courage, their strength and their martyrdom. "Thinking himself a martyr," as scholar Max Lerner said, "the assassin succeeds only in creating a martyr for the cause he hates."[35] The language of the media sanctifies the fallen leader's heroic status and helps to justify his or her policies.

The near deification of some heads of state (and the whitewashing of other, more problematic characters) asserts to the public that it must pay attention.

Calling Rabin "a man of Herculean courage" or saying that Sadat "stood like a colossus" signals to an American audience that this crisis is of paramount importance.[36] The media counts on the fact that compassion fatigue is unlikely to arise if the slain leader is represented as a giant among men, a figure so great that no one of education and intellect can afford to turn the page on the coverage of the death.

Yet unlike the coverage of other types of crises, explicit metaphorical expressions are rarely used in reporting on assassinations. But phrases and word choices are often reminiscent of prior pivotal events, such as the start of World War II, in the mention of a killing as an "act of infamy," or the Kennedy assassination, in the mention of a "lone gunman." For example, less than half an hour after Rabin had been pronounced dead, CNN was attributing the murder to a "lone gunman," and the phrase was in the first two paragraphs of the lead stories the next day of *The Washington Post* and the *Chicago Tribune*. *The New York Times* called Yigal Amir "a lone assassin" in the first sentence of its lead article.

And common too are explicit references to previous assassinations. In 1981, for example, UPI carried on the wire highlights from *The London Times'* editorial on Sadat. "Not since John F. Kennedy died, nearly 18 years ago," it repeated, "has the world been brutally robbed of a statesman so well known, or of one who had shouldered the burden of so many people's hopes." And in the first day of coverage of the Rabin assassination in the newspapers, an article in *The Washington Post* noted: "The killing of Rabin by a Jewish extremist paralleled in many ways the 1981 shooting of Egyptian president Anwar Sadat by Muslim fundamentalists opposed to peace with Israel. . . . But the impact on Israel and the Middle East of Rabin's murder is likely to resemble more closely the trauma Americans suffered from the assassination of John F. Kennedy in 1963."[37]

In telling the story of an assassination, the method of presentation can substantially support the emotional and sensationalized language. Breaking news bulletins that interrupt regularly scheduled television shows, bold, black headlines that march across the front pages of newspapers and the solemn, dignified faces of the assassinated leaders that gaze off into middle distance from the covers of the newsmagazines boost the prominence of the story. They signal an event's importance. They substantiate the crisis mentality so instrumental in banishing the "So what?" of compassion fatigue.

Graphics and visual images are critical components in the media's positioning of the assassination story. Five defining categories of images suggest the outlines of the events and suggest as well the ramifications of those events. These categories remain the same across the varied media and tend to repeat in subsequent assassinations. And, as is the case in the media's coverage of other types of

crises, the images can be further roughly divided into two types: descriptive pictures that detail the "what" or "who" or "how" of the events and confrontational pictures that are primarily used to provoke an emotional response in their viewers. These latter images may parenthetically describe a scene, but are clearly not the best choice if simple description is the primary intent. By this standard, close-ups of extreme grief or wild-eyed fanaticism are confrontational.

The first of the five categories is images of the assassinated head of state. To put a face to the crime, the media begin their stories with close-ups that humanize the fallen leader. The first picture in a series tends to show a formally dressed victim with a serious expression on his or her face, as befitting the mood of the story; subsequent ones can depict the victim in a cheerful frame of mind, to communicate that he or she was a warm, accessible person.

Other pictures of the head of state typically follow the portraits. To certify the leader's importance and connection to the United States, the media publish or broadcast a picture of him or her with an identifiable and significant American dignitary—ideally in a candid, collegial pose. And to verify the victim's humanity, the media run family snapshots of casual moments, especially when the leader is interacting with his or her children or grandchildren.

Second, to put a face to the "terrorism," the media run photos and video (if available) of the assassin or assassins. Images of the perpetrators at the scene of the murder, in action or after capture by security forces, indelibly brand the assailants as guilty. And pictures that accompany stories detailing the motives of the assassins typically certify their fanaticism by showing them with a crazed expression, wild eyes and disheveled hair and clothing. Similarly, the media can run videotape and photographs of the political opposition to suggest that it has a certain complicity with the assassins and their terrorist acts. These images may help to undermine the opposition's viability—even if the opposition has been wronged by the assassinated leader.

Third, to certify that the death is a great loss to the world, pictures of mourners are prominently shown. Photos of foreign kings, presidents and prime ministers delivering eulogies with clenched jaws and tears in their eyes, suggest, as *Time* columnist Hugh Sidey wrote after Sadat's death, that "the exclusive circle of world leaders has been momentarily broken." Close-ups of shocked compatriots reacting to the declaration of death and midrange images of distraught countrymen in the days following the assassination—either in active protest or prayerful vigils—highlight the leader's loss to the nation. And photographs of relatives, such as the two-page, full-bleed (to the margins) image of three generations of Rabin's family—widow, daughter and grandson and granddaughter—that

opened *Newsweek's* funeral coverage, confirm both the personal bereavement of the family as well as their dignified stoicism under the strain.[38]

Fourth, images of the rituals of public mourning in the victim's country also help position the event as a major tragedy. Photos and film of the funeral procession, the religious ceremonies and the gravesite or cremation site farewells attest to the gravity of the occasion and lend a cultural context to the assassination. When possible, these images mimic those from that chill November day when Kennedy was buried: the military honor guard escorting the caisson; the lines of heads of state in the funeral march from the White House, led by the imposing figures of Charles de Gaulle and Haile Selassie; and the flag-covered coffin and the mass of floral tributes.

Fifth, photographs of the successor to the dead leader ratify that the government will continue, changed, but uninterrupted.

Despite the media's shoehorning of assassinations into a formulaic pattern, despite the emotional and judgmental coverage that emerges in the language and visuals of the stories, despite their linkages of the crises to American political and cultural icons and interests, the media are still clearly concerned that their audience's attention span for even a major assassination can be counted only in days, not in weeks or months.

The Kennedy assassination could have, should have taught the media two lessons, not just one. The four days in November trained the media to cover future assassinations in the same shooting-to-funeral fashion as they covered the Kennedy story. But the subsequent years of mourning and controversy and confusion in the wake of Kennedy's death didn't translate to the media giving ongoing, long-term coverage of international assassinations. It's odd. It's as if the media so imprinted the four days of reporting on President Kennedy's assassination that coverage of subsequent assassinations couldn't help but be patterned on that long weekend, but failed to internalize that his death has reverberated for years in American—and world—politics, society and culture.

Or perhaps they don't forget that fact. They are just willing to draw their audience into a distant assassination by borrowing the Kennedy chronology and the Kennedy aura, but they assume that even if that new death will affect that country as strongly as Kennedy's death affected the United States, they can't get Americans to care about it for very long. So they pre-empt further coverage of an assassination crisis to forestall what they believe will be inevitable compassion fatigue on the part of the American public. Once the sensational bits of the crisis are over—the drama of the death, the mystery of the assailant, the pomp of the

funeral—all that is left is the hard, slogging, unglamorous (and absolutely essential) part of re-establishing order. Ho hum. And, at any rate, with the media's final stories suggesting that assassinations accomplish little, the earlier order has already been declared unaffected.

Assassinations should be covered as long-term crises. Assassinations have long-term ramifications, despite the media's ending coverage of assassinations quickly, despite their contentions that assassinations are inept or, at best, clumsy political weapons. The assessment of assassinations as relatively futile is a historical view, for certainly many assassinations are extremely disruptive—perhaps even more to the society's concept of self than to the daily political operation of the country.

DEATH IN THE INDIAN SUBCONTINENT: INDIAN PRIME MINISTER INDIRA GANDHI, WEDNESDAY, OCTOBER 31, 1984, & PAKISTANI PRESIDENT MOHAMMAD ZIA UL-HAQ, WEDNESDAY, AUGUST 17, 1988

"Good evening," intoned PBS anchor Robert MacNeil on August 17, 1988. "Leading the news this Wednesday, Pakistani President Zia and the American Ambassador were killed in a plane crash. George Bush said Dan Quayle is qualified to be a heartbeat from the Presidency. U.S. and Soviet scientists carried out their first joint nuclear test in the Nevada Desert. We'll have details in our News Summary in a moment."

For foreign news watchers, the preview sounded promising. The events in Pakistan were "leading the news." Public television viewers could expect to hear "details" about the crash.

But they had been misled. Out of a total number of 9,792 words in the hour-long broadcast, fewer than 300 (or 3 percent of the newscast) covered the story about the deaths of President Zia, U.S. Ambassador Raphel, the U.S. military attaché and 27 senior Pakistani army officers and crew members.

Ninety-seven percent of the broadcast was taken up by the "almost official Republican ticket" for the presidency, Vice President George Bush and Senator Dan Quayle, who had met the press together that day for the first time. "After the News Summary," said co-anchor Jim Lehrer, "it's what do you think of Dan Quayle Day at the Republican Convention." And it was, in all its permutations.

What the broadcast didn't have was any more than the barest facts from Pakistan and rumors that the cause of the fatal crash was sabotage. One hundred of

the 300 words were taken up by the canned State Department message of condolences to the government of Pakistan and the families of those who had died. The broadcast dismissed the 11-year rule of Zia in a single sentence and omitted entirely any discussion of Pakistan's relations with the United States and with its neighbors (although one rumor that Robert MacNeil reported was that "India had shot down the aircraft"). No background on Ambassador Raphel was given and the name of the U.S. Army general who perished was not even mentioned.[39] The following evening, the day after Vice President Bush's nomination as the Republican presidential candidate, the Pakistan story merited barely more than 100 words on the *NewsHour*.

The clear lesson for foreign heads of state to take from this coverage was don't get killed during the peak moments of the American presidential election season.

Four years earlier, Indian Prime Minster Indira Gandhi was slightly more fortunate in the timing of her assassination. Even though her death came less than a week before the presidential election, the campaign between Ronald Reagan and Walter Mondale was hardly shaping up to be a cliffhanger. While the nomination of Dan Quayle in 1988 was a juicy story about a politician with Robert Redford looks and Gerald Ford skills, the final days of the 1984 election was a snorer. There was more danger—for a few days at least—of the public collapsing into fatal boredom over the campaign than of Americans lapsing into compassion fatigue over the spectacular death of India's prime minister. It wasn't the fact of Gandhi's death that provoked the attention, it was the manner of her death. She died at the hands of her Sikh bodyguards—news that, when released, prompted Hindus to batter and kill more than a thousand Sikhs by the day of Gandhi's funeral. The assassination story, already of some interest, turned into a dramatic tale of religious violence.

While President Zia's assassination never made the lead story in *The New York Times*, Prime Minister Gandhi's death and the aftermath of killing it provoked made the lead for four days in a row, only to get pushed off on the Sunday after her death—the day *The Times* reported on her Saturday funeral—by a story about the final election weekend. And television paid the news from India even greater interest. By the day after her death, ABC News had 18 people on the scene in India, including Pierre Salinger from Paris and Jim Hickey from Frankfurt, CBS had 15, including its chief European correspondent Tom Fenton, Richard Roth from Rome and Wyatt Andrews from Tokyo, and NBC had 15 as well, including Henry Champ who flew in from London and Lloyd Dobyns who came in from Tokyo.

That Sunday *New York Times*, though, signaled the handwriting on the wall for the Gandhi story. It ran three editorials that day: The lead one endorsed Walter Mondale in the election, the second castigated the Soviet Union for blaming the CIA for Gandhi's death and the resulting violence, and the third contrasted the "generous" response of "sympathetic Western donors" to the famine in Ethiopia with the "paltry" contributions of the Soviet Union. The election in two days had elbowed Gandhi off the front pages and the "pictures of children with distended bellies and listless eyes" from Ethiopia were to shoulder India out of the news as the international crisis du jour. In the news business, dying children will usually trump men acting thuggish.

The day after Indira Gandhi's death obituaries spoke of her as "one of [the] world's most powerful, controversial women." "Beneath the soft fold of her pastel saris," said another article, "was a steel backbone."[40] Few seemed surprised that she had been assassinated. She had so many enemies.

Indira Gandhi, born in 1917, the only child of Jawaharlal Nehru, independent India's first prime minister in 1947, grew up as her father's confidant, but not his obvious political heir. She became leader of India's millions almost by accident. She had been an able administrator of the bureaucracy of her father's Congress Party for a time during his years in office and after his sudden death from a stroke in 1964, she became the minister of information and broadcasting, a minor post. When Nehru's successor died two years later, the Congress Party bosses could not agree on whom to replace him with. They turned to Gandhi as an interim solution while the political struggle continued.

The first years were grim. Although she knew everyone there was to know in the political back rooms, she had little official experience. So at age 49, she began learning on the job. By 1971 she had found her stride. When civil war broke out in Pakistan, she helped the province of East Pakistan break away from West Pakistan to become the independent nation of Bangladesh. The quick victory won Gandhi the respect of many Indians, but it created grave social and economic problems as millions of refugees flooded into India.

Still, the dismemberment of Pakistan made India the undisputed power in South Asia. In 1974 Gandhi detonated India's first atom bomb, and began overtures to the Soviets for aid in rebuilding India's armed forces.

Then came crisis. In 1975 the courts convicted Gandhi of violating election laws. They canceled her election to Parliament and barred her from holding office for six years. While her opponents called for her immediate resignation, she declared a state of emergency. The constitution was rewritten, civil liberties were suspended, the press censored, and 50,000 people were arrested—student

demonstrators, union leaders and opposition politicians. For 20 months she suspended basic rights and became a virtual dictator. Then she called for elections. The opposition, united under the banner "End Dictatorship, Dethrone the Queen," triumphed.

But the opposition soon fell apart, and after a vigorous grassroots campaign, she swept back into power in January 1980, her party again winning two-thirds of the seats in Parliament. Six months later she lost her equilibrium when her favored younger son and anointed heir, Sanjay, was killed in a stunt plane crash.

The next several years were characterized by her maneuvers to bring India's 22 state governments into her party's camp. One method she employed in her divide-and-conquer strategy was to back an obscure Sikh sect in the rich and politically important Punjab, a province split between India and Pakistan in the partition of the country. The strategy backfired. Jarnail Singh Bhindranwale, a village preacher and militant exponent of Sikh nationalism, chosen because he was supposed to be too obscure to be a real threat, incited violence with his fiery rhetoric. Then, according to *The Washington Post*, he took "refuge with his well-armed supporters in Amritsar's Golden Temple, the sacred shrine of India's 12 million Sikhs, after being implicated in the murder of a Hindu newspaper editor and accused of a variety of security offenses."[41]

(India's Sikhs, comprise less than two percent of its total population, but they have a prominence and influence beyond their numbers. They comprise 52 percent of the population of Punjab state and 15 percent of the nation's civil service and army and 30 percent of the army's officers. At the time of Gandhi's assassination, the president of India, Zail Singh, was a Sikh, and the widow of Gandhi's son was Sikh. Sikhism was founded in the 15th century as a creed that blended elements of Hinduism and Islam. From Islam Sikhs took the notion of a monotheistic deity and from Hinduism they accepted the cycle of birth, death and rebirth and the idea of *karma*, which states that the nature of a person's life is determined by his or her actions in a previous life. Male Sikhs are distinguished by their religious customs of never cutting their hair or beard, covering their head with a turban of 15 feet of cloth, carrying a curved dagger and a comb and wearing a steel bracelet on their right wrist.)

While the followers of Bhindranwale stockpiled weapons in the Golden Temple and used it as a base for political sabotage and murder, causing hundreds of deaths, Indira Gandhi did nothing to assuage their demands. Finally on June 6, 1984, Gandhi ordered the Indian Army to invade the Golden Temple. According to *The New York Times*, "some battle-seasoned officers reported later that they had never had to face such withering gunfire from so small an enemy position."[42] Bhindranwale died in the fighting. After it was all over the

government claimed that 492 Sikhs and 93 soldiers had been killed; other accounts said that 220 soldiers and over 1,000 Sikhs had died. The battle which invaded the holy shrine, demolished the marble inlay and gilded dome and filled the sacred pool with bloated bodies created militants among Sikhs in India and around the world in a way that Bhindranwale's tactics could never have done.

After the attack, the Army occupied the Punjab for four months—which only further exacerbated the Sikh's feelings of oppression. Rumors that Gandhi and her son, Rajiv, were targets for assassination began to circulate. Gandhi professed not to be concerned. At the end of the summer, when asked if she could trust the Sikhs in her service, she glanced at one man, Beant Singh, and said, "When I have Sikhs like this around me, then I don't believe I have anything to fear." She reinstated Sikh soldiers—including her assassins-to-be, Beant Singh and Satwant Singh—as part of her personal security guards after they had been transferred in the aftermath of the Golden Temple assault.

That fall, Gandhi prepared to seek a fifth term as prime minister. On Wednesday, October 31, after days of campaigning, she woke up early in her private bungalow in Delhi and had breakfast with her grandchildren and her daughter-in-law, Sonia, as was her custom. Shortly after 9 A.M. she walked through the garden that led to her office for her first appointment that morning, an interview with British actor and director Peter Ustinov. Following her were five security men. She greeted Beant Singh and Satwant Singh who were stationed at the gates to the office compound. Beant Singh drew a .38 revolver and fired three times into her abdomen. Satwant Singh opened up with an automatic combine. Her bodyguards dived for cover. Gandhi lay on the ground, struck by 32 bullets. The two assassins calmly dropped their weapons. Beant Singh said, "I've done what I had to do. You do what you want to do." The two were led off to a nearby guardhouse, where they were shot by their guards. Beant Singh died immediately; Satwant Singh was critically wounded, but recovered to stand trial for the murder.

With Sonia cradling her head in the backseat of a car, Gandhi was taken to the All-India Institute of Medical Sciences, 20 minutes away. There were other closer hospitals, but AIIMS kept a stock of Gandhi's O-type Rh negative blood. No one warned the hospital that the prime minister was coming. Once they arrived, it took several minutes for an emergency team to be put together. An electrocardiogram showed faint traces of a heartbeat, but it was evident that there already was brain damage. Still, she was given oxygen, linked to a heart-lung machine and taken up to an operating room where surgeons began to remove the bullets. Her liver was ruptured, both intestines were extensively

damaged, one lung had collapsed and her spine had been severed. The surgeons gave her 88 pints of blood. As *Time* reported a young doctor saying, "They would not accept that she was gone." Finally at 2:30 that afternoon, five hours after she had been shot, she was officially declared dead. (The BBC world service had broken the news of the shooting within minutes of the event. By 11 A.M. Delhi time, the BBC was saying that she was reported to be dead. Indian radio, meanwhile, played Hindi songs.[43])

For two days she lay in state in her father's old mansion. Hundreds of thousands came to pay their respects. Early Saturday afternoon her body was transported in a gun carriage seven miles, to the banks of the Yamuna River. Mohandas Gandhi, Nehru and her son Sanjay had also been cremated there. Surrounded by foreign dignitaries, her family and a throng of Indians, her flower-covered funeral pyre was set afire by her son, Rajiv. Her face was visible among the flowers and sandalwood.

In the days between her death and her funeral, many in the media repeated her prescient words the day before her death, when she spoke to a political rally in the eastern state of Orissa. She recalled that on the previous day someone had hurled a rock at her. "But I am not afraid of these things," she said. "I don't mind if my life goes in the service of the nation. If I died today, every drop of my blood will invigorate the nation. Every drop of my blood, I am sure, will contribute to the growth of this nation to make it strong and dynamic." Although she was no Martin Luther King, Jr., her portentous phrases recalled to some the equally prophetic speech of King's the evening before his assassination. "Like any man, I would like to live a long life," he had said. "But I'm not concerned about that now. . . . I've seen the promised land. I may not get there with you. But I want you to know tonight, that we, as a people will get to the promised land." *Time* magazine commemorated Indira Gandhi's death with a painting of her on its cover, and as its headline her words, "If I die today, every drop of my blood will invigorate the nation."[44]

The New York Times finessed the description of Pakistan's President Mohammad Zia ul-Haq in its editorial the day after he perished in the plane crash. "The catch phrases," the editors said, "were largely correct. He was a strong man, a devout Moslem certain it was his mission to impose unity on a fractious country. He brooked no rivals, groomed no heirs." Others were not so diplomatic. The *Chicago Tribune*'s editorial bluntly called him a "military strongman" and the *Los Angeles Times* said he "was a brutal politician who hanged his predecessor, ordered his opponents flogged, called and then canceled elections on whim and seemed unable to tolerate any semblance of democracy."[45]

Like Gandhi, the death of Zia came as no surprise. "Who Killed Gen. Zia?" asked *Newsweek*'s headline in its story after the crash. "Many people might have wanted Zia dead," it answered. Then the article proceeded to count the possibilities: "the Soviet Union and its client government in neighboring Afghanistan"; "India, another longtime foreign foe"; and "inside Pakistan, political opponents and religious adversaries."

USA Today even made a graphic out of the potential assassin candidates entitled "Presidential Enemies." It included three possibilities on its list: "The Afghanistan secret service, because of Zia's support for rebels"; "Afghan rebels unhappy with Zia's support of an Islamic fundamentalist state in Afghanistan" and "Abu Nidal terrorists responsible for the hijacking of a Pan Am plane two years ago—now on trial in Pakistan. Zia urged the death penalty for them."[46]

Clearly, there was plenty of latitude for speculation and tales of conspiracy and terror.

General Mohammad Zia ul-Haq had none of the hereditary authority in Pakistan that Indira Gandhi wielded in India. His power base was in the Punjabi-dominated Pakistan Army, a massive force of almost half a million men. After West Pakistan's military defeat in 1971 with India when it lost East Pakistan, the strength of the military within the new and smaller Pakistan quickly recovered. The debacle of 1971 led to an organizational restructuring within the army and to an emphasis on the higher education of army officers. Many within the officer corps were exposed to the Islamic doctrine of the Jamaat-e-Islami, the party of the religious right which dominated most campuses. By the mid-1970s, said political scientist Shireen Mazari, the army had lost its neutrality and its ability to act independently of any particular political group.[47]

Born in 1924 in a middle-class family in East Punjab, Zia served as an enlisted man under the British in World War II and saw action in Southeast Asia. Later, he graduated as a lieutenant from the Royal Indian Military Academy in May 1945, in the last class of officers to be commissioned before Britain granted independence to India. In partition his home remained part of India, and so, as a devout Muslim, he decided to move to the new nation of Pakistan.

His career was in the armed forces, where he specialized in the command of tanks and artillery. He attended the United States Command and General Staff College at Fort Leavenworth in the early 1960s. Soon after Bangladesh's independence, the now General Zia got his foothold in the political hierarchy. Prime Minister Zulfikar Ali Bhutto promoted him over the heads of several more senior officers to make him Army Chief of Staff. During the next several

years Bhutto became increasingly repressive. He rigged the 1977 elections to secure 80 percent of the vote, convincing those who had continued to support him that he intended to create a dictatorship. People rioted in the streets. Bhutto panicked, declared martial law in the three major cities and ordered troops to fire on his opponents as they came out of the mosques after Friday prayers. The army refused. Finally in the early morning of July 5, in an operation code-named "Fairplay," General Zia led a military coup and put Bhutto under house arrest.

Zia imposed martial law but promised civilian elections within 90 days. But when Bhutto was freed, his charisma made it likely that he would be re-elected. So Zia canceled the elections and charged Bhutto with conspiring to murder an opposition politician three years earlier. Bhutto was convicted of the crime and his appeal to the Supreme Court went against him. Convinced that even while locked up Bhutto posed a threat, Zia authorized his execution. Bhutto was hanged on April 4, 1979, over the protests of governments around the world. The execution was a mistake. In one act, Zia turned Bhutto from a ruthless leader into a martyr.

In search of legitimacy for his regime, Zia launched a program of Islamiza-tion to make Pakistan a theocracy. Zia hoped that religion could hold the coun-try together in the face of persistent internal rivalries and ethnic independence movements in the individual provinces. The loss of West Pakistan haunted the still new nation. But Westernized elites charged that Islamization only further divided an already divided society. As Christina Lamb, correspondent for the British *Financial Times*, noted: "Even in Pakistan today, its people call them-selves Sindhis, Baluch, Pathans first, Muslims second and finally Pakistanis."[48]

Then, on Christmas Eve 1979 came Zia's salvation in the guise of the Soviet invasion of Afghanistan. Pakistan became of sudden critical importance to the superpowers. Overnight the man whom Bhutto's daughter, Benazir, called a silent-film-style villain, became a heroic defender of the free world. Zia was said to have described the invasion as "Brezhnev's Christmas present." He pledged Pakistan's support to the Afghan rebels in their attempt to push the Soviets out.

Western aid, especially from the United States streamed in. Under the Rea-gan administration Pakistan became a cornerstone of the Reagan Doctrine aimed at pushing back the influence of communism in the developing world (although there was continual strain over whether Pakistan was clandestinely developing a nuclear weapons program). Between 1981 and 1988, Pakistan was granted or promised more than $7 billion in military and economic aid, making it the third largest U.S. aid recipient—after Israel and Egypt. At least

$2 billion more in covert aid was channeled through Pakistan to the Afghan rebels seeking to topple the Soviet-backed Kabul government.[49] But along with the money came drugs and weapons that only added to Pakistan's social problems.

And adding to Zia's personal problems was the emergence of the Harvard and Oxford-educated Benazir Bhutto, who began touring the country preaching her father's message. In a subcontinent inspired by political dynasties, she began to attract large crowds. Zia countered with prison spells and house arrests for her and her mother. In 1984, Benazir left for exile in London.

The following year, pressured by the Americans, Zia allowed the election of a National Assembly and handpicked an unknown mango farmer for prime minister. The new National Assembly and prime minister gave a handy veneer of democracy to his regime. Gorbachev had come to power and was making noises about withdrawing the Soviet troops from Afghanistan. If that happened, Zia knew that his international standing would plummet.

Then in the spring of 1986, Benazir triumphantly returned, having tutored herself in the process of overthrowing dictatorships by watching tapes of Corizon Aquino's movement in the Philippines. She drew record audiences around the country. Zia believed she was backed by the Americans; he felt the United States, surreptitiously through the CIA, was trying to oust him.

Five months later, in the spring and summer of 1988 three crises occurred in quick succession. On April 10, a series of explosions destroyed a weapons depot used as a transit facility for arms and ammunitions for the Afghan rebels. The explosions triggered an unchecked rain of missiles that randomly hit targets in the twin cities of Islamabad and Rawalpindi. By the time the pyrotechnics were over, 7,000 tons of bombs had been destroyed, 100 had died and 1,100 had been wounded. Two hundred bomb disposal teams combed the area for days to defuse live bombs. An inquiry commission uncovered security lapses, lack of a fire-fighting system and administrative failures, among other problems. Still, Zia called the incident an act of sabotage by the Soviets and the Afghan secret police.

On May 29, Zia dissolved the 3-year-old government, charging it with incompetence, corruption and indifference to Islam. Few believed national elections would be held; there was too great a chance of Benazir Bhutto winning. Indeed Zia had chosen the date for the election in mid-November, to coincide with her final month of pregnancy. (But Bhutto and her doctor had fooled Zia; she was actually due in September, not December, giving her time to campaign for the November 16 date.) Since Pakistan has a parliamentary

system, another way to forestall Bhutto's success was to prevent her party from winning broad-based support. So in July, Zia announced that candidates for the November election could not identify themselves with a political party.

Then on Wednesday, August 17, 1988, Zia and 16 other generals, as well as U.S. Ambassador Arnold Raphel, a South Asian expert who spoke fluent Urdu, and the U.S. Defense Attaché, Brigadier General Herbert Wassom, went to the Pakistan desert to review the performance of an American-made tank. The tank missed its target.

For varied reasons, after the demonstration almost all of the VIPs decided to travel back with Zia on Pak One, a C-130, a reliable workhorse of an airplane. Within four minutes after take-off, the control tower lost contact with the hand-picked pilot. According to villagers on the ground, the plane was engulfed in a ball of fire and then plummeted to the earth. All aboard were killed.

The Pakistani officials charged with investigating the crash immediately claimed "foul play." "What else could it be?" asked the information minister. Some thought the army itself must have been involved, as they were the only ones to have had access to the plane. Rumors circulated that a box of mangos, Zia's favorite fruit, which were placed on the plane at the last minute, contained a bomb. Others suggested that the pilot who was Shia deliberately crashed the C-130 in retaliation for the assassination of Shia leaders a few weeks earlier. Indian missiles were considered as well as sabotage by the Soviets or the CIA—notwithstanding the deaths of the two Americans. Even Benazir Bhutto's forces were suspect; Bhutto had called the crash "divine retribution," and said, "I do not regret the death of Zia."[50]

No autopsies were carried out on the plane's crew members and the hospital was ordered to return the remains the day after the crash. Despite the death of the U.S. ambassador and the defense attaché, Secretary of State George Shultz recommended that there be no FBI inquiry. The United States sent only six Air Force investigators, who, together with the Pakistan team, later concluded in a 350-page report that "in the absence of technical reasons that explain the cause of the mishap," the crash "was most probably caused through the perpetuation of a criminal act or sabotage." Traces of chemicals that could have been from a poison gas and others that could have been used to make an explosive detonator were found.[51] According to British journalist Lamb, the U.S. State Department admitted the following year that there had been a cover-up so as not to "rock the boat in an unstable political situation."

As Lamb said, "No one knew who had done it and few seemed to care. Zia's death was just too convenient. The Americans had started to say he was a liability,

distrusting his talk of an Islamic Confederation and his unswerving support for the fundamentalists among the Afghan *mujaheddin*. The Soviets were eager to stop his support for the *mujaheddin* and felt Bhutto would favour a negotiated settlement and an early end to the conflict."[52]

The day after the crash, Pakistani Army honor guards escorted back to the capital the series of plain wooden crates, the dimension of coffins, covered with wreaths of flowers and draped by the national flags. As foreign dignitaries arrived for Zia's funeral on Saturday, the American media generally observed that "there have been no noticeable outpourings here of public grief" over his death. *The Washington Post* continued, "Nor has there been an upsurge in violence. Instead, the country has remained unexpectedly calm and quiet."[53] Zia's funeral, broadcast live on Pakistani television was held in Islamabad outside the modern, newly completed King Faisal Mosque, a gift of the Saudis. A gun carriage carried his casket the five miles from the presidential residence to the mosque. Thousands lined the streets. Diplomats from more than 70 nations, including 30 heads of state, stood for the two-hour ceremony, sheltered from the intense August heat by an open-sided tent cooled by electric fans.

Secretary of State Shultz carried the remains of the U.S. ambassador and the defense attaché aboard his plane back to Washington that evening. Ambassador Raphel was buried at Arlington National Cemetery on Monday the 22nd. Brigadier General Wassom was buried there the following day.[54]

The first full day of coverage after the "assassinations" of Prime Minister Gandhi and President Zia the pre-eminent story, of course, was the simple news of the deaths. But two other key types of stories accompanied those that detailed the assassination event: Most prominent were those that outlined the expected effect of the death on the United States—"Pakistani's Death 'Major Blow' to U.S." said *USA Today*, for example. These stories were just the first symptom in the Americanizing of the assassination events.

Less prominent than the U.S.–related stories were those that introduced the known or expected successor to the slain leader—"Son in Charge in New Delhi" said *The New York Times*, for example. Other lesser stories filled out the first day of coverage: extensive biographical obituaries of Gandhi and Zia, reactions from world leaders—including the formal message of condolence from the United States—and assessments about how the deaths would affect the region. Brief speculation about the causes of the death—Sikh revenge or sabotage—appeared, but just in passing.

Stories unique to the individual news events also appeared. Because Gandhi's death came in a year of multiple assassination attempts, trend stories

surfaced. That first evening, for example, *ABC World News Tonight* ran a two-minute piece at the end of their newscast on political assassinations, mentioning the deaths of John F. Kennedy, Anwar Sadat and Bashir Gamayel of Lebanon and the recent attempts on the lives of Margaret Thatcher and Pope John Paul II. Gandhi's assassination also prompted articles and television pieces on India's turbulent history and on the political dynasty of which she was a part. *CBS Evening News*, for instance, ran a commentary on the justification of violence through religion and used examples that brought the topic home to Americans. In addition to the Sikh revenge killing of Gandhi, the commentary mentioned the U.S. Marines' rationale for being in Lebanon, the Army of God's threats against Supreme Court justices and a Michigan campaign focusing on Jews versus fundamentalist Christians.

Zia's death also prompted some unique coverage. Since it was not clear whether his death was an assassination or an accident, the first-day stories finessed that point, saying, as did the lead article in *The Washington Post*, that "'sabotage cannot be ruled out' as the cause of the explosion."[55] And since he did not die alone, stories on the two Americans who were killed in the crash accompanied the pieces on Zia's death. The bios of the ambassador and the defense attaché didn't make the front pages or the top of the news, but the stories were conspicuous in the inside coverage or later in the television packages.

If the first stage of coverage was the first full day following the deaths of the two South Asian leaders, the second stage consisted of the intervening days until the funeral. Since both Gandhi and Zia died on a Wednesday and were buried on a Saturday, the second stage was effectively two days long.

In both instances the immediate circumstances of the deaths took a backseat to other related events. Mourning for the deceased received attention — more so in Gandhi's case, as her body lay in state, although numerous media outlets covering Zia did follow the story of the recovery of the bodies at the crash site and the military escort of them back to the capital of Islamabad. The compelling visuals of Gandhi's bier and Zia's wooden coffin, prompted many in the print media to consign their reporting on the public mourning to large photographs and descriptive captions. Television, of course, made greater use of the dramatic funerary images.

Preparations for the funeral ceremonies were also mentioned in this two-day span — especially the arrival of the U.S. and other foreign delegations. And follow-up pieces on the expected effects internationally and domestically of the loss of the two heads of state discussed, for example, India's ties with the two superpowers, the survival of democratic institutions in India, Pakistan's relations with Afghanistan and the likelihood of the holding of the November

elections. Blame leveled at the superpowers for the crimes also received attention: "Moscow Hints CIA Behind Assassination," said *The Post* in covering Gandhi's death, and "Soviet Newspaper Rejects Notion of Moscow Role in Death of Zia," said *The Times*. But all of these sundry stories tended to be relatively short and relegated to deep inside the newspapers or well into the broadcast stories.

During these two days, the media reserved their greatest attention for the most dramatic of the repercussions: the overtones of sabotage after the Pak One plane crash and Hindu-Sikh violence following Gandhi's assassination. The networks focused on the mystery behind Zia's crash on the second day—although they buried the story deep in the half hour. But by the third day, only two of the three evening news programs—ABC's and CBS's—included even a newsbrief from Pakistan. Both pieces flashed on Secretary of State Shultz's arrival in Pakistan. Following Gandhi's assassination, by contrast, the violence led the TV news on both day two and three. The networks also upped the ante on the violence, suggesting a more global dimension to its outbreak by linking the events in India with global terrorism. On Thursday, November 1, for example, ABC ran a minute and a half commentary early in the broadcast contrasting terrorism with political violence. Three assassinations were compared: Indira Gandhi's, Abraham Lincoln's and John F. Kennedy's.

Both the print and electronic media upheld the standards of crisis coverage in these two days: Conflict and violence led the news and connections between the foreign events and the United States were stressed.

The third stage of coverage, the day of the funeral, harkened back to the first stage, the first full day of coverage after the two deaths. The media, both print and television, returned to a focus on the dead: the funeral processions, the ceremonies of cremation and burial, the eulogies—especially by American representatives and by the national leaders—and the mood of the population.

And just as the days of the assassinations were distinguished by newspaper editorials on the deceased, the funeral coverage was augmented by news analysis that appeared in the week-in-review sections, since both Saturday funerals were covered by the newspapers in their Sunday editions—with the exception of the *L.A. Times*, which managed to include the funeral in its Saturday paper. The news analysis often made the American connection: "Now Is the Best Time for the Americans to Push Democracy," argued a *New York Times* Week in Review article.

It was on this day, too, that several periodicals chose to make an explicit link to terrorism. On the day of Gandhi's funeral, Janet Cawley wrote a story in the

Chicago Tribune headlined "Terror Has Been Drawing a Bead on Many World Leaders Since '80." That same day R. W. Apple conflated terrorism with assassination in a *Times* front-page article, titled "Terrorism Changes the Way World's Leaders Live." "World political leaders," he wrote, "are finding it more and more necessary to adopt rigorous measures to protect themselves against terrorists and assassins."[56]

After the funeral, television dropped the Gandhi and Zia stories—including all their permutations—within three days. They lingered longer in the newspapers, but not much. This fourth-stage consisted of mop-up stories that featured the final events in the funeral saga: the collection of Gandhi's ashes and the burials of the two Americans who died in the Zia crash. They discussed the continuing—but diminishing—violence in India and the continuing investigation of the downing of the C-130 in Pakistan. They covered, perhaps more aggressively, the trials of succession and the elections that were to be held shortly in both countries. And, also receiving significant attention in 1988, was a just-released State Department study charging that international terrorism was up 7 percent from the previous year—again linking the region with terrorism. *The Washington Post*, one of those which reported on the study, said in its lead that the year's rise was "largely as the result of attacks in Pakistan by agents of Afghanistan's Soviet-backed government. . . . 'designed to deter the government of Pakistan from aiding resistance fighters in Afghanistan.'"[57]

The civilian autocrat Gandhi and the military dictator Zia could not personally be easily compared to the great fallen leaders of United States history, as Sadat and Rabin were. So the media, deprived of the most obvious method of gaining Americans' interest in the crises, turned to other, almost generic, story lines. They carried the dramatic rituals of death and mourning. And they discovered violence and mystery. The holy wars in the streets, the cloak-and-dagger conspiracy theories, the romance of the Nehru-Gandhi dynasty, the intrigue of Zia, the devious strongman, the exoticism of a Hindu funeral pyre and even the brooding presence of the Soviet evil empire in Afghanistan all contained elements known for their perennial appeal. But the media was not especially sanguine about even these topics holding Americans' attention for long. They viewed the religious turmoil in India as perhaps the most compelling of the stories—judging by the relatively greater coverage of that story line—but they did not believe that India's bloody battles could capture Americans' interest for long. Because most Americans know little about Hindus and Sikhs (and because most Americans don't know any Hindus and Sikhs), the impulses behind the conflict remained relatively abstract for the public. Violence carried the media in the days between the death of Gandhi and

her funeral, but then—with the exception of the newsmagazines, which hadn't even begun their coverage of the story yet—the media dropped it. The media pre-empted their audiences' compassion fatigue.

When the print and TV coverage of Gandhi's and Zia's deaths is compared, it becomes evident that much more space and time was expended on the Gandhi story—notwithstanding the deaths of the two Americans in the Pakistani crisis. It wasn't just the drama of violence nor the immediate identification of the Sikh assassins and their motives for killing Gandhi that prompted the greater cover-age. Most critical in the media's allotment of space and time was the greater familiarity that Americans had with India. Americans are always more interested in reading or looking at news of those foreign countries of which they have some knowledge.

Americans hadn't learned about India through reading newspapers or watch-ing the network news. And it wasn't that India had historically received so much more attention in the media than Pakistan. Indeed, even the former *New York Times* correspondent for the region observed, "As with many other Third World nations, India is 'news' mostly when there is bad news to report. Otherwise, India often vanishes from the global radar screen."[58] No, American knowledge about India came from a recent flurry of movies and television miniseries prior to the assassination on Halloween 1984. Richard Attenborough's blockbuster *Gandhi* about the Indian independence leader had been released in 1982, and the following year had won eight Oscars, sweeping most of the major awards, including best picture, best actor, best director and best screenplay. As a result of its acclaim, it had a second life in the theaters in 1983. Then in 1984, just two months before Indira Gandhi was assassinated, the film made its cable debut. Although Indira Gandhi was no relation to Mohandas Gandhi, their sharing of a name and their similar manner of death by assassination provoked déjà vu in the audience that witnessed both the *Gandhi* film and the Indira Gandhi assassi-nation.

1983 also saw the release of James Ivory and Ismail Merchant's film *Heat and Dust*, starring Julie Christie as an Englishwoman in India. And two television dramas about India aired in the spring of 1984. HBO spent $12 million to trans-late M. M. Kaye's novel *Far Pavilions* to the small screen. *TV Guide* featured the three-night miniseries, which began on April 22, on its cover. In those homes that received cable the Indian epic received a rating of 23.8 and a 33 share, beat-ing the networks. A month later, on May 16, CBS aired its made-for-television three-hour movie of Rudyard Kipling's *Kim*, starring Peter O'Toole, John Rhys-Davis and Bryan Brown as three of the lead characters.[59]

The movie and television industries had Americans primed for epic and tragedy in India. The various big- and small-screen films had given their audiences a passing knowledge of Indian history and culture and a passing enthusiasm for things Indian—for example, after the success of *Gandhi* at the Oscars the fashion industry appropriated the look of both its floating saris and its khaki uniforms. It was enough so that when the news of Indira Gandhi's assassination broke, American media institutions could count on a basic level of interest from their readers and viewers.

As was to happen with the Ebola outbreak in 1995, American popular culture helped to make the Gandhi story the lead article or a top-of-the-news piece for four days—considerably longer and more prominently placed than the story of President Zia's death. Still, the media counted on compassion fatigue kicking in if the news from India lingered too long—a film-industry aura can cast its magic only so long. Soon, went the implicit argument, the cinematic-style Indian tragedy would become just one more pedestrian incidence of violence. Better to dump the story, before the audience dumped the media.

Gandhi and Zia were problematic figures for the media. Instinctively it seems appropriate to style an assassination a tragedy, to call a fallen leader a hero and to characterize an assassin as evil incarnate. But what was to be done in Gandhi and Zia's case? They weren't all bad, certainly, but they hardly epitomized sweetness and light. They weren't warriors turned peacemakers like Sadat and Rabin, although they could be—and were—called martyrs.

The media weren't as obviously partisan in their coverage of the assassination events in India and Pakistan as they were in Israel and Egypt, but they weren't neutral either. Unable to unequivocally praise or condemn Gandhi and Zia, the media emphasized Gandhi's and Zia's roles in maintaining a social order congruent with American values and interests. A day after Gandhi's death, *USA Today*'s front-page story noted: "Reagan, hailing Gandhi as leader 'of the world's largest democracy and chairman of the non-aligned movement,' praised her for promoting 'peace, security and economic development.'" And in the first-day, front-page article in *USA Today* announcing Zia's death, these were the only two quotations: "Said Ray Cline of the Washington-based U.S. Global Strategy Council: 'The loss of Zia will be a major blow to American interests in the region,' and 'Zia,' said Jeanne Kirkpatrick, former U.S. ambassador to the United Nations, was 'very important to the freedom fighters of Afghanistan.'"[60]

Gandhi and Zia were also portrayed as inseparable from their countries' identities; their faults were their countries', their virtues were their countries'. "'Indira Is India,'" read a headline in *The Washington Post*. "For 11 years, Zia

was Pakistan," said an article in the *Chicago Tribune*.[61] Good guys, guys who Americans like who get assassinated, such as Sadat and Rabin, are universalized. They surmount their surroundings. Bad guys or so-so guys who get assassinated, such as Gandhi and Zia, are localized. They are a product of their environment.

For both events, dramatic storytelling featurized the news; it brought an audience into the events through the same techniques that novelists use. Headlines and text were reminiscent of mysteries and thrillers. "Death in the Garden" was *Time*'s headline for Gandhi's assassination. "Death in the Skies" was theirs for Zia's. Numerous stories, especially in the newsmagazines, theatrically set the scenes immediately before the fatal shots or fatal crash. For example, *Newsweek* began its article on Gandhi's assassination with this lead: "Indira Gandhi had spent the early morning with two of her grandchildren. Now it was time to leave her bungalow and stroll the hundred yards or so through the garden to her office. . . ." The lengthy paragraph ended evocatively: "The constable snapped down the muzzle of his sten gun and sprayed her with bullets. The prime minister spun around with a quiet little gasp and crumpled to the ground, her saffron-colored sari already soaked with blood." And *Time* started its story with these sentences: "*Namaste*, in Hindi, means 'Greetings to you.' . . . At 9:08 last Wednesday morning, Indira Gandhi folded her hands in front of her face, looked at the two guards standing along the path to her office and said, '*Namaste*.' It was to be her last word."[62]

Four years later, this was *Newsweek*'s lead for Zia's death: "The camouflage-painted C-130 transport lifted off routinely from the airfield. . . . It climbed to about 5,000 feet without any sign of trouble. But then the four-engine plane suddenly cartwheeled back to earth, exploding somewhere on the way down and crashing in flames." *Time* began its article with these words: "Mohammed Zia ul-Haq spent his last hours on a dusty patch of desert. . . ."[63] Any one of these four beginnings could easily be mistaken for the opening gambit of a suspense novel or screenplay.

A second method the media used to draw their audiences into the distant crises was to make the American connection, to relate South Asian personalities to American personalities (like Sikh farmers to Midwestern farmers), to linger on American involvement (was the CIA complicit in either situation?), to emphasize the comments of American officials at home (such as President Reagan and Henry Kissinger) and the condolences of the American delegations to the funerals (led on both occasions by Secretary of State George Shultz), and most tellingly to reference iconic American assassinations—directly or implicitly. For example, in the second paragraph of *Newsweek*'s story on Gandhi,

immediately after she "crumpled to the ground," the reporters reminded Americans of the assassination attempts on Presidents Reagan and Kennedy: "The rest of the drama," they wrote, "followed a sickeningly familiar pattern: the struggle with the assailants, the frantic rush to the hospital in a blood-spattered car, the operating room full of desperate surgeons trying everything within the scope of their skill and technology. Sometimes on these occasions, the victim is saved, as were President Reagan and Pope John Paul II. This time, after five hours of heroic but hopeless measures, an official of Mrs. Gandhi's Congress (I) Party appeared before a crowd of 100,000 Indians waiting outside the hospital and announced simply: 'She is no more.'"[64]

The Americanizing of the crises brought the disasters home; it made Americans feel they had an investment in the story. But the third tactic of defining the assassinations as terrorist acts managed that feat even more effectively. Numerous media outlets reported that Gandhi's death "was being widely interpreted . . . as part of a conspiracy by Sikh terrorists." And when *The Washington Post*, for example, mentioned the earlier Army attack on the Golden Temple, the paper called it an "incident" to "quell an outbreak by Sikh terrorists"—in other words, Gandhi's role was downplayed to an "incident," but justified even so by the actions of "terrorists."[65] Most worrisome, however, was this sentence in a *New York Times* page-one story the day after Gandhi's death, written by William Stevens, *The Times*'s New Delhi correspondent for the previous two years: "Some say," he wrote (although he didn't let us know who "some" are), "Some say they fear that Sikh terrorism might convert the wealthy but unhappy breadbasket state [of Punjab] into a Northern Ireland on the Subcontinent."

In the aftermath of Zia's death too, according to the media, the specter of terrorism menaced the subcontinent. "The possibility of terrorism lurked below the surface on a bright day when families went to picnic in the parks," wrote Barbara Crossette in *The Times* two days after the Zia's plane crash.[66] "Terrorist conspiracies" were believed to be responsible for the crash—although since there was no clear indication who was to blame for the explosion and crash, the naming of those responsible as "terrorists" meant little—except to scare the American audience.

Most quoted sources put their money on the Soviet-backed Afghan secret police, the Khad, since they could be blamed without "antagonizing anybody they don't want to antagonize," noted Paul Kreisberg, a senior associate at the Carnegie Endowment for International Peace. The Khad, already blamed by the U.S. State Department for two-thirds of the world's state-sponsored terrorism

in the past year, seemed the perfect culprit. There was just one problem. The organization had not previously been known to employ terrorist tactics against specific officials; their signature had been marketplace bombings. According to the State Department report released the week of the crash, Afghan intelligence had killed or wounded 1,400 people in Pakistan that year, the world's second highest number of terrorist victims after Beirut. But not one of those victims had been targeted for being in the government. Kreisberg, for one, didn't believe the Khad was at fault in the Zia crash. "There are so many middle steps they could have taken," he said. "This is like moving from hammer strokes to a giant TNT detonation of a bridge. You have to ask why they would have done it this way. I can't understand why."[67]

Although a fiery plane crash is arguably a very dramatic way to die, the Zia story suffered from a lack of visual excitement. The explosion and plummet of the airplane were not captured on tape, so the most evocative images from the four days following Zia's death were of military investigators at the crash site and of the tall honor guards carrying the rough wooden crates bedecked with flags and flowers.

The events surrounding Zia's death were just not very photogenic—or those events that were, were not documented. Many articles in print ran without photographs or with head shots or posed images of the various characters: Zia, Bhutto, Raphel, George Shultz. And television gave the story essentially perfunctory coverage. Visually, it was all pretty boring. Given the options, it was surprising that of all the print sources surveyed only *The Washington Post* ran a photograph of the wreckage of the C-130. Their image, from Agence France Presse, illustrated their Friday front-page article announcing the recovery of the bodies of Zia and Raphel. Since the C-130 had effectively disintegrated on impact, the wreckage in the photograph was not identifiable as that of an airplane. But it still clearly communicated that some disaster had occurred.

Gandhi's assassination, by contrast, offered much more arresting visuals—a fact exploited by the greater television and print coverage. Roughly twice as much time and space was devoted to her in the four days between her death and funeral than were devoted to Zia four years later. And it helped that every day, new, compelling images were available. From the start the events surrounding the assassination had sufficient visual interest that ABC's *Good Morning America* scrapped all two hours of its scheduled show on Wednesday, just hours after the news of her death. "If we had put on Suzanne Somers and Raquel Welch, it wouldn't have been appropriate," said a spokesperson for the show. The producer, Amy Hirsh, said, "We made a decision early (in the) morning. I assumed

the other news shows were doing the same, and they didn't." NBC's *Today* show ran features on modern-day witches and vampires. *CBS Morning News* went ahead with a Paul McCartney interview.[68]

The Gandhi story broke in the middle of the night, Eastern time. *Nightline* interrupted ABC programming at 2:30 A.M. with a special on her death. In print that Wednesday, the newspapers had only had time to insert file photos into their breaking-news articles which had come in on Tuesday night's deadline. But by the next day, they showed pictures of her dead face as she lay in state, they ran maps of the garden through which she walked to her death, they included images of Sikhs celebrating and already of Sikhs being attacked—in addition to the more conventional photos of her son and heir, Rajiv, and the historical images that accompanied her obituaries.

That first day television quickly moved its people to India to cover the days of mourning and also—as it turned out—to cover the days of rioting. ABC News correspondent Mark Litke was "roughed up" and its crews lost equipment and tapes to angry crowds in New Delhi. CBS News also reported on the violence, but a spokesperson said that none of the "pushing and jostling . . . seems directed towards the news organization. However," he admitted, "it makes it difficult to maneuver and the local drivers working for us are fearful." NBC News, by contrast, said that their people had suffered "no hassles whatsoever," nor had "any problem getting our stuff in and out of New Delhi."[69]

But by the weekend all the journalists were running into trouble. The international media had no difficulty beaming images of the Saturday funeral worldwide—NBC even carried the funeral live to the United States—but it was stymied in getting pictures of the violence out of the country. Since the Indian Army's battle at the Golden Temple, foreigners had been forbidden from traveling to the Punjab, complicating the American media's news gathering about reaction to Gandhi's death in the home state of the assassins, Beant Singh and Satwant Singh. (Although many American news organizations circumvented the restriction by asking their Indian stringers to go into the region. *The New York Times*, for example had Pranay Gupte, who had worked for *The Times* from 1970 to 1982, cover the Punjab.[70])

Other problems also hampered news gathering—particularly of a visual nature. Television networks were unable to arrange satellite feeds and several news organizations, including *Time* magazine, had film confiscated at the New Delhi airport. Three photographers, Dieter Ludwig of the Paris-based Sipa Press photo agency and Alon Reininger and Dilip Metha, both on contract to *Time*, were attacked and beaten as they were trying to take pictures of several men dragging

a body across the street. About 60 policemen sitting ten feet away did nothing. *CBS Evening News* on Saturday evening opened with the story of Gandhi's funeral, but then it reported on the Hindu-sponsored censorship of photography; the program ran a piece on Derek Williams's effort to film a truckload of Sikh corpses. On Monday, the Indian Foreign Office called in both the American ambassador and the British high commissioner to protest American and British TV coverage of the violence, which the Foreign Office said showed Sikhs "rejoicing and drinking champagne" and "inciting people to riot and murder."[71]

Certainly the images that made it back to the States of the mob violence—of the crowds rioting in the streets, of burning corpses in the train stations, of piles of bodies in the morgues—would have been gripping even without the initiating fillip of the assassination. And the images directly relating to Gandhi's death and funeral were also unusually compelling—of her uncovered face and her body wreathed in flowers resting on top a Soviet-made howitzer in the cortege to her father's house, of close-ups of her profile as she lay in state, of her son and family, torches held high, lighting the sandalwood funeral pyre. The pictures captured not only the death of the leader of one of the world's most populous countries, but the novelty (to Americans, at least) of the Hindu funeral rites. *Newsweek* in its Christmas issue featuring the "Images of 1984" ran just four photographs in its International section; one showed Rajiv Gandhi setting ablaze his mother's pyre.

For distinctive reasons, neither Gandhi's nor Zia's death offered many direct parallels with the mythic assassinations of Kennedy and Lincoln. Not in person or personality, nor in motive or method were the events very similar—although in both situations a certain few elements did resonate (the race to the hospital, the death vigil, the military caissons carrying the bodies to the funerals, the foreign dignitaries paying tribute). But if the occasions were all too different from the American icons, the coverage still fit an assassination formula. The media covered only the span from death to funeral, then dropped the story—with the exception of a relatively few wrap-up pieces. They treated the deceased kindly— if not precisely as his or her mother would like, than at least more positively than the cold facts should have warranted. They emphasized the American investment in and connections to the country. They played up the controversial aspects of the four days: the assassin conspiracy theories, the oppositions' responses, the public's reaction (either frenzied violence or uncanny quiet). And, especially, they drew linkages between the act of assassination and acts of terrorism.

The week after Gandhi's death, at the end of its 12 pages of coverage of her assassination, *Newsweek* ran a one-page article by David Gelman and Peter

McKillop headlined "The Assassins: Terror Breeds the Politics of Homicide." In it Gelman and McKillop conflated assassination with terrorism. They casually juxtaposed the suicide bombing of the Marine barracks in Lebanon with the man who attempted to assassinate the pope, and the Israeli "retaliatory air strikes" against Arab "terrorism" with the murders of Indira Gandhi and the Philippine opposition leader Benigno Aquino. "There may be no way, ultimately," they said, "of deflecting an impulse as old as the stabbing of Julius Caesar, as recent and ruthless as the shooting of Indira Gandhi." Terrorism and assassination threaten us all. "The very fact that, short of nuclear apocalypse, large-scale wars no longer seem possible may account for the small wars of attrition being waged by assassins and terrorist groups. Rising waves of nationalism and religious zealotry are also helping to foster a kind of homicidal politics."[72]

Coverage of homicidal politics can keep compassion fatigue at bay for a while. Random acts of violence that pose little or no threat to the larger community of nations are routinely ignored. But homicidal politics—terrorism—will get the juices flowing. The media's coverage of assassinations is ultimately like their coverage of epidemic disease. Only those diseases that pose a perceptible risk to Americans receive much attention. Those assassinations that are construed as posing the greatest risk to American well-being are those assassinations that are the most assiduously covered.

DEATH IN THE MIDDLE EAST: EGYPTIAN PRESIDENT ANWAR EL-SADAT, THURSDAY, OCTOBER 6, 1981 & ISRAELI PRIME MINISTER YITZHAK RABIN, SATURDAY, NOVEMBER 4, 1995

"Lincoln, two Kennedys, King, Gandhi, Sadat, and now Yitzhak Rabin joins the list of great world leaders felled by a madman's bullet," wrote Michael Goodwin in the New York Daily News the day after Rabin's assassination. "In my lifetime," said CBS's house curmudgeon, Andy Rooney, a week after Rabin's death, "there have been seven significant assassinations: John F. Kennedy, Robert Kennedy, Martin Luther King, Medgar Evers, Mahatma Gandhi, Anwar Sadat and now Yitzhak Rabin."[73]

Sadat and Rabin joined the immortal pantheon; the meaning of their deaths was framed for Americans by journalists associating them with the iconic martyred leaders of the past. "Yitzhak Rabin, like Anwar Sadat of Egypt, was a martyr for peace," wrote Frank Richter in The Detroit News that November week in 1995. "Both were generals who, knowing the horrors of war, pursued peace. Like Mohandas Gandhi of India, all three were killed by religious fanatics who

thought them traitors. Rabin joins Sadat and Gandhi in a panoply of peace as a hero in the holy war against religious hate."[74] And in the conservative *Washington Times*, Martin Sieff noted that same week that Rabin's assassination "has sobering parallels with the murders of American presidents Abraham Lincoln and John F. Kennedy. And there were also striking parallels and contrasts with the murder of Egyptian President Anwar Sadat 14 years ago."

> Lincoln had led the United States victoriously through the greatest war and worst political crisis in its history, the 1861–65 Civil War. Mr. Rabin as army chief of staff planned the greatest military victory in Israeli history, the 1967 Six-Day War. . . . Like Lincoln, Mr. Rabin was sick of war and longed for peace. . . . In both cases, the murder was followed by an extraordinary and unprecedented outpouring of national grief.
>
> For modern Americans, the striking parallel to the Rabin murder appears to be the assassination of John F. Kennedy 32 years ago. . . . With the benefit of hindsight, the Kennedy assassination and the continuing controversy and allegations surrounding it marked the end of a great era of national consensus. . . . For Israelis, Mr. Rabin's murder already appears to have ended an "age of innocence" when it was assumed that Jews did not kill other Jews. . . . The Rabin assassination has also demolished the comforting myth among Israelis that their robust, outspoken little democracy was immune to the virus of assassinations and politically motivated plots to topple the government that have long plagued neighboring Arab nations.
>
> President Anwar Sadat of Egypt perished that way in 1981. Like Mr. Rabin he was a heroic war leader who had won the Nobel Peace Prize for making peace with his adversary in the Israel-Arab conflict and like Mr. Rabin he was murdered for it by extremists from his own nation and of his own faith.[75]

The assassinations of Sadat and Rabin prompted hyperbole—how better to rivet attention to the news stories? How better to forestall the "Who cares?" the yawn of boredom, the fatigue (if not precisely the "compassion" fatigue) for international affairs. So, the two men were called "great world leaders," two of "seven significant assassinations," "martyrs for peace," and "heroes in the holy war." Sadat and Rabin were made into legendary figures, but to make them so, journalists practiced creative editing. The very real negative traits and actions of

Sadat and Rabin were euphemized or omitted outright from the laudatory epistles. Were Sadat and Rabin on balance good men? Yes. Were there similarities among this pantheon of the dead, among Rabin and Sadat and Gandhi and Lincoln and Kennedy? Sure. But the direct analogizing obfuscated more than it illuminated. Sadat and Rabin were being compared, not to men, but to myths — and in so doing they were also mythologized. And in becoming myths themselves, their global reputations were burnished and their assassins were demonized. By the end of the coverage of the Sadat and Rabin assassinations, Americans had learned that "great" men on a par with Lincoln and John Kennedy had been killed, but Americans had little comprehension of the breadth of the forces that had supported Sadat's and Rabin's removal from power — if not actually participated in or condoned their assassinations.

The lead *Washington Post* editorial on Wednesday, October 7, 1981, opened with these words: "Anwar Sadat was, to put it simply, a great man, a historic figure. . . . He expelled the Soviets, on his and his country's own regained Egypt's honor in war, and then made possible the first Arab-Israeli peace." In American eyes, Sadat returned Egypt to the Western fold. He was the one Arab leader Americans thought they understood. But they understood him only to the extent of his relationship to the outside world. "America is shocked, bereft and, quite properly, worried," read the first sentence in *The New York Times* editorial that same day. "Was it only one extraordinary man they gunned down in Cairo yesterday — or did a whole structure of foreign policies collapse with him?"[76] Self-absorbed, as always, Americans looked to their own interests in the aftermath of this assassination. They did not understand Egyptian politics.

Mohammed Anwar el-Sadat was born December 25, 1918, in a Nile Delta village. In his autobiography he described himself as "a peasant born and brought up on the banks of the Nile,"[77] but while he had been born there he grew up from the age of six in Cairo, the son of a black woman, the daughter of a slave from Africa. Sadat's father, an interpreter for the British army medical corps, kept the family in a four-room apartment: in one room lived Sadat, his mother, two brothers and one sister, in another lived his grandmother, in the third lived his father's second wife, and in the fourth lived his father's third wife, and soon, in quick succession, her nine children. It was not an ideal childhood for the son of the lowliest wife, and the fact that Sadat had inherited his mother's dark complexion and some of her African features was to shadow the rest of his life.

Sadat's early education was centered on the traditional Muslim practice of memorizing the Koran, but his grandmother sent him to a Christian school to

broaden his learning and then later to a city school with middle-class children. A 1936 treaty with Britain that allowed the Egyptian army to expand coincided with his high school graduation, and Sadat received an appointment to the national military academy, the first time the school was opened to boys of the working class. Men he met at the academy, including Gamal Abdel Nasser, formed a secret group known as the Free Officers Organization, dedicated to ending British occupation of Egypt.

During World War II, Sadat, together with other Egyptian officers, secretly supported the Axis powers, in the hope of ending British rule. Both during and after the war he plotted ineffectively against the British and was arrested and imprisoned in 1942 and again in 1946. During his last two years in prison, he became convinced that he wanted a political career, and he decided to end his arranged marriage, believing his wife, with whom he had had three daughters, would be a liability.

After being tried, acquitted and released from jail in 1948, Sadat then fell in love with a half-English distant cousin, Jehan, a white woman, who in later years as the president's wife became an outspoken crusader for women's rights in Egypt. In 1950, Sadat was reinstated in the army as a captain and helped plan the 1952 coup that overthrew King Farouk. The revolution led to the exile of the king, the withdrawal of British troops from Egypt and the emergence of Nasser as president. During the 18 years of Nasser's rule, Egypt established close ties with the Soviet Union and became a founder of the nonaligned movement, the Suez Canal and all major industries and banks were nationalized and the Aswan Dam was built.

Sadat was a faithful public servant of Nasser's, without his own constituency, but in posts of high visibility, culminating as the vice president. When Nasser died suddenly of a heart attack in September 1970, Sadat automatically became acting president. He quickly consolidated his position. Convinced that the only road to prosperity for Egypt lay in peace with Israel, he mapped out his strategy. In order to have a hand strong enough to bring to the negotiating table, he needed to restore the national pride, destroyed in the devastating Six-Day War, and he needed to involve the Americans on his side, believing they had leverage over the Israelis. To accomplish all this he first expelled the 15,000 Soviet military advisors who were preventing him from going to war. Then, together with Syria, Egypt invaded Israel on October 6, 1973. The army's initial success in crossing the Suez Canal was the first success that any Arab force had had against Israelis. Although Israeli troops later encircled the Egyptian Third Army, Egypt claimed a great victory. Sadat had accomplished his objectives. Egyptian morale

was restored and the Americans—in the guise of Secretary of State Henry Kissinger—came in posthaste to negotiate a cease-fire.

Now, peace with honor was possible—and a "peace dividend," in the form of economic opportunity, greatly desired. But interminable rounds of shuttle diplomacy followed with nothing gained except a partial Israeli withdrawal from the Sinai. By 1977, the patience of the Egyptian people was wearing thin. Sadat thought to salvage his image with the grand gesture of a trip to Israel. Although technically a state of war existed between the two countries, Sadat flew to Jerusalem on November 19, 1977, the first Arab leader to visit the state of Israel. In his speech in Arabic to the Knesset, he said, "If you want to live with us in this part of the world, in sincerity I tell you that we welcome you among us with all security and safety." Prime Minister Begin responded, "We, the Jews, know how to appreciate such courage."[78] As a result of this thaw, both men were jointly awarded the Nobel Peace Prize in 1978.

In an article in *TV Guide*, two prominent media critics, Edwin Diamond and Paula Cassidy, assessed Egyptian President Anwar Sadat's televised image during his historic trip to Jerusalem. "Urbane, pipe-smoking, English-speaking Sadat not only looked 'Western' but sounded statesmanlike when he talked of peace," they wrote. His television presence on that occasion not only changed how Americans viewed him, but how they viewed other Arabs. At the time of his visit to Israel, columnist Meg Greenfield wrote in *The Washington Post* that he "has transformed more than the political landscape of the Middle East. He has surely also transformed, or at least substantially altered, the American perception of the Arab and his cause. Unlike the set pieces to which we have become accustomed—the oil-rich sheik, the terrorist, the ululating crowd—Sadat was neither alarming nor strange. He was politically plausible and humanly familiar."[79]

Sadat's journey to Jerusalem received massive media coverage in the United States—and as a consequence helped television become dominant in the coverage of breaking international news. By 1977 the networks had converted their domestic bureaus from film to portable videotape; Sadat's visit to Israel greatly accelerated that transition overseas.[80]

Sadat and Begin became among the foreign leaders most well-known to Americans. Sadat became *Time* magazine's man of the year, his wife the "first lady" of the Arab world. As Ted Koppel said on ABC at the close of the Jerusalem spectacle: "In the course of 48 hours, American television flooded the world with a series of indelible visual impressions: Sadat and Begin—men of courage, men of goodwill, men of peace. The substance of their discussions

remains shrouded in mystery, but their television images alone created a new diplomatic reality and what was said is of far less importance at the moment than what was seen."[81]

Sadat arrived home from Jerusalem a hero. He rode triumphantly through the Cairo mobs chanting "Sadat. Hero of war. Hero of peace." Few of those in the streets that night seemed bothered by his first steps to end the Arab struggle with Israel. With peace would come prosperity.

The following year, as talks bogged down between the two countries, both sides seized on the idea of a summit brokered by President Jimmy Carter. The Camp David accords that resulted in September 1978 was the most significant foreign policy achievement of the Carter administration: It temporarily halted the growth of Israeli settlements in the Sinai, initiated negotiations about the Palestinians and promised negotiations about the West Bank. Israel promised to give up two air bases in the Sinai in return for two air bases given it by the U.S. inside the earlier boundaries of Israel. Egypt would get back the Sinai lands in stages. A peace treaty between Israel and Egypt was finally signed in March 1979.

American coverage of the 13 days and 12 nights of the summit was intense (by 1978, around 15 percent of the average weeknight network news broadcast was devoted to the Middle East) and overwhelmingly positive, and Sadat, especially, was treated kindly in the media. Camp David provided another intensive look at Sadat and Egypt, and it only reinforced for Americans the popular and charismatic persona Sadat had acquired on his dramatic trip to Jerusalem.[82]

But Camp David, together with a border war with Libya in 1977 and the arrival of the deposed and dying Shah of Iran in 1980, left Egypt with few Arab friends. Seventeen Arab nations adopted political and economic sanctions against Sadat's government—although they had little real impact, thanks largely to the more than $1 billion a year in American aid. Egypt's economic growth rate continued to grow at a rate of 9 percent a year, one of the highest among developing nations. After Israel, Egypt was the second-largest recipient of U.S. aid in the world. All told during Sadat's years as president, the United States provided Egypt with more than $17 billion.

But by 1980, the high growth rate had brought a troubling inflation rate of 30 percent a year. And although Israeli forces had withdrawn from two-thirds of the Sinai, no progress was being made on home rule for the Palestinians. Talks with the Israelis grew stormy, and domestic dissent increased. In the first week of September 1981, Sadat ordered mass arrests of his political opponents. In three days more than 1,500 people were imprisoned. Most were members of Muslim activist groups, but about 250 were among the most prominent political, religious

and intellectual figures in the country. Sadat also ordered the expulsion of more than 1,000 Soviet citizens, including the ambassador, accusing them of conniving with former Egyptian officials to destabilize his government.

Then on October 6, Sadat traveled to the outskirts of Cairo, to a suburb called Victory City, to review the annual military parade celebrating the 1973 war. At 10 A.M. he took his center seat on the platform decorated with the gods of ancient Egypt. At around 12:40 P.M. one of the army trucks towing a Russian antitank gun swerved toward the reviewing stand and halted abruptly. A young officer, Lieutenant Khaled al-Islambouli, leaped from the cab and threw several grenades. They were duds. He raced back to the truck, grabbed an automatic weapon and fired as he charged toward Sadat. Three other accomplices in the back of the truck threw grenades and pumped automatic-weapon fire.

The attack so stunned the crowd on the dais that there was little initial resistance; even the security forces and military police dived for cover. But in the end return fire from the guards killed one of the attackers and wounded the other three. A helicopter arrived several minutes later to pick up the president. His wife, who had been watching the parade from a glass enclosure with her grandchildren, joined him for the flight to the hospital. Sadat arrived at the hospital in a coma; bullets and shrapnel had ripped into the left side of his chest, neck and leg. His official time of death was 2:40 P.M., Egyptian time.

Four others had been killed in the attack, and 28 wounded. Vice President Hosni Mubarak, who had been sitting next to Sadat on the platform, escaped with only cuts on his left hand. The following day, the Egyptian Parliament, controlled by Sadat's National Democratic Party, named Mubarak to succeed the slain Sadat as president.

In its news coverage that second day, *The New York Times* carried a story with the headline "Key Suspect: Moslem Gang of Terrorists." *The Times* article, which ran no byline, said that "a group called Takfir Wahigra, or Repentance and Atonement, was the focus of suspicion so far." The story described the "small, violent Moslem fundamentalist group" as "a well-organized band of urban guerrillas with a lust for power."[83] From the first, the media called the assassination an act of terror.

In his last years, Sadat should have listened less to the modern American public relations firm he hired and more to the Renaissance citizen of Florence, Niccolò Machiavelli. In 1513, Machiavelli wrote *The Prince* in which he presumed "to discuss the rule of princes and lay down principles for them." In his short work he advised that "a prince should not worry too much about conspiracies, as long as his people are devoted to him; but when they are hostile, and feel hatred toward him, he should fear everything and everybody."[84]

In the course of the trial of the assassins, it came out that the brother of Islambouli had been imprisoned in the September 3 roundup for his active involvement with the fundamentalists at one of the universities. Khaled promised to avenge his brother Muhammad's arrest. The aggression Sadat had committed, Islambouli and others in the "jihad" movement believed, was not against individuals, but against God. Sadat had to be killed.

The fatal threat to Sadat ultimately didn't come from abroad. The conspiracy that killed him came from within — and on the very day and place that he thought he had least to fear: the military parade celebrating the anniversary of the Egyptian "victory" over Israel in the 1973 war.[85]

For decades American foreign policy has been invested in the Israeli-Palestinian peace process. At least since Kissinger's "shuttle diplomacy," the United States has helped shepherd negotiations in the Middle East. So it was perhaps no surprise that in the editorials following Yitzhak Rabin's assassination the same point was emphasized by both *The New York Times* and *The Washington Post*. Unlike the editorials commemorating Anwar Sadat on the day after his death, the editorials about Rabin were less about the man than about re-establishing sufficient order in Israel to keep the Palestinian peace talks on track. "Because it is a democracy and a government of laws — a rarity in its part of the world," said *The Post* in a snide dig at Israel's Arab and Muslim neighbors, "Israel will, in our judgment, be able to master the gritty challenge of making clear and certain in this time of pain that continuity and order will follow the terrible disorder of the murder." "A country that has survived so many military threats from outside must now hold course through the most severe internal political strain that can confront a democratic government. Israel's basic values and the strength of its people will enable it to meet this test," agreed *The Times*.[86]

Yitzhak Rabin was born in Jerusalem on March 1, 1922 to Russian-born parents, Nehemiah and Rosa Rubitzov. *The Post*'s obituary said that "even as a child he was dour" — befitting his education and training in the schools and on battlefields of Palestine. In later years, Rabin was known as "taciturn, introspective, controlled, intensely private," according to *The Times*'s obituary. "Even in private he was almost devoid of humor."[87]

As a boy Rabin wanted to be an agronomist and he attended the Kadoorie Agricultural School in Galilee, but he gave up agriculture for war during World War II. Moshe Dayan, then a young commander in the Haganah, the Jewish army clandestinely organizing under British rule, invited Rabin to join the Palmach, the elite strike force of the Haganah. In June 1945, at the age of 23, Rabin

commanded a bold assault to liberate about 200 illegal Jewish immigrants held by the British in a camp south of Haifa. The raid was presumed to be the model for a similar incident in Leon Uris' later best-selling novel, *Exodus*, and Rabin, with his movie star good looks, was assumed to be the prototype for the hero, Ari Ben Canaan, played by Paul Newman in the film version. Rabin always insisted he was not Ari Ben Canaan.

Rabin was arrested by the British and imprisoned for six months in a camp in Gaza. Soon after he was released, the British turned the Palestine problem over to the United Nations, which in 1947 voted for its partition into an Arab and a Jewish state. At 26, Rabin became a brigade commander during Israel's war for independence, charged with keeping open the supply route from Tel Aviv to Jerusalem which ran through Arab-held territory. In his autobiography, published in 1979, Rabin disclosed his role in forcing 50,000 Arab civilians at gunpoint from their homes because their villages straddled the vital supply line. His admission provoked a furor in Israel; Israeli officials had always insisted that they had not pushed Arabs off their lands.

In the middle of the war, in August 1948, Rabin married Leah Schlossberg, a member of his Palmach battalion. They had two children, a son and a daughter. At the end of the fighting, Rabin received his first political appointment; he represented the military at armistice talks in Rhodes with the Arabs. After the war, Rabin rose quickly through the ranks. By age 32, he was a major general. And at 42, in 1964, he was named chief of staff of the army.

As chief of staff, Rabin planned, trained, built and armed the Israeli military; their resounding triumph in the Six-Day War in 1967 was essentially his triumph—although critics charged that his mobilization of troops and other provocative moves in the weeks before the war prodded Egyptian President Nasser to escalate his own rhetoric and aggressive troop deployments and helped draw both countries into a war that neither really wanted. On the eve of the battle, Rabin went to Israeli statesman David Ben-Gurion for advice and support. Instead, as Rabin wrote in his memoirs, he was reproved. "You have led the state into a grave situation," Ben-Gurion told him. "We must not go to war."

After the war, Rabin retired from the army and asked for and received the state's most important diplomatic post: ambassador to the United States. In his five years in Washington, he developed a close relationship with Henry Kissinger, President Nixon's national security advisor and later secretary of state. Despite his lack of diplomatic experience, Rabin became known as an effective advocate for Israel and a master at procuring American aid and weaponry.

Rabin returned to Israel in 1973, in time for the Yom Kippur surprise attack by Egypt and Syria. Prime Minister Golda Meir and her Minister of Defense Moshe Dayan were blamed for Israel's lack of preparedness, but her party won enough votes in the election that fall to form a new government. Rabin was given the post of minister of labor. Within a month Meir resigned and the Labor party turned to Rabin to succeed her as prime minister. The fact that he had not been in the government at the time of the October War and was therefore not responsible for the heavy casualties that Israel suffered made him more appealing than the alternative Shimon Peres.

So at age 52, Rabin became Israel's fifth and youngest prime minister—and the only one to have been born in the land of Palestine. During his term in office, he became the first Israeli prime minister to make an official visit to West Germany, and he signed an Egyptian-Israeli disengagement agreement. He authorized the successful commando assault and rescue of almost 100 Israeli citizens on a plane hijacked to Entebbe, Uganda. But the next year, in 1977, he was forced to step down after disclosures that he and his wife had violated currency laws by maintaining bank accounts in the United States and after discoveries that he had lied about how much money was in the accounts.

His resignation opened the door for the Likud party and the victory of Menachem Begin. For seven years he sat on the back benches of the Knesset and feuded with his party mate Shimon Peres. Finally they put aside their personal differences and ran as a united ticket in the 1984 election. Rabin returned to the cabinet as minister of defense in a Labor-Likud coalition that presided over the Israeli pullout from Lebanon and he was personally responsible for instituting the "iron fist" policy of forceful reprisals for guerrilla raids against the withdrawing army.

For six years Rabin served as defense minister. When the Intifada broke out in December 1987 he was blamed for the army's slow reaction to the uprising, then after weeks of the Israeli army's firing upon unarmed Palestinians he issued the apocryphal "break their bones" command. He later said that he was trying to save lives by substituting clubs for bullets, but he underestimated the reaction to his order.[88] The globally televised beatings of Palestinians reminded Americans of the 1960s beatings of civil rights protesters in the American South and the hand-to-hand combat demoralized the Israeli forces. The army's distaste for its role helped Rabin to conclude that occupation demanded too high a price.

He pressed Yitzhak Shamir, the right-wing prime minister to launch a peace initiative calling for Palestinian autonomy in the territories. But when Shamir scuttled his own initiative after criticism from extremists in his own party, Rabin and Peres tried to bring down the government. They failed and sat on the back benches for two years.

But in the June election in 1992, Rabin led Labor to victory. In his speech to the Knesset, he said that Israelis had voted to change not just their government but their relationship to the world: "It is our duty, to ourselves and to our children, to see the new world as it is now—to discern its dangers, explore its prospects. . . ." But it wasn't Rabin, but Peres who first contacted the outlawed Palestinian Liberation Organization through talks in Oslo. Indeed, not only were the Oslo talks begun without Rabin's knowledge, but at a later date Peres refused the Prime Minister's request to briefly suspend the talks. Ultimately, however, the Oslo accords received Rabin's blessing and his handshake of acceptance at the White House ceremony. The letters of mutual recognition and the agreement, signed on May 4, 1994, granting self-rule to the Palestinians of Gaza and Jericho, was, as commentator George Will said, "the Nixon to China paradigm . . . that only Richard Nixon, with his record of anti-communism, could have opened American relations with Red China. . . . [P]erhaps only Mr. Rabin with his warrior's reputation, could have taken the risks dependent upon this peace process."[89] Together with Peres and PLO Chairman Yasser Arafat, Rabin was awarded the Nobel Peace Prize.

On September 13, 1993, in a ceremony on the South Lawn of the White House in Washington, Rabin and Peres and Arafat, overshadowed by President Bill Clinton, stood together. "The time for peace has come," said Rabin in his televised address. "Let me say to you, the Palestinians, we are destined to live together on the same soil, in the same land. We, the soldiers who have returned from battle stained with blood, we who have seen our relatives and friends killed before our eyes, we who have attended their funerals and cannot look into the eyes of their parents . . . we who have come from a land where parents bury their children, we who have fought against you, the Palestinians—we say today in a loud and clear voice: Enough of blood and tears. Enough." Standing next to him on the podium, Arafat moved to shake Rabin's hand. For a moment Rabin hesitated. But then he took Arafat's hand and shook it hard for a long moment. Sitting in the audience were several victims of terror attacks and their families—Rabin's way of saying both that Israel would not forget the years of conflict and that such bloodshed must stop, but also aimed at showing his domestic critics that even terror victims supported the accords.

That morning Rabin had given interviews to all the networks. Barbara Walters, who wanted to do a repeat of her famous 1977 Begin-Sadat joint interview in the Knesset, asked Rabin and Arafat to sit down together for a television interview at the White House. Rabin refused.

For Rabin and Israel the next two years were difficult. Although the PLO terrorist activity had ceased, radical Islamic violence had not—and neither had

violence from Jewish extremists. After each new incident, Rabin was denounced. On September 28, 1995, Rabin signed another agreement with Arafat at the White House, expanding Palestinian self-rule in the West Bank. This time the handshake came easier.

A little over a month later, on November 4, 1995 Rabin attended a massive peace rally in Tel Aviv, attended by over 100,000 supporters. After he addressed the crowd, together they all sung the "Song of Peace," a popular anthem. Shortly after 9:30 P.M. Israeli time, as Rabin walked to his car, Yigal Amir, a 25-year-old Jewish law student at a religious institution near Tel Aviv shot at him three times. A single bullet struck one of Rabin's bodyguards, the other two hit Rabin at point-blank range. Rabin had always refused to wear a bulletproof vest; one shot ruptured his spleen, the other shattered his spinal cord.

Thrown up against the wall by security personnel, Amir was taken into custody. He later told police, "I did it to save the state. He who endangers the Jewish people his end is death. He deserved to die, and I did the job for the Jewish people."[90] Meanwhile, another set of bodyguards took Rabin to a car and rushed him to the nearby Ichilov Hospital. As had been the case with Indira Gandhi, no one in the emergency room had been alerted to his identity. Only when the resident physician looked at Rabin's face did he realize who he was trying to resuscitate. Rabin had no heartbeat or blood pressure. He could have been pronounced dead on arrival, but it wasn't until 11:15 P.M. Israeli time that Rabin's chief of staff read a brief statement to the crowds waiting outside the hospital: "The Government of Israel announces with shock and deep sorrow the death of the Prime Minister, Yitzhak Rabin, who was murdered by an assassin tonight in Tel Aviv."

In news story after news story the same shocked litany was repeated: "We were brought up on the idea that we are a Jewish nation and that never could a Jew kill another Jew," *USA Today* quoted a 16-year-old Israeli as saying. *Newsweek* translated the shock for the American audience: "In the Middle East, at least in the American mind," it said in its cover article, "the face of terror is usually wrapped in a kaffiyeh. But the assassin who put three bullets into Rabin last Saturday night as he left the peace rally was a clean-shaven 27-year-old [*sic*] Israeli law student." In this news story, as in the story of Sadat's death, assassination was equated with terrorism. An act so sudden and so dislocating to Americans had to be more than a revengeful murder; it had to be called by the term of ultimate opprobrium: terrorism.

Rabin, like Sadat, was struck down by one of his own people who felt he had abandoned them. Many of the news pieces lingered on the similarities between the two men . . . and between Rabin and other martyred icons. "Rabin shared the fate of peacemakers who have been killed by their own kind," said the

Newsweek article. "After leading India from colonialism, Mohandas Gandhi was killed in 1948 by a fellow Hindu who believed he was giving away too much to the Muslims. In Egypt, Anwar Sadat brought peace and respect to a vanquished nation and was slaughtered for his efforts by some of his own soldiers in 1981. For Rabin, the most apt analogy may be Abraham Lincoln. He was a war leader whose personal strength held together a divided nation."[91] Monday, November 6, the day of Rabin's funeral, *USA Today* ran as its political cartoon an image of two men, Sadat and Rabin. Sadat's arm circles around Rabin's shoulders, as they stand together in the clouds of heaven.[92]

Television once again scored a major beat on its print competition in covering the breaking news of the Sadat and Rabin assassinations. The hour when both men were killed meant that it was a day before the stories could get into the newspapers—and, of course, even longer before the newsmagazines could carry the news. It took a week before the newsmagazines's coverage of Sadat's death were on the stands; he was killed on a Tuesday, and the deadline for the magazines is typically on Saturday. The news of Rabin's death made it in more quickly; as he was killed on a Saturday, his death just made it in under the wire for the newsmagazines to carry the story in that coming week's issue. Both *Time* and *Newsweek* dumped their cover stories and ran Rabin's photograph on their covers and lengthy articles inside.

But it was television that defined the two international crises for Americans. Just past noon in Paris, on October 6, 1981, a reporter for Agence France-Presse, the French news agency, was monitoring a routine radio broadcast from Cairo when suddenly explosions, machine-gun fire and anguished screams could be heard. Then the radio fell silent. Within moments, at around 7:10 A.M. Eastern Daylight Time, AFP and other news services around the world carried the first bulletins: Someone had shot at President Sadat. Little else was known.

For the third time that year, television swung into crisis mode to cover the story of an assassination attempt on a world figure. Once again, soap operas were pre-empted as the three American networks and the fledgling CNN moved to live assassination coverage. The two earlier attacks in 1981, one on President Reagan and the other on Pope John Paul II had prepared the networks and CNN for this successful assassination—there were no gross errors in the coverage of the Sadat story as there had been in the reporting on the Reagan shooting (all three networks had erroneously declared presidential press secretary James Brady to be dead) and in the coverage of the attempt on the pope (NBC's handling of it was so botched that a Philadelphia affiliate dropped the network feed and covered the story on its own). "By this time," said TV critic Tom Shales, "the

mechanics of crisis coverage have become virtually ritualistic—the parade of guest experts, the tentative and heavily qualified nature of early reports, the final confirmation, the worldwide reaction. A horror scenario becoming as familiar as any other video rite."[93]

In the hours that followed first word of the attack, the networks marshaled the usual suspects and plunged into analysis of what Sadat's death—if confirmed—would mean to U.S. foreign policy, the Camp David Accords, the sale of high-tech radar planes to Saudi Arabia (the AWACS). Henry Kissinger appeared on all three networks. The Americanizing of the crisis had begun.

The three networks called in their backups. NBC anchor John Chancellor worked side by side with his successor, Tom Brokaw. ABC *Good Morning America* correspondent Steve Bell co-anchored with Frank Reynolds, assisted by Ted Koppel, Barbara Walters and David Brinkley, in his debut on ABC. And Walter Cronkite, who had recently stepped down from his anchor position at CBS News, pitched in, as his replacement Dan Rather repeated, "to put this thing into perspective."[94] Cronkite cautioned Rather against accepting the early reports from Cairo that Sadat had not been seriously hurt, but in fact CBS aired the first report that Sadat was dead. It came at 10:26 A.M., New York time, from the CBS Cairo bureau manager, Scotti Williston, who attributed her news to separate hospital sources. Still, all the networks stressed how unofficial the early reports of the death were; they were all hampered by the fact that the Egyptian government closed down the airport and embargoed all the satellite transmissions from the scene of the shooting until after the official pronouncement was made.

In the absence of positive confirmations or videotape footage, the networks aired conflicting reports within moments of each other. Jimmy Carter told Rather that his sources in Cairo assured him that Sadat was not seriously hurt. Then Senate Majority Leader Howard Baker announced Sadat's death on the Senate floor at 11:30, citing Vice President Bush as his source, in a move Daniel Schorr, reporting for CNN, called "hamhanded." The news on television became a scramble for sources. Pointing out a prostrate figure in the first still photograph of the shooting at 12:02 P.M., CBS's Rather said, "It is believed, reportedly, supposedly, allegedly, President Sadat in the lower right hand corner of this photograph."[95] The flag at the Egyptian embassy was watched for clues as was the programming on Cairo television—which had abruptly gone off the air, only to resume with prayer readings from the Koran, something that had last occurred when the death of Sadat's predecessor, Gamal Nasser, was about to be announced.

Finally at 1:20 P.M., CBS's Scotti Williston reported that an Egyptian newspaper was on the street headlining Sadat's death. Ten minutes later, it was official from the Egyptian government.

In the confusion that morning, while on the air, Dan Rather announced that CBS News correspondent Mitchell Krauss, who had been present at the military parade and had been wounded by shrapnel during the shooting, had left Cairo for Rome before the airport was closed, a reel of videotape under his arm. But before Krauss landed in Italy, the announcement of Sadat's death was made and the BBC secured permission to feed Egyptian television footage to the waiting world. ABC got its own footage piggybacked on the satellite transmission.

All of the footage that came over the satellite showing the assassination was shot by ABC News cameraman Fabrice Moussos. The rule was, as an ABC spokesperson said, "Whoever got birded out first would be pooled." In other words, any of the networks could use the ABC footage. Technically the other networks were supposed to use the footage only once, but later ABC decided that the other networks could use it as long as they attributed it to ABC and not to "Egyptian Television" as NBC had credited it. The images of "violence and terror," said Shales, were "raw." They included:

> A man whose arm had been completely shattered by gunfire, trying desperately to get to his feet. Officials in business suits, some red-spattered, scrambling for cover as shots continued to fly; and a man in ornate military regalia, standing dazed and disbelieving, watching helplessly, blood trickling down his cheek. A jungle of toppled chairs and bodies, lying on the floor of the reviewing stand, survivors sifting through the rubble for more casualties. And one incredibly dramatic shot of a hand, dripping with blood, reaching up from the floor and trying to grasp the rim of a chair.

By evening the ABC footage had been joined by the Krauss tapes, and both had been "played, replayed, freeze-framed and edited," as Shales said. "Soon scenes that were monstrous and horrifying the first time would grow tame through repeated exposure."

According to Shales, the antidote to this calloused compassion fatigue was the engagement of the newscasters. "ABC's [Frank] Reynolds more than any other network newsman let the tragedy of the day's events show in his face and his delivery," wrote Shales. "His kind of demonstrative involvement with the story—'this dreadful news'—may be increasingly important to viewers as Crisis Television becomes more and more common, and as the possibility that we will all grow numb to these public tragedies grows more likely."[96]

The three networks and CNN made rapid plans to cover the funeral which was to be attended by a galaxy of world leaders. CBS sent Cronkite to Cairo;

Dan Rather stayed on the desk in New York. ABC sent Barbara Walters and Peter Jennings to Egypt and had Frank Reynolds at the anchor desk. Tom Brokaw went to the Middle East for NBC and John Hart anchored from New York and Marvin Kalb from Washington. And CNN sent its London and Rome bureau chiefs, Richard Blystone and Tony Collings, to supplement its man in Cairo, Dean Vallas. All four news programs covered the funeral live, beginning at 5 A.M. Eastern time. More than 800 journalists were on hand to witness the interment of the Egyptian president.

Fourteen years and one month later, at 3:09 P.M. Saturday, November 4, 1995, CBS's Saturday anchor Bob Schieffer interrupted the Northwestern Mutual Life World Team Skating Championships to inform viewers that Israeli Prime Minister Yitzhak Rabin had been shot in Tel Aviv.[97]

It was an inconvenient time for the networks. Sponsors were paying major money for commercials during the Saturday afternoon sports programs. To interrupt them meant the loss of some of those premium dollars. ABC, airing college football, broke into the Penn State–Northwestern game with special reports only twice between 3:00 and 5:00 P.M., the first time at 3:30. CBS interrupted the skating championships seven times. And NBC, which was televising the Notre Dame–Navy football game, waited until 3:27 to first tell its audience of the shooting. But then they confused matters. At 3:45, NBC's Tel Aviv correspondent Martin Fletcher broke into the game to contradict the earlier report, saying that Rabin had not been hurt. By 4:22, when NBC corrected the second report and confirmed that Rabin had been wounded and was now dead, CNN and CBS had already informed their viewers that Rabin had died. "I fail to understand the network's non-logic in this Saturday situation," wrote TV critic Dusty Saunders. "Did the networks feel this assassination was unimportant because it didn't happen within our shores? Or was it simply a matter of bean-counter economics?"[98]

It was CNN which excelled in reporting the breaking news. Its coverage, headed by Wolf Blitzer—at the time CNN's White House correspondent, but formerly based in the Middle East—gave both news bulletins and news analysis. At 3:42, CNN came on the air with video of Amir in the hands of police and by 5:00 it had live coverage from Israel. From Atlanta, CNN provided a biography of Rabin, a history of the Middle East conflict and reactions from world leaders.[99]

At 5:51, President Clinton addressed the nation. ABC was the only network not to televise live Clinton's short speech. Afterward CNN anchor Jeanne Meserve spoke to former President Jimmy Carter. "This tremendous tragedy," Carter said, was "equivalent to when we lost John Kennedy."[100]

Through Sunday CNN continued to provide the most comprehensive—and creative—coverage. On Sunday afternoon it aired a full hour of live newsfeed from Israel's commercial television station Channel 2, with simultaneous translation from Hebrew to English. All told, between 3 P.M. Saturday and 7 P.M. Monday, the day of the funeral, the network booked 53 hours of live satellite transmission time from Jerusalem, at a cost of $1,000 an hour.

On the networks, the Sunday morning magazine shows discussed the assassination, Peter Jennings, who had already left to cover the funeral, anchored a special edition of *World News Sunday* from Israel and CBS's *60 Minutes* dumped its previously scheduled features so that Bob Simon, reporting from Israel, could put Rabin's death into context.

On ABC's *This Week with David Brinkley*, Brinkley asked the regulars at the end of the program, "What does this mean to us as a civilized people trying to help the world get along?" George Will answered, "Israel still is what it always has been, an embattled salient of our values in an inhospitable portion of the world." Sam Donaldson linked the assassination to those who killed Lincoln, Gandhi and Sadat. Cokie Roberts expanded on Donaldson's comparisons by mentioning "our shock at learning that it was an American" who committed the terrorist attack in Oklahoma City and picked up on Will's identification with Jewish Israel by saying "what is happening in that region has been this rise of fundamentalism, mainly Islamic fundamentalism, which has been very, very dangerous, and the countervailing rise of fundamentalism among Jewish Israelis."[101]

In this brief conversation among these four extremely prominent commentators, several connections were made that were to be emphasized throughout the media's coverage of Rabin's assassination. First, the crisis was tied to American interests: "What does this mean to us?" Second, despite the fact that a Jew had murdered Rabin, the audience was reminded that "our values" as a "civilized people" were embodied in Israel but not in its Arab neighbors—that "inhospitable portion of the world" and that host for the "very, very dangerous" "mainly Islamic fundamentalism." Third, in case talk of politics and values was too abstruse for viewers, a visceral association was drawn; the death of Rabin was Americanized to be like Lincoln's (and Gandhi's and Sadat's, too). And fourth, the assassination was compared to the bombing of the federal building in Oklahoma City, the most deadly terrorist incident in American history.

On Monday morning, CNN and the networks began their broadcast day with live coverage of Rabin's funeral. "It's hard to envision a funeral for any other foreign leader getting such TV attention," wrote *L.A. Times* TV critic Howard Rosenberg, "its sheer bulk indicating Israel's significance to the media as well

as to a U.S. government that has dealt some of the cards at the Middle East peace table."[102] The journalists took their cue for their major coverage from the American delegation: It was unprecedented. It included President Clinton and former Presidents Bush and Carter, the leaders of Congress of both parties and both Houses, and three present and former secretaries of state, going back four administrations.

The service ran during the morning shows. ABC's Charles Gibson and Peter Jennings anchored from Jerusalem for *Good Morning America*, Dan Rather hosted *CBS This Morning* from the funeral, and Katie Couric and Bryant Gumbal interviewed Israeli experts in the NBC *Today* studio in New York while Tom Brokaw reported from Jerusalem. For the opening and the major eulogies given by Jordan's King Hussein, President Clinton and acting Prime Minister Shimon Peres, the four news broadcasts carried the pool-camera video and live audio from Israeli television uninterrupted.

But with the big guns of the evening anchors, the morning show hosts, the regular correspondents and scheduled guests in the lineup, "the networks," said TV critic David Bianculli, "seemed unforgivably itchy to cut from the podium and get on with their own 'exclusive' discussions." NBC's *Today* show paid an estimated $25,000 for a satellite interview with former Secretary of State Henry Kissinger in his Shanghai, China, hotel room. *Good Morning America* got Kissinger's comments too, but through a much cheaper telephone interview.

As a result of the high-profile guests, Egyptian President Hosni Mubarak was snubbed by NBC even though it was his first trip to Israel—Katie Couric in New York began an interview with former Secretary of State James Baker. CBS and NBC showed file footage and chatted through several other speakers, including Israeli President Ezer Weizman. All three networks defected during U.N. Secretary-General Boutros Boutros-Ghali's remarks—CBS went to a commercial. Perhaps the most moving eulogy, that delivered by Rabin's 19-year-old granddaughter, Noa Ben Artzi, was televised by them all—except NBC, which stayed with Bryant Gumbal's interview with Israeli spokesman Uri Dromi. And during the most dramatic moment, when Rabin's closest aide, Eitan Haber, announced his intention to read the hymn "Song of Peace" from a paper Rabin had folded and put in his pocket just before the shooting, only CNN and ABC were carrying the speech. When Haber said the chilling phrase, "Your blood, however, covers the words," and unfolded the bloody page, CBS and NBC cut back to the podium—as Bianculli remarked, "like sharks drawn to the first whiff of blood." (It was no coincidence that two out of three newsmagazines carried a photo of the bloody page.)[103]

· · ·

The media's tendency to sensationalize international events in order to compel attention to the news coverage needed little prodding on the occasions of Sadat's and Rabin's assassination. Not only were the victims the leaders of two of the states most critical to Middle East security—and therefore would have prompted major coverage even if they had died natural deaths—but in both circumstances the assassinations happened in public, before crowds of people, with representatives of the media in attendance. When professional journalists are watching, the dynamic of coverage can change. The assassination narrative is set up so that the journalists emerge as authoritative spokespeople. The assassinations of Sadat and Rabin, for example, had their Boswells—just as the assassination of JFK was recounted in the highly personalized terms of the journalist "eyewitnesses" who accompanied the president to Dallas (*Time*'s Hugh Sidey) or waited outside the hospital for news of his condition (CBS's Dan Rather) or attended the swearing-in of Lyndon Johnson aboard Air Force One (*Newsweek*'s Charles Roberts).[104]

But the clearest indication of the lack of objectivity in the coverage of these two assassinations was the language and characterizations used to describe the victims and the assassins. Such actions as didn't accord with the victims' "peacemaker" images, for example, were either buried, as was the case with both men's earlier military careers, or with Rabin's first handling of the Intifada, or blamed on others, as was the case with Sadat's September roundup and imprisonment of his opposition. For example, James LeMoyne explained Sadat's arrests in *Newsweek* this way: "Vice President Hosni Mubarak and Interior Minister Nabawi Ismail warned him that Egypt was boiling with assassination plots, that fundamentalists were brazenly pillorying him in village mosques and that radicals on the left were grousing about his palaces, his suits and his wife's jewelry. They feared a coup d'état; they urged a crackdown. . . . At first he refused to undertake a purge," said LeMoyne, but when he "finally did move last month, he apparently failed to go far enough."[105] In other words, it wasn't Sadat's doing that the human rights of his opposition were abridged. In fact he had erred, fatally, on the side of tolerance.

The American media were clearly partisan. If Sadat and Rabin were all that was wonderful, the assassins were characterized as terrorists. As Edward Said pointed out in his book *Covering Islam*, Americans place Moslems into two camps: the good and the bad. "Good Muslims," said Said, include Sadat and Pakistan President Zia ul-Haq, bad Muslims are "terrorists."[106] Even before they were identified with a specific political faction, Sadat's assassins were clearly in the "bad" category, considered to be "Moslem fundamentalists," part of a "fanatic Islamic revivalist" sect or "other extremist Moslem group." The fundamentalists

were considered to be invariably violent; there were no in-depth explorations of their religious tenets or even much discussion about the intersection of religion and politics in Egypt, despite the clear evidence of serious divisiveness, witness the September arrests, the assassination itself and the observed lack of mourning among Egyptians for Sadat (especially as compared to the public sorrow following the death of Nasser). In most of the media stories fundamentalism simply equaled terrorism. Takfir Wahigra, the group with which Sadat's assassins were suspected to be affiliated, said a professor quoted in an article in *Newsweek,* "is the largest such fundamentalist group in Egypt. . . . Each of the hard-core members is a walking time bomb—waiting to go off." A *New York Times* headline stated the connection most bluntly: "Assassins Portrayed as 'Islamic Fundamentalists.'"[107]

For Americans, perhaps the most telling cue to the media's perfunctory linkage of Sadat's assassins with terrorism was their initial assumption (supported by the U.S. government's claims) that the assassins were allied with the world's most notorious "terrorist" leader, Muammar Qaddafi of Libya. "In the shock and upheaval that followed the Sadat assassination, one prime initial suspect as the instigator of the crime was inevitable: Libyan Strongman Muammar Gaddafi," said an article in *Time.* "As Vice President George Bush put it last week: 'He's the world's principal terrorist and trainer of terrorists.'"[108]

Fourteen years later, in the stories about Rabin's Jewish assassin, the equating of assassination with terrorism was not quite so reflexive. Several reporters felt obliged to first note, as Evan Thomas in *Newsweek* put it, that assassination was "the kind of thing that Arabs did to each other," before they went on to say that Yigal Amir was part of the "virulent radical right," an "extremist," a "zealot" and a "terrorist."[109] Few stories explored the full spectrum of religious sentiment among Jews in Israel; most suggested that all but the fringe elements supported the Oslo accords that Rabin and Peres had helped to craft. Most in the American media ignored the long-standing deep splits between the left and right in Israeli society, between the labor Zionists and the revisionist Zionists. There was on the part of many media commentators an assumption that the assassination of Rabin marked a fault line—that it was the beginning, not the culmination of a bitter process (such as the Altalena incident, the murder of Chaim Arlozoroff, or, more recently, the grenade "murder" of Emile Gruzweig) that could be traced back to independence. The history of violent political disagreements among Israelis didn't fit into the American frame of reference—and the media's Americanizing of the assassination practically guaranteed that they would miss it.

Most stories which focused on Amir and his supporters made a point of noting that his brand of fundamentalism was not the norm—unlike the discussion of Islamic fundamentalism in the aftermath of Sadat's death, in which Islamic

fundamentalism was assumed to be more monolithic and more generally supportive of assassinations and terrorism. Even the closing words of *Newsweek's* article on Amir which spoke about "when peace is under assault," noted that former general Ehud Barak, who Rabin "was grooming" as his successor, "may prove his value to Peres as Israeli troops withdraw from the West Bank, or when the next Arab suicide bomber strikes." The story which asked "Who Is to Blame?" answered, in effect, by saying that the next threat will come from the Arabs. "It is still possible to say things about Islam," observed Said, "that are simply unacceptable for Judaism, for other Asians, or for blacks. . . ."[110]

Newsday, briefly, had it right. In one of their articles covering the Rabin funeral, reporter Paul Vitello, interviewed James Clarke, an expert on assassinations. Vitello asked Clarke: "Are most assassins more or less crazy?" "No," said Clarke. "In this country we have always tried to dismiss our assassins as nuts. That's the easiest way to deal with the events politically. . . . But sometimes there is widespread support in the population for the point of view of the shooter."[111]

Traditionally, a dominant element in the coverage of a crisis is the question: What does this mean for Americans? How does the media keep the attention of their audience? By suggesting that a crisis has repercussions for the public. In the case of the Sadat and Rabin assassinations, the most obvious possibility was that the deaths would provoke more violence. Did the deaths mean instability in the Mideast? With American investment—economic and political (and in the case of Israel, social, as well)—so high, inevitably front-page stories and leading items on the news emphasized the threat to the peace processes.[112] And there were mentions of other more direct threats. "U.S. security agencies believe it is too risky for President Reagan or Vice President Bush to visit Cairo for the funeral of assassinated President Anwar Sadat," said the lead to a front-page story in *The Washington Post*, clearly stating that Americans—or at least the president and vice president—were at risk to terrorists still at large. In another front-page story, this time in *The New York Times*, Leslie Gelb mentioned that Sadat had been one of several "friendly leaders" in the Middle East who the CIA helped protect "against potential attacks by Libyans, Palestinian guerrillas, Moslem fundamentalists or their own armed forces," thereby lumping together in one "terrorist" class all members of the groups listed.[113]

During the coverage of the Rabin assassination, the media also identified homegrown threats—Americans who supported his assassination. Many articles made the connection explicit up front: "American Sympathizers: Where the Killer Is a Hero," read a headline in *U.S. News*. "We felt that this whole incident saved hundred of thousands of Jewish lives," the article quoted Moshe

Gross, a 28-year-old from Brooklyn as saying. "It was equivalent to somebody killing Adolf Hitler before the Holocaust." And stories commonly made a connection between Yigal Amir and, as *Time* described him "the late Meir Kahane, the American-born founder of the militant, occasionally violent Jewish Defense League." (In a Nexis search for the month following Rabin's death there were 265 cites that mentioned Amir and Kahane.)[114]

But the most blatantly manipulative Americanization of the crises was the ubiquitous drawing of parallels between the assassinations and iconic American people and events. Entire stories were given over to the resemblance between Kennedy's death and that of Sadat or Rabin. In a lengthy article in the *L.A. Times*, for example, not only did the reporters themselves suggest comparisons between Kennedy's and Rabin's assassination, but they interviewed the chief counsel for the reinvestigation of the Kennedy assassination and the director of the Dallas study center devoted to the Kennedy assassination to support the contention that the Rabin assassination was the product of a conspiracy. "As with Kennedy, the issue is not whether the chief suspect [Amir] was involved but whether the whole story is really as simple as the initial explanations make it appear."[115]

The Kennedy connection was not only made in the words of journalists covering the assassination events. The public was reminded of the past icons through photography, too. The day the *L.A. Times* reported on Rabin's funeral, it promoted its JFK/Rabin conspiracy article with a front-page photograph of John Kennedy. And *Time* magazine illustrated columnist Hugh Sidey's article on Sadat's death with a photograph of the funeral caisson of President Kennedy.[116]

But often the explicit use of historic images was unnecessary. The subjects and compositions alone were sufficiently reminiscent of the Kennedy assassination events: the flag-draped caisson, the stately march of the foreign dignitaries, the gathering at the gravesite, the grieving families. The widows of Sadat and Rabin must have used images of Jacqueline Kennedy as their guides as to what to wear—chic black suits and dark sunglasses—and how to conduct themselves—sorrowful but composed. The *L.A. Times* led a story on Rabin's widow in its funeral issue with these sentences: "As a younger woman and diplomat's wife, Leah Rabin admired Jacqueline Kennedy and tried to emulate her elegant style. She adopted the haircut and well-tailored suits. She had Kennedy's knack for hospitality. But never did she imagine she would find herself in Kennedy's shoes as the widow of a visionary head of state." All five of the photographs in that day's issue that included or featured Mrs. Rabin, pictured her in this Kennedy-esque fashion.[117]

Many of the same genres of images that dominated the visual coverage of the Gandhi and Zia assassinations dominated the coverage of the deaths of Sadat and Rabin: file photos of the dead men—often with a visionary light in their eye, gazing off into the middle distance; pictures of the men with American presidents—especially during the historic handshakes at the White House; images of mourning countrymen and solemn world leaders; photographs of the successors; photographs of the families. But there was one very significant difference between the two sets of assassinations. Because the Sadat and Rabin assassinations had occurred in public and because the assassins had been captured, the most dramatic images were from the scenes of the shootings: the freeze-frames from the videotapes of the gunmen charging the Cairo reviewing stand and the images of the capture of Yigal Amir at the peace rally.

Americans saw over and over again—on television and in print—tapes, still photographs and diagrams of the assassinations. On TV the tapes were viewed slo-mo and freezed-frame. In newspapers and the newsmagazines the photographic images were cropped and captioned like a storyboard; the same diagrams and wire service and TV pictures were used repeatedly to illustrate the chronology of events. In the coverage of Sadat's assassination, for example, both the print and broadcast media prominently ran the images of the killers charging the stands and of the victims wounded and dying in the aftermath.

Dramatic images predominated during the first stage of the Rabin assassination as well. As had been the case in 1981, the same images kept reappearing. Three pictures were used ubiquitously: a photo by Nati Harnik for AP of Rabin delivering his speech, a Reuters image of police scrambling to aid Rabin after he was shot before entering his car, and Biman's photograph for AP showing an Israeli police officer grabbing Amir around the neck. The *Chicago Tribune*, the *L.A. Times* and *The Washington Post* used two out of those three images on their front pages that Sunday after the Saturday assassination, and *The New York Times* used all three. So too did *Time* in its first double-page spread.

Conflict and calamity sell; they fascinate. They make for a good story. More than a month later, a videotape of Rabin's assassination, showing Amir stalking the prime minister before shooting him in the back, sold to Israel's commercial television station and its largest-circulation newspaper for nearly $400,000. (*Life* magazine paid dressmaker Abraham Zapruder $150,000—in 1963 dollars—for his film of the Kennedy assassination.) The tape, made by a 37-year-old Israeli civil servant and Polish immigrant named Gershon Shalvinsky, had been used as evidence in the state inquiry.

Few in the media employed diagrams this time around to tell the story of the actual shooting, although both on television and in print maps were used to

show the site of the rally in Tel Aviv and the position of Tel Aviv in Israel and to the West Bank and the Gaza Strip.

Essentially the media employed images to support their dramatic telling of events and to legitimate their definitions of the key players. As Nixon learned when he became embroiled in Watergate, pictures can be chosen to make a figure look like a statesman or like a crook, to look like a visionary peacemaker or a vindictive strongman, to look like a crazed terrorist or a religious zealot. Both Sadat and Rabin were most often portrayed as dignified soldier-statesmen, while their assassins, by contrast, were pictured as sneering and smirking fanatics.[118]

"If the Romans had had television, we'd all know exactly how Caesar was stabbed at the Senate," said Andy Rooney in his column on the Sunday following the death of Sadat. "In our own time, the assassination of President Kennedy and the subsequent murder of his assassin, Lee Harvey Oswald, have added specific and incontrovertible detail to the story of mankind.

"Television," Rooney said, "is at its best with death." And so it is. Death is dramatic, tragic. Death of a world figure brings an end to a great story which we have all read. But as Rooney noted, "television news seldom reports the demise of a prominent world figure in more than a few words, unless that figure is an outstanding entertainer or government official about whom ample footage exists in film libraries." Television covers "a story in detail," he said, when "it has good pictures."[119]

Well, Rabin and Sadat made the cut. Their deaths were reported in detail. They were prominent government officials of whom ample pictures had been taken. And their assassinations were captured on film. As Andy Rooney would say, it all made for "fascinating viewing"—at least for a short while, until the media, exercising their prerogative, decided to pre-empt further coverage after all the exciting bits had been reported.

Throughout the days of assassination coverage, the media's focus remained on the great men and their great deeds, as if to talk in depth—and sympathetically, or at least impartially—about the swirling storm clouds of national politics and religious tension would eclipse Sadat's and Rabin's stature. The media handled the stories of Sadat and Rabin as biography, not epic. Stature is equated with newsworthiness; to speak credibly about forces opposed to a leader, the media must believe, is to diminish the importance of the man. And that, of course, is the opposite of what the media want. Fatigue for international news creeps in more quickly when an audience believes a story to be of lesser importance, when people believe a person to be of negligible significance—or of negligible ongoing significance.

Biography, not epic, is another reason why media audiences were reminded so persistently of past great men. Saying John F. Kennedy or Martin Luther King, Jr. does little to explain what's happening in a country and does much to parallel the new death with a famous, mythic forebear. "We remember those who have been cut down violently just as they have won a victory for righteousness: Abraham Lincoln, Martin Luther King Jr., Anwar Sadat," said *Time* in its cover story on Rabin. "The Egyptian President—Rabin's mirror image in the Middle East conflict, killed not by his nominal enemies, but by those among his own people who accused him of treachery. Rabin joins the ranks of such men. . . ."[120]

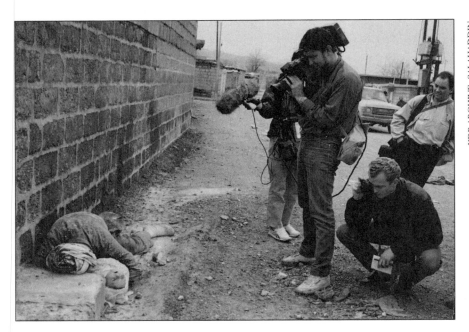

"Poison Gas Attack Kills Hundreds," *The Washington Post*, 24 March 1988
"A man and a baby, victims of a poison gas attack, lie dead outside a house in Halabja,
a Kurdish city in Iraq."[1]

CHAPTER FIVE

COVERING WAR:
GETTING GRAPHIC
ABOUT GENOCIDE

The term "ethnic cleansing" may be new, but the practice is not. . . . It was Hitler who, more than any other figure of our century, successfully taught and implemented the doctrine that certain types of people are garbage, and that by driving them out of your country, or by killing them, you can make yourself "clean"—that mass murder is the path to "purity."

—Jonathan Schell
"Hitler's Shadow," *The Courier-Journal,*
December 9, 1992

This generation's entry in the mass-murder category is ethnic cleansing. . . . it has become a major coinage, now used without quotation marks or handled without the tongs of so-called. . . . If the practice is not stopped the term will continue in active use; if the world forces the forcible separation and killing to end, the phrase ethnic cleansing will evoke a shudder a generation hence much as final solution does today—as a phrase frozen in history, a terrible manifestation of ethnocentrism gone wild.

—William Safire
"On Language: Ethnic Cleansing,"
The New York Times, March 14, 1993

"World War II, with its global carnage and the Holocaust, is the epic of our age," wrote *New York Times* correspondent Steven Erlanger in February 1997. "Each generation has its own increasingly complicated interpretation of the war's meaning and mysteries, its heroes and villains, and more than 50 years later it retains the power to shock and surprise."[2]

Four years earlier, in the spring of 1993, President Clinton and Israeli President Chaim Herzog together with other dignitaries, attended the opening of the United States Holocaust Memorial Museum in Washington, D.C. Elie Wiesel, the Nobel Prize–winning author and a survivor of Auschwitz, spoke at

the dedication ceremony. Wiesel told of the death of his mother in the camps and described his own experience there. "We found ourselves in an unfamiliar world, a creation parallel to God's," he said. "There were only two categories— those who were there to kill and those who were there to be killed."

At the end of his brief remarks, Wiesel addressed himself to Clinton. "Mr. President, I cannot not tell you something. I have been in the former Yugoslavia last fall. I cannot sleep since for what I have seen. As a Jew I am saying that we must do something to stop the bloodshed in that country. People fight each other and children die. Why? Something, anything must be done. This is a lesson."

That Sunday, The New York Times ran an article in its Week in Review section titled "Does the World Still Recognize a Holocaust?" John Darton's lead quoted former British Prime Minister Margaret Thatcher: "I never thought I'd see another holocaust in my life." "Not for half a century," Darton continued, "has the world witnessed events in Europe that have stirred such an agonizing echo of past horrors. The television footage of houses reduced to rubble, the bombed-out churches and mosques, the lined-up bodies and mass graves—they all evoke the flickering black-and-white newsreels of World War II. The words 'genocide,' 'massacre,' 'holocaust,' 'civilian bombing' and 'ethnic cleansing' haunt every day speech and stir up guilt-ridden memories like smoke rising from a crematorium."[3]

The week of the "discovery" of the Serbian detention camps in August 1992, Time magazine led with that kind of loaded imagery. Opposite a grainy video-tape still of the faces of two men, J. F. O. McAllister wrote, "The shock of recognition is acute. Skeletal figures behind barbed wire. Murdered babies in a bus. Two and a half million people driven from their homes in an orgy of 'ethnic cleansing.' Detention camps, maybe even concentration camps. Surely these pictures and stories come from another time—the Dark Ages, the Thirty Years' War, Hitler's heyday. Psychic defenses struggle to minimize, to deny, to forget."[4]

Two years later the United States and much of Western Europe celebrated the 50th anniversary of D-Day. Steven Spielberg's harrowing film Schindler's List came out. And Rwanda happened. On CNN, anchor John Holliman commented on the crisis images: "The pictures from Rwanda are reminiscent of those from the Holocaust," he said. "Perhaps too horrible to believe." In a Washington Post front-page story on Rwanda, Keith Richburg used such words as "holocaust," "pogrom" and "extermination."[5]

Only three weeks into the Rwandan genocide, on April 24, 1994, Jennifer Parmelee, another reporter for The Post, made the same connection. "At first the world was riveted in horror to scenes of carnage," she noted. "Women and

children were hacked to pieces by machete-wielding gangsters who reveled in the gore; the heads and limbs of victims were sorted and piled neatly, a bone-chilling order in the midst of chaos that harked back to the Holocaust. . . ."

And then, Parmelee observed, the inevitable occurred. Holocaust or not, compassion fatigue set in. "At a certain point, however, the eyes of the world closed, the cameras clicked off, the capacity to absorb such a living nightmare shut down. Ironically, Rwanda's 15 minutes of infamy—which confirmed the clichés in the minds of many foreigners that Africa is doomed to an eternal hell of ethnic violence—may consign it to an even deeper oblivion. The camera lens of international attention is restless and clinical; Sarajevo and South Africa beckon. Another day dawns, so does another story, another crisis."[6]

The most searing metaphors of the century had been trotted out to be compared to these new crises, and attention still wavered and faltered. Even though Parmelee was premature in her eulogy for the media's attention to Rwanda—greater coverage was to come during the summer, when the million refugees who had fled to Goma, Zaire, succumbed to cholera—she was correct in her assessment about the attention given to the genocide. Rwanda received front-page attention through May, but during the first weeks of the killing spree, when upward of 200,000 were killed, it did not command the same prominence or number of column inches or time on the news as the elections in South Africa that brought Nelson Mandela to the presidency or as the Serbian siege of the "safe haven" of Gorazde that demonstrated the farce of the U.N. presence in Bosnia.

The Holocaust is to a massacre as the assassination of Lincoln or JFK is to a murder. Holocaust imagery reverberates for Americans as the extreme benchmark of atrocity. The Holocaust has been appropriated as a cultural icon unequivocal in its meaning. To apply the term to a situation is to make an imperative—and sensational—statement. "Would there have been such a furor over the war in Bosnia"—in early August 1992, asked Charles Lane writing in *Newsweek*—"if New York *Newsday* had not used the phrase 'death camps' in its front-page headline? Maybe not."

Verbal and visual cues and references to the Holocaust, death camps and pogroms, to Hitler, Neville Chamberlain and Munich, is, as Lane maintained, "a bold use of some of the most loaded imagery in the lexicon of 20th-century politics." Comparison of a crisis to the Holocaust is an exercise in moral equivalence; it signals to readers and viewers the scale of deaths in a crisis as well as the intent of the murderers. "In Western society," said Lane, "there is something uniquely evocative, and politically potent, about the image of a concentration

camp and the charge of genocide. The ghosts of Hitler, Stalin and Pol Pot flit through Western consciences. And once again the world is haunted by the vow 'Never again.'"[7]

How better to communicate the urgency of a crisis to an audience than to evoke scenes from Auschwitz and Bergen-Belsen? How better to cut through the impenetrable internecine politics of a Bosnia or a Rwanda than by suggesting that the Serbs or the Hutus are the new Nazis and the Bosnian Muslims or the Tutsis are the new Jews? The outlines of a crisis are modeled by such references, resulting, it is to be hoped, in a more compelling and evocative story—and perhaps even in some tangible commitment of men or matériel. "Americans are still willing to fight to win a war that seems morally unambiguous," wrote Eric Schmitt in *The New York Times*. "But the stakes have to be high enough and clearly defined and the bad guy must be really bad."[8] Even in covering the extreme of genocide, the stereotypes of crisis coverage pertain: a formulaic chronology, sensationalized language, Americanized metaphors and imagery. The media hopes to transfer both the simplistic good guy-bad guy narrative and Americans' sense of moral obligation—"Never again"—from the Holocaust to this new situation. The media, once again, hopes to forestall compassion fatigue.

Sometimes it works. Sometimes, as *Time* put it, "The world's revulsion at all this is genuine and appropriate." The public's interest is seized—or so at least the media believe. The story garners front-page and top-of-the-news coverage. But then the "Never again" is seen really to be "Not again." "If I ever see a child with flies swarming around it one more time, I'm not going to watch that show again," a viewer told an NBC audience researcher. CNN's continuous coverage, speculated Ken Hackett, executive director of Catholic Relief Services, "may have been to blame" for the lack of public response to what was happening in Rwanda. "They give it to us every 15 minutes and we don't notice." From April through July, private relief agencies "got virtually no money whatsoever" from the media audience "when television was broadcasting images of Rwandans who had been hacked to death."[9]

And the Holocaust analogies and images of genocide don't necessarily prompt the United States government to send in the cavalry, either. "So far," said *Time*, the week after the Bosnian "death camp" story broke, "the responses have been confused and tentative." Said Roy Gutman, the *Newsday* reporter who won the Pulitzer Prize for breaking that story, "What you had is a lot of reaction to reports, but never any policy change."[10]

Stories and editorials in *The New York Times* and *The Washington Post* and pieces on CNN and the nightly newscasts may, in fact, slightly "squeeze" foreign

policy options. With the real-time airing of crises, the government doesn't have the time for internal debate that it used to. Intense television scrutiny robs presidents of the cocoon of privacy they enjoyed before satellite uplinks. Said John F. Kennedy's Secretary of Defense Robert McNamara about the 1962 Cuban Missile Crisis, "I don't think I turned on a television set during the whole two weeks of that crisis."[11] Now cabinet officials—not to mention the president—may be monitoring the pictures from several TVs at once during a crisis. Now presidents have to respond to the images. But, as Gutman observed, their responses tend to be more "crisis management" than "crisis prevention."

Warren Zimmermann, the last U.S. ambassador to Yugoslavia, agreed that in Bosnia the media made little difference to American policy. "It wouldn't have mattered if television was going 24 hours around the clock with Serb atrocities. Bush wasn't going to get in," he said. Lawrence Eagleburger, the former secretary of state, confirmed that opinion. "We had largely made a decision we were not going to get militarily involved. And nothing, including those stories, pushed us into it," he said. "It made us damn uncomfortable. But this was a policy that wasn't going to get changed no matter what the press said."[12]

And the Holocaust language and images of the genocide in Rwanda did not force American military intervention there either. Stabilizing the internal situation appeared to officials at the Pentagon and elsewhere to be a black hole of commitment. But once the slaughter ended and the refugees settled in camps at the borders, a potential military debacle turned into a doable humanitarian effort that the U.S. forces were well-equipped to solve. So the Americans went in.

In the two months after Clinton's July 22, 1994, decision to send troops to assist in aid work, individuals gave almost $5 million in cash donations for Rwandan relief. Contributions poured in when there was hope that a check could help, when the pictures of women and children showed them alive—if suffering from malnutrition and cholera. Perhaps the American soldiers who were sent gave people a sense of optimism strong enough to overcome their feelings of futility.

One can bear witness to a genocide, but an individual—Oskar Schindler notwithstanding—is impotent to save the victims. With famine there is at least the prospect of being able to alleviate the suffering of a few. "Perhaps people found it easier to respond to images of the hunger and disease of a refugee crisis than to the machete-hacked bodies of a genocide," mused Elizabeth Kastor of *The Washington Post* about Rwanda. "Each day we turn on the TV, open the paper and decide which new shards of information we will admit into our lives, what cruelties we will contemplate, for whom we will feel empathy."[13]

Crying Holocaust, unfortunately, may establish a hierarchy of death, but it does not guarantee attention. We have to make judgments, said psychologist Dorothy Rowe, "about what we can afford to give away, in terms of money and emotions." "People in the philanthropy business talk bleakly about 'compassion fatigue,'" said Kastor, "about people who help for the first crisis, then the second, but eventually begin to feel resentful or skeptical or just hopeless, certain that their contribution makes no difference."[14] In a world that moves steadily from massacres to genocide, from images of chaos, destruction, death and madness, from the gassing of the Kurds to the death camps of the Serbs to the streets and fields of slaughter of Rwandans, the public resorts to compassion fatigue as a defense mechanism against the knowledge of horror.

On New Year's Eve 1992, U.N. Secretary-General Boutros Boutros-Ghali visited Sarajevo for the first time and called what was going on there "a rich man's war." He chided the astonished Sarajevans, "I understand your frustration, but you have a situation that is better than ten other places in the world . . . I can give you a list." Then he left.

David Rieff, a writer for *The New Yorker*, who reported from Bosnia and wrote a book on the conflict, responded to Boutros-Ghali's remarks. "Once I had started spending time in Bosnia," he wrote, "it was not even a question of agreeing or disagreeing so much as feeling that all this comparative martyrology, all these dueling body counts" were "irrelevant." "Having been in Bosnia, I could find no meaning in the exercise of trumping one people's suffering with another's," he continued. "The exercise seemed pointless. 'Rate the best Jacobean poets in order of importance'; 'Rate the worst human tragedies in the world.'" Rieff argued that such debates — "in moral terms" — made the killing of "only" 5,000 people the "enemy" of the death of tens of thousands.[15]

As one media critic mentioned to Rieff, "Bosnia was just the best-publicized instance of the horrors that were taking place all the time, all over the world." "What about Angola, Sudan, East Timor, Tibet, Haiti, Rwanda?" he was asked.[16]

Often there is hyperbole in the application of the words "Holocaust" and "genocide," and sometimes there is racism or at least partisanship in their use. While many have argued that "Holocaust" imagery has been abused, even cheapened by overuse, it is informative to recognize which crises are consistently labeled with World War II–era metaphors. We live in a culture of triage. There has been a greater use of Holocaust analogies to Bosnia than to Rwanda, and more to Rwanda than to Kurdistan. And not coincidentally there has been

greater coverage of Bosnia than of Rwanda, and greater coverage of Rwanda than of Kurdistan.

Genocide, of course, is a news story, that should, by all the canons of journalism, be covered—although, admittedly, there are genocidal acts that fall through the cracks of coverage. According to newsroom legend, a British press baron once tacked up this memo for his Fleet Street staff: "One Englishman is a story. Ten Frenchmen is a story. One hundred Germans is a story. And nothing ever happens in Chile." On this side of the Atlantic, the now defunct *Brooklyn Eagle* reminded its reporters: "A dogfight in Brooklyn is bigger than a revolution in China." Certain locales just don't make the cut. "Recently, in Sudan and in Angola," argued British reporter Martin Walker in 1994 on CNN, there have been "scenes just as reminiscent of the Nazi death camps" as those in Bosnia, "except there haven't been cameras there to record them. Probably in the former Soviet republics of Georgia and Tajikistan, we're seeing scenes of similar horror, but again without the cameras being there."[17]

By relative standards, the coverage of both Bosnia and Rwanda has been extensive—far greater than that of the gassing of the Kurds, for example, or of the decades-long massacre of the East Timorese. How many know about the 1988 Iraqi extermination campaign of the Kurds known as the "Anfal"? According to Human Rights Watch, in the six months of the Anfal 4,000 Kurdish villages were destroyed and 180,000 people "disappeared." And how many know that since Indonesia invaded East Timor in 1975, 200,000 people, one-third of the island's population, have been starved to death or killed—in proportional terms one of the largest massacres of the 20th century? Because East Timor is about as far away physically and politically from the United States as is possible, the story never made the front pages—even when several Western journalists were eyewitnesses to the murder of 150 protesters in 1992. "Look, Timor is an interesting sad, horrible story," said Michael Mossettig, senior producer for foreign affairs for *The MacNeil/Lehrer NewsHour*, in 1992. "Unfortunately, there are a lot of interesting, sad, horrible stories all around the world."[18]

One possible, seemingly disinterested measure of a "genocide" is the total number of people who lost their lives. Is that the measure by which the media should cover such events? How should other elements be factored into the equation? What impact should such concerns as the locale (Europe versus Africa, for instance), deviance (the use of chemical weapons or the massacre of friends and neighbors, for example) and relevance (the country's importance to the United States, politically, culturally, militarily or economically) have on the media's

coverage? The thinness of the news net means that the American media can't go everywhere. Even when the news is compelling.

The terms "genocide" and "Holocaust" are tossed around pretty frequently in the media—if rarely casually or lightly. Are there really that many genocides? Do the Nazis have soulmates in countries around the globe? "The word genocide has a cachet, and people want to use it," said Steven Ratner, a professor of law and an expert on the Cambodian killing fields.[19]

When is it appropriate to use the term "genocide"? Does the definition matter?

In the shadow of the Holocaust, toward the close of World War II, Winston Churchill stated that the world was being brought face to face with "a crime that has no name."[20] What words could describe what had happened in the camps? So Raphael Lemkin, an advisor to the U.S. War Department, a jurist, Polish-born and Jewish, whose entire family fell victim to the Nazis, coined the word "genocide" from the Greek "genos" meaning race or tribe and the Latin "cide" meaning to kill.

Genocide as it came to be defined in the 1948 United Nations Convention on the Prevention and Punishment of the Crime of Genocide is the deliberate and systematic destruction, "in whole or in part," of a national, ethnic, racial or religious group. Genocide can include any of the following acts: "Killing members of the group, causing serious bodily or mental harm to members of the group, deliberately inflicting on the group conditions of life calculated to bring about its physical destruction in whole or in part, imposing measures intended to prevent births within the group, forcibly transferring children of the group to another group."[21] On the books, genocide is the ultimate crime against humanity. Other crimes against humanity are heinous and egregious, but genocide is the greatest and gravest crime because it implies an intention to exterminate the chosen group. But it is still only one among an internationally recognized body of crimes against humanity established by the jurists at the Nuremberg Trials.

In effect, the 1948 genocide convention (which went into effect—in some countries—in 1951) established two standards: massive scale and specific intent. But in practice these two apparently straightforward tests have been difficult to apply. How does genocide differ, for example, from ethnic, tribal or civil war? "The world is full of places where one ethnic group is feuding with another," wrote Charles Lane. "Sinhalese kill Tamils in Sri Lanka, Muslims and Christians do battle in Nigeria, Liberia's ethnic groups engage in mutual slaughter, the Chinese snuff out an ancient culture in Tibet. In every case, the fighting is characterized by atrocities, and the victims cry genocide."[22] In common parlance and in the media the term genocide has lost its specific meaning and

become almost commonplace. It has become synonymous with massacre and gross oppression or repression. But it retains its legal significance.

Forty years after its drafting, the genocide convention was finally ratified by the U.S. Senate in 1988 and incorporated into the U.S. Criminal Code. With that ratification, the United States, like the 120 or so other signers, is legally bound to respond to genocide by investigating and punishing those who are responsible. The driving principle behind this injunction stems from the writings of Lemkin, who insisted that "to treat genocide as a crime that only concerns an individual nation makes no sense because by its very nature the author is either the state itself or powerful groups backed by the state. . . . By its legal, moral and human nature, genocide must be regarded as an international crime." As a result of the United States' ratification of the convention the Bush and Clinton administrations have been loathe to characterize situations as genocides. During and after the massive slaughter in Rwanda in 1994, for example, the Clinton State Department and the National Security Council drafted guidance instructing their spokespeople not to describe the deaths there as genocide—to say merely that "acts of genocide may have occurred." "As a responsible government, you don't just go around hollering 'genocide,'" said U.S. ambassador to Rwanda David Rawson. "You say that acts of genocide may have occurred and they need to be investigated."[23]

The New York Times reported a senior administration official as saying, "Genocide is a word that carries an enormous amount of responsibility." Voters would expect an American response to genocide to include dispatching troops—but there were no overwhelming economic or security reasons to become involved in Rwanda. Rwanda is a small, poor, landlocked country, without oil or other resources of interest to the West. But as *The Times* quoted Herman Cohen, a former assistant secretary of state for Africa, the killing in Rwanda "must be called genocide." The Clinton Administration was taking a "wimpish approach." "Another Holocaust may just have slipped by, hardly noticed," said Cohen.[24]

A genocide, or even a genocidal act, is not typically like a famine that can be predictably anticipated a long way off—although, like a famine, it may last for a period of weeks or months or even years. The media can't "gear up" to cover a genocide, although once the killing starts, there is usually plenty of time to go and see what is happening (although access can be a problem). Nor is a genocide like an assassination, whose measure can be taken immediately—although, like many assassinations, it is a manifestation of pervasive problems within the society. The media can't typically tell, even if they are in from the start, that

"this" is genocide, although there are usually signs that suggest the intent of extermination. So a genocide is difficult to cover. Only in retrospect can one fully recognize its outlines, but in hindsight it may appear so monstrous that criticism of the early coverage is inevitably harsh.

Invariably in reporting on genocides there are problems of access. Since genocides are effectively state-sponsored, the state has an interest in preventing information about the crimes from emerging. Even though since Nuremberg (to date), individuals from only two countries—Bosnia and Rwanda—have been brought before the United Nations Tribunal to face judgment for crimes against humanity, perpetrators, who are often prominent officials in their own nations, do not care to be tried in the court of world opinion for their crimes, either. As a result of this almost insurmountable problem, the chronology of coverage is almost bound to be affected. And often when coverage of such crimes *does* occur, the stories mention the obstacles that had to be overcome or the deals that had to be struck in order to bring home the news.

Roy Gutman's story that broke the news of the Bosnian "death camps," for example, put the difficulties in the second paragraph. "The testimony of the two survivors appeared to be the first eyewitness accounts of what international human rights agencies fear may be systematic slaughter conducted on a huge scale. *Newsday* has not been able to visit the camps. Neither has the International Red Cross or any other international agency."[25]

And a story written by Theodore Stanger who traveled to the Kurdish city of Halabja to report on the poison-gas attack that killed more than 3,000 Kurds, was prefaced by his *Newsweek* editors with these sentences: "Last week the Iranians had a grisly opportunity to make their case when they allowed a few Western reporters to tour Halabja, a city in eastern Iraq recently occupied by Iranian forces after a brief but bloody siege. According to Iran, the Iraqis bombarded the city with chemical weapons after their defeat. The Iranians said the attack killed more than 4,000 civilians." As Stanger noted at the close of his article: "Many of the rotting corpses had been left unburied for one week so our group could see them."[26]

In keeping with the difficulty in access and the fact that genocidal acts can break out in regions of the world relatively unfamiliar to the media, often the entire first stage of coverage of the crisis misrepresents the genocide as something else. The massacres in Rwanda were viewed as a civil war, for example, and the systematic killing and deportations of Kurds in Iraq were depicted—if at all—as part of the Iran-Iraq war. The frequent failure of the media to accurately identify the murderous acts as genocide causes several problems: Genocide may only be recognized once it is all over, giving the public as well as politicians no

time to prevent the deaths—a surefire recipe for compassion fatigue. Being able to help survivors is intrinsically more engaging than feeling paralyzed by the mounds of dead. And while claims of "genocide" and "holocaust" do not assure interest, they command more attention than sporadic reports of deaths in some out-of-the-way locale.

Once the crisis is generally recognized as having genocide potential—the legal standard for genocide can often take years and literally tons of documents to confirm—the second stage in the chronology is reached. But depending on the crisis, stage one and stage two can occur simultaneously, as in the case of Bosnia. Or it may take weeks, as in the case of Rwanda. Or it may never happen—except in historical terms—as in the cases of the Kurds and the Armenians.

This second stage is full of ranting and raving about "Never again" and "How can we let this happen?" and "What should the president or NATO or the U.N. do?" The whole sorry mess is compared to all the icons of the past, to the Holocaust, of course, and the killing fields, and maybe to the kulaks under Stalin and the 30 million famine victims during Mao's Great Leap Forward. All the current problems in the world are weighed in the balance of the editorial and opinion pages and on the television magazine news shows and suggestions are made about how America's resources should be apportioned. Partisans argue for definitive action, detractors counsel caution. Quagmires and Munichs are mentioned.

During this second stage, journalists play up the American angle: What does this mean for *us*? What should *we* do? The subhead to a *Time* cover story on the "Killing Fields" of Rwanda asked "Are these the wars of the future?" Is this a portent of things to come? Should we be afraid? And the subhead to the *Newsweek* cover story on the Bosnian camps charged that the "Shocking images from battered Bosnia put pressure on Bush to decide what America should do—or can do—to stop the nightmare."[27] These headlines framed the events. The stories became not a simple hard-news telling of the "Killing Fields" of Rwanda or the "barbarism in Bosnia" but more a commentary on the meaning of these events for Americans.

These few subheads illustrate the typical Americanizing of genocide stories that takes place in the media. The Americanizing usually follows two tacks. One, language is employed that ties a new genocidal event to iconic events of the past—the Holocaust, the killing fields, and so forth. And two, once the Holocaust connection is made, once enough horrific stories are told so that the comparison seems sufficiently apt, a crusade for action begins. "The ghastly images in newspapers and on television screens," said *Time*, "conjured up another discomfiting

memory: the world sitting by, eager for peace at any price, as Adolf Hitler marched into Austria, carved up Czechoslovakia. For months, leaders in Europe and the U.S. have been wringing their hands over the human tragedy in the Balkans, yet have shied away from facing the hard choices that any effort to stop the killing would entail." But now, said *Time*, "The cruelty captured in powerful pictures of dead children and imprisoned adults succeeded in rousing moral outrage." In other words, we did it. We, the media, changed minds.

For a time the call for action, for some kind of action, is at the forefront of the news. Occasionally, as in the case of Rwanda and even Bosnia, eventually, some real action is taken—a "humanitarian" mission, NATO airstrikes—although usually long after the initiating genocidal acts are over. And then, at some point, that's it. Another crisis comes along and the noise in the media lessens. A few voices charge the public and the media with fickleness or forgetfulness, but then they too fall silent. The genocide is buried deep in the jump of context stories and recalled in the end-of-the-year wrap-up pieces, not to surface again on the front pages or on the nightly news until war crimes charges are brought or until violence on a massive scale starts anew.

As journalists and the government know well, language is not neutral. The lead to *The New York Times* story disclosing the State Department's moratorium on the word "genocide" for the Rwandan situation stated: "Trying to avoid the rise of moral pressure to stop the mass killing in Rwanda, the Clinton Administration has instructed its spokesmen not to describe the deaths there as genocide, even though some senior officials believe that is exactly what they represent." "American officials say that so stark a label could inflame public calls for action the Administration is unwilling to take," the article continued.[28]

But of course, public calls for action—or at least public interest—is precisely what drives journalism. And the force of language and metaphor to seize that attention was perhaps never so clearly demonstrated as by the lack of public and governmental response to Roy Gutman's first article breaking the news of the existence of the Serbian prisoner-of-war camp at Omarska which was headlined "'There Is No Food, There Is No Air'" and by the overwhelming response to his follow-up article two weeks later. As Gutman recalled, "The editors of *Newsday* decided to give the [second] story the dramatic cover treatment that only a tabloid can. THE DEATH CAMPS OF BOSNIA read the headline in two-inch-high letters. It was a daring decision. The report was immediately picked up by news wires, television and radio in the United States and around the world."[29]

The media clearly believes—encouraged by such responses as this—that vivid, graphic metaphors can capture an audience's attention. But not all genocide references are to the Holocaust. For example, Theodore Stanger's *Newsweek* piece on the gassing of the Kurds led with an intense nuclear war image of the scene in Halabja: "At ground zero in this once teeming market city, death struck in seconds. Bodies of Halabja's Kurdish residents lay scattered in the dirt streets, in backyards, in living rooms." Then, Stanger switched to another apocalyptic metaphor: "Like the dead of Pompeii," he wrote, "some were frozen in escape attempts: at the wheel of a car, in doorways. One woman was huddled protectively over her baby, also dead. Nearby, a lifeless father vainly shielded his son. A family sheltered in its cellar was killed by the heavier-than-air fumes that seeped down. Everywhere, the stench of rotting corpses was overpowering."[30]

Apocalyptic metaphors were de rigueur in the coverage of Rwanda, as well. *Time* magazine's lead on the genocide in mid-May 1994 described the ultimate debacle:

> "There are no devils left in Hell," the missionary said. "They are all in Rwanda." Actually they brought Hell with them; you have only to watch the rivers for proof. Normally in this season, when the rains come to these lush valleys, the rivers swell with a rich red soil. They are more swollen than ever this year. First come the corpses of men and older boys, slain trying to protect their sisters and mothers. Then come the women and girls, flushed out from their hiding places and cut down. Last are the babies, who may bear no wounds: they are tossed alive into the water, to drown on their way downstream.[31]

Accompanying the metaphors—of death camps, ground zero, Pompeii and Hell (with a capital *H*)—were the litany of horror stories so vile and so revolting that they made Stephen King's and Wes Craven's fiends seem like Boy Scouts. The perpetrators were described as "mad," "diabolical," with "a dull gleam in their eyes," caught in "a kind of bloodlust" and "killing frenzy"—and those were just some of the characterizations from just one story. The victims were characterized either as survivors to whom unspeakable things had been done, in which case they were "hollow eyed and mute," or, more often, as dead: "two dozen bodies rotted in the sun," "heaps of corpses lay sprawled on straw mats," "20 or 30 bodies were crammed inside a small church library," "the skeletons of a man

and a woman were locked in a final embrace" and "two corpses had been stuffed headfirst into a latrine pit"—and those were just some of the descriptions from another single article.[32]

Some periodicals did their readers a favor and buried the tales of horror deep into their articles, so at least there was some warning of their telling. Other news outlets led with the stories. "Most of the horror stories were impossible to confirm and came from hurt, frightened people," read the opening line of *Newsweek*'s cover story on "Ethnic Cleansing" in Bosnia. "Near Tuzla in eastern Bosnia," the article continued, "a distraught eyewitness saw three Muslim girls who were stripped to the waist and chained to a fence 'for all to use.' After three days of rape, the witness said, they were doused with gasoline and set on fire."[33] In either case the accounts were described so clearly that readers were left with unwelcome mental images that were difficult to shake—and undoubtedly led some to avoid future mental confrontations by ignoring the stories completely.

Thankfully, the photographs and video that accompanied the genocide stories did not illustrate the worst of the tales. But they were still evocative of the tragedies: a close-up of the faces of a Kurdish man and the baby in his arms, both seemingly frozen, with the telltale poison-gas dusting of white around their faces; a distant shot of the ragtag lineup of prisoners having their heads shaven in the Serbian detention camp at Manjaca; a panorama of the clot of swollen bodies floating at the base of Rusumo Falls on the Kagera River near the border of Rwanda and Tanzania. These three images, to cite just three, were ubiquitous and representative.

In most stories, the point of the images was as documentary evidence that genocide—or at least some lesser crime against humanity—happened "here." So the pictures showed the dead, preferably in large piles, and the "hollow-eyed" survivors, preferably women and children—although men and children or just gaunt men alone also were shown. A sprinkling of pictures of politicians and soldiers—American or U.N., for the most part—also accompanied the pieces.

On CNN, anchor John Holliman showed the river image from Rwanda. "I was struck," he said, by this "haunting picture . . . of hundreds of Rwandan bodies, slaughtered and dumped in the river, creating a picture not seen since the Nazi death camps of the 1940s. An image of almost unimaginable horror. Will the world react to these pictures and do anything?" he asked his guest, *Post* reporter Jennifer Parmelee. "John, I'm sure these images to many of your viewers seem very remote and very savage in a way they can't imagine," answered Parmelee. But, "quite simply, this is a case of what goes around comes around.

These phenomena do, in fact, impinge on our national interest. And I think we ignore the Rwandas of the world at our own risk."[34]

Some pictures do get through. Of the thousands that are shot daily by photographers or film crews in all the trouble spots of the world, a few—a year—do touch the public's conscience. *The Boston Globe* reported on the response of Americans to the images from Rwanda. "Since April," wrote reporter Usha Lee McFarling, "when the first reports of ethnic slaughter began filtering out of Rwanda, Oxfam America's John Hammock has asked anyone who would listen for help for the beleaguered nation. Few offered." On a normal day, Oxfam would get ten calls. The images of the genocide spurred few to donate money. Then in mid-July, after the genocide was over, but at the height of the refugee crisis, Oxfam received more than 1,000 calls in 24 hours, raising $50,000 — more money in one day than the past four months. Said McFarling, "All attribute the sudden interest to news coverage of the cholera epidemic that in the past four days has killed 7,000 Rwandans who have fled to refugee camps in Zaire. The link is so direct, they say, that phone calls peak immediately after graphic reports of dying Rwandan refugees are broadcast on news reports. . . . Many callers are crying when they phone. Some ask if they can adopt orphaned children; others want to fly to Rwanda to volunteer. One caller donated $7,500 worth of stocks to Oxfam."[35] In the case of Rwanda, clearly, the famine images touched people. The genocide pictures did not.

Maybe the genocide pictures didn't get through because no one was looking. *The Post* quoted Carolyn Dixon, a Florida doctor, as saying "One of the things I try never to do is watch the news at 11, because that really makes you an insomniac." And two "graying" visitors to the Mall said that they also avoided the news. "'I don't like to see these horrors,' said one. 'All these terrible things. When you turn on the news, they almost glory in it. They can't wait to tell you the horrible stuff.' 'Rwanda,' says the other, as if this is all she needs to say. 'I don't listen,' says the first. 'What can you do? You listen and there's nothing you can do.'"[36]

Such sentiments are not precisely compassion fatigue—rather compassion avoidance. How would those two older ladies express compassion for what happened to the Ilijaz family in Bosnia: "'They [the military] took electric drills and bored them into their chests,'" said their next-door neighbor, a source of Roy Gutman's. "The three children, ages one, three and five, were impaled on spikes. 'We saw it with our own eyes.'" Or how would they express compassion for what happened to the mayor of the southern town of Butare, Rwanda, who, according to *Time*, "was offered a Sophie's choice by Hutu peasants: he could save his wife and children if he gave up his wife's family—both her parents and her sister—to be killed. He made the deal."[37] They could express

revulsion and disbelief. But the stories were beyond such a mild emotion as compassion.

Even the journalists who cover the tragedies can finally find that it can all be too much. "After a while," said BBC filmmaker George Alagiah, "you become numb to what you see and hear around you, especially to the suffering, the wailing, the crying and coughing." Reporter Janine DiGiovanni agreed after visiting the Rwandan refugee camps. "By the time I reached Goma," she wrote,

> I could not have prepared myself for what I would see: the dead piled on the side of the road, naked and rotting, fathers clutching sons in a death grip, dead adolescent girls lying next to the living in the cholera tents, still weakly clutching their IV drips. The stench of decaying flesh was unbearable, the claustrophobia of so many bodies and the very notion of one million refugees in one place was incomprehensible, and it took me five or six days to feel any emotion at all. Most of the time I felt nothing, and that was five days of rising at dawn to wander through the refugee and cholera camps where people were in pain, where people were dying all around you and would grasp your ankle with their last bit of strength to ask for a drink of water.

Even though the journalists are present, in person, at "ground zero," at some point they too have to turn it all off. "Like the television viewers who switch the channel because they are tired of seeing the same image of the crying child, the dead lying neatly with their arms crossed, or the food fights breaking out at a Red Cross distribution point," wrote DiGiovanni, "I had simply had enough. Some part of my brain had switched out."[38]

So if the public won't watch and the journalists at times can't, why then do the media bother to cover such stories at all? In 1994, *Time* and *Newsweek*'s biggest sellers of the year were their cover obituaries of Jacqueline Kennedy Onassis. *Newsweek*'s biggest newsstand duds were its cover stories about a Bosnian girl whose diary of life under fire was excerpted and another about war-torn Sarajevo.[39] Reporter DiGiovanni told of seeing a man in a store pick up the May 16, 1994, issue of *Time* magazine with the faces of a Rwandan mother and child on the cover, and superimposed over them the line THERE ARE NO DEVIL'S LEFT IN HELL . . . THEY ARE ALL IN RWANDA. "And yet," said DiGiovanni, "it appeared to make no impact. The man's eyes registered, and this was entirely believable boredom. He put the magazine down and bought a copy of *Vanity Fair* with

Cindy Crawford on the cover in a bikini rising out of a seashell like Aphrodite. Given the choice of a glorious Cindy Crawford or a starving child, can you, in a sense, blame him?"[40]

If the public is not going to get exercised over a massacre here or a mass killing there, why do the media? If the use of the words "Hell" and "Holocaust" doesn't really compel ongoing interest, why do the journalists continue to write about genocidal events in such explicit and metaphorical terms?

Foreign correspondents quite simply report on genocides and call them holocausts, because they are human. They are the ones choking on the smell of death, gagging at the sight of toddlers who "lay sliced in half."[41] They can try and disassociate themselves from what they are witnessing—if only to get through the day—but the horrors pursue them.

So they become activists. As with famine reporting, objectivity in the face of rape, torture and mass murder is not possible. And the choice of value-laden language and Holocaust imagery—or other unequivocal metaphors—marshals the most powerful tools at a journalist's discretion. If World War II was the war against evil, the war that had to be fought, the "good" war in effect, that mantle is borrowed for any new conflict that is so labeled. Even when qualified, the call for action is evident. "As yet, the atrocities against the Bosnian Muslims, heinous as they are, do not rank on the same quantitative level as the Nazi extermination of the Jews," wrote Charles Lane in August 1992. "But if smaller in degree, they do seem similar in kind. . . . Bosnia may not be Buchenwald, but it's bad enough. . . ."[42]

To an astonishing extent, the media don't tailor their coverage to anticipate or accommodate the public's indifference. Of course, compassion fatigue or compassion avoidance ultimately prevails—the story is yanked from sight long before it is truly over, and even before that happens it receives less play than it deserves. But the coverage of genocide—at least the coverage of those few cases of genocide that make it into the news in the first place—may be one of the few instances where the media really do put their foot down, when they really do insist on covering a story because the public should know. Public apathy about Bosnia or Rwanda, for example, argues that few are watching or reading such stories—and that perhaps the media needs to change their manner of telling this kind of news. But even if every reader and every viewer turns the page or hits the button on the channel surfer when the horrific images pop up, at least the media can say that they bore witness. "While much of the world was ignorant in 1940 of the efficiency of the Nazi killing machine," said *The Cleveland Plain Dealer*, "today on the doorsteps of the global village a media-driven culture delivers fresh images daily of atrocities in Bosnia and Rwanda. . . ."[43]

Many foreign correspondents ultimately become quite partial about the events they cover. The two sides (or three or four) to a conflict are no longer neutral pieces on a chess board, playing a game that needs to be recorded. When covering genocide, one party is seen to be holding the higher moral ground. Journalists become advocates for more coverage and more action to improve the conditions for the survivors. *Newsday* reporter Roy Gutman quoted "famed Nazi hunter" Simon Wiesenthal in the acknowledgments to the collection of his dispatches from Bosnia. Wiesenthal, said Gutman, "who has devoted his life to documenting genocide and bringing justice to the victims," gave him an "eloquent reason" for writing: "All of us need an alibi so that we can say we were not silent, that we informed people, that we did everything to bring knowledge about this to the public."[44]

Journalists become witnesses who charge themselves with the keeping of memories—memories of the survivors and of the "immensity of evil" that killed the thousands and the tens of thousands and the hundreds of thousands of victims. "Nothing could have prepared me for the scale of what I witnessed," wrote BBC filmmaker Fergal Keane. "I am not an especially religious person but I went to Rwanda believing in a spiritual world in which evil was kept at bay by a powerful force for good," he continued. "In any event after Rwanda I lost that optimism. I am not sure that it will ever return. For now I can only promise to remember the victims: the dead of Nyarubuye, the wounded and the traumatized, the orphans and the refugees, all of the lost ones whose hands reach out through the ever lengthening distance."[45]

Marcel Ophuls, the great French documentary filmmaker who directed *The Sorrow and the Pity*, spent many months filming in Sarajevo. One icy winter night in 1993 he used candles to light the dining room of the Holiday Inn there—the hotel where most of the media camped out. He turned his camera on the assembled journalists and asked them what they found to be most difficult about reporting in Bosnia. When he came to Janine DiGiovanni, she said that "the most difficult thing of all was not the blood or the crying or the coughing or even the hardship of not being able to wash or have a cup of tea or turn on the lights but the fact that we were covering a story that the public had grown tired of."[46]

POISON GAS, DEPORTATION AND EXECUTION: IRAQ'S "ANFAL" CAMPAIGN AGAINST THE KURDS, FEBRUARY–AUGUST 1988

Near Ypres, Belgium, on the morning of April 22, 1915, German officers woke up and tested the wind. It was blowing just right. So the order was given to open

up the valves of 5,000 canisters of chlorine gas at the edge of No Man's Land. The breeze wafted the cloud of poison gas across to the French-Algerian troops opposite the Germans. The chemicals, which were heavier than air, settled down into the French trenches.

Wrote one correspondent about that spring morning: "Hundreds, after a dreadful fight for air, became unconscious and died where they lay—a death of hideous torture with the frothing bubbles gurgling in their throats and the foul liquid welling up in their lungs. With blackened faces and twisted limbs, one by one they drowned—only that which drowned them came from inside and not from out."[47]

That single day in April, 5,000 men died from the effects of the gas and another 10,000 were disabled—many for the remainder of their lives.

A decade later, in 1925, 29 nations signed the Geneva Protocol outlawing use of poison gases in war—although it took another 50 years, until the end of the Vietnam War in 1975, before the U.S. Senate ratified the agreement. "The treaty is an artifact of a more genteel age," wrote Richard Cohen in 1988, in a column in *The Washington Post*. "The international community outlaws poison gas but not atomic warfare, saturation bombings, fire bombings and—of course—war itself. What the treaty lacks in logic, however, it makes up in emotion, and that emotion is fear. Few forms of death are more horrible, more painful and more protracted than those caused by chemical weapons."

"Tell that to the Kurds," he said.[48]

Twice in 1988 the Kurds briefly made the news. The media didn't consider them to have "cover" potential or to be worthy of the top of the news on the nightly television newscasts. Still they received attention: a very few front pages, a couple of newspaper editorials here, some dramatic footage on TV there, a sprinkling of articles in the three newsmagazines. Not much in the balance, considering that by the estimate of Human Rights Watch (which was supported in its findings by a staff report to the Senate Foreign Relations Committee) at least 50,000 and possibly as many as 180,000 Kurds—many women and children—were killed between February and September 1988, during the six months of the "heroic Anfal operations" of Saddam Hussein's cousin Ali Hassan al-Majid.

The coverage the Kurds did receive was for two reasons: for getting caught in the middle of the death throes of the Iran-Iraq war (for which they were mentioned only in passing) and, more notably, for becoming the victims of the most massive gas attack since Ypres—during the Iraqi bombing of the Kurdish border town of Halabja on March 16, 1988, when at least 3,200 were killed.[49] It wasn't for the literal razing of hundreds of Kurdish villages, or the massive deportations

of men, women and children or the summary executions that the Kurds made the news. It was for the twist of fate that made them the prime civilian victims in Saddam Hussein's use of chemical weapons. Poison gas is sexy. It's novel. It has news appeal. People disappearing, rumored to have been buried in mass graves, happens all around the world. Just ask the Argentineans or the Timorese.

Jim Hoagland wrote a column for *The Post* ten days after the deaths in Halabja. "Did you catch those pictures on television the other night, all those bodies in that village in Iraq, and not a mark on them?" he asked. "Poison gas, the announcer said, and it sure looked like it. Victims were the Kurds. Again."

Hoagland explained the rationale for their killing. The Kurds "got on Baghdad's nerves this time by joining up with the Iranians in that organized slaughter that is dignified with the name of the Iran-Iraq war. Seems they helped the Iranians capture a few Kurdish villages inside Iraq last week. Big mistake."

So the Kurds were slaughtered. But "Kurdish calamities never seem to make a big impression in the outside world," said Hoagland.

> The White House says it is disgusted by what seems to have happened at Halabja. But the U.S. policy response to Iraq's escalation is to keep on pushing for an arms embargo—against Iran. With logic like this shaping policy, Washington's friendship for Baghdad is likely to survive one night of poison gas and sickening television film. TV moves on, shock succeeds shock, the day's horror becomes distant memory. The Kurds will stay on history's margins, and policy will have continuity.[50]

In those few days in March and early April when the Kurds were in the news and again when they hit the headlines six months later after another spate of poison-gas bombings in August and September, Iraq and Saddam Hussein were roundly condemned. Holocaust metaphors made their appearance (although the relative scarcity of voices claiming genocide and holocaust would be especially evident when compared to the ubiquity of people calling the detention camps in Bosnia another Holocaust). Paul Conrad drew a political cartoon for the *L.A. Times* of Kurds and Iranians overcome by gas. The caption read: "Iraq's 'Final Solution.'"[51] Senator Claiborne Pell (D-RI), the chair of the Senate Foreign Relations Committee at the time, introduced legislation imposing sanctions against Iraq for its use of chemical weapons. "A crime of unthinkable proportions is emerging," said Pell in a speech to the Senate. "For the second time in this century, a brutal dictatorship is using deadly gas to exterminate a distinct ethnic minority. There can be no doubt but that the Iraqi regime of Saddam

Hussein intends this campaign to be a final solution to the Kurdish problem." So what was the world's response? "While people are gassed, the world is largely silent," said Pell. "Silence, however, is complicity. A half century ago, the world was also silent as Hitler began a campaign that culminated in the near extermination of Europe's Jews. We cannot be silent to genocide again."[52]

Secretary of State George Shultz told a senior Iraqi official the second week in September that a continuation of gas attacks would affect overall U.S.-Iraqi relations—a threat equivalent to closing the barn door after the horse has already bolted. And despite the fact that the Senate unanimously favored imposing U.S. sanctions of some sort on Iraq, and the House agreed, 388 to 16, by the end of the legislative session on October 22, all such legislation had been killed.

So the American rebuke to Iraq was effectively a whisper. "The world," said columnist Richard Cohen, "kept on dozing." "When Adolf Hitler was asked how the world would react to the genocide of the Jews, he recalled Turkey's attempt to exterminate its Armenian population. 'Who remembers the Armenians?' he is said to have asked. Soon," Cohen continued, "yet another despot with murder on his mind may ask the same question about the Kurds—and once again the world will wonder how these things happen. The answer is always the same: because good people did nothing."[53] That is what compassion fatigue or compassion avoidance amounts to, when genocide is in the balance. People die because other good people did nothing.

"How many of you Americans remember what happened that day?" asked a Halabja survivor of an *L.A. Times* reporter. "Do you know that this is our Hiroshima, the Kurdish Hiroshima?"[54]

The Kurds are the fourth most numerous people of the Middle East, after the Arabs, the Turks and the Persians. At present they number around 20 million, but in the wide swath of territory they call Kurdistan, they live as minorities. Often economically deprived and poorly educated, they have neither the financial resources nor the political connections of, say, the Palestinians. Predominantly Sunni Muslim, they speak three dialects of Kurdish, a distinct language related to Persian not Arabic. Many Kurds are more European than Arabic in appearance; it is not uncommon to see children with blond or red hair.

Historically, the Kurds have been in conflict with the central governments in their lands; as a result they have often fought to counter the balance of power in the region. During the Crusades, they battled with the Arabs to defeat the Christian armies. During the 17th and 18th centuries, Germany, France and Britain curried favor with rival Kurdish tribes to secure and maintain trade routes to the East.

Their best chance of forging an independent state came and went soon after the close of World War I. The Ottoman Empire, which had controlled much of the Middle East for more than 600 years, was carved up. In 1919 the victorious Allies redrew the map, creating such countries as Iraq, Kuwait and Syria. The Treaty of Sèvres in 1920 promised the Kurds their own separate state, but Britain, which controlled Iraq under a League of Nations mandate, blocked their chance. The British claimed Kirkuk, located in what the tribes claimed as Kurdistan; Iraq's largest oil deposits were discovered there in 1927.

Denied their own state, the Kurds became residents of five other nations: Turkey, Iraq, Syria, Iran and the former Soviet Union. Thirteen million Kurds live in Turkey, four million in Iraq. They are the largest ethnic group in the world without a country.

In Turkey, Kemal Ataturk, founder of the Turkish Republic, crushed a series of Kurdish uprisings as part of his strategy to forge a modern "Western" state. The Kurds lost their right to be educated in their own language or even to call themselves Kurds.

In Iraq, the Kurds sporadically revolted against the Baghdad government. Until 1958 when the British mandate ended, these insurrections were put down with the assistance of bombing campaigns by the British Royal Air Force. In 1961, the Kurds launched a series of major guerrilla attacks against the government, followed by cease-fires granting cultural and political concessions. But because the Baghdad government rose and fell four times during the next six years, the cease-fires and the concessions often went unhonored.

In 1968, Saddam Hussein's Ba'ath Party came to power, inheriting the history of Kurdish insurrection in Iraq stretching back almost 50 years. At first all went reasonably well. From 1970 to 1974, the Ba'ath Party even allowed an autonomous Kurdish region and Kurdish was taught in schools. Then in 1974, Mollah Mustafa Barzani and his Kurdish Democratic Party (KDP) rebelled again, this time supported by covert aid from the CIA, Israel and the Shah of Iran. But in March 1975, at the OPEC conference in Algiers, the Shah struck a deal with Saddam Hussein, who was emerging as the sole power in Iraq. Barzani was cut out and the guerrilla movement soon collapsed. As many as a hundred thousand Kurds, civilians and *peshmergas* (Kurdish fighters, literally "those who face death"), fled to Iran. Barzani went into exile in the United States, where he died in 1979.

Over the next several years Iraq obliterated hundreds of Kurdish villages in a zone 12 miles deep along its lengthy borders with Iran, Syria and Turkey. Tens of thousands of Kurds were resettled in the interior or deported to the South. A campaign of Arabization was launched. Arabs were sent to the oil-rich region of

Kirkuk to dilute the Kurdish influence there. The Baghdad government gave a financial bonus to every Arab man who married a Kurdish woman.

With the onset of the Iran-Iraq War in 1980 (called the Persian Gulf War—until the "new" Persian Gulf War came along), the Kurds again went on the offensive. Barzani's son Mas'oud assumed the leadership of the KDP. Young Kurds joined the *peshmergas* in the mountains rather than be drafted into the Iraqi army. At first Iran ignored the Kurds, putting more energy into prompting fellow Shiite Moslems in Iraq to overthrow Saddam Hussein, a Sunni. But by 1985, the Iranians needed the Kurds to force Iraq to divert troops to the North. Ayatollah Khomeini aided Barzani's KDP and enlisted the help of the other main Kurdish group, the Patriotic Union of Kurdistan (PUK), led by Jalal Talabani.

Knowing they were being used as pawns, the Kurds still saw the Iran-Iraq conflict as offering their best chance to gain autonomy. Never before did they wage such large-scale warfare. The *peshmergas* staged hit-and-run raids against oil installations in Kirkuk. Eventually they claimed a 4,000-square-mile liberated zone in an arc from the Syrian border to part way down the frontier with Iran. But from Baghdad's perspective, the Kurds were a Trojan horse for the Iranians, who swept into the areas that the Kurds had captured.

In hindsight, the turning point back in Iraq's favor vis à vis the Kurds was the appointment in March 1987 of Ali Hassan al-Majid as the chief of the Ba'ath Party's Bureau for Northern Affairs. He was given absolute control over civilian and military activities. A month after he came to power in the North, al-Majid responded to the PUK's capture of positions near the city of Sulaymaniya with a chemical attack on the PUK's regional command in several Kurdish villages. Survivors who sought medical attention were seized and all the males were executed, a practice that became routine. In April and May, his forces carried out at least seven separate chemical attacks.[55]

Al-Majid made himself more feared than Saddam. In June 1987, he defined large regions of Kurdistan as prohibited areas and ordered that "the armed forces must kill any human being or animal present within these areas. They are totally prohibited."[56] He razed 500 villages to deny the *peshmergas* food and shelter, deporting those who lived there. Those families that evaded deportation were ordered to be executed when caught.

By the new year, Kurdistan had become the major front in the war between Iran and Iraq. Elsewhere the conflict had ground to a standstill. Partly to soften up the territory before Iraqi ground troops occupied the area, al-Majid initiated Operation Anfal, a series of assaults on *peshmerga*-controlled territory, using chemical and high-explosive air attacks, and the orderly campaign of village destruction and forcible relocation of hundreds of thousands inhabiting "prohibited" areas.

The name Anfal or "the spoils" came from the eighth "sura" or chapter of the Koran, part of a revelation to the Prophet Mohammed after the first battle when his group of believers routed a larger force of Meccan unbelievers. The revelation was designed to define how the spoils of battle should be divided among the Muslims, many of whom had had their own property confiscated when they joined the new religion.[57] Calling the campaign "al-Anfal," therefore, gave the extermination of the Kurds and the appropriation of their land, homes and goods a religious authority. All was licensed. In the eight Anfals, from February 23, 1988, to September 6, 1988, al-Majid systematically put large numbers of Kurds to death days or weeks after they were rounded up in villages marked for destruction or after they were caught fleeing army assaults in the prohibited areas.

According to David McDowall's authoritative history of the Kurds, most of those rounded up were sent to the army base of Topzawa, near Kirkuk, where

> registration and segregation took place with a brutality reminiscent of Nazi death camps. Teenage and adult males were lined up . . . and stripped of everything but their clothes. . . . After two or three days at Topzawa, all these males were loaded onto closed trucks. They were not seen again. Through the testimonies of six survivors we know the end of the road for the men of the Anfal. Taken to the execution grounds at Ramadi, Hatra and elsewhere, they were tied up in long lines alongside deep trenches, and shot. When the trenches were full, they were covered in.[58]

One of the most ominous pieces of evidence of the Anfal campaign was found among documents and tapes seized in a Kurdish uprising in March 1991 from al-Majid's headquarters in Kirkuk. On the recording, al-Majid mentions a telegram he received from a high-ranking army commander, Tali Al Duri, asking him to look after Kurdish prisoners and families of *peshmerga* guerrillas. "Yes, I'll certainly look after them. I'll do it by burying them with bulldozers. That's how I'll do it," his voice said.[59]

Al-Majid did his dirty work in private. In 1987 and early 1988, a few rumors emerged about what was happening in northern Iraq, but they were squelched. In March 1988, *Post* columnist Jim Hoagland mentioned a cover-up. "Reports last year that Kurdish civilians were being destroyed and chemical weapons used by the Iraqis on Kurdish civilians caused a military attaché at the American embassy to go up for a look-see," he wrote. "Came back and told other diplomats he's seen destroyed villages. Told a visiting journalist that he hadn't."[60]

Al-Majid was a busy man. During the six months of the Anfal, he launched at least 32 separate chemical attacks—not including the March 16 attack on Halabja, which was not considered part of the Anfal, but rather part of the war against Iran. Although the rationale for the Anfal cannot be divorced from the Iran-Iraq War—the coordination between the Kurdish and the Iranian forces convinced Saddam that the war was one and the same—the Anfal operations went much farther than was required to restore the authority of Baghdad in Kurdistan. "Saddam Hussein's regime," charged Human Rights Watch, "committed a panoply of war crimes, together with crimes against humanity and genocide."[61]

How many Kurds were actually killed in the Anfal will probably never be known. But Iraqi writer Kanan Makiya tells this story in his book *Cruelty and Silence*. Al-Majid attended a meeting between Kurdish leaders and government officials late in the spring of 1991, at the end of the (second) Persian Gulf War. The Kurdish delegates raised the matter of those who had disappeared during the Anfal. At which point al-Majid became enraged. "Then," quoted Makiya, "as if to end all talk of the campaign, al-Majeed shouted: 'What is this exaggerated figure of 182,000? It couldn't have been more than 100,000.'" As Human Rights Watch noted, his number "was a telling order of magnitude, not to mention an admission of guilt."[62]

But Americans didn't learn about the Anfal from the media in those months. Indeed, the first time the Kurds received any significant attention was in the wake of the bombing of Halabja. Two days after the Wednesday, March 16, 1988 poison gassing, the news started trickling out. The source for the information was Iran's Islamic Republic News Agency—not exactly, in American eyes, at least, an unimpeachable news source. As always in international crises, the U.S. media is not comfortable going with a story that has no "Western" confirmation—American is best, of course, but also credible are European or Japanese witnesses, for example. So, barring that type of confirmation, the news briefs that emerged in those first few days were careful to prominently attribute the information on the Halabja bombing to the Iranians and to follow up the charges with disclaimers from the Iraqis. "Baghdad has denied reports of fighting," noted *The Washington Post*. "It said it withdrew from Halabja and another town, Khormal, 'some time ago.'"[63]

On Sunday, the 20th, Iran renewed its accusations against Iraq, but the media were still leery of believing its assertions—as the *Chicago Tribune* put it the next day, "There was no independent confirmation of the attacks on Kurdish towns, allegedly carried out Thursday [*sic*], and Iraq made no mention of them."[64]

It wasn't until Tuesday that the story received any real play. There were several reasons for the change of heart. First, on Monday, Iran's chief delegate to the United Nations accused Iraq of killing 5,000 people and wounding that many more in the chemical assault—an accusation, which because it was made in the context of an international organization, seemed more trustworthy. Second, also on Monday, "foreign reporters" visiting the Iranian capital of Tehran "were shown several dozen hospital patients with blotched, peeling skin and labored breathing" that the Iranian doctors said was due to the gas attack.[65] *The New York Times* folded the news into their front-page story about an Iraqi raid on an Iranian oil terminal and CBS did the same—leading a two-and-a-half minute story with the shipping raid, and then going to Tom Fenton in London with a story about the agony suffered by the Halabja survivors.

But most critical of all, said *The Post*, was the "startling evidence of Iraqi chemical attacks provided by television cameras that filmed scores of dead Iraqi Kurds in the northern Iraqi border town of Halabja."[66] The footage, shot for Iranian television, was "grim" and "gruesome." Both CBS and ABC aired the scenes that Tuesday night.

The next day, one week after the actual attack, the Reagan administration condemned as a "particularly grave violation" of international law the Iraqi use of chemical weapons in Halabja. Referring to the television pictures broadcast on Tuesday evening, White House spokesperson Marlin Fitzwater told reporters: "Everyone in the administration saw the same reports you saw last night. They were horrible, outrageous, disgusting and should serve as a reminder to all countries of why chemical warfare should be banned."[67] The television images had the force of revelation and authority in the way that no other medium or message had had.

Then starting on that Wednesday, the foreign media were invited to go on an Iranian propaganda tour of Halabja. (The guided tours of Halabja lasted well into April.) The journalists were issued gas masks in case of further attack and then helicopered across the border. The poison gases had dissipated, but, said Reuters' Patrick Worsnip, "The stench of death was overpowering." Scores of corpses remained unburied so the journalists could see how they died. None of the bodies had visible wounds. All were civilians; any Iranian military casualties had presumably been removed before the reporters and photographers arrived. Patrick Tyler of *The Washington Post* identified the dead as Kurds and twice repeated the Iranian charge that the incident was part of "a systematic campaign to punish the Kurdish population in northern Iraq that is assisting Iran's military operations." This was as close to a report on the Anfal as the media ever came in 1988.[68]

As a result of the eyewitness reports, the news received better play—*The Post* and the *L.A. Times* ran front-page articles on Thursday, and all the networks carried stories over the next several days—although the longest was a minute-forty seconds and none appeared near the beginning of their newscasts.

On Friday, the Secretary-General of the United Nations Javier Perez de Cuellar condemned the attack and agreed to an Iranian demand that unless he sent a team of experts to investigate the accusations that Iraq had used chemical weapons against civilians Iran would boycott the Gulf War peace talks.

That weekend numerous editorials appeared. The *L.A. Times* railed that no tactic seemed to deter Iraq from the use of this "ghastly weapon." *The New York Times* offered some policy advice, suggesting that both "Washington and Moscow have to get an urgent message to Baghdad now: Stop using these weapons or forfeit outside support." Since the foreign journalists who traveled to Halabja only saw about 100 corpses, *The Times* editorial conservatively accused Iraq of killing "more than 100 Kurds—women, children and elderly people." But it still concluded that "the deed is in every sense a war crime."[69]

In several ways *The Washington Post* had the most curious take on the incident. Their editors' suggestion was that the Soviet Union and the United States should impose an arms embargo on Iran—not Iraq—because Iran was the one "sitting on Iraqi territory" and the one rejecting the settlement called for by the United Nations. But, they continued, "While Iraq does disgusting things like mounting chemical attacks, however, nobody is going to pay attention to its distress." That was the curious part—who's in distress? Not the Kurds, who were not mentioned once in the editorial. Iraq's in distress. The editors' assessment of blame was another indication that at times *The Post* is unarguably the Company Town newspaper—for certainly the Reagan administration supported the Iraqis over the Iranians.

But another section of *The Post* editorial was telling, too. "Outsiders" to the Iran-Iraq War, the editorial said, "have trouble staying engaged in what looks like an endless struggle that is immune to foreign interventions and that, anyway preoccupies two unloved regimes. The outsiders tend to nod off."[70]

And so they did. Over the next several weeks or so only a smattering of stories aired on the networks or appeared in print. Most related to the news that about 100 victims of the Halabja attack were airlifted to the West for medical treatment, five to a hospital in Queens. "Hands shielding swollen eyes from the glare of television lights," said the *L.A. Times*, "the three little girls squirmed uncomfortably in the hospital room as they were displayed as survivors of a poison gas attack."[71]

At the beginning of April, *The New York Times* carried a front-page article breaking the news that Iran was again charging Iraq with new attacks on its own civilians with mustard and nerve gas. The Iranian press agency identified the villages that were hit as in the Qara Dagh region west of the Iranian border. It said that 75 people had been killed and another 100 injured. The credibility that Iran had gained with the Halabja story clearly prompted *The Times* to give the story front-page treatment. And as Human Rights Watch's interviews of Kurdish refugees and research into captured Iraqi documents later demonstrated, the Iranian charges were again correct.[72]

Still, the news of the Kurds was typically wrapped into larger stories on the Iran-Iraq war. "In recent weeks, as the Iranians have become frustrated and neutralized by Iraqi military strength on other fronts," said an article in the *L.A. Times*, "the focus of fighting has been squarely on the four northeastern Iraqi provinces that constitute Kurdistan. . . ." Other mention of the Kurds came in trend stories on chemical weapons. *New York Times* science editor Malcolm Browne called poison gas "the poor man's atomic bomb," and led a piece on the spread of chemical weapons with images—"seared lungs, clouded eyes and scarred flesh"—of the five casualties from Halabja recuperating in New York.[73]

In July Iraq finally admitted to having used chemical weapons, mainly mustard gas and nerve gas—but only as a defensive measure. In the middle of the month, on July 18, after eight years of fighting, both Iran and Iraq agreed to accept unconditionally a U.N. cease-fire resolution. The end of the war that had caused more than a million deaths was in sight. Discussion of the Kurds was buried deep in the stories. Only in its map graphic did a *U.S. News* article on the war's end mention the Kurds, citing the Halabja attack in March and the recapture of "its Kurdish region" in July. In fact the piece did include a photograph of two Kurdish children killed in Halabja, but the caption implied they were Iranian: "Iraqi poison gas wiped out villages and sapped Iran's fighting will."[74]

Time magazine chose that month to do a scare story on the "Return of the Silent Killer." The Iran-Iraq cease-fire was the news peg for its four-page story on the "hellish poisons" of chemical weapons. It ran two pictures on the opening spread, one of a dead man and baby in Halabja and another of a young girl receiving treatment in Iran after the attack in Halabja, but, like *U.S. News*, in neither case were the victims identified as Kurdish. In the text there were only two mentions of the Kurds: that Iran charged Iraq with using gas "to dislodge Kurdish separatists from a mountain stronghold" and that after the attack on "the village of Halabja" (a city of 70,000 people) "bloated Kurdish bodies littered the streets." The lack of identification of Kurds in the photographs, the minimal

mention of them in the copy's discussion of Halabja and the comment that the Iraqis were using chemical weapons against "Kurdish separatists" made it appear that Iraq was not targeting Kurdish civilians.[75]

By the end of August, as the Geneva peace talks continued and a truce approached, the media began to acknowledge that the Iraqis were launching a "major drive against Iranian-backed Kurdish separatists in the north." In July, Baghdad sent 20,000 elite forces into Kurdistan. "The result," said *The New York Times*, "was to further reverse the power balance that enabled Iran to exact concessions from Iraq when the two sides made their last major deal in 1975. . . . In their campaign against the Kurds, said a regional diplomat knowledgeable about the mountainous area in the north, 'we got the impression that the Iraqis wanted to finish the whole business.' Thousands of villages have been razed in the region to deny sanctuary to the guerrillas of Jalal Talabani and Massoud Barzani."[76] The newspapers reported in news briefs or at the end of truce stories that Kurdish leaders were claiming more chemical attacks.[77]

By the end of the first week in September, the Kurds were back more prominently in the news. The sustained offensive which had involved 60,000 Iraqi Army troops and helicopter gunships dropping chemical weapons had "dealt Kurdish nationalists their most serious setback in their half-century struggle for an autonomous homeland." More than a hundred thousand refugees had fled over the borders into Turkey and Iran. *The Post* quoted one Western ambassador in Baghdad as saying, "If they had successfully kept them in Iraq, they could have done what they like without the world knowing about it."[78]

When legislation calling for economic sanctions against Iraq was introduced almost simultaneously with a State Department announcement that U.S. intelligence agencies had intercepted Iraqi military communications indicating that Iraq had used poison gas against Kurdish guerrillas, the press buzz grew. The media noted the discrepancy between the Reagan administration which was charging the Iraqis with bombing Kurdish fighters and the House and Senate bills which stated that the Iraq army "had undertaken a campaign to depopulate the Kurdish regions of Iraq by destroying all Kurdish villages in a large part of northern Iraq and by killing the civilian population." When asked if the administration shared the legislators' assessment of genocide, State Department spokesperson Charles Redman said, "I don't have any way to go to that question directly."[79]

It was now Iraq's turn to take the journalism community on a propaganda tour. Iraq had rejected demands for a U.N. inspection team to investigate the Kurdish charges and instead had invited television and print reporters to visit the disputed area. Two dozen foreign journalists in five big Soviet MI8 helicopters

flew around northern Iraq for two days in mid-September. Iraqi Defense Minister Adnan Khairallah quipped to the assembled group, "I was struck by the fact that you haven't brought your gas masks with you."[80]

The Post's Patrick Tyler, for one, was convinced by his hosts. Sure, there had been destruction, but there hadn't been genocide. In a report filed from Iraq he detailed the damage: "This part of Kurdistan has been burning. All that remains is the scorched earth, bombed-out villages and the rotting harvest abandoned by more than 5,000 Kurds who fled a punishing Iraqi Army assault on this remote valley. . . . Reporters were not allowed to inspect individual villages that had been destroyed, but from the air, many appeared to have been leveled, with only foundation stones and shrubbery remaining."[81] Yet a week later, still filing from Iraq, he categorically denied that what was happening in Iraq was genocide. Yes, "life is changing here drastically. . . . It is now illegal in Iraq to have a single house in the mountains. . . . More than 200 small villages have been demolished in one province, their residents collectivized in 'complexes'. . . . Within a few years, this relocation program will have drastically changed the culture of Kurdistan. . . ." But, he said, "it is clear that the major towns and cities of Kurdistan are still standing, unscathed and populated by Kurds who cling to their rich culture under the protection of a government that recognizes some amount of Kurdish autonomy and condones and encourages the preservation of the Kurdish way of life.

"Life is going on," he wrote. "It is not as pretty as the life the Kurds used to live with their flocks in the high valleys—a sort of noble Hobbit land of mud-roof houses covered with spring grass, where men in blousy pants and women in colorful costumes spoke to each other in a unique and lyrical tongue." So what, that al-Majid had obliterated the Kurdish rural existence. The term genocide, Tyler concluded, "does not apply."[82]

Opinion writer Milton Viorst, also a guest of the Iraqis, agreed. "From what I saw, I would conclude that if lethal gas was used, it was not used genocidally—i.e. for mass killing," he said. "The Kurds compose a fifth of the Iraqi population, and they are a tightly knit community. If there had been large-scale killing, it is likely they would know and tell the world about it. But neither I nor any Westerner I encountered heard such allegations. Nor did Kurdish society show discernible signs of tensions. . . . In Baghdad, I attended a gala Kurdish wedding, where the eating, drinking and dancing belied any suggestion that the community was in danger." Viorst even questioned whether the Iraqis used chemical weapons. "Iraq probably used gas—of some kind—in air attacks on rebel positions," he said. But the symptoms of the refugees "could have been produced by a powerful tear gas."[83]

So, according to some in the media, the "noble Hobbit" people really weren't so bad off.

Veteran *New York Times* foreign correspondent Clyde Haberman, who also went on the Iraqi helicopter rides, was skeptical of the dancing Kurds. He noted more cautiously in his dispatch that "the poison-gas issue defied resolution on this visit, in which access to local Kurds was limited. Those who did speak were always under the gaze of Government officials and soldiers. And physical evidence was as evanescent as the gas itself." "In addition," he noted,

> reporters' dispatches were monitored. On Friday, an article written for *The New York Times* was first censored and then entirely prevented from being transmitted. Stricken from the article was a reference to the use of chemical weapons by Iraq during the war against Iran, as well as how Iraqi authorities made it difficult for reporters on this visit to talk to Kurdish villagers and ordinary Iraqis. Television crews were forced to give their videotapes to Government officials before leaving the Kurdish region. At several locations, the Government arranged interviews with, and speeches by, Kurds so that it could support its contention that it commands the loyalties of the Kurdish minority and that rebel fighters are few and despised.[84]

On that unsatisfying note, news of the Kurds essentially fizzled out—just as the legislation calling for sanctions in Congress was allowed to die a quiet death. But the fizzle shouldn't have come as much of a surprise. During the Iran-Iraq War the Reagan administration had covertly funneled money to Saddam—indirectly funding as well Saddam's campaign against the Kurds. And the United States had not been alone in aiding, not censuring Iraq. No country in the world enacted sanctions against Saddam. Iraq was not ostracized from the community of nations. Most countries even avoided direct criticism of the regime. "Iran's support for international terrorism and hostage-taking, coupled with its fiery brand of Islamic fundamentalism, make Iran an unsympathetic victim," said an article in a *Christian Science Monitor* series on chemical warfare. "In the end, Iraq's decision to use chemical weapons was a calculated one. 'They (the Iraqis) were willing to take the opprobrium, the diplomatic isolation,' a Western diplomat in Baghdad says. 'They made the calculation that as soon as peace broke out, businessmen would run to invest in their country. . . . they were right.'"[85]

Certainly the American government invested in Iraq. According to a magazine article in the *L.A. Times*, President Bush, once in office, "signed a top-secret directive paving the way for $1 billion in new aid that helped make possible the

Iraqi aggression that spun the world into war, and later drove the Kurds to their death in the mountains. Classified government documents indicated that the United States footed the bill for more than $2 billion in loans to Hussein."[86]

In October 1988, the presidential election which was only a month away had usurped the media's and the government's time and energy. Just as it had seemed that the story of the Anfal would come out, news about the Kurds disappeared. The Anfal never became quite identifiable. A few sporadic reports appeared over a period of months detailing deportations, and alleging executions and gas attacks, but a systematic pattern was never very discernible. Genocide was claimed, first by a few and then by many (although there were always detractors), but the cries of genocide were more often passionate outbursts about the horror of the use of poison gas, than clear-eyed recognition that Saddam Hussein's cousin had mounted a deliberate campaign of extermination. "'I'm outraged that we haven't shown more outrage,'" *The Monitor* series on chemical warfare quoted a U.S. official as saying.

A few did know about the genocide and did say something—and they were vindicated four years later when the U.S. military airlifted out of northern Iraq 18 tons of documents, videotapes and cassette recordings captured by Kurdish rebels from provincial secret police headquarters during an uprising. These documents formed the basis for the definitive report on the Anfal written by Human Rights Watch and supported by the Senate Foreign Relations Committee which had taken custody of the captured material.

One of the few who had the courage of his convictions back in 1988 was the acerbic Jim Hoagland. In a column a few weeks before the election, Hoagland noted that after the September public condemnation of Iraq, reports of new chemical weapons attacks had stopped. "The Kurds, I suppose, should be thankful for small favors. But is the world really prepared to look the other way and do nothing in the most ghastly case of the use of poison gas since the Nazi death camps of World War II?" he asked. Then he answered his own question. "Throughout World War II, reports of massive gassing of Jews by the Nazis were regularly dismissed because they lacked 'evidence.' Recently uncovered documents soon to be published in Geneva show that the International Committee of the Red Cross was convinced as early as 1942 that the Nazis were carrying out a policy of extermination. But it said nothing publicly and sought no condemnation of this horrible crime. Who says history does not repeat itself?"[87] Indifference in the face of horror has a long history.

You'd think that a genocide would prompt the same kind of riveting story as famines do—the only distinguishing limitation, of course, being that the

cameras weren't likely to be rolling while people were actually dying and that there might be fewer survivors to interview.

If you thought that about the coverage of the Anfal, you'd be wrong. Lack of access to Iraq during the Anfal itself, except on the self-serving trips sponsored by the Iranians and the Iraqis, prevented journalists from accumulating unimpeachable human-interest details. Both in Iran and Turkey, journalists could speak with Kurdish refugees, but the refugee stories—often told well after the fact and without the confirming evidence of location—were treated somewhat skeptically, always qualified with words such as "according to" or "her mother said" and then followed by denials or strong cautions from opposing spokespeople—the Turks, the Iraqis, even medical personnel.

As a result, most of the stories that spoke about the Kurds were domestic political pieces pegged to government reactions and charges, confirmations and contradictions from various spokespeople, and legislative efforts. Deep into the print stories certain abbreviated details would emerge, like *The New York Times* article on Halabja that mentioned halfway through that "bodies were hanging out of cars in which they had evidently tried to escape." But that was all that was told. Readers didn't learn whether the bodies were young or old, how many were "hanging," or what they looked like—"peaceful" or "grotesque," "pale" or "livid." And there was no accompanying photograph to assist with the details.[88]

The Washington Post story the same day was slightly less grudging, saying in its second paragraph that "Some victims hugged children in silent embraces, others sprawled in doorways. One family lay near a table set for lunch." And the photograph which illustrated the front-page story did show bodies "sprawled in doorways." But *The Post's* article was actually more lyrical in its description of some unexploded weaponry: "A dozen unexploded aerial bombs stood half-sunk in the soft earth in the fields and along the shoulder of the road apron, their gray tail fins pointing skyward." Why didn't we hear about the faces half-sunk in the soft earth or the toes pointing skyward? What happens to people when they are gassed?

Perhaps the questionable source for learning about the bombing—the Iranian propaganda tour—made reporters wary of making the victims too sympathetic in case the situation was a setup. After all, *The Post* was careful to caption its image: "Reporters photograph victims of what Iran charges was an Iraqi gas attack in Halabja, a Kurdish city in Iraq." And it was also careful to include in the picture frame a cameraman filming the scene—clearly to show the wizard behind the curtain. (It included a photographer in the picture on its jump-page, as well.)[89]

Of course, the newsmagazines could be counted on for a little more zing. All three ran stories on Halabja in their April 4 issues, and led with evocative open-

ing paragraphs, each describing the streets "scattered" or "littered" with the dead. *Time* and *U.S. News's* leads sounded as if they had been written by the same person. "Even by the macabre standards of the Iran-Iraq War," said *Time*, "the scene was shocking." "Even in a war of repeated macabre extremes," said *U.S. News*, "the images were shocking. . . ." And then both briefly described those "shocking" scenes. Still that was about it for the newsmagazines, too. They mentioned survivors, but there were no heartbreaking tales of lost families and dead children.

Really, the grimmest details were in the photographs. All three magazines had images of the bodies: *Time* had three, and *Newsweek* and *U.S. News* had one each. *Time* and *U.S. News* even used images of the same two victims (the same two as *The Washington Post* on its jump-page), a man holding an infant—although from two different angles by two different photographers. *U.S. News* had the close-up, but ran it in black and white—so the effect of the doll-like waxy face of the child was diminished. Judging by their style of coverage, the newsmagazines worried less than the newspapers about the source of the news. No Western photographers appeared on the margins of their images to signal to readers that these scenes did not exist in a political vacuum.[90]

Television coverage, of course, as always, could be predicted on the availability of gripping images. Tape from Halabja, Iranian video of an attack on the Kurds, scenes from the hospitals in Iran and the West, images from the refugee camps in Turkey—all appeared on television in March and again in September. Brent Sadler of Independent Television News filed a typical report in early September on Kurdish refugees in Turkey for *The MacNeil/Lehrer NewsHour*. The brief dispatch featured an injured baby with an angry rash on her back, an image that graphically gave weight to the Kurdish claims of gassing and genocide. "Iraq," said Sadler, "is again denying the use of chemical weapons. This 12 month old girl developed a painful skin condition and one eye has been closed ever since, her parents say, an Iraqi plane dropped chemical bombs. The Kurds claim injuries like these prove the Iraqis are now hiding the truth. The circumstantial evidence against Iraq for launching chemical attacks against the Kurds is already very strong, but whatever international response it brings will make little or no difference to the lives of these refugees."[91]

But there was astonishingly little coverage on the news shows. *New York Times* columnist William Safire castigated television for its lack of concern for the Kurds. He pointed his finger at "the world's film crews" who are "too comfortable in Israel's West Bank, covering a made-for-TV uprising of a new 'people,' to bother with the genocidal campaign against a well-defined ethnic group that has been friendless through modern history and does not yet understand the publicity business." Safire believed that of all the media, television shouldered

the greatest responsibility to bear witness. "For television, inaccessibility is no excuse for ignoring the news," he said, "the ability of color cameras to bring home the horror of large-scale atrocities imposes a special responsibility on that medium to stake out murder scenes or get firsthand accounts from refugees."[92]

As Safire suggested, a range of images were possible, although it was perhaps unfair to ask camera crews to "stake out murder scenes" in a genocide. Photographers stumbled on the smoking-gun pictures of the Sadat and Rabin assassinations; even if enterprising, they weren't likely to luck into scenes from the Iraqi Anfal. As a result, the photos closest to incontrovertible evidence of Baghdad's deliberate intention to target Kurdish civilians—the images from Halabja—were, unsurprisingly, used extensively. From March until the end of the year, print and television reprised the Halabja images. They were trotted out to illustrate the trend stories on chemical weaponry and then to help summarize the horrors of the Iran-Iraq War when the truce pieces came out in August and September. Three times in 1988, for example, *Time* magazine ran an image of that man and infant, twice the picture was identical. The last time it appeared was in the end-of-the-year issue summing up the events of 1988 in photographs. "Kurdish victims frozen in death after Iraq bombed its own Iranian-held village with poison gas," read the main caption. "The cork is out of the bottle," it quoted a chemical-weapons expert as saying. And just so readers wouldn't think that such scenes left those who covered them unmoved, the third caption said "[Photographer] Ramazan Ozturk—Sipa: An experienced war photographer, Ozturk could not help weeping as he filmed the horror at Halabja."[93]

Ozturk's image was compelling. The father and son did appear to be literally frozen in death. And opinion pieces, like Safire's did supplement the more staid news articles. Snide, even bitter comments castigated the government, the media and the public for turning away. But even taken all together, the coverage just never reached a critical mass. In the newspapers more maps appeared than photographs. Maps, the Halabja images—and even the other still photos and video of the dead and the living—were not enough to sustain the public's concern about what was happening to the Kurds in the absence of compelling narratives, too. Without a constant flow of stories and pictures of individual people, there was not enough passion to sustain interest. Where were the people the media's audience could care about? Well, of course, that was the point. Where were they? Deported somewhere or dead probably, but without pictures, without stories of their terrified last moments, the media . . . and the public couldn't sustain their interest.

Of course, the media carried the news basics. But in keeping with their tendency to prioritize news events that pose a risk to Americans, their emphasis on

Iraq's violation of international law by using chemical weapons shifted the consequences of Iraq's acts away from the Kurds. By so doing, the world community became the victims of the attacks—and Americans suddenly became at risk. Chemical weapons proliferation was an international problem. The Anfal was a Kurdish one.

This is not to say that the media ignored the Kurds. They did not. But neither did they make them ubiquitous like the starving Ethiopians or the starving Somalis, once their stories got going. You couldn't count on turning on the evening news and seeing the Kurds or opening up the morning paper and reading about them over your coffee. Without sustained attention their troubles floated on the margins of attention—a group to be recalled when the topic of chemical weapons came up, but not a group that the public perceived as in grave and constant danger.

The same hesitations and hurdles that had prevented the media from giving major attention to the Cambodian killing fields a decade earlier caused the new shortfalls. Like Cambodia, limited access and sources stopped the media from plastering news of the Kurdish tragedy everywhere. In telling the Cambodian trauma, as in the telling of the Kurdish Anfal, the primary news source was refugees. And although the Kurdish refugees told a consistent story, there were always charges that they had been coached to say what they said. Soon after Halabja, there was a general consensus that Iraq had indeed gassed the Kurds, but there was greater reluctance to believe that the Kurds had been targeted by al-Majid as an ethnic group for elimination. Yet, as the September 1988 staff report to the Senate Foreign Relations Committee concluded, to dismiss eyewitness reports of what was later to become known as the final Anfal campaigns "would require one to believe that 65,000 Kurdish refugees confined in five disparate locations were able to organize a conspiracy in 15 days to defame Iraq and that these refugees were able to keep their conspiracy a secret not only from us but from the world press."[94]

Another problem was that also like Cambodia, there was no good-guy nation to root for in the resolution of the conflict. The media like heroes and villains. Even more, the American government likes heroes and villains (even if it incorrectly identifies them). The government likes to feel that if it gets involved there will be an outcome with positive repercussions for the United States. In both cases—the Cambodian killing fields and the Iran-Iraq War—the United States had a hard time deciding which side it was on. And, in both situations, civilians were caught between two "unloved" governments. "We have said little about the war," a *New York Times* editorial admitted about Cambodia, "because we do not know what outcome to prefer."[95] The Khymer Rouge or the Vietnamese. That

was a tough one for the United States. So too were Iran and Iraq: Iran, home to the Ayatollah and the hostage crisis of the Carter administration, and Iraq, admonished by the U.N. Security Council three times since 1984 for using chemical weapons.

It's perhaps not surprising to realize that those journalists who were most engaged by the Kurdish story were those who used the most sensationalized language and those who Americanized the story the most, those who paralleled the Kurdish situation with iconic people and events. As they played for readers' and viewers' attention, these were some of the very few means at their disposal. In early September, William Safire called Saddam Hussein's military offensive against the Kurds "a campaign of extermination aimed against an ancient ethnic group that wants only to keep its own language and customs in sarbasti—freedom. A classic example of genocide is under way," he wrote, "and the world does not give a damn. Three men are alive today who can boast of having made a major contribution to world depopulation: Idi Amin of Africa, Pol Pot of Asia and Saddam Hussein of the Middle East. The Iraqi trails the Asian in the number slaughtered only because his nuclear capability was curtailed by the Israelis; otherwise, he would surely have incinerated five million residents of Teheran. However, Saddam is still active, and with several million Kurds at his mercy, he may yet pass Pol Pot in megamurders."[96]

"ETHNIC CLEANSING": THE "DEATH CAMPS" IN BOSNIA, AUGUST 1992

On Thursday morning, August 6, 1992, four days after *Newsday* reporter Roy Gutman announced that there were "death camps" in the former Yugoslavia, readers of *The New York Times* had their pick of stories about Bosnia. The lead article on *The Times* front-page announced that Secretary of State Lawrence Eagleburger was calling for a war crimes investigation of the reports of atrocities at the detention centers. Three articles inside detailed the dim prospects for a cease-fire, the black market in Sarajevo and Americans' interest in adopting Bosnian orphans. Former British Prime Minister Margaret Thatcher wrote an op-ed calling Serbian "ethnic cleansing" a combination of "the barbarities of Hitler's and Stalin's policies towards other nations."[97]

And media critic Walter Goodman described the television visuals that had come out that week of the "grim scenes from what used to be Yugoslavia." All depicted the fighting in the cities: sniper fire at a funeral, "civilians dashing across dangerous streets to do their daily chores, like people seeking sanity in a madhouse" and the corpses of two small children. But "there have been no pictures

yet," continued Goodman, "of what some have charged are detention centers for former Yugoslavs of non-Serbian extraction, but news programs have made up for that by illustrating the reports with the still-painful photographs of prisoners found in Hitler's concentration camps." Still, Goodman ended, "can anyone help wishing that cameras had brought pictures of German concentration camps into American homes 50 years ago?"[98] The camera, Goodman's article suggested, has an unmatched ability to communicate the reality of a news story. Even images from an unrelated event a half century ago can validate a contemporary story in a way mere words cannot. Text can allow us to "imagine" what the Bosnian camps must be like, but only photographic evidence can make our nightmares concrete.

The very day Goodman's article appeared the most famous pictures to ever come out of Bosnia appeared on television screens across the world. "If there is one image that epitomizes the war in Bosnia," wrote Anna Husarska, a writer for *The New Yorker*, four years later, "it is probably the now-famous photograph of skinny men behind the barbed wire of the Omarska [*sic*] concentration camp."[99] Roy Gutman's charge of "death camps" had seized the world's attention, but the reporting on the camps at Omarksa and Trnopolje by Penny Marshall and Ian Williams of the British Independent Television News (ITN) caused an immediate response.

Within an hour of the airing of the ITN footage President George Bush was in the White House briefing room to condemn the camps and promise that the United States "will not rest until the international community has gained access to all detention camps."[100] The next day, Serbian leader Radovan Karadzic gave the Red Cross permission to visit the detention camps and proposed closing them or handing their control over to the International Committee of the Red Cross (ICRC).

The power of the verbal and visual images was all the politicians and the media could talk about that weekend. "You've got to stop the slaughter of the innocents," said Senator Alphonse D'Amato (R-NY) on the Larry King talk show, "We have to open up those camps." "This week, finally," said CNN anchor Bernard Shaw, "when you saw these videotaped horrors of these orphans being shot at and certainly these death camps or detention camp starvation victims you finally put a human face on the conflict." "For months," said ABC News correspondent Barrie Dunsmore, "we've had reports of atrocities of the most incredible nature taking place and people became kind of bored with them. But the moment they heard words like 'death camps'—'sealed box cars' was another phrase that has been used—all of a sudden . . . that made it a much more politically explosive thing." "This is another case where pictures and information drive

emotions," said commentator George Will. "The pictures make all the difference here, as they have domestically with the Birmingham riots and civil rights."[101]

A senior Red Cross official, who'd seen it all before, took note of the brouhaha. "Governments have been compelled through these [ITN] pictures to put the issue of prisoners at the top of the agenda." Then he cynically added, "at least for several weeks." And that's what happened. The breaking news and real-time pictures affected the Bush administration's conduct and its process of making foreign policy, but they did not change the policy itself. The death camps or concentration camps or detention camps stayed prominently in the news for two weeks or so, then the news petered out. There was a slight sense of closure—on Wednesday, August 13, the U.N. Security Council authorized the use of military force if necessary to deliver humanitarian aid. But there was no real end to the camp saga at that time. Diplomats and the media charged the Serbs with playing a "shell game" with prisoners. "Once world attention is focused on a Serb-run detention camp where inhumane conditions or abusive treatment are alleged to have occurred," wrote Peter Maass in *The Washington Post*, "it is cleaned up, closed down or depopulated. Prisoners are quickly shuffled off to other facilities."[102] Eventually, most camps were emptied, but slowly. Over the next several months, many surviving prisoners were transferred outside of Bosnia to refugee camps under ICRC supervision. But even by the following summer the Serbs still operated POW camps that were closed to the Red Cross.

What really finished the story, however, what caused the camps to be relegated to yet one more itemized atrocity in the litany of abuses in Bosnia—"ethnic cleansing," rapes, torture, concentration camps—was not any sea change in the political environment, but was compassion fatigue. "If Serb gunmen do not kill the 3,500 men, women and children jammed into this cold, muddy, disease-ridden prison camp, relief workers say, the world's indifference might," wrote George Rodrigue about the Trnopolje camp for *The Dallas Morning News*. "The world has seen it all before," observed Croatian writer Slavenka Drakulic in *The New Republic*, "meticulously documented by countless TV cameras and described by millions of words."[103]

"Only the proposal to send troops has captured even the *attention* of the American public," said CBS anchor Dan Rather. "Most of our fellow citizens cannot locate Bosnia, Serbia, and Croatia on a map, much less understand what's going on there. And they don't seem to care, except in so far as our troops are concerned." "Many reporters were stunned when the first pictures and stories—concentration camps, maimed and raped children, starving grandmothers—didn't interest more Americans," Rather continued. "Because their first efforts failed, many news organizations told themselves the audience didn't want

to hear the story. So they covered it less, losing more opportunities to serve the public. . . . So there have been times when we've run stories on apple picking back home and forgotten the babies that are being blown up in Bosnia. Even the best of us have succumbed."[104]

Boston Globe photographer Michele McDonald told of the *Globe* running a story on ethnic cleansing as the Sunday lead only because the editor "lost" the pictures to an article on country clubs. Since the paper had run a lead story the previous week on Belgrade, the editor didn't want to run two lead stories two weeks in a row on the same region. After all, McDonald quoted the editor as saying, the ethnic-cleansing story was "just another massacre." "It is an embarrassment to me as a citizen," remarked Peter Jennings in a speech about ABC's coverage of Bosnia, "to read what horror we have all learned to tolerate."[105]

Dan Rather also blamed some vague, nebulous power structure for the media's backing away. "We too often heed the prevailing corporate mantra, which says that international news is too expensive and doesn't interest viewers. 'Americans don't care about the rest of the world,' we're told. 'If you show them pictures of Sarajevo, they'll change the channel.'"[106]

And, in keeping with the one-crisis-at-a-time principle inherent in compassion fatigue, there were other stories begging for attention. Said *Post* reporter John Pomfret, "There is definitely a 'bloodshed du jour' feeling."[107] Helping push the Bosnian camps off the agenda was the Republican convention the week of August 17th, and then Hurricane Andrew the week of August 24th. Other major stories also jostled for coverage in that same time period: The Olympics in Barcelona were just ending and attention to the famine in Somalia was just beginning. A military debacle threatened in Iraq over Saddam Hussein's refusal to allow an international inspection of the Baghdad ministry buildings. Secretary of State James Baker resigned to salvage the president's reelection campaign. And archaeologists discovered the family tomb of Caiaphas, the Jewish High Priest who presided at the trial of Jesus and delivered Him to the Romans to be crucified.

But this business-as-usual, be-alert-to-compassion-fatigue-in-the-audience and on-to-the-next-story behavior seduced more editors and producers back in the United States than reporters in the field. Many reporters in Bosnia didn't want to let the story go. Some, denied sufficient outlet in the daily media, wrote passionate books about their time in Bosnia.[108] Such correspondents took a moral stance in their reportage. Journalists, such as NPR's Tom Gjelten and CNN star Christiane Amanpour, made a distinction between objectivity and neutrality, arguing that accurate reporting demands determining responsibility. "We say we are affected," wrote Samantha Power, a reporter who covered Bosnia. "We say we are

outraged. We say privately we want action, perhaps. But most of us believe that reporting the atrocities as we see them—even with a bit of the 'do-something' sentiment thrown in—IS objective." Then she added, "Maybe we are wrong." "In certain situations, the classic definition of objectivity can mean neutrality," said Amanpour, "and neutrality can mean you are an accomplice to all sorts of evil. In this case, genocide and crimes against humanity," she said, speaking of Bosnia. "An element of morality has to be woven into these kinds of stories. . . . Life obviously is full of gray areas most of the time. But sometimes in life, there are clear examples of black and white. . . . I think during the three-and-a-half-year war in Bosnia, there was a clear aggressor and clear victim."[109]

According to their detractors, reporters such as Amanpour often demonized the Serbs and underreported atrocities by the Muslims and Croats. As independent journalism has discovered in the years since the height of the conflict, there was no side with purity-of-victim status. News reports in 1997 and 1998, for example, have revealed that all parties participated in ethnic purges—in torture, rape and murder.[110] "Our job," said David Binder of *The Times*, "is to report from all sides, not to play favorites." Critics charged that the partisan reporting on Bosnia did a disservice to the public: Since the media is often the sole source of information on international affairs for Americans, editorializing in so-called "news" stories doesn't allow the public to make its own assessment of events. But a front-page *New York Times* article that came out in March 1995 vindicated Amanpour and other like-minded journalists. In the story, Roger Cohen disclosed that a CIA report assessed that the Serbs carried out 90 percent of the acts of ethnic cleansing—making "nonsense of the view . . . that the Bosnian conflict is a civil war for which guilt should be divided between Serbs, Croats and Muslims rather than a case of Serbian aggression."[111] In this light, the Serbs were not unduly maligned by the television and print coverage they received. With the benefit of hindsight, it appears that those correspondents tarred for practicing advocacy journalism might have been more objective than even they had realized. They did not treat all sides equally, all participants were not subjected to the same intensity of exposure, but they may have given each a reasonably fair hearing. "There can be no minimizing of what the Serbs have done in Bosnia," said George Kenney, who resigned from the State Department in mid-August 1992 to protest the "do-nothing" policy of the United States in Yugoslavia. "Their punishment of the Muslims far outweighs any Muslim transgression."[112]

To understand the Bosnian conflict, it was generally argued, one must have some knowledge of history. In that first week in August 1992, President Bush said he was "outraged and horrified" at the "vile policy of ethnic cleansing," but

went on to describe the war as "a complex, convoluted conflict which grows out of old animosity. The blood of innocents is being spilled over centuries-old feuds. The lines between enemies and even friends are jumbled and fragmented."[113]

Events dating back centuries became part of the rhetorical justification for all sides in the conflict in Bosnia and part of the rhetorical context for the media's pieces on the region. Stories commonly gave once-over-lightlies of Balkan history, often picking out the "high" points of the Serbian defeat by the Ottomans at the Battle of Kosovo in 1389 and the triggering of World War I by the shooting of Archduke Franz Ferdinand. But for many the real troubles could be dated to the Versailles Treaty.

The Yugoslavia that had been created at the close of World War I had been a marriage of convenience among three large groups of people—the Eastern Orthodox Serbs, the Roman Catholic Croats and the Muslim Slavs—and many smaller ones. In 1939, amidst tensions, Croatia won internal autonomy. A separatist movement known as the Ustashi—the Croat word for rebel—regarded the two million Serbs within Croatia's borders as an impediment to Croatia's national integrity. At a banquet in June 1941 the Croatian minister of education remarked that "one-third of the Serbs we shall kill, another we shall deport and the last we shall force to embrace the Roman Catholic religion and thus meld them into Croats."[114]

At the start of World War II, Hitler's Wehrmacht made fast work of Serbia and Croatia, conquering them in about a week and installing a puppet regime in Belgrade. Hitler made a triumphant visit to Zagreb, the capital of Croatia, where he sponsored the fascist Ustasha. "What followed," charged a 1993 article in *Foreign Affairs*, "was less a cleansing than a wholesale massacre."[115] According to some sources, one Serb in ten died in the war—and when it was over Marshal Josip Tito's Partisans took their revenge on the Croats. The Muslims suffered too, often at the hands of the Serb royalist forces, known as the Chetniks. Each of the three groups claims that it lost more than 100,000 people—Serb nationalists say their death toll was closer to one million.

Virtually every family lost someone, but Tito's nonaligned communist regime that controlled the six republics (Bosnia-Herzegovina, Croatia, Macedonia, Montenegro, Serbia and Slovenia) within Yugoslavia after the war kept the lid on any seething passions. By 1990, ten years after Tito's death, no serious ethnic quarrels had disturbed Bosnia-Herzegovina for nearly half a century. "Sarajevo was the site," noted Roy Gutman, "of the Olympics in 1984, with an ancient bazaar where young people in blue jeans drank Turkish coffee to the strains of pop music in the cobblestoned marketplace. An atmosphere of secular

tolerance characterized the entire republic. Bosnia-Herzegovina was a genuine melting pot."[116]

Tito's death, however, had left a political vacuum—Tito himself had banished many of his ablest potential successors. Into this vacuum came Slobodan Milosevic, a Serb politician with business and personal connections to Lawrence Eagleburger and Henry Kissinger. Milosevic traded on the belief of many Serbs that they had been the losers in Tito's Yugoslav federation. (Tito had been of Croat-Slovene ancestry.) Milosevic repeatedly won elections by claiming that only he could protect Serb rights. And since the Serbs were the largest group within Yugoslavia, with six of nine million in Serbia, 1.4 million in Bosnia-Herzegovina, and 600,000 in Croatia, his success challenged the cohesiveness of the state.

The more Westernized republics of Slovenia and Croatia took exception to Milosevic's authoritarianism, called for political and economic reforms and together with Bosnia-Herzegovina and Macedonia proposed a looser confederation. Milosevic refused, and also blocked the routine rotation of the president's position to a Croat. Warned by the United States that it would not recognize independent republics—but seeing no possible internal compromise—Croatia, Slovenia and Macedonia seceded from Yugoslavia on June 25, 1991.

The Yugoslav National Army, commanded by Milosevic from Belgrade and with an officer corps largely made up of Serbs and ethnic Serbs from Montenegro, attacked Slovenia and Croatia. Slovenia, which had been secretly preparing for such an eventuality, routed the federal army in ten days. Croatia was a different matter—it had not prepared for war and the federal army had an overwhelming advantage in weaponry. After the U.N. Security Council imposed an arms embargo on Yugoslavia, the status quo was effectively set. Belatedly, the newly reunited Germany pressured the European Community to recognize Croatia and Slovenia in December 1991. Recognition may have contributed to a cease-fire, but it did not turn the tide. In all, the war in Croatia lasted about six months, ending in January 1992 after Serb forces had damaged much of the centuries-old tourist town of Dubrovnik, wasted the Danube city of Vukovar and seized roughly a quarter of Croatian territory.

Serb attention now turned to Bosnia-Herzegovina. Bosnia-Herzegovina was the most ethnically mixed of the six republics that made up Yugoslavia. While the Muslims, Serbs and Croats are all Slavs who speak Serbo-Croatian, Muslims (Slavs who had converted to Islam during the centuries that the region had been ruled by the Turks) made up 44 percent of the 4.5 million population, Serbs 31 percent and Croats 17 percent. As had been the case across Yugoslavia, mixed marriages among all three groups were common, and many Muslims, Serbs and

Croats lived next door to each other. Muslims and Croats voting in a plebiscite the last day of February had overwhelmingly called for independence (although the Serb minority in the republic had boycotted it), and so led by Alija Izetbegovic, a Sarajevo lawyer, Bosnia-Herzegovina seceded. War began on April 6, 1992 just as the United States and the EC accorded diplomatic recognition to the new state. The next day, Serbian forces began to shell Sarajevo, the Bosnian capital.

Despite the fact that Bosnia could claim internationally recognized independence, the United States and Britain decided to honor the previous arms embargo on Yugoslavia, effectively leaving Bosnia in the same weak military position relative to the Serbs as Croatia had been. While the international community dithered over possible negotiated solutions—most prominently the "cantonization" of Bosnia along ethnic lines—Serb forces effectively closed all supply routes to the predominately Muslim areas and seized territory to create links between the Serbs in Bosnia, the Serbs in Serbia and the Serbs in Croatia.

A million or so Muslims lived in the captured corridors between the Serbian areas. To remove them, the Serbian policy of "ethnic cleansing" began, promulgated by the Bosnian Serb leader Radovan Karadzic. Stephen Engelberg and Chuck Sudetic, writing in *The New York Times*, defined what they called "the workings of an overall plan" of ethnic cleansing. "In village after village," they wrote in mid-August 1992,

> it begins with local Serbs demanding that their Muslims or Croat neighbors hand over their weapons. That is generally followed by the cutoff of electricity and water and an ultimatum. Shortly after, Serbian soldiers backed by armor roll through the town, shooting a few people, dynamiting houses and mosques and driving men, women and children first into fields and then into camps.
>
> The detention centers play a major role in the Serbian strategy. The intention, it seems, is that a few days' or weeks' incarceration in grim conditions will overcome the civilians' reluctance to give up their property and flee their ancestral homes forever. Indeed, thousands of Muslims have signed documents "voluntarily," relinquishing all their goods and property in exchange for their release from the camps.[117]

The Serbian efforts at "ethnic cleansing" proceeded apace through May and June largely out of sight of outside observers. The concealment of their actions, charged *The Times*, was achieved through a series of intentional acts that drove

aid workers and journalists out of the country. On May 18, the new chief of the ICRC in Sarajevo, Frederic Maurice, negotiated safe passage though the Serbian positions around the city. But his convoy, clearly marked with the Red Cross emblem, came under mortar assault. Maurice was killed and two others were wounded. Two days later the Red Cross departed Sarajevo, and on May 27 the ICRC pulled out of Bosnia-Herzegovina altogether. Monitors from the EC left Bosnia that same week after they, too, came under fire, and most journalists also abandoned Sarajevo after a photographer was killed by a mortar shell. By early summer, the Serbs had captured about 70 percent of Bosnian territory. The Croatian forces took control of most of the remainder. The Bosnian government held out in Sarajevo, Bihac, central Bosnia and some eastern enclaves.[118]

On July 7, the Red Cross resumed operations, and reporters too returned to Sarajevo. Almost immediately word of the existence of the detention centers and the possibility that summary executions were taking place was made known to the international community. At a summit meeting in Helsinki on July 9, attended by President Bush and the leaders of 53 other nations, Bosnian President Izetbegovic mentioned that the Serbs had set up detention camps. Ten days later Izetbegovic wrote to Bush and complained of "genocide" in Bosnia.

The Bush administration took no steps of its own to ascertain what was going on and didn't want to hear from others. "The danger," said George Kenney, who at the time was a foreign service career officer and the acting chief of the Yugoslav desk in the State Department, "was that discovering additional horrifying details would multiply demands that the United States intervene." "There was no way for dissonant information to get through the door, making State Department brass look something like children who block out the world by covering their ears and humming loudly." It was only when the story erupted in the press two weeks later that President Bush directed U.S. intelligence-gathering agencies to use "every asset available" to investigate conditions in the camps.[119]

During those same weeks in July, Roy Gutman, Long Island *Newsday*'s bureau chief in Germany, was hot on the trail of the detention camps. Interviewing refugees, aid workers and political and military officials, he collected reports about concentration camps set up by the Serbs around northern Bosnia, the most notorious of which seemed to be at Omarska, an open-pit iron mine near Bosnia's second largest city, Banja Luka. He asked the Serb authorities to take him to Omarska. They refused, but countered with a trip to the army-run prisoner-of-war camp at Manjaca. Gutman determined that the men at Manjaca were not POWs, but "underage civilians caught in a vast roundup. Beatings and

torture were routine." But it was not a death camp. "The army released the prisoners who were about to die," said Gutman.[120]

Still, appalled by his discoveries and convinced that something worse was happening at Omarska, Gutman set aside his journalistic standards of not writing about situations when he had no eyewitnesses. His first article on Omarska appeared on July 19, 1992.[121] He felt so strongly about the information that he was uncovering that he asked *Newsday* to alert U.S. government agencies about the story. "No one responded," he said. So he went back to the area and kept digging. After a week of searching he located two former detainees from the camps at Omarska and Brcko Luka. Both agreed to tell their stories and to be photographed.

Gutman's article appeared on Sunday, August 2, with a huge headline, "Death Camps," and a chilling 1,700-word account of survivors' tales of systematic execution in two detention centers. Although in hindsight it was undoubtedly the ITN photographic images that sent the world into the greater tizzy, few in the public or even in the government raised questions about the veracity of the oral testimony offered in Gutman's story (or in that of a very few others—Maggie O'Kane in England and Dan Stets of the *Philadelphia Inquirer*, for instance). Bosnian refugees were not treated like the Kurdish refugees in 1988, whose stories of gassing were related in print and on TV, but significantly couched with qualifiers and denials. Indeed the testimony of one refugee in Gutman's August 2 article ended with the comment: "International relief agencies said his statement, given to *Newsday* in the presence of officials of the Bosnian Red Cross-Red Crescent—was the first confirmation of their suspicions that Omarska is a death camp. They said they had heard rumors for more than a month about such camps, but no one had talked to a survivor."[122] In the Bosnian instance, refugee testimony carried appreciable weight.

The next day, Monday, August 3, State Department spokesperson Richard Boucher "inadvertently provided a detonator for a political explosion over the camps," said Don Oberdorfer in *The Washington Post*. Boucher told reporters, "We do know from our own reports of information similar to the press reports that the Serbian forces are maintaining what they call detention centers for Croatians and Muslims. And we do have our own reports, similar to the reports that you've seen in the press, that there have been abuses and torture and killings taking place in those areas." News organizations immediately reported that the U.S. government had "confirmed" or "corroborated" Gutman's story.[123]

But there was no shift in U.S. policy as a result of the information coming out of the Balkans. As a consequence, the Bush administration—in a tough re-election bid—was seen to be "confirming some of the worst horrors of the day and proposing to do hardly anything about them," as Oberdorfer put it.[124]

But what Boucher had not said in his press conference was that the State Department reports were fragmentary and secondhand. On Tuesday, August 4, Assistant Secretary of State Thomas Niles testified on Capitol Hill that the State Department could *not* confirm the atrocity reports, although he did not deny what Boucher had said. This new comment was widely taken by lawmakers and journalists alike to be "diplomatic double-talk" and only added to the public furor. Democratic candidates Clinton and Gore and a bipartisan group of senators all stepped into the fray. Senator Carl Levin, (D-MI) told CNN, "So far, the response of the world to this genocidal behavior has been a diplomatic shuffle." And Senator D'Amato said, "What the Serbs are doing is an international crime. And what the world community is not doing is also an international crime."[125] (It would take until the end of September before the State Department said that it had eyewitness confirmation of the execution of 3,000 Muslims at Serbian prison camps in May and June. And it was well into October before the State Department submitted a report to the United Nations for possible war-crimes prosecutions that spelled out grisly atrocities attested to by witnesses.)

On Wednesday, August 5, Christiane Amanpour summarized the controversy: "What's happening right now are the first allegations of a sort of Nazi-styled, World War II-styled genocide going on, and this is obviously why it's created such an uproar." Then on Thursday, August 6, photographic "proof" was offered when the pictures from the camps taken by ITN aired on CNN and ABC, the British network's American associate. ITN's interest in the story had been stirred by an article which appeared on July 29, in the British newspaper, *The Guardian*. The report, written by Maggie O'Kane, revealed more details about the concentration camps at Omarska, Trnopolje and Bratunac than had Gutman's story ten days earlier. The Bosnian Serb leader Radovan Karadzic, who happened to be in London when the paper came out, responded to the story by denying the camps' existence. ITN's diplomatic editor Nik Gowing then challenged Karadzic to allow an ITN team access to the camps to check the allegations. "After a heated exchange," said Gowing, "Karadzic agreed."[126]

Serbian armed guards escorted ITN's correspondents Ian Williams and Penny Marshall and reporter Ed Vulliamy of *The Guardian* into two camps, Omarska and Trnopolje. During their several-day trip, ITN filmed ten tapes worth of material. Finishing, Marshall and the others then drove to Hungary. In the middle of the night, Nigel Baker, a news producer for ITN, was called to fly to Hungary to meet them. Said Baker, they "were numbed by what they had encountered. After viewing their ten tapes, I advised that the image that would shake the world was of skeletal men behind barbed wire. They sparked thoughts of Auschwitz and Belsen."[127]

The image was broadcast that night. In the television footage, Marshall walks fast toward the wire surrounding the Trnopolje camp and stretches out her hand. A bony hand reaches out and shakes hers. She greets the men. "Dobar dan." "Good day." The men are penned together like sheep. The camera slowly pans up the shrunken torso of one prisoner. "It is the picture of famine," wrote media critic Frederick Baker, "but then we see the barbed wire against his chest and it is the picture of the Holocaust and concentration camps."[128]

The ITN report carried scenes from Omarska as well, scenes of several hundred of the prisoners eating watery soup and a piece of bread. Penny Marshall did the voice-over. "This is all we saw of the prisoners and of Omarska itself. They never spoke. The only voices, those of the guards ordering them to eat faster and leave," she said. "And then the men left, back to where ever they had come from, away from our cameras and questions, hidden from the United Nations and the Red Cross, who have been denied access to Omarska. Hidden, until now, from the world. We were not allowed to follow them to their living accommodation, what appeared to be the larger of the two buildings, to see the other 2,000 detainees and how they live."[129]

Afterwards, Marshall said her report was not sensationalist, despite the iconic image of the man behind the wire. "I bent over backwards, I showed guards— Bosnian Serb guards—feeding the prisoners. I showed a small Muslim child who had come of his own volition. I didn't call them death camps. I was incredibly careful, but again and again we see that image being used."[130]

By Friday, August 7, the day after the ITN pictures aired, "nearly the entire U.S. political system—Congress, the Democratic presidential campaigners and outside interest groups as well as the State Department and White House—had become deeply engaged," as *The Post* reported. Radovan Karadzic announced "We are ready to open any corner of this country, any prison of this country to Red Cross." In response, President Bush's message was mixed, saying he wouldn't rest until the detention camps were inspected, but concluding with cautionary words raising the specter of Vietnam. "I do not want to see the United States bogged down in any way into some guerrilla warfare. We lived through that once, and yet, I have a lot of options available to me and I will contemplate every one very seriously, but in conjunction with the United Nations."[131]

On Saturday, President Bush held his third news conference in three days dealing with the topic. "Nothing is ruled in or out, and I will say that the object of providing humanitarian assistance is our goal," he said. "I owe it to the military not to make some rash decision based on politics."[132]

On Sunday, one week after Gutman's revelations, the opinion pages were full of advice and commentary. The political cartoonists neatly illustrated the

various perspectives. Chip Bok, from the *Akron Beacon Journal* (reprinted in *The New York Times*) drew a picture of a demented Serbian Militia marksman holding up his paper target—an image of a baby, with bullet holes scattered across the bull's eye on its chest. Jim Borgman, from *The Cincinnati Enquirer*, drew an image of a group of skeletal people labeled Croats and Muslims, walking from the barbed wire enclosure of the "Serbian Concentration Camp" through a door marked SHOWERS and into a room empty except for one ominous shower head. And Pat Oliphant drew a Willie and Joe–type cartoon—a young soldier asks two grizzled veterans labeled WWI and WWII, "Pardon me—which way to the quagmire?" A signboard in the background with the names Bosnia, Serbia and Croatia upon it, points in the same direction as the two veterans.[133] The cartoons captured the two sides of the argument: so the Serbs are baby killers and organizers of a systematic Nazi-like genocide, should Americans get sucked into another quagmire? Yes, the Serbs are evil, but should we get involved? The news had been Americanized.

Over the next week, as more journalists were given access to the camps, more horrific details emerged.[134] But already the beginning of the end of the stories could be seen. First, the focus of the Bosnian stories themselves were changing, to questions about how the United Nations would guarantee the sending of humanitarian aid. Would American ground troops be needed? Sieges of various Muslim enclaves, Bihac, Gorazde and Sarajevo, all made the front pages and the television news programs. The headline of one article told the story. "Camp Revelations Spur Allied Action on Bosnian Relief," said a front-page article in *The Post* on Tuesday, August 11. The subhead noted, "UN Resolution Also Seeks Access to Detention Sites." The news of the camps had galvanized the international community to action, but the priority of that action was to make deliveries of humanitarian aid to Sarajevo and the other civilian enclaves. Access to the camps, prisons and detention centers was a matter of secondary concern, since Karadzic had already said he would grant the Red Cross entry to them. The point of controversy was becoming, as *The Post* said, "the structure and potential cost of such an ambitious operation [the delivery of aid] and the number of troops that might be needed to enforce it."[135]

That same day in *The Post* another front-page article signaled the coming-of-age of another international crisis—the famine in Somalia. The lead to the Somalia story read: "This country appears to be dying." Two days later *The Post's* lead editorial quoted the Irish foreign minister as saying that Somalia was the "single worst human horror ever in the world." Move aside Bosnia. "Inhumane suffering in Somalia has grown in part," the editors charged, "because that poor nation, unlike the former Yugoslavia, was allowed to slide off the world's screen

once its role as a Western outpost in the Cold War ended."[136] Stories on Bosnia didn't quite slide off the news under this onslaught, but with the anointing of Somalia as "the world's worst humanitarian crisis," tales of the "death camps" did disappear to the jump-pages of newspapers or to asides on the Sunday morning TV news shows.

There was one last event that hustled the death camps off the front burners, and that was the death that same week of the first American journalist in Bosnia, ABC senior producer David Kaplan. Kaplan was part of an ABC contingent, led by correspondent Sam Donaldson, accompanying Milan Panic, the prime minister of Yugoslavia, to peace talks in Sarajevo. Kaplan was hit by a sniper's bullet while riding in the backseat of a van traveling from the Sarajevo airport to the headquarters of the U.N. Protection Force. The bullet had smashed through the back closed doors, precisely between the *T* and the *V* taped on the van. (It is common practice in hot spots around the world for journalists to tape *TV* or *Press* on their vehicles to discourage attack.) Donaldson and Panic had been riding in an armored vehicle in front of the van. According to the Committee to Protect Journalists, Kaplan was the 25th journalist to be killed in the region since the Yugoslav federation dissolved in June 1991. Others put the number killed at 30.

In the immediate aftermath of the killing on Thursday the 13th, ABC pulled out the rest of its team: Donaldson, another producer, a soundman and a cameraman. ABC and CBS decided to continue stationing their reporters in Belgrade, the Serbian capital and to rely on freelancers and pool reports from Sarajevo. NBC reporter Rick Davis and his crew remained in Sarajevo as did CNN correspondent Christiane Amanpour.

That night *PrimeTime Live* spent its entire hour on Yugoslavia. "We decided we didn't want David to have gone there for naught," said an ABC spokesperson.[137] The program began with details about Kaplan's death, interviewed Panic, outlined some basic history of the conflict, spoke about the siege of Sarajevo, and ended with Donaldson eulogizing his longtime producer and friend. In the more than 8,000 words of the show there were only two isolated mentions of the camps: a news brief announcing the passage of the U.N. Security Council resolution authorizing military force to bring relief supplies to Bosnia and demanding access to the detention camps and a two-sentence mention by correspondent Sylvia Chase that camps had been set up by all the rival groups: Muslims and Croats as well as Serbs.[138]

The bookending of *PrimeTime Live* with thoughts of Kaplan was only natural, perhaps, and was quite thoughtfully and gracefully handled. But Kaplan's death

and the coverage of it did have the immediate effect of drawing American eyes—and in particular the eyes of the media—back to the plight of the cities, back especially to the siege of Sarajevo, and away from the story of the camps and the plight of the thousands still held there hostage, tortured and abused.

The two little words, "death camps," resonated powerfully in Americans' imagination. As commentator Bernard Kalb noted on CNN's roundtable discussion program *Reliable Sources*, "Those two words, 'death camps,' are among the most explosive words of the 20th century. . . . when those two words exploded before your eyes, reinforced by the pictures we've seen this week, it is difficult to back away from what, in fact, is the quintessential portrait of 20th-century horror."[139]

The Bosnian detention camps demanded dramatic, graphic description. The media identified the places, the acts and the characters with vivid, sensational language, selected metaphors that layered those places, acts and characters with the veneer of past traumas and told tales of personalized horror that seared the mind and triggered repulsed, reflexive disbelief. The unintended effect was to provoke compassion avoidance.

Reporters described the dozens of camps in which prisoners were held with short but evocative details: Men held in "the warehouse of a ceramic factory" near Prijedor were "ordered to sit in their own urine and excrement for weeks at a time while victims were ordered outside for beating and execution"; one holding area at Omarska consisted of a "metal superstructure" which "contained cages stacked four high, separated by grates. There were no toilets, and the prisoners had to live in their own filth, which dripped through the grates."[140]

The media characterized the victims by using qualifying adjectives and phrases: "pale and gaunt," "frail," "hollow-eyed," "skeletal," "motionless," "fearful," looking like "a battered corpse," with "skin . . . stretched like a transparent scarf over his ribs and shoulder bones" or with "elbow and wrist joints" that "bulged under his taut gray skin"—and those were just some of the descriptions from two front-page articles, one in *The Post*, one in *The Times*. Most of the media's references to the Serbs were more studiedly neutral; the Serbs in the camps were most commonly described either as "guards" or "security officials," although the heads of the camps were called "commandant"—a word with a strong World War II ring to it. And in juxtaposition to the description of the prisoners, words that out of context could seem simply descriptive took on pejorative connotations: "burly guards" or "well-armed guards," who "boasted" that the men were not skeletons, "insisted" that the prisoners had not been mistreated or "smiled" when asked about the alleged torture. (Again, all these phrases came

from the same two articles in *The Post* and *The Times*.) As Henry Kissinger pointed out, "In typical Wilsonian fashion, the media see that war not as the expression of real geopolitical differences between two or three groups, but as a war caused by bad and evil men."[141]

Grim first-person narratives became a prominent feature of the stories. An article in *USA Today* told of Marianna, a 17-year-old, who "was raped as many as ten times a day by Serbian soldiers" in a Serbian camp. "The rapes took place day and night, sometimes on the floor, sometimes with women pinned against the walls, sometimes with two, three or more soldiers on one woman. 'It was different men, different days,' Marianna says." *Newsweek* related the story of Mijat Sirovina, an ethnic Croat, who saw guards "force men into a chest-deep tank, big as a swimming pool, then tighten a net over the top and feed electrodes into the water—just enough voltage to deliver agonizing, but not fatal, shocks."[142] Roy Gutman's pieces told the worst tales. In one article he quoted Brcko camp survivor Alija Lujinovic (who later testified to his abuses before Congress): "The very worst day—and I saw it with my own eyes—was when I saw ten young men laid out in a row. They had their throats slit, their noses cut off and their genitals plucked out."[143]

But perhaps the most ubiquitous characterizations of the camps—characterizations that appeared in the feature as well as the hard-news stories—were the historical allusions. It is an immense challenge for journalists who feel moral outrage at a particular horror to put that horror into perspective. Faced with what they believed to be the bureaucratized evil of the Serbian concentration camps, journalists translated the extraordinary into the understandable—if not the comprehensible—by using historical allusions and metaphors. The Sunday following *Newsday's* disclosure of the camps, for example, commentator David Brinkley opened his morning week-in-review show with words about Serb "barbarism" in Bosnia. "It's worse than Nazi Germany, they say, and so, must be stopped."[144]

The major papers, too, unanimously referred to the Holocaust and the Nazis in their first editorials on the Bosnian death camps. *The Washington Post* editorial on August 3 said: "Images like these have not come out of Europe since a war whose depredations and atrocities—it has been agreed again and again—would never be allowed to recur." The following day *The New York Times* editorial said: "The chilling reports from Bosnia evoke this century's greatest nightmare, Hitler's genocide against Jews, Gypsies and Slavs." On August 5, the *Los Angeles Times* editorial said: "Are there death camps in Bosnia, run by Serbs determined to 'cleanse' the territory they claim of Muslims and Croats? *Judenrein*. That was the unspeakably hideous word the Nazis used: 'cleansed of Jews.'" And on

August 6, the *Chicago Tribune* editorial said: "Are Nazi-era death camps being reprised in the Balkans? Unthinkable, you say? Think again. . . . The ghost of World War II genocide is abroad in Bosnia. . . ."[145]

The urge to find a Holocaust connection was so strong that just about every media outlet did a story on the Jewish response to the news from Bosnia. In a CNN segment on the "feeling of horror in many Jewish survivors of the Nazi-led Holocaust," reporter Jerrold Kessel paraphrased the comment of an Israeli politician: "Jews, of all people, cannot afford to ask themselves in a few years, where were we and what did we do, and to come up with a blank answer." For the same reason, prominent Jews were often sought out as sources for comments on stories about the camps. An *L.A. Times* article quoted a leading rabbi as saying, "It is happening again."[146]

Farther than that journalists could not go. The Holocaust is the ultimate metaphor in the dictionary of horrors, tempting reporters "to make their own plight more Holocaust-like," as said Michael Berenbaum, the director of the Holocaust Research Institute.[147] But were the camps really "death camps"? Was there genocide?

No, believes George Kenney. "Bosnia isn't the Holocaust or Rwanda; it's Lebanon," he said. "By my count, the number of fatalities in Bosnia's war isn't 200,000 but 25,000 to 60,000—total, from all sides. . . . For Bosnia, an area slightly larger than Tennessee, to have suffered more than 200,000 deaths would have meant roughly 200 deaths per day, every day, for the three-plus years of war. But the fighting rarely, if ever, reached that level." And, he added, "Neither the International Committee of the Red Cross nor Western governments have found evidence of systematic killing. Nobody, moreover, has found former detainees of concentration camps who witnessed systematic killing. Random killing took place in the camps, but not enough to account for tens of thousands of dead. And, apart from the few well-known massacres, nobody sees signs of missing villages, either."

"Magnitude matters," he said. "Genocide with a small 'g' (in which we might lump Bosnia with East Timor, Liberia, Guatemala, Sudan and Chechnya, among a score of others) is quite different from Genocide with a big 'G' (the Holocaust—and, perhaps, Cambodia or Rwanda)."[148]

But in the confusion in the weeks following the exposure of the Serb camps in August 1992, the appalling images and ghastly reports made it seem all too plausible that the "ethnic cleansing" was a version of the Nazis' Final Solution. The eyewitness tales of "death camps," random slaughter, terror tactics of rape and castration and systematic deportations made the analogies to World War II horrors seem appropriate.[149] And it was often to World War II and before, that

analysts looked to explain how such savagery could erupt on the European continent at the end of the 20th century.

The media evoked other World War II–era images as well — most notably that of Munich, Neville Chamberlain and appeasement. *Time* magazine's cover story noted: "The ghastly images in newspapers and on television screens last week also conjured up another discomfiting memory: the world sitting by, eager for peace at any price, as Adolf Hitler marched into Austria, carved up Czechoslovakia." And a *New York Times* editorial observed: "As Margaret Thatcher rightly reminds Americans . . . inaction is immoral. When many risk sounding like Neville Chamberlain in 1938, Lady Thatcher's words sound positively Churchillian."[150]

But as more information came out of Bosnia, the Holocaust images were less frequently applied — in fact, some decried the use of such analogies and metaphors as bordering on the hysterical. Israeli Prime Minister Yitzhak Rabin, interviewed on CNN, was one of the most vehement protesters of the comparison. "There were attempts to compare what goes on in Bosnia to the Holocaust of six million Jews during the Second World War," he told CNN. "By no means one can draw any parallel to the unique tragedy, terrible phenomenon of the Holocaust." And ABC News diplomatic correspondent Barrie Dunsmore advised that "words like 'death camps' are very, very special words. They conjure up not a few hundred people being killed, but an entire race being threatened with extinction, millions and millions of people. And frankly, it's not like that in Yugoslavia right now."[151]

As the Nazi-era analogies became discredited, other historical analogies came to the fore. "The debate over Bosnia is inflamed with historical analogies, some apt (Beirut), some not (Auschwitz)," warned columnist Charles Krauthammer. But in each case the analogy carried baggage. Just as journalists' use of the Holocaust comparison suggested that the world should not stand by and allow another genocide to happen and the Munich parallel castigated politicians and the public for inaction, the later historical analogies of Bosnia to Vietnam and Lebanon also carried a message: Watch out. "Memories of Vietnam and Lebanon provoked caution," said CNN reporter Leon Harris. "Western countries have succumbed to a paralysis spun of short-term operational and political prudence," said an editorial in *The Washington Post*, "and of a patent exaggeration of the risks of involvement in another — take your pick — Vietnam, Beirut or Northern Ireland."[152]

Numerous news stories and news analysis articles picked up on President Bush's characterization of Bosnia as a potential Vietnam. *USA Today* foreign

editor Johanna Neuman observed that "one of the things that the Bush adminis-tration did very ably was to counter the weight of those pictures with a deliber-ately calculated policy. Whenever the pictures came out they sent Larry Eagleburger, or some other administration official, out there to talk about Viet-nam and quagmires, and to educate the public that Bosnia was a danger, that it had the potential to be another Vietnam."[153]

Although comparisons to historic events were well-nigh omnipresent, not all the analogies used by the media were to past debacles of some kind. When dis-cussing particular people or groups, journalists turned to characters well-known to Americans. "Serb general Ratko Mladic might have stepped out of a night-mare novel by Charles Dickens," wrote Dan Rather, "and so might his tiniest victims." And Lance Morrow in *Life* magazine called the "blood-feuding peo-ples" in Bosnia the "Hatfields and McCoys installed along the fault lines of empires." As had been the case with reporting on other crises, use of analogies and metaphors helped to place events in a context familiar to Americans. The intention was to engage American interest for the distant troubles. The effect, however, was that readers and viewers came to overlook the complexity of the conflict and to believe in the simplicity of the comparisons. As a reader to the *L.A. Times* wrote in, "Is humanity doomed to repeat the atrocities of the past in an endless cycle?"[154]

The wrenching testimony in Roy Gutman's early stories from the camps offered documentary evidence to black crimes against humanity. But as had been the case with crises in the past, it was the televised images — and the stills taken from that footage — that prompted the greatest response, that pushed the issue (albeit briefly) to the highest rung on the public agenda. Morrow wrote, "The scenes from Bosnia arrived heavy with that unmistakable darkness, the real thing, the density of evil. They sank straight to the moral bottom of the century."[155]

The images from Bosnia galvanized a consensus that something had to be done, but there was no consensus on what that ought to be. Jack Germond from the *Baltimore Sun* noted that the TV pictures were "killing" Bush "because the television news reports show that some people think we ought to be able to do something."[156] As was to be the case with Rwanda two years later, the television pictures didn't prompt military intervention, but they did provoke humanitarian aid (and the introduction of armed peacekeepers). Humanitarianism is a smoke-screen behind which the United States can hide its political and military neglect. Tragedies shown in print and on television spur relief convoys much more readily than they markedly change foreign policy.

In a curious way the photographic coverage of the Bosnian death camps was similar to the coverage of the Ethiopian famine—in other ways the coverage was significantly different. Without underestimating the importance of Gutman's "death camp" story on August 2, both the Bosnian and the Ethiopian crises came to dramatic attention with a single television report—coincidentally videotaped for a British television network. But unlike the Ethiopian famine, that was effectively it for graphic images from the detention camps. While grim famine pictures poured out of Africa, each new image trumping the last (a cycle that repeated for the Somalia famine—at the very moment of the Bosnian crisis), there were only a few other "smoking gun" pictures out of the Bosnia camps. There were compelling new images from other parts of the Bosnian crisis—from the women who were raped, from the siege of Sarajevo, etc.—but only a couple from the camps. Even in the newsmagazines' cover stories in mid-August on the camps, the secondary images were from Sarajevo. And those photographs showed more incontestable violence: a morgue of the dead, a bloodied child, an injured grandmother.

The prevailing image of the death camps was the ITN picture of the emaciated Muslim man looking through the barbed wire fence at Trnopolje. The footage was repeatedly shown on television and with only few exceptions (*U.S. News* and the *Chicago Tribune*, for example), all the elite print media gave the picture prominent placement. Other images from the same sequence were also excerpted in print; in each case, the focus remained on the emaciated faces of men behind the wire. Both *Time* and *Newsweek* ran the photos across a page and a half of their opening cover spreads; the men's eyes gaze into the readers.[157] By the following week other photos of emaciated victims at Trnopolje appeared. One, taken by AP, showed a stick-thin man seated on a mattress on a tiled floor.[158] These photos of skeletal figures played well into the "death camp" pronouncement; they recollected the famous images from the liberation of the Nazi concentration camps of the haunted faces of the survivors behind the barbed wire. (Of course the images that best recollected the Holocaust were actual images of it—used to give context to the "death camp" story on television in that brief period between Gutman's August 2 article and the airing of the ITN tape on August 6.)

Over the years, the greatest photographic icons for Americans have been of solitary figures or of a very few, still identifiable people—the naked girl running down the road in Vietnam, the Sudan toddler menaced by the vulture, the Oklahoma firefighter cradling the little child, the lone man facing down the tanks in Tiananmen Square. In each instance, Americans cried out after seeing those figures, not to save every child or threatened person, but to save that threatened one—or one like him or her. The rescue of one may not be enough, but it

can be sufficient. And the energy expended in the call for rescue can delay compassion fatigue for the whole crisis.

So if activists within the media want to arrest Americans' attention, they need to identify that one person—that skinny man behind the wire—and then find another and then another for Americans to care about. Seeing only one picture repeated—like the picture from Halabja—no matter how compelling, signals to readers and viewers that help is ineffective—for the image of the crisis literally doesn't change. To shake Americans out of their lassitude, there needs to be enough photographs often enough and different enough that the public is prompted to care, but not so many and so repetitive that Americans are inundated by a backwash of misery and horror.

The second, but less prominent set of images to come out of the camps came from Manjaca and showed long lines of men sitting on a warehouse floor, their shoes lined up in military order at their feet. Several photographers had taken similar images; both Srdjan Sulja with AP and Patrick Robert with Sygma, for instance, took comparable wide-angle shots of the multiple lines of men, all eyes anxiously on the camera. These photos and a few others obviously taken at the same barracks gained their force from their representation of the close quarters and regimentation of the men. While they were strong images composed simply, by themselves they didn't document the "death camp" argument. They clearly showed the incarceration of prisoners, but the men did not look ill-fed or abused. The men were not the modern-day equivalent of the Nazi death camp survivors pictured crammed in their bunks after liberation. For the Bosnian photos, the captions, not the images drew the direct connection to the World War II–era death camps: "Misery in Manjaca," said Newsweek; "Helpless," said Life. "The camps are known to house not only men of military age, as shown here, but also women and children of all ages. Former inmates and human rights groups have reported widespread malnutrition, torture, rape and executions. One veteran of Manjaca, speaking through missing teeth and a broken jaw, said he saw 30 deaths in the 40 days he spent there. He added that the corpses were buried curled up in shallow graves to save space."[159]

A more intrinsically powerful image from Manjaca was the portrait of a single young, slender detainee, selected by several photographers because of his newly shaven head, his red-rimmed eyes and his apprehensive biting of his fingernails. "'Ethnic cleansing' was the chilling name for the tool Serbia used to oust its Bosnian neighbors, like these prisoners in a detention camp in Manjaca," read the caption in Newsweek. The anxiety and trepidation in the teenager's face suggested that he could well have been himself a victim of abuse or could have witnessed it firsthand.[160]

A scattering of other images emerged, most credited to the wire services. But they appeared in few outlets. Because the story really only lasted in the headlines for two weeks, the newsmagazines ran few images, although those they ran, ran large. And the newspapers too seemed to care relatively little about using the new images when they appeared. In the two weeks after the "death camp" story broke, for example, only *The New York Times* used an image of camp prisoners identified as Croatian, not Muslim. But of the print media, it was *The Washington Post* which made the greatest commitment during that initial span of time to the pictorial representation of the camps. Not only did it run more photographs than did the other sources, but it used many of them on its front page. It ran miscellaneous images of the prisoners inside the camps as well as a picture of Muslims released from the Serb camps awaiting transportation and another of a Croatian former POW hugging his family shortly after his release.[161]

(An interesting subcategory of photos in *The Post* was of prisoners and food: a prisoner at Omarska eating a chunk of bread, prisoners at Manjaca being served bowls of beans, prisoners at Manjaca carrying sacks of bread, prisoners at Trnopolje queuing up for food.[162] While the photographs were generally well-composed and it could be argued deserved publication on that ground alone, their subject matter appeared to undercut the contention that the prisoners were being mistreated. While it is likely that photographers allowed into the camps were directed to photo opportunities of prisoners being fed, that possibility was not reflected in the photo captions, which only stated, matter-of-factly, what was occurring in the images.)

In comparison to the photographic coverage of the Anfal of the Kurds, the coverage of the Bosnian detention camps was more extensive. Photographs represented more than just a single incident—the gassing at Halabja. But only a literal handful of them appeared to document the "death camp" contention of genocide. Horrific stories bubbled out in the text, but there were no confirming images of prisoners with slit throats, or mutilated or buried jammed together in fetal positions. Logically those pictures would have been nearly impossible for the outside media to obtain—since they would be direct evidence of Serbian (or the analogous Muslim and Croat) war crimes.[163] But the intellectual knowing of that made little emotional difference. The effect of the photos' absence was that the crimes did not exist for the American audience.

"For those who look back at World War II with perplexity," said a *Washington Post* editorial, "who wonder and can't grasp how the world stood by, it is now possible to observe several forms of inertia that are playing a role. For Americans, it's all too easy to view the Yugoslav tragedy as a far-off, impenetrable and even

perhaps faintly comical ethnic muddle, source of clever words like 'balkanization' to apply to other regions and of endless, ponderous place-names. The many-sided politics of the war are in fact stupefyingly complex, and talk of possible military action, such as easing sieges by bombing Serb artillery emplacements bogs down swiftly in practical and political calculations."[164] One can, in other words, grasp why Americans might keel over in a compassion fatigue stupor or practice compassion avoidance as a matter of course.

To try and forestall that eventuality, journalists became engaged. They wrote passionate accounts of the horrors of the camps. Some received front-page attention. Some received top-of-the-news coverage on the nightly news. But the images from Bosnia never really backed those stories up. The journalists' advocacy was an attempt to force Americans to care. But the reporters couldn't overcome the paucity of damning visual evidence. And without it—and because Radovan Karadzic precluded the necessity for immediate political intervention with his agreement to allow the Red Cross access to the camps—nothing much happened.[165]

It has often been said that the Bosnian case proves the point that photos don't make a difference to foreign policy, that Somalia is the anomaly in this instance where the photos there really did seem to get the United States in and then out of an international crisis. But a critical assessment of the photographic coverage of the death camps suggests something else: that single, iconic images such as the ITN picture of the men behind the wire are important—although not always essential—for riveting American attention to a particular crisis, but that what really makes a difference in the foreign policy equation is how long the photos continue to have prominence in the news and how effective those pictures are in illustrating a political stance: save the starving Somalis, rescue the imprisoned Bosnians.

The question as it has been formulated is wrong. The question that foreign policy observers should be asking is not "Why didn't the pictures get us into Bosnia?" The atrocities in the camps had been known about at least for weeks, but that first set of images, those broadcast from ITN, pushed Bush, during his Maine vacation, to meet the press three times in three days. That set of pictures accomplished a lot. The question that should be asked is "What would have happened if Americans had then been made privy to the images of horror represented in the stories coming out of the camps?" What would have happened if Somalia hadn't come along to pipe Americans away to a more tractable problem (it seemed), and instead some intrepid photographer had captured on camera a camp full of thousands of skeletal men or incidents of torture or bodies buried in mass graves? And what would have happened if those images had emerged earlier in the "ethnic

cleansing" operation, when Radovan Karadzic would have been less likely to give the Red Cross permission to visit the detention camps or to propose their closing?

Perhaps it would still have ended as did Rwanda. Perhaps even though Bosnia is in Europe, even though the death camps occurred in the last decade of the 20th century, the United States would still have done nothing until the genocide was over, until it became a manageable refugee, "humanitarian" disaster. Perhaps only when Americans know what they—the people—want to accomplish, perhaps only when they feel they can help—even if just a bit—and not themselves be drained dry or made vulnerable to every subsequent solicitation, is compassion fatigue disarmed, and the public made clamorous for foreign policy changes.

"ACTS OF GENOCIDE": RWANDA, APRIL–AUGUST 1994

It wasn't easy killing 800,000 people in a hundred days. In fact, as one man admitted to BBC correspondent Fergal Keane, "It was tiring work."[166]

Imagine having to kill at least five people a minute for more than three months—and having to kill them mostly by machete, with perhaps some help from nail-studded clubs, miscellaneous kitchen implements and garden tools and with the only occasional recourse to grenades or automatic rifle fire. It *would* be hard work. Philip Gourevitch wrote in *The New Yorker* that when he traveled to Rwanda a year after the genocide there, he came across a man in a market butchering a cow with a machete. "His big, precise strokes made a sharp hacking noise, and it took many hacks—two, three, four, five hard hacks—to chop through the cow's leg. How many hacks to dismember a person?" he wondered.

Although the killing in Rwanda was low-tech, it took place at high speed. "By comparison," considered Gourevitch, "Pol Pot's slaughter of a million Cambodians in four years looks amateurish, and the bloodletting in the former Yugoslavia measures up as little more than a neighborhood riot. The dead of Rwanda accumulated at nearly three times the rate of Jewish dead during the Holocaust."[167]

To butcher so many so quickly took a lot of help from everybody. The genocide in Rwanda was a group effort. It was a job. Sometimes the massacres were part of a military operation, a matter of guns and fragmentation grenades, and the duty of the civilians was "cleaning up" the survivors—in French, *nettoyage*.

Other times the killing was a more local operation encouraged by political leaders and egged on by exhortations on the radio. The local Hutu officials would draw up lists of victims and every morning the peasants would gather with their machetes and set to work. They'd go home for lunch and resume in the

afternoon. Those victims they had collected who they hadn't gotten around to killing by the evening they'd hobble by severing their Achilles tendons. If they crawled away, so be it. There was a certain dispassionate level to it that made it possible for elementary-school teachers to kill their students and for neighbors to kill their neighbors. Sure some must have enjoyed their work, like those young men who vied to be the first to murder 200 Tutsis, or the man who crushed 900 people in a church with a bulldozer. But what about the man who killed the friend he had played chess with every night for 20 years and the woman who killed two small children because their parents had already been killed and as she put it, "they wouldn't have had a good life anyway"? What was their motivation? "All of them said they killed because government leaders told them to," reported CNN correspondent Gary Strieker.[168]

"I took three trips to Rwanda between early May and mid-August," wrote Mark Fritz, the Associated Press's West Africa correspondent who won a Pulitzer Prize for his coverage. "Each was a study in the ways a human being can die." But the "scope and scale and swiftness," he said, of "the robotic massacres in the town and villages, the thousands of moments when one group of villagers suddenly rose up and killed another group with every device at its disposal" in April and early May, "gave Rwanda its standing among history's truly horrible moments."[169]

"Virtually every journalist in Rwanda had witnessed plenty of human cruelty," wrote Jennifer Parmelee of *The Washington Post*. "Yet most of us still drew a distinction—however fine it might seem—between the act of standing back and shooting a fellow human with a gun and that of standing over a child and hacking him or her to pieces, blood spurting all over you, then sorting the body parts into tidy heaps."[170]

"I doubt if there is any other place in the world where so many people who write for a living have used the phrase, 'Words cannot describe. . . .'" And then Fritz tried. He simply catalogued the killings. He used few adjectives or adverbs in his inventory, although he did use active verbs. The acts hardly needed further sensationalizing. "Women were raped before and during their deaths," he wrote. "Eyes were gouged out, testicles cut off, babies decapitated, pregnant women speared through the womb. One mother of five told me how she killed two of her neighbor's children. While the men dealt with the adults, the women in her town gathered up the children of the families deemed to be enemies. They put them in a circle and began pounding their heads with bulbous clubs designed for this unfathomable task. 'They didn't have time to scream,' the woman told me. 'They just made big eyes.'" And the stories got worse. "In much of Africa," Fritz continued, "women grind a root called cassava into a paste by

using what are essentially huge mortars and pestles. The pestles are like clubs and the mortars are about the size of a bassinet. A young student I spoke with said he saw babies being placed in these mortars and ground to a bloody pulp."[171]

"You don't just see death here, you feel it and you smell it," said reporter Fergal Keane's voice-over narration for a *Frontline* documentary on Rwanda. "It is as if all the goodness had been sucked out and replaced with the stench of evil."[172]

After the killing was all over the prosecutors charged with bringing the genocide cases to trial created a ranking system for the brutality. Category 1 was reserved for the leaders, their lieutenants as well as "sexual torturers" and "notorious murderers" who demonstrated "zeal or excessive malice" in the commission of atrocities. A journalist asked Kigali's prosecutor Emmanuel Rukangira whether it was worse to bury one person alive or kill ten people with a machete. "He smiles," the journalist wrote, "as if he's thought about this before. 'With a machete, you can do it with one hack. To bury somebody alive, it takes him a long time to die. Sometimes they didn't bury him completely. They left him there alive and came back in a couple days with a stick to finish. Others killed pregnant women and cut the babies out of their wombs. That is a cruel way to kill. Category 1.'"[173]

It all made for quite a story—a story that fit quite nicely into the stereotyped "Joseph Conrad" portrait of Africa. As Parmelee put it, "Rwanda . . . somehow has gone way off the charts of international 'norms' in times of conflict. It's a plunge deep, deep into the heart of darkness. . . ."[174] But other elements, too, contributed to the Western media's attention. Initially the journalists went to Rwanda to cover the American story, the story of 250-odd Americans who needed to be evacuated. Then the journalists found that the killing fields of Rwanda were accessible, albeit dangerous. "They reached," said David Lamb, in the *L.A. Times*, "from Kigali, the capital, to the interior where the Tutsi-dominated Rwandan Patriotic Front assigned press officers to border crossings to escort journalists to massacre sites." And third, it just so happened that right at the moment when it was becoming clear that what was happening was genocide—and not merely another two-bit African dustup—the world's press was already in the continent covering the first elections of the post-apartheid-era in South Africa. So it didn't take so much for news organizations to divert their people up to Central Africa for a look see. "Certainly the sheer magnitude and vividness of the massacre explains, in part, why Rwanda has been in the news while

other African tragedies have gone by almost unnoticed," Gary Strieker said. "But the more I think about it, the more I think it has a lot to do with the presence of so many journalists in South Africa for the elections."[175]

By happenstance and on its own merits the story received moderate media attention. During the April height of the genocide, the Big Three networks gave Rwanda a total of 32 minutes on the evening news—about one and a half percent of the total time for the month. Americans saw print and TV images of colorful piles of corpses and bleached bloated bodies bobbing in rivers. Strieker's camera even filmed a group of Hutu villagers who wandered over and began beating four captured Tutsi men and women. They beat them until they were dead. Then as the camera rolled, several Hutu boys beheaded the corpses with their machetes and nonchalantly wiped the bloody blades on their pants. No wonder that the anchors back in Washington often cautioned before a segment from Rwanda aired: "A warning for our viewers, this report contains pictures which may disturb some of our viewers."[176]

The public's response to these images and tales of horror, said television critic Julia Keller, "was curiously muted." One poll showed that only one percent of the television public was interested in the genocide. "What to do with these pictures, these horrors? Where in our minds do we store the image of bloated bodies floating down a river in Africa?" wrote *Washington Post* reporter Elizabeth Kastor. "And so we become inured to it, or attempt somehow to respond, all the while striking bargains with ourselves about how much we will let in." For 12 weeks the flow of horrific pictures came out of Africa, and, said the Gannett News Service, "the overstuffed nations watched CNN and shook their heads in silence."[177]

The Clinton administration actively resisted taking any action. "Rwanda was on your television screens," said a senior official, "but not on our diplomatic radar screens." While the relief workers and the journalists who had spent considerable time on the story were willing to make moral judgments and called for international intervention, many others took refuge in the history of relations between the Tutsi and Hutu in the region. Roger Rosenblatt commented in mid-July on *The MacNeil/Lehrer NewsHour* that there are "people naturally who from time to time set aside what they have called their souls and recalled their under-developed evolutionary state and murder one another in great numbers for the hell of it. On the plains of the American West, in China, in Indochina, in Japan, and Western Europe, and Eastern Europe, in Latin America, in Sudan, and now Rwanda."[178] Genocide happens sometimes. So what can anyone do?

Only when the genocide turned into a refugee crisis, did either the public or the government take any aggressive action. And then, as one frustrated relief worker said, she was glad to see the world responding to the needs of the Hutu refugees. But she asked, "Where was the world when Tutsis were being slaughtered?"[179]

Three days into the April genocide, correspondent Joseph Verrengia wrote, "Rwanda once was dubbed the 'Switzerland of Africa' for its lofty peaks and green vistas. Now it has become the Yugoslavia of Africa, splashed with the blood of tortured and slain priests, peacekeepers and humanitarians trying to do good in the middle of an ethnic cleansing zone. Instead of Bosnians, Serbs and Muslims, the age-old conflict in Rwanda is between Hutus and Tutsi. The results are the same."[180]

Even after the fact, the Rwandan war, like the Bosnian war, is not a simple one to explain to an American audience. As with Bosnia there are two levels of blame influencing the interpretations of the conflict: blame for the Hutu extremists for planning and executing the genocide and blame for the international community for not stepping in and stopping it.

No one really knows when the first Hutus and Tutsis settled Rwanda, but the Hutus were already living in the forested hills when the Tutsis (also known as the Watusi) immigrated from Ethiopia. For centuries before white involvement in the region the two tribes spoke the same language, followed the same religion, shared the same social and political systems of small chiefdoms and intermarried. Ethnographers agree that Hutus and Tutsis are not distinct ethnic groups—but the two words did continue to have meaning, perhaps more as a kind of class or caste, for one distinction has remained between the two groups: Hutus are farmers and Tutsis are herdsmen. And, because since time immemorial cattle have been more valued than vegetables, the name Tutsi became synonymous with the elites.

The area was historically divided into the rival kingdoms of Ruanda and Urundi, both dominated by Tutsi aristocracy. "Europeans who stumbled into Rwanda a century ago," said *Time* magazine, "found a country ruled by tall, willowy Tutsi cattle lords under a magical Tutsi king, while darker-skinned, stockier Hutu farmers tended the land, grew the food, kept the Tutsi clothed and fed." "They were a reasonably contented rural society," said African historian Basil Davidson.[181] The order of life seemed to the Europeans to have a natural basis in science, and so, naturally, the colonial rulers allied themselves with the Tutsi, who made up 14 percent of the population in both kingdoms, in order to control the Hutu, who comprised 85 percent of the population.

When the Belgians inherited the colony from Germany at the end of World War I, they tried to quantify the still somewhat fluid differences between the two groups, claiming that the average Tutsi nose was 55.8 millimeters long and 38.7 millimeters wide, compared with Hutu dimensions of 52.4 and 43.2. The Belgians made other distinctions, based on property: those who owned fewer than ten cows were said to be Hutus, those who owned more were Tutsi.[182] In 1933–34, the Belgians conducted a census, placing everyone into these official categories, and issued identity cards, making it virtually impossible for Hutus to become Tutsis.

But by the late fifties, as the European colonial powers began to read the independence movements' writing on the wall, the Belgians began to side with the emerging Hutu Power force. An uprising in 1959 aided the Hutus coming to power, as in the fighting 20,000 to 100,000 Tutsi were killed and another 200,000 fled to Burundi.

With independence in 1962, the first president of Rwanda became Grégoire Kayibanda, a Hutu, while in Burundi the Tutsi held on to power. Ten years later, in 1972, the Hutu in Burundi tried to overthrow the government, slaughtering hundreds of Tutsi in the rural hillsides. The Burundi army, almost entirely Tutsi, crushed the rebellion and then some, executing scores of the Hutu intelligentsia and killing between 100,000 to 300,000 other Hutus. Again in 1988 in Burundi another clash occurred, when unannounced military maneuvers made Hutu villagers fearful of another army massacre. The Hutu struck first; almost 25,000 people died in the first day of fighting.

By comparison through all this, Rwanda was a model of social order, although internal feuding among the Hutu elite had resulted in the ouster of Kayibanda by Hutu General Juvénal Habyarimana in 1973. Still, there were major population problems. Rwanda is the most populous country in Africa; it has eight million people in a nation only "slightly larger than Vermont," as *The New York Times* put it. (A neat Americanization of the country.) Ninety-five percent of the land is under cultivation. The average family consists of eight people subsisting on less than half an acre. Under Habyarimana's rule, Tutsis who had been pushed from the country by the Hutu Power movement were not welcome to come home. In 1986, Habyarimana announced that Rwanda was full. (Burundi, at roughly the same size, has 5.8 million people.)[183]

With each new battle or sign of stress, refugee groups had ping-ponged from one country in the region (Rwanda, Burundi, Uganda, Zaire, Tanzania) to another. Many Tutsi Rwandan refugees had moved to Uganda and become officers in the Ugandan Army. In 1987 they founded a secret fraternity called the Rwandan Patriotic Front (RPF). Three years later the RPF invaded Rwanda,

demanding an end to the Tutsi exclusion. Within days of the RPF movement into the country, the government began arresting Tutsis and Hutu moderates. A week later 350 Tutsis were massacred on Hutu orders, and shortly thereafter the newspaper *Kangura*, published the infamous "Hutu Ten Commandments" which warned Hutus not to intermarry, fraternize or go into business with Tutsis. Commandment number eight decreed "The Hutu must not have mercy on the Tutsi"—instead of the more conventional, "Thou shalt not steal."[184]

The fighting in Rwanda between the government forces and the RPF lasted for three years, ending in a stalemate in 1993, which forced Habyarimana to sign a power-sharing agreement with the RPF rebels. Hutu extremist leaders delayed implementing the agreement, and instead began drawing up lists, lists of Tutsis and lists of Hutu sympathizers.

For that one brief moment in 1993, it looked as if the tensions in both Rwanda and Burundi had eased. In June 1993, Melchior Ndadaye became Burundi's first democratically elected president, and the first Hutu to lead the country. Hutus also held the majority in the parliament and the cabinet, but Tutsis continued to control the provincial and local governments and the military. Then four months after his election, on October 21, Ndadaye was overthrown by his palace guard and assassinated. Reprisals on both sides ensued. Between the end of October 1993 and March 1994 perhaps as many as 300,000 Hutus and Tutsis died. More than half a million refugees fled, many into Rwanda.

The story never really made the news. As David Lamb noted, "100,000 Burundians died in October and November, and no one came to the party." Steven Weisman, *The New York Times* deputy foreign editor defended the media's poor performance with the standby excuse of only one crisis at a time. "Perhaps we should all have done more earlier," said Weisman, "but Somalia used up a lot of our resources." Nancy Cooper, senior editor of foreign affairs at *Newsweek*, believed the lack of attention had to do with a lack of visual interest, "One could speculate that it had something to do with pictures." And certainly access played a part. Unlike Rwanda a year later, the massacres in Burundi took place in countryside that was difficult to reach.[185]

On April 4, 1994, regional leaders gathered in Dar es Salaam, Tanzania to address the regional crisis. The Tanzanian president pleaded for peace. "Now is the time to say no to a Bosnia on our doorstep."[186] Two days later Habyarimana and the new Hutu president of Burundi, Cyprien Ntaryamira, decided to fly home together on Habyarimana's Mystere-Falcon private jet, a gift from the son of President Mitterand of France. At 8:30 P.M., the plane came under rocket fire as it was landing at Kigali airport. It smashed through a banana grove and tore

through a wall surrounding the president's garden, finally coming to rest at the edge of a small pond. Rwanda's U.N. ambassador told members of the Security Council that the crash "was not an accident. It was an assassination."[187]

Just as was the case with the downing of President Zia ul-Haq's airplane in Pakistan six years earlier, speculation was rampant as to who had actually killed the two presidents. Just as with Zia, the possibilities abounded—from RPF forces, to extremist Hutu members of Habyarimana's party who didn't want to see him make concessions to the Tutsis, to Hutus who wanted to frame the Tutsi and use Habyarimana's death as an excuse for genocide, to Tutsis from Burundi who wanted to kill both presidents in one fell swoop, or perhaps even some combination of the above. And just as with Zia, it is still not known who was responsible for the deaths of all aboard the plane—although many fingers point to the Hutu extremists.

One major factor in the belief of many that the Hutu Power structure was to blame for the crash is the fact that the extremists instantaneously exploited the deaths to begin their genocide. Within an hour of the plane crash the murder of moderate Hutu political figures had begun, their names taken from prepared hit lists. Acting Prime Minister Agathe Uwilingiyimana and other Hutu ministers died within the first hours of fighting. Yet despite such early signs of an extermination campaign, few reporters said clearly that it was the Hutus who were doing the preponderance of the killing. Many journalists were confused into thinking that it was either all one mad "orgy of bloodletting," as USA Today and the Chicago Tribune phrased it, or another "tribal war," just the "latest round of mass murder by the Hutu and Tutsi tribes," as the L.A. Times believed. Syndicated columnist Georgie Anne Geyer, got it all wrong in her column, when she said on April 21, "Now, in the last three weeks, we have the essence of the last stage, the carnage in Rwanda, where tall tribesmen massacre short tribesmen with a savagery not even seen in colonial times; where not even tribal divisions and hatreds make sense anymore; and where we may have reached the final Hobbesian realization of the 'war of all against all.'"[188]

There was some justification for the confusion. "'At first the killing wasn't purely ethnic. It was also political,'" Time magazine in May quoted one Hutu moderate as saying. The vast majority of those who were killed in April and May around the country were Tutsi, a May page-one article in The New York Times, related, "singled out for extermination in a systematic and orchestrated campaign by Hutu militia groups backed by Hutu extremists in the army and government. But thousands of Hutus have also been victims—massacred by those same death squads out of suspicion that they sympathized with the rebels or simply because they were not card-carrying members of Habyarimana's party," it said. Still, the

genocide had extermination of Tutsis as its top priority. "Some Hutus are believed to have been killed because they refused to participate in the mob violence against Tutsis," said *The Times*, "and some may have been killed simply because they had narrow noses and long necks more characteristic of Tutsis." The state radio station exhorted, "All Tutsi will perish; slowly, slowly, slowly, we kill them like rats."[189] With some success, the Hutu interim government portrayed the killings as a spontaneous outbreak of tribally motivated revenge.

In those first hours after the plane crash ten Belgian soldiers who had tried to protect the prime minister were also tortured and killed.[190] Almost immediately world interest focused on the safety of the white foreigners caught in Rwanda. The evacuation of the expatriates dominated the news. The faces of desperate, fleeing foreigners appeared on television and in photographs; in the background were the stoic expressions of the Rwandans soon to be left behind. Media critics charged racism—racism in the choice of what to cover and racism in the amount of coverage. Many within the media agreed with the assessment. *Post* reporter Jennifer Parmelee argued that "the reason that the story appeared on our front pages at all was in fact the evacuation of foreigners and that ten Belgium peacekeepers were killed." "Last fall in Burundi," she continued, "a similar conflict happened in which well over 100,000 people were killed in a very short period of time and it barely rippled the world's attention at all. So I think either you have that situation where the presence, or where the situation of Africans killing Africans is not worth covering by the news media."[191]

Over that week, French and Belgian troops evacuated all the Americans and Europeans in the country. Carol Pott Berry, an American who fled Rwanda, wrote for *The Washington Post* about the Rwandan family she had been sheltering in her home. "It was awful telling the Rwandan family that I was being evacuated and that they had to go. The mother begged me to take her three children with me and as her small daughter hugged my legs I had to tell her that I could not," she said. "Looking into the eyes of that small child is an awful memory I will carry with me always." Eighteen Belgian nuns and lay brothers abandoned a hospital for the insane, leaving behind 200 patients and the 500 Tutsi refugees camped on the grounds. "They're finished," said the hospital's administrator. "A huge number will be killed." Christian missionaries accounted for most of the 250 or so Americans who were residents of Rwanda. They were among the last to leave Rwanda by a convoy of vehicles on Sunday the 10th, encouraged to do so by U.S. Ambassador David Rawson, himself the son of missionaries. In honorable diplomatic fashion, Rawson evacuated and closed the American embassy and rode in the last car of the some 200 vehicles which traveled from Kigali to Burundi, more than 60 miles away.[192]

Catherine Bond, an experienced freelance television correspondent for CNN and the British network ITN, who had flown into Kigali with a relief plane shortly after the killings began, joined a convoy of French troops charged with evacuating the Western expatriates. "We drove through the behind-the-airport suburb and two young boys came crawling out of the swamp. One was about 14. He pleaded for the life of his younger brother, a toddler. We all just sat in our jeeps—stunned," she said. "We were driving very slowly and could have stopped, but we didn't know what to do. The French soldiers, who could so easily have taken the boys and protected them, needless to say, did nothing."[193] And Alain Destexhe, the former Secretary General of Médecins Sans Frontières, commented, "With very rare exceptions, the UN agencies, the embassies and non-governmental agencies did not evacuate their local personnel. Throughout the world people watched film of armed soldiers helping to save their compatriots. These same soldiers were ordered to turn their backs on women and children being slaughtered by adolescents armed only with machetes and sticks. Rarely has there been an episode in history when differences in the status and destiny of groups of human beings has been so obvious."[194]

On Wednesday, April 13, a particularly horrendous massacre occurred—the slaughter of close to 1,200 people in a church where Tutsis had sought refuge. The church pastor told reporters that soldiers from the Presidential Guard kicked in the doors to the church, opened fire with automatic weapons and threw grenades. Then with knives, bats and spears, they waded into the sanctuary to kill those who survived. The pastor said he counted 1,180 bodies, including 650 children. By April 14, with the exception of about 20 foreign journalists holed up in the Milles Colines Hotel in Kigali and about 30 Red Cross workers and a half-dozen members of Médecins Sans Frontières, all the nonmilitary foreigners had departed. But that day, more than a dozen of the journalists flew out of the country under the protection of Belgian troops. "Men, women and children gathered in the lobby" of the journalists' hotel, reported *Post* correspondent Jennifer Parmelee, "some begging with tears streaming down their faces to go too." That same day, the Red Cross temporarily suspended operations when one of its trucks carrying six wounded Rwandans was stopped, and all six of the injured were pulled out onto the street and hacked to death. Even so, noted *Times* reporter Donatella Lorch, "Many Rwandans have taken to sewing homemade scarves with a Red Cross emblem, hoping it will save their lives."[195]

Then, five days after their soldiers had been killed, on April 12, Belgium notified the U.N. Secretary-General of its intention to withdraw its troops from the United Nations Aid Mission to Rwanda (UNAMIR). Boutros Boutros-Ghali presented the Security Council with his assessment of the situation, saying that the

Belgian withdrawal would make it extremely difficult for the rest of the U.N. force to carry on. Belgium, the United States, and to a lesser extent France and Britain, argued for a complete withdrawal, while Nigeria suggested a larger and more effective force. On April 21, the U.N. Security Council approved the reduction in strength of the UNAMIR force from 2,500 to 270. It would be almost a month—May 17—before a second Security Council resolution approved increasing the force to a maximum of 5,500. Eight days later, on May 25, the Human Rights Commission authorized a Special Rapporteur, René Degni-Ségui, to investigate the charges of genocide. He returned a month later, at the end of June, with his findings. The "systematic massacres" soon went beyond political opposition figures, he wrote. "Whole families are exterminated—grandparents, parents, and children. No one escapes, not even newborn babies." He concluded that it has been a "genocide," a "holocaust." And then he recommended either the creation of an international court to try those responsible for the crimes or an extension of the mandate given to the tribunal dealing with the war crimes in the former Yugoslavia to cover Rwanda as well. The American public, meanwhile, was at best ambivalent. A *Time*/CNN poll in May showed that only 34 percent of the respondents favored doing something to quell the violence, and 51 percent opposed any action.[196]

By the end of April, estimates were that at least 100,000 had been killed and figures ranged up to the half a million mark. But with few international observers out on the streets and in the countryside, the numbers reflected opinions rather than facts. By mid-May the International Red Cross was saying that the actual figure would never be known and that they had just stopped counting. The only official body counts were made in mid-May in Kigali when the garbage trucks picked up 60,000 bodies and in late May in Uganda, when authorities buried 40,000 corpses which had floated over from Rwanda. Donatella Lorch described a Ugandan fisherman's shock after pulling out the corpse of a woman with five children tied to her limbs and back.[197]

The Clinton administration, trying to keep a low profile on Rwanda after the Somalia debacle, held a press conference on June 10, after a long period of embarrassed silence. State Department spokesperson Christine Shelley carefully acknowledged that "acts of genocide" had occurred. The press at the briefing challenged her on the use of the phrase "acts of genocide" rather than "genocide." She stammered, "I have phraseology which has been carefully examined"—carefully examined, it was clear, to ensure that the administration's admission of "acts of genocide" would not make the United States vulnerable to the U.N. Genocide Convention obligating action in cases of genocide. As a

parting shot during the press conference, one reporter asked Shelley, "How many acts of genocide does it take to make a genocide?"

While the genocide was occurring, and within 36 hours of the plane crash, the RPF had begun an offensive, moving in toward Kigali from its base in the north, near Uganda. As the RPF forces moved toward the capital it became difficult for those journalists who wanted to to go back in. And once the enormity of the genocide was discovered, almost no TV crews dared to enter Rwanda—they were particularly vulnerable to attack because of their need to get visuals. After the evacuation, there were two primary ways for journalists to reenter the city: "in a hair-raising Canadian Air force flight that was more often than not canceled due to the fighting or by road from Uganda with a Tutsi rebel minder and an armed escort. The trip was grueling and took as long as three days to get to Kigali," said Lorch. "Once in Kigali, the fighting was so intense, journalists could hardly move out of their hotel. Several were wounded. Many more, including myself, came down with malaria."[198]

The war between the Rwandan army, led by Hutus, and the primarily Tutsi rebel army lasted through June around Kigali, as both sides battled with automatic weapons, artillery and mortars. Hutu extremists used the Tutsi offensive as a rationale for their exhortations to genocide, broadcasting on their radio station that the rebels had plans to kill all Hutus—so there was a necessity to exterminate the Tutsi first. For the international audience, the Hutu interim government also tried to conflate the war and the genocide, insisting that a cease-fire was a precondition for halting the massacres.

The small core of Africa-based correspondents, supplemented to a certain degree with others based in Paris or London, covered the genocide extensively. *The New York Times* and *The Washington Post* gave the story the best coverage in the United States—a function of their reporters' courage and talent and their editors' interest. For these few, like Lorch and Parmelee, "the massacres were not a story but a horror that desperately needed to be publicized."[199] *The Times* and *The Post* were carrying the news, but generally the American media and public had yet to express any great interest in the story.

By the end of the month, still at the height of the genocide, many Africa correspondents had gone back down to South Africa, to monitor the voting there which began on Tuesday, April 26. Numerous reporters and producers normally based outside the continent then weighed the decision to travel up to cover Rwanda on their way home. Some, including those in TV, stopped off to cover the quarter of a million refugees who had just fled to Tanzania—what David Brinkley called "the greatest exodus in known history."[200] Few dared to go into

Rwanda itself, but the refugee story on the border had strong visuals, panoramas of the camps and interviews with the genocide victims to commend it. And the television networks could always insert clips into their own packages that had been taken by freelancers who had actually gone into Rwanda.

Other media institutions made the decision that the trip was worth neither the money nor the risk. As Lorch put it, "Rwanda was a logistically difficult story to cover. It was also very dangerous."[201] And it was expensive. In a news budget meeting on May 5, the top editors at *USA Today* discussed whether to send one of their two correspondents who were in South Africa covering the swearing-in of President Nelson Mandela up to Rwanda. Thomas McNamara, the managing editor for the news, offered his opinion. "Proximity is the only argument," he said. "We can't get them into Rwanda, just to the Tanzanian border. It will eat up a lot of our money and the return is questionable." Well, said John Simpson, managing editor for the international edition, "We can send someone to Rwanda from South Africa by way of Nairobi or from the U.S. they can go on an aid flight—in which case they'd either charge for a seat (although probably less than a commercial airliner) or *USA Today* would make a contribution. But either way, it's not cheap." "The problem is dropping someone in," added McNamara, "We get three stories and get backed up with 16. What we do," he admitted candidly, "is bang, bang, bang. Where would we find room?" Peter Prichard, the editor, ended the discussion. "Talk it over. See what it costs. But it's a major story. We can certainly get one or two covers out of it—there aren't that many Western journalists who've been there." But after weighing the factors, they decided to "let the wires get us Rwanda"—although Tom Squitieri did go into Rwanda later in the month and did file a "cover" story for the paper.[202]

Through May and into June, European news services supplied much of the limited television coverage—although some of the networks had to fall back on telephone interviews to supplement their reporting because with no mobile satellite dishes or uplinks and no regular flights to and from Kigali at times no one could get any video or even photos out of the country. "This is one of those stories where everything seems to go wrong," said CNN executive vice president Ed Turner in mid-May. CNN reporter Gary Strieker entered Rwanda by way of Nairobi, but, said *TV Guide*, he "was forced out at gunpoint," although he went back in later in May—the first television journalist to enter Kigali with the Tutsi rebels. Peter Jennings acknowledged the danger in a lead-in to a piece on the evening news. "It has been enormously difficult to move freely in the country since this bloodletting began. But ABC's cameraman Carlos Medrolian [sp?] [*sic*] has been able to move around there and he has now managed to get some

videotape out to ABC's Ron Allen." Throughout the late spring and early summer, NBC's *Now* and more notably ABC's *Nightline* featured special reports on the crisis, but, as *TV Guide* said, "the risks to news correspondents trying to get in and (more difficult) *remain* in have been 'considerable,' says CBS News v-p Lane Venardos."[203]

As a result of the risks and costs, "a lot of coverage has been superficial," said Jennings in May. "None of us is doing a particularly good job at getting at the truth of this. Part of the dilemma for all of us has been that we are not as familiar with the situation of the Hutus and Tutsis as we ought to be." As Ted Koppel explained in his intro to a *Nightline* program on Rwanda the first week in May, "It's hard to believe that we would handle the slaughter of more than 100,000 Europeans with quite the same equanimity, and even the names of the two tribes, the Hutu and the Tutsi, conjure up colonial images of half-naked savages. More than anything else, we seem relatively immune to the human tragedy in Rwanda because we have seen so little of it, and because, other than the movie 'Gorillas in the Mist,' which documented Dian Fossey's study of gorillas in Rwanda, other than that, most of us would be hard-pressed to come up with another single fact about the place."[204]

Then two months into the genocide, France announced that it had "a duty to intervene." It sought and received authorization from the U.N. Security Council for Operation Turquoise on June 22. Operation Turquoise set up a security zone in the southwest of the country, undoubtedly saving some Tutsi lives in the area, all without the loss of a single French soldier—although tens of thousands of Tutsis had already been killed before the French established its perimeter. As Alain Destexhe sardonically observed, "this can only be considered a relative success in comparison to the hundred of thousands of victims of the genocide and the *a posteriori* realisation that if such a small action could be successful then it should have been possible to intervene over a far larger area." Operation Turquoise, said Destexhe, served "principally as a public relations vehicle for France," and as a goad to the public's interest—with the arrival of the French troops the television cameras could go in (at least to the secured zone) with relative impunity.

The media attention made it easy to forget that the security zone only accounted for 20 percent of the country and that the rest of the country was neither secured nor safe. "The genocide," said Prunier, "began to recede into the misty past for millions of fast-zapping TV viewers. Rumours of summary executions by the RPF began to spread, starting to give credibility to a notion we would see more fully developed later, that of the 'double genocide', the 'Hutu killing the Tutsi and the Tutsi killing the Hutu' as the UN Secretary-General

Boutros Ghali put it. Rwanda was too much, and compassion fatigue was beginning to set in."[205]

By early summer the RPF was gaining on all fronts, controlling almost half the country and pushing Hutu refugees in front of its forces. The first major Hutu exodus out of the country had been at the end of April when a quarter of a million refugees, in "one of the largest and fastest refugee exoduses" ever, crossed into Tanzania in just 24 hours, immediately before the RPF captured and closed Rwanda's frontier with Tanzania. "Most of the refugees are Hutus," said an Associated Press story, but "most of the wounded in the [refugee] camp appear to be Tutsis."[206] By July, and the imminent collapse of the government more than two million Hutus, including those who had organized and participated in the genocide, fled to the bordering countries. On July 14, the RPF took Ruhengeri, the main town in the north of the country and three days later Gisenyi, the last bastion of the interim government's forces, fell. A new government was sworn in on July 19, 1994. The cabinet had a majority of Hutu (16 out of 22 posts), including the president and the prime minister, but the real power lay in the newly created position of vice president, given to the Tutsi RPF General Paul Kagame.

By Thursday, July 14 and the fall of Ruhengeri, more than 100,000 refugees—primarily Hutus—had crossed the border to Goma, Zaire. And more were on their heels. Some were Tutsi still running in fear from the genocide, but most were Hutu, newly afraid for their lives under a government controlled by the RPF. "They seem to be fleeing what they're hearing on these government radio broadcasts," said ABC correspondent Ron Allen, "the propaganda warning them that Hutus . . . are going to be executed by the Tutsi. . . ." By Friday the 15th, there were 300,000 refugees in Goma. They were flowing past the border post at a rate of 600 people every minute, 10,000 to 15,000 every hour. TV correspondent James Schofield said that the day after his arrival in Goma, "We awoke early to the news that 350,000 refugees had crossed the border overnight." It was, said *U.S. News*, the "refugee flight of the century," the most rapid exodus of such large numbers of refugees in recorded history. Carole Simpson on ABC reported on Sunday the 17th that "A staggering one million refugees from the bloodbath in Rwanda crossed the border into Zaire today, creating a scene of death amid the chaos. When machine gunfire filled the air over the border city of Goma, terror gripped the fleeing refugees and they began to stampede across the border. Up to 50 people, most of them children, were trampled to death." The new exodus to a desolate place, in the lee of an active volcano, covered in volcanic rock, too hard in which to dig latrines, too hard in which to bury the dead, made the late April–early May refugee flight look small.[207]

For the journalists, the refugee crises, first in early May and more especially in mid-July, were easy to cover. Dozens of daily relief flights flew into Goma, for example, and the drama and tragedy were all around: the relief workers overwhelmed by the numbers of the needy, the dead and the dying, the soldiers bulldozing mass graves. "Journalists poured in," said Donatella Lorch, "from small-town newspapers in the U.S., Canada, Europe, Australia, New Zealand, and Japan to multiple television crews from every known network and nation." "There are two television images that stand out in my mind," Lorch remembered. "One showed Rwandans dying somewhere near Goma. The camera then panned out toward 10 other cameras surrounding and filming the dying. The other showed an American correspondent giving her stand-up to the camera. In the background filthy refugees wandered about or lay in the dirt. She was immaculately dressed in pressed khaki pants and jacket with makeup and lipstick."[208]

Then on July 20, doctors confirmed an outbreak of at least 120 cases of cholera in the Goma camp. One day later, Peter Jennings began the evening's broadcast with these words: "Mounting tragedy in Rwanda—cholera took a thousand lives today. What can the world do to help? Why can't the world do more?" The next day, the epidemic was taking "one life a minute," Jennings reminded viewers twice in his broadcast. President Clinton addressed the nation that morning, calling the situation in the Goma camp "what could be the world's worst humanitarian crisis in a generation." He recapped the minimal aid that the United States had sent to the region since May, and then announced that "Today I have ordered an immediate massive increase in our efforts in the region in support of an appeal from the United Nations High Commissioner for Refugees." "Our aim," he said, "is to move food, medicine and other supplies. . . . [and] to establish a safe water supply." The operation would be "in excess of $100 million," with "modest commitments of American manpower."[209]

In line with previous administrations, Clinton ignored Rwanda when it carried too high a cost. "U.S. officials now talk about the 'mom test' in deciding where U.S. troops should be deployed," noted *Boston Globe* reporter Tom Ashbrook a year later. "Will it be a mission that soldiers' parents can accept as worthy of their child's sacrifice? It is a hard test to pass." "When to intervene?" asked Victor LeVine, in the *St. Louis Post-Dispatch*. "Perhaps, the world is really suffering from compassion fatigue, or we simply care less, because sad to say, the answer is increasingly, 'Only when it is politically safe to do so.'" "Somalia showed just how difficult and dangerous the mission of saving a country can be," said Robert Oakley, the Clinton administrations' former special envoy to Somalia, one week after the Rwandan genocide began. "The international community

is not disposed to deploying 20, 40, 60,000 military forces each time there is an internal crisis in a failed state."[210]

The humanitarian crisis of Goma was so much easier to respond to than the military and political crisis inside Rwanda—and no matter that among the refugees were many thousands who had taken part in the genocide. "Having done little to stop the genocide, the international community," observed Donatella Lorch, "poured millions into humanitarian aid for the refugee camps, inadvertently (but also fully aware that they were) feeding the Rwandan militias." The media were partly at fault. "All too often," said Lorch, "television in particular, would forget to remind its viewers that the refugees were not fleeing the massacres. In fact, many of those fleeing had participated in the killings or were just escaping, gripped by the fear of rebel retribution. If the massacres had never happened, there would not have been a refugee exodus."[211]

That weekend Sam Donaldson questioned Secretary of State Warren Christopher about the American response to the situation in Rwanda. "You're saying, Mr. Secretary," demanded Donaldson, "that as long as the Rwandans were killing each other in Rwanda, we didn't have any business going in there and helping them. The moment they crossed the border into Zaire and started dying of cholera, though, that was when we decided that we had some responsibility?" "A very mysterious plane crash," said Christopher, "produced a tremendous civil war within the country. The United States did all that they could to try to support the UN at that time to encourage the end of that civil war. But that was not a time for the United States to try to intervene in that civil war. It was a bloody, fighting war. The situation changed dramatically just 10 days ago when a million people began crossing that border and I think the United States' response after that tremendous exodus, an exodus that history probably has never had a comparable one in years and years—I think the United States' response has been very good."[212] The Clinton administration's spin doctoring was in full force: The war, according to Christopher, was a "civil war," not genocide, and the U.S. did "all that they could" to support the U.N.—not clamor for a complete withdrawal of the U.N. forces back in April. The U.S. humanitarian efforts were fodder for American television sets.

Within two days of the outbreak of cholera 7,000 to 8,000 people had died. Cholera had killed 95 percent of its victims. By July 25, 14,000 had died. The next day Operation Hope began. The Clinton administration announced that some of the American troops would go into Rwanda itself to coordinate the shipment of relief supplies and the first 38 planes unloaded tons of food and medicine and gear in Goma. On July 30, the first U.S. soldiers were deployed in Kigali. On August 7, Joint Chiefs of Staff Chair General John Shalikashvili and

the wife of the vice president, Tipper Gore, visited Goma. By then, five percent of the refugee population had died, upward of 50,000 people.[213]

The greater coverage of the cholera epidemic and the exponentially rising death toll obscured the fact that there were at best only one-tenth the number of victims of the epidemic as there were of the genocide. "However great the suffering in the camps in Goma," wrote James Schofield, "it was as nothing compared with the terror and the horror of the genocide. But it was Goma, not the genocide, that moved the international community to action. . . . Many journalists, myself included, found themselves anguished and dismayed that this was so."[214]

Lorch took away two lessons from her time covering both Rwandan crises: "News coverage should not be in competition for the largest, most horrible event. The magnitude of both the massacres and the cholera was appalling. But it was the responsibility of the editors and their reporters to constantly remind the public of the connection between the genocide and the epidemic."[215]

On August 9, *Nightline* did its wrap-up piece on the crisis. Ted Koppel summed up the situation in his opening remarks:

> Maybe it's a natural outgrowth of the age of television but we do prefer to keep our crises simple, stories with a definable beginning and a predictable end. We like our villains to be foreign and our heroes home-grown. What we do not like are long, open-ended, complicated involvements far from home, in which America's good intentions are misunderstood.
>
> By those standards, we will not much like even our limited involvement in Rwanda. It is one thing to respond with American skill and generosity to a human disaster, fly in the food and the medicine, build the roads, set up the water purification plants. But at that point, our national attention span starts to lag. If people are no longer dying at the rate of 2,000 a day, Rwanda slowly, inevitably, begins moving off our radar screen.[216]

When it was all over, a multinational evaluation project of the media's coverage of Rwanda, called the Joint Evaluation of Emergency Assistance to Rwanda, found that the American television networks' coverage of the genocide trailed far behind their coverage of the O. J. Simpson trial, Bosnia, South Africa and Haiti. Rwanda only outpaced the other stories during the cholera epidemic and the American relief effort in late July and early August. The Joint Evaluation report did acknowledge, however, that the early coverage had been handicapped by "the real danger, the genuine confusion on the ground, the restricted mobility of

the reporters and the inability to fly out photos or videos." But it also observed other failings: of an overuse of the United Nations as a source and of the characterization of the genocide as a result of "tribal anarchy" or of "civil war."[217]

The 1996 report called "The International Response to Conflict and Genocide: Lessons from the Rwanda Experience" also charged that newspapers, including *The New York Times* and the *Times* of London, published "appallingly misleading" stories early in the conflict. The analysts concluded that since the press reports were cited by the United Nations when it withdrew its forces from the country, "the Western media's failure to report adequately on the genocide in Rwanda possibly contributed to international indifference and inaction, and hence the crime itself."[218]

William Dowell, the media correspondent for *Time* magazine noted that "On the Richter scale of human heinousness, Rwanda ranks a clear 10. But beyond the dimensions of the tragedy, what can one say about Rwanda, except that the experience had once again moved the goal posts on human atrocity?"[219] Although in retrospect there was a pretty clear line that could be drawn to distinguish the good guys from the bad guys, for a sizable portion of the three months of genocide that distinction was not clear to outsiders. And in keeping with traditions of objectivity and neutrality, journalists bent over backward to counter the report of a Hutu massacre with a report of an RPF offensive. As with Bosnia, the acts of genocide were described and condemned more thoroughly than were the perpetrators. Although even news articles referred to the "marauding gangs," "mobs," "drunks," "thugs," "animals" and "monsters" who were "armed with machetes, spears, bows and arrows and automatic weapons," these villains were typically not identified as either Hutu or Tutsi. Only by association could a reader tease out that the killers were most likely Hutu, as often the "gangs" of murderers were mentioned in the same breath as "soldiers" who were out on killing sprees—and the soldiers, of course, were Hutu, although that fact was also rarely spelled out.[220]

The notion that what the world was witnessing was in fact a textbook case of genocide came slowly. While a *New York Times* editorial on April 23 declared, "What looks very much like genocide has been taking place in Rwanda. People are pulled from cars and buses, ordered to show their identity papers and then killed on the spot if they belong to the wrong ethnic group." CNN took a month longer to say—in Gary Strieker's words, "this was actually a planned and premeditated type of genocide." The word "genocide" had been thrown around even early on, as it often is when massacres are discovered. But the recognition that the Hutu interim government had meticulously organized and abetted the

mass murder took a while. Only after reporters grasped that there was a close relationship between the Rwandan army and the militia groups who were doing much of the killing in Kigali, did they understand that the slaughter had the blessing of the state.[221]

During the first stage of the crisis, the chief word used to signal the horror of the slaughter was "blood." All the media, newspapers, magazines and television, drenched their stories in bloody imagery. To give just a few examples: Americans were fleeing "blood-soaked Rwanda"; Hutu radio broadcasts are "bloodthirsty"; Hutus launched a "bloody campaign of 'ethnic cleansing'"; a "continuing bloodbath" may have claimed as many as 500,000 dead and a "hemorrhaging of intertribal hostilities" has Rwanda "awash with blood."

Other grand metaphors described Rwanda in Old and New Testament terms. Journalists called the carnage "a human tragedy of biblical proportions," compared the massacres with the story of King Herod's "slaughter of the innocents" and characterized the refugee flight into Tanzania as "an exodus of biblical sweep."[222]

But by mid-May and the recognition of the genocide, the dominant comparison was to the Holocaust. There were other metaphorical references as well, simple references such as "nightmare," "time bomb" and "human doomsday device," or historical references, such as Cambodia's killing fields, the Jonestown suicides or the Cherokee nation's "trail of tears." But the image of the Holocaust and the Nazis predominated. Sometimes the allusions were in the descriptions—of bodies "stacked like cordwood," for instance—but often the metaphor was used directly: as with the simple headline in *The Rocky Mountain News*: "Hutu Holocaust: Rwanda's Ethnic 'Final Solution'"; or "This can only be compared to what the Nazis did," in an *L.A. Times* news story.[223]

Journalists paralleling of the Rwandan slaughter with the Holocaust, was, in this instance, not simply a reflexive act triggered by the use of the word genocide. The instinct to apply the Holocaust metaphor was heightened by the fact that several of the journalists who prominently covered the genocide, such as Catherine Bond, had recently seen *Schindler's List*. The killings in Rwanda just happened to occur one month after Spielberg's movie won at the Oscars and the same month as the first anniversary of the Holocaust Memorial Museum in Washington, D.C. "If there's such a thing as a good year for the Holocaust—as measured by a bull market in public awareness—this is it," wrote *New York Times* columnist Frank Rich.[224]

But as with the Bosnian situation, the choice of metaphors often signaled a political stance: What does this crisis mean for the United States? Journalists never lost sight of the American angle to the story. Rwanda may have, as Ted

Koppel put it, "no natural resources to speak of, no strategic value to the rest of the world, and just for good measure, it has been ravaged by AIDS. There is, in other words, not a single practical reason why the United States should become involved, no reason at all, in fact, beyond simple humanity." But the simple human angle was enough to start the debate over engagement. Drawing on the iconic image from the Oklahoma bombing of the federal building, political cartoonist Walt Handelsman drew a field of bodies, indistinguishable one from the other, except for a single baby cradled in the arms of a firefighter, the word "Rwanda" written on his helmet.[225]

If during the debate over whether Americans should become involved after the discovery of the Serb "death camps" pro-interventionists mentioned World War II analogies and anti-interventionists raised the specter of the Vietnam quagmire, during the discussion of what to do about Rwanda, those who demanded U.S. action recollected the Nazis and the Holocaust, and those who counseled minding "our" own business brought up Somalia. As NPR commentator Daniel Schorr noted, Rwanda "is for American policy makers Somalia multiplied, where no good deed is likely to go unpunished. Were it not for the Somalia fiasco, the Clinton administration might be more inclined to get involved in Rwanda, but how do you rate the holocaust in Africa on the scale of pragmatic national interest that the Clinton administration has been trying to devise for itself?"[226]

Only when the genocide had ended and the "humanitarian" refugee crisis had begun were references to Somalia set aside—and in their place references to the "successful" Kurdish relief operation in the wake of the Persian Gulf War.[227]

The breaking-news coverage of the Rwanda genocide was not like that of the Ethiopian famine or the Bosnian death camps. Rwanda did not come to the attention of the mass of Americans because of a single powerful report seen on television. It crept up on them, so, only gradually, over a period of weeks and even months did Americans realize that some extraordinary horror was occurring.

But Rwanda did share some similarities with the Ethiopian saga. Unlike Bosnia, when few new indicting images emerged from the death camps after the first shocking photos of the emaciated men behind the barbed wire, Rwanda kept pumping out new pictures of the horrors. "Ethiopia was similar to Rwanda today," said Mohammed Amin, the cameraman who took the pivotal images of the 1980s famine, "in that the pictures create the demand for more pictures and the news coverage feeds on itself as more journalists write more stories that end up eliciting a response from the United Nations or whomever. But I think it's

quite possible that if there hadn't been such vivid pictures from Rwanda early on, the massacre might have gone largely unreported."[228]

The media was primed for drama and gore. During the first week after the downing of the president's plane, Peter Jennings introduced a segment from Rwanda with a tale about the photographer who had made the videotape. "Our cameraman, who spent this terrifying week in Rwanda," said Jennings, "has just made it out with his pictures to nearby Kenya." Then Ron Allen, in a voice-over to the images, described what was on the tape. "Belgian UN peacekeepers shot their way out of Kigali today. Ducking for their lives were several missionaries; some of the last foreigners to escape. The photographer was so close to the shooting he now has trouble hearing." Two days later, a CNN interview of a newly evacuated staff member of Médecins Sans Frontières pumped him for tragedy: "Did you hear stories of any Europeans being killed?" "Did you hear of any other stories that especially affected you?"[229]

Tired of the bodies tossed by the roadside? Take a look at the bodies bloating in the rivers. Tired of the bodies in the rivers? Take a look at the bodies decomposing in a churchyard. The permutations were endless. And the graphic portrayal of horror, like the acts themselves, was ratcheted increasingly higher. As Ted Koppel said in his lead-in voice-over to *Nightline*, "The horrific pictures, they come into your living room, leaving nothing but questions of how far humanity can sink, of how irreparable the damage is that's been done, of whether the world could and should help. . . . Tonight, Rwanda: The New Killing Fields."[230]

Most of the most dramatic images appeared on television or in the glossy pages of the newsmagazines. But a few of the grimly spectacular ones were featured in the papers. "I saw a picture on the front page of *The New York Times* this morning of bodies strewn all over the place," said CNN host Mary Tillotson on April 12, "and I do think it's worth a thousand words." Senator John McCain (R-AZ) saw the same Reuters image and it prompted him to ask, "Whose responsibility is that? And what can we do that's effective?" *The Washington Post* ran a large aerial photograph of the stream of refugees pouring down a road into Tanzania in early May. For its readers who had grown up on a diet of aerial shots of demonstrations at the Lincoln Memorial and who had thought those photos showed a dense crowd, this image was a revelation. It looked more like a picture taken through a high-powered microscope of millions of tiny blood cells jammed so tightly in an artery that the walls had burst, leaking them out into the surrounding tissue. (Other papers ran photos of equally impenetrable crowds of refugees—but from more conventional angles.)[231]

By the end of April, and the dawning of the realization that the massacres constituted genocide, the media had pulled out all the stops. ABC anchor Forrest Sawyer announced that "there are new pictures from Rwanda which show all too clearly the horror after three weeks of bloodshed. What you're about to see is not easy to look at," he warned. In their April 25 issues, *Time* and *Newsweek* both ran large photographs across their opening spreads of bodies collapsed in bloody heaps on the sidewalks of Kigali. *Time*'s image, taken by Bernard del Entree, gained its force from the three rivulets of brilliant red blood pooling at the feet of the victims. *Newsweek*'s image, taken by Liz Gilbert, achieved its effect from the blur of the subjects. The photo had evidently been snapped through the window of a moving car—causing the viewer to wonder not only about the deaths of the Rwandans in the frame, but the safety of the photographer who had taken the picture.[232]

Then beginning in early May Americans saw virtually identical images of the bloated bodies floating down the rivers and collecting in miserable clots in eddies and at the base of waterfalls. On the front page of *The New York Times*, in *Time*, on the networks and CNN, the pictures were shown accompanied by descriptions of the "appalling sight" and the "gagging stench." The accompanying story in *The Times* told that the bodies had been "carried by the current for weeks" and must have been dumped by the killers "by the truckload." "Many are mutilated," the story quoted the head of the Ugandan clean-up operation as saying. "Children are skewered on sticks. I saw a woman cut open from the tail bone. They have removed breasts and male genital organs." *The Times* ran those descriptions centered, above the fold on its front page—not on the jump.[233]

Newsweek, which didn't run an image of the bodies in the river, did publish a "photo journal" on two pages of its May 9 issue, with one photograph, prominently placed on the lower right-hand page, a close-up of a dead woman, taken from behind her. Her arms are tied behind her back by a crude rope cinching her elbows together. She is lying in the hot sun and her skin has ballooned such that her arms and especially her hands look plastic, like the obscene features of a blowup doll. It is difficult to look at the image even long enough to read the caption stating that the "woman's arms were bound before she was killed." The reader who does linger long enough to consider the image can only be grateful that the photograph that was reproduced depicted the woman from behind.[234]

Television too upped the ante of explicitness. "ABC News has just obtained new pictures which capture the horror of the civil war that has already taken more than 100,000 lives," announced Diane Sawyer on May 6. "The pictures were taken this week . . . by an officer working for the United Nations so that the world can see what's going on." And then the audience was shown a victim

suffering from a shrapnel wound that partially severed the Achilles tendon, another man whose "skin was burned off when a grenade exploded in his home," and "a special area" where the people were "singled out and butchered, even the children."[235]

The grim images continued through June. ABC's Renee Poussaint did a voice-over of the "graphic pictures" of a massacre in Nayatamah, "where 130,000 Tutsis used to live; 100,000 of them have been killed. Inside this church, beneath the colorful clothing," she said, "lie the bodies of 500 men, women and children; all killed by members of the Hutu militia. The men who did the killing and maiming here went after everyone, no matter how young."[236]

For three months the photographs and videotape of the genocide were unrelenting. The photographic carnage was surely not as extreme as what was described in the text of stories and the tales told by the television reporters. Ted Koppel admitted, "Cameras have their limitations. They cannot capture a thickness in the air, or the sense of claustrophobia that comes with being surrounded by death." But it was more extreme than Americans had ever witnessed before in the pages of mainstream publications and on the network evening news programs.[237] Other pictures than of bodies or of bandaged survivors did appear—of the fleeing expatriates, of the advancing rebel soldiers, of the masses of refugees, but the images of the bodies were what commanded attention.

So it was almost a relief for Americans at home when the massive exodus began in July and cholera broke out. The scale of the misery was unprecedented, but the details were recognizable from previous disasters. When the media turned to Goma, Americans could look at Rwanda again. They could care again, because the disaster was familiar. These problems—of disease, sanitation, water and food—had time-tested solutions. But what could any individual do about a nation full of sadistic butchers? As *Time* magazine put it, "The horrifying slaughter is another explosion in a mainly ethnically based civil war that outsiders understand imperfectly if at all—and therefore do not know how to solve."[238] Americans weren't naive enough to think that their five dollars sent to Oxfam would rescue a child trapped by genocidal killers. It might however buy a refugee child a blanket.

Journalists suffered overload in Rwanda—in Goma, but more especially during the genocide in Kigali. "For the first time ever in my journalistic career," British reporter Richard Dowden told CNN, "I came out of Rwanda and actually did not want to write what I had seen. I felt, does the world really need to know about what I had experienced there." He described the scenes he had witnessed. "You have this dreadful smell of rotting flesh and then you see the bodies and it

is that in every single village. . . . There are stories of people surviving under piles of three or four bodies and survivors crawling out hours afterwards. And even one place where there was a dead mother and the baby still trying to suckle its mother's breast, three days after the mother died. I mean, these sort of absolutely unspeakable images." And reporter John Sweeny believed it was even worse for the photojournalists. "A writer can stand back," he said, and "observe the scene without being a part of it. Physically you don't have to get that close. For a photographer to capture the agony of a split second, he/she has to be right there, staring at it down the lens."[239]

The public at home suffered from overload, too, but of a different sort. "Every time I returned . . . from Rwanda and Zaire, friends asked me: 'What was it like? Horrible?' and then changed the subject before I had time to answer," remembered reporter Janine DiGiovanni. "I watched their eyes glaze over, and I can't blame them, because hellholes are a bore, and there are a limited number of ways you can describe death and destruction."[240] But why did people respond that way? Was it because the extreme horror of the genocide defied comprehension and rational explanation—and therefore, perhaps, compassion? Did the turning aside of Americans, the not wanting to see any more pictures on our television screens or in our print periodicals—or the not wanting to see them quite so large, not so much in our faces—mean that we stopped caring? Did we become emotionally anaesthetized? Or did we find the situation so beyond our understanding and so hopeless that we just didn't want to think about it anymore?

If those within our own community were slaughtered and our own family along with them, we would, of course, care mightily. Even if we felt hopeless. Well, compassion fatigue is a way of explaining why we do not care about others as much as we do about ourselves. Through various means, journalists try to make us care about those distant others by making them into our neighbors—by Americanizing the events in various ways, by individualizing the stories, by bringing the images into our living rooms. But their efforts don't quite work. In fact, according to many, the symptoms of compassion fatigue are getting worse.

"It wasn't too long ago," wrote Richard O'Mara in *The Baltimore Sun*, "that the face of an African child, frightened and hungry, could draw out the sympathies of people in the richer countries and, more importantly, stimulate a reflex toward rescue. That face became emblematic of the 1980s. But with all symbols it soon lost its human dimension, its link to the actual flesh-and-blood child. Now that face stirs fewer people. The child has fallen victim again, this time to a syndrome described as 'compassion fatigue.'"[241]

Ted Koppel concluded that "the world is suffering from a form of overload, from what the Secretary-General of the United Nations described to me today as

'donor fatigue.' It is, on a global scale, the way some of us city dwellers feel when we're approached by what sometimes seems like a never-ending succession of street people." He iterated the laundry list of bleeding countries: the former Yugoslavia, East Timor, South Africa, Angola, Burundi, Tajikistan, Nagorno-Karabakh. "Rwanda," he reflected, "which has had more deaths in a shorter period of time than anywhere, and whose refugees are more numerous and desperate than most, has the misfortune of coming at the tail end of a particularly noxious stretch of history."[242]

By Rwanda, compassion fatigue was even striking communities formerly renowned for leading efforts to bring relief, such as the recording industry superstars who had been so engaged in Band Aid and Live Aid. A group of artists known as Music Relief and the country mother and daughter duo, the Judds, both recorded singles while others planned a concert to raise money for the Rwandan refugees. But Peter Cunnah, the D:Ream frontman who took part in the recording of the Marvin Gaye classic, "What's Going On?" for Music Relief, said he believed the "big names in pop are suffering from 'charity fatigue.' I was disappointed at the turnout for the recording session," he said. "There is a lot of apathy around."[243]

Church groups too were seeing a lessening of interest in charity. "Give a dollar. Say a prayer. Brush up on your knowledge about Africa. Those are some recommendations being made as churches around the world are being called to a 'Day of Prayer and Healing for Rwanda' next Sunday." It all was, *The Fresno Bee* reported, an effort by the National Council of Churches of Christ in the USA and the All-Africa Council of Churches to thwart their congregations falling into "compassion fatigue from a recurring sense of crisis in a little-known region of the world."[244]

But once the stories of cholera among the refugees hit the television screens, appeals for aid immediately received an outpouring of funds. "During the past few weeks, a debate has been raging within the aid community about donor fatigue. Were Americans tired? Will Americans respond to yet another crisis in Africa?" Peggy Connolly of Oxfam said. Certainly they weren't responding to the news of the genocide. Knight-Ridder conducted interviews with officials from ten U.S.-based relief agencies with operations in Rwanda and found that "donations have skyrocketed since the focus of the disaster switched from civil war and genocide to the plight of stranded refugees and children suffering from disease and starvation." The response, said Connolly, proves that "the capacity of the American people to care for other people around the world is still great. Rwanda was the litmus test for donor fatigue and the American people have passed. It demonstrates that when the American people see a problem that has a

solution, where they can see their money doing some real good, they will respond."[245]

From the moment the epidemic began in mid-July to the end of the month, 15 of the largest relief groups with operations in Rwanda raised $39.4 million, $35 million of that in corporate donations. "Exposure and publicity" were the key, said Willis Logan, Africa director of Church World Service, the National Council of Churches' relief wing. "To have your name splashed across the television screen for a few seconds can be worth millions of dollars." Donor response, said officials, "has been almost directly proportional to the amount of television and newspaper coverage." Médecins Sans Frontières found that out when shortly after one of their physicians appeared on one of the network news programs, a bartender in Alaska called the organization to say that his patrons had just collected $9,000 for the doctors. And Oxfam American began receiving seven sacks of mail daily, up from its normal level of a half a sack a day.[246]

What had happened during the coverage of the genocide was in hindsight less compassion fatigue, and more compassion avoidance. The public flinched when confronted with the images of putrefying corpses or swollen bodies bobbing along river banks. They looked away—even when they believed that the story was important. A reader from Cedar Crest, New Mexico, wrote in to *Newsweek* magazine after it published a one-and-a-half page black-and-white photo by Magnum photographer Gilles Peress of a decomposing corpse as the opening spread in a three-page article. "You wouldn't publish some obscenities, however common or benign the usage or print photos of a healthy, naked human body—yet you think it's appropriate that I be shocked nearly to the point of vomiting by a full-spread, close-up photo of the hideous corpse of a Rwandan civil-war victim," complained Jefferson White. "I support your right to publish what you wish, and it may be necessary to display such an image. But you might have featured it less prominently and on a smaller scale."[247]

Americans could rise to the occasion of the epidemic of cholera. They could help heal the sick and feed the hungry. But they did not know what to do in the face of evil. So they did very little. And because they did very little, they did not want to confront, at least up close and personal, what they were avoiding.

By contrast, the media—or at least some in the media—knew what to do. The task of a journalist when confronted by evil is to bear witness, to ensure that the genocide of Rwanda "should not," as Donatella Lorch affirmed, "be forgotten, misunderstood, or misinterpreted."[248] If "Never again" is to have any meaning at all, there must be those who carry history forward, who teach others what happened, who remember, who do not flinch.

BBC reporter Fergal Keane's passionate documentary on the Rwandan genocide for *Frontline* called "Valentina's Nightmare," traced the traumas of a 13-year-old girl named Valentina Iribagiza, who suffered machete wounds on her head and hands, and who alone among her family had survived a massacre by hiding in a church among the corpses of relatives and friends. "Valentina's nightmare happened in our world and in our time," Keane said in the documentary, "and those who might have helped to stop it looked the other way."[249] Keane did not look away.

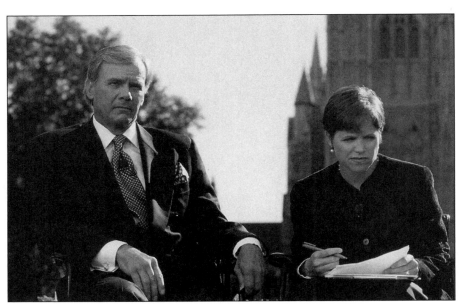

"Winners and Losers in Story of the Year," *TV Guide,* 20–26 September 1997
"NBC's Tom Brokaw, Katie Couric: Audiences crown victors with ratings laurels and decide who best covered the death of the princess."

CONCLUSION

The images rush into our lives: a terrified Bosnian orphan behind a bullet-riddled bus window, a desperate Somalian mother and her stick-thin starving child.

Tragedies everywhere, filling the newspaper pages and television screens.

Our hearts and minds struggle like a frantic war-zone doctor in a crowded medical tent as the cries for help inundate us. Which hands reaching out for us shall we take, which shall we pass by?

Should we, who can afford double lattes and extravagant air shows by the Blue Angels, help everyone? Or should we—personally and nationally—perform ethical and psychological triage, deciding which victims of human suffering we will help, which we will ignore?

Or should we just give in to the impulse to succumb to "compassion fatigue" and pull the all-cotton premium goosedown covers over our heads?

—Carol Ostrom
"Our Struggle with Our Hearts,"
The Seattle Times, August 10, 1992

Through a simple twist of fate, Mother Teresa, the saint of Calcutta, died the same week as Diana, Princess of Wales. On the evening news that week of September 1, 1997 the networks devoted a total of 197 minutes to the death of Princess Diana. That same week they devoted a total of 16 minutes to the death of Mother Teresa.[1]

Howard Stern, self-styled cultural critic, castigated the media for "shafting" Mother Teresa. But, noted *Newsweek*'s Jonathan Alter, "this wasn't strictly true. Had she died in a different news cycle than Diana, Teresa would have received respectful coverage but nothing close to what she got last week. . . . there's no doubt that Mother Teresa's legacy . . . got a cosmic boost from the shame felt at

hyping an adulterous princess over a living saint." "Life seldom linked Mother
Teresa, 87, and Princess Diana, 36, despite a much-reproduced photograph of
their last meeting, earlier this year," noted *Life* magazine's story on the two
deaths. "But an accident of timing links them in death. Rarely had the founder
of the Missionaries of Charity seemed so much a celebrity, or the Princess of
Wales so saintly. Comparisons that would otherwise never have occurred sud-
denly felt inevitable."[2]

But certainly in that media deemed elite, and even more so in the tabloid
outlets, Diana received the lion's share of the news coverage. Might Mother
Teresa be a topic on the Geraldo Rivera show on NBC's cable channel? "Only if
she had been run over by Prince Charles," replied Steve North, the producer of
the program.[3]

The death of Princess Diana was a great story. It fit every definition of news.
"Actually"—wrote Joan Konner, publisher of the *Columbia Journalism Review*,
"the death of 'the people's princess' is the *ideal* story, born in fantasy and ending
abruptly in brutal fact." From her fairy-tale wedding to her nightmare marriage
and struggle for self, from her activism on behalf of charitable causes to her
death by a drunk driver trying to outspeed the motorcycle-riding paparazzi, it all
added up to "the stuff of ledes and legends." Treating the story as news wasn't a
problem. It was news. Big news. Big, money-making news. "It would be childish
to be shocked—shocked!—to find that the media made a lot of money off
Diana's death," observed essayist Lance Morrow. "After all, *Life* made a lot of
money covering World War II."[4]

But it wasn't the only news story that Labor Day week. In covering Diana's
death the media lost all sense of proportion; their overkill made it appear as if
nothing else of moment happened anywhere else in the world. In the early days
after the crash *Good Morning America* reporter Sheila MacVicar asked a British
matron how she felt. "Terribly, terribly sad," she said. "I watched television for
20 hours yesterday." The media and especially television became part of the
Diana phenomenon. "It was a tribute to the medium's power," noted Susan
Stewart in *TV Guide*, "that Diana's death, which at first seemed a sudden, tragic
accident, had by week's end attained the standing of destiny unfolding before
our eyes."[5] The ubiquity of coverage, the fact that a British matron—or an Amer-
ican or Asian or African one, for that matter—could turn on the television and
find all-day and all-night coverage of the Diana story was not evidence of good,
responsible journalism.

"The foundation of compassion fatigue," noted former CBS News producer
and vice president Peter Herford, "is overload, isn't it? The confluence of the

commercial imperative of news as a profitable vehicle and the need to fill up the pages, the minutes, the hours, the round-the-clock live coverage to satisfy what? Our innate curiosity?"[6] Dozens of TV commentators of varying degrees of expertise talked nonstop to fill the airtime on the networks' morning wake-up shows, their evening news programs and their nighttime magazine shows in that week between Diana's death and burial. "Joan Lunden and Kathie Lee Gifford both suggested the U.S. Constitution be rewritten to allow celebrities their pursuit of happiness. Gifford was particularly passionate" in this regard, commented Susan Stewart dryly.[7]

In the case of Diana's death—like that of Sadat or Rabin or Gandhi or Zia—the death-to-funeral schedule defined the parameters of the media's coverage. The media's blitz made the neatest package anyone could want. It had a clear beginning, middle and end. But there wasn't enough information to fill up the endless hours in the week. "The continuing story was the accident," commented Herford. "The finite story was the death and funeral. But most of the anchors spoke with as much authority about the accident as they did about the funeral schedule. The problem was that like all accident investigations, this one would take a while—longer than most—before we had a clue what really happened. Yet that sense of a continuing story did not come through clearly. . . . We speculated on the causes within milliseconds of the crash. And there wasn't any justification for that other than the natural curiosity of wanting to know the unknowable—and editors' hypersensitivity to compassion fatigue." The editors and producers knew that they had a week to bring the story in. "Either the story gets told in that time frame," said Herford, "or forget it. And when it comes to bringing the story back months later or a year later. . . . well, forget it pal."[8] As early as mid-September, a *Wall Street Journal*/NBC News poll of more than 2,000 people suggested that the editors and producers were correct in their assessment that they had to bring the story in quickly. Fifty-six percent of the respondents thought there had already been too much coverage of Diana's death.

The workings of the marketplace are often cited as a reason for why the media act as they do. The media try to anticipate the wishes of their audience. Since the media is driven by the profit motive, said John Ruggie, former dean of Columbia University's School of International and Public Affairs, they "cover what the editors think that their audience is interested in." And they don't cover what they think their audience will be bored by. Does a story have "sizzle"? asked Marvin Kalb, former foreign correspondent and currently the director of the Joan Shorenstein Center on the Press, Politics and Public Policy at Harvard. Does it

deal with a topic that will stir the emotions, such as a riot, a hijacking, a disaster or a famine? Are U.S. troops involved? If the answer is yes, coverage is likely.[9]

Even the tracking of what the president says, contended former anchor Robert MacNeil, is a marketplace concern. The president, said MacNeil, "is like the chief passenger on a cruise ship. When he goes to the rail and points at something, that's interesting for the rest of the passengers."[10]

But perhaps the clearest example of the marketplace driving coverage, some argue, is the Princess Di phenomenon, the ubiquity of personality journalism. As newspaperman James Hoge, Jr., noted, "If the death and funeral of Princess Diana were the appropriate indicator, there is no dearth of foreign news in American media." But, he corrected, "the story of Diana, of course, was not foreign news. Rather it was a compelling human-interest tale of the tangled life, shocking death, and ceremonial funeral of the best-known celebrity in the world that happened to take place abroad."[11]

The public's fascination with the stars of Hollywood and politics, its seemingly insatiable appetite for even the most trivial private information is cited as the reason for the push toward entertainment-oriented reports—and for why the "paparazzi" hound celebrities. Since there was no detectable compassion fatigue for stories about Princess Diana in the years leading up to her death, for example, the "paparazzi" (and all the media that bought their images) felt legitimated in their pursuit of her. Hey, if the public had a problem with their style of coverage, said some within the media after Princess Diana's demise, they could have stopped buying magazines or watching tabloid news shows with her pictures in them.

As that contention blatantly argues, and as the rationale for following the audience's interest in the coverage of international affairs more subtly suggests, democracy rules. Let the people dictate coverage. Let the people decide.

And according to many within the industry, the people have decided—they don't want to hear about international events, but if a compelling event surfaces, it should be reported as expeditiously as possible, with efforts made to Americanize the event and to represent it with graphic images and vivid language. Even so, Maynard Parker, the editor of *Newsweek* said that featuring a foreign subject on the newsmagazine's cover results in a 25 percent drop in newsstand sales. Mortimer Zuckerman, the editor in chief of *U.S. News* agreed. "The poorest-selling covers of the year are always those on international news." As a result of such observations the space devoted to international news has shrunk in all three newsweeklies in the decade from 1985 to 1995, from 20 to 24 percent of the publications to 12 to 14 percent. The networks have also posted a 72 percent

drop in the amount of time they devote to foreign news—from 45 percent of their newscasts in the 1970s to 13.5 percent by 1995.[12]

The media's agenda-setters defend this decline by arguing that since the mid-1980s, "Week in and week out, international news has been a bit less urgent," as Walter Isaacson, the managing editor of *Time* put it. The world is currently less frightening to Americans, this argument goes. International economic news, while directly connected to American jobs and trade, just doesn't prompt as much interest as security threats. And the other types of international news, such as regional conflicts or diplomatic affairs, for example, are just too confusing and seemingly without sufficient direct significance for an American audience. A recent report by the Pew Research Center for the People and the Press summarized the trend: "most Americans fundamentally doubt the relevance of international events to their own lives. . . . Majorities of varying sizes say events in Europe, Asia, Mexico and Canada have little or no impact on them. Similarly large majorities say the news media carries about the right amount of foreign news." So the shifting news agenda away from security concerns is blamed by the media for the public's lack of interest in news from abroad—and the media's concommitant lack of attention to it.[13]

But by such behavior, the media abdicate responsibility in the forum where they are privileged with the greatest access and the most information. They could, they should arrest the decline in both media coverage and audience interest. To do so they need to address the causes of compassion fatigue. Compassion fatigue, and even more clearly, compassion avoidance are signals that the coverage of international affairs must change.

These are some of the lessons of compassion fatigue:

1. The formulaic coverage of crises, the if-it's-Tuesday-it's-time-to-wrap-this-all-up coverage of deaths and assassinations, for instance, shoehorns crises into a preordained time slot, ignoring the inevitable slop of a crisis beyond its formulaic moments. Few crises, and certainly not an assassination of a national leader, are over and done with within a week. Why should the coverage of the crisis last for a shorter span of time than the crisis itself? The media should commit to covering international affairs as they cover domestic crime. If they report on the arrest of a suspect, they have an ethical responsibility to follow up and report on the outcome of that arrest. Was there a plea bargain or a trial? Was the defendant found innocent or guilty? Too often the media cover an international crisis as they would a dramatic incident like an arrest, but then the story is dropped, and

the public never learns whether the victim survived or whether the suspect arrested was really the person responsible.

The media also too infrequently revisit stories six months or even six years later. "It is rarely done," admitted former NBC News president Bill Small, "but whenever it is, one finds insights in the follow-up, and, often, the discovery that the original story was either wrong or lacked vital ingredients that the follow-up discovers."[14]

And there's another problem with formulaic coverage. It levels the particularities and anomalies of each crisis into a uniform Ur history and pigeonholes all situations into a good guy-bad guy dichotomy. "How many starving orphans are you going to have?" asked media analyst Ellen Hume on CNN. "The captions of the pictures are getting to be almost interchangeable." "Rwanda, Bosnia, Sarajevo, Haiti. Does the media cover death the same way?" wondered CNN anchor Bernard Kalb. "You know," admitted Scripps Howard correspondent Martin Schram, "we really do try to cover it the same way."[15] Of all the bad habits of media coverage that lead to compassion fatigue, the stereotyping of crises is one of the easiest to correct. The media shouldn't simplify the causes and streamline the protagonists and antagonists to accord with an Oliver Stone screenplay.

News shouldn't be marketed as a product. Journalism should not come off a storyboard or out of a PR kit. Yet news as packaged by the mega-conglomerates tends toward the familiar. And when the "familiar" news is passed off as the real thing, readers and viewers mutiny. They stop reading, they stop watching. Market-focused journalism, argued Tom Rosenstiel, a former media critic for the *Los Angeles Times,* has always failed. "The models for success in journalism, even recently, are not grounded in giving up editorial independence for a market-driven approach to news." "Why, then," he asked, "do journalism companies creep toward a marketing vision? In part because technology, changing economics and an increasingly fragmented society are causing audiences for traditional news to shrivel. The natural business reaction is to market." But "in the end," he concluded, "what journalism companies are selling is their authority as a public asset. And that depends, especially with an ever more skeptical public, on proving you're in it for more than a buck."[16] Proving that means covering the news that people can't get anywhere else—and covering it as truthfully and thoughtfully as possible.

As disasters multiply and compassion runs thin, it only becomes more important to report the news conscientiously, to distinguish among the crises. "The grim news looks the same year after year, with only the names and places changing," foreign correspondent Reena Shah noted. But that shouldn't be the case. The disasters all run together in people's minds because they are all covered in

the same way. "Our eyes glaze over," said Shah. "There is a famine now in Somalia that is killing about 5,000 people a day. Last year, there was a famine on a 'biblical' scale in Sudan and Ethiopia. And later this year, there might be a famine in drought-stricken southern Africa if there isn't enough rain. There are ethnic massacres in Bosnia instead of Liberia and Sudan. There is a hurricane in Florida and Louisiana, a giant wave in Nicaragua, a rumbling volcano in the Philippines, flash floods in Pakistan and northern India."[17]

"There is no way we can 'cover' the world," admitted Herford. "Selectivity— editing is still the key. . . . But when a Rwanda happens, and first-class reporters and editors get on the story, then a bang-up job can be done in short order. You do not have to cover the story all the time for people to understand it. You have to know when to raise it to the level of concern. We can background the reader or viewer, catch them up on history if we keep a manageable focus. But by flitting around the world and filling all these great barrels of news, we create compassion fatigue. It's just plain fatigue."[18]

The public may not know where Bosnia is, or which group are the aggressors and which are the victims in Rwanda, but the media has a responsibility to explain why they ought to know—and a responsibility to explain it in such a fashion as will attract the attention of their audience. The origins of compassion fatigue lie in ignorance. It's easy to run a map indicating where Bosnia is or a graphic clarifying who's who in Rwanda. More difficult, more time consuming, more expensive in terms of both money and energy is for the media to show their readers and viewers why they should care about Bosnia and Rwanda. "The greatest threat today to intelligent coverage of foreign news," said Seymour Topping, the former managing editor of *The New York Times*, "is not so much a lack of interest as it is a concentration of ownership that is profit-driven and a lack of inclination to meet responsibilities, except that of the bottom line."[19]

2. The Americanizing of events (once called the "Coca-Colonization" of events) can be a positive force to attract the public's attention to a far-off event, but it should not be the defining characterization of that event. Foreign correspondents and bureau chiefs always look for the American angle as a surer way of getting play for their international stories. But once in play, the Americanization can become a crutch, simplifying a crisis beyond recognition, and certainly beyond understanding. Metaphors, historical allusions and iconic images should be ways into, not ways out of a comprehensive coverage of a crisis. And much of that change has to come from the newsrooms in New York and Washington where there is a tendency to repeat the official spin on stories—like the Bush administration's contention that Bosnia was another Vietnam. As Bill

Small noted, "overseas reporters will begin to ignore the American angle once their bosses back home preach that gospel."

Another limiting factor of coverage is whether an event or country is perceived to be of economic, strategic or even cultural significance to Americans. Americans are already too self-involved. They do not need further encouragement to be interested in what the U.S. troops are up to; but they may need encouragement to learn about crises where American military force is not at issue. As former *New York Times* foreign editor Bernard Gwertzman said, a good writer can find "a good story" in any situation.[20]

One way of finding those other "good stories" is to toss out the news net differently than it has been thrown. Now foreign correspondents are based in those countries and regions where the United States has a history of strategic interests. But foreign correspondents could be more judiciously placed around the globe. "For editorial and financial reasons, television can only 'smother-cover' one zone of crisis at any time," wrote TV diplomatic editor Nik Gowing in 1994. "There are some 30 conflicts world wide—including Sudan, Angola, Tajikistan and Georgia—that are rarely seen on television if at all."[21] The news net doesn't have to operate as a prior restraint on the coverage of certain stories.

Given the fact that the wires and foreign news services already supply much of American media institutions' international news coverage, the U.S. print and broadcast media could stagger their own people more around the world. They could worry less about each placing a major bureau in London, Paris, Tel Aviv and Tokyo and be concerned more with bringing a broader swath of the news home. Since scoring a beat on the competition is rare in the coverage of the developing world because breaking news doesn't typically originate with the American media's own foreign correspondents but with freelancers and the wires and the various European news services, the issue of scoring a beat in Europe and Israel and Japan should be re-evaluated, too. Of course a major story would still trigger a migration of individual correspondents to a country, but the management of quotidian coverage could be spread around.

A second, perhaps more intellectually viable solution in the current climate of newsgathering is the uncomplicated, albeit more expensive resolution of having the media place more bureaus in more cities—have the major print and broadcast media each commit to establishing several permanent bureaus in Africa and Central and South America, for example, as well as in South Asia and elsewhere on the Asian continent.

The media's entrenched news net and news priorities are a chief cause of their neglect of certain events or countries. But sometimes their neglect is due to censorship and the difficulties in gaining access to a region. Yet, as *New York*

Times columnist A. M. Rosenthal wrote back in 1988, even censorship and lack of access do not have to prevent coverage of a sort. "American newspapers and TV news shows carry firsthand accounts of all the important news of the world—except. Except two terrible continuing wars, a famine, a startling insurrection, the occupation of an ancient land and racial brutality as an organized way of government," said Rosenthal, talking about the Iran-Iraq War and the war in Afghanistan, the famine in Ethiopia, the Armenian insurrection, the Chinese destruction of Tibet and apartheid in South Africa.

"Americans take news blackouts abroad for granted now. Nobody even asks what we can do to show we care. There are things to be done, at least to take a moral stance," he continued. "Newspapers and TV cannot fight their way into a country. But they could keep the pressure on by running frequent and prominent reminders to the public of stories they are not permitted to cover."[22] Former TV and wire service president Small agreed. "When doors are shut, that should be reported as a matter of journalistic necessity and public importance." And, Small reminded, the shut doors are not always in other countries. Government and corporate America can also prohibit the media from acting as witness and watchdog. "During the Gulf War," recalled Small, "the press overall—newspapers, television and even their professional societies—were remarkably quiet as the military played the game of news managment to the hilt."[23]

3. More sensational is not necessarily better—although, of course, the most space, the best time slot will always be reserved for the extravagantly sensationalistic. Whether the crisis is a single death or an epidemic, a massacre or a famine, the Ebola/Rwanda/Somalia Standard encourages the sensationalizing of a disaster and unbearably ratchets up the criteria for further coverage. As a result, crises that threaten or even kill many but are not intrinsically horrific—say measles, for example, or the massacre of hundreds, but by guns and not by machetes—do not make the newsroom cut. And situations that have not yet ballooned into the crisis stage—say the starvation, but not unto death, of thousands—also do not make the news budget.

Good writing and good camerawork can turn measles, a massacre-by-any-means or a famine-in-the-making into compelling stories, but not if the only template is the Ebola/Rwanda/Somalia Standard.

4. By the same token, more graphic is not better. Since the first living-room war, the first war that Americans read about and saw photographs of as it was happening—the Spanish-American War at the turn of the century—there has been a steady tendency toward increasingly grim portrayals of conflict. The

argument has been that images in order to be arresting must be "new." And so the envelope of the depiction of horror has been pushed ever larger.

But as the public's reaction to the coverage of the genocide in Rwanda clearly showed, many and maybe even most Americans are uncomfortable with the graphic explicitness of the tales and images of genocide. While there may be some who want to know chapter and verse of the atrocities, more wince and even recoil from learning the details. Compassion avoidance is a learned behavior.

So what can be gleaned from Americans' generally generous response to the Goma crisis—and the Somali and Ethiopian famines—and their lack of response to the debacles in Kurdistan, Bosnia and Rwanda? That Americans care to hear more about survivors than they care to hear about the dead. That their deep-seated Wilsonian impulse to see themselves doing good deeds around the world is triggered by refugee crises, but not by genocides. Stopping a genocide seems beyond the abilities of concerned individuals. And at any rate, one can't help those already dead. The existence of genocides—and the helplessness of individuals in the face of them—also wars with basic ideals and values cherished in American society: the emphasis on personal achievement and the belief in social progress. Such concepts remain vital to Americans only because Americans avoid confrontations with certain realities—those realities that suggest that class or race or gender have more impact on one's ability to achieve success than any bootstrap philosophy, and those realities that suggest that the dark and brutal impulses of mankind have not been rooted out by the humanitarian efforts of the late 20th century. It's true Americans' greater engagement with famines than genocides may war with journalists' news values, where on the face of it a genocide is a greater story than a flight of refugees, but it accords with another firmly held belief of Americans—the compassion principle of the Good Samaritan. The Good Samaritan parable is not about mourning for those who have perished, it is about binding up the wounds and caring for those who are injured. The coverage of genocide or genocidal acts, by this formulation, therefore, should emphasize the struggles of the innocent, not just the terrors perpetrated by the evil. The validity of such a charge can be seen by reference to the literature of the Holocaust. Why is *The Diary of Anne Frank* such a perennial favorite? Although Frank died in the Nazi camps, her writings tell the story of her search for humanity amidst horror. That is a tale that generations have been inspired by. The context of the Final Solution is integral to the story, but the survival of hope against all odds is the most potent message.

Still, the media's coverage (especially the print media's coverage) of the genocide in Rwanda was, on balance, a fine example of what journalism should be.

If it took too long for the reporters to understand what was happening, many eventually told the story—at some personal risk—even when it had become plain that the public didn't much care, or caring didn't want to know the details. It was in the telling of the genocide in Rwanda that the media came closest to remembering their reason for existence—not as a carrier device for advertisements and commercials, but as the chief source of information for Americans to learn about the world.

Compassion fatigue should not be allowed to constrain or distort the collection and the imparting of knowledge. "There's a very low level of general knowledge of the rest of the world among Americans," said history professor Susan Broadhead. A crisis "tends to fall into the sort of great pool of things that are subject more to stereotypes and generally being pushed to the back of our consciousness unless we see really grim and grisly pictures on TV. Then it just becomes one of a series of horrible things that happens someplace else."[24] The global significance of a story, not the expected American reception of it, should be the main criterion for coverage. If knowledge about a place or an event make people care more about them, then a rise in Americans' general knowledge about the world (the responsibility of the schools as well as the media) can only help Americans become more engaged.

"Why do we have those homeless guys?" asked psychology professor Georg Kunz. "Because we've said they're expendable. There's not a lot of difference between that and the people in Somalia and Bosnia." Those who suffer from compassion fatigue have—at some level—stopped caring about others. "We may be horror-struck by the chaos that starvation and civil strife inflict on victims in foreign places like Somalia or Sarajevo, but to be horror-struck is a frugal form of charity," reflected retired English professor Lawrence Langer.[25]

According to the gospel of Luke, Jesus was asked by a lawyer how he could inherit eternal life. The answer was to love "the Lord thy God with all thy heart, and with all thy soul, and with all thy strength, and with all thy mind" and to love "thy neighbour as thyself." Well then, asked the lawyer, "Who is my neighbor?" In response, Jesus told the parable of the Good Samaritan, the archetype of the compassionate stranger.

> A certain man went down from Jerusalem to Jericho and fell among thieves, which stripped him of his raiment, and wounded him, and departed, leaving him half dead. And by chance there came down a certain priest that way: and when he saw him, he passed by on the

other side. And likewise a Levite, when he was at the place, came and looked on him, and passed by on the other side. But a certain Samaritan, as he journeyed, came where he was: and when he saw him, he had compassion on him. And went to him, and bound up his wounds, pouring in oil and wine, and set him on his own beast, and brought him to an inn, and took care of him. And on the morrow when he departed, he took out two pence, and gave them to the host, and said unto him, Take care of him; and whatsoever thou spendest more, when I come again, I will repay thee.

Finishing, Jesus asked the lawyer, Which of the three was the neighbor to him who fell among the thieves? And the lawyer answered, he who showed compassion. Then said Jesus, "Go, and do thou likewise."[26]

The Good Samaritan had nothing in common with the victim of the thieves. The Samaritan as a member of a group considered outcasts and religious heretics by the Jews might have done as the other travelers along that way had done—passed by on the other side of the road or even taken advantage of the victim. The Samaritan had nothing to gain from caring for the injured man, yet he showed him compassion.[27]

In the apportionment of blame for the existence of compassion fatigue, the media's value system and our value system are in question. The media decide what in the world is worth covering. They introduce us to our global neighbors. And the manner in which they do so influences our concern for those "others." "Compassion fatigue is real," said Peter Herford, "but it happens faster than it ever happened before. I'm convinced the fatigue sets in because it is latent at all times. We are kept on a threshold of fatigue." What's happening much of the time around the globe is not terribly uplifting. It's essentially the story of crisis, human conflict, contravening interests. It isn't often about good people doing great deeds. What's happening, most often, is nothing but bad news. And that is fatiguing.

"Any composer knows that there are rhythms to follow and pace that make a great composition," said Herford. "Few can produce a St. Matthew Passion and keep the soul riveted for a couple of hours. We somehow feel we can keep nations riveted forever. Hence: instant fatigue. The fatigue is there before the genocide happens."[28]

Reporting the news is both a political and a moral act. An element of shame is involved in not reporting responsibly and reporting equitably. If the media don't bear witness truthfully and thoughtfully, the good/bad stereotypes endure and the lack of concern persists.

We need to be put in as close contact as possible with people at risk. We need nuanced and in-depth coverage of crises and we need to hear and see the human side too. The former without the latter is boring, the latter without the former is sensationalized. To get it right, the media need to think of both the short term and the long term. They need to think of both their own interests and the "public interest."

Perhaps Bill Small said it best. "The answer to compassion fatigue," he noted simply, "is in how the story is done. Most of the time, most of the media does a mostly mediocre job. The need is for great reporters, producers and editors." As journalism has become just another pure-business operation, its raison d'être has been blunted. The way today to become a successful "journalist" is to give up what is involved in being a "reporter," noted James Fallows in his best-selling book *Breaking The News*. As journalism has become synonymous with entertainment, the notion that events matter most is being lost.[29] But it is precisely that dedication to news that built the great institutions. With little hindsight, we may believe that the media's embracing of celebrity journalism, of if-it's-Tuesday-it-must-be-Belgium journalism, of more-gory-and-graphic-than-thou journalism is unique to our degenerated culture at the turn of the millennium. Not so. One hundred years ago the tabloids of Hearst and Pulitzer battled each other while papers such as *The New York Times* and *The New York Tribune* somberly reported world events. Which have survived? Not the two which catered to the lowest common denominator.

Choosing to invest in such an un-sexy news beat as international affairs must be viewed as a long-term business decision—and such decisions are increasingly hard to make in a world where news institutions are a line-item in quarterly stockholder reports. But those who run the businesses need to understand that their best asset is their role as public servants. Credibility, integrity, authority win audience loyalty—a precious commodity, easy to lose, and requiring much effort and contrition to regain. Just ask *The Washington Post* where a feature writer won and then lost a Pulitzer prize for a story that turned out to be pure fiction. Or ask NBC News which rigged detonators to be sure that a supposedly defective fuel tank on a pickup truck caught fire in a crash. As has been often demonstrated, establishing that credibility, integrity and authority entails giving audiences not the "Twinkie" news they think they want at the moment, but the Smorgasbord of domestic and global events that influence their lives. Facile news is not sustaining. It may be pleasant going down, but the calories are empty.

To confirm this, just reflect on the phenomenon of compassion fatigue. In effect, compassion fatigue signals the public's weariness with the menu. The public is saying: "Enough. We don't want what you are giving us." The solution

to compassion fatigue—as has been proven repeatedly—is not for the media to respond with entertainment journalism, sensationalist journalism, formulaic journalism. The solution is to invest in the coverage of international affairs and to give talented reporters, camerapeople, editors and producers the freedom to define their own stories—bad and good, evil and inspiring, horrific and joyous. The solution is for those talented number to cover that panoply of stories day in and day out, year in and year out, and to be concerned less about the "bottom line" than for the "morning line." The solution is for the media business to get back to the business of reporting all the news, all the time.

NOTES

Introduction

1. Germaine Greer, "An African Feast for Flies and Other Parasites," *The Guardian*, 25 July 1994, Features section, p. 18.

Compassion Fatigue

1. Paul Hoversten and Sharen Shaw Johnson, "Global Hard Times Stretch Relief Groups," *USA Today*, 9 May 1991, News section, p. 1A; Neil Lewis, "String of Crises Overwhelms Relief Agencies and Donors," *The New York Times*, 4 May 1991, sec. 1, p. 5; *Nightline*, ABC News, 1 May 1991; David Ferrell, "Burnout Hits Relief Network," *Los Angeles Times*, 4 May 1991, sec. A, p. 1.
2. David Ferrell, "Burnout Hits Relief Network," *Los Angeles Times*, 4 May 1991, sec. A, p. 1.
3. Editorial, "Calamity's Lessons," *The New York Times*, 17 May 1991, sec. A, p. 30.
4. Tom Post et al., "Donor Fatigue," *Newsweek*, 13 May 1991, p. 38; Jack Payton, "Donor Fatigue, Writ Large," *Chicago Tribune*, 23 May 1991, Perspective section, p. 31.
5. Post et al., "Donor Fatigue," pp. 38, 41.
6. Elaine Sciolino, "The Disasters Multiply and Compassion Falters," *The New York Times*, 12 May 1991, sec. 4, p. 3.
7. Hugh Dellios, "The Miracle Merchants: For Sponsors, Image and Reality Worlds Apart," *Chicago Tribune*, 15 March 1998, The Miracle Merchants sec., p. 8.
8. "Whether she lives or dies, depends on what you do next," Save the Children ad appearing in *The New York Times*, 4 Nov. 1984, p. 89.
9. Interview with Jim Yuenger, 16 March 1994.
10. Interview with Bob Martin, 5 May 1994.
11. Interview with Robert Kaiser, 10 March 1994.
12. Interview with Jim Yuenger, 16 March 1994; interview with Allen Alter, 2 August 1993; Milan Kundera, *The Book of Laughter and Forgetting* (New York: Alfred A. Knopf, 1980), 5.
13. Correspondence with Bill Small, 15 Oct. 1997.

14. Academics have also noted this tendency. See for example, John Kingdon, *Agendas, Alternatives, and Public Policies* (New York: HarperCollins, 1995), 58–59.

Jeff Danziger, The Christian Science Monitor/Los Angeles Times Syndicate reproduced in Edward Girardet, ed. *Somalia, Rwanda, and Beyond: The Role of the International Media in Wars and Humanitarian Crises* (New York: CROSSLINES Global Report, 1995), 48; and also in Thomas Weiss and Cindy Collins, *Humanitarian Challenges and Intervention: World Politics and the Dilemmas of Help* (New York: Westview Press, 1996), 188.

15. Interview with Bernard Gwertzman, 29 July 1993.
16. Interview with Tom Kent, 22 April 1994.
17. Post et al., "Donor Fatigue," p. 38.
18. *Nightline*, ABC News, 1 May 1991.
19. Conrad Smith, *Media and Apocalypse: News Coverage of the Yellowstone Forest Fires, Exxon Valdez Oil Spill and Loma Prieta Earthquake* (Westport, CT: Greenwood Press, 1992), 157.

More than two-thirds of the journalism students surveyed in a study in the 1980s said one of the reasons they went into the profession was because "journalism is exciting" and fewer than half said that it was because they had an interest in public affairs. Lee Becker, Jeffrey Fruit, and Susan Caudill, *The Training and Hiring of Journalists* (Norwood, NJ: Ablex, 1987), 33.

20. Interview with Malcolm Browne, 29 July 1993.
21. See Neil Postman, *Amusing Ourselves to Death* (New York: Penguin, 1985), 13; interview with Malcolm Browne, 29 July 1993.
22. Post et al., "Donor Fatigue," pp. 38, 41.
23. Interview with Karen Elliot House, 10 May 1994; interview with Walter Mossberg, 30 July 1993.
24. Richard Neustadt and Ernest May, *Thinking in Time: The Uses of History for Decision Makers* (New York: Free Press, 1986), 4; Johanna Neuman, *Lights, Camera, War: Is Media Technology Driving International Politics?* (New York: St. Martin's Press, 1996), 238–39.
25. Interview with Karsten Prager, 2 August 1993; interview with John Walcott, 9 May 1994.
26. Interview with Tom Kent, 22 April 1994.
27. Interview with Jim Yeunger, 16 March 1994; correspondence with Bill Small, 17 Oct. 1997; interview with Malcolm Browne, 29 July 1993.
28. Peter Coffee, "Speedy Systems Must Brake at the Low End," *PC Week*, 18 March 1991, p. 63.
29. Max Frankel, "The Shroud," *The New York Times Magazine*, 27 Nov. 1994, p. 44.

There are also greater threats, of course. Harvard economist Amartya Sen has pointed out that great famines such as that of 1958–61 in China, in which close to 30 million people are estimated to have died, have only taken place in societies in which there is no free press to publicize such catastrophes. See also Jasper Becker, *Hungry Ghosts: Mao's Secret Famine* (New York: Free Press, 1997).

30. Interview with Bernard Gwertzman, 29 July 1993.

31. See the Pew Research Center for the People and the Press, *News Release*: "The Times Mirror News Interest Index: 1989–1995," 1996, p. 3. For an earlier study, see James Larson, *Television's Window on the World: International Affairs Coverage on the U.S. Networks* (Norwood, NJ: Ablex Publishing Company, 1984), 53; Barry Rubin, "International News and the American Media," a SAGE Policy Paper (Washington, D.C.: The Center for Strategic and International Studies, 1977), 52. See also Mort Rosenblum, *Coups and Earthquakes: Reporting the World for America* (New York: Harper & Row, 1979).

32. Times Mirror Center for the People and the Press, *News Release*: "A Content Analysis: International News Coverage Fits Public's Ameri-Centric Mood," March–June 1995, pp. 6–8.

 For recent academic studies which have assessed the media's coverage of international news, see especially: William C. Adams, "Whose Lives Count?: TV Coverage of Natural Disasters," *Journal of Communication* 36(2) 1986: 113–22; Tsan-Kuo Chang, Pamela J. Shoemaker, and Nancy Brendlinger, "Determinants of International News Coverage in the U.S. Media," *Communication Research* 14(4) 1987: 396–414; W. James Potter, "News from Three Worlds in Prestige U.S. Newspapers," *Journalism Quarterly* 64(1) 1987: 73–79, 276; Pamela J. Shoemaker, Lucig H. Danielian, and Nancy Brendlinger, "Deviant Acts, Risky Business and U.S. Interests: The Newsworthiness of World Events," *Journalism Quarterly* 68(4) 1991: 781–95; Charles Ganzert, and Don Flournoy, "The Weekly 'World Report' on CNN," *Journalism Quarterly* 69(1) 1991: 188–94; Eleanor Singer, Phyllis Endreny, and Marc Glassman, "Media Coverage of Disasters: Effect of Geographic Location," *Journalism Quarterly* 68(1) 1991: 48–58; William J. Gonzenbach, M. David Arant, and Robert L. Stevenson, "The World of U.S. Network Television News: Eighteen Years of International and Foreign News Coverage," *Gazette* 50(1) 1992: 53–72; Tsan-Kuo Chang and Jae-Won Lee, "Factors Affecting Gatekeepers' Selection of Foreign News: A National Survey of Newspaper Editors," *Journalism Quarterly* 69(3) 1992: 554–61; Michael Salwen and Frances Matera, "Public Salience of Foreign Nations," *Journalism Quarterly* 69(3) 1992: 623–32; Pippa Norris, "The Restless Searchlight: Network News Framing of the Post-Cold World," *Political Communication* 12, 1995: 357–70; Steven Earl Bennett, Richard Flickinger, John Baker, Staci Rine, and Linda Bennett, "Citizens' Knowledge of Foreign Affairs," *The Harvard International Journal of Press/Politics* 1(2) 1996: 10–29.

33. Correspondence with Bill Small, 15 Oct. 1997; interview with Bernard Gwertzman, 29 July 1993; "Hits" and "Misses," *Time*, 9 March 1998, p. 177; interview with Mark Seibel, 8 January 1996.

34. An average of 45 percent of Americans watch coverage of disasters and U.S. war or terrorism stories. "The Times Mirror News Interest Index: 1989–1995," p. 4.

35. Interview with Malcolm Browne, 29 July 1993; Paul Schwitzer, quoted in Jane Mayer, "Shooting the War," *The Wall Street Journal*, 30 Oct. 1983, sec. 1, p. 1.

36. Felicity Barringer, "Seeking Dramatic Footage No Matter What the Cost," *The New York Times*, 18 May 1998, Sect. D, p. 1, 8.

37. *Nightline*, ABC News, 1 May 1991.

38. Interview with Allen Alter, 2 August 1993.
39. Ibid.
40. Interview with Chuck Lustig, 29 July 1993; correspondence with Peter Herford, 1 Oct. 1997.
41. Interview with Bernard Gwertzman, 29 July 1993; interview with Simon Li, 18 January 1996.
42. Hess' book is the best in-depth look at the culture of foreign correspondents. His lengthy appendix of tables summarizing his studies is invaluable. The best resource for a directory of foreign correspondents is Ralph Kliesch, a professor of journalism at Ohio University, who has conducted multiple censuses of the foreign press corps. *The Tyndall Report* is the best reference for how much time the networks devote to international news. Stephen Hess, *International News & Foreign Correspondents* (Washington, D.C.: Brookings Institution, 1996), 43, 41, 39.
43. Hess, *International News & Foreign Correspondents*, 64.
44. Interview with Tom Palmer, 12 October 1993.
45. Interview with Robert Greenberger, 30 July 1993.
46. Interview with Walter Mossberg, 30 July 1993.
47. *Nightline*, ABC News, 1 May 1991.
48. Ibid.; Eleanor Randolph, "Foreign Casualties," *Chicago Tribune*, 30 Jan. 1990, Tempo section, p. 7.
49. For a few recent works discussing the media's portrait of Africa, see: Peter Dahlgren, "The Third World on TV News: Western Ways of Seeing the 'Other,'" in William Adams, ed. *Television Coverage of International Affairs* (Norwood, NJ: ABLEX Publishing Corp., 1982), 45–65; Jo Ellen Fair and Roberta Astroff, "Constructing Race and Violence: U.S. News Coverage and the Signifying Practices of Apartheid," *Journal of Communication* 41(4), autumn 1991; pp. 58–74; Beverly Hawk, ed. *Africa's Media Image* (New York: Praeger, 1992; Tunju Lardner, "Rewriting the Tale of the 'Dark Continent,'" *Media Studies Journal* 7(4) fall 1993; pp. 95–102; Dennis Hickey and Kenneth Wylie, *An Enchanting Darkness: The American Vision of Africa in the Twentieth Century* (East Lansing: Michigan State University Press, 1993); and Neta Crawford, "Imag(in)ing Africa," *The Harvard International Journal of Press/Politics* 1(2), spring 1996; pp. 30–44; see also Eleanor Singer, Phyllis Endreny and Marc Glassman, "Media Coverage of Disasters: Effect of Geographic Location," *Journalism Quarterly* 68(1) 1991: p. 48.
50. Interview with Michael Getler, 30 July 1993.
51. Interview with Tom Kent, 22 April 1994.
52. Interview with Jim Yuenger, 16 March 1994.
53. Interview with Jim Yuenger, 16 March 1994; interview with Walter Mossberg, 30 July 1993; interview with Carroll Bogert, 29 July 1993.
54. Henry A. Grunwald, "The Post–Cold War Press," *Foreign Affairs* 72(3) 1993: pp. 14, 15, 16.
55. Interview with Juan Tamayo, 8 January 1996.
56. Christopher Hitchens, "African Gothic," *Vanity Fair*, Nov. 1994, pp. 92–117; Roland Oliver quoted in Jonathan Benthall, *Disasters, Relief and the Media* (New York: I. B. Tauris, 1993), 187.

57. See, for example, Catherine A. Lutz and Jane L. Collins, *Reading National Geographic* (Chicago: University of Chicago Press, 1993).

The Times Mirror Research Center for the People and the Press surveyed more than 7,000 international news stories in print and television during a four-month period in 1995. There were 353 stories from the sub-Sahara region and 68 from North Africa. Terrorism and politics were the chief topics in North Africa, and politics and health/medicine (including AIDS and Ebola stories) were the chief topics in the South. "A Content Analysis: International News Coverage Fits Public's Americ-Centric Mood," 1996, p. 8.

58. Interview with Karen Elliot House, 10 May 1994.

59. Quoted in Arthur M. Schlesinger, Jr., *The Age of Roosevelt: The Politics of Upheaval, 1935–1936* (New York: Houghton Mifflin, 1966), 10.

60. Correspondence from Bill Small, 15 Oct. 1997; Malcolm Browne, *Muddy Boots and Red Socks* (New York: Times Books, 1993), 208.

61. Television stations have also turned increasingly to satellite news services. Conus, a cooperative of 125 member stations which began in 1985, ran a recent ad in *RTNDA Communicator* with the headline "Winning the News War Takes an Elite Force." "By joining this elite team," it read, "you'll gain an advantage over other news organizations. You'll be the victor of the news war with more service and better results." The accompanying photograph showed a military helicopter coming in for an attack. Conus Communications ad, *RTNDA Communicator*, March 1995, inside front cover.

For an excellent recent overview of the status of international news reporting, see Claude Moisy, "The Foreign News Flow in the Information Age," discussion paper D-23 (The Joan Shorenstein Center for Press, Politics and Public Policy, Harvard University John F. Kennedy School of Government, Nov. 1996).

62. Frankel, "The Shroud," p. 44.

A year and a half later, as of mid-1996, CBS had only four major foreign bureaus, Moscow, Tel Aviv, Tokyo and London, down from as many as 20 in its heyday; NBC had seven, including Mexico City and Frankfurt; and ABC had eight, the same four as CBS plus Beijing, Hong Kong, Paris and Rome. CNN, however, had more than the Big Three combined — 20, including Amman, Brussels, Bangkok, Berlin, Cairo, Jerusalem, Johannesburg, Nairobi, Santiago, Djakarta, New Delhi, Seoul and Rio. Figures quoted in Neil Hickey, "No News Is Not Good News," *TV Guide*, 3 Aug. 1996, p. 34.

Alternatively, a survey by the Newspaper Research Journal identified 820 full-time U.S. foreign correspondents in the early 90s versus 429 in the mid-70s, although part of the growth is explained by the growth of business and economic publications and news services, such as Bloomberg, Dow Jones and Reuters.

63. Frankel, "The Shroud," p. 44.

64. David Gergen, "Diplomacy in a Television Age: The Dangers of Tele-democracy," in *The Media and Foreign Policy*, Simon Serfaty, ed. (New York: St. Martin's Press, 1991), 51; Ken Auletta, *Three Blind Mice: How the TV Networks Lost Their Way* (New York: Random House, 1991), 273.

65. See Johanna Neuman, *Lights, Camera, War: Is Media Technology Driving International Politics?* (New York: St. Martin's Press, 1996), 213; Hess quoted

in Neil Hickey, "No News Is Not Good News," *TV Guide*, 3 Aug. 1996, p. 35; see the examples given in Hess, *International News & Foreign Correspondents* 79–80.

66. Both quoted in Tal Sanit, "The New Unreality: When TV Reporters Don't Report," *CJR* May/June 1992, p. 17.
67. Interview with Susan Meiselas, 24 Nov. 1997.
68. Interview with Allen Alter, 2 August 1993.
69. Gergen, "Diplomacy in a Television Age: The Dangers of Teledemocracy," 50.
70. Sanford Ungar and David Gergen, "Africa and the American Media," occasional paper 9 (Freedom Forum Media Studies Center, Columbia University, Nov. 1991), pp. 9–10.
71. Interview with Lee Lescaze, 22 April 1994.
72. Larry McGill, et al., "Headlines and Soundbites," The Freedom Forum Media Studies Center, August 1995, p. 9; interview with John Walcott, 9 May 1994.
73. Figures quoted in Neil Hickey, "No News Is Not Good News," *TV Guide*, 3 Aug. 1996, p. 34; and RTNDA Bulletin, 1996.

 According to *The New York Times*, the O.J. Simpson story set "a new standard for network news": the white Bronco chase caused all three networks to pre-empt prime time to cover it. Both ABC and CBS pre-empted more than two hours of their regular programming. (Prime-time leader NBC pre-empted only five minutes of programming.) In the previous year, the only other events to merit pre-empting were the Los Angeles earthquake, Nixon's death and funeral, and five addresses by President Clinton—including one on Somalia, one on health care and the State of the Union speech. Elizabeth Kolbert, "We Interrupt This Program," *The New York Times*, 26 June 1994, sec. E, p. 18. Bill Small cautions that critics must "be careful of over-reliance on the number of minutes given by television to foreign news. I suspect," he said, "that in 1997 with the death of Di (and to a lesser extent Mother Teresa), the numbers will be way up. . . . It always spikes up with big, ongoing stories overseas and the long-run average may be higher than one suspects." Correspondence from Bill Small, 15 Oct. 1997.
74. Correspondence from Bill Small, 15 Oct. 1997; Browne, *Muddy Boots and Red Socks*, 218.
75. Interview with Allen Alter, 2 August 1993.
76. Interview with Robert Kaiser, 10 March 1994.
77. Interview with Jim Yuenger, 16 March 1994; interview with Simon Li, 18 Jan. 1996.
78. Correspondence with Peter Herford, 1 Oct. 1997; correspondence with Bill Small, 15 Oct. 1997.
79. Interview with Tom Kent, 22 April 1994; correspondence with Bill Small, 15 Oct. 1997.
80. Interview with Walt Mossberg, 30 July 1993.
81. Interview with John Walcott, 9 May 1994.
82. Interview with Carroll Bogert, 29 July 1993.
83. Interview with Robert Kaiser, 10 March 1994; interview with John Walcott, 9 May 1994; interview with Jim Yuenger, 16 March 1994.
84. Interview with Alvin Shuster, 18 January 1996.

85. Martin Amis, "The Mirror of Ourselves," *Time*, 15 Sept. 1997, p. 64; Howard Kurtz, "Extra! Read All About It! Overcoverage Shocks Press!" *The Washington Post*, 5 Sept. 1997, sec. D, p. 1.

86. "Picture Perfect," *Life*, Nov. 1997, p. 42; Jonathan Alter, "Dying for the Age of Diana," *Newsweek*, 8 Sept. 1997, p. 39.

87. Max Frankel, "No Pix, No Di," *The New York Times Magazine*, 21 Sept. 1997, p. 53.

88. Jonathan Alter, "Genuflect Journalism," *Newsweek*, 22 Sept. 1997, p. 37; Jacqueline Sharkey, "The Diana Aftermath," *American Journalism Review* (November 1997): 22.

89. Interview with Tom Palmer, 12 Oct. 1993; interview with Allen Alter, 2 Aug. 1993. See also Arthur Kleinman and Joan Kleinman, "The Appeal of Experience; the Dismay of Images: Cultural Appropriations of Suffering in Our Times," *Daedalus* (January 1996).

90. See, for example, Michael Singeletary and Chris Lamb, "News Values in Award-Winning Photos," *Journalism Quarterly* 61(1), 1984: 104–8, 233; and Kuo-jen Tsang, "News Photos in Time and Newsweek," *Journalism Quarterly* 61(3), 1984: 578–84, 723.

91. See interview with Malcolm Browne, 29 July 1993; also see, for example, Timothy O'Keefe, "The Anti-Smoking Commercials: A Study of Television's Impact on Behavior," *Public Opinion Quarterly* 35(2), 1971: 242–48; and Evelyne Dyck and Gary Coldevin, "Using Positive vs. Negative Photographs for Third-World Fund-Raising," *Journalism Quarterly* 69(3), 1992: 572–79, esp. 573.

92. Dyck and Coldevin, "Using Positive vs. Negative Photographs for Third-World Fund-Raising," 577.

93. Max Frankel, "I Am Not a Camera," *The New York Times Magazine*, 27 Oct. 1994, p. 28.

94. Quoted in Neuman, *Lights, Camera, War*, 20.

95. Payton, "Donor Fatigue, Writ Large," p. 31.

96. Celia Dugger, "International Calamities Tax America's Compassion," *The New York Times*, 12 May 1991, sec. 1, p. 6.

97. Quoted in ibid.; Neil Lewis, "String of Crises Overwhelms Relief Agencies and Donors," *The New York Times*, 4 May 1991, sec. 1, p. 5.

98. Dugger, "International Calamities Tax America's Compassion," p. 6; Lewis, "String of Crises Overwhelms Relief Agencies and Donors," p. 5.

99. Observation on Delahaye photo made by Goksin Sipahioglu, the owner of the Paris photo agency, Sipa. "Future Stock," *American Photo* (Sept./Oct. 1996): 102; James Martin, *America*, 13 May 1995.

100. Interview with Jim Yeunger, 16 March 1994.

101. Interview with Bernard Gwertzman, 29 July 1993; interview with Tom Kent, 22 April 1994.

102. Interview with Carroll Bogert, 29 July 1993.

103. Save the Children advertisement, *The New York Times Sunday Magazine*, 24 March 1996, p. 59.

104. The photograph to which I refer won the 1994 Pulitzer Prize for feature photography. The photo was taken in March 1993. In it an eager vulture watches

an emaciated toddler collapsed from hunger en route to a U.N. feeding center in Ayod, Sudan. See Chapter 3 on the famine in Sudan and Somalia for further discussion.

105. Peter Martin, "I'm Really Sorry I Didn't Pick the Child Up," *The Sunday Mail* (England), 16 Oct. 1994, p. 42.

106. Raymond Schroth, "'But It's Really Burning': Tragedy and the Journalistic Conscience," *Columbia Journalism Review* (Sept./Oct. 1995): 45.

107. Steuben advertisement, p. 27; Hellmann's Real Mayonnaise advertisement, pp. 34–35; James Nachtwey, photo-essayist, "Somalia 1992: The Casualties," *The New York Times Magazine*, 6 Dec. 1992, pp. 36–41.

108. MetLife advertisement, p. 38; Habitrol advertisement, p. 41; Andrew Purvis, reporter and Christopher Morris, Black Star, photographer, "A Day in the Death of Somalia," *Time*, 21 Sept. 1992, pp. 32–34, 39–40.

109. Paul J. Bauermeister, "Letters to the Editor," *Time*, 12 Oct. 1992, p. 16.

110. Quoted in W. J. T. Mitchell, *Picture Theory* (Chicago: University of Chicago Press, 1994), 35.

111. And a photograph that places the photographer (or his arm or identifiable shadow) in the setting has the same effect that seeing the "man behind the curtain" had on Dorothy—it destroys the illusion. It suggests to viewers that the photographer who is so obviously there, could have himself done something to alleviate the situation. As a result, resentment is turned against the photographer rather than against the originating cause of the distress. See the photo, for example, in *The New York Times*, captioned "A photographer holds a light meter to the body of a man discovered in the Cité Soleil section of Port-au-Prince, Haiti." Librado Romero, photographer, "The New Press Criticism: News as the Enemy of Hope," *The New York Times*, 9 Oct. 1994, sec. 4, p. 4

112. Quoted in Barbara Tuchman, *Practicing History* (New York: Ballantine Books, 1981), 62; Dave Marash, "Big Story, Small Screen," *Columbia Journalism Review* (May/June 1995): 9.

113. Eugene Richards, "Family Values in the '90s," *American Photo* (Sept./Oct. 1996): 66; interview with Susan Meiselas, 24 Nov. 1997.

114. Quoted, for example, in Ellen Goodman's syndicated column. Ellen Goodman, "Delights for Summer Readers," *The Boston Globe*, 7 July 1996, sec. 1, p. 73.

115. Miriam Wasserman, "Trafficking with Images: Journalism, History, and the Image of Columbia in the United States," (senior honors thesis, Brandeis University, History of Ideas Department, 1993), 10; and John Berger and Jean Mohr, *Another Way of Telling* (New York: Vintage Books, 1982), 89.

116. Jeffrey Griffin and Robert Stevenson, "The Effectiveness of Locator Maps in Increasing Reader Understanding of the Geography of Foreign News," *Journalism Quarterly* 71(4), 1994: 937–46; Melvin De Fleur, Lucinda Davenport, Mary Cronin and Margaret DeFleur, "Audience Recall of News Stories Presented by Newspaper, Computer, Television and Radio," *Journalism Quarterly* 69(4), 1992: 1017; and Doris Graber, "Seeing Is Remembering: How Visuals Contribute to Learning from Television News," *Journal of Communication* 40(2), 1990: 134–55.

117. Interview with Larry Armstrong, 18 January 1996; interview with Mark Seibel, 8 January 1996.

118. Roland Barthes, *Camera Lucida* (New York: Hill & Wang/Farrar, Straus and Giroux, 1981).
119. Quoted in Berger and Mohr, *Another Way of Telling*, 280.
120. Interview with Jim Yuenger, 16 March 1994.
121. For a brief but salient discussion on this issue see Mitchell, *Picture Theory*, ch. 13.
122. Interview with Jim Yuenger, 16 March 1994.
123. See Mort Rosenblum, *Who Stole the News?* (New York: John Wiley & Sons, 1993), 4; see also *Nightline*, ABC News, 24 May 1995; Geoffrey Cowley, et al., "Outbreak of Fear," *Newsweek*, 22 May 1995, p. 48.
124. See the reflections on this subject by John Berger in *Another Way of Telling*.
125. But even given Mark Twain's cynical observation, those sobbing Romans wouldn't have wailed so loudly if all they had to react to was the label by itself—without Guido Reni's painting.
 Mark Twain, "City Sights," *Life on the Mississippi*, ch. 44.
126. Susan Sontag, *On Photography* (New York: Dell Publishing, 1977), 23.
127. Francis Haskell, *History and Its Images* (New Haven: Yale University Press, 1993), see introduction.
128. Interview with Bernard Gwertzman, 29 July 1993.
129. For other detailed portraits of how individual news icons function, see Susan D. Moeller, *Shooting War: Photography and the American Experience of Combat* (New York: Basic Books, 1989); W. Lance Bennett and Regina Lawrence, "News Icons and the Mainstreaming of Social Change," *Journal of Communication* 45(3), 1995: 20–39; and Megan Dahl and W. Lance Bennett, "Media Agency and the Use of Icons in the Agenda-Setting Process: News Representations of George Bush's Trade Mission to Japan," *The Harvard International Journal of Press/Politics* 1(3), 1996: 41–59.
130. Interview with Susan Meiselas, 24 Nov. 1997.
131. See J. W. Kingdon, *Agendas, Alternatives, and Public Policies* (Boston: Little, Brown, 1984).
132. For a discussion of the role that art plays in shaping political beliefs, see Murray Edelman, *From Art to Politics: How Artistic Creations Shape Political Conceptions* (Chicago: University of Chicago Press, 1995).
133. Spencer Weart, *Nuclear Fear: A History of Images* (Cambridge: Harvard University Press, 1988), xii.
134. I have found it useful in my attempts to understand the workings of imagery to consider imagery's relationship to a cultural system and to the concept of political culture. In this context it has been useful to look at the works of cultural anthropologist Clifford Geertz, intellectual historian Michael Hunt and political scientists Gabriel Almond and Sidney Verba, among others. See, for example, Michael H. Hunt, *Ideology and U.S. Foreign Policy* (New Haven: Yale University Press, 1987), and Clifford Geertz, *The Interpretation of Cultures: Selected Essays* (New York: Basic Books, 1973).
135. Eric H. Erikson, *Young Man Luther* (New York: Norton, 1958), 22.
136. "Tough Talk on Entertainment," *Time*, 12 June 1995, pp. 33, 35.
137. Garry Trudeau, "Doonesbury," 1 May 1991.
138. Interview with Carl Mydans, 9 May 1994.

139. Neuman, *Lights, Camera, War*, 231.
140. Hunt, *Ideology and U.S. Foreign Policy*, 16.
141. Quoted in Kirsty Scott, "What It Takes to Move the World," *The Herald* (Glasgow), 18 July 1995, p. 8.
142. Quoted in ibid.; Johanna Neuman, "Is Satellite TV Driving Foreign Policy? Not Really," *USA Today*, 17 Jan. 1996, News section, p. 11a.
143. Save the Children advertisement, *The New York Times Sunday Magazine*, 24 March 1996, p. 59.
144. Kundera, *The Book of Laughter and Forgetting*, 3.

Covering Pestilence:
Sensationalizing Epidemic Disease

1. William Underhill, "Britain: Fears of Flesh-Eating Bacteria," *Newsweek*, 6 June 1994, p. 42.
2. Michael D. Lemonick, "Streptomania Hits Home," *Time*, 20 June 1994, p. 54.
3. William Schmidt, "Field Day for the Press," *The New York Times*, 29 May 1994, sec. 4, p. 2; Lemonick, "Streptomania Hits Home," p. 54.
4. Underhill, "Britain: Fears of Flesh-Eating Bacteria," p. 42.
5. For the purposes of this work, epidemic disease is defined as a disease which causes high mortality or morbidity, and is often accompanied by social dislocation.
6. See, for example, Allan Brandt, "AIDS and Metaphor: Toward the Social Meaning of Epidemic Disease," *Social Research* 55(3), 1988: 413–32, esp. 415.
7. Laurie Garrett, *The Coming Plague: Newly Emerging Diseases in a World Out of Balance* (New York: Penguin Books, 1994), 607.
8. The Freedom Forum Media Studies Center Research Group, *The Media and Foreign Policy in the Post–Cold War World* (New York: Freedom Forum Media Studies Center, Columbia University, 1993), 41.
9. According to the Centers for Disease Control (CDC) the rise and fall of U.S. media coverage of AIDS is tied not to numbers of dead or scientific developments, but to the extent to which the threat to mainstream Americans seemed to be increasing. James Kinsella, *Covering the Plague: AIDS and the American Media* (New Brunswick, NJ: Rutgers University Press, 1989), 156.
10. Joseph McCormick and Susan Fisher-Hoch, *Level 4: Virus Hunters of the CDC* (Atlanta: Turner Publishing, 1996), 43, 66.
11. As before, the media outlets which have been consistently canvassed for this study are: five major newspapers (*The New York Times*, *The Washington Post*, the *Los Angeles Times*, the *Chicago Tribune* and *USA Today*); the three newsweeklies (*Time*, *Newsweek* and *U.S. News & World Report*) and ABC and CNN. Other print and electronic media have been referenced, but have not been factored in as regularly. Those outlets are cited specifically.
12. Editorial, "Same Old Strep?" *The New York Times*, 10 June 1994, sec. A, p. 28; Lemonick, "Streptomania Hits Home," p. 54.
13. Sheryl Stolberg, *Los Angeles Times*, 15 June 1994, sec. A, p. 1.

14. See Spencer Reiss and Nina Biddle, "The Strep-A Scare," *Newsweek*, 20 June 1994, pp. 32, 33; "News," CNN, 25 May 1994, 2:03 P.M.; *CNN & Company*, CNN, 10 June 1994, 4:30 A.M.

15. See, for example, Bernard Cohen, *The Press and Foreign Policy* (Princeton: Princeton University Press, 1963).

16. Tribune Wires, "Deadly Epidemic Triggers Panic in India as Thousands Flee Plague," *Chicago Tribune*, 25 Sept. 1994, News section, p. 9.

17. John Ward Anderson, "Rumor Fuels Plague Panic in India," *The Washington Post*, 26 Sept. 1994, sec. 1, p A16; *The Week in Review*, CNN, 2 Oct. 1994, 1:00 P.M.

18. For an historical perspective on epidemics, see Terence Ranger and Paul Slack, eds. *Epidemics and Ideas: Essays on the Historical Perception of Pestilence* (Cambridge: Cambridge University Press, 1990), esp. introduction.

19. Tim Radford, "Influence and Power of the Media: Coverage of Medical Issues," *The Lancet* 347(9014), 1 June 1996: 1533.

20. See "'Galloping Gangrene' Reportedly Kills 5," *Los Angeles Times*, 25 May 1994, part A, p. 9; Tom Post, et al., "The Plague of Panic," *Newsweek*, 10 Oct. 1994, p. 40; Ray Moseley, "'Mad-Cow' Scare Threatens Britain's Beef Industry," *Chicago Tribune*, 22 March 1996, Business section, p. 9; and Geoffrey Cowley, et al., "Outbreak of Fear," *Newsweek*, 22 May 1995, pp. 3, 48.

21. See "Same Old Strep?", p. 28; J. Madeline Nash, et al., "The Killers All Around," *Time*, 12 Sept. 1994, p. 61; Shannon Brownlee, et al., "Horror in the Hot Zone," *U.S. News & World Report*, 22 May 1995, p. 57.

22. Nash, et al., "The Killers All Around," p. 66; Mark Caldwell, "Ebola Tamed— For Now," *Discovery*, January 1996, p. 16.

23. Robert Preston, *The Hot Zone* (New York: Anchor Books, 1994), 136.

24. Joseph Contreras, et al., "On Scene in the Hot Zone," *Newsweek*, 29 May 1995, p. 49.

25. Caldwell, "Ebola Tamed—for Now," p. 16.

26. See, for example: Shannon Brownlee, et al., "The Disease Busters," *U.S. News & World Report*, 27 March 1995, p. 48; "The War Room," *Life*, July 1995, p. 14; Associated Press, "India Battles Plague in Western City," *Los Angeles Times*, 25 Sept. 1994, part A, p. 9; John Burns, "With Old Skills and New, India Battles the Plague," *The New York Times*, 29 Sept. 1994, sec. A, p. 3.

27. Susan Sontag, *Illness as Metaphor and AIDS and its Metaphors* (New York: Anchor Books, 1989).

28. Jamie Feldman, *Plague Doctors: Responding to the AIDS Epidemic in France and America* (Westport, CT: Bergin & Garvey, 1995), 58.

29. See James Kinsella, *Covering the Plague: AIDS and the American Media* (New Brunswick, NJ: Rutgers University Press, 1989), esp. 112–14.

30. Richard Preston, "The Vaccine Debacle," *The New York Times*, 2 Oct. 1994, sec. 4, p. 17.

31. Sontag, *Illness as Metaphor*, 43; Quoted in ibid., 174.

32. As Joan Deppa reported in her work on the coverage of the Lockerbie disaster, photographers may jockey for position to get an especially graphic shot, but very few periodicals ever use such pictures. Joan Deppa, et al., *The Media and Disasters: Pan Am 103* (New York: NYU Press, 1994), 171–72.

33. Compare these findings with those of Catherine A. Lutz and Jane L. Collins, *Reading National Geographic* (Chicago: University of Chicago Press, 1993), esp. ch. 6.

34. Evelyne Dyck and Gary Coldevin, "Using Positive vs. Negative Photographs for Third-World Fund-Raising," *Journalism Quarterly* 69(3), 1992: 575.

35. See, for example, the commentary on AIDS victim Ryan White, in James Kinsella, *Covering the Plague: AIDS and the American Media* (New Brunswick, NJ: Rutgers University Press, 1989).

36. Correspondence with Peter Herford, 1 Oct. 1997.

37. Radford, "Influence and Power of the Media," p. 1533.

38. See William Montalbano, "British Beef Crisis: A Menu for Despair," *Los Angeles Times*, 31 March 1996, part A, p. 1; John Micklethwait, "How Now Mad Cow?: The Making of a Major Political Disaster," *Los Angeles Times*, 31 March 1996, part M, p. 2; Richard Rhodes, *Deadly Feasts: Tracking the Secrets of a Terrifying New Plague* (New York: Simon & Schuster, 1997).

39. The sources used in the writing of the history and pathology of spongiform diseases include: Paul Brown, "Bovine Spongiform Encephalopathy and Creutzfeldt-Jakob Disease," *British Medical Journal* 312(7034): 790; "Bovine Spongiform Encephalopathy," *British Medical Journal* 312(7042): 1313; Lawrence Altman, "Mad Cow Epidemic Puts Spotlight on Puzzling Human Brain Disease," *The New York Times*, 2 April 1996, sec. C, p. 3; Arno Karlen, *Man and Microbes: Disease and Plagues in History and Modern Times* (New York: G. P. Putnam's Sons, 1995), esp. 195–201; Ann Giudici Fettner, *Viruses: Agents of Change* (New York: McGraw-Hill, 1990), esp. 253–59; and John Lanchester, "A New Kind of Contagion," *The New Yorker*, 2 Dec. 1996, p. 70.

40. John Darnton, "The Logic of the 'Mad Cow' Scare," *The New York Times*, 31 March 1996, sec. 4, p. 1.

41. John Darnton, "Britain Ties Deadly Brain Disease to Cow Ailment," *The New York Times*, 21 March 1996, sec. A, p. 1.

42. Ibid.

43. *News*, CNN, 1 April 1996, 6:05 P.M.

44. Gina Kolata, "New Finding Bolsters Mad-Cow Link to Humans," *The New York Times*, 24 Oct. 1996, sec. A, p. 15.

45. Larry Laudan, "Mad Cows and Englishmen," *Consumers' Research Magazine* 79(5) May 1996: 36; Tony Delamothe, "Meltdown: The Media and Mad Cows," *British Medical Journal* 312(7034), 30 March 1996: 854.

46. Delamothe, "Meltdown," p. 854; *News*, CNN, 21 March 1996, 1:06 P.M.

47. Delamothe, "Meltdown," p. 854; William Montalbano, "British Beef Shunned," *Los Angeles Times*, 22 March 1996, part A, p. 1.

48. Ray Moseley, "Mad-Cow Disease Is Leaving British Farms 'Devastated,'" *Chicago Tribune*, 31 March 1996, News section, p. 8.

49. All the headlines are from March 22 to March 31 and are from the following newspapers: *The Atlanta Journal-Constitution*, *Chicago Tribune*, *The Christian Science Monitor*, *Los Angeles Times*, *The Miami Herald*, *The New York Times*, and *The Washington Post*.

50. *World News Sunday*, ABC News, 24 March 1996, 6:30 P.M.; *News*, CNN, 21 March 1996, 8:07 A.M.

51. See, for example, Michael Serrill, "Mad Cows and Englishmen," *Time*, 1 April 1996, p. 47; William Underhill, "Hold the Kidney Pie," *Newsweek*, 1 April 1996, p. 59.
52. *ABC World News Tonight*, ABC News, 21 March 1996, 6:30 P.M.; *News*, CNN, 21 March 1996, 5:15 P.M.
53. *News*, CNN, 29 March 1996, 12:02 A.M.
54. Stephanie Strom, "Clunbury Journal: 'Mad Cow Disease' Threatens the Farming Life," *The New York Times*, 25 March 1996, sec. A, p. 4; *News*, CNN, 29 March 1996, 12:02 A.M.
55. See, for example, "Notebook," *Time*, 8 April 1996, p. 17, model maker David O'Keefe; and David Nyhan, "Mad Cows and Englishmen," *Boston Globe Magazine*, 14 July 1996, p. 16, illustrator Barry Blitt.
56. For images of brain tissue, see: Mary Hager and Mark Hosenball, "'Mad Cow Disease' in the U.S.?" *Newsweek*, 8 April 1996, p. 58; or Lawrence Altman, "Mad Cow Epidemic Puts Spotlight on Puzzling Human Brain Disease," *The New York Times*, 2 April 1996, sec. C, p. 3.

 For images of cows, see: "'Mad Cow Disease' in the U.S.?" photographer David Frazier, Photo Researchers; "Mad Cows and Englishmen," photographer Chris Close, The Image Bank; Lawrence Altman, "WHO Seeks Barriers Against Cow Disease," *The New York Times*, 4 April 1996, sec. A, p. 12, photographer Jonathan Player, *NYT*; "Bans Spreading on British Beef," *Chicago Tribune*, Business section, p.1, photographer AP; Robin Knight, "The Mad Cow Scare, *U.S. News*, 1 April 1996, p. 14, photographer Barry Batchelor, PA/AP.

 For images of restaurants, see: John Darnton, "The Logic of the 'Mad Cow' Scare," *The New York Times*, 31 March 1996, sec. 4, p. 1, photographer Jonathan Player, *NYT*; John Darnton, "British Beef Banned in France and Belgium," *The New York Times*, 2 March 1996, sec. A, p. 8, photographer Jonathan Player, *NYT*.

 For images of politicians, see: Fred Barbash, "Britain Wrangles with Human Fear Over Mad Cows," *The Washington Post*, 22 March 1996, sec. A, p. 27, photographer AP; Patrick Rogers, "This Terrible Madness," *People*, 22 April 1996, pp. 95–97, photographer M. Polak, Sygma.
57. See *News*, CNN, 21 March 1996, 10:13 A.M.; William Montalbano, "British Beef Crisis: A Menu for Despair," *Los Angeles Times*, 31 March 1996, part A, p. 1; Patrick Rogers, "This Terrible Madness," *People*, 22 April 1996, pp. 95–97; *People* spelled her name "Vicky." The *L.A. Times* spelled her name "Vicki."
58. Darnton, "The Logic of the 'Mad Cow' Scare," p. 1.
59. *News*, CNN, 27 March 1996, 6:12 P.M.; *News*, CNN, 21 March 1996, 10:13 A.M.; *News*, CNN, 1 April 1996, 6:54 P.M.
60. John Micklethwait, "How Now Mad Cow?: The Making of a Major Political Disaster," *Los Angeles Times*, 31 March 1996, part M, p. 2.
61. Larry Laudan, "Mad Cows and Englishmen," *Consumers' Research Magazine* 79(5) May 1996: 36; "Letters," *Time* (international edition), 22 April 1996, p. 8; "British Beef Banned in 'Mad Cow' Scare," *USA Today*, 22 March 1996, News section, p. 6A.

62. Micklethwait "How Now Mad Cow?"; Darnton, "The Logic of the 'Mad Cow' Scare."
63. Andrew Purvis, "Mourning the Angels of Mercy," *Time*, 29 May 1995, p. 47.
64. For a description of the nuns' deaths and funeral see: Celestine, Bohlen, "Virus Kills a 3rd Italian Nun at Zaire Hospital," *The New York Times*, 12 May 1995, sec. A, p. 7; Anita Manning "Ebola, and Fear, Take Toll," *USA Today*, 15 May 1995, News section, p. 1A; Bob Drogin, "Ebola Appears Even Stronger Than in 1976," *Los Angeles Times*, 15 May 1995, part A, p. 1; and Purvis, "Mourning the Angels of Mercy."
65. See Laurie Garrett, "Ebola Humbles the Virus Hunters," *Newsday*, 24 Sept. 1996, Health and Discovery section, p. B25; *World News Sunday*, ABC, 14 May 1995, 6:30 P.M.; and "Fighting Back," *USA Today*, 15 May 1995, News section, p. 12 A.
66. For a more detailed description of how the virus operates, see Stephen Morse, ed. *Emerging Viruses* (New York: Oxford University Press, 1993), esp. ch. 5, 7 and 15.
67. McCormick and Fisher-Hoch, *Level 4*, 55.
68. Sources used for this chronology include: numerous newspaper articles and William Close, *Ebola* (New York: Ivy Books, 1995); Elizabeth Etheridge, *Sentinel for Health: A History of the Centers for Disease Control* (Berkeley: University of California Press, 1992); Garrett, *The Coming Plague*; McCormick and Fisher-Hoch, *Level 4*; Stephen Morse, ed. *Emerging Viruses* (New York: Oxford University Press, 1993); Preston, *The Hot Zone*; Ed Regis, *Virus Ground Zero: Stalking the Killer Viruses with the Centers for Disease Control* (New York: Pocket Books, 1996).
69. Garrett, "Ebola Humbles the Virus Hunters," Health and Discovery section, p. B25.
70. Garrett, "We Did It. We Beat the Virus," p. B4.
71. This history has been drawn from numerous newspaper, magazine and journal articles—at the time of the outbreak, and since. My heaviest debt, however, is to those articles written by Laurie Garrett for *Newsday*, starting on 10 May 1994.
72. *Your Health*, CNN, 13 May 1995.
73. For use of these terms, see, for example, Purvis, "Mourning the Angels of Mercy"; and Sharon Begley, "Commandos of Viral Combat," *Newsweek*, 22 May 1995, p. 50.
74. "'Emerging Viruses' in Films and Best Sellers," *The New York Times*, 10 May 1995, sec. A, p. 14.
75. Anita Manning, "Deadly Virus's Cause, Cure Puzzle Scientists," *USA Today*, 11 May 1995, News section, p. 6A.
76. Ronald Kotulak, "U.S. Ebola Outbreak Unlikely, Experts Say," *Chicago Tribune*, 11 May 1995, News section, p. 8; editorial, "Who Will Be the World's Doctor?" *The New York Times*, 12 May 1995, sec. A, p. 30.
77. See Anita Manning, "Ebola, and Fear, Take Toll," *USA Today*, 15 May 1995, News section, p. 1A; *News*, CNN, 15 May 1995, 5:25 A.M.; Stevenson Swanson, "Enemies Within," *Chicago Tribune*, 21 May 1995, Perspective section, p. 1.

78. Laurie Garrett, "Virus Kills 56 in Zaire," *Newsday*, 10 May 1995, News section, p. A7; Bob Drogin, "Outbreak: From Awful Rumor to Deadly Truth," *Los Angeles Times*, 14 May 1995, part A, p. 1; and Brownlee, et al., "Horror in the Hot Zone."

79. See Cowley, et al., "Outbreak of Fear," p. 51; *Nightline*, ABC, 10 May 1995; Marlene Cimons, "Scientists Confirm Ebola Is Causing Deadly Outbreak in Zaire," *Los Angeles Times*, 12 May 1995, part A, p. 12; Traci Watson and Shannon Brownlee, "In the Lair of the Ebola Virus," *U.S. News*, 29 May 1995, p. 44; for example, *News*, CNN, 13 May 1995, 5:07 P.M. and 5:53 P.M.; *News*, CNN, 15 May 1995, 8:00 A.M.; Preston, *The Hot Zone*, 121; Garrett, *The Coming Plague*, 6; descriptions from (in order): Editorial, "Who Will Be the World's Doctor?" *The New York Times*, 12 May 1995, sec. A, p. 30; Bob Drogin, "Outbreak: From Awful Rumor to Deadly Truth," *Los Angeles Times*, 14 May 1995, part A, p. 1; *Nightline*, ABC, 10 May 1995, 11:30 P.M.; and Susan Ince, "Deadly Viruses," *Redbook* 185(5) Sept. 1995: 118.

80. See Marlene Cimons, "Scientists Confirm Ebola Is Causing Deadly Outbreak in Zaire," *Los Angeles Times*, 12 May 1995, part A, p. 12; Brownlee, et. al., "Horror in the Hot Zone," p. 61; John Kelley and Chris Erasmus, "Ebola Outbreak Triggers Terror, *USA Today*, 11 May 1995, News section, p. 6A; Bob Drogin, "Ebola Appears Even Stronger Than in 1976," *Los Angeles Times*, 15 May 1995, part A, p. 1; Nicholas Wade, "Ideas and Trends: Ebola's Vengence," *The New York Times*, 14 May 1995, sec. 4, p. 4; editorial, "Who Will Be the World's Doctor?" *The New York Times*, 12 May 1995, sec. A, p. 30.

81. Andrew Purvis, "In Search of the Dying," *Time*, 29 May 1995, p. 44; Geoffrey Cowley, et al., "Outbreak of Fear," pp. 50–51.

82. "News Special," *CNN Presents*, CNN, 14 May 1995, 9:00 P.M.; John Schwartz, "Media's Portrayal of Ebola Virus Sparks Outbreak of Wild Scenarios," *The Washington Post*, 14 May 1995, sec. A, p. 3.

83. *Nightline*, ABC, 10 May 1995, 11:30 P.M.

84. Marlene Cimons, "Scientists Confirm Ebola Is Causing Deadly Outbreak in Zaire," *Los Angeles Times*, 12 May 1995, part A, p. 12.

85. See Ronald Kotulak, "U.S. Ebola Outbreak Unlikely, Experts Say," *Chicago Tribune*, 11 May 1995, News section, p. 8; Lemonick, "Return to the Hot Zone," p. 63.

 The crediting of Africa as the original source of AIDS has provoked bitter debate for well over a decade. A literature has grown up on how the origin of AIDS has been attributed to Africa and, more generally, on how the Western media covers Africa. See, for example: Beverly Hawk, ed., *Africa's Media Image* (New York: Praeger, 1992); Richard and Rosalind Chirimuuta, *AIDS, Africa and Racism* (London: Free Association Books, 1989); and Lawrence Altman, "Linking AIDS to Africa Provokes Bitter Debate," *The New York Times*, 21 Nov. 1985, sec. A, p. 1.; also see Anita Manning, "Ebola Strikes Zaire's Vulnerable Heart," *USA Today*, 18 May 1995, Life section, p. 10D; and Basil Davidson, "Zaire: A Geographic Label Is No Match for a Killer Virus," *Los Angeles Times*, 21 May 1995, Opinion section, p. 1M.

86. For virus images, see, for example, Cimons, "Scientists Confirm Ebola Is Causing Deadly Outbreak in Zaire," p. 12; Geoffrey Cowley, et al., "Outbreak

of Fear," p. 48; Brownlee, et al., "Horror in the Hot Zone"; and Lemonick, "Return to the Hot Zone," p. 63.

For bedside images, see, for example: Jean-Marc Bouju, pool photographer in Joseph Contreras and Marcus Mabry, "On Scene in the Hot Zone," *Newsweek*, 29 May 1995, p. 49; and Patrick Robert, Sygma for *Time*, photographer in Purvis, "In Search of the Dying," table of contents and p. 44.

For mask images, see, for example: Cedric Galbe, JB pictures, photographer, in Brownlee, et. al., "Horror in the Hot Zone," p. 61 (a reader glancing though this article would assume that the image depicts a child masked against the Ebola virus—it actually portrays a young Rwandan boy masked against contagion in Zairean refugee camps); L. Gilbert, Sygma, photographer, in "Morbid Fascination," *U.S. News*, 25 Dec. 1995, p. 103; and Jean-Marc Bouju, AP photographer, in multiple outlets, including a page-one photograph for a page 5 article in *The New York Times*, 13 May 1995; and all three newsweeklies: "Horror in the Hot Zone," p. 57; "Return to the Hot Zone," p. 63; "Outbreak of Fear," pp. 48–49; Lemonick, "Return to the Hot Zone," pp. 62–63; and see, for example: Patrick Robert, Sygma for *Time*, photographer in Purvis, "In Search of the Dying," table of contents; and Malcolm Linton, Black Star for *U.S. News* in Watson and Brownlee, "In the Lair of the Ebola Virus," p. 44; and Jean-Marc Bouju, pool photographer in Contreras and Mabry, "On Scene in the Hot Zone," p. 49.

87. Lemonick, "Return to the Hot Zone," p. 62.
88. *Nightline*, ABC, 24 May 1995, 11:30 P.M.
89. See, for example: Patrick Robert, Sygma for *Time*, photographer in Purvis, "In Search of the Dying," pp. 46, 47; and Malcolm Linton, Black Star, photographer for *U.S. News* in Eric Ransdell, "The Most Persistent Virus," *U.S. News*, 29 May 1995, p. 44.
90. "Morbid Fascination," *U.S. News*, 25 Dec. 1995, p. 103.
91. "Overexposed," *Newsweek*, winter 1995, p. 23; Howard French, "Sure, Ebola Is Bad. Africa Has Worse," *The New York Times*, 11 June 1995, sec. E, p. 3.
92. Ibid.

Covering Famine: The Famine Formula

1. Senator Paul Simon, "Letters to the Editor," *Forbes MediaCritic* 2(2), 1994–95: 8; Walter Goodman, "Why It Took TV So Long to Focus on the Somalis," *The New York Times*, 2 Sept. 1992, sec. C, p. 18; *World News Tonight with Peter Jennings*, ABC News, 13 Aug. 1992.
2. "Letters," *Time*, 12 Oct. 1992, p. 15.
3. "Landscape of Death," *Time*, 14 Dec. 1992, p. 30.
4. David Shaw, "Media Impact," *Los Angeles Times*, 26 Oct. 1992, sec. A, p. 16; *News*, CNN, 30 Aug. 1992, transcript #162–4; Editorial, "What's the Goal in Somalia?" *The New York Times*, 5 Dec. 1992, sec. 1, p. 18; Charles Paul Freund, "Images from Somalia," *The Washington Post*, 6 Dec. 1992, Outlook section, p. C3.
5. Freund, "Images from Somalia," p. C3.

6. Richard Lacayo, "Images '92," *Time*, 28 Dec. 1992, p. 48.

7. Alexander de Waal, *Famine That Kills: Darfur, Sudan, 1984–1985* (New York: Clarendon Press, Oxford, 1989), 3.

8. Helen Young and Susanne Jaspars, *Nutrition Matters: People, Food and Famine* (London: Intermediate Technology Publications, 1995), 4; and G. A. Harrison, ed. *Famine* (New York: Oxford, 1988), introduction.

9. Editorial, "Calamity's Lessons," *The New York Times*, 13 May 1991, sec. A, p. 30.

10. Amartya Sen, *Poverty and Famines: An Essay on Entitlement and Deprivation* (New York: Clarendon Press, Oxford, 1981), 40.

11. W. Paddock and P. Paddock, *Famine—1975!* (London: Weidenfeld and Nicolson, 1967), 50; Stephen Devereux, *Theories of Famine* (New York: Harvester Wheatsheaf, 1993), 11–14, 17.

12. Quoted in Peter Gill, *A Year in the Death of Africa: Politics, Bureaucracy and the Famine* (London: Paladin, Grafton Books, 1986), 50.

13. For an insightful discussion of "insider" and "outsider" definitions of famine, see Alexander de Waal, *Famine that Kills: Darfur, Sudan, 1984–1985* (New York: Clarendon Press, Oxford, 1989), ch. 1, "'Famine' in English."

14. Peter Gill, *A Year in the Death of Africa: Politics, Bureaucracy and the Famine* (London: Paladin, Grafton Books, 1986), 26.

15. Quoted in Nick Charles, "The Whole World Sees Their Pain," *The Plain Dealer*, 20 Dec. 1992, National section, p. 19A.

16. Paul Hoversten and Sharen Shaw Johnson, "Global Hard Times Stretch Relief Groups," *USA Today*, 9 May 1991, News section, p. 1A.

17. Helen Young and Susanne Jaspars, *Nutrition Matters: People, Food and Famine* (London: Intermediate Technology Publications, 1995), 19.

18. For a detailed clinical description of famine-related diseases, see Kevin Cahill, "The Clinical Face of Famine in Somalia," in Kevin Cahill, ed. *Famine* (Maryknoll, NY: Orbis Books, 1982), 39–43; and Arline Golkin, *Famine: A Heritage of Hunger* (Claremont, CA: Regina Books, 1987), 101–15.

19. François Jean, Médecins Sans Frontières, *Populations in Danger* (London: John Libbey, 1992), 139; Young and Jaspars, *Nutrition Matters*, 21.

20. De Waal, *Famine that Kills*, 22–23.

21. Megan Dahl and W. Lance Bennett, "Media Agency and the Use of Icons in the Agenda-Setting Process," *The Harvard International Journal of Press/Politics* 1(3), summer 1996: 41; Pippa Norris, "The Restless Searchlight: Network News Framing of the Post–Cold War World," *Political Communication* 12, 1995: 358; "Voting, of a Sort," *The Economist*, 4 June 1994, p. 44.

22. See, for example, Rony Brauman, "When Suffering Makes a Good Story," in *Populations in Danger*, 150; Michael Maren, "Feeding a Famine," *Forbes MediaCritic* 2(1), 1994: 32–34; Michael Maren, *The Road to Hell: The Ravaging Effects of Foreign Aid and International Charity* (New York: The Free Press, 1997), 205–6; Timothy Weaver, "Prostituting the Facts in Time of War and Humanitarian Crisis," in Edward Girardet, ed. *Somalia, Rwanda, and Beyond: The Role of the International Media in Wars and Humanitarian Crises* (New York: CROSSLINES Global Report, 1995), 204–5; Edward Girardet, Introduction to Edward Girardet, ed. *Somalia, Rwanda, and Beyond*, 19.

23. I have used the terms "magical agent" and "princess" found in Jonathan Benthall, *Disasters, Relief and the Media* (New York: I. B. Tauris, 1993), esp. 188–213.

24. I am indebted to Michael Maren for his breakdown of the chronology of famine reporting. See Michael Maren, "Feeding a Famine," *Forbes Media Critic* 2(1) 1994: 32–34, and Michael Maren, *The Road to Hell* (New York: The Free Press, 1997), 205–06.

25. *The MacNeil/Lehrer NewsHour*, 22 July 1992, transcript #4383.

26. Quoted in Conrad Smith, *Media and Apocalypse: News Coverage of the Yellowstone Forest Fires, Exxon Valdez Oil Spill, and Loma Prieta Earthquake* (Westport, CT: Greenwood Press, 1992), 158–59.

27. Michael Maren, "Feeding a Famine," *Forbes MediaCritic* 2(1) 1994: 32.

28. Rony Brauman, "When Suffering Makes a Good Story," in *Populations in Danger*, 154.

29. Ibid.

30. See, for example, the juxtapositon of two such full-bleed photographs, covering three pages, taken by Betty Press, photographer, Picture Group, and Turpin, photographer, Gamma-Liason, in *Newsweek*, 14 Dec. 1992, pp. 26–28.

31. Nick Charles, "The Whole World Sees Their Pain," *The Plain Dealer*, 20 Dec. 1992, National section, p. 19A.

32. Nikki van der Gaag and Cathy Nash, *Images of Africa: The U.K. Report* (Oxford: Oxfam, 1987), 18–19.

33. See "When Suffering Makes a Good Story," 153–54; See also John Hammock and Joel Charny, "Emergency Response as Morality Play," in Robert Rotberg and Thomas Weiss, eds. *From Massacres to Genocide: The Media, Public Policy, and Humanitarian Crises* (Washington, D.C.: Brookings Institution, 1996), 116; and Rakiya Omaar and Alex de Waal, "Doing Harm, Doing Good? The International Relief Effort in Somalia," *Current History* 92(574), May 1993: 202.

34. Quoted in Benthall, *Disasters, Relief and the Media*, 190.

35. Graham Hancock, *Lords of Poverty* (London: Mandarin, 1989).

36. Peter Turnley, photographer for *Newsweek*, p. 52; and Jeffrey Bartholet, "The Road to Hell," *Newsweek*, 21 Sept. 1992, p. 57.

37. Henry A. Grunwald, "The Post–Cold War Press," *Foreign Affairs* 72(3) 1993: 14, 15, 16.

38. Interestingly, however, the *Journalism Quarterly* study discovered that the "'pleasure principle' . . . subconsciously causes people to turn away from painful or threatening images," resulting in its finding that potential donors who were sent fund-raising appeals that featured positive photographs, of, say, a child smiling, on average gave more than those prospective donors sent the same literature, but illustrated with negative photographs. Evelyne Dyck and Gary Coldevin, "Using Positive vs. Negative Photographs for Third-World Fund Raising," *Journalism Quarterly* 69(3), fall 1992: 572–79.

39. See Walter Lippmann, *Public Opinion* (New York: Harcourt, Brace, 1922), 364; quoted in Mort Rosenblum, *Who Stole the News?* (New York: John Wiley & Sons, 1993), 12.

40. The BBC estimated that the film was shown by 425 of the world's broadcasters for a total audience of 470 million viewers. Kurt Jansson, Michael Harris, and Angela Penrose, *The Ethiopian Famine* (Atlantic Highlands, NJ: Zed Books, 1990), 154.

41. See B. G. Kuman, "Ethiopian Famines 1973–1985: A Case-Study," in Jean Drèze and Amartya Sen, eds. *The Political Economy of Hunger*, vol. II, "Famine Prevention" (New York: Clarendon Press, 1990), 197, 191; and Andrew Natsios, "Illusions of Influence: The CNN Effect in Complex Emergencies," in Robert Rotberg and Thomas Weiss, eds. *From Massacres to Genocide: The Media, Public Policy, and Humanitarian Crises* (Washington, D.C.: Brookings Institution, 1996), 164; Jansson, Harris, and Penrose, *The Ethiopian Famine*, 153. Jansson was the head of the U.N. Relief Operation in Ethiopia from December 1984 to January 1986; and Russell Watson et al., "An African Nightmare," *Newsweek*, 26 Nov. 1984, p. 52.

42. Harry Anderson et al., "A Flood of Generosity," *Newsweek*, 26 Nov. 1984, p. 57.

43. Anatole Kaletsky, "As Much a Man-Made as a Natural Disaster," *Financial Times*, 3 April 1985, sec. 1, p. 14; and Kathleen Hendrix, "Africa and Politics of Compassion," *Los Angeles Times*, 14 June 1985, View section, p. 41.

44. For a discussion of the civil war in the northern provinces of Eritrea and Tigre, published at the time, see Jonathan Tucker, "The Politics of Famine in Ethiopia," *The Nation.* 240(19) Jan. 1985: 33.

45. Quoted in Stephen Devereux, *Theories of Famine* (New York: Harvester Wheatsheaf, 1993), 149.

46. Dawit Wolde Giorgis, *Red Tears: War, Famine and Revolution in Ethiopia* (Trenton, NJ: Red Sea Press, 1989), 15.

47. See Peter Kaplan, "Grim Images: How Ethiopia Became News," *The New York Times*, 16 Dec. 1984, sec. 1, p. 9; interview with Larry Armstrong, 18 January 1996; and Joanne Omang, "TV Film of Emaciated Children Ended Apathy on Ethiopian Famine," *The Washington Post*, 21 Nov. 1984, sec. 1, p. A10.

48. Gill, *A Year in the Death of Africa*, 92.

49. The NBC quotes and chronology of the October 23 events are pieced together from Omang, "TV Film of Emaciated Children Ended Apathy on Ethiopian Famine," p. A10; Peter Kaplan, "Grim Images: How Ethiopia Became News," *The New York Times*, 16 Dec. 1984, sec. 1, p. 9; Sally Bedell Smith, "Famine Reports Show Power of TV," *The New York Times*, 22 Nov. 1984, sec. C, p. 25; Peter J. Boyer, "Famine in Ethiopia: The TV Accident That Exploded," *Washington Journalism Review* (January 1985): 21; and Robert Donovan and Ray Scherer, *Unsilent Revolution: Television News and American Public Life* (New York: Cambridge University Press, 1992), 153–59.

50. Examples culled from Harry Anderson et al., "A Flood of Generosity," *Newsweek*, 26 Nov. 1984, p. 57; and Hilary DeVries, "The World Responds to Grim Scenes of Africa's Worst Drought," *The Christian Science Monitor*, 2 Nov. 1984, National section, p. 1

51. Sally Bedell Smith, "Famine Reports Show Power of TV," *The New York Times*, 22 Nov. 1984, sec. C, p. 25.

52. David Willis, "How Marxist Ethiopia Meets the West's Press," *The Christian Science Monitor*, 9 Nov. 1984, International section, p. 1.

 In England, an uproar ensued when two days after the Amin/Buerk film, Thames Television aired a documentary by Peter Gill called "Bitter Harvest" that focused on the West's inaction. "The food which would save them is already in store in Britain and Europe," said Gill. "Why don't we give our unwanted food to save the lives of those who need it?"

53. Sally Smith, "Famine Reports Show Power of TV," *The New York Times*, 22 Nov. 1984, sec. C, p. 25.

54. Harry Anderson et al., "Too Little—And Too Late," *Newsweek*, 12 Nov. 1984, p. 71; Omang, "TV Film of Emaciated Children Ended Apathy on Ethiopian Famine," sec. 1, p. A10.

55. See Smith, "Famine Reports Show Power of TV," p. 25; see also Harry Anderson et al., "A Flood of Generosity," *Newsweek*, 26 Nov. 1984, p. 57; and again in Smith's "Famine Reports Show Power of TV," p. 25.

56. William McPherson, "Visiting a Famine—Briefly," *The Washington Post*, 11 Dec. 1984, Op-Ed section, p. A19.

57. Dawit Wolde Giorgis, *Red Tears* (Trenton, NJ: The Red Sea Press, 1989), 215.

58. Russell Watson et al., "An African Nightmare," *Newsweek*, 26 Nov. 1984, p. 52.

59. *The MacNeil/Lehrer NewsHour*, 9 November 1984, Friday transcript #2380.

60. See Watson et al., "An African Nightmare," p. 52; see also Pico Iyer, "The Land of the Dead," *Time*, 26 Nov. 1984, p. 66; and Clifford May, "At Relief Camp in Ethiopia, Scenes of Horror and Hope," *The New York Times*, 24 Nov. 1984, sec. 1, p. 1.

61. Joseph Shapiro, "Starving—A Close-Up View of Famine in Africa," *U.S. News*, 24 Dec. 1984, p. 33.

62. Photo by Frilet, Sipa-Special Features, in Watson et al., "An African Nightmare," pp. 50–51.

63. Photos by David Burnett, Contact, and Magubane, Gamma/Liaison in Pico Iyer, "The Land of the Dead," p. 66; and photo by Mohammed Amin, Camerapix-Alan Hutchison Library, in Harry Anderson et al., "Too Little—Too Late," *Newsweek*, 12 Nov. 1984, p. 71. For an image of just a single body, see the photograph by Mohammed Amin, Camerapix via AP, accompanying the boxed story "Saving the Children," *Newsweek*, 5 Nov. 1984, p. 46.

64. Photo by David K. Willis, in David K. Willis, "How Marxist Ethiopia Meets the West's Press," *The Christian Science Monitor*, 9 Nov. 1984, International section, p. 1; photo by David Kryszak, Black Star, in "What You Can Do," *Newsweek*, 26 Nov. 1984, p. 57; and photo by William Campbell, in Jamie Murphy and James Wilde, "Bare Cupboard," *Time*, 10 Dec. 1984, p. 44.

65. AP photo in Kenneth Sheets, "Roots of Africa's Famine Run Deep," *U.S. News & World Report*, 3 Dec. 1984, p. 32; see also photo by Chiasson, Gamma-Liaison, in Watson et al., "An African Nightmare," p. 53; and photos by David Burnett, Contact, and William Campbell, in Pico Iyer, "The Land of the Dead," p. 66.

66. Photo by Carl W. Bauer, AP, in Anderson et al., "Too Little—Too Late," p. 71, and also in "A Child of Hunger in Ethiopia," *Life*, Dec. 1984, p. 194. For a

similar image of a mother with a starving child see the photo by William Campbell, in Pico Iyer, "The Land of the Dead," p. 66. Photo by John Isaac, United Nations, in "Images of 1984," *Newsweek*, 24 Dec. 1984, p. 44. For a similar image of a child with a feeding tube, see the photo by Mohammed Amin, Camerapix-Alan Hutchison Library, in Watson et al., "An African Nightmare," p. 52.

67. Jay Ross, "Ethiopian Famine Claims Children First," second in a series "Africa: The Politics of Hunger," *The Washington Post*, 27 June 1983, sec. A, p. A1.

A year and a half later, in December 1984, *U.S. News* wrote about a similar situation: "Salmou Souleyman brings her severely malnourished daughter Fari Mata to one center every day for a bowl of rice mixed with milk. The 4-year-old girl weighs only 10 pounds. Too weak to walk, she is carried by her mother." Joseph Shapiro, "Starving—A Close-Up View of Famine in Africa," *U.S. News & World Report*, 24 Dec. 1984, p. 33.

68. See Peter Kaplan, "Grim Images: How Ethiopia Became News," *The New York Times*, 16 Dec. 1984, sec. 1, p. 9; see also Harry Anderson et al., "A Flood of Generosity," *Newsweek*, 26 Nov. 1984, p. 57; Peter J. Boyer, "Famine in Ethiopia: The TV Accident That Exploded," *Washington Journalism Review* (January 1985): 19.

69. Bernard Gwertzman, "Memo to the *Times* Foreign Staff," in *Media Studies Journal* 7(4) fall 1993: 38.

70. Jack Kelley, "In Somalia, a Lost Generation," *USA Today*, 9 Sept. 1992, News section, p. 4A.

71. Interview with John Walcott, 9 May 1994; Bill Keller, "Africa Allows Its Tragedies to Take Their Own Course," *The New York Times*, 7 Aug. 1994, Section 4, p. 1.

72. Interview with John Walcott, 9 May 1994.

73. Interviews with Robert Greenberger, 30 July 1993; and Tom Palmer, 12 October 1993.

74. Interview with Alvin Shuster, 18 January 1996.

75. Interview with Allen Alter, 2 August 1993.

76. Tom Post et al., "Donor Fatigue," *Newsweek*, 13 May 1991, p. 39.

77. Sources for this history include: Raymond Bonner, "Famine," *The New Yorker*, 13 March 1989, pp. 85ff; Patrick Brogan, *The Fighting Never Stopped: A Comprehensive Guide to World Conflict Since 1945* (New York: Vintage, 1990), pp. 103–7; Tom Post, et al., "A New Alliance for Terror?" *Newsweek*, 24 Feb. 1992, p. 32; Mark Hertsgaard, "The Hungry Heart," *The Independent*, 12 April 1992, Sunday Review section, p. 9; Jeffrey Bartholet and Carol Berger, "Hidden Horror in Sudan," *Newsweek*, 12 Oct. 1992, p. 49; *The MacNeil/Lehrer NewsHour*, 9 Nov. 1992; Khalid Medani, "Sudan's Human and Political Crisis," *Current History* 92(574), May 1993: 203–7; Vivienne Walt, "Sudan Starves," *Newsday*, 2 May 1993, News section, p. 40; Bill Berkeley, "The Longest War in the World," *The New York Times Magazine*, 3 March 1996, pp. 58–61.

78. *The MacNeil/Lehrer NewsHour*, 9 Nov. 1992.

79. Liz Sly, "Global Apathy Fueled Somalia Tragedy," *Chicago Tribune*, 13 Sept. 1992, News section, p. 1.

80. Ibid.

81. Julie Jolin, "Torn by Civil Wars," *Chicago Tribune*, 22 May 1991, News section, p. 4.

82. Jon LaFayette, "CBS in Somalia: 'You See Death,'" *Electronic Media*, 31 Aug. 1992, p. 3.

83. *PrimeTime Live*, ABC News, 9 May 1991; *Nightline*, ABC News, 29 January 1992.

84. Michael Hiltzik, "No Relief for Africa's Troubled Horn," *Los Angeles Times*, 18 June 1991, World Report section, p. 1; Denis Boyles, "An Entirely Man-Made Disaster: Famine in Africa," *Playboy*, November 1991, p. 124; editorial, "The Disaster of Not Responding," *Los Angeles Times*, 26 June 1991, Metro section, part B, p. 6; Diane Sawyer, *PrimeTime Live*, ABC News, 9 May 1991.

85. Photo by Anthony Suau, Black Star, in Michael Hiltzik, "No Relief for Africa's Troubled Horn," *Los Angeles Times*, 18 June 1991, World Report section, p. 1.

86. Tom Post, et al., "A New Alliance for Terror?" *Newsweek*, 24 Feb. 1992, p. 32; Hannah Morre and Robin Knight, "Somalia Sinking Fast," *U.S. News*, Jan 20, 1992, p. 39; Mark Hertsgaarg, "The Hungry Heart," *The Independent*, 12 April 1992, Sunday Review section, p. 9.

87. Jane Perlez, "Trek to Misery," *The New York Times*, 10 June 1992, sec. A, p. 1.

88. Steven Livingston and Todd Eachus, "Humanitarian Crises and U.S. Foreign Policy: Somalia and the CNN Effect Reconsidered," *Political Communication* 12, 1995: 425.

Other sources for this history include: Liz Sly, "Global Apathy Fueled Somalia Tragedy," *Chicago Tribune*, 13 Sept. 1992, News section, p. 1; Jeffrey Clark, "Debacle in Somalia," *Foreign Affairs* 72(1), 1993: 109–23; Peter Schraeder, *United States Foreign Policy Toward Africa* (New York: Cambridge University Press, 1994), 153–87; Patrick Gilkes, "Descent into Chaos: Somalia, January 1991–December 1992," in Charles Gurdon, ed. *The Horn of Africa* (London: University College London Press, 1994), 47–59, 115–17; Jonathan Stevenson, "Hope Restored in Somalia?" *Foreign Policy* 91, summer 1993: 138–54.

89. Anna Quindlen, "Somalia's Plagues," *The New York Times*, 12 Aug. 1992, sec. A, p. 19.

90. Andrew Natsios, the Assistant Administrator, Bureau for Food and Humanitarian Assistance, USAID, "Letters to the Editor," *The Washington Post*, 26 July 1992, Editorial section, p. C; Barbara Reynolds, "Color Can't Dictate USA's Response to Suffering," *USA Today*, 14 August 1992, News section, p. 15A.

91. Andrew Natsios, briefer, "USIA Foreign Press Center Briefing," Federal News Service, 17 Sept. 1992.

92. *Nightline*, ABC News, 9 Sept. 1992; Don Oberdorfer, "Bush Orders Food Airlift to Combat Somali Famine," *The Washington Post*, 15 Aug. 1992, sec. 1, p. A1; Editorial, "Every Minute a Child Dies," *Los Angeles Times*, 19 Aug. 1992, Metro section, part B, p. 6.

93. James Kindall, "Disturbing Questions," *Newsday*, 15 Sept. 1992, News section, p. 4; Walter Goodman, "Why It Took TV So Long to Focus on the Somalis," *The New York Times*, 2 Sept. 1992, sec. C, p. 18; Jon LaFayette, "CBS in Somalia: 'You See Death,'" *Electronic Media*, 31 Aug. 1992, p. 3.

94. Editorial, "Hope Amid Starvation in Somalia," *The Boston Globe*, 18 Aug. 1992, Editorial section, p. 14; Anna Quindlen, "Somalia's Plagues," p. 19.

95. *World News Tonight*, ABC News, 14 Aug. 1992; and *World News Tonight*, ABC News, 13 Aug. 1992; *World News Saturday*, ABC News, 15 Aug. 1992.

96. LaFayette, "CBS in Somalia: 'You See Death,'" p. 3.

97. *World News Tonight*, ABC News, 3 Sept. 1992; Greg Marinovich (AP), "Scenes of Suffering, Starvation Abound in Famine-Plagued Somalia," *Chicago Tribune*, 25 Aug. 1992, News section, p. 2.

98. Editorial, "Every Minute a Child Dies," *Los Angeles Times*, 19 Aug. 1992, Metro section, part B, p. 6; *Nightline*, ABC News, 9 Sept. 1992.

99. Tom Dorsey, "Covering Tragedies Doesn't Necessarily Have Disastrous Consequences," *The Courier-Journal*, 7 Sept. 1992, Features section, p. 5D; *News*, CNN, 2 September 1992, transcript #108-1, p. 2.

100. Michael Hiltzik, "Where a Gun Is a Meal Ticket," *Los Angeles Times*, 11 Aug. 1992, sec. A, p. 1.

101. *Nightline*, ABC News, 9 Sept. 1992.

102. Editorial, "Every Minute a Child Dies," p. 6; *The MacNeil-Lehrer NewsHour*, 14 Sept. 1992.

103. *Times* Wire Services, "U.S. Marines on Way to Aid Somalia Airlift," *Los Angeles Times*, 16 Sept. 1992, sec. A, p. 4; Steven Livingston and Todd Eachus, "Humanitarian Crises and U.S. Foreign Policy: Somalia and the CNN Effect Reconsidered," *Political Communication* 12, 1995: esp. the graphs of coverage, 420, 421, 423.

104. "Letters," *Time*, 12 Oct. 1992, pp. 15, 16; Andrew Purvis, "A Day in the Death of Somalia," *Time*, 21 Sept. 1992, pp. 34, 39; Jack Kelley, "A Firsthand View of Hell," *USA Today*, 21 Sept. 1992, News section, p. 2A.

105. Purvis, "A Day in the Death of Somalia," pp. 33, 39; "Letters," *Time*, 12 Oct. 1992, p. 15.

106. Barbara Crossette, "Crisis Is Seen for Sub–Saharan Africa," *The New York Times*, 17 Sept. 1992, sec. A, p. 14; Marilyn Greene, "Death, Despair Unravel Fabric of Somalia," *USA Today*, 21 Sept. 1992, News section, p. 8A; Kelley, "A Firsthand View of Hell," p. 2A.

107. Post, et al., "How Do You Spell Relief," p. 38; Carla Anne Robbins, "One Man's Plea for Somalia," *U.S. News*, 23 Nov. 1992, p. 14.

108. Again, I have used the terms "magical agent" and "princess" found in Benthall, *Disasters, Relief and the Media*, 188–213.

109. Keith Richburg, "Pests Amid Famine," *The Washington Post*, 13 Oct. 1992, Style section, p. E1; "Model with a Cause," *Newsweek*, 23 Nov. 1992, p. 54; *News*, CNN, 29 Sept. 1992, transcript #126-4.

110. Howard Kurtz, "*Life's* Jim Gaines Named Top Editor of *Time*," *The Washington Post*, 17 Nov. 1992, Style section, p. D1.

111. AP, "Crisis After Crisis Tiring Aid Donors," *Chicago Tribune*, 29 Sept. 1992, News section, p. 10.

112. Sam Dillon, "Mission to Somalia," *The New York Times*, 21 Dec. 1992, sec. A, p. 12.

113. Another indication of the step-up to stage-four coverage, was that Somalia crowded other international stories off the news: "So laser-focused are the Big

Three networks on the 28,000 U.S. troops flowing to this largely devastated African land," said Howard Rosenberg in the *L.A. Times*, "that to them much of the rest of the world now either ceases to exist or exists in miniature. The hundreds of deaths caused by this week's fierce rioting across India earned no coverage on Tuesday's *NBC Nightly News* and only a brief mention on *CBS Evening News*, for example." Howard Rosenberg, "It's the Only Show in Town for Single-Minded Newscasters," *Los Angeles Times*, 10 Dec. 1992, sec. A, p. 13.

114. Walter Goodman, "Re Somalia: How Much Did TV Shape Policy?" *The New York Times*, 8 Dec. 1992, sec. C, p. 20; James Barron, "Live, and in Great Numbers: It's Somalia Tonight with Tom, Ted and Dan," *The New York Times*, 9 Dec. 1992, sec. A, p. 17.

115. Jonathan Yardley, "In Somalia, a Picture-Perfect Military Maneuver," *The Washington Post*, 14 Dec. 1992, Style section, p. B2.

116. Brian Donlon, "TV News Teams Also March on Somalis," *USA Today*, 4 Dec. 1992, Life section, p. 1D; Kenneth R. Clark, "In Operation Restore Hope, Networks Tuned Into Bottom Line," *Chicago Tribune*, 20 Dec. 1992, Business section, p. 2.

117. Clark, "In Operation Restore Hope, Networks Tuned Into Bottom Line," p. 2.

118. John Lancaster, "Hitting the Beach in Glare of the Night," *The Washington Post*, 9 Dec. 1992, sec. 1, p. A1; Barron, "Live, and in Great Numbers: It's Somalia Tonight with Tom, Ted and Dan," p. 17.

119. Jonathan Alter, "Did the Press Push Us Into Somalia?" *Newsweek*, 21 Dec. 1992, p. 33; Barron, "Live, and in Great Numbers: It's Somalia Tonight with Tom, Ted and Dan," p. 17.

120. Tom Shales, "Television's Beachhead in Somalia," *The Washington Post*, 9 Dec. 1992, Style section, p. C1; Lancaster, "Hitting the Beach in Glare of the Night," p. A1; Barron, "Live, and in Great Numbers: It's Somalia Tonight with Tom, Ted and Dan," p. 17.

121. Howard Rosenberg, "It's the Only Show in Town for Single-Minded Newscasters," *Los Angeles Times*, 10 Dec. 1992, sec. part A, p. 13; Jonathan Yardley, "In Somalia, a Picture-Perfect Military Maneuver," *The Washington Post*, 14 Dec. 1992, Style section, p. B2.

122. Russell Watson, et al., "It's Our Fight Now," *Newsweek*, 14 Dec. 1992, pp. 3, 31.

123. Charles Paul Freund, "Images from Somalia: Reality, Rationalization and Politics," *The Washington Post*, 6 Dec. 1992, Outlook section, p. C3.

124. Richard Dowden, "Covering Somalia—Recipe for Disaster," in Girardet, *Somalia, Rwanda, and Beyond*, 94.

125. See Watson et al., "It's Our Fight Now," pp. 3, 31; see also Charles Krauthammer, "Drawing the Line at Genocide," *The Washington Post*," 11 Dec. 1992, Editorial section, p. A27; and Peter Applebome, "Seared by Faces of Need, Americans Say, 'How Could We Not Do This?'" *The New York Times*, 13 Dec. 1992, sec. 1, p. 16.

126. DeNeen Brown and Graciela Sevilla, "The Apocalypse Now Is Famine, Many Agree," *The Washington Post*, 6 Dec. 1992, Metro section, p. B1.

127. According to a study by an independent NGO, the Refugee Policy Group, 202,000–238,000 died from famine in Somalia, 100,000 were saved by outside assistance—only 10,000 of whom were saved after the Marines landed in December 1992. George Church, "Anatomy of a Disaster," *Time*, 18 Oct. 1992, p. 40.

128. Clarence Page, "A Foreign Policy Driven by the Fickle Focus of TV," *Chicago Tribune*, 9 Dec. 1992, Perspective section, p. 29.

129. Donatella Lorch, "Genocide Versus Heartstrings," in Girardet, *Somalia, Rwanda, and Beyond*, 106.

130. Judy Keen and Andrea Stone, "Explosion of Outrage, Concern for the Troops," *USA Today*, 8 Oct. 1993, News section, page 3A; Nick Gelifianakis, "Effect of Slain Soldier's Photo," *USA Today*, 8 Oct. 1993, News section, p. 3A.

131. Michael Elliott, "The Making of a Fiasco," *Newsweek*, 18 Oct. 1993, pp. 34–35; David Hackworth, "Making the Same Dumb Mistakes," *Newsweek*, 18 Oct. 1993, p. 43.

132. Scott MacLeod, "The Life and Death of Kevin Carter," *Time*, 12 Sept. 1994, p. 70; "Editors' Note," *The New York Times*, 30 March 1993, sec. A, p. 2.

133. Peter Martin, "I'm Really Sorry I Didn't Pick the Child Up," *The Sunday Mail* (England), p. 42; John Marchese, "Final Exposure: The Life, Violent Times, and Untimely Death of Kevin Carter, *The Village Voice*, 9 May 1995, Features section, p. 29.

134. Andrew Purvis, "A Day in the Death of Somalia," *Time*, 21 Sept. 1992, pp. 32–34, 39–40; *News*, CNN, 15 May 1992, transcript #35-4; Editorial, *The Boston Globe*, 26 July 1992, Editorial section, p. 62; *All Things Considered*, NPR, 1 Aug. 1992; Hiltzik, "Where a Gun Is a Meal Ticket," p. 1; *News*, CNN, 2 Sept. 1992, transcript #108-1; Editorial, *The New York Times*, 1 Sept. 1992, sec. A, p. 16; Marilyn Greene, "A Quilt of Humanitarian Concern," *USA Today*, 21 Sept. 1992, News section, p. 8A; Robert Press, "Somalia's Selfless Heroes of Relief," *The Christian Science Monitor*, 20 Oct. 1992, People section, p. 14; Jeffrey Bartholet, "'Invade Us, Please,'" *Newsweek*, 21 Dec. 1992, p. 31; Peter Applebome, "Seared by Faces of Need," *The New York Times*," 13 Dec. 1992, sec. 1, p. 16.

135. See, for example: *World News Tonight with Peter Jennings*, ABC News, 13 Aug. 1992; *World News Tonight with Peter Jennings*, ABC News, 14 Aug. 1992; *Nightline*, ABC News, 9 Sept. 1992; *News*, CNN, 15 May 1992, transcript #35-3; *News*, CNN, 15 May 1992, transcript #35-2; Michael Hiltzik, "A War Within a War in Somalia," *Los Angeles Times*, 18 Aug. 1992, World Report section, p. 1; James Kindall, "Disturbing Questions," *Newsday*, 15 Sept. 1992, News section, p. 4; Anna Quindlen, "Somalia's Plagues," p. 19; Tom Dorsey, "Covering Tragedies Doesn't Necessarily Have Disastrous Consequences," *The Courier-Journal*, 7 Sept. 1992, Features section, p. 5D.

136. See, for example: Jonathan Yardley, "In Somalia, a Picture-Perfect Military Maneuver," *The Washington Post*, 14 Dec. 1992, Style section, p. B2; Lancaster, "Hitting the Beach in Glare of the Night," p. A1; Shales, "Television's Beachhead in Somalia," p. C1; Hiltzik, "Where a Gun Is a Meal Ticket," p. 1;

Jane Galbraith, "Writers' Groups Visits Hot Spots," *Los Angeles Times*, 4 Dec. 1992, sec. F, p. 8; *Nightline*, ABC News, 30 Nov. 1992.

137. See, for example: "Letters to the Editor," *The Washington Post*, 12 July 1992, Editorial section, p. C6; Robert Rotberg, "In Three Trouble Spots, Bush Should Act Now," *The Christian Science Monitor*, 10 Sept. 1992, Opinion section, p. 19; *The MacNeil/Lehrer NewsHour*, 22 July 1992; Editorial, *The Washington Post*, 10 Dec. 1992, Opinion section, p. A20; Editorial, "It's Not Our Fight, But . . ." *Newsday*, 26 July 1992, Section Currents, p. 27; Editorial, *The New York Times*, 23 July 1992, sec. A, p. 22.

138. Peter Applebome, "Seared by Faces of Need," *The New York Times*," 13 Dec. 1992, sec. 1, p. 16; Yardley, "In Somalia, a Picture-Perfect Military Maneuver," p. B2; Charles Krauthammer, "Drawing the Line at Genocide," *The Washington Post*, 11 Dec. 1992, Editorial section, p. A27.

139. John Durniak, "Pictures Needn't Move to Be Moving," *The New York Times*, 13 Dec. 1992, sec. 9, p. 19; James Warren, "Doing What the UN Failed to Do," *Chicago Tribune*, 8 Nov. 1992, Tempo section, p. 2.

140. Photo by John Trotter, *The Sacramento Bee*/JB Pictures, *U.S. News*, 30 Nov. 1992, pp. 36–37; photo by Christopher Morris, Black Star, *Time*, 14 Dec. 1992, cover, and p. 32; photo by Gianni Giansanti, Sygma for *Time*, *Time*, 14 Dec. 1992, p. 30.

141. Photo by David Turnley, Detroit Free Press/Black Star, *U.S. News*, 14 Dec. 1992, pp. 26–27.

142. For pictures of the gunmen see, for example, photo by Gideon Mendel, Network/Matrix, *U.S. News*, 14 Dec. 1992, p. 30; and photo by Turpin, Gamma-Liason, and Benoit Gysembergh, Camera Press, *Newsweek*, 14 Dec. 1992, pp. 28, 31; for pictures of the American troops see, for example, photos by Joe Traver, Gamma-Liason and by Mike Groll, AP, *Newsweek*, 14 Dec. 1992, cover and pp. 26–27; photo by Denis Paquin, AP, *U.S. News*, 21 Dec.1992, p. 4.

143. See, for example, photo by Alexandra Avakian, Contact for *Time*, *Time*, 21 Dec. 1992, p. 36; photo by Gianni Giansanti, Sygma for *Time*, *Time*, 14 Dec. 1992, p. 33; photo by Jean-Claude Coutausse, Contact Press Images, *Time*, 7 Sept. and 28 Dec. 1992, pp. 48–49 and 46–47, respectively; photo by Betty Press, Picture Group, *Newsweek*, 14 Dec. 1992, pp. 26–27.

144. For pictures of the washing of the dead, see, for example, photos by James Nachtwey, Magnum, *The New York Times Magazine*, 6 Dec. 1992, p. 41; and photo by Christopher Morris, Black Star for Time, *Time*, 14 Dec. 1992, p. 39; for pictures of the collection of the dead, see, for example, photos by James Nachtwey, Magnum, *The New York Times Magazine*, 6 Dec. 1992, pp. 38–39, 40–41; photo by Cheryl Hatch, *U.S. News*, 21 Dec. 1992, p. 62; photos by Peter Turnley, *Newsweek*, 21 Sept. 1992, p. 53; photo by Christopher Morris, Black Star for *Time*, *Time*, 14 Dec. 1992, p. 33.

145. A reference made by Clarence Page, "A Foreign Policy Driven by the Fickle Focus of TV," *Chicago Tribune*, 9 Dec. 1992, Perspective section, p. 29.

146. Johanna Neuman, "Media Brings Landing 'In Living Color,' " *USA Today*, 10 Dec. 1992, News section, p. 1A; George Kennan, "Somalia, Through a Glass Darkly," *The New York Times*, 30 Sept. 1993, sec. A, p. 25.

147. "Reliable Sources," CNN, 16 Oct. 1994.

148. Johanna Neuman, "Media Brings Landing 'In Living Color,'" *USA Today*, 10 Dec. 1992, News section, p. 1A.

149. Walter Goodman, "Somalia: How Much Did TV Shape Policy," *The New York Times*, 8 Dec. 1992, sec. C, p. 20; Tom Dorsey, "Covering Tragedies Doesn't Necessarily Have Disastrous Consequences," *The Courier-Journal*, 7 Sept. 1992, Features section, p. 5D; *World News Tonight with Peter Jennings*, ABC News, 8 Dec. 1992.

150. Stephen Hess, *International News and Foreign Correspondents* (Washington, D.C.: Brookings Institution, 1996), 2.

151. Rita Ciolli, "Somalia Images Looming Large," *Newsday*, 11 Oct. 1993, sec. A, p. x.

152. Dan Rather, "The United States and Somalia: Assessing Responsibility for the Intervention," in Girardet, *Somalia, Rwanda, and Beyond*, 32, 37.

153. Ciolli, "Somalia Images Looming Large," p. x.

Covering Death: The Americanization of Assassinations

1. Tom Wicker, "From Man to Martyr to Myth," *The New York Times*, 21 Nov. 1993, sec. 4, p. 1, 3.

2. For the best discussion of the media's reduction of the assassination story to discrete moment of coverage, see Barbie Zelizer, *Covering the Body: The Kennedy Assassination, the Media, and the Shaping of Collective Memory* (Chicago: University of Chicago Press, 1992), esp. ch. 4; but see also Art Simon, *Dangerous Knowledge: The JFK Assassination in Art and Film* (Philadelphia: Temple University Press, 1996), and Michael Rogin, "Body and Soul Murder: JFK," in *Media Spectacles*, Marjorie Garber, Jann Matlock and Rebecca Walkowitz, eds. (New York: Routledge, 1993), 3–21.

3. Wicker, "From Man to Martyr to Myth," p. 3.

4. According to a Nexis survey, the number of stories in the U.S. media during the three days following these assassinations were: for Israeli Prime Minister Yitzhak Rabin, more than 1,000; for Swedish Prime Minister Olof Palme, 96; for Sri Lankan President Ranasinghe Premadasa, 48.

5. For a discussion of the meaning of assassination in addition to those books already cited, and those mentioned below, see also: Brian Bailey, *The Assassination File* (London: WH Allen, 1991); Nachman Ben-Yehuda, "Political Assassinations as Rhetorical Devices: Events and Interpretations," in *Terrorism and Political Violence* (winter 1991): 324–50; Franklin Ford, *Political Murder: From Tyrannicide to Terrorism* (Cambridge: Harvard University Press, 1985); Brian McConnell, *Assassination* (London: Leslie Frewin, 1969); David Rapoport and Yonah Alexander, *The Morality of Terrorism: Religious and Secular Justifications* (New York: Pergamon Press, 1982); Alex Schmid, Albert Jongman, et al., *Political Terrorism* (New York: SWIDOC, 1988); Paul Wilkinson and Alasdair Stewart, eds., *Contemporary Research on Terrorism* (Aberdeen: Aberdeen University Press, 1987).

6. I use the masculine pronoun here to describe an assassin. Most assassins and would-be assassins are male, but as President Gerald Ford discovered, that is not always the case.

7. Within social science literature, such motives would fall into the concept of the "propaganda of the deed." Scholars have classified assassination into five categories, defined by the motives of the assassins: (1) Anomic Assassination, the murder of a political figure for essentially private reasons (e.g., John Hinckley and President Ronald Reagan); (2) Elite Substitution, the murder of a political leader in order to replace him with an opposing leader; (3) Tyrannicide, the murder of a despot in order to replace him with one more amenable to the needs of the people and the nation; (4) Terroristic Assassination, the murder of specified categories of people (rather than specific people) in order that an organized group may suppress and subjugate a population (e.g., the era of terror during the French revolution) although also the murder of a specific political leader by a minority group in order to intimidate those holding power (e.g. the kidnapping and assassination of Aldo Moro); (5) Propaganda by Deed, the murder of a political leader to direct attention to a problem with the hope of bringing some alleviation. (William Crotty, ed. *Assassinations and the Political Order* [New York: Harper & Row, 1971], 10–13.) See also, esp. Robert Picard, *Media Portrayals of Terrorism: Functions and Meaning of News Coverage* (Ames: Iowa State University Press, 1993), 46–47.

8. H.H.A. Cooper, *On Assassination* (Boulder: Paladin Press, 1984), 9.

9. Ibid., 7, 6.

10. Bernard Lewis, *The Assassins* (New York: Octagon Books, 1980), 129–30.

11. David Rapoport, *Assassination and Terrorism* (Toronto: Canadian Broadcasting Corp, 1971), 37–38.

12. Walter Lippman, *Public Opinion* (New York: The Free Press, 1922), 54–55.

13. Noam Chomsky and Edward Herman, *The Washington Connection and Third World Fascism* (Boston: South End Press, 1979), 6.

14. A study by L. John Maratin found that reporters will quote sources calling an act "terrorism" and its perpetrators "terrorists" if the reporters are neutral or opposed to the group involved but will not do so if there is support for the group or its cause. Study cited in Picard, *Media Portrayals of Terrorism*, 90.

15. Peter Grier, "U.S. Uncertainty at Loss of Key Ally," *The Christian Science Monitor*, 18 Aug. 1988, National section, p. 1.

16. William Safire, "Retracing the Analysis," *The New York Times*, 1 Nov. 1984, sec. A, p. 31.

17. Barbara Crossette, "Assassins Portrayed as 'Islamic Fundamentalists,'" *The New York Times*, 7 Oct. 1981, sec. A, p. 12; Daniel Williams, "Israeli Official Calls Slaying A Conspiracy; Five Held in Rabin Assassination," *The Washington Post*, 10 Nov. 1995, sec. A, p. 1.

18. David Atlee Phillips, *The Night Watch* (New York: Atheneum, 1977), 140.

19. George Gerbner, "Symbolic Functions of Violence and Terror," in *In the Camera's Eye: News Coverage of Terrorist Events*, Yonah Alexander and Robert Picard, eds. (New York: Brassey's [U.S.], Inc., 1993), 3.

20. Lippman, *Public Opinion*, 223.

21. Robert Entman, "Framing U.S. Coverage of International News: Contrasts in Narratives of the KAL and Iran Air Incidents," *Journal of Communication* 41(4) (autumn 1991): 6.

22. Barbie Zelizer, *Covering the Body* (Chicago: University of Chicago Press, 1992), 51.

23. Tom Wicker, "A Reporter Must Trust His Instinct," *Saturday Review*, 11 Jan. 1964, p. 81; *News*, CNN, 4 Nov. 1995, 3:14 P.M., transcript #783-1.

24. Lee Lescaze and Martin Schram, "U.S. Reacts Bitterly to Loss of Sadat," *The Washington Post*, 7 Oct. 1981, sec. A, pp. 1, 21; Tom Shales, "The Caution and the Fear," *The Washington Post*, 7 Oct. 1981, sec. B, p. 1.

25. David Ottaway, "Egyptian Leader Was Key U.S. Ally," *The New York Times*, 7 Oct. 1981, sec. A, p. 1; Norman Kempster, "3 Groups Claim Role in Killing," *L.A. Times*, 7 Oct. 1981, sec. A, p. 1.

26. Dwaine Marvick and Elizabeth Wirth Marvick, "The Political Consequences of Assassination," in William Crotty, ed. *Assassinations and the Political Order* (New York: Harper & Row, 1971), 510.

27. Elaine Sciolino, "Assassins Usually Miss the Larger Target," *The New York Times*, 12 Nov. 1995, sec. E, p. 4.

28. A study of broadcast news decision makers found that terrorism is covered the same as all other news: Emphasis is placed on getting the facts about the breaking news events and only later, if there is time and interest, is any explanation or interpretation of the events given. Study by L. John Martin and Yossi Draznin, quoted in Picard, *Media Portrayals of Terrorism*, 87.

29. Editorial, "Anwar Sadat," *The Washington Post*, 7 Oct. 1981, sec. A, p. 26; editorial, "Yitzhak Rabin," *The Washington Post*, 5 Nov. 1995, sec. C, p. 6.

30. Tom Squitieri, "Investigation of Jewish Extremism Reaches into USA," *USA Today*, 7 Nov. 1995, sec. A, p. 3.

31. See, for example, Richard Pearlstein, "Tuned-in Narcissus: the Gleam in the Camera's Eye," in *In the Camera's Eye*, 49–57; Russell Farnen, "Terrorism and the Mass Media: A Systemic Analysis of a Symbiotic Process," *Terrorism* 13, 1990: 99–143; and Robert Entman, "Framing U.S. Coverage of International News," pp. 6–27.

32. Max Frankel, "Scene but Not Heard," *The New York Times Magazine*, 10 May 1998, p. 18.

33. For another study of language and assassinations and terrorism, about Aldo Moro, see Howard Davies and Paul Walton, "Death of a Premier: Consensus and Closure in International News," in *Language, Image, Media*, Howard Davies and Paul Walton, eds. (Oxford: Basil Blackwell, 1983), 7–49.

34. Robert Entman, "Framing U.S. Coverage of International News," p. 9.

35. Max Lerner, "Assassination," in *Encyclopaedia of the Social Sciences*, ed. Edwin Seligman, vol. II (New York: MacMillian, 1930), 275.

36. Editorial, "Legacy Worthy of Rabin: Overall Mideast Peace," *USA Today*, 6 Nov. 1995, sec. A, p. 10; editorial, "Sadat," *L.A. Times*, 7 Oct. 1981, sec. II, p. 6.

37. UPI, "Times Likens Sadat to JFK," 6 Oct. 1981, International section, AM cycle; Jim Hoagland, "Rabin Perished in Brutal War," *The Washington Post*, 5 Nov. 1995, sec. A, p. 31.

38. Hugh Sidey, "Bonds of a Very Small Club," *Time*, 19 Oct. 1981, p. 33; John Ficara, photo in *Newsweek*, 20 Nov. 1995, pp. 54–55.
39. *The MacNeil Lehrer NewsHour*, 17 Aug. 1988, transcript #3239.
40. Tyler Marshall, "Gandhi One of World's Most Powerful, Controversial Women," *L.A. Times*, 1 Nov. 1984, sec. I, p. 19; and Sylvana Foa, "She Wanted a Better India; Hate Hurt Her," *L.A. Times*, 1 Nov. 1984, sec. I, p. 19.
41. Richard Weintraub, "Gandhi and the Sikhs: A Policy Gone Awry," *The Washington Post*, 2 Nov. 1984, sec. A, p. 30.
42. Eric Pack, "Sikh Separatism Dates Back to '47," *The New York Times*, 1 Nov. 1984, sec. A, p. 24.
43. Pranay Gupte, *Vengeance: India After the Assassination of Indira Gandhi* (New York: W. W. Norton, 1985), 65–66.
44. *Time* cover, 12 Nov. 1984. Painting by Mario Donizetti.
 Works used for this history, in addition to those already cited, include: H. W. Brands, *India and the United States: The Cold Peace* (Boston: Twayne Publishers, 1990); M. Srinivas Chary, *The Eagle and the Peacock: U.S. Foreign Policy Toward India Since Independence* (Westport, CT: Greenwood Press, 1995); Beau Grosscup, *The New Explosion of Terrorism* (Far Hills, NJ: New Horizon Press, 1991); Pranay Gupte, *Mother India: A Political Biography of Indira Gandhi* (New York: Charles Scribner's Sons, 1992); Satu Limaye, *U.S.–Indian Relations: The Pursuit of Accommodation* (San Francisco: Westview Press, 1993); Ian Mulgrew, *Unholy Terror: The Sikhs and International Terrorism* (Toronto: Key Porter Books, Ltd., 1988); Ritu Sarin, *The Assassination of Indira Gandhi* (New Delhi: Penguin Books, 1990)
45. Editorial, "Pakistan After Zia," *The New York Times*, 18 Aug. 1988, sec. A, p. 26; Editorial, "Pakistan Tests Get No Easier," *Chicago Tribune*, 18 Aug. 1988, sec. 1, p. 24; and editorial, "Pakistan: A Changing Picture," *L.A. Times*, 18 Aug. 1988, sec. II, p. 6.
46. Russell Watson, "Who Killed Gen. Zia?" *Newsweek*, 29 Aug. 1988, p. 30; James Barron, "The Foes of Zia: So Many, So Bitter, *The New York Times*, 19 Aug. 1988, sec. A, p. 8; and graphic by Jeff Dionise, "Presidential Enemies," *USA Today*, 18 Aug. 1988, sec. A, p. 6.
47. Shireen Mazari, "The Militarization of Pakistan's Civil Society," in *Internal Conflicts in South Asia*, ed. Kumar Rupesinghe and Khawar Mumtaz (London: Sage Publications, 1996), 96–108.
48. Christina Lamb, *Waiting for Allah: Pakistan's Struggle for Democracy* (London: Hamish Hamilton, 1991), 26.
49. Steven Weisman, "What Zia's Death Means For Pakistan and the U.S." *The New York Times*, 21 Aug. 1988, sec. 4, p. 1.
50. Bhutto quoted in Michael Serril, "Death in the Skies," *Time*, 29 Aug. 1988, p. 32.
51. From the U.S. Air Force report, quoted in Masroor Hussain and Muzammil Pasha, *Nineteen Eighty-Eight* (Islamabad: Profile Publishing, 1989), 78.
52. Lamb, *Waiting for Allah*, p. 91.
53. Karen DeYoung, "Shultz in Pakistan for Zia Burial," *The Washington Post*, 20 Aug. 1988, sec. A, p. 11.

54. Works used for this history, in addition to those already cited, include: General Khalid Mahmud Arif, *Working with Zia: Pakistan's Power Politics: 1977–1988* (Karachi: Oxford University Press, 1995); Shahid Javed Burki and Craig Baxter, *Pakistan Under the Military: Eleven Years of Zia ul-Haq* (San Francisco: Westview Press, 1991); Kumar Rupesinghe and Khawar Mumtaz, eds. *Internal Conflicts in South Asia* (Thousand Oaks, CA: Sage Publications, 1996).

55. Kamran Khan, "Zia, U.S. Envoy Killed in Pakistan Plane Blast," *The Washington Post*, 18 Aug. 1984, sec. A, p. 1.

56. R. W. Apple, "Terrorism Changes the Way World's Leaders Live," *The New York Times*, 4 Nov. 1984, sec. A, p. 1.

57. John Goshko, "World Terrorism Up 7%, U.S. Says," *The Washington Post*, 23 Aug. 1988, sec. A, p. 10.

58. Gupte, *Mother India*, p. 25.

59. And a month and a half after Gandhi's death, in mid-December 1984, two more extravaganzas about India came out: first David Lean's movie version of E. M. Forster's *A Passage to India* on Friday, December 14, and then two days later the start of public television's lengthy retelling of Paul Scott's *Raj Quartet*, retitled *The Jewel in the Crown*, which garnered the highest ratings ever for a PBS miniseries. Even though *A Passage to India* and *The Jewel in the Crown* appeared after Indira Gandhi's assassination, there was already considerable talk in the media about them.

60. "Karen De Witt, "Pakistani's Death 'Major Blow' to U.S.," *USA Today*, 18 Aug. 1988, sec. A, p. 1.

61. Stuart Auerbach, "'Indira Is India,'" *The Washington Post*, 1 Nov. 1984, sec. A, p. 27; and Terry Atlas, "Pakistanis Are Left Wondering Who Will Fill Vacuum After Zia," *Chicago Tribune*, 21 Aug. 1988, sec. 1, p. 12.

62. Russell Watson, et al., "After Indira," *Newsweek*, 12 Nov. 1984, p. 42; Smith, "Death in the Garden," p. 42.

63. Michael Serril, "Death in the Skies," *Time*, 29 Aug. 1988, p. 32.

64. Watson, et al., "After Indira," p. 42.

65. William Stevens, "Gandhi, Slain, Is Succeeded by Son," *The New York Times*, 1 Nov. 1984, sec. A, pp. 18–19; and P. P. Balachandran, "Gandhi's Son Sworn In," *The Washington Post*, 1 Nov. 1984, sec. A, p. 29; and Linda Charlton, "Indira Gandhi, Born to Politics, Left Her Own Imprint on India," *The New York Times*, 1 Nov. 1984, sec. A, p. 21.

66. Barbara Crossette, "Pakistanis Quietly Showing Rare Unity After Zia's Death," *The New York Times*, 20 Aug. 1988, sec. A, p. 3.

67. James Barron, "The Foes of Zia: So Many, So Bitter, *The New York Times*, 19 Aug. 1988, sec. A, p. 8.

68. Monica Collins, "'GMA' Shelved Stars to Cover Gandhi Story," *USA Today*, 1 Nov. 1984, sec. D, p. 7.

69. John Carmody, "The TV Column," *The Washington Post*, 2 Nov. 1984, sec. C, p. 8.

70. Gupte, *Mother India*, p. 25.

71. "India Protests U.S. TV Coverage," *The New York Times*, 9 Nov. 1984, sec. A, p. 8.

72. David Gelman and Peter McKillop, "The Assassins: Terror Breeds the Politics of Homicide," *Newsweek*, 12 Nov. 1984, p. 65.

73. Michael Goodwin, "A Soldier of Peace," *Daily News* (New York), 5 Nov. 1995, News section, p. 2; Andy Rooney, "Pondering an Unnatural Death," *The Ledger* (Lakeland, FL), 11 Nov. 1995, sec. C, p. 7.

74. Frank Richter, "Lessons from the Assassination of Rabin," *The Detroit News*, 7 Nov. 1995, Opinion section, p. x.

75. Martin Sieff, "Sobering Parallels with U.S. History," *The Washington Times*, 12 Nov. 1995, sec. B, p. 4.

76. Editorial, "Anwar Sadat," *The Washington Post*, 7 Oct. 1981, sec. A, p. 26; editorial, "One Extraordinary Man," *The New York Times*, 7 Oct. 1981, sec. A, p. 26.

77. Quoted in Thomas Lippman, "Anwar Sadat, 1918–1981," *The Washington Post*, 7 Oct. 1981, sec. A, p. 20.

78. Quoted in Eric Pace, "Anwar el-Sadat, the Daring Arab Pioneer of Peace with Israel," *The New York Times*, 7 Oct. 1981, sec. A, p. 10.

79. Edwin Diamond and Paula Cassidy, "Arabs vs. Israelis: Has Television Taken Sides?" *TV Guide*, 6 Jan. 1979, p. 7; Meg Greenfield, "Our Ugly Arab Complex," *The Washington Post*, 30 Nov. 1977, sec. A, p. 23.

80. For an excellent study of the television coverage of the Jerusalem trip, see Magda Bagnied and Steven Schneider, "Sadat Goes to Jerusalem: Televised Images, Themes, and Agenda," in *Television Coverage of the Middle East*, ed. William Adams (Norwood, NJ: Ablex Publishing Corp., 1981), 53–66; and for a study of television coverage of global events in general see James Larson, *Television's Window of the World: International Affairs Coverage on the U.S. Networks* (Norwood, NJ: Ablex Publishing Corp., 1984), 13.

81. Quoted in Bagnied and Schneider, "Sadat Goes to Jerusalem," p. 59.

82. For an excellent study of the television coverage of the Camp David accords, see William Spragens and Carole Ann Terwood, "Camp David and the Networks: Reflections on Coverage of the 1978 Summit," in *Television Coverage of International Affairs*, pp. 117–27.

83. "Key Suspect: Moslem Gang of Terrorists," *The New York Times*, 8 Oct. 1981, sec. A, p. 11.

84. Niccolò Machiavelli, *The Prince*, trans and ed. Robert Adams (New York: W. W. Norton, 1977), p. 53.

85. Works used in this history, in addition to those cited above, include: Raymond Baker, *Sadat and After* (Cambridge: Harvard University Press, 1990); William Burns, *Economic Aid and American Policy toward Egypt, 1955–1981* (Albany: SUNY Press, 1985); Fred Halliday, *Islam and the Myth of Confrontation* (New York: I. B. Tauris Pub., 1995); Mohamed Heikal, *Autumn of Fury: The Assassination of Sadat* (New York: Random House, 1983); Nabeel Jabbour, *The Rumbling Volcano: Islamic Fundamentalism in Egypt* (Pasadena, CA: Mandate Press, 1993); Thomas Lippman, *Egypt after Nasser: Sadat, Peace and the Mirage of Prosperity* (New York: Paragon House, 1989); Jehan Sadat, *A Woman of Egypt* (London: Bloomsbury Pub., 1987).

86. "Yitzhak Rabin," *The Washington Post*, 5 Nov. 1995, sec. C, p. 6; "The Rabin Assassination," *The New York Times*, Nov. 15, 1995, sec. E, p. 14.

87. Glenn Frankel, "Yitzhak Rabin, 1922–1995," *The Washington Post*, 5 Nov. 1995, sec. A, p. 1, 36; Marilyn Berger, "Yitzhak Rabin, 73, a Soldier Turned Prime Minister and Peacemaker," *The New York Times*, 15 Nov. 1995, sec. A, p. 16.

88. For a brief discussion of the so-called "break the bones" command, see Clyde Haberman, "Recalling a Peacemaker, Hard Crust and All," *The New York Times*, 6 Nov. 1995, sec. A, p. 1.

89. *This Week with David Brinkley*, ABC News, 5 Nov. 1995, transcript #732.

90. David Horovitz, ed. *Yitzhak Rabin: Soldier of Peace* (London: Peter Halban, 1996), 12–13.

91. Evan Thomas, "Can Peace Survive," *Newsweek*, 13 Nov. 1995, pp. 42–43.

92. Cartoon by Michael Ramirez, *Memphis Commercial Appeal*, for *USA Today*, 6 Nov. 1995, sec. A, p. 10.

Works used in this history, in addition to those cited above, include: Dan Kurzman, *Soldier of Peace: The Life of Yitzhak Rabin* (New York: HarperCollins, 1998); Yitzhak Rabin, *The Rabin Memoirs* (New York, Little, Brown, 1979); David Schoenbaum, *The United States and the State of Israel* (New York: Oxford University Press, 1993); Samuel Seger, *Crossing the Jordan: Israel's Hard Road to Peace* (New York: St. Martin's Press, 1998).

93. Tom Shales, "The Year of the Terrible," *The Washington Post*, 27 Dec. 1981, sec. F, p. 5; and Tom Shales, "The Caution and the Fear," *The Washington Post*, 7 Oct. 1981, sec. B, p. 1.

94. Janice Castro and Janice C. Simpson, "Groping for News from Cairo," *Time*, 19 Oct. 1981, p. 62.

95. Ibid.

96. Shales, "The Caution and the Fear,"sec. B, p. 1.

97. CNN was the first network on the air that afternoon with a wire service report of gunshots at the rally—one minute before CBS.

98. Dusty Saunders, "CNN Left Commercial Networks on Sidelines in Rabin Coverage," *Rocky Mountain News*, 7 Nov. 1995, sec. D, p. 12.

99. Some of the details of this history are from David Bianculli, "Interruptions Wrong at Rabin Service," *Daily News* (New York), 7 Nov. 1995, Television section, p. 77; John Carmody, "The TV Column," *The Washington Post*, 7 Nov. 1995, sec. E, p. 4; Monica Collins, "TV Shows Its Strength," *The Boston Herald*, 7 Nov. 1995, Television section, p. 38; Tim Cuprisin, "Sharing in the Moment," *Milwaukee Journal Sentinel*, 7 Nov. 1995, Cue and Family section, p. 3; Phil Kloer, et al., "Rabin Assassination," *The Atlanta Journal-Constitution*, 6 Nov. 1995, sec. A, p. 9; Ellen O'Brien, "CBS, CNN Led Networks on Reporting Shooting," *The Boston Globe*, 5 Nov. 1995, sec. A, p. 22; Howard Rosenberg, "Television: From Rabin's Funeral, the Scene and the Unseen," *L.A. Times*, 7 Nov. 1995, sec. F, p. 1

100. *News*, CNN, 4 Nov. 1995, 5:51 P.M., transcript #783-18.

101. *This Week with David Brinkley*, ABC News, 5 Nov. 1995, transcript #732.

102. Howard Rosenberg, "Television: From Rabin's Funeral, the Scene and the Unseen," *L.A. Times*, 7 Nov. 1995, sec. F, p. 1.

103. David Bianculli, "Interruptions Wrong at Rabin Service," *Daily News* (New York), 7 Nov. 1995, Television section, p. 77.

Bloody page photo: David Ruginger for *Time*, *Time*, 20 Nov. 1995, p. 84; and Levine, Sipa, *Newsweek*, 20 Nov. 1995, p. 57.

104. See David Ottaway, "Pandemonium," *The Washington Post*, 7 Oct. 1981, sec. A, pp. 1, 16; and Steven Hindy, "I Heard 'Pop, Pop' of Killers' Guns," *Chicago Tribune*, 7 Oct. 1981, sec. 1, p. 1; also see, for example, the "first-person" article by Mary Curtius, "Tough, Sentimental—Rabin Personified Israel," *L.A. Times*, 5 Nov. 1995, sec. A, p. 9. Even Amir had his first-person commentators, see Yossi Klein Halevi, "A Murder Foreshadowed," *Time*, 20 Nov. 1995, p. 84.

105. James LeMoyne, et al., "Behind the Gunmen," *Newsweek*, 19 Oct. 1981, p. 36.

106. Edward Said, *Covering Islam: How the Media and the Experts Determine How We See the Rest of the World* (New York: Pantheon, 1981), 114, 6.

107. See, for example, Michael Getler and Scott Armstrong, "Sadat May Have Had Warning Signs of Assassination Attempt," *The Washington Post*, 7 Oct. 1981, sec. A, p. 19; and James LeMoyne, et al., "Behind the Gunmen," *Newsweek*, 19 Oct. 1981, p. 36; Barbara Crossette, "Assassins Portrayed as 'Islamic Fundamentalists,'" *The New York Times*, 7 Oct. 1981, sec. A, p. 12.

108. George Russell, et al., "A Nasty Reality of Our Times," *Time*, 19 Oct. 1981, p. 28.

109. See, for example, Evan Thomas, "Can Peace Survive?" *Newsweek*, 13 Nov. 1995, p. 43; and Tom Masland, et al., "Israel vs. Israel: The Enemy Within," *Newsweek*, 13 Nov. 1995, p. 47.

110. Russell Watson and Mark Dennis, "Who Is to Blame?" *Newsweek*, 20 Nov. p. 57; Said, *Covering Islam*, 140.

111. Paul Vitello, "The Rabin Funeral: The Shots that Wound Us All," *Newsday*, 7 Nov. 1995, sec. A, p. 6.

112. See "Now the Shock Waves," *U.S. News & World Report*, 19 Oct. 1981, cover, p. 24; Evan Thomas, "Will Peace Survive?" *Newsweek* 13 Nov. 1995, cover, pp. 42–43; Oswald Johnson, "Sadat's Death Clouds Mideast Peace Accords," *L.A. Times*, 7 Oct. 1981, sec. 1, p.1; Lee Michael Katz, "Peace Process Could Falter Without Rabin," *USA Today*, 6 Nov. 1995, sec. A, p. 1.

113. Lee Lescaze, "The Funeral," *The Washington Post*, Oct. 8 1981, sec. A, p. 1; and Leslie Gelb, "U.S. Had Advised Sadat Since '74 on Security," *The New York Times*, 8 Oct. 1981, sec. A, p. 1.

114. Jonathan Sapers, "American Sympathizers: Where the Killer Is a Hero," *U.S. News*, 20 Nov. 1995, p. 74; Jonathan Peterson, "Israeli Settlers Rely on U.S. Donations to Keep Effort Alive," *L.A. Times*, 6 Nov. 1995, sec. A, p. 11; Michael Lemonick, "Roots of Israeli Extremism," *Time*, 13 Nov. 1995, p. 63.

115. Richard Cooper, "Rabin's Death, Like J.F.K.'s, Could Breed Skeptics," *L.A. Times*, 7 Nov. 1995, sec. A, p. 5.

116. Photo reefer, *L.A. Times*, 7 Nov. 1995, sec. A, p. 1; UPI photo in Hugh Sidey, "Bonds of a Very Small Club," *Time*, 19 Oct. 1981, p. 33.

117. Marjorie Miller, "Leah Rabin 'Larger Than Life,'" *L.A. Times*, 7 Nov. 1995, sec. A, p. 9.

118. For smirking images of the assassins, see, for example, AP photo in Barton Gellman and Laura Blumenfeld, "Israel's Mainstream Brings Forth a Killer,"

The Washington Post, 12 Nov. 1995, sec. A, p. 1; Ziv Koren, Sygma, *Newsweek*, 20 Nov. 1995, p. 56B; Patrice Barrat, Gamma-Liaison photo in Michael Reese and John Walcott, "Uniting Against Libya," *Newsweek*, 19 Oct. 1981, p. 39.

119. Rooney, "When Television Is at Its Best," p. 5.

120. Goodwin, "Soldier of Peace," *Time*, 13 Nov. 1995, p. 56.

Covering War: Getting Graphic About Genocide

1. This photograph, from the KDP Archive, Salahaddin, obtained through the courtesy of Susan Meiselas and Random House (and reprinted in color on p. 314 of Meisela's book *Kurdistan: In the Shadow of History*) is similar but not identical to the image that ran in *The Washington Post* on 24 March, 1988. *The Post*'s image, credited to the Islamic Republic News Agency via Agence France Presse, was unobtainable. Both images show members of the news media filming or taking photographs of the same father and infant son victims.

2. Steven Erlanger, "World War II's Unfinished Business," *The New York Times*, 16 Feb. 1997, sec. E, p. 14.

3. John Darnton, "Does the World Still Recognize a Holocaust?" *The New York Times*, 25 April 1993, sec. 4, p. 1.

4. J. F. O. McAllister, "Atrocity and Outrage," *Time*, 17 Aug. 1992, p. 21.

5. "International Correspondents," CNN, 9 May 1994, transcript #104; Keith Richburg, "Witnesses Describe Cold Campaign of Killing in Rwanda," *The Washington Post*, 8 May 1994, sec. A, p. 1.

6. Jennifer Parmelee, "Fade to Blood," *The Washington Post*, 24 April 1994, sec. C, p. 3.

7. Charles Lane, "When Is It Genocide?" *Newsweek*, 17 Aug. 1992, p. 27.

8. Eric Schmitt, "Americans Decide War Might Not Be Quite So Scary," *The New York Times*, 30 Nov. 1997, sec. 4, p. 1.

9. See McAllister, "Atrocity and Outrage," p. 21; Warren Strobel, "The CNN Effect," *American Journalism Review*, May 1996, p. 32; Elizabeth Kastor, "Indelible Images," *The Washington Post*, 30 Sept. 1994, sec. F, p. 1; Strobel, "The CNN Effect," p. 32.

10. McAllister, "Atrocity and Outrage," p. 21; Strobel, "The CNN Effect," p. 32.

11. Michael Beschloss, "The Video Vise: TV Squeezes Our Bosnia Options," *The Washington Post*, 2 May 1993, sec. C, p. 1.

12. Strobel, "The CNN Effect," p. 32.

13. Elizabeth Kastor, "Indelible Images," *The Washington Post*, 30 Sept. 1994, sec. F, p. 1.

14. Janine DiGiovanni, "Tired Moving of the Pictures," *Sunday Times* (London), 14 Aug. 1994, Features section; Kastor, "Indelible Images," p. 1.

15. David Rieff, *Slaughterhouse: Bosnia and the Failure of the West* (New York: Touchstone, 1995), 24.

 The categorizing and assigning of numerical rankings to countries in crisis is not only a habit of U.N. officials or journalists. Population Crisis Committee, a nonprofit organization in Washington, D.C. produces a cheerfully colored chart called the "Human Suffering Index" rating misery around the globe.

16. Rieff, *Slaughterhouse*, 24.
17. Mort Rosenblum, *Who Stole the News?* (New York: John Wiley & Sons, 1993), 9; "International Correspondents," CNN, 9 May 1994, transcript #104.
18. Brigid Schulte, "Why Did Press Ignore East Timor Massacre?" *Washington Journalism Review*, July/Aug. 1992, p. 12.

 For another interesting account of the press coverage of East Timor, see Edward Herman, "Diversity of News: 'Marginalizing' the Opposition," *Journal of Communication* 35(3) 1985; and "a response," *Journal of Communication* 36(1) 1986: 189–92. For an account of the press coverage of Cambodia, see William Adams and Michael Joblove, "The Unnewsworthy Holocaust," in *Television Coverage of International Affairs*, ed. William Adams (Norwood, NJ: Ablex, 1982), 217–26.
19. Barbara Crossett, "Before Rwanda, Before Bosnia," *The New York Times*, 25 Feb. 1996, sec. 4, p. 5.
20. Alain Destexhe, *Rwanda and Genocide in the Twentieth Century* (New York: New York University Press, 1995), 2.
21. Walter Laqueur and Barry Rubin, eds. *The Human Rights Reader* (New York: Meridian, 1989), 203–4.
22. Charles Lane, "When Is It Genocide?" *Newsweek*, 17 Aug. 1992, p. 27.

 Other useful references to the meaning of genocide and the Holocaust other than those cited above and below include: Israel Charny and Chanan Rapaport, *How Can We Commit the Unthinkable? Genocide: The Human Cancer* (Boulder: Westview Press, 1982); Barbara Harff and Ted Gurr, "Toward Empirical Theory of Genocides and Politicides," *International Studies Quarterly* 32, 1988: 359–71; Herbert Kelman, "Violence without Moral Restraint," *Journal of Social Issues* 29, 1973: 25–61; Leo Kuper, Genocide: Its Political Use in the Twentieth Century (New Haven: Yale University Press, 1982); Michael Marrus, *The Holocaust in History* (Hanover, CT: University Press of New England, 1987); Ervin Staub, *The Roots of Evil: The Origins of Genocide and Other Group Violence* (Cambridge: Cambridge University Press, 1989); John Thompson and Gail Quets, "Genocide and Social Conflict," *Research in Social Movements, Conflict and Change* 12, 1990: 245–66; Isador Wallimann and Michael Dobkowski, eds. *Genocide and the Modern Age* (New York: Greenwood Press, 1987).
23. Dextexhe, *Rwanda and Genocide in the Twentieth Century*, p. 14; Douglas Jehl, "Officials Told to Avoid Calling Rwanda Killings 'Genocide,'" *The New York Times*, 10 June 1994, sec. A, p. 8.
24. Jehl, "Officials Told to Avoid Calling Rwanda Killings 'Genocide,'" sec. A, p. 8.

 The United States had only a small AID program in Rwanda, $19.4 million, of which $15.8 million was food assistance. The Peace Corps program had had 32 volunteers in the country when the program was shut down in 1993 due to unrest. John Hammock and Joel Charny, "Emergency Response as Morality Play," in *From Massacres to Genocide*, ed. Robert Rotberg and Thomas Weiss (Washington, D.C.: Brookings Institution, 1996), 120.
25. Roy Gutman, *Witness to Genocide* (New York: Macmillan, 1993), 44.
26. Theodore Stanger, "Massacre in Halabja," *Newsweek*, 4 April 1988, p. 38.

27. Russell Watson, et al., "Ethnic Cleansing," *Newsweek*, 17 Aug. 1992, p. 16.

28. See note 24.

29. Gutman, *Witness to Genocide*, xiii.

30. Theodore Stanger, "Massacre in Halabja," *Newsweek*, 4 April 1988, p. 38.

31. Nancy Gibbs, "WHY? The Killing Fields of Rwanda," *Time*, 16 May 1994, p. 57.

32. See Gibbs, "WHY? The Killing Fields of Rwanda," pp. 56–63; Joshua Hammer, "The Killing Fields," *Newsweek*, 23 May 1994, pp. 46–47.

33. Watson, et al., "Ethnic Cleansing," p. 16.

34. "International Correspondents," CNN, 9 May 1994, transcript #104.

35. Usha Lee McFarling, "Donations Pour into Relief Agencies," *The Boston Globe*, 24 July 1994, sec. 1, p. 1.

36. Elizabeth Kastor, "Indelible Images," *The Washington Post*, 30 Sept. 1994, sec. F, p. 1.

37. See Gutman, *Witness to Genocide*, p. 41; Gibbs, "WHY? The Killing Fields of Rwanda," p. 59.

38. DiGiovanni, "Tired Moving of the Pictures."

39. Paul Colford, "In Magazine Sales, The World Is Too Big," *Newsday*, 9 March 1995, sec. B, p. 2.

40. DiGiovanni, "Tired Moving of the Pictures."

41. Gibbs, "WHY? The Killing Fields of Rwanda," p. 58.

42. Lane, "When Is It Genocide?" p. 27.

43. Joan Connell, "The Laws of War," *The Plain Dealer*, 26 Nov. 1995, sec. C, p. 1.

44. Gutman, *Witness to Genocide*, p. v.

45. Fergal Keane, *Season of Blood* (New York: Viking, 1995), 191. Keane did a episode for PBS's *Frontline* featuring Nyarubye, called "Valentina's Nightmare."

46. DiGiovanni, "Tired Moving of the Pictures."

47. Leonard P. Ayres, *The War with Germany: A Statistical Summary* (Washington, D.C., 1919), 78.

48. Richard Cohen, "And Iraq Keeps Spreading its Poison Gas," *The Washington Post*, 7 Sept. 1988, sec. A, p. 19.

49. Jim Hoagland, "Atrocity du Jour," *The Washington Post*, 26 March 1988, sec. A, p. 2.

 The figure of 3,200 for the number of deaths comes from the total number of individual names collected in the course of systematic interviews with survivors. The total number is certainly higher. The Kurdish and Iranian estimates are that at least 4,000 died and possibly as many as 7,000. Human Rights Watch/Middle East, *Iraq's Crime of Genocide: The Anfal Campaign Against the Kurds* (New Haven: Yale University Press, 1995), 72.

50. Hoagland, "Atrocity du Jour," sec. A, p. 2.

51. Paul Conrad, political cartoon: "Iraq's 'Final Solution,'" *L.A. Times*, 3 Oct. 1988, sec. 2, p. 5.

52. Norman Kempster, "U.S. Says Iraqi Use of Poison Gas on Kurds is 'Abhorrent,'" *L.A. Times*, 9 Sept. 1988, sec. 1, p. 9; Don Oberdorfer, "U.S. Charges Iraq Used Poison Gas on Kurds," *The Washington Post*, 9 Sept. 1988, sec. A, p. 1.

53. Cohen, "And Iraq Keeps Spreading its Poison Gas."
54. Kevin McKiernan, "Kurdistan's Season of Hope," *LA Times Magazine*, 23 Aug. 1992, p. 30.
55. Human Rights Watch, *Iraq's Crime of Genocide*, p. 262.
56. Document 14 in Human Rights Watch/Middle East, *Bureaucracy of Repression: The Iraqi Government in Its Own Words* (New York: Human Rights Watch, 1994), 68.
57. Definition given in Kanan Makiya, *Cruelty and Silence; War, Tyranny, Uprising, and the Arab World* (New York: W. W. Norton, 1993), 156–57.
58. David McDowall, *A Modern History of the Kurds* (New York: I. B. Tauris & Company, 1996), 359.
59. Gwynne Roberts, "Silent Holocaust of the Kurds," *The Independent*, 11 January 1992, Foreign News section, p. 9.
60. Hoagland, "Atrocity du Jour," p. 2.
61. Human Rights Watch, *Iraq's Crime of Genocide*, p. xvii.
62. Makiya, *Cruelty and Silence*, p. 168; Human Rights Watch, *Iraq's Crime of Genocide*, p. xxi.
 In addition to the works mentioned above, the important and groundbreaking work of Susan Meiselas, *Kurdistan: In the Shadow of History* (New York: Random House, 1997) was invaluable.
63. News services and staff, "Iran Says It Has Iraqi Border City," *The Washington Post*, 18 March 1988, sec. A, p. 19.
64. *Chicago Tribune* wires, "Iran Claims Iraq Gassing Killed 5,000," *Chicago Tribune*, 21 March 1988, News section, p. 4.
65. Alan Cowell, "54 Feared Dead on 2 Oil Tankers in Iraqi attack on Iran Terminal," *The New York Times*, 22 March 1988, sec. A, p. 1.
66. David Ottaway, "U.S. Decries Iraqi Use of Chemical Weapons," *The Washington Post*, 24 March 1988, sec. A, p. 37.
67. Ibid.
68. Patrick Worsnip, "Gas Bombing Empties Town of Life," *Chicago Tribune*, 24 March 1988, News section, p. 5; Patrick Tyler, "Poison Gas Attack Kills Hundreds," *The Washington Post*, 24 March 1988, sec. A, p. 1.
69. Editorial, "Ghastly Weapon," *L.A. Times*, 26 March 1988, sec. 2, p. 8; editorial, "Poison Gas: Iraq's Crime," *The New York Times*, 26 March 1988, sec. 1, p. 30.
70. Editorial, "Chemical War, Again," *The Washington Post*, 27 March 1988, sec. 6; p. 6.
71. *Tribune* wire service, "Iraq Threatens Iranian Cities with Toxic Gas," *The San Diego Union-Tribune*, 29 March 1988, sec. A, p. 1; Candice Hughes, AP, "Five Survivors Find Themselves Trapped in Middle of Iran-Iraq Propaganda War," *L.A. Times*, 1 May 1988, sec. 1, p. 12.
72. Youssef Ibrahim, "Iran Reports New Iraqi Gas Raids," *The New York Times*, 2 April 1988, sec. 1, p. 1.
73. Charles Wallace, "Rebels Join Forces with Iran," *L.A. Times*, 3 April 1988, sec. 1, p. 1; Malcolm Browne, "Chemical Weapons," *The New York Times*, 17 April 1988, sec. 4, p. 7.
74. John Barnes, et al., "Truce in Troubled Waters?" *U.S. News*, 1 Aug. 1988, p. 28.

75. Jill Smolowe, "Return of the Silent Killer," *Time*, 22 Aug. 1988, pp. 46–49.

76. Alan Cowell, "Gulf Truce Leaves Revels in a Quandary," *The New York Times*, 28 Aug. 1988, sec. A, p. 15.

77. See, for example, Reuters, "More Chemical Attacks Reported," *The New York Times*, 28 Aug. 1988, sec. A, p. 15; *Tribune* wires and Uli Schmetzer, "Border Issue Slows Talks by Iran, Iraq," *Chicago Tribune*, 27 Aug. 1988, News section, p. 1.

78. Jonathan Randal, "Kurds Tell of Mass Gassing," *The Washington Post*, 25 Sept. 1988, sec. A, p. 1; Patrick Tyler, "The Kurds: It's Not Genocide," *The Washington Post*, 25 Sept. 1988, sec. C, p. 5.

79. AP, "Genocide Alleged," *L.A. Times*, Sept 11, 1988, sec. 1, p. 1.

80. Jill Smolowe, "Where Is the Outrage?" *Time*, 26 Sept. 1988, p. 36.

81. Patrick Tyler, "Scorched Kurdish Villages Bear Witness to Iraqi Assault," *The Washington Post*, 17 Sept. 1988, sec. A, p. 1.

82. Patrick Tyler, "The Kurds: It's Not Genocide," *The Washington Post*, 25 Sept. 1988, sec. C, p. 5.

83. Milton Viorst, "Poison Gas and 'Genocide': The Shaky Case Against Iraq," *The Washington Post*, 5 Oct. 1988, sec. A, p. 25.

84. Clyde Haberman, "Kurds Can't Go Home Again Because the Homes Are Gone," *The New York Times*, 18 Sept. 1988, sec. 1, p. 1.

85. Gary Thatcher and Timothy Aeppel, "Poison on the Wind," *The Christian Science Monitor*, 13 Dec. 1988, sec. B, p. 1.

86. Kevin McKiernan, "Kurdistan's Season of Hope," *L.A. Times Magazine*, 23 Aug. 1992, p. 30.

87. Jim Hoagland, "A 'Furlough' for Iraq," *The Washington Post*, 12 Oct. 1988, sec. A, p. 19.

88. Alan Cowell, "Iran Charges Iraq with Gas Attack," *The New York Times*, 24 March 1988, sec. A, p. 11.

89. Patrick Tyler, "Poison Gas Attack Kills Hundreds," *The Washington Post*, 24 March 1988, sec. A, p. 1, 36.

90. "Sudden Death from the Clouds," *Time*, 4 April 1998, p. 29 (photos by Pessemier, Sygma); Theodore Stanger, *Newsweek*, 4 April 1988, p. 38 (photo by Patrick Tyler, *The Washington Post*); "New Horrors in a Long-Running Horror Show," *U.S. News*, 4 April 1988, p. 11 (photo by Irna, AFP).

91. *The MacNeil/Lehrer NewsHour*, 9 Sept. 1988, transcript #3256.

92. William Safire, "Stop the Iraqi Murder of the Kurds," *The New York Times*, 5 Sept. 1988, sec. 1, p. 21.

93. Photo by Ramazan Ozturk, Sipa, *Time*, 26 Dec. 1988, p. 57. The same image also appeared 22 Aug. 1988, p. 47.

94. Senate Foreign Relations Committee Staff Report, "Chemical Weapons Use in Kurdistan: Iraq's Final Offensive," (Washington, D.C.: 21 Sept. 1988).

95. Quoted in William Shawcross, *The Quality of Mercy: Cambodia, Holocaust and Modern Conscience* (New York: Touchstone, 1984), 68.

96. William Safire, "Stop the Iraqi Murder of the Kurds," *The New York Times*, 5 Sept. 1988, sec. 1, p. 21.

97. Margaret Thatcher, "Stop the Excuses. Help Bosnia Now," *The New York Times*, 6 Aug. 1992, sec. A, p. 23.

98. Walter Goodman, "TV Images of Bosnia Ignite Passions and Politics," *The New York Times*, 6 Aug. 1992, sec. C, p. 20.

99. Actually that image was taken at the Trnopolje camp. Anna Husarska, "Darkness Visible," *The New York Times* , 1 Dec. 1996, sec. 7, p. 29.

100. Nik Gowing, "Real-Time TV Coverage from War," in *Bosnia by Television*, ed. James Gow, Richard Peterson, and Alison Preston (London: British Film Institute, 1996), 89.

101. See *Larry King Live*, CNN, 7 Aug. 1992; *News*, CNN, 7 Aug. 1992; "Reliable Sources," CNN, 8 Aug. 1992, transcript #25; *This Week with David Brinkley*, ABC News, 9 Aug. 1992.

102. Gowing, "Real-Time TV Coverage from War," p. 89.; For more discussion on the so-called CNN effect, see Warren Strobel, *Late Breaking Foreign Policy: The News Media's Influence on Peace Operations* (Washington, D.C.: U.S. Institute of Peace Press, 1997); Steven Livingston, "Clarifying the CNN Effect: An Examination of Media Effects According to Type of Military Intervention," research paper R-18 (Joan Shorenstein Center on the Press, Politics and Public Policy, Harvard University, Jan. 1997); Steven Livingston and Todd Eachus, "Humanitarian Crises and U.S. Foreign Policy: Somalia and the CNN Effect Reconsidered," *Political Communication* 12, 1995.

103. Peter Maass, "The Search for a Secret Prison Camp," *The Washington Post*, 13 Aug. 1992, sec. A, pp. 18, 20; George Rodrigue, "Response to Bosnian Refugees' Plight Blasted," *The Dallas Morning News*, 24 Oct. 1992, sec. A, p. 1; Slavenka Drakulic, "A Winter's Tale," *The New Republic*, 10–17 Jan. 1994, p. 14.

104. Dan Rather, "Bosnia: The Story that (Almost) Got Away," *TV Guide*, 23–29 Dec. 1995, pp. 37–38.

105. Interview with Michele McDonald, 19 Sept. 1993; Peter Jennings, "Excerpts of Remarks by Peter Jennings at the Goldsmith Awards Ceremony," *Press/ Politics* (spring 1996): 14.

106. Rather, "Bosnia," pp. 37–38.

107. Howard Kurtz, "Bosnia Overload: Is the Public Tuning Out?" *The Washington Post*, 13 Sept. 1993, sec. D, p. 1.

108. See, for example, Martin Bell, *In Harm's Way* (London: Hamish Hamilton, 1995); Tom Gjelten, *Sarajevo Daily* (New York: HarperCollins, 1995); Misha Glenny, *The Fall of Yugoslavia* (New York: Penguin Books, 1992); Peter Maass, *Love Thy Neighbor: A Story of War* (New York: Vintage, 1996); David Rieff, *Slaughterhouse* (New York: Touchstone, 1996); David Rohde, *Endgame* (New York: Farrar, Straus and Giroux, 1997); Ed Vuilliamy, *Season in Hell* (New York: Simon & Schuster, 1994).

109. E-mail correspondence with Samantha Power, 2 April 1998; Sherry Ricchiardi, "Over the Line?," *American Journalism Review* (September 1996): 26–27.

110. See, for example, Mark Porubcansky, "Truths of Bosnia War Are Revealed," Associated Press, 20 March 1998.

111. Ibid.; Roger Cohen, "C.I.A. Report on Bosnia Blames Serbs for 90% of the War Crimes," *The New York Times*, 9 March 1995, sec. A, p. 1.

112. George Kenney, "The Bosnia Calculation," *The New York Times Magazine*, 23 April 1995, p. 42.

113. Excerpted from President Bush's statement in Colorado Springs, Col., announcing full diplomatic relations with Slovenia, Croatia and Bosnia-Herzegovina, 6 Aug. 1992.

114. Andrew Bell-Fialkoff, "A Brief History of Ethnic Cleansing," *Foreign Affairs* 72(3), summer 1993: 116.

115. Ibid.

116. Gutman, *A Witness to Genocide*, p. xix.

117. Stephen Engelberg and Chuck Sudetic, "Clearer Picture of Bosnia Camps: A Brutal Piece of a Larger Plan," *The New York Times*, 16 Aug. 1997, sec. A, p. 14.

118. Ibid.

119. George Kenney, "See No Evil, Make No Policy," *Washington Monthly* (November 1992); Stephen Engelberg and Chuck Sudetic, "Clearer Picture of Bosnia Camps: A Brutal Piece of a Larger Plan," *The New York Times*, 16 Aug. 1997, sec. A, p. 1.

120. Gutman, *A Witness to Genocide*, pp. xi-xii.

121. Roy Gutman, "There Is No Food, There Is No Air," *Newsday*, 19 July 1992, in *A Witness to Genocide*, 34–35.

122. Roy Gutman, "Death Camps," *Newsday*, 2 Aug. 1992, in *A Witness to Genocide*, 46.

123. Don Oberdorfer, "Week of Publicity and Policymaking Started Off with a Chilling Headline," *The Washington Post*, 9 Aug. 1992, sec. A, p. 26; See, for example, *News*, CNN, 3 Aug. 1992, transcript #121-3.

124. Don Oberdorfer, "Week of Publicity and Policymaking Started Off with a Chilling Headline," *The Washington Post*, 9 Aug. 1992, sec. A, p. 26.

125. *News*, CNN, 4 Aug. 1992, transcript #137-1.

126. *News*, CNN, 5 Aug. 1992, transcript #92-1; Gowing, "Real-time Television Coverage of Armed Conflicts and Diplomatic Crises: Does It Pressure or Distort Foreign Policy Decisions?" working paper 94–1 (The Joan Shorenstein Barone Center on the Press, Politics and Public Policy, John F. Kennedy School of Government, Harvard University, 1994), 42.

127. Nigel Baker, "Sending in the Troops," *RTNDA Communicator* (February 1996): 25.

128. Frederick Baker, "They Can't Read the Words . . . ," *The Independent*, 5 Aug. 1993, Comment section, p. 23.

129. *Nightline*, ABC News, 6 Aug. 1992.

130. Baker, "They Can't Read the Words . . .", p. 23.

131. Oberdorfer, "Week of Publicity and Policymaking Started Off with a Chilling Headline," sec. A, p. 26; *World News Tonight*, ABC News, 7 Aug. 1992.

132. *World News Tonight*, ABC News, 8 Aug. 1992.

133. Chip Bok in *The New York Times*, 9 Aug. 1992, sec. E, p. 4; Jim Borgman in *L.A. Times*, 10 Aug. 1992, sec. A, p. 21 or in *The Washington Post*, 9 Aug. 1992, sec. C, p. 7; Pat Oliphant in *The Washington Post*, 9 Aug. 1992, sec. C, p. 2.

134. See for example the stories by Peter Maass in *The Washington Post*, by Tom Squitieri in *USA Today* and Charles Powers in the *L.A. Times*.

135. Trevor Rowe, "Camp Revelations Spur Allied Action on Bosnian Relief," *The Washington Post*, 11 Aug. 1992, sec. A, p. 1.

136. Keith Richburg, "Famine, Disease Place Somalis in Death Grip," *The Washington Post*, 11 Aug. 1992, sec. A, p. 1; editorial, "'A Land Forgotten by God,'" *The Washington Post*, 13 Aug. 1993, sec. A, p. 24.

137. John Carmoody, "The TV Column," *The Washington Post*, 14 Aug. 1992, sec. C, p. 4.

138. It was during this week, that the ICRC, together with the journalists began releasing information about the camps set up by the Muslims and Croats. The information received universal attention, but was typically placed in the context of the greater abuses by the Serbs—as, for instance, in this comment by *The Times*: "Croats and Muslims are, to a lesser extent, setting up their own prison camps." Stephen Engelberg and Chuck Sudetic, "Clearer Picture of Bosnia Camps: A Brutal Piece of a Larger Plan," *The New York Times*, 16 Aug. 1997, sec. A, p. 14.

139. "Reliable Sources," CNN, 8 Aug. 1992, transcript #25.

140. Thom Shanker, "Survivor Describes Serb Camp Deaths," *Chicago Tribune*, 7 Aug. 1992, sec. 1, p. 8; Charles Powers, "Bosnians Tell of Brutality at Serb-Run Camps," *L.A. Times*, 7 Aug. 1992, sec. A, p. 12; Gutman, "Death Camps," p. 45.

141. Peter Maass, "Away from Guards, Inmates Whisper of Abuse," *The Washington Post*, 11 Aug. 1992, sec. A, pp. 1, 13; Chuck Sudetic, "Inside Serbs' Bosnian Camp: Prisoners, Silent and Gaunt," *The New York Times*, 8 Aug. 1992, sec. A, pp. 1, 4; The Freedom Forum Media Studies Center Research Group, "The Media and Foreign Policy in the Post–Cold War World," 1993.

142. Tom Squitieri, "Weapons in Bosnia: Rape, Degradation," *USA Today*, 10 Aug. 1992, sec. A, p. 1; Joel Brand, et al., "Life and Death in the Camps," *Newsweek*, 17 Aug. 1992, p. 23.

143. Roy Gutman, "Personal Account of Terror," *Newsday*, 3 Aug. 1992, and "Witness's Tale of Death and Torture," *Newsday*, 2 Aug. 1992, in *A Witness to Genocide*, pp. 51, 58.

144. *This Week with David Brinkley*, ABC News, 9 Aug. 1992.

145. Editorial, "Atrocity in Bosnia," *The Washington Post*, 3 Aug. 1992, sec. A, p. 18; editorial, "Milosevic Isn't Hitler, But . . ." *The New York Times*, 4 Aug. 1992, sec. A, p. 18; editorial "A Matter of Conscience—as Well as Policy," *L.A. Times*, 5 Aug. 1992, sec. B, p. 6; editorial "What Goes On in Bosnia's Camps?" *Chicago Tribune*, 6 Aug. 1992, sec. 1, p. 24.

146. The explicit Jewish connection was legitimized by newspaper ads appealing to world leaders to stop the camps, taken out by the Jewish community. And Israel had said it would send humanitarian aid to Croat and Muslim victims.
 News, CNN, 13 Aug. 1992, transcript #145-1; Nancy Hill-Holtzman, "Images of Atrocities in Bosnia Stir Protest," *L.A. Times*, 8 Aug. 1992, sec. B, p. 1.

147. Quoted in George Kenney, "The Bosnia Calculation," *The New York Times Magazine*, 23 April 1995, p. 43.

148. Kenney, "The Bosnia Calculation," pp. 42–43.

General Charles Boyd, USAF (Ret.) was the Deputy Commander in Chief, U.S. European Command from Nov. 1992 to July 1995. In an article entitled "Making Peace with the Guilty," that appeared in the Sept./Oct. 1995 issue of *Foreign Affairs*, he stated that he believed the number of total dead in the conflict to be "in the 70,000–100,000 range."

149. The U.S. Senate released a report on Aug. 19 detailing Serb atrocities in the camps: "Killings in the camps often appear to be recreational and sadistic. There is evidence that paramilitary groups from Serbia and Montenegro have entered certain camps, often drunk and by night, for the purpose of torturing, killing and raping." Jim Hoagland, "August Guns: How Sarajevo Will Reshape U.S. Policy," *The Washington Post*, 9 Aug. 1992, sec. C, p. 1.

150. J. F. O. McAllister, "Atrocity and Outrage," p. 21; editorial, "Margaret Thatcher as Churchill," *The New York Times*, 11 Aug. 1992, sec. A, p. 18.

151. *News*, CNN, 12 Aug. 1992, transcript #93-4; "Reliable Sources," CNN, 8 Aug. 1992, transcript #25.

Although four days earlier, two days after the ITN images appeared, CNN had quoted Rabin as saying, "These pictures, these stories remind us of the greatest tragedy in the history of the Jewish people—the Holocaust." *News*, CNN, 8 Aug. 1992, transcript #126-4. Two years later columnist A. M. Rosenthal, writing in *The New York Times*, wrote one of the most thoughtful pieces on the similarities and differences between Bosnia and the Holocaust. "Bosnia and the Holocaust," *The New York Times*, 24 April 1994, sec. A, p. 23.

152. Charles Krauthammer, ". . . Partition," *The Washington Post*, 4 Sept. 1992, sec. A, p. 25; *The Week in Review*, CNN, 9 Aug. 1992, transcript #20-1; editorial, "And Now, Death Camps," *The Washington Post*, 5 Aug. 1992, sec. A, p. 22.

153. Brown Bag Lunch talk with Johanna Neuman, The Joan Shorenstein Center on the Press, Politics and Public Policy, John F. Kennedy School of Government, Harvard University.

154. Dan Rather, "Bosnia: The Story that (Almost) Got Away," *TV Guide*, 23–29 Dec. 1995, pp. 37–38; Lance Morrow, "Blood and Tears," *Life*, Oct. 1992, p. 12; James Staroscik, "Letters," *L.A. Times*, 12 Aug. 1992, sec. B, p. 6.

155. Morrow, "Blood and Tears," p. 10.

156. "Capital Gang," CNN, 8 Aug. 1992, transcript #27-1.

157. A whole literature grew up about the ITN images—whether or not it showed a Muslim prisoner. It did. Other critics charged that it was misleading, that even if the image depicted what it purported to other men next to the emaciated man with his shirt off appeared to be well fed. By the time the controversy was over, the crew from ITN and *The Guardian*, as well as others had all weighed in with their opinions. See, for example, Baker, "They Can't Read the Words . . ." p. 23; Peter Brock, "Dateline Yugoslavia: The Partisan Press," *Foreign Policy*, Dec. 1993, p. 150; Charles Lane, *The New Republic*, 3 Jan. 1994, p. 43, "Picture of a Prisoner," *Time*, 14 March 1994, p. 16; Charles Lane, Brock Crock, *The New Republic*, 5 Sept. 1994, pp. 18–21; Peter Brock, "Brock Party," *The New Republic*, 10 Oct. 1994, p. 4; Andrew Kelly, "Reporter Tells of Living Skeletons at Omarska Camp," Reuters, 7 June 1996, BC Cycle; Ed

Vulliamy, "I Stand By My Story," *The Guardian*, 2 Feb. 1997, p. 25; Luke Harding, "Second Front: A Shot That's Still Ringing," *The Guardian*, 12 March 1997, p. T2; Phillip Knightly, "Battle Rages over Bosnia," *The Guardian*, 14 March 1997, p. 16.

158. See, for example, AP photo, *The Washington Post*, 13 Aug. 1992, sec. A, p. 20.

159. See, for example, Srdjan Sulja's picture in *Life*, Oct. 1992, pp. 18–19 and Patrick Robert's picture in *Newsweek*, 24 Aug. 1992, pp. 44–45. Other similar photos which appeared in *The New York Times* and *The Washington Post*, among other outlets, credited Gamma Liaison, Reuters or AP. See, for example, Marleen Daniels, Gamma Liaison, *Time*, 24 Aug. 1992, p. 47; AP photo, *The New York Times*, 9 Aug. 1992, sec. A, p. 12; AP photo, *The Washington Post*, 11 Aug. 1992, sec. A, p. 13; and Reuter photo, *The New York Times*, 16 Aug. 1992, sec. A, p. 14.

160. Patrick Robert, Sygma, *Newsweek*, 4 Jan. 1993, p. 20; and 24 Aug., p. 3. See also Marleen Daniels, Gamma Liaison, *Time*, 24 Aug. 1992, p. 49.

161. See Philip Sherwell photo, *The Washington Post*, 7 Aug. 1992, sec. A, p. 1; AFP photo, *The Washington Post*, 15 Aug. 1992, sec. A, p. 16. For other pictures of released Croatian prisoners as part of the Serb-Croatian POW exchange, see AP photos in the *L.A. Times*, 15 Aug. 1992, sec. A, p. 1, and 16 Aug. 1992, sec. A, p. 1.

162. See, for example, AP photo, 9 Aug. 1992, sec. A, p. 26; AFP photo, 10 Aug. 1992, sec. A, p. 12; AP photo, 11 Aug. 1992, sec. A, p. 1; AP photo, 14 Aug. 1992, sec. A, p. 26.

163. Actually, by mid-1995 a U.N. tribunal on war crimes had collected a computerized database of 350 videotapes and 1,000 photographs documenting atrocities in the former Yugoslavia. Robin Knight, et al., "The Hunt for the Killers of Bosnia," *U.S. News*, 10 April 1995, p. 52.

164. Editorial, "Atrocity in Bosnia," *The Washington Post*, 3 Aug. 1992, sec. A, p. 18.

165. Peter Maass wrote about the same syndrome the next spring, in covering the rest of the Bosnian war. "The fruits of my labors were drifting into a realm of journalism that was known in the Bosnian press corps as 'horror porn': The woman who was raped nearly every day for two months; the guy who crawled through a battlefield after both his legs were blown off; the morgue stacked full of frozen bodies; the massacre in which a boy was shot dead along with the puppy in his arms; the grandmother burned to a crisp in her home, or the doctor who amputated without painkillers. You were on the lookout for these stories, not because anybody back home was going to do anything about it, but because it was good copy." Maass, *Love Thy Neighbor: A Story of War*, 247.

166. Fergal Keane, "Valentina's Nightmare," *Frontline*, PBS, 1 April 1997.

According to a June 28, 1994 report by the United Nations' Special Rapporteur of the commission on Human Rights, Rene Degni-Segui, at least 500,000 and as many as 1 million Rwandans—mostly Tutsis, but also Hutu moderates—were killed by Hutus. By a year later a generally agreed upon figure was 800,000 dead by the end of the summer.

167. Philip Gourevitch, "After the Genocide," *The New Yorker*, 18 Dec. 1995, pp. 84, 78.

At the height of the Holocaust in 1944, the Nazis executed about 400,000 during a three-month period, the same length of time it took Hutus to kill approximately twice that many.

168. *News*, CNN, 24 May 1994, 10:31 P.M., transcript #874-5; *News*, CNN, 21 May 1994, 6:37 P.M., transcript #821-1.

169. Mark Fritz, "'Words Cannot Describe . . .'" *IPI Report*, May/June 1995, pp. 24, 32.

170. Jennifer Parmelee, "Fade to Blood," *The Washington Post*, 24 April 1994, sec. C, p. 3.

171. Fritz, "'Words Cannot Describe . . .'", pp. 24, 32.

172. Keane, "Valentina's Nightmare."

173. Alan Zarembo, "Judgment Day," *Harper's Magazine*, April 1997, p. 70. Those convicted of Category 1 were to receive the death penalty. Category 2 was for common killers, who, if convicted, would serve between seven years and life. Category 3, those who maimed, would receive one-third the penalty mandated in standard criminal law. And Category 4, those who looted, were to work out compensation plans within their community.

174. Parmelee, "Fade to Blood," p. 3.

175. David Lamb, "Rwanda War Isn't Just Horrific, It's Telegenic," *L.A. Times*, 12 July 1994, World Report section, p. 2.

176. Ibid.; *News*, CNN, 13 April 1994, 3:13 P.M., transcript #588-3.

177. Julia Keller, "'Frontline' Brings Killing Fields of Rwanda to American Viewers," *The Columbus Dispatch*, 1 April 1997, sec. B, p. 7; Eleanor Randolph, "Journalists Find Little Neutrality Over Objective Reporting," *L.A. Times*, 22 April 1997, sec. A, p. 5; Elizabeth Kastor, "Indelible Images," *The Washington Post*, 30 Sept. 1994, sec. F, p. 1; John Omicinski, "'Superpower' Disappearing from Lexicon," Gannett News Service, 30 July 1994.

178. Nik Gowing, "Lights! Camera! Atrocities!" *The Washington Post*, 31 July 1994, sec. C, p. 1; *The MacNeil/Lehrer NewsHour*, 15 June 1994.

179. Robert Press, "Surviving Tutsis Tell the Story of Massacres by Hutu Militias," *The Christian Science Monitor*, 1 Aug. 1994, p. 9.

180. Joseph B. Verrengia, "Renewed Violence in Rwanda Turns Languid Capital into Slaughterhouse," *Rocky Mountain News*, 9 April 1994, sec. A, p. 48.

181. Gibbs, "Why?" p. 61.

182. Alan Zarembo, "Judgment Day," *Harper's Magazine*, April 1997, p. 73.

183. Jerry Gray, "2 Nations Joined by Common History of Genocide," *The New York Times*, 9 April 1994, sec. A, p. 6; Philip Gourevitch, "After the Genocide," *The New Yorker*, 18 Dec. 1995, p. 86.

184. Andrew Jay Cohen, "On the Trail of Genocide," *The New York Times*, 7 Sept. 1994, sec. A, p. 23.

185. James MacGuire, "Rwanda Before the Massacre," *Forbes MediaCritic*, fall 1994: 41; David Lamb, "Rwanda War Isn't Just Horrific, It's Telegenic," *L.A. Times*, 12 July 1994, World Report section, p. 2.

186. MacGuire, "Rwanda Before the Massacre," p. 43.

187. News services, "Two African Presidents Are Killed in Plane Crash," *The New York Times*, 7 April 1994, sec. A, p. 18.

188. Staff and wire reports, "Rwandans Kill Premier, Belgians," *USA Today*, 8 April 1994, sec. A, p. 6; and *Tribune* wires, "Rwanda Descends into Bloody Chaos," *Chicago Tribune*, 8 April 1994, sec. 1, p. 4; editorial, "Deadly Reality: Rwanda Is Dying," *L.A. Times*, 4 May 1994, sec. B, p. 6; Georgie Anne Geyer, "Rwanda Anarchy an Omen for U.S.," *The Cincinnati Enquirer*, 21 April 1994, sec. A, p. 8.

189. Gibbs, "Why?" p. 58; Keith Richburg, "Rebels Gain Support from Both Sides," *The New York Times*, 15 May 1994, sec. A, p. 31; Walter Goodman, "Young Witness to Rwanda Massacre," *The New York Times*, 1 April 1997, sec. C, p. 14.

190. In a May 1998 article (see p. 288) in *The New Yorker*, reporter Philip Gourevitch writes of a fax sent by the U.N. commander in Rwanda, Major General Roméo Dallaire, to the peacekeeping headquarters at the United Nations in New York. The fax, sent three months before the genocide, reported that a Hutu informant had told, in detail, of the preparations being made for an extermination campaign. The plan was to "provoke a civil war," and use that as an excuse to kill Tutsis. According to the informant, the Belgian troops were to be attacked and a number killed, "and thus guarantee Belgian withdrawal from Rwanda." The fax came into U.N. headquarters, and despite its allegations, prompted no response. Three months later, everything the informant said came true. Philip Gourevitch, "The Genocide Fax," *The New Yorker*, 11 May, 1998, pp. 42–44, 46.

191. "International Correspondents," CNN, 9 May 1994, 6:30 A.M., transcript #104; Ileane Rudolph, "Covering Rwanda," *TV Guide*, 14 May 1994, p. 38.

192. Carol Pott Berry, "3 Days of Terror in Kigali Precede Evacuation to Safety," *The Washington Post*, 12 April 1994, sec. A, p. 13; Donatella Lorch, "Anarchy Rules Rwanda's Capital and Drunken Soldiers Roam City," *The New York Times*, 14 April 1994, sec. A, p. 12.

193. James Schofield, *Silent Over Africa* (Sydney: HarperCollins, 1996), 143.

194. Destexhe, *Rwanda and Genocide in the Twentieth Century*, 48.

195. Jennifer Parmelee, "Rwandans Ever More Isolated," *The Washington Post*, 16 April 1994, sec. A, p. 12; Jennifer Parmelee, "Fade to Blood," *The Washington Post*, 24 April 1994, sec. C, p. 3; Donatella Lorch, "Anarchy Rules Rwanda's Capital and Drunken Soldiers Roam City," *The New York Times*, 14 April 1994, sec. A, p. 12.

196. Robert Press, "Surviving Tutsis Tell the Story of Massacres by Hutu Militias," *The Christian Science Monitor*, 1 Aug. 1994, p. 9; "Kind Words, But Not Much More," *Time*, 16 May 1994, p. 61.

197. Donatella Lorch, "Genocide Versus Heartstrings," in *Somalia, Rwanda, and Beyond: The Role of the International Media in Wars and Humanitarian Crises*, ed. Edward Girardet (Dublin: CROSSLINES Communications, 1995), 101.

198. Lorch, Genocide Versus Heartstrings," pp. 104–5.

199. Ibid., p. 102.

200. *This Week with David Brinkley*, ABC News, 1 May 1994, transcript #653.

201. Lorch, "Genocide Versus Heartstrings," p. 104.

202. *USA Today* news budget meeting, 5 May 1994, 12:30 P.M.

203. Ileane Rudolph, "Covering Rwanda," *TV Guide*, 14 May 1994, p. 38; *World News Tonight*, ABC News, 4 May 1994, transcript #4088-6.

204. Ibid.; *Nightline*, ABC News, 3 May 1994, transcript #3377.

205. Destexhe, *Rwanda and Genocide in the Twentieth Century*, pp. 53, 54–55; Gérald Prunier, *The Rwandan Crisis: History of a Genocide* (New York: Columbia University Press, 1995), 297.

206. Donatella Lorch, "Rains and Disease Ravage Refugees Fleeing Rwanda," *The New York Times*, 2 May 1994, sec. A, p. 10; AP, "Rwandan Refugees in Tanzania Quickly Exhausting Relief Efforts," *Chicago Tribune*, 2 May 1994, sec. 1, p. 4.

207. "ABC Breaking News," ABC News, 22 July 1994, transcript #160-1; James Schofield, *Silent Over Africa* (Sydney: HarperCollins, 1996), 185; "Refugee Flight of the Century," *U.S. News*, 25 July 1994, p. 9; *World News Sunday*, ABC News, 17 July 1994, transcript #429-1.

208. Lorch, "Genocide Versus Heartstrings," pp. 102–3, 105.

209. *World News Tonight*, ABC News, 21 July 1994, transcript #4144-1; "ABC Breaking News," ABC News, 22 July 1994, transcript #160-1.

210. Tom Ashbrook, "Slain Soldier's Family Ponders Sacrifice," *The Boston Globe*, 30 April 1995, sec. A, p. 29; Victor LeVine, "International Responsibility," *St. Louis Post-Dispatch*, 28 Aug. 1994, sec. B, p. 3; Elaine Sciolino, "For West, Rwanda Is Not Worth the Political Candle," *The New York Times*, 15 April 1994, sec. A, p. 3.

211. Lorch, "Genocide Versus Heartstrings," pp. 102–3, 105–6.

212. *This Week with David Brinkley*, 24 July 1994, transcript #665.

213. Destexhe, *Rwanda and Genocide in the Twentieth Century*, 56.

214. Schofield, *Silent Over Africa*, 198–99.

215. Lorch, "Genocide Versus Heartstrings," pp. 101, 106.

216. *Nightline*, ABC News, 9 Aug. 1994, transcript #3447.

217. Schofield, *Silent Over Africa*, 138–41.

218. Eleanor Randolph, "Journalists Find Little Neutrality Over Objective Reporting," *L.A. Times*, 22 April 1997, sec. A, p. 5.

219. Dowell, "Reporting the Wars," in *Somalia, Rwanda, and Beyond*, p. 73.

220. See, for example, Donatella Lorch, "Anarchy Rules Rwanda's Capital and Drunken Soldiers Roam City," *The New York Times*, 14 April 1994, sec. A, p. 1.

221. Editorial, "Cold Choices in Rwanda," *The New York Times*, 23 April 1994, sec. 1, p. 24; *News*, CNN, 24 May 1994, 10:31 P.M., transcript #874-5.

 African Rights, a human rights organization based in London, wrote a comprehensive 750-page book on the genocide and in it they assessed the international media's coverage of Rwanda, and excoriated much of the media, especially television, for their use of such phrases as "tribal violence," "anarchy" and "orgy of violence." African Rights, *Rwanda: Death, Despair and Defiance* (London: African Rights, 1994), 198–205.

222. See, for example, editorial, *Chicago Tribune*, 24 April 1994, sec. 4, p. 2; and Joshua Hammer, "Escape from Hell," *Newsweek*, 16 May 1994, p. 34.

223. *News*, CNN, 4 May 1994, 9:35 P.M., transcript #597-3; "Mass Murder," *Newsweek*, 9 May 1994, p. 40; Steven Roberts, "Rwanda's Trail of Tears," *U.S. News*, 16 May 1994, p. 10; Jennifer Parmelee, "Fade to Blood," *The Washington*

Post, 24 April 1994, sec. C, p. 3; AP, "Hutu Holocaust: Rwanda's Ethnic 'Final Solution,'" *The Rocky Mountain News*, 22 May 1994, sec. A, p. 41; Reuters, "Witness Likens Rwanda to Nazi Atrocities," *L.A. Times*, 2 May 1994, sec. A, p. 11.

224. Schofield, *Silent Over Africa*, 142; Frank Rich, "The Holocaust Boom," *The New York Times*, 7 April 1994, sec. A, p. 27.

 In a discussion paper written at the Kennedy School, *Boston Globe* columnist James Carroll investigated the recent media revisitation of the Holocaust as a major story. James Carroll, "Shoah in the News: Patterns and Meaning of News Coverage of the Holocaust," discussion paper D-27 (The Joan Shorenstein Center for the Press, Politics and Public Policy, John F. Kennedy School of Government, Harvard University, Oct. 1997).

225. *Nightline*, ABC News, 3 May 1994, transcript #3377; Walt Handelsman, *The Times-Picayune*, cartoon reproduced in *The New York Times*, 30 April 1995, sec. E, p. 6.

226. *All Things Considered*, NPR, 2 May 1994, transcript #1470-3.

227. See, for example, *This Week with David Brinkley*, ABC News, 24 July 1994, transcript #665.

228. Lamb, "Rwanda War Isn't Just Horrific, It's Telegenic," p. 2.

229. *World News Tonight*, ABC News, 13 April 1994, transcript #4073-4; *News*, CNN 15 April 1994, 3:15 P.M., transcript #589-4; *World News Tonight*, ABC News, 18 April 1994, transcript #4076-7.

230. *Nightline*, ABC News, 3 May 1994, transcript #3377.

231. *CNN & Company*, CNN, 12 April 1994, 4:30 A.M., transcript #334; *Crossfire*, CNN, 14 April 1994, 7:30 P.M., transcript #1071; photo, Michael Williamson, *The Washington Post*, 8 May 1994, sec. A, p. 25.

232. *World News Tonight*, ABC News, 28 April 1994, transcript #4084-3; photo, Bernard del Entree, La Nouvelle Gazette, *Time*, 25 April 1994, pp. 44–45; photo, Liz Gilbert, Sygma, *Newsweek*, 25 April 1994, pp. 32–33.

233. Donatella Lorch, "Thousands of Rwanda Dead Wash Down to Lake Victoria," *The New York Times*, 21 May 1994, sec. A, p. 1 (photo by Jean-Marc Bouju, AP).

234. Photo, Patrick Robert, Sygma, *Newsweek*, 9 May 1994, pp. 40–41.

235. *World News Tonight*, ABC News, 6 May 1994, transcript #4090-6.

236. *World News Tonight*, ABC News, 7 June 1994, transcript #4118-4.

237. *Nightline*, ABC News, 3 May 1994, transcript #3377; *Nightline*, ABC News, 26 July 1994, transcript #3437.

238. "Kind Words, But Not Much More," *Time*, 16 May 1994, p. 61.

239. *News*, CNN, 16 May 1994, 4:06 A.M., transcript #105-1; John Sweeny, "Through the Lens Darkly," *The Observer*, 11 Sept. 1994, p. 9.

240. DiGiovanni, "Tired Moving of the Pictures."

241. Richard O'Mara, "Refugees: 20 Million and Counting," *The Baltimore Sun*, 5 June 1994, sec. E, p. 1.

242. *Nightline*, ABC News, 4 May 1994, transcript #3378.

243. Paul Sexton, "Rwanda Relief Efforts Reach Near–Band Aid Proportions," *Billboard*, 17 Sept. 1994, p. 11; "Charity Apathy Riles D:Ream," *Daily Mirror*, 9 Sept. 1994, p. 19.

244. John Taylor, "Prayers, Cash for Rwanda," *The Fresno Bee*, 26 July 1994, sec. B, p. 1.
245. Charles Mitchell, "Americans Rush to Aid Rwanda," *The Times Union*, 29 July 1994, sec. A, p. 1.
246. Mitchell, "Americans Rush to Aid Rwanda," sec. A, p. 1; Vivienne Walt, "Battle for Donations," *Newsday*, 29 July 1994, sec. A, p. 7.
247. Jefferson White, "Letters," *Newsweek*, 25 July 1994, p. 12.
248. Lorch, "Genocide Versus Heartstrings," p. 107.
249. Keane, "Valentina's Nightmare."

Conclusion

1. Although, to be fair, Mother Teresa died on Friday, September 5. Diana died early Sunday morning, August 31, 1997.
2. Jonathan Alter, "Genuflect Journalism," *Newsweek*, 22 Sept. 1997, p. 37; "The Big Picture," *Life*, Nov. 1997, p. 14.
3. Alter, "Genuflect Journalism," p. 37.
4. Joan Konner, "Rewriting the Script of History," *CJR*, Nov./Dec. 1997, p. 6; Lance Morrow, "Journalism After Diana," *CJR*, Nov./Dec. 1997, p. 39.
5. Susan Stewart, "TV Bids Farewell to Its Princess," *TV Guide*, 20–26 Sept. 1997, pp. 50–51, 53.
6. E-mail correspondence with Peter Herford, 26 Oct. 1997.
7. Stewart, "TV Bids Farewell to Its Princess," pp. 50–51, 53.
 The scale of the coverage fed the scale of the mourning, so much so that the 30 million Americans who woke up, many before dawn, to watch her funeral, and the two and a half billion others around the world who watched the service in Westminister Abbey so outran the importance of the event that commentators groped helplessly for explanations, even if (unfortunately) they weren't rendered speechless. Richard Sennett in his 1977 book *The Fall of Public Man* may have been one of the few to discern the meaning of such a tremendous outpouring of emotion. Sennett wrote that we the public practice an "ideology of intimacy;" that we "seek to find personal meaning in impersonal situations." "In an intimate society," he said, "all social phenomena, no matter how impersonal in structure, are converted into matters of personality in order to have meaning. Political conflicts are interpreted [especially since the advent of television] in terms of the play of personalities; leadership is interpreted in terms of 'credibility' rather than accomplishment." (Richard Sennett, *The Fall of Public Man* [New York: Knopf, 1977.]) By this analysis, the confessional, therapeutic, sensitive tone of Diana's public life tempted many to see their own struggles reflected in hers. Diana had always made a vivid impression in the media; in mourning her death the public not only grieved her loss but grieved for the loss of her media-mediated presence in their lives, for the loss of their future ability to project their lives on her. "For years to come we will think of Princess Diana's [life]," said *Life*, "in ever more abbreviated terms—morality tales we tell our children. This one was pretty. . . . This one suffered despite the riches that surrounded her. . . .

Such reflection is part of mourning. We say goodbye to the person as we welcome a mythology to stand in her place. In this way do we make those who have left us part of our lives once again." ("The Big Picture," *Life*, November 1997, p. 24.)

8. E-mail correspondence with Peter Herford, 30 Oct. 1997.
9. The Freedom Forum Media Studies Center Research Group, "The Media and Foreign Policy in the Post–Cold War World," The Freedom Forum Media Studies Center Research Group, 1993, p. 25.
10. Ibid.
11. James Hoge, Jr. "Foreign News: Who Gives a Damn?" *CJR*, Nov./Dec. 1997, p. 48.
12. Ibid., p. 49.
13. Ibid., p. 49; Pew Research Center for the People and the Press, "America's Place in the World II," Oct. 1997, pp. 1, 6.
14. Correspondence with Bill Small, 15 Oct. 1997.
15. "Reliable Sources," CNN, 18 Sept. 1994, transcript #134.
16. Tom Roenstiel, "Investing in Integrity Pays," *The New York Times*, 20 Oct. 1997, sec. A, p. 23.
17. Reena Shah, "As Disasters Multiply, Compassion Runs Thin," *St. Petersburg Times*, 16 Sept. 1992, sec. A, p. 4.
18. E-mail correspondence with Peter Herford, 26 Oct. 1997.
19. Hodge, "Foreign News: Who Gives a Damn?" p. 51.
20. Interview with Bernard Gwertzman, 29 July 1993.
21. Nik Gowing, "Behind the CNN Factor," *The Washington Post*, 31 July 1994, sec. C, p. 1.
22. A. M. Rosenthal, "This Censored World," *The New York Times*, 26 Apr. 1988, sec. A, p. 31.
23. Correspondence with Bill Small, 15 Oct. 1997.
24. Leslie Scanlon, "Where to Send Money . . ." *The Courier-Journal*, 6 Dec. 1992, sec. A, p. 1.
25. Carol Ostrom, "Our Struggle with Our Hearts," *The Seattle Times*, 10 Aug. 1992, sec. A, p. 1.
26. Luke 10: 25–37. *The Holy Bible*, authorized King James version.
27. *The Kansas City Star* ran an interesting year-long series of article on values, including compassion. George Gurley, "Compassion Is a Basic Principle of Life," *The Kansas City Star*, 22 March 1995, sec. F, p. 1.
28. E-mail correspondence with Peter Herford, 26 Oct. 1997.
29. Correspondence with Bill Small, 15 Oct. 1997; James Fallows, *Breaking the News: How the Media Undermine American Democracy* (New York: Vintage, 1997), 53.

Acknowledgments

1. Opening lines to *Seinfeld*, aired 26 Feb. 1998.

ACKNOWLEDGMENTS

During the countdown to the final episode of *Seinfeld* in the spring of 1998, one show began with a vignette of Jerry Seinfeld sitting across from George Costanza in the coffee shop they frequent. George looked up at Jerry as he closed and folded *The New York Times* he was reading. "When are they ever going to learn," George said with a nod to the newspaper, "that any news about China is an instant page turner?"[1]

It was then that I knew with certainty that the topic of how the media covers international affairs—that the topic of compassion fatigue itself—had crossed over into the realm of pop culture concern. If the show that prided itself on being about "nothing" chose to lead-in to one of its last episodes with a jab at the public's supposed disinterest in world events, then there might be some faint hope. Stand-up comedy targets the oxymorons in our lives that everyone accepts as rational behavior. No one cares about China, George suggested, yet every day newspaper readers are fed a regular diet of China stories. To identify that oxymoron in such an arena is to serve notice that the public's disinterest is a problem and that the media needs to adjust accordingly. When the nihilism that seems to have become our view of world events has threatened even the ephemeral *Seinfeld*, perhaps change is possible.

The idea for this book arose from my concern that vital international stories are misrepresented in the United States; they are undervalued, overvalued or even unnoticed by the news media and by the public. But what turned this book into a passion was the occurrence of two events which on their face seemed completely unrelated to the topic of compassion fatigue. Those two events were the births of my two children. So many of the stories I write about in this book have children as leading figures. Before I had my own, children were a rather abstract premise to me. Now as I do research about tragedies in far-off places, I grieve for the mothers and the children who are too often the sacrificial pawns in power games in which they have no investment. And I grieve more because too

often their suffering or their deaths do not even rate a line of black ink in the columns of America's newspapers. Does my new-found engagement make me too partisan a critic? I don't believe so. I believe it makes me human.

I have learned, thankfully, that others, too, are not all George Costanzas. To my great benefit, there are many who do care very deeply about "news about China." And an astonishing number of people have helped me to make my case about the problems the media has in telling such stories — although, I hasten to add, any mistakes or errors in judgment present in this book are all my own doing.

The counsel and collegiality of many at Brandeis University gave me a supportive environment in which to write. Joyce Antler, Jerry Cohen, Larry Fuchs and Steve Whitfield, all supported me and helped me carve out the time I needed in order to complete the manuscript. The awarding to me of a Bernstein fellowship and a Mazar grant enabled me to take a semester off and pour all my energies into the research and writing of this work. My assistants, too, over the years, gave unstintingly of their time, both relieving me of some of my administrative load so that I could spend more time on the book and helping me with some of the unglamorous research or the transcription of interviews that were so essential to me. I have been fortunate to work with such people as Becca Klein, Michelle Jaeger, Jenna Ivers, Pierre Cenerelli, Mitt Beauchesne and Jenni Ratner. Darra Mulderry put much effort into a first-rate index; and Angelina Simeone as the departmental administrator is in a class by herself, and in my estimation has been both an invaluable friend and an incomparable resource at all times. Students, too, have been uncommonly supportive of me and of my work — even when they have been guinea pigs for me as I have tested out my arguments in the classroom. To mention one is to omit too many others who have kept me excited and enthusiastic about the subject, but I do need to thank two students who became not only friends but themselves teachers — the specific nature and caliber of their work informed me and has informed this book: Miriam Wasserman and Justyna Pawlak. I hope my other students who have become my friends over the years will understand that I am unable to thank all of them by name here in this small space, and will understand that their contributions to my professional and personal life have been immense.

This book would have been quite literally impossible to write if numerous foreign editors, reporters, photo editors and photographers hadn't allowed me the opportunity to gain a glimpse into their lives so that I could better understand how international affairs are translated into news. I would like to especially thank Allen Alter, Larry Armstrong, Carroll Bogert, Malcolm Browne, Jackson Diehl, Michael Getler, Robert Greenberger, Bernard Gwertzman, Peter Herford, Karen

Elliot House, Robert Kaiser, Tom Kent, Lee Lescaze, Simon Li, Chuck Lustig, Bob Martin, Susan Meiselas, Walter Mossberg, Tom Palmer, Karsten Prager, Mark Seibel, Alvin Shuster, John Simpson, Bill Small, Juan Tamayo, John Walcott and Jim Yuenger who all gave me—often at short notice—a significant amount of their time and attention and who allowed me to come back to them— on occasion repeatedly—to clarify small points and details that I overlooked in my first round of questioning. I have tried hard not to take their comments out of context and I hope I have not distorted their own analysis of how the media covers the world. For all my criticism of the media, again and again in my interviews with these leading journalists I was impressed by their commitment to principle and their struggle to tell the public the most news possible in the best manner available.

Librarians and archivists too, also went out of their way to help. Maire Holcombe at the CDC tracked down a critical photographic image for me and Verne Gay tracked down some stubborn statistics. And Christine Flaherty, librarian at the Bigelow Free Public Library in Clinton, Massachusetts, bent the rules so I could take home back issues of magazines, making my analysis of their color images immeasurably easier.

As my research made its transition into a manuscript, I turned to rely on the guidance of other engaged journalists and scholars. Numerous readers gave me invaluable assistance, prodding me to further clarify my points or to make further connections among seemingly disparate issues. Daniel Aaron, Steve Ansolabehere, Malcolm Browne, Lance Lindblom, Samantha Power, David Shapinky, Anne-Marie Slaughter, Bill Small, Rob Snyder and John Stilgoe all helped me to ask the right questions at the right time. They taught me, too, in their own areas of expertise, making my book incomparably richer. Joyce Seltzer, at a critical moment, helped me hone my argument. My editor Bill Germano poured his energy and his intellect into it. His direction made a significant difference—as did the help of Lai Moy and Nick Syrett. Susan Meiselas, a friend and a continuing inspiration, remained throughout the years of this project one of the few who had an instinctive understanding of what I was trying to accomplish, and who, through both example and exhortation, helped me realize it. Carl Mydans continues at age 91 to be one of the lights of my life; he and his wife Shelley are exemplars of the best of journalism—and the best of humanity. And I can find no higher accolade than to say that Peter Herford will always be my archetype of a true gentleman and a true scholar-journalist—generous and brilliant.

Every year of my life I have been supported and encouraged by my mother and father. When this manuscript was finished my mother, who was visiting,

stayed up all night to read it. My father did similarly on another occasion. Their interest and pride in my work have been a tremendous source of strength for me. My success in great measure is merely a reflection of what they have accomplished; my achievements flow ineluctably from theirs.

Friends have also been a keen source of support. Donna Pavlin gave me the time I needed to work away from my children, and made me believe that they were as well loved and cared for as if I had been with them every minute. Edgar James and Kathy Kinsella, Karin Kiewra and John LaBine, Michele Ward and Ken Hoffman and Shanti Fry and Jeffrey Zinsmeyer all aided me in the innumerable little ways that are almost invisible at the time, but that in the aggregate are invaluable. I monopolized their attention on the telephone or sat at their tables while they poured into me the energy I needed to continue — in the form of both stimulating conversation and refined sugar products. And whatever large or small favors I asked of Michele Gammer and Andy Salter and Nina Kammerer and Rick Parmentier I never heard the word "no." Late-night pizzas or late-night legal advice were cheerfully dispensed along with liberal encouragement and a hand with diaper changing.

If there is a single person who has made this book possible it has been my husband Richard. There is, of course, no way I can repay the debt that I owe him for his love and care, except to say that this book is a poor and only partial payment for the dinners he made and the dinners I missed, for the children put to bed and the children shepherded downstairs in the morning as I lay asleep after another late night at the computer. Thank you.

Finally, I have been blessed with the presence of two amazing children, who can't possibly realize how much they have enriched my life. In moments of crisis, one or the other of them has patted me on the shoulder and said, "It's all right, Mommy, it's all right." And then paused a beat and followed it up with "Now come and read a book." And in moments of joy, their smiles and laughter have made my heart sing.

INDEX